Richard Ettinghausen Oleg Grabar
Marilyn Jenkins-Madina

Islamic Art and Architecture
650–1250

Yale University Press
New Haven and London

For Maan
Henry, Olivia, and Margaret
and to the memory of Richard Ettinghausen

Copyright © 2001 Oleg Grabar, Elizabeth Ettinghausen, and
Marilyn Jenkins-Madina

10 9 8 7 6 5 4 3

Some sections of this book were previously published in *The Art
and Architecture of Islam 650–1250* by Penguin Books Ltd, 1987

Set in Ehrhardt by Best-set Typesetter Ltd, Hong Kong
Printed and bound by CS Graphics, Singapore

Designed by Sally Salvesen

LIBRARY OF CONGRESS CATALOGING-IN-PUBLICATION DATA

Ettinghausen, Richard.
 Islamic Art and Architecture 650-1250 / Richard
Ettinghausen, Oleg Grabar, Marilyn Jenkins-Madina.– 2nd ed.
 p. cm. (Yale University Press Pelican history of art)
Includes bibliographical references and index.
 ISBN 0-300-08867-1 (cloth : alk. paper) –- ISBN 978-0-300-
08869-4 (alk. paper)
 1. Art, Islamic. 2. Architecture, Islamic. 3. Art, Medieval—
Islamic Empire. 4. Architecture, Medieval—Islamic Empire. I.
Grabar, Oleg. II. Jenkins-Madina, Marilyn, 1940– III. Title.
IV.Series.
N6260 E79 2001
709´.17´67109021—dc21

 00-043769

TITLEPAGE: Detail of a *Minbar* of bone and various species of
wood from the Kutubiyya Mosque, Marrakesh, begun 532/1137.
Badiʿ Palace, Marrakesh

Maps

pages XII–XIII	The Islamic World
12–13	Central Islamic Lands in Early Islamic Times
80–81	Western Islamic Lands in Early Islamic Times
102–03	Eastern Islamic Lands in Early Islamic Times
136–37	Eastern Islamic Lands in Medieval Islamic Times
184–85	Central Islamic Lands in Medieval Islamic Times
266–67	Western Islamic Lands in Medieval Islamic Times

Contents

Preface to the Second Edition VII
Preface to the First Edition X
Chart of the Principal Dynasties XI

INTRODUCTION

1. *The Rise of Islam and the Artistic Climate of the Period* 3

PART ONE: Early Islamic Art and Architecture (*c.*650–*c.*1000)

Prologue: *Historical and Cultural Setting* 10

2. *Central Islamic Lands* 15
 Architecture and Architectural Decoration 15
 The Art of the Object 59
 The Art of the Book 73
 Conclusion 78

3. *Western Islamic Lands* 83
 Architecture and Architectural Decoration 83
 The Art of the Object 91
 The Art of the Book 98
 Conclusion 100

4. *Eastern Islamic Lands* 105
 Architecture and Architectural Decoration 105
 The Art of the Object 116
 The Art of the Book 128
 Conclusion 129

PART TWO: Medieval Islamic Art and Architecture (*c.*1000–1250)

Prologue: *Historical and Cultural Setting* 133

5. *Eastern Islamic Lands* 139
 Architecture and Architectural Decoration 139
 The Art of the Object 165
 The Art of the Book 181
 Conclusion 182

6. *Central Islamic Lands* 187

 Part I The Fatimids in Egypt, Palestine, and Syria

 Architecture and Architectural Decoration 187
 The Art of the Object 201
 The Art of the Book 211
 Conclusion 212

 Part II The Saljuqs, Artuqids, Zangids, and Ayyubids in Iraq, Anatolia, Syria, Palestine, and Egypt

 Architecture and Architectural Decoration 215
 The Art of the Object 243
 The Art of the Book 257
 Conclusion 264

7. *Western Islamic Lands* 269

 Architecture and Architectural Decoration 269
 The Art of the Object 274
 The Art of the Book 285
 Conclusion 288

CONCLUSION: The Impact of Islamic Art

8. *Islamic Art and non-Muslims* 291

List of the Principal Abbreviations 303
Notes 304
Bibliography 329
Glossary 338
Index 339

Preface to the Second Edition

However much admiration can and should be legitimately bestowed upon the many volumes of the *Pelican History of Art* inspired by the late Sir Nikolaus Pevsner since the foundation of the series in 1953, readers' expectations regarding the appearance of books dealing with the arts have greatly changed during the last decades. When the series was taken over by Yale University Press in 1992, a new format was introduced, colour illustrations were added, and, without loss in seriousness of content, something of the stodginess of the earlier tomes disappeared. The volume on Islamic art and architecture after 1250, by Sheila Blair and Jonathan Bloom (1994), shone by comparison with its predecessor and, prompted by John Nicoll, the director of Yale University Press in London, a new version of the Ettinghausen–Grabar volume seemed in order. Marilyn Jenkins-Madina, Research Curator of Islamic Art at the Metropolitan Museum of Art in New York, a former student as well as long-time colleague of Richard Ettinghausen, was invited to revise and expand the sections dealing with the decorative arts and with the arts of the book which had initially been written by Ettinghausen. Dr Jenkins-Madina would like to thank Philippe deMontebello, Director, Metropolitan Museum of Art, for lending his personal support and that of the Museum to this project. Oleg Grabar undertook to review, rewrite, and occasionally expand the sections on architecture which he had authored in the first edition.

As we began to plan our work, we realized that much concerning our knowledge and understanding of early Islamic art had changed since 1983–85, the years when the first edition was finally put together, and even more so since 1959, when the structure and plan of the book were set out. Explorations, excavations (published or not), doctoral dissertations all over the world, and exhibitions with learned catalogues have multiplied. Some thirty Departments of Antiquities and academic institutions of different sorts put together newsletters, bulletins, checklists, occasionally even longer studies which contain much information about known, unknown, or obscure remains. Thematic, regional, or temporal monographs have introduced new definitions of periods or proposed new groupings of objects and made it unnecessary to argue anew reasonable, if not always accepted, conclusions in otherwise accessible books. Even though different in scope and expression, several good, succinct books now exist which can introduce any reader to the study of Islamic art. All these achievements of a generation of active scholarship in the history of the field compelled us to review the special needs of a volume which was to cover large areas and periods of time and yet was not meant to be simply an introduction.

In doing so, we took into account the fact that the fields of political, social, and cultural studies have been affected by an even more spectacular number of publications of hitherto unknown written sources, new interpretations, debates with or without generally accepted conclusions, and new sensitivities to cultural explanations and judgments. It became clear to us that it would be impossible to become aware of and responsive to all these conclusions and to the discussions which led to them. If a scholarly consensus exists today on the formation and growth of Islamic civilization during the first six centuries of its existence, it is not the same consensus as was operative thirty years ago. Thus it became evident that the very sequence of the first edition's table of contents – The Caliphate, The Breakdown of the Caliphate, The Eleventh to Thirteenth Centuries – reflected an understanding of the first six centuries of Islamic art and history in terms which may have been justified a generation ago, but which no longer corresponds to contemporary views of these centuries. Some regions, such as the Arabian peninsula or Yemen, were neglected in the first version, while some periods, like the complicated time of feudal rule in twelfth- and thirteenth-century Syria, Iraq, Anatolia, and the Muslim West had not received sufficient attention.

A special problem was posed with respect to surveys and excavations and to the information that new archeological methods like photogrammetry, statistics, or spectographic analyses provide. These have brought to light, especially for the earlier centuries of our survey, many traces of hitherto unknown Islamic settlements, Islamic levels at long-lived sites of habitation, thousands of ceramic types and sequences essential for reconstructing or, at least, imagining the material culture of the time. It was not possible to include all this information, and we chose our examples, for the most part, from among works of some aesthetic or historical merit, leaving to others or to other occasions the task of assessing the immense documentation provided by archeology. Another difficulty was raised by the many repairs and restorations which have affected buildings nearly everywhere. The result was often that the present appearance of a building does not correspond to whatever description and photographs we provided. Many of the repairs were basically maintenance work connected with excellent archeological investigations; often, as in Isfahan or Jerusalem, the original state of a building was revealed. But, in other instances such as the rehabilitation of Fatimid buildings in Cairo, major overhauls took place which provided some buildings with a truly 'new' look. Our illustrations and comments do not necessarily prepare the reader for the present state of some monuments. In spite of many efforts by architects and restorers to use care in their work, local needs, means and ambitions are sometimes out of tune with historical accuracy.

Three major changes have been introduced. The first one involves the overall plan and organization of the book. Without altering the principle of a *history*, i.e. a chronological development, of the arts in lands dominated by Islam and by Muslim power, we have divided these six centuries into two broad chronological categories: Early Islamic (roughly 650 to 1000) and Medieval Islamic (roughly 1000 to 1250). The justifications for the divisions and some elaboration of their historical and cultural characteristics are provided in the prologue to each section. We realized the difficulties

involved in using dynasties as the primary criterion of periodization within each category, because too many among them overlapped geographically and also because they often shared the same general culture as well as artistic taste. We have, therefore, organized the monuments according to regions and divided the Muslim world into three areas: western (from the Atlantic to Libya), central (Egypt through the Mesopotamian valley), and eastern (from the Zagros and eastern Anatolian mountains to the Indus and the Tarim basin in Central Asia). We recognize that, like all divisions of cultural zones, this one is in part arbitrary, but it seemed to us better suited than political ones and more manageable than if we had sliced time periods across the entire Muslim world. At the end of each chapter we have provided a summary of such art historical, stylistic, or expressive categories as seemed applicable to a given area at a given time; occasionally, we have suggested avenues for further research.

The wealth of available information and the first steps toward a critical discourse on Islamic art make it possible to handle its history with a greater theoretical sophistication than was possible only a couple of decades ago. To these organizational divisions we made one partial exception. The rich and brilliant period of the Fatimids (909–1171) could not, we felt, be cut into separate temporal or regional components in order to fit into our broad order of Islamic history. It belongs to the Muslim west as well as to the area of central lands and it flourished during a period covered by both of our broad categories. We ended by putting most of its art in the Medieval Islamic section and in the central lands for reasons that will be explained in due course, but some early Fatimid objects are discussed under western Islamic lands in the earlier period. This is, no doubt, a shaky accommodation to a reluctant history.

Second, we modified the presentation of the arts in two significant ways. One was to give up the Vasarian notion of painting as a separate and idiosyncratic genre and, instead, to integrate mural painting with architectural decoration and to consider manuscript illuminations and illustrations, as well as calligraphy, within the wider category of the art of the book. We also introduce the category of 'art of the object', rather than 'decorative arts', in order to reflect a reality of early and medieval Islamic art rather than a hierarchy of techniques developed for western Europe. Except for Chapter 7, the presentation of the art of objects is arranged by media. The other modification is the inclusion of a new section devoted to the impact of Islamic art on the creativity of non-Muslims within the Muslim realm and especially on the artistic output of the neighbours of the Muslim world or on that of those, often remote, areas which were attracted by certain features of Islamic art. It seemed to us that such particular aspects of Armenian art or of the art of Norman Sicily which are, quite correctly, associated with Islamic art are better understood first within the context of their own culture rather than as occasional instances of 'floating' or 'marauding' influences. A major feature of medieval culture in general would be missing if the impact, however strong or weak, of forms and ideas issuing from the Muslim world were either ignored or separated from their non-Muslim setting.

Third, in an attempt to broaden the picture of the artistic production of each major area, objects representing as many media as possible have been discussed and illustrated. In addition to providing a wider scope, an endeavour has also been made here to incorporate as many dated and datable objects as possible as well as those with an intrinsic provenance in order to establish secure foundations around which other, similar but less well documented, objects can be grouped. This has entailed eliminating certain illustrations from the earlier edition and adding many others, a number of which are now in colour. The captions for these illustrations reflect only what is unequivocally known about the work depicted, e.g. materials, technique, intrinsic date or firmly datable time of execution, and specific place of manufacture. The notes refer to most of the immediately pertinent literature and occasionally include alternative views and opinions or discussions of technical issues. The bibliography is an attempt to make a truly useful instrument for further work. After much hesitation, we decided that, since the text is primarily chronological and geographical, the bibliography should be thematic according to media. A glossary picks up and defines all words which are not common in English or which are particularly important to Islamic practices.

Thus, even though in practice many paragraphs and pages of the first edition have been preserved, the changes we have introduced in the presentation of the monuments are major indeed. Even if inspired and affected by the first edition of this book, this is in fact a new book. The present work illustrates an approach to Islamic art which focuses on the cultural and artistic evolution of numerous regional centers from the great hubs in the central Islamic lands in the seminal early Islamic period and on the wealth of ways of creating a beautiful environment rather than on the assumption of a single visual ideal which would have found different local expressions. The tension between these two approaches should be a creative one. A later edition, by new writers, may indeed return to a greater dose of pan-Islamic unity or, in all likelihood, will require separate volumes to treat the ever expanding knowledge we have of the arts of Muslim peoples. In the meantime we do acknowledge the presence of an occasional awkwardness in the contrast between different styles of writing.

For transliterations from Arabic and Persian, we have omitted all diacritical marks in the text except for direct quotations from the original language. Full transliterations appear in the glossary. Most of the time proper names of people or of places or words like *mihrab* which are in most dictionaries are spelled according to their common English usage. We have made an exception for the book of Muslim Revelation and written Qur'an instead of the Webster-accepted Koran. We have tried to eliminate all references to the 'Near or Middle East', to the 'Orient', or to the 'Levant'. We sought to identify regional spaces in their own terms rather than from an external, western European, point of view. The noun 'Islam' is used to mean either a faith and its doctrine or, more rarely, the whole culture covered in this book. The adjectives 'Islamic' and 'Muslim' are used interchangeably. We limited the use of the word 'Turkish' to matters pertinent to the contemporary land and people of Turkey; 'Turkic' is applied to all other appro-

priate instances. All dates are given according to the Common Era (or *A.D.* as it used to be); where there are two dates separated by a slash, the first is the *hijra* date according to the Muslim lunar calendar which begins in 622 *C.E.*

The two living authors want to acknowledge, first of all, their debt to the third, Richard Ettinghausen, who was their teacher, mentor, colleague, and friend. Dr Elizabeth Ettinghausen continued to help in the making of this book, as she had done with the first version; the suggestions resulting from the astute care with which she read most of the drafts helped to improve them and her interest in all aspects of this publication is gratefully acknowledged. Several colleagues – Renata Holod, Linda Komaroff, Maan Z. Madina, Larry Nees, Megan Reed – read whole chapters and made useful comments for which we are truly grateful. Others – James Allan, Sumer Atasoy, Naci Bakirci, Michael Bates, Sheila Blair, Jonathan Bloom, Linda Fritzinger, Abdallah Ghouchani, Rosalind Haddon, Rachel Hasson, Nobuko Kajitani, Charles Little, Louise Mackie, Abd al-Razzaq Moaz, Gönul Öney, Nasser Rabbat, Scott Redford, D. Fairchild Ruggles, George Scanlon, Priscilla Soucek, Yassir Tabbaa, Antonio Vallejo Triano, Oliver Watson, Donald Whitcomb, Aysin Yoltar, – sent comments or answered queries with a sense that this book will also become theirs, as they had been influenced by their own use of the first edition.

Without two young scholars, the work simply could not have been completed. Dr Cynthia Robinson, Oleg Grabar's assistant during the years of writing this book, put on diskettes the original text which had been published in the pre-computer age, searched libraries for accurate references, helped edit whole sections by cutting up long sentences, prepared the initial bibliographical survey which we eventually simplified, and supported Marilyn Jenkins-Madina with vigour and enthusiasm in her argument for the independence of western Islamic culture. Jaclynne Kerner was first given the difficult task of co-ordinating and numbering illustrations gathered by three authors; she accomplished this task with true brilliance. She was then responsible for the making of the glossary, the collation of data for the maps, the maintenance of consistency in spelling, and the final bibliography. Finally, we would like to acknowledge the hard-working, creative, friendly, and co-operative spirit with which we operated together and surmounted occasional disagreements. Different from each other in knowledge, temperament, and professional experience, we enriched each other when trying to amalgamate into a single text statements written at different times and involving different attitudes towards the history of art.

Technical and financial support was provided by the following institutions and individuals: The Institute for Advanced Study in Princeton; The Metropolitan Museum of Art in New York; The Barakat Foundation; Hess Foundation, Inc.; Mr and Mrs James E. Burke; and Dr Elizabeth Ettinghausen.

The immense task of gathering illustrations was, as had been the case with the first edition, in the imaginative hands of Susan Rose-Smith. We owe her a great debt of gratitude, especially when one considers the roughly 28 countries from which photographs were required. Without the constant and competent help of Mary Doherty, of the Metropolitan Museum of Art, the task could not have been completed with ease. We also want to thank the staff of Yale University Press, an anonymous reader with important comments and suggestions, many of which we tried to follow, John Banks, who read the text with patience and care, Sally Salvesen, who supervised it all, and John Nicoll, with whom the first discussions about a new edition of the book were held.

OLEG GRABAR and MARILYN JENKINS-MADINA

Preface to the First Edition

It was in 1959 that the late Professor Richard Ettinghausen asked me to collaborate with him on a Pelican volume devoted to Islamic art. Over the following five or six years, we planned the book and wrote a great deal of it. But somehow, when we had in fact completed nearly every chapter up to the Mongol conquest of the thirteenth century, other pressures and commitments took over and the book remained unfinished. At that time it was difficult to argue that a presentation of Islamic art required more than one volume. Over the past twenty-odd years, however, a considerable amount of new information, some imaginative scholarship, a deepening specialization within the study of Islamic art, and especially a greater interest in the the world of Islam in general has warranted the decision to deal separately with the properly medieval Muslim art up to *circa* 1260, on the one hand, and the centuries of the great empires, on the other.

The basic framework for this first volume was ready and all that was needed was to bring up to date chapters written sometimes over twenty years ago, to choose new and additional illustrations, and to improve the technical apparatus. Dr Sheila Blair and Dr Estelle Whelan agreed to help in the accomplishment of these tasks and for much of the merit of the work I am in their debt. They looked at texts written long ago with a sense of new requirements and an awareness of new scholarship; they decided on appropriate illustrations and especially were always available when help was needed. I must also record the good-humoured and charmingly competent Judy Nairn and Susan Rose-Smith, the pillars of the series, without whose patience and devotion this book would not have been completed. On a more personal note, I would also like to record the constant support and concern of Dr Elizabeth Ettinghausen.

Professor Ettinghausen and I had from the very beginning conceived of this book as a survey and as a manual, not as a vehicle for speculation and for broad cultural interpretations. The point of a survey is to provide, as clearly and interestingly as possible, the basic information on the monuments of an artistic tradition, to suggest something of the major unresolved scholarly issues; although possibly incompletely and erroneously in serveral places, I trust that this objective has been met. The point of a manual is to make it possible for students and readers to pursue such questions as may interest them; much of this possibility lies in the notes and in the bibliography derived from them. The latter, with some omissions no doubt, is meant to reflect the state of the field until 1985. Throughout our concern has been historical, to identify and explain what happened in specific areas at specific times. Without denying the value of the interpretative essays on Islamic art cutting across regions and periods which have become so popular over the past decades, our position is simply that this is not what this book set out to do. It is a traditional history of the art of a culture – something, curiously enough, which has, with a few short and unsatisfactory exceptions, not been attempted for Islamic art since the twenties of this century.

It is not, I suppose, possible to dedicate a book to the memory of one of its authors, Yet in this instance I do want to do so and to recall the memory of Richard Ettinghausen. I do so first of all on a personal level, in order to record how much I have owed to him over the years and to express my gratitude to him for having trusted someone who was not even thirty years old then with the task of helping him with a survey of Islamic art. And then it is only fitting to recall that, after the generation of the great pioneers in Islamic art (Max van Berchem, Ernst Herzfel, Ernst Kühnel, Thomas Arnold, Georges Marçais), it was Richard Ettinghausen and the only slightly older Jean Sauvaget who charted the new directions taken by the study of Islamic art towards an understanding of the cultural meanings of objects and of monuments of architecture and towards precise definitions of the characteristics of specific times and places. This book, I trust, reflects the directions.

OLEG GRABAR

Chronological chart of the principal dynasties

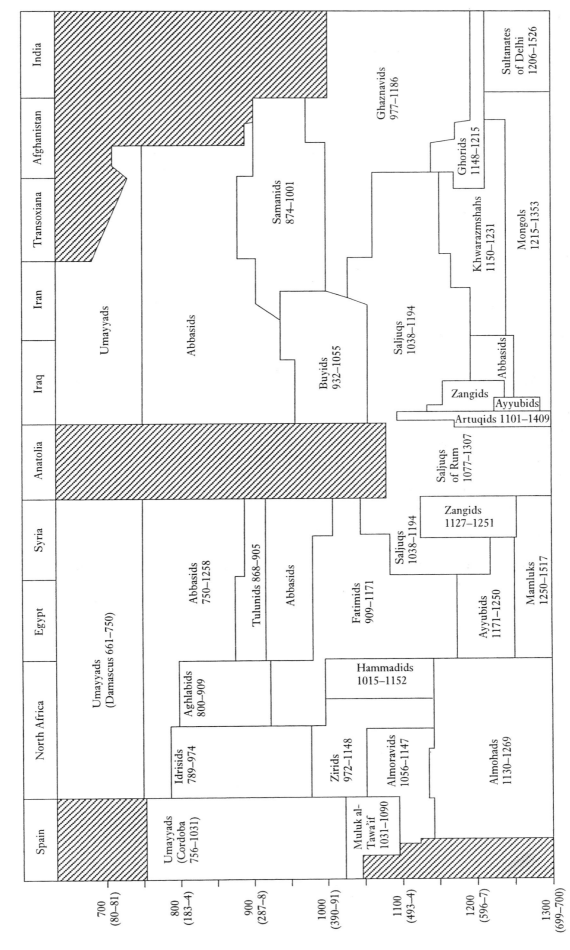

India	Sultanates of Delhi 1206–1526	
Afghanistan	Ghaznavids 977–1186	Ghorids 1148–1215
Transoxiana	Samanids 874–1001	Khwarazmshahs 1150–1231 / Mongols 1215–1353
Iran	Abbasids / Saljuqs 1038–1194	
Iraq	Umayyads / Buyids 932–1055	Zangids / Abbasids / Ayyubids / Artuqids 1101–1409
Anatolia		Saljuqs of Rum 1077–1307
Syria	Abbasids 750–1258 / Abbasids	Saljuqs 1038–1194 / Zangids 1127–1251
Egypt	Tulunids 868–905 / Fatimids 909–1171	Ayyubids 1171–1250 / Mamluks 1250–1517
North Africa	Umayyads (Damascus 661–750) / Aghlabids 800–909	Hammadids 1015–1152
	Idrisids 789–974 / Zirids 972–1148	Almoravids 1056–1147 / Almohads 1130–1269
Spain	Umayyads (Cordoba 756–1031)	Muluk al-Tawā'if 1031–1090

700 (80–81)
800 (183–4)
900 (287–8)
1000 (390–91)
1100 (493–4)
1200 (596–7)
1300 (699–700)

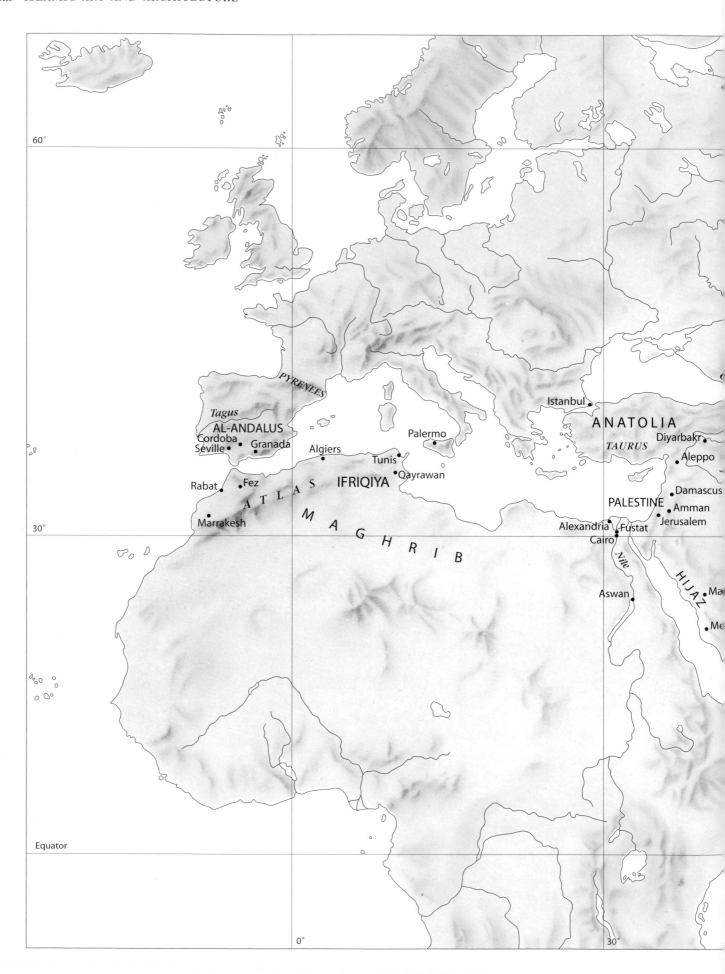

60°

PYRENEES

Tagus

AL-ANDALUS

Cordoba
Seville • • Granada

Palermo

Algiers
Tunis
Qayrawan

Rabat • • Fez

ATLAS IFRIQIYA

MAGHRIB

Marrakesh

30°

Istanbul

A N A T O L I A

TAURUS

Diyarbakr

Aleppo

Damascus

PALESTINE Amman

Jerusalem

Alexandria Fustat

Cairo

Nile

HIJAZ Ma

Aswan

Me

Equator

0° 30°

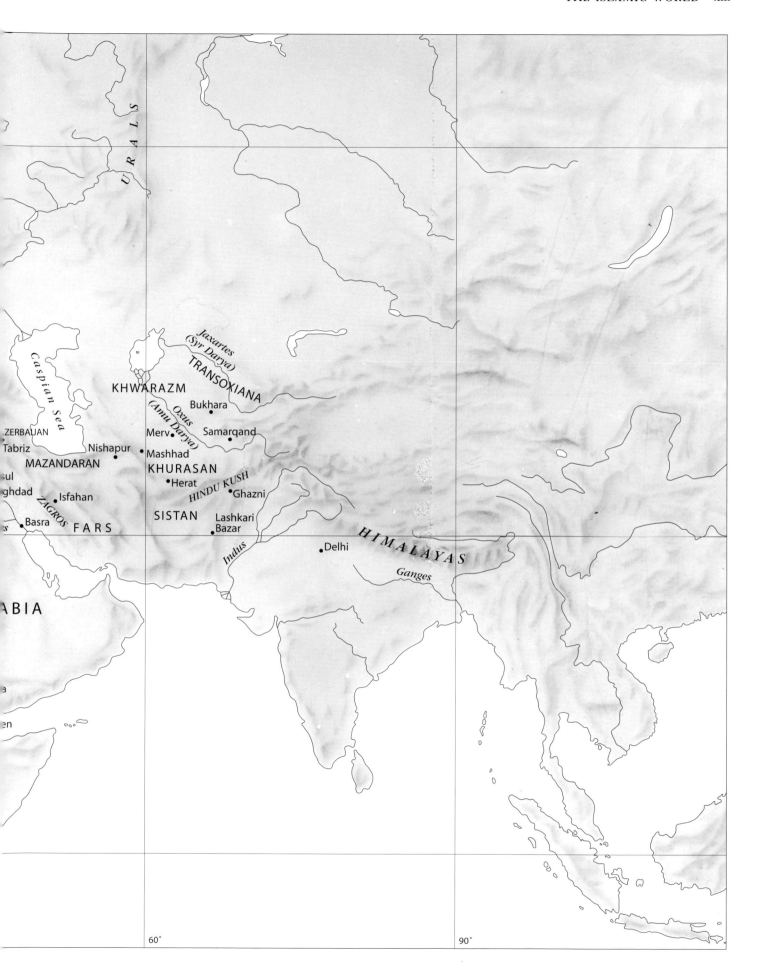

URALS

Caspian Sea

Jaxartes
(Syr Darya)

TRANSOXIANA

KHWARAZM

Bukhara

Oxus
(Amu Darya)

ZERBAIJAN

Tabriz

Nishapur

Merv

Samarqand

Mashhad

MAZANDARAN

KHURASAN

Herat

HINDU KUSH

sul

ghdad

Isfahan

Ghazni

ZAGROS

SISTAN

Lashkari
Bazar

Basra

FARS

Indus

Delhi

HIMALAYAS

Ganges

ABIA

a

en

60°

90°

INTRODUCTION

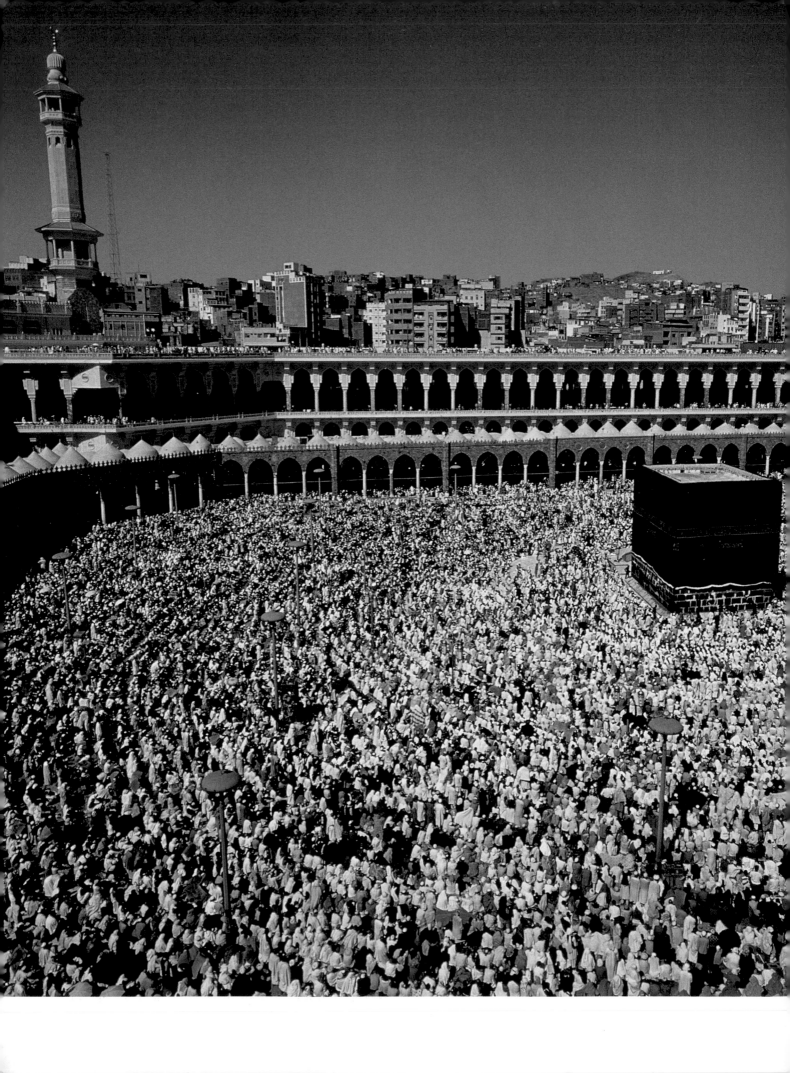

The Rise of Islam and the Artistic Climate of the Period

A great deal of occasionally acrimonious confusion surrounds the use and meaning of the word 'Islamic' when applied to art. The origins of the adjective lie clearly in the faith of Islam, about which more will be said presently. But, when applied to art, it refers to the monuments and remains of material culture made by or for people who lived under rulers who professed the faith of Islam or in social and cultural entities which, whether themselves Muslim or not, have been strongly influenced by the modes of life and thought characteristic of Islam. 'Islamic', unlike 'Christian', identifies not only a faith but also a whole culture, since – at least in theory – the separation in the Gospels of the realm of Caesar from that of God is not applicable to Islam. Also unlike Christianity, Islam did not develop first as the faith of a few, increasing the numbers of its adherents under the shadow of a huge state alien to it, slowly developing the intellectual and artistic features which would characterize it, finally to blossom centuries later into an empire and giving birth to an art as well as a philosophy and a social doctrine.

In the Islamic case, these developments were telescoped into a few decades of the seventh and eighth centuries C.E. In 622, the year of the Hijra, when the Prophet Muhammad left Mecca to found the first Islamic state in Madina (originally, Madina al-Nabi, 'the town of the Prophet', ancient Yathrib), a handful of followers from the mercantile cities of western Arabia constituted the entire Muslim community, and the private house of the Prophet was their only common, political and spiritual, centre. But by 750 Arab Muslim armies had penetrated into southern France, crossed the Oxus (Amu Darya) and the Jaxartes (Syr Darya) in Central Asia, and reached the Indus. The first Islamic dynasty, the Umayyads, had come and gone. New cities had been created in North Africa, Egypt, and Iraq. The Dome of the Rock had been built in Jerusalem, while also in Jerusalem, as well as Damascus, Madina, and many other cities, large and small mosques had been erected as gathering places for prayer as well as to strengthen the political and social ties which bound the faithful together. Dozens of splendid palaces had been scattered throughout the lands of the 'Fertile Crescent', the lands of Mesopotamia and the Syro-Palestinian coast. In other words, Islamic art did not slowly evolve from the meeting of a new faith and state with whatever older traditions prevailed in the areas over which the state ruled. Rather, it came forth almost as suddenly as the faith and the state, for, whatever existing skills and local traditions may have been at work in the building and decoration of early Islamic monuments, their common characteristic is that they were built for Muslims, to serve purposes which did not exist in quite the same way before Islam.

In order to understand this art and the forms it created as well as the way it went about creating them, it is necessary to investigate first whether the Arabs who conquered so vast an area brought any specific tradition with them; second, whether the new faith imposed certain attitudes or rules which required or shaped artistic expression; and, finally, what major artistic movements the Muslims encountered in the lands they ruled.

Written information about pre-Islamic Arabia is not very reliable, because it is almost always coloured by later prejudices downplaying the heritage received by medieval Islam from the 'jahiliyya', the 'time of ignorance' which preceded the advent of Islam. It is, however, likely that the full investigation of texts like al-Azraqi's *Akhbar al-Makkah* ('Information about Mecca,'), written in the ninth century C.E. when many pre-Islamic practices and memories were still alive, will yield a great deal of information on the religious and other ways of pre-Islamic Arabia and on the spaces needed for their expression.[1] A serious archeological exploration of the area has only begun in recent decades with a few surveys and some excavations, the most notable of which is that of al-Faw in southwestern Arabia.[2]

It has generally been assumed that, at least in the period immediately preceding the Muslim conquest, the Arabs of Arabia had very few indigenous artistic traditions of any significance. The Ka'ba in Mecca [1], the holiest sanctuary of Arabia, was the shrine where tribal symbols were kept for the whole of Arabia. It was a very simple, nearly cubic building (10 by 12 by 15 metres), for which a flat roof resting on six wooden pillars was built around the turn of the seventh century, according to tradition, by a Christian Copt from Egypt. Its painted decoration of living and inanimate subjects, whatever their symbolic or decorative significance may have been, was also in all probability an innovation of the early seventh century under foreign influences.[3] If the most important and best-known building of Arabia, venerated by practically all the tribes, lacked in architectural quality, it is probable that the other sanctuaries for which we have references in texts were even less impressive.

With respect to secular arts, our information is even slimmer. No doubt the wealthy merchants of Mecca and the heads of other settled communities had palaces which showed their rank and wealth,[4] but the only private house of Arabia which has acquired some significance and about which much more will be said later, the house of Muhammad in Madina, consisted of a simple square court with a few small rooms on the side and a colonnade of palm trunks covered with palm leaves. Nor do we know much about the artefacts, metalwork, or textiles which must have been used by the inhabitants of Arabia in the first centuries of our era. Were they of local manufacture or imported? The excavations at al-Faw brought to light a fairly rich array of objects brought in from the Mediterranean area, some possibly of Indian origin, and several enigmatic fragments

1. Mecca, Ka'ba

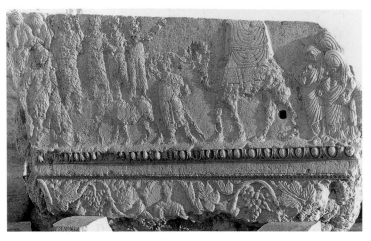

2. Palmyra, temple of Bel, relief, first century

of paintings. But the archeological record is too meagre to draw too many conclusions, and the dominant ideal of life, that of the nomad, held the artisan in low esteem.[5] This contempt need not have carried over to the artisan's work, but pre-Islamic Arabic legend does not appear to have given to manufactured objects the attention it lavished on horses, and there is no trace of the specific attachment to a sword or armour found in classical, Iranian, or western medieval epics.

This impression of poverty in the artistic development of pre-Islamic Arabia must be tempered by the paucity of excavations and explorations, and by the very spotty study of literary documents.[6] But the lack of remains or descriptions should not obscure the fact that the religious, intellectual, and social milieu out of which Islam grew espoused concepts and modes of thought and behaviour which exerted an influence on the development of the faith and of its art. For instance, in Mecca and a number of other oases we find the ancient Semitic notion of a *haram*, i.e. of an area, often quite large, physically mapped out in a more or less crude fashion, which was both holy and forbidden except to certain people and at certain times. The word *masjid* (a place for prostration, whence 'mosque') is also of pre-Islamic origin. In the rather simple religious ceremonies of the pre-Islamic Arabs, the symbol of the divinity was often placed in a tent, at times referred to as *qubba* (dome), or covered by a cloth on an apparently domed frame, as can be seen on a well-known Palmyrene relief [2].[7] The *mihrab*, later a characteristic element of the mosque, was the hallowed part of a religious or secular institution.[8] These and other examples show that many of the forms and terms developed by Islam with precise connotations in the new faith and the new civilization already existed in pre-Islamic Arabia, even though they rarely found more than a rudimentary monumental or artistic expression.

In addition to these rather simple notions with few tangible effects, the inhabitants of central Arabia at the time of Muhammad were also conscious of the earlier artistic achievements of Arab rulers in the steppes and the deserts extending from Anatolia to the Indian Ocean. Although the monuments of the Nabateans (in what is now more or less

the modern state of Jordan) and the Palmyrenes (in central Syria) from the first century B.C.E. to the fourth century C.E. seem to have left little impression, three other early Arab cultures made a more lasting impact. One was that of the Lakhmids, an Arab Christian dynasty centred in Iraq which served as a buffer state between the Persians and the Byzantines in the fifth and sixth centuries. Their half-legendary palaces of al-Khawarnaq and Sadir, symbols of a royal luxury unavailable in the Arabian peninsula, counted among the marvels of the world.[9] They introduced a fair number of Iranian features into the Semitic world of the Arabs and, most importantly, even though the matter is still under discussion, it would have been in their capital of al-Hirah, in south central Iraq, that the scripts which led to the common written Arabic would have been developed.

Another civilization which struck the imagination of the Arabs before and on the eve of Islam was that of Yemen, at the southern edge of the peninsula, where the Queen of Sheba was assumed to have lived. In recent years numerous explorations of pre-Islamic and Islamic Yemen have taken place. Their primary emphasis has been on modern and pre-modern times, but, from literary sources as well as from a small number of actual excavations, we know that many centuries before Islam Yemen had developed a brilliant architecture of temples and palaces, together with an original local sculpture.[10] From later legends we know also that Yemeni painters were of sufficiently high repute to be called to the Persian Sasanian court.[11] And by the late sixth century a short-lived Christian domination of the area led to a specifically Christian architecture which, for a long time, remained in the collective memory of Arabs, even if the buildings themselves barely lasted a generation. The high level of South Arabian civilization in general was made possible by an expensive and highly organized system of irrigation symbolized by the Marib dam, the destruction of which (apparently in the late sixth century) was taken as the main cause of the decline of Yemen. Actually, the wealth of Yemen grew from its role in the trade between India and Ethiopia on the one hand and the Mediterranean on the other; in the sixth century much of this trade was diverted to the Persian Gulf. Whilst best known today for its numerous temples, South Arabia is chiefly important because of the appeal of its secular monuments to a later Arab imagination. The tenth-century al-Hamdani's *Antiquities of South Arabia* allows us not so much to reconstruct the architectural characteristics of the great Yemeni buildings (although some of its information can in fact be verified in remaining ruins) as to perceive a half-imaginary world of twenty-storey-high palaces with domed throne rooms, sculpted flying eagles, roaring copper lions, and black slaves guarding the royal house.[12]

The third pre-Islamic Arabian culture of note is that of the Christian Ghassanids, who, as occasional instruments of Byzantine policies, dominated the Syrian and Jordanian countryside as late as the sixth century. Many buildings, secular and religious, which are part of the so-called Byzantine Christian architecture of Syria, such as the *praetorium* in Rusafah, were sponsored by Ghassanid rulers, but the exact nature of their visual identity, if any, is still very vague and no objects or works other than architectural can be attributed to them. Their importance lies primarily in the fact

that they lived in and exploited the areas where the Umayyads settled in the seventh century. There may well have been a direct passage from Ghassanid to Umayyad patronage which makes it often difficult to disentangle one from the other.[13]

Thus the memories of Yemen, of the Lakhmids, and of the Ghassanids kept alive by the legends and poems recited at camp fires or at occasional meetings in the richer oases, fed the minds and the imagination of early Muslims with the vision of a splendid secular art created many centuries earlier by Arabs at the two extremities of the arid desert. Together with the rudiments of symbolic forms found in their religious life, and some awareness of the more expensive techniques of architectural decoration and of the arts of objects, this vision, based on monuments which were, by then, little known, furnished a major component to the making of an Islamic art.

When we turn to those attitudes and requirements which the faith established and which sooner or later influenced Islamic art, a number of difficulties arise. First, our only fully acceptable source for the period is the Qur'an; the Traditions (hadith) which sprang up to supplement or clarify the Prophet's thought are not always reliable as historical documents and the time of their first codification is the subject of much discussion.[14] Second, since such questions did not arise in his lifetime, Muhammad did not rule on or consider problems which immediately affected the arts or artistic activities either in the Qur'an or in his otherwise well-documented actions.[15] Those statements, attitudes, or prescriptions which were eventually of consequence to the arts were not consciously aimed at them. Their identification has therefore to be based, at least in part, on later intellectual commentaries and artistic developments.

As far as later architecture is concerned, the major contribution of early Islam in Arabia was the development of a specifically Muslim masjid (pl. masajid) or mosque. Muhammad took over the ancient masjid al-haram of Mecca and transformed it into the qibla (place towards which prayer is directed) of the new faith (Qur'an 2:144). In addition, every Muslim was enjoined to try once before he or she died to make the pilgrimage to Mecca. The Meccan sanctuary underwent few modifications over the centuries, and very few buildings in Islam attempted to copy it; in general it remained a unique and inimitable centre towards which all Muslims turn to pray.[16] Muhammad also introduced a ritual of individual prayer (salat), a pure act of devotion, to be performed five times a day wherever the worshiper happens to be. On certain occasions however, such as Fridays at noon, it should take place in the masajid Allah (Qur'an 9:17–18, 'the mosques of God'), because, from the time of Muhammad on, a sermon (khutba) on moral, religious, and also political and social themes formed an integral part of the ceremony, and because this was the time and the place when through the leader of prayer (the imam) the Muslim community expressed its allegiance to its rulers. The corollary – an essential point for understanding early Islamic architecture – was that every major Islamic community required a suitable masjid adapted to the size of the community for its religious as well as its political and social functions.

The masajid of Muhammad himself are not really known.

3. Madina, House of the Prophet, 624, reconstructed plan

For certain major ceremonies or feasts the Prophet used to go outside the town of Madina into large musalla(s) (lit. 'places for prayer'), probably ancient holy spaces in most cases. In the town itself the major centre was Muhammad's own house. Modern historians have generally argued that the sudden and rapid development of Muhammad's new faith transformed what started as a private dwelling into a place of worship and of government, and that this was an accidental, not a willed, development. The Prophet himself would have considered his house merely a convenient centre for his manifold activities (cf. Qur'an 33:53, asking the believers not to enter his house at will, although this may have referred to private side rooms only). But numerous later accounts describe it as the first Muslim-built masjid and more recent historiography has argued that its growth, as told in the hadith, is one of a public space acquiring private functions rather than the other way around.

Regardless of the explanation of its origins, this mosque/house or house/mosque was not a very spectacular building. It consisted of a square of sun-dried bricks approximately fifty metres to the side [3]. On the east of the southern part of the eastern wall were rooms (nine of them by 632, when Muhammad died) for the Prophet's wives. On the southern and northern sides short colonnades (suffa) of palm trunks supporting palm branches were erected after complaints about the heat of the sun in the court. On each of the other sides was a door; the southern wall had become the qibla.[17] The Prophet used to lean on a lance near the northern edge of the southern colonnade to lead prayer and deliver sermons. At times he would climb a simple pulpit known as the minbar, a judge's seat in pre-Islamic times which eventually became the symbol of authority in the ceremony of prayer and in all related mosque activities.[18]

Although the reconstruction and interpretation of exclusively written evidence, often hagiographic in character, can be no more than hypothetical, it must be conceded as pos-

sible (in spite of very scanty evidence)[19] that the Prophet eventually built a separate mosque near his house. Literary sources refer to Muslim *masajid* in neighbouring villages or towns,[20] implying a consciousness on the part of the early Muslims that theirs was a new kind of structure, if not in its physical appearance, at least in its purpose of harbouring the believers of the new faith. But, of all buildings mentioned in texts, the only one to have had a great impact on later religious architecture is the very one whose contemporary identification as a *masjid* is least certain. Perhaps the safest hypothesis is that there occurred in Madina between 622 and 632 a coincidence between the accidental development of the Prophet's house into a centre for the faithful and a general idea of restricted sanctuaries for God. With respect to architecture, not much else can be derived from the Qur'an or, for that matter, from most other early textual sources.[21] To be sure, specific Qur'anic texts came to be almost standard in the decoration of certain parts of mosques or other buildings for functions only invented later; for instance, Qur'an 24:35, the beautiful verse evoking God as 'the Light of the heavens and the earth', became common on *mihrabs* many centuries afterwards and a group of three minarets near Isfahan quote Qur'an 61:33, praising those who call men to God. Such later interpretations and uses do not imply a direct impact of the Qur'an or of the Prophet on future Islamic architecture, but the fact that they occurred points to the uniquely Islamic relationship between the Qur'an and buildings.[22]

On the aesthetics of paintings, sculpture, and other arts the Holy Book is silent. Nevertheless it contains a number of precise statements and general attitudes whose impact on later Islamic art was significant. One such is Qur'an 5:93: 'O you who believe, indeed wine, games of chance, statues, and arrows for divination are a crime, originating in Satan.' While the word used here (*al-ansab*) is often translated as 'statue', in fact it refers to idols, many of which were in human form. The same ambiguity exists in a second passage (Qur'an 6:74), in which Abraham chides his father for taking idols in the shape of statues (*asnam*) for gods. While it is uncertain – indeed unlikely – that the Revelation implied a condemnation of representational statuary in these and a number of related passages, its statements are quite unambiguous with respect to idolatry. As we shall see later, at the time of the growth of Islam images had acquired a meaning much beyond their value as works of art; they were symbols of mystical, theological, political, imperial, and intellectual ideas and were almost the equivalents of the acts and personages they represented. Thus, the opposition to idols, a fundamental principle of Islam, when taken in its setting of almost magically endowed images, eventually led to an opposition to representations of living forms. However, this opposition manifested itself principally in architecture and in the arts of the object and the book specifically associated with the religion of Islam. In the secular realm, the figural tradition – which had been so very strong in most of the areas conquered by the Muslims during the seventh century – not only survived (contrary to a common misconception) but continued to develop throughout the period covered by this volume.

The position of Muhammad in Islam also differed radi-

cally from that of most religious reformers: he was but a man and the Messenger of God. No miracles were officially attributed to him, and he constantly reiterated that he could not perform them; he did not undergo a Passion for the salvation of others; except for a few episodes at the beginning of his prophetic life, there was no particular significance attached to the narrative of that life; and even the example of his life was superseded by the doctrine of the Qur'an. Thus, despite the eventual development of a hagiography of Muhammad (probably already by the middle of the eighth century), it never acquired the deep significance given to the lives of Christ or the Buddha, at least not on the level of official Islam. Lacking a specific life as a model of behaviour or as a symbol of the faith, Islam in general and early Islam in particular were little tempted by an iconographic treatment of the Revelation.

Opposition to figurative art was also read into another Qur'anic statement of principle, that of God as the only Creator. 'God is the Creator of everything, and He is the Guardian over everything' (Qur'an 39:62) is but one of the ways in which this creed is formulated. And in view of the almost physically meaningful nature of images at that time, one can understand the often repeated tradition that the artist who fashions a representation of a living thing is a competitor of God and therefore destined to eternal damnation.[23] The one Qur'anic passage referring to the creation of a representational object (3:49) strikingly confirms this point. The meaning of the statement there attributed to Jesus – 'Indeed I have come to you with a sign from your Lord; I shall create for you from clay in the form of a bird; I shall blow into it and it will become a bird, by God's leave' – is clear: not only is this a miraculous event, made possible only through God's permission and for the purpose of persuading people of the truth of Jesus's mission, but the act of bringing to life the representation of a living form was the only possible aim of its creation. Therefore, in many later traditions, on the Last Day the artist will be asked to give life to his creations, and his failure to do so – since God alone can give life – will expose him as an impostor as well as one who assumes God's power.

These and other similar texts were not elaborated, nor were corollaries concerning the arts established, for many decades after the death of Muhammad,[24] and all theologians did not propound the doctrine of opposition to images with the same absoluteness.[25] Yet, from the time of the very first monuments of Islam, Muslims evinced reluctance or shyness with respect to human or animal representation. This attitude manifested itself in an immediate veto in the case of religious art, and a subtler reaction concerning secular art. It is, therefore, incorrect to talk of a Muslim iconoclasm, even if destruction of images did occur later; one should rather call the Muslim attitude aniconic.

The final aspect of the Qur'an's importance to Islamic art is the very nature and existence of the Book. It represents a complete break with the largely illiterate Arabian past. From the beginning, Islam replaced the iconographic, symbolic, and practical functions of representations in Christian or Buddhist art with inscriptions, first from the Qur'an and by extension from other works.[26] Writing not only became an integral part of the decoration of a building, at times even of

an object, but also indicated its purpose. In addition, the greatest possible care was taken over copying and transmitting the divinely directed Book. As a result, calligraphy spread to works other than the Qur'an and came to be considered as the greatest of all arts. For a long time it was the only one whose practitioners were remembered by their names in written sources, thereby rising above the general level of artisanal anonymity.[27]

These four elements – a ritual for prayer to be accomplished by preferences in a mosque, an accidental prototype for the mosque in the house of Muhammad in Madina, a reluctance concerning representation of living beings, and the establishment of the Qur'an as the most precious source for Islamic knowledge and of the Arabic script as the vehicle for the transmission of that knowledge – comprise the most important contributions to the formation of Islamic art during the ten years which elapsed between the Hijra (622) and the death of Muhammad (632). With the partial and possibly controversial exception of Muhammad's house, it is a question largely of moods and attitudes; forms and motifs came almost exclusively from the lands conquered by Islam.

We can summarize briefly the major characteristics of Western Asian art by the middle of the seventh century. All the lands taken over by the Muslims in the seventh century, which formed the core of the Islamic empire, had been affected by the classical art of Greece and Rome in its widest sense. Carl Becker put it succinctly: 'Without Alexander the Great there would not have been a unified Islamic civilization.'[28] The significance of this is twofold. On the one hand, Islamic art, like Islamic civilization and Byzantine and western Christian arts, inherited a great deal from the Greco-Roman world. On the other hand, in varying degrees of intensity, from northwestern India to Spain, a remarkably rich vocabulary of formal possibilities had developed more or less directly from the unity-within-variety of the Hellenistic *koiné* and became available to the new culture. In architecture the main elements of building from central Asia to Gaul were columns and piers, vaults and domes, 'basilical' plans and 'central' plans, stone and brick, with manifold local variations. In human or natural representation, the most illusionistic traditions of the first century C.E. coexisted with the more abstract, linear, or decorative modes which developed after the third century, and the vast majority of the techniques of decorative and industrial arts had been elaborated. The Muslim conquest did not take over large territories in a state of intellectual or artistic decay. Although the empires of Byzantium and Iran had been weakened in the first part of the seventh century by internal troubles and wars, these disturbances barely hampered their intellectual or artistic activities. The Muslim world inherited not exhausted traditions but dynamic ones, in which fresh interpretations and new experiments coexisted with old ways and ancient styles. The whole vast experience of ten brilliant centuries of artistic development provided the Islamic world with its vocabulary of forms.[29]

The traditions of this world were many and diverse, and early Muslim writers were fully cognizant of the distinctions in culture between the Byzantine and Sasanian empires, between *Qaysar* and *Kisra*, 'Caesar' and 'Khosrow', names of emperors transformed into symbols of imperial rule and behaviour. The Muslims conquered two of the wealthiest Byzantine provinces, Egypt and Greater Syria (including Palestine). Syria is best known for the excellence of its stone architecture, still visible in hundreds of ancient churches, the sobriety of its stone-carving, and the wealth of its mosaic floors. In addition, it was a centre of great imperial foundations, such as the Christian sanctuaries of the Holy Land. The actual presence of imperial Constantinople in much of this art is subject to debate, and there is the special problem of Coptic art, the art of heterodox Christian Egypt, whose monuments of sculpture, painting, and the minor arts are preserved in large numbers, but whose exact position, as original or provincial, is a much debated topic.[30] In North Africa and Spain the pre-Islamic traditions may have been less vigorous, because of a more chequered and unfortunate political history. The crucial point in dealing with the Christian art known to or seen by the newly arrived Muslims, however, is not so much its specific character in this or that province (which had mostly a technical impact on the young Islamic art) as the presence in the background of the awesome and dazzling, even though unfriendly, power and sophistication of the Byzantine ruler, the *malik al-Rum* of the sources. His painters were recognized as the greatest on Earth, and the early Muslims had the mixed feelings towards his empire of a successful *parvenu* for an effete aristocrat. Whenever an early Islamic building was held to be particularly splendid, contemporary or even later legend – the facts are uncertain[31] – asserted that the Byzantine emperors sent workers to execute it.

On the other side, beyond the Euphrates, the Sasanian empire of Iran was entirely swallowed up by the Muslims, and its artists and traditions were almost immediately taken over by the new empire. To contemporaries, the Sasanian ruler was the equal of the Byzantine emperor, but unfortunately our knowledge of Sasanian art is far less complete than our understanding of the Christian tradition. Most of what we know concerns secular achievements: great palaces, with one exception (the celebrated vaulted hall of Ctesiphon) of mediocre construction, but lavishly covered with decorative stucco; rock reliefs and silver plate glorifying the power of the kings; and textiles presumably made in Iran and sold or imitated from Egypt to China. But the paucity of our knowledge – which tends to reduce Sasanian art to a small number of decorative patterns such as pearl borders on medallions, royal symbols like pairs of wings or fluttering scarves, and a few architectural peculiarities like the majestic *iwan* (a vaulted rectangular room with one side giving on an open space) and stucco decoration – should not obscure the fact that at the time of the Muslim conquest it was one of the great arts of its period and, more specifically, the imperial art *par excellence*, in which everything was aimed at emphasizing the power of the King of Kings. Yet, however originally they used or transformed them, the Sasanians derived many of their architectural and representational (but not always decorative) forms from the older classical *koiné*.[32]

The political and artistic importance of the two great empires of the pre-Islamic Near East should not overshadow the existence of other cultural and artistic traditions. Their

monuments are less clearly identified, but their importance is considerable because many of them became heavily Islamicized or served as intermediaries between Islam and the rest of the world. An example is furnished by the Semitic populations of Syria and the upper Euphrates region. Although they were Christians and ostensibly part of the Byzantine world, their artistic individualization began before their conversion to Islam, and in general they rejected Hellenization in favour of various heretical movements. They were often supported by the Sasanians and affected by eastern traditions in art. In their midst the early Muslims found many supporters and, most probably, converts. We do not know their art well, especially in the centuries immediately preceding the Muslim conquest; but through the monuments of Dura-Europos, Palmyra, Hatra, and the Tur Abdin, we can imagine what must have been their great centre, Edessa; and we may assume that they had begun before the third century and continued most wholeheartedly the transformation of classical motifs and forms into abstract modes and decorative shapes which became a feature of Byzantine art.[33] Another such area, of secondary importance in the seventh century as far as Islam is concerned, acquired a greater significance in later centuries: Armenia. Torn between the rivalries of Byzantium and Iran, it developed an individuality of its own by adopting elements from both sides. Further out in the mountains, in later centuries, Georgia fulfilled a similar role. But despite their specific significance and artistic peculiarities, these cultures depended a great deal on the two imperial centres of Byzantium and Iran.[34]

In addition mention should be made of two peripheral regions, whose impact was more sporadic, at least at the beginning. The first is India, reached by the Muslims in the eighth century and soon a great goal for Islamic mercantilism as well as for centuries the proverbial exotic 'other'. The other is Central Asia, long thought to be a mere variation on the Sasanian world, but now, after spectacular archaeological discoveries, identifiable as a culture of its own, where Chinese, Indian, Sasanian, and even western elements curiously blended with local Soghdian and Kharizmian features into an art at the service of many faiths (Manicheism, Christianity, Buddhism, Mazdaism) and of many local princes and merchants.[35] Far in the background lies China, whose influence will appear only sporadically.

Beyond its unity of formal and technical origin and its innumerable local variations, the art of the countries taken over by Islam shared several conceptual features. Much was at the service of faith and state and, in the Christian world at least, even part of the faith and of the state. This point is significant because, as was mentioned earlier, it was the Christian use of images that, in part, influenced Muslim attitudes towards representation. The Byzantine crisis of Iconoclasm, which followed the Muslim conquest by a few decades, may not have been inspired by Muslim ideas, but it certainly indicates a concern within Christian circles over the ambiguous significance of images.[36] We know less about the purposes and values of Sasanian art. Yet the very official nature of its iconography on silver plates or on stone reliefs strongly suggests that there were more than mere images of some kind of reality; they were symbols of the kings themselves and of their dynasty. Soghdian merchants, Coptic monks, Aramaic-speaking Syrian villagers, petty Turkic dynasts, all sought by means of buildings, decoration, and objects to communicate their power, wealth, and beliefs.

Thus the conquering Arabs, with relatively few artistic traditions of their own and a limited visual culture, penetrated a world which was not only immensely rich in artistic themes and forms yet universal in its vocabulary, but also, at this particular juncture of its history, had charged its forms with unusual intensity. The methodological and intellectual originality of Islamic art in its formative stages lies in its demonstration of the encounter between extremely complex and sophisticated uses of visual forms and a new religious and social system with no ideological doctrine requiring visual expression.

PART ONE

Early Islamic Art and Architecture
(c.650–c.1000)

Historical and Cultural Setting

The transformation of a vast area – from north central Spain to the delta of the Indus and from the northern fringes of the Sahara desert and the Indian Ocean to the Mediterranean, the Caucasus, the Central Asian deserts, and the Hindu Kush – into a land controlled by Islam (the *dar al-Islam* or 'house of Islam' of later sources) was accomplished within roughly a century. Egypt, Palestine, Syria, and Iraq fell into the hands of Muslim Arabs between 632, the date of the Prophet's death, and 643, the year of the creation of Fustat, the first step in the development of what would eventually become the modern megalopolis of Cairo. By 740 two-thirds of the Iberian peninsula was in Muslim hands, an Arab marauding party had been turned back near Poitiers in west central France, and significant Arab settlements had been established in Merv and Samarqand (in the modern countries of Turkmenistan and Uzbekistan respectively), preparing the way for the military, but especially symbolic, encounter in 751 of the Muslim conquerors with the Chinese imperial army at Talas, Djambul in present-day Kazakhstan.

This extraordinary achievement took place under the rule of the first four caliphs, or successors of the Prophet, called al-Rashidun (The Rightly Guided or Orthodox ones) who ruled from Madina between 632 and 661, and, then, of the Umayyad dynasty (661–750). The latter came from a merchant family of Mecca which had originally opposed the Prophet Muhammad and which converted to Islam relatively late; they moved the capital to Damascus in Syria, although ruling princes often moved around the countryside and the primary residence and virtual capital, between 726 and 744, was in Rusafah, in the northern part of the Syrian steppe. A remarkable succession of brilliant Umayyad caliphs like Mu'awiyah (r. 661–80), Abd al-Malik (r. 695–705), al-Walid (r. 705–15), and Hisham (r. 724–43) formalized the basic administrative structure of the Umayyad empire into provinces with often very talented governors appointed by the rulers. They maintained for a while many Byzantine, Sasanian, and other practices, but eventually (around 691) imposed Arabic as the language of administration and coinage. Umayyad rulers collected an immense wealth from the booty of the conquest and from levies gathered though taxes. This wealth allowed them to keep a large standing army and navy and to invest in an agricultural and commercial expansion well documented in the Fertile Crescent and probably true in other provinces as well. Diplomatic relations with non-Muslim lands were mostly with the Byzantine empire, and, altogether, the Umayyad princes maintained a delicate equilibrium between the traditional patterns of life and culture in the Late Antique world they controlled, a new class of affluent Arab leaders with strong tribal attachments as well as brilliant administrative and military talents, and a newly emerging Islamic culture.

The way in which the latter came about is still a matter of much debate between those who imagine its creation as quite rapid, the sudden appearance of a fully shaped socio-ethical system, and those who prefer to postulate the slow evolution of responses to many different needs and challenges. But there is no real disagreement about the components of that culture. One of them was the codification, copying, and endless discussion of the Scripture, the Qur'an, usually referred to in earlier sources as the *masahif*, the 'pages'. It went along with the gathering and criticism of the *hadith*, 'traditions', on the life of the Prophet, which served as guidelines for social and economic as well as personal behaviour. Little by little, a legal system was created, the *sharia*, with its more or less independent schools of interpretation of the sources. Internal divisions made their appearance with the growth of Shi'ism with its alternative view of the rights to political power, and even of heresies, all of which led to social strife. The conversion of Jews, Christians, Zoroastrians, and others created large and at times powerful groups of Muslims without an Arabian past, while Arabs from the central Arabian peninsula and Yemen moved into the old cities of the classical world or, a particularly original phenomenon, to new cities created for them, like Kufa, Basra, and Wasit in Iraq, Fustat in Egypt, and Qayrawan in Ifriqiya (more or less coinciding with modern Tunisia).

Relations between the dynastic state of the Umayyads and the emerging Muslim culture in its manifold varieties were not always easy. The cities of southern Iraq were often in a state of insurrection, tribal feuds were still affecting Arabia and the Syrian steppe, and the very legitimacy of the Umayyad caliphate was often challenged. A series of revolts began around 746, primarily in the northeastern province of Khurasan, with considerable support elsewhere. In 750 the Umayyad dynasty was defeated, most members of the family were murdered, and a new dynasty issuing from the lineage of the Prophet took over the caliphate. The Abbasids remained as caliphs until 1258; the assassination of the last of them by the Mongols marks the end of the period of Islamic art covered by this volume.

Abbasid rule was not constant in its political importance nor as a cultural force. The heyday of its domination – especially under powerful and celebrated caliphs like al-Mansur (r. 754–75), Harun al-Rashid (r. 786–809), al-Ma'mun (r. 813–33), and al-Mutawakkil (r. 847–61) – covered the second half of the eighth century, all of the ninth, and the first decades of the tenth. During these two centuries, the city of Baghdad was founded, soon to become the greatest and wealthiest urban concentration in Asia, Europe, and Africa. It was a major consumer of goods of all sorts and remained the spiritual and cultural centre of the Muslim world for many centuries to come; the four canonical *madhahib* (pl. of *madhhab*) or 'schools of law' by which all Muslim life was regulated were established at this time, thereby identifying the Sunni majority of believers. Shi'ism became the dominant Muslim heterodoxy as the twelfth descendant of Ali disappeared in 873–74 and his followers developed complex esoteric doctrines around his eventual return. Mysticism or

sufism appeared as a significant modifier to the automatic acceptance of the *sharia*. A stupendous boost was given to philosophy, mathematics, and science with a massive programme of translations from Greek, Syriac, Old Persian, and Sanskrit. The appearance of paper and the standardization of the Arabic script made possible the rapid spread of knowledge and information on nearly anything from one end of the empire to the other. A court culture in the capital coexisted with a mercantile one, a military one (soon consisting mostly of Turkic slaves), and a richly diversified populace in which speakers of Arabic, Turkish, Persian, and many other, rarer or now vanished, languages practised Islam, Christianity, Judaism, Buddhism, Zoroastrianism, and other religions, albeit with restrictions for some and occasional persecutions, under the broad rule of a Muslim order.

From Baghdad during the early Islamic period the Abbasids governed practically the whole Muslim world, as only Spain escaped them. There, the last surviving member of the Umayyad family had succeeded in establishing an independent dynasty that maintained, at least initially, an allegiance to its Syrian roots and looked towards Baghdad for sustenance in matters of taste, eventually producing a brilliant literary and artistic culture of its own. Elsewhere Abbasid rule was secured through a strong army, mostly of Turkic slaves and mercenaries, and a system of governors reproducing in their provincial capitals something of the glamour of Baghdad. In Ifriqiya and in Egypt the governors appointed from Baghdad became semi-independent and often formed dynasties of their own. Such were the Aghlabids (800–909) based in Tunisia who also sponsored the conquest of Sicily or the Tulunids (868–905) and Ikhshidids (935–69) in Egypt. While these dynasties enjoyed considerable political and fiscal independence, the degree of their cultural and, therefore, artistic, independence from Baghdad is not always clear, inasmuch as they all shared the same language, the same rules for living, the same foundation myths, and more or less the same history. These dynasties did, however, provide a sense of specific identity to Tunisia and Egypt in ways that are not visible in Syria, Palestine, western Iran, or even remote Yemen.

Politically, something quite similar was happening in northeastern Iran, in the provinces of Khurasan and Transoxiana. There also, administrative appointees of the Abbasid caliphate developed dynasties like the Tahirid (821–91), Samanid (819–1005), and Saffarid (851–1003). Some of these dynasties, most particularly that of the Samanids originating from an old Persian aristocratic lineage, sponsored a revival of Iranian historical, literary, and probably artistic traditions. The huge area of Khurasan – especially in or around the four main cities of Nishapur, Merv, Balkh, and Herat (located today in three different countries) – was populated by Persians, Arabs, and Turks, all divided into many linguistic, ethnic, and social subgroups. An extremely original cultural mix was thus created in this area, combining pre-Islamic Iranian features, the Arabic language, a revived Persian written in the new Arabic alphabet, and the new Muslim legal and ethical culture.

Ferdosi's *Shahnama*, the great historical epic of Iran, was created within that culture, even though its real impact and the time and place of its formal dedication, to the Turkic ruler Mahmud in Ghazna in central Afghanistan, belong to the second part of this volume. The dynasties of northeastern Iran helped to focus and to formulate a very novel and more or less permanent phenomenon: a new Iranian Muslim culture, still at that time expressing itself mostly in Arabic rather than in various Middle Persian dialects. One should add that there were, in northern Iran (the provinces of Gilan and Daylam) and on the Caucasian frontier, dozens of minor dynasties, mostly of local origin and often not converted to Islam, that were paying some sort of homage (or merely taxes) to the caliphs in Baghdad. With minor exceptions, their import on the arts before 1000 was minimal. Yet it is these northern Iranian provinces that produced the military dynasty of the Buyids (932–1062). They professed Shi'ism rather than the prevalent Sunni orthodoxy and took over the running of the caliphate itself. The year which symbolizes the collapse of direct Abbasid rule is 945, when the Buyid prince Mu'izz al-Dawlah entered Baghdad and assumed power under a shadow caliphate.

Muslim political power was like an inkblot spreading from a centre in Arabia, then in Syria and eventually in Iraq to wherever it could fix itself, at times leaving whole areas (much of southern Iran for instance, the Hindu Kush of present-day Afghanistan, or the Atlas mountains in North Africa) with only minimal control, at other times letting indigenous forces take charge in exchange for some sort of formal allegiance and indirect collection of taxes. Culturally these centuries witnessed both the Islamization of large numbers of people mostly through conversion and marriage, and the domination of the whole Muslim world by the spectacular explosion of systematic learning and thought in Baghdad and, even earlier, in the Iraqi cities of Kufa and Basra. From grammar to abstract mathematics, everything was studied, written down, and codified; wild mystics lived alongside highly rationalist philosophers, with several religious sects in between. This coexistence was not always peaceful, as persecutions abounded and social strife often used religious or intellectual partisanship for its own aims. But, when all is said and done, after an Umayyad century of constant conquest, accumulation of wealth, and innovations, the first two Abbasid centuries truly formulated the basic core of the Islamic culture which is still active today. The cultural presence of the Umayyads was limited to the Fertile Crescent and to the former provinces of the Roman empire. The Abbasids may have been based in Iraq, but their culture extended everywhere and, by the tenth century, local variations, most forcefully in Spain (al-Andalus) and Khurasan, asserted themselves with considerable originality.

Because of their overwhelming importance in the formative centuries of Islamic culture, we have given pre-eminence in this part to the central lands of Islam and dealt with them first. What happened in North Africa and Andalusia or in Iran can best be understood through the novelties invented and choices made first in Syria and Iraq.

Mediterranean Sea

Fayyum

Bahnasa

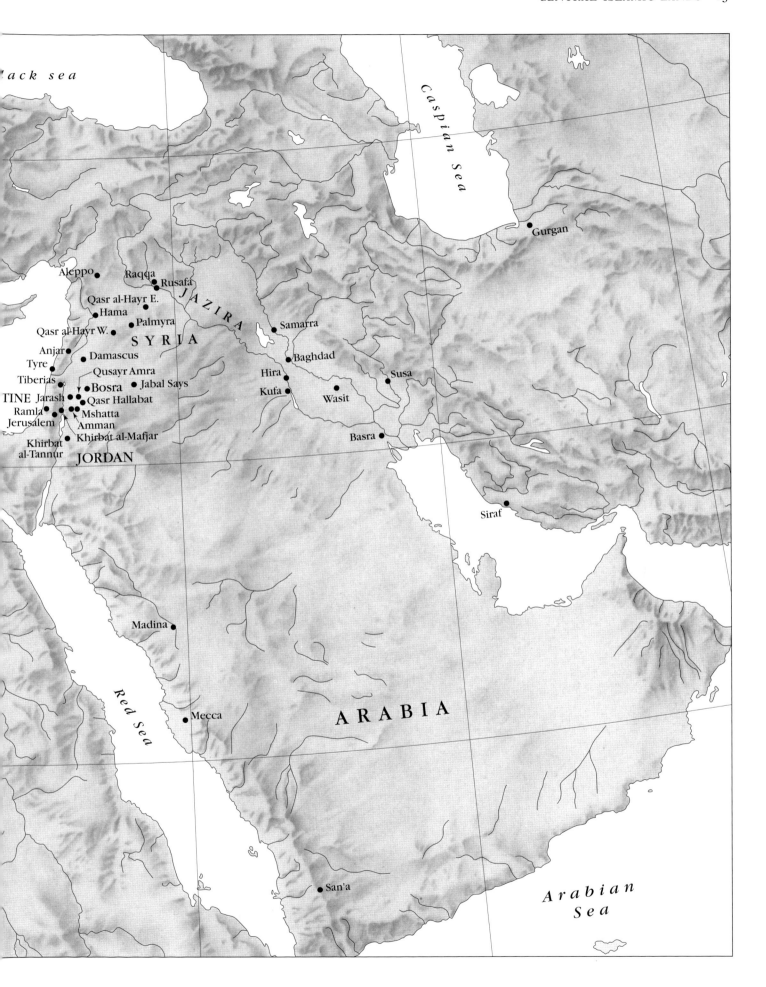

Black sea

Caspian Sea

Gurgan

Aleppo
Raqqa
Rusafa
Qasr al-Hayr E.
Hama
Palmyra
Qasr al-Hayr W.
SYRIA
JAZIRA
Samarra
Anjar
Damascus
Baghdad
Tyre
Qusayr Amra
Hira
Susa
Tiberias
Bosra
Jabal Says
Kufa
TINE
Jarash
Qasr Hallabat
Wasit
Ramla
Mshatta
Jerusalem
Amman
Khirbat
Khirbat al-Mafjar
Basra
al-Tannur
JORDAN

Siraf

Madina

Red Sea

Mecca

ARABIA

San'a

Arabian
Sea

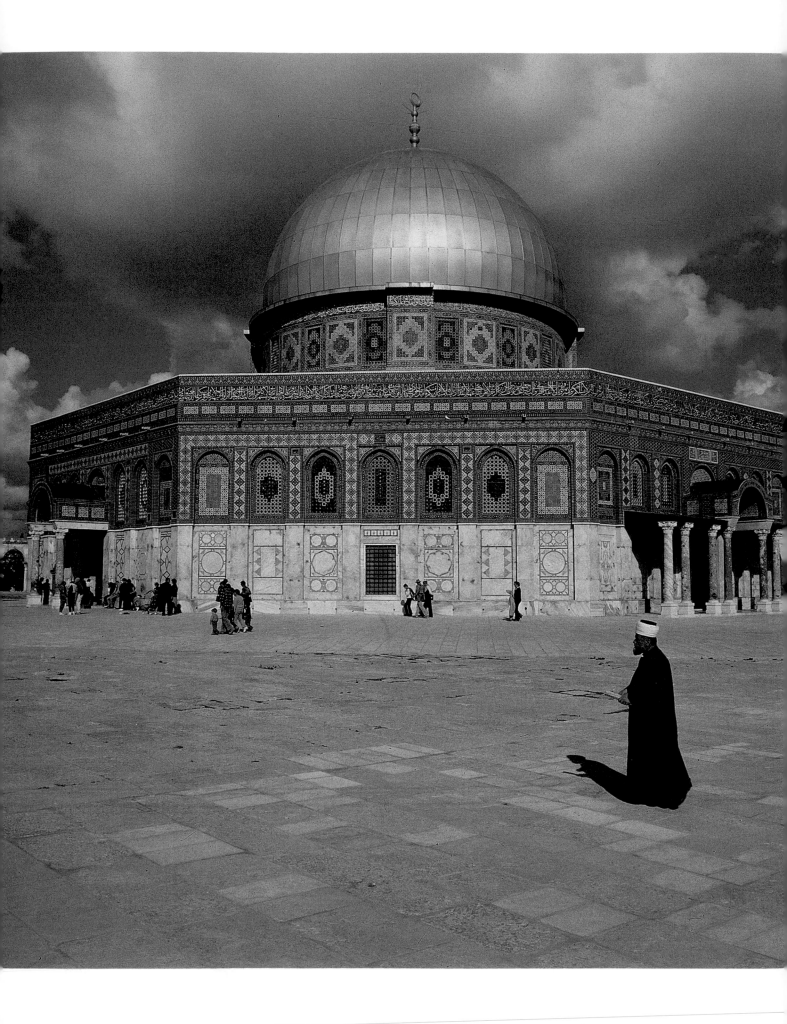

Central Islamic Lands

ARCHITECTURE AND ARCHITECTURAL DECORATION

The architecture and the architectural decoration of the central lands of the Muslim world during the first three centuries of its existence are the result of the encounter of the new Muslim faith and state with the ancient traditions of the Near East. These monuments had to be meaningful to the Arabs from Arabia as well as to the old settled population of the area and to reflect the needs and aspirations of the former and the competencies of the latter. Initially this art depended entirely on the technology and craftsmanship available locally and it is only slowly and in rhythms which are almost impossible to reconstruct that techniques from one area were moved to another one, craftsmen drafted by powerful patrons, artisans established on their own in new areas of employment.

Early Islamic civilization was both novel and traditional: novel in its search for intellectual, administrative, and cultural forms to fit new people and new ideas and attitudes; traditional in seeking these forms in the world it conquered. Selective of its models, it combined them in an inventive way and slowly modified them, thereby creating a basis for later Islamic developments. With their capital in Damascus and their numerous military campaigns against Byzantium, the Umayyads were mostly aware of the Christian past of the Near East, but they were also fully conscious of being rulers of a huge empire. The east – Iran and Central Asia – provided the conquerors with most of their booty and their most vivid impressions of a new and fascinating world. Settled in Iraq, a region of less significant pre-Islamic artistic wealth than the Mediterranean area, the Abbasids built on these Umayyad foundations without being restricted by local traditions of construction and craftsmanship.

We shall return, at the end of the chapter, to a broad evaluation of Umayyad and Abbasid arts. Their architectural monuments can be divided into three functional groups: the unique Dome of the Rock, the congregational and other mosques, and secular buildings, primarily palaces. Architectural decoration will, most of the time, be discussed with each building, with the one exception of Samarra's stuccoes and paintings, which have from the very beginning been seen and published as separate categories and whose connection with the buildings from which they came is not always well established. A number of key monuments are more or less irretrievably lost: the first mosques at Kufa, Basra, Fustat; the second mosque at Madina; the palace of the Umayyads in Damascus;[1] the original city of Baghdad and its palaces; the secular buildings of Fustat in the ninth century; most of the objects which belonged to the ruling princes and the new Arab aristocracy. Yet, altogether, over one hundred monuments still remain from these first centuries or can be easily reconstructed from textual evidence.[2] Almost all belong to the period after 690, following the end of a series of internecine struggles in the new Muslim empire.

THE DOME OF THE ROCK

Completed in 691, the Dome of the Rock in Jerusalem [4] is the earliest remaining Islamic monument, and in all probability the first major artistic endeavour of the Umayyads.[3] The reasons for its erection are not given in contemporary literary or epigraphic sources. Very early, Abbasid sources antagonistic to the Umayyads claimed that the caliph Abd al-Malik wanted to replace Mecca with Jerusalem and to divert the ritual pilgrimage known as the *hajj* to the Palestinian city. Although still found occasionally, this explanation is not acceptable for a variety of historical reasons. Eventually the Dome of the Rock became connected with the miraculous Night Journey of the Prophet to the *Masjid al-Aqsa* (the 'farthest mosque', Qur'an 17:1) – generally presumed to be in Jerusalem, although the earliest evidence in our possession is not clear on this point – and with Muhammad's ascent into Heaven from the Rock. This is today the conception of the Muslim believer.

In fact, however, the location of the mosque on Mount Moriah, traditionally accepted as the site of the Jewish Temple and associated with many other legends and historical events, its decoration of Byzantine and Sasanian crowns and jewels in the midst of vegetal motifs, its physical domination of the urban landscape of Jerusalem, its inscriptions with their many precisely chosen Qur'anic quotations, and a number of recently rediscovered early Muslim traditions[4] suggest several purposes for the original Dome of the Rock: to emphasize the victory of Islam that completes the revelation of the two other monotheistic faiths; to compete in splendour and munificence with the great Christian sanctuaries in Jerusalem and elsewhere; to celebrate the Umayyad dynasty with a shrine containing Solomonic connotations through the representation of paradise-like trees and through references in recently published later accounts of the religious merits of Jerusalem.[5] And, in very recent years, attention was brought to Traditions of the Prophet (*hadith*) which claimed that the rock was the place from which God left the Earth after creating it and returned to heaven. For a variety of theological reasons, these traditions were rejected in the ninth century, but they had been accepted earlier, at least by some, and they reflect an old, Christian and Jewish, sense of Jerusalem as the site where time will end, the Messiah come, the Resurrection and the Last Judgment begin. This messianic eschatology became part of Muslim piety and has always been associated with Jerusalem. Only after the full establishment of the Islamic state as the gov-

4. Jerusalem, Dome of the Rock, completed 691

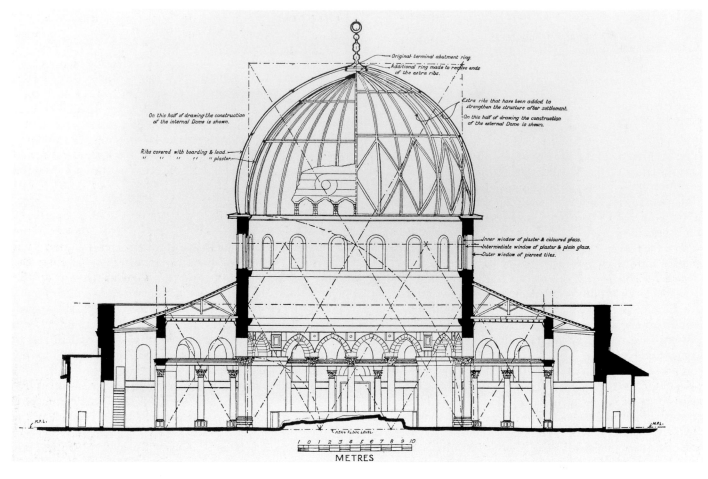

5. Jerusalem, Dome of the Rock, completed 691, section

erning body of the area did these precise, ideologically laden, early aims fade away, to be replaced by a more strictly pious and religious explanation probably derived from popular beliefs and practices.

The building is admirably located on an artificial platform, itself part of a huge area known today as the *Haram al-Sharif* (the 'Noble Sacred Enclosure'), created in Herodian times. The platform is ascended by six flights of stairs, two on the southern and western sides, one on each of the other two. An arcade crowns each flight. Both stairs and arcades can be documented only from the tenth century onwards, and no information exists about access to the platform in Umayyad times. Not quite in the centre of the platform, the building has a large central dome (about 20 metres in diameter and about 25 metres high) consisting of two wooden shells originally gilded on the outside and placed on a high drum pierced by sixteen windows in its upper part [5, 6]. It rests on a circular arcade of four piers and twelve columns; around the central part two ambulatories are separated by an octagonal arcade of eight piers and sixteen columns. The marble columns, together with most of the capitals, were taken from older buildings. The piers are of heavy stone masonry. A continuous band of tie-beams separates the capitals of the columns and the shafts of the piers from the spandrels. The sloping roof of the octagon abuts the drum of the dome just below the windows. Outside, each side of

the octagon is divided into seven narrow vertical panels separated by pilasters. Five contain windows with double grilles dating from the sixteenth century; the original ones probably had marble tracery on the inside and ironwork on the outside.[6] There are four entrances preceded by porches, one on each side of the cardinal points. Above the roof of the octagon runs a parapet.

The building is richly decorated [7]. The mosaic which – together with marble – adorned the outside were almost completely replaced[7] in Ottoman times by magnificent Turkish tiles, but the interior decoration, while often repaired and at times replaced, has maintained a great deal of its original character. The walls and piers are covered with marble. Mosaics [8–11] decorate the upper parts of the piers, the soffits and spandrels of the circular arcade, and both drums; only the latter show traces of extensive repairs and restorations, which, however, did not alter significantly the nature of the designs. Marble now sheaths the inner spandrels and the soffits of the circular arcade as well as three friezes, one between the two drums, the other two above and below the windows of the outer wall. It is likely, however, that these areas were originally covered with mosaics, which – from the remaining decoration of the porch – one can surmise were also used on the vaults of the porches. The ceilings of the octagon and of the dome are Mamluk or Ottoman carved woodwork and stamped leather.

The Umayyads probably used only wood, as we can conclude from other buildings. The tie-beams were covered with repoussé bronze plaques [85]. Finally, we must imagine the thousands of lights which supplemented the meagre illumination from the windows, making the mosaics glitter like a diadem crowning a multitude of columns and marble-faced piers around the somber mass of the black rock surmounted by the soaring void of the dome.

In its major characteristics the Dome of the Rock follows the architectural practices of Late Antiquity in its Christian version. It belongs to the category of centrally planned buildings known as *martyria* and, as has often been pointed out, bears a particularly close relationship to the great Christian sanctuaries of the Ascension and the Anastasis, to name only those in Jerusalem itself. Similarly, most of the techniques of construction – the arches on piers and columns, the wooden domes, the grilled windows, the masonry of stone and brick – as well as the carefully

6. Jerusalem, Dome of the Rock, completed 691, plan

7. Jerusalem, Dome of the Rock, completed 691, interior view

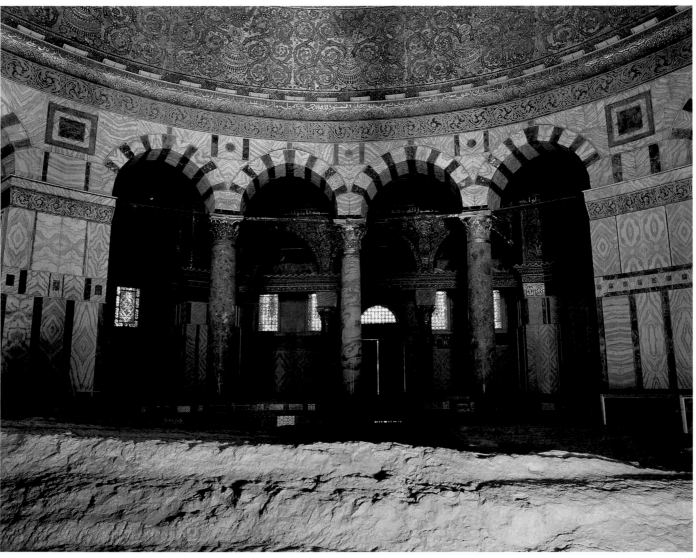

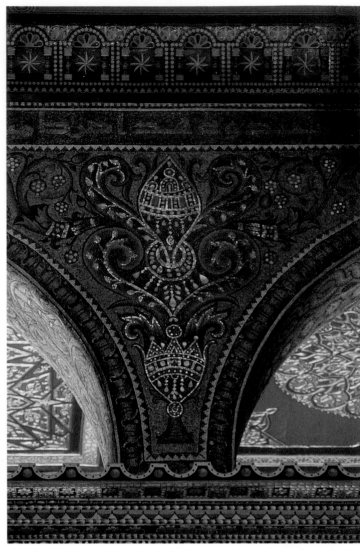

8. Jerusalem, Dome of the Rock, completed 691, mosaic

9. Jerusalem, Dome of the Rock, completed 691, mosaic

10. Jerusalem, Dome of the Rock, completed 691, mosaic

11. Jerusalem, Dome of the Rock, completed 691, mosaic, soffit

thought-out and intricate system of proportions also derive directly from Byzantine church architecture, perhaps quite specifically from local Palestinian practices.[8] The same is true of the decoration. Although few examples remain, wall mosaics and marble facings were common in Christian sanctuaries. The endless variations on vegetal subjects, from the realism of certain trees to highly conventionalized garlands and scrolls to all-over carpet-like patterns, are mostly related to the many mosaics of Christian times in Syria and Palestine.[9] The same holds true for the decoration of the tie-beams (see below p. 60).

Yet it would be a mistake to consider all this a mere reuse of Byzantine techniques and themes. In addition to the fact that its significance was not the same as that of its presumed ecclesiastical models, this first monument of the new Islamic culture departs in several areas from the traditions of the land in which it was built: the nature of the mosaic decoration, the relationship between architecture and decoration, and the composition of its elevation.

The mosaic decoration, which has remained almost entirely in its original state on a huge area of about 280 square metres, does not contain a single living being, human or animal. Evidently the Muslims already felt that these would be inconsistent with the official expression of their faith, and they were selective about the artistic vocabulary offered by the lands they had conquered. However, the mosaics were not purely ornamental in the sense that their purpose was not exclusively one of pleasing the eye. Thus, only the inner facings of the octagonal and circular arcades and the drums introduce jewels, crowns, and breastplates [10], many of which occur as the insignia of royal power in the Byzantine and Sasanian empires. Their position, added to the fact that no traditionally trained artist would willingly mix royal symbols with vegetal designs, indicates that these are the regalia of the princes defeated by Islam, suspended like trophies on the walls of a strictly Muslim building. It has also been possible to propose iconographic meanings for many other features of the mosaics. Thus, the trees, some realistic and others quite artificial, have been seen by some as recollections of Solomon's palace, which had been located somewhere in Jerusalem and whose brilliance was much enhanced in early medieval lore. Others have selected certain details of the rich decoration of the intrados of arches [11] to detect the presence of Christian or Jewish motives, or at least artisans. More cautious scholars prefer to emphasize the all-over effect of brilliance rather than specific details. Discussions and debates around the meaning of this decoration will continue, because of the astounding quality of the work and the absence of comparable monuments or of direct written information about them.

Writing, in the form of a long mosaic inscription running below the ceiling of the octagons, appears with both decorative and symbolic significance, possibly the earliest known instance in medieval art of this particular use of writing in a building. It is decorative because it takes over the function of a border for the rest of the ornamentation. And it is symbolic because, although barely visible from the ground, it contains a carefully made selection of passages from the Qur'an dealing with Christ which do not contradict Christian doctrine. Thus, the inscription emphasizes the

Muslim message in Christ's very city. Furthermore, the later caliph al-Ma'mun saw fit to substitute his own name for that of the founder, 'Abd al-Malik, thus showing his acceptance of the aims and purposes of the building.[10] Unwilling to use the traditional figurative imagery derived from Antiquity, the Muslim world expressed its ideas in non-figural terms.

Alongside classical motifs the mosaics have palmettes, wings, and composite flowers of Iranian origin. Thus the Umayyad empire drew upon features from the whole area it had conquered, amalgamating them to create an artistic vocabulary of its own.

Finally, the mosaics of the Dome of the Rock introduced two decorative principles which would continue to develop in later Islamic art. The first is the non-realistic use of realistic shapes and the anti-naturalistic combination of naturalistic forms. When they felt a more brilliant decoration was needed, the artists did not hesitate, for instance, to transform the trunk of a tree into a bejewelled box. The possible combinations of forms and themes are limitless, without the restraints imposed by the naturalism of classical ornament.

The second principle is that of continuous variety. On close analysis, the mosaics of the Dome of the Rock show comparatively few types of design – mainly the acanthus scroll, the garland, the vine scroll, the tree, and the rosette. Yet nowhere do we find exact repetition. Certain differences are qualitative, as when an apprentice reproduced the design of a master.[11] But in most instances each variation within a theme represents an individual interpretation of some general principle of design. The social or psychological reasons for these variations remain unexplained.

As far as future development is concerned, the most significant artistic feature of the Dome of the Rock is the establishment of a new relationship between architecture and decoration. Until this time the Mediterranean had continued, albeit with modifications, the classical principle of decoration, especially ornamental decoration, as the servant of architecture, emphasizing certain parts of the building, but rarely suppressing the essential values of the construction itself. The builders of the Dome of the Rock, however, hid almost all of their clearly defined, classically based structure with brilliant marble and mosaic. Particularly striking in this respect is one of the soffits of the arches of the octagon [11]. We see three bands of design, two of which take over one half of the surface, the remaining one the other half. However, the composition is asymmetrical, for the wider band is not in the centre but towards the inner side of the building, thus deliberately destroying the basic unity of the surface. Furthermore, one motif, and one only, continues on to the vertical surface of the spandrel, thereby emphasizing one curve of the arch as against the other one.

This does not mean that the mosaicists of the Dome of the Rock completely rejected the architecture they decorated: in using trees for high rectangular surfaces and scrolls for square ones, they certainly adapted their ornamental forms to the areas provided by the architects. But in the choice of many specific motifs (for instance, the rosettes on the soffits) as well as in the total covering of the available walls, they created an expensive shell around the structure which broke away from the traditions of the area. The

17. Damascus, Great Mosque, 706, mosaics from the western portico

and Madina, to Umayyad royal ceremonies, and to show that this architectural feature, which appeared first in what we may call Umayyad 'imperial' mosques and was to be frequently copied, originated in an attempt to emphasize the area reserved to the prince, and imitated a palace throne room.[35]

Thus, the plan of the mosque of Damascus is important in two ways. First, the arrangement is more organically conceived than in the diffuse and additive mosques of Iraq, as it has a clearly defined central focus. Second, its three-aisled sanctuary with axial nave and its proportions partly imposed by the Roman foundations became a standard model in Syria and elsewhere, although not for the other two mosques built by al-Walid, which were both hypostyle with many parallel aisles including a wider central one, leading to the *qibla*, and which had peculiar features pertaining to their sites.

The mosque in Damascus also has the earliest remaining concave *mihrab*.[36] The philological and formal background of the *mihrab* is remarkably complicated:[37] for the sake of clarity we shall consider only its common application to the mosque. It is generally understood today as a niche on the *qibla* wall of a mosque indicating the direction of Mecca. But it is absent from all the earliest mosques; it is never visible from more than a fraction of the area of the building; and the whole plan of a mosque makes the direction of prayer so obvious that there is no need for so small a sign. Nor is it fully satisfactory to explain the *mihrab* as an abbreviated throne room, as has been suggested by Sauvaget, for it became almost immediately a fixture of all mosques, and eventually a common artistic motif on pious objects.

In order to understand its original purpose, we should bear in mind two points. To begin with, medieval writers generally agree that a concave *mihrab* first appeared at al-Walid's mosque in Madina, which replaced and embellished the Prophet's own house/mosque. Second, the *mihrab* there was set not in the middle but by the place where according to the Traditions the Prophet used to stand when holding prayers.[38] We can suggest then that its purpose was to symbolize the place where the first *imam* (or leader of prayer) stood; that it began as a precise memorial in the Prophet's mosque, and then, through the foundations of al-Walid, spread out to the whole Islamic world.[39] Just as the office of the successor of the Prophet had royal connotations, so did the *mihrab*; but only through its significance as a religious memorial could it have become accepted almost immediately in *all* religious buildings.

The point is strengthened by comparing such immediate adoption with the development in Umayyad times of the *minbar*, the pre-Islamic throne-chair used by the Prophet in Madina. Under the Umayyads the *minbar* began to appear in mosques other than the one in Madina, and it was clearly a symbol of authority.[40] As such, its adoption was more carefully controlled than in the case of the *mihrab*. It was often a movable object which did not properly belong in the religious institution, and for several centuries the existence of mosques with *minbars* was one of the criteria which distinguished a city or an administrative centre from a mere village. The entirely different destiny of the *mihrab* suggests that, whatever its relationship with royal ceremonies in the mosque, its primary function was not royal but religious.

doors; the curtains reported by a fourteenth-century source may or may not have been the original arrangement.[32]

Just as in the Dome of the Rock, practically all the elements of construction derive from the traditional architecture of Syria.[33] The innovations are two: the plan and the introduction of the *mihrab*.

The problem of creating a plan on a pre-established site was solved by the Umayyad architects as follows. They adopted Madina's basic order of a porticoed court with a deeper sanctuary, but, instead of transforming their sanctuary into a hypostyle hall on the pattern of the Iraqi mosques, they created a tripartite division, possibly under the impact of Christian churches, although the Damascus aisles differ in being of equal width. But a more remarkable innovation, in plan as well as elevation, is the axial nave. Its aesthetic significance in relieving the monotony of a façade 137 metres long is obvious enough; its historical importance is far greater. Creswell pointed out that it closely resembled a façade of the palace of Theodoric as represented on a well-known Ravenna mosaic.[34] Sauvaget was the first to relate the axial nave in Damascus, as well as similar ones in Jerusalem

18. Damascus, Great Mosque, 706, mosaics from the western portico

The formal origin of the *mihrab* is certainly to be sought in the niche of classical times, which through numerous modifications appeared as the *haikal* of Coptic churches, the setting for the Torah scrolls in synagogues,[41] or simply as a frame for honoured statues. It is also related to the growth, still unsystematic, in the Umayyad period of a dome in front of the central part of the *qibla* wall. Domes, of course, are well-known architectural means of honouring a holy place and, as such, already existed in pre-Islamic Arabia. The earliest reference we have to a dome in front of a *mihrab* is in the eighth-century mosque of Madina.

The axial nave, the concave *mihrab*, the *minbar*, and the dome in front of the *mihrab* were destined to play an important part in the history of Islamic architecture. In Umayyad times their precise functions and purposes emerged from still rather obscure origins; more specifically, all of them appear together in the imperial mosques of al-Walid. They are difficult to interpret because they fulfilled an ambiguous role, and their varying functional and formal origins and destinies are not yet fully understood. Their ambiguity reflects that of the Umayyad mosques built by al-Walid. Just as these features which in Umayyad times can be related to royal functions will tend more and more to acquire a religious meaning, similarly the mosque's significance as a place of worship grows in importance without its ever losing completely its function as a social and political centre. This ill-defined shift in emphasis explains the peculiar characteristic of the Umayyad mosque of the early eighth century: its architectural elements reflect both royalty and religious concerns, the former more often creating specific forms and the latter the dimensions of their coming interpretation.

While the architectural characteristics of the three mosques of al-Walid can be reconstructed on the basis of texts and archeological data, for their adornment we must rely almost entirely on the one at Damascus, which has preserved important parts of its original decoration.[42] Like the Dome of the Rock, it had magnificently carved window grilles. The marble panelling on the lower part of its walls was renowned from the very beginning for the extraordinary beauty of its combinations, of which only a small and poorly reset fraction remains by the east gate. The most celebrated decorative element was, however, the mosaics [17, 18] which originally covered most, if not all, of the walls in the porticoes, on the court façade, in the sanctuary, and perhaps even on the northern minaret. There are many literary references to these mosaics,[43] but much uncertainty remains: we do not know, for instance, whether the many accounts of the importation of Byzantine mosaicists are true, or merely reflect the

feeling that works of such quality doubtless are of Constantinopolitan origin. Most scholars tend towards the first hypothesis.[44]

In spite of the disgraceful restorations which have affected sizeable segments of the original mosaics since the 1960s, large fragments can be identified everywhere in the courtyard, and drawings made shortly before the fire of 1893 record something of the sanctuary mosaics. In most instances, the motifs are vegetal [18], akin to those of the Dome of the Rock, although more realistic in their depiction of specific plants and with fewer mixtures of forms of different origins. Their greatest originality consists in the massive introduction of architectural themes. On the façade of the axial nave and on some of the spandrels of the northern and western porticoes, buildings of all types appear in the foliage. The best preserved of these compositions is the large (34.50 by 7.155 metres), richly framed panel on the wall of the western portico [18]. In the foreground a number of small rivers flow into a body of water along which stand splendid tall trees, rather irregularly set, but providing a frame for a series of smaller architectural units remarkable for their thematic variety (small houses clustered around a church; vast piazzas surrounded by porticoes, stately palaces on the banks of a river) and for their stylistic differences (illusionistic techniques next to fantastic constructions of unrelated elements).

These mosaics raise two questions. The first is formal: how should one explain the coexistence of widely different manners of representation, and is there a style specific to them? Mosaicists and painters since the first century C.E. had availed themselves of all the different styles found on the Damascus walls; the apparent innovation of the artists working for the caliphs was to use them alongside each other. These artists, or their patrons, show a remarkable catholicity of taste, an interest in all available forms, whatever their date or original purpose. To an even greater extent than in the Dome of the Rock, the pre-Islamic models of the Damascus mosaics usually included human or animal forms. None is found here – which implies that the Muslim patrons imposed themes and manners of representation upon the mosaicists, whatever their country of origin. The large trees [18] – although not the main subject matter and amazingly artificial in relation to the rest of the landscape – may have fulfilled the formal function of figures in comparable older work.[45]

The other question raised by the mosaics is that of their meaning. Some later medieval writers saw in them images of all the towns in the world, and a few contemporary scholars have interpreted the remaining panel as the city of Damascus.[46] Topographical representations are known in pre-Islamic art, and the Damascus mosaics – like those of the Dome of the Rock – could be explained simply as symbols of the Umayyad conquest. Or perhaps an ideal 'city of God'[47] is intended, derived from classical and post-classical representations of paradise, but omitting all living things. The theme of an idealized landscape could be related to the setting of the Muslim paradise (for instance Qur'an 4:57ff.); later indications suggest that mosque courts were at times compared to a paradise,[48] and the most recent interpretations of the mosaics of Damascus have accepted their paradisiac meaning.

Objections exist to every one of these explanations. Reference to specific cities throughout the building could hardly have led to the peculiar stylistic and iconographic inconsistencies of mixing precise depictions with artificial constructions, and to the appearance together of architectural units of such different character (towns, villages, single buildings) and on such different scales. And, while a landscape with water and buildings could be understood as a representation of a Muslim paradise, the idea of illustrating the Holy Book at such an early date does not seem to coincide with the contemporary Muslim uses of the Qur'an.

Instead, a combination of these explanations remains possible. Writing in the late tenth century, al-Muqaddasi, our earliest interpreter of the mosaics, pointed out that 'there is hardly a tree or a notable town that has not been pictured on these walls',[49] and a fourteenth-century author redefined the idea, including a precise identification of the Ka'ba.[50] It is, therefore, valid to assume that there was an attempt to portray, within the confines of the imperial mosque, the fullness of the universe – cities even with their churches and surrounding nature – controlled by the Umayyad caliphs. But, at the same time, the golden background, the unreal and unspecific character of many of the compositions, the open ensembles of buildings as opposed to the walled cities of pre-Islamic models, and the centrally placed tall trees give these mosaics an idyllic and earthly feeling, which contradicts any attempt to identify actual cities. Instead one can suggest that the imperial theme of rule over the natural and human world has been idealized into the representation of a 'Golden Age' under the new faith and state in which a peaceful perfection has permeated all things.[51]

Thus, some fifteen years later, the mosaics of Damascus recall those of Jerusalem, but, instead of being an assertion of victory, they reflect the newly acquired security of the Muslim empire. Their most striking feature is that whatever meaning they had does not seem either to have maintained itself within Islamic culture or to have spawned a clearly defined programme for mosques. They should possibly be understood as an attempt at an Islamic iconography which did not take roots because it was too closely related to the ways of Christian art.

Mosaic decoration existed also in the other two mosques built by al-Walid, but no Umayyad work remains, although the much later mosaics on the drums of the Aqsa mosque in Jerusalem probably reflect Umayyad models. In spite of some controversy around the subject, the wooden panels preserved from the ceiling of the same mosque [87], with their remarkably original variety of decorative motifs, are possibly Umayyad or slightly later.[52] It should, finally, be mentioned that, during excavations carried out in Ramlah in Palestine, an early eighth-century mosaic floor was found with the representation of an arch over two columns which may or may not be a *mihrab* and with a fragment from, possibly, the Qur'an.[53] The context of this floor, so different from most other examples of Umayyad mosaics, makes it almost impossible to explain without additional archaeological information.

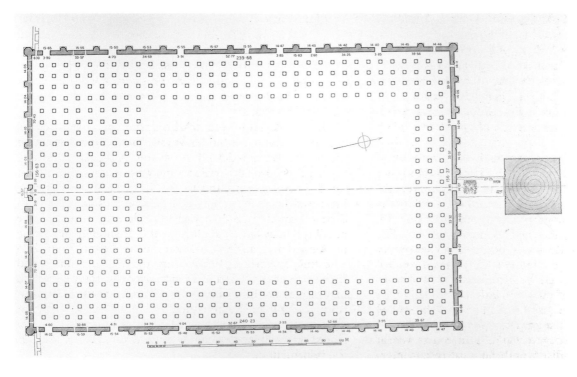

19. Samarra, Great Mosque, 847–61, air view

20. Samarra, Great Mosque, 847–61, plan

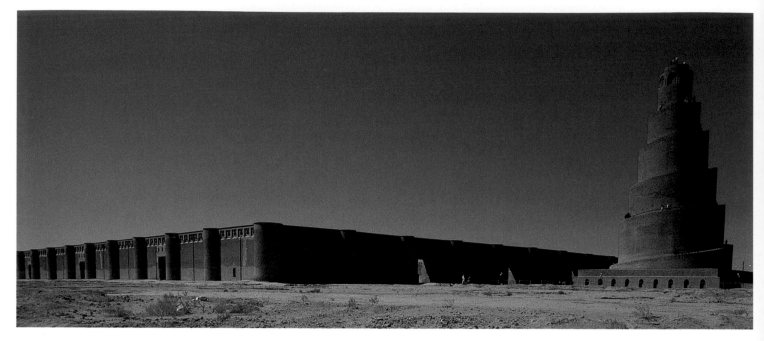

21. Samarra, Great Mosque, 847–61, outer wall

22. Samarra, Great Mosque, 847–61, minaret

OTHER MOSQUES OF THE SEVENTH AND EIGHTH CENTURIES

The mosques of al-Walid are major monuments because of their patronage and their quality. They exemplify the transformation of the rather shapeless hypostyle into a building with a formal relationship between open and covered spaces (court and what is usually called sanctuary), with symbolic and compositional axes (*mihrab* and axial nave), and with a real or potential programme of decoration.[54] But two points should be kept in mind. First, the evolution from the house of the Prophet at Madina to the Iraqi hypostyle before *c.*700 is based almost exclusively on textual evidence. The first (and soon modified) mosque in Wasit is the only reasonably certain late seventh-century example of a large hypostyle mosque in Iraq, but it is known only through soundings, and poses still unresolved problems. Recently published accounts of the pious merits of Jerusalem contain references to an early mosque which suggest rather different reconstructions than the current ones proposed for the Aqsa Mosque.[55] In short, the linear evolution of the mosque from the house of the Prophet in Madina to the Great Mosque of Damascus is hypothetical and may assume a far more centralized ideology and formal concern than was actually the case.

The second point is that explorations and excavations have brought to light a number of additional early mosques, or proposed an early, possibly even Umayyad, original date for mosques with a long subsequent history. Examples of other mosques are the ones at Uskaf-Bani-Junayd in Iraq,[56] Qasr Hallabat in Jordan, Siraf in Iran (where the earliest ascertainable minaret attached to a mosque may be found),[57] Raqqa on the Euphrates, Qasr al-Hayr East,[58]

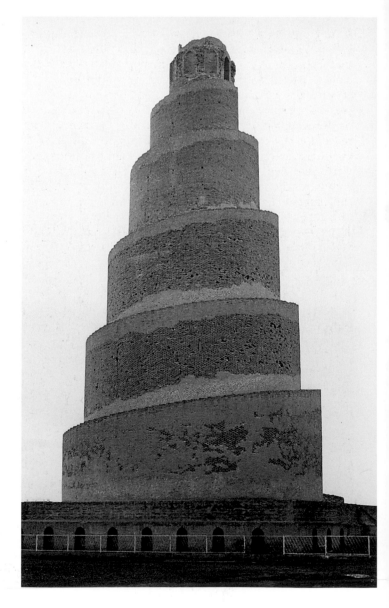

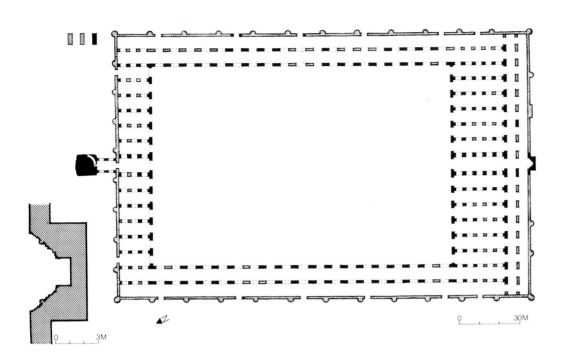

23. Samarra, mosque of Abu Dulaf, 847–61, plan, with detail of mihrab

24. Samarra, mosque of Abu Dulaf, 847–61, air view

Shanqa off the northern coast of Kenya, with some uncertanity about the earliest date of the settlement,[59] and Banabhore in Pakistan, if the eighth-century date of the earliest mosque is confirmed.[60] The congregational mosques at Sanaa in Yemen and at Busra in Syria[61] are obvious examples of later mosques which may well have had an Umayyad predecessor, but there are many more. Most of them did not reflect the new types created by al-Walid, nor is it likely that they were directly influenced by Iraqi mosques; all, however, were provided with a *mihrab* and qualify as hypostyle because of the multiplicity of interior supports. Altogether, they suggest that, while there may have been a tendency toward standardization in large cities and under direct imperial patronage, the first century of mosque building witnessed a much greater variety, corresponding, no doubt, to all sorts of local pressures and traditions, than earlier historiography had assumed. It is even possible that, next to the 'imperial' type based on the axial nave, there developed as early as in the eighth century a type with nine bays set in rows of three. The matter is still not entirely clear, even though small mosques of this type became prominent on the Darb Zubayda, the great pilgrimage road from Iraq to Mecca developed by the end of the eighth century under the patronage of the Abbasid court.[62]

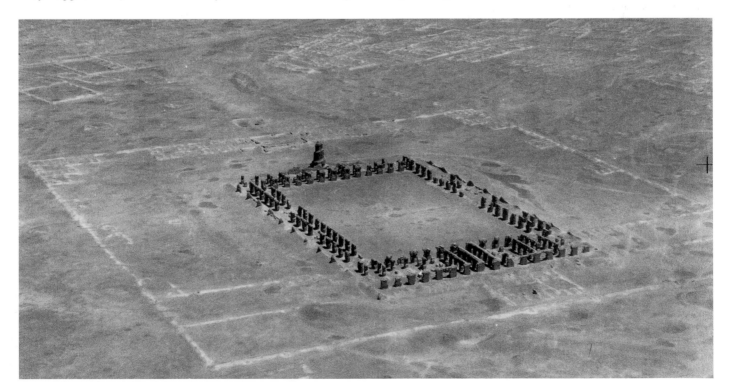

25. Fustat, mosque of Ibn Tulun, completed 879, general view

NINTH-CENTURY MOSQUES

It is particularly unfortunate that nothing remains from any one of the three late eighth-century and early ninth-century mosques in Baghdad, the newly created capital of the Abbasid empire, especially from the one located right next to the caliphal palace, in the centre of the city (see below, p. 52). It was a large building, certainly on a hypostyle plan, with a tower/minaret added in the early ninth century.[63] Whether it had any other distinctive features is not clear from written sources, but its impact must, almost by definition, have been considerable.

Two mosques remain in Samarra, the short-term capital of the Abbasids north of Baghdad (see below, pp. •54ff.), both apparently built under the caliph al-Mutawakkil (847–61). The earlier, the Great Mosque, the largest known in the Islamic world, is an immense rectangle of 376 by 444 metres [19, 20]. Inside a second rectangle, 240 by 156 metres, surrounded by walls and separated from the first by largely empty tracts (used for storage, latrines, ablutions) known as *ziyadas*, is the sanctuary proper, essentially a hypostyle hall with a court and porticoes. It features octagonal brick piers with four engaged columns on a square base, an inordinately large *mihrab* decorated with marble columns and mosaics, a flat roof, exterior towers which serve both to alleviate the monotony of a long, flat brick wall and as buttresses [21], and a curious spiral minaret [22] on the main axis of the mosque but outside its wall. Such minarets have generally been connected with the ziggurats of ancient Mesopotamian architecture, but this is hardly likely since none has survived in its original shape and they were on an altogether different scale. In fact the source remains a puzzle.[64]

The second Samarra mosque, Abu Dulaf, is also quite large (350 by 362 metres for the larger enclosure; 213 by 135 for the second one) and has the same type of minaret and roof [23]. It introduces two new features. First, its arcades stop short of the *qibla* wall, and two transverse aisles parallel to the *qibla* separate it from the main part of the sanctuary. Together with the wider axial nave, these aisles form a T with its crossing at the *mihrab*; hence the type is known as a T-mosque.[65] The *mihrab* is again very large, and excavations have shown that it was connected to a small room behind the building which the prince or the imam could have used before prayer.[66] The second characteristic of the mosque is its large rectangular and T-shaped brick piers. Hypostyle buildings usually create the impression of a forest of supports leading the eye in several directions; in contrast the feeling here is of walls pierced :by large and frequent openings leading in a very clearly defined direction.

The inordinate size of these buildings is to be connected

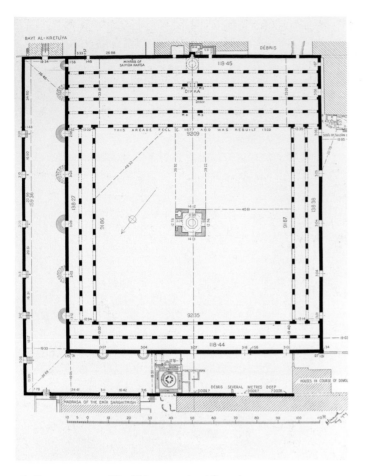

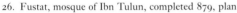

26. Fustat, mosque of Ibn Tulun, completed 879, plan

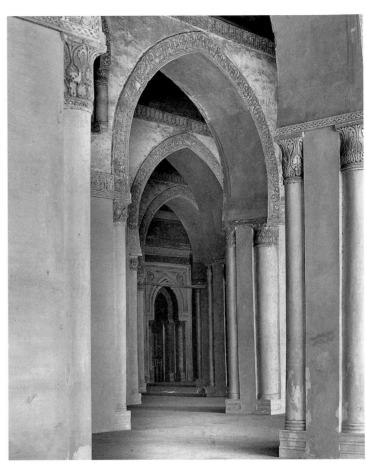

27. Fustat, mosque of Ibn Tulun, completed 879, piers of the east portico

with the grandiose scale of all Samarra constructions and not with the need to accommodate a sizeable population.[67] Decoration is simple and sober. The rectangular pier is explained by the custom in the early hypostyle mosque of reusing earlier columns, or of employing wood. As neither was readily available in Iraq, a new support was invented which would not alter the now almost canonical plan. But the very size of the pier entailed a step towards a different equilibrium. For a large simple covered space with small but numerous supports, Abu Dulaf [23, 24] exchanged a more equal balance between fulls and voids arranged in linear fashion, without the possibility of looking in all directions. Later Islamic architecture in Iran was to refine this new aesthetic approach.

The introduction of the T-plan is more difficult to explain. It may have been an attempt to impose on a large and diffuse plan of equal units a skeleton emphasizing certain major lines; in this sense the T-plan could be understood as a continuation of the axial naves of Umayyad times. In addition, as the Abbasid princes withdrew into their palaces, the mosque began to lose some of its social and political character as the locale where the Commander of the Faithful or his representative met with the faithful to worship and transmit decisions and policies; a professional *khatib* (preacher) replaced the caliph, and the religious and devotional aspects of the building became further empha-

sized, particularly the wall indicating the direction of prayer and its holiest place, the *mihrab*. This could be another explanation for the T-plan. However, ruling princes still built mosques at that time, even if they did not use them regularly, so perhaps the plan was intended to emphasize the *maqsura*, the enclosed area reserved for the prince and his suite; this interpretation coincides with the explanation proposed for the axial nave under al-Walid and also fits with certain later developments, like those at Cordoba. The sources do not help us to choose between these technical or aesthetic, religious, and royal ceremonial hypotheses; all provide fruitful lines of investigation, and it can be argued that all contributed to the newly created type.

Outside Iraq, the major remaining mosques of the period are in Egypt and North Africa. In Fustat the old mosque of Amr, though radically redone in 827, remained a rather simple hypostyle structure which was greatly refashioned in the following centuries. Much more important is the mosque built by Ahmad ibn Tulun and completed in 879 [25, 26].[68] Like those of Samarra, it was a monument in a new city to the glory of the talented and ambitious Turkish general who had become the almost autonomous ruler of Egypt. Comparatively little altered during the following centuries (except for the *mihrab*, the fountain, the minaret, and modern restorations), the mosque of Ibn Tulun is perhaps the most perfectly harmonious of the ninth-century

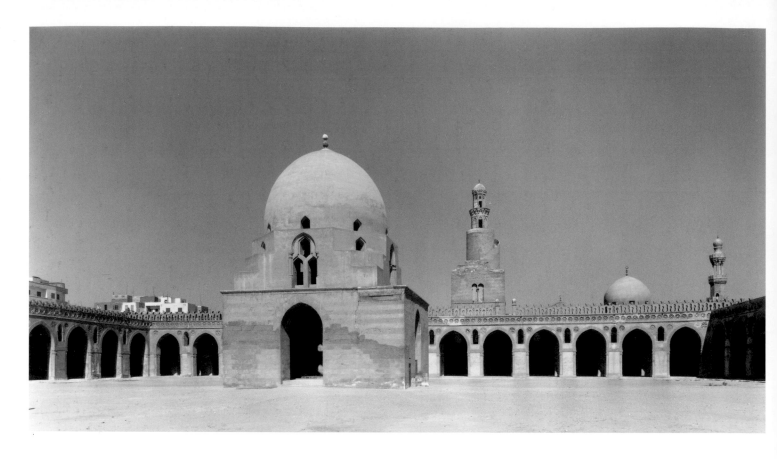

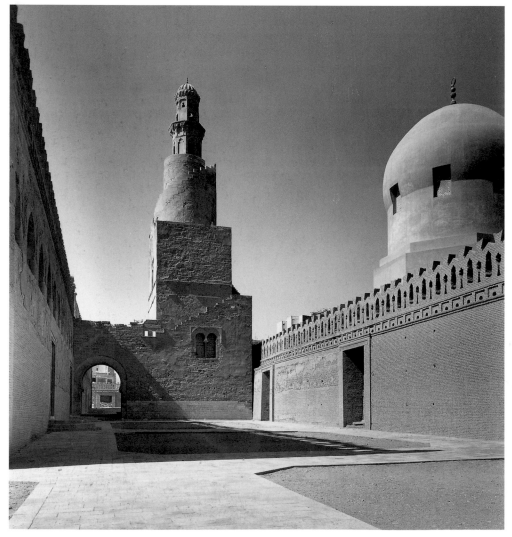

28. Fustat, mosque of Ibn Tulun,
completed 879, court façade

29. Fustat, mosque of Ibn Tulun,
completed 879, outer walls with minaret

Abbasid mosques. In plan it consists of two squares and a rectangle. Its outer area is a square of 162 metres; the court is also a square (of 92 metres) which occupies the major part of the inner area of the mosque, a 122 by 140 metre rectangle. In the centre of the court was a magnificent fountain protected by a gilded dome which fell in 968. The covered parts of the mosque consist of five aisles parallel to the qibla wall and a double arcade on the other three sides of the court. It is entirely of brick, and the supports are rectangular brick piers with engaged columns [27]; the minaret is a fourteenth-century replacement of the original spiral. All these features are atypical of earlier Egyptian architecture and (although later medieval writers embellished them with a great deal of legend) clearly derive from Samarra, where Ibn Tulun had spent many years and to whose Abbasid ideals he was devoted.

The designers of the mosque of Ibn Tulun fully understood the possibilities of the architectural elements with which they were dealing. They opened up those parts of the walls (spandrels of arches, outer walls) which were not essential to the construction and thereby established a simple but effective rhythm of solids and voids both on the court façade [28] and in the sanctuary proper. They also lightened the outer walls [29] by means of grilled windows and niches whose position is logically related to the structure of the interior. In addition, the decoration was fully subordinated to architectural forms: the narrow band of designs following every arch subtly emphasizes the lines of construction without overpowering them. Finally, much of the mosque's harmony derives from the artful use of a two-centred pointed arch slightly returned at the base. It was not invented in Egypt, and its structural advantages are not of great consequence in this flat-roofed building, but it provided the architects with a more refined form to achieve lightness in the monotonous succession of open bays, and represents the earliest preserved example of the aesthetic changes implied by the mosque of Abu Dulaf.

The last major ninth-century mosque related to the Abbasid group is the Great Mosque in Qayrawan [30–35].[69] The conqueror of North Africa, 'Uqba ibn Nafi', had founded a mosque there around 670, and its memory is preserved in a wall hidden behind the present *mihrab*. The Umayyad mosque was destroyed in the early ninth century, when the semi-independent Aghlabid governors planned a new building. The first reconstruction took place in 836, and there were major additions in 862 and 875, by which time the mosque had acquired essentially its present form, although Lézine has shown that there was much restoration in the thirteenth century.[70] The building, a rectangle of 135 by 80 metres, was of stone, with narrow rectangular buttresses on the outside. Inside is a perfect example of a hypostyle (its supports mostly columns from older buildings) with courtyard and porticoes. Like Abu Dulaf, it combined the traditional hypostyle with a T, which was raised above the rest of the aisles and punctuated by two domes, one at the crossing of the T, the other (later in its present form) at the opening on the court. The composition of the building exhibits one peculiarity noted by Christian Ewert for which no explanation exists so far. While making a systematic study of the columns and capitals reused from older

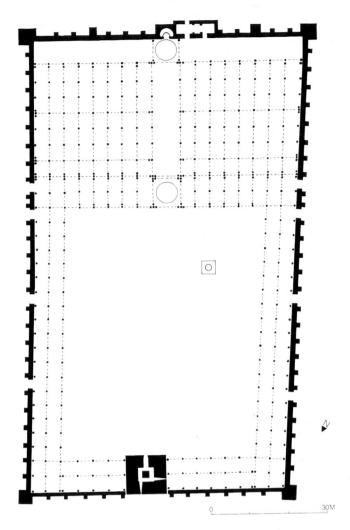

30. Qayrawan, Great Mosque, 836, 862, and 875, plan

31. Qayrawan, Great Mosque, 836, 862, and 875, dome (exterior)

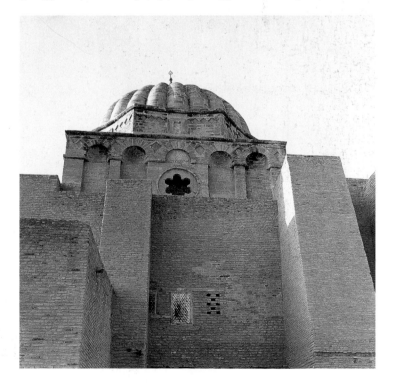

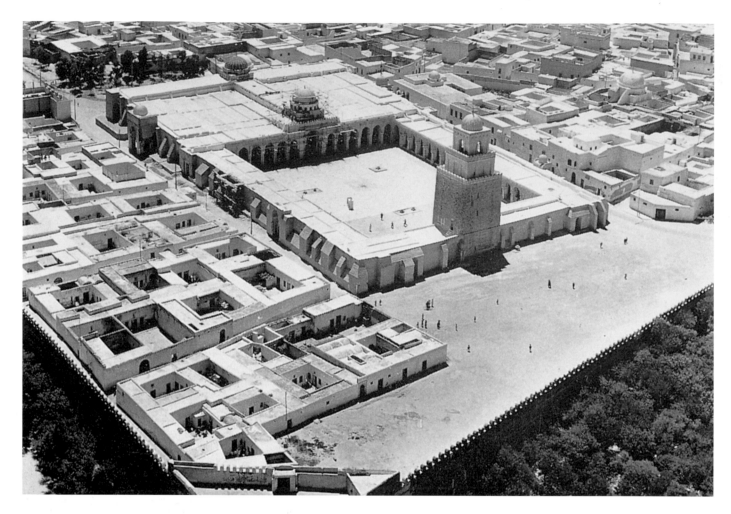

32. Qayrawan, Great Mosque, 836, 862, and 875, air view

33. Qayrawan, Great Mosque, plan according to Ewert

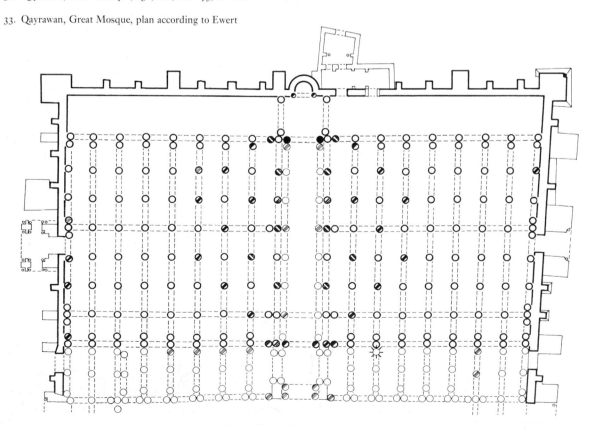

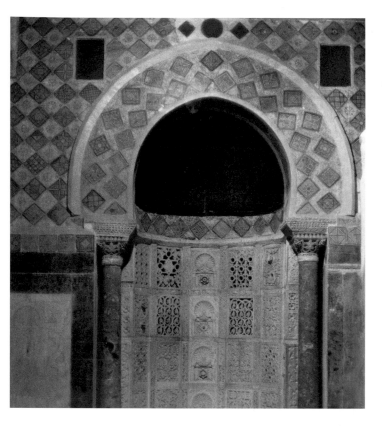

buildings in the new mosque, Ewert noticed that reused capitals were set in such a way as to recreate, inside the mosque, the plan of the Dome of the Dome of the Rock [32].[71] This could hardly have been a coincidence and yet it does not register visually as one walks through the mosque. It must, therefore, have corresponded to some other, pious or magical, process.

Two further architectural features of the mosque of Qayrawan deserve further discussion. The first is the domed area in front of the *mihrab* where, almost for the first time, we see a conscious effort to outshine the rest of the building by the wealth of the brilliant canopy before its holiest place. Magnificent tiles and marble covered the lower part, particularly the *qibla* wall and the *mihrab* [34] (see below, p. 68). Four massive arches support a carefully delineated square; an octagonal arcade on small columns, with four shell-like squinches and four blind arches of similar profile, effects the transition to the base of the dome; above, a drum with eight windows and sixteen blind niches precedes a cornice and the ribbed stone dome itself [35]. All the empty areas, such as the spandrels of the four lower arches and the transitional arcade, are covered with designs of architectural origin. The outside of the dome is similarly divided into three, but an outer square corresponds to an inner octagon, and an octagon to the twenty-four-sided area.

34. Qayrawan, Great Mosque, 836, 872, and 875, mihrab

35. Qayrawan, Great Mosque, 836, 872, and 875, dome (interior)

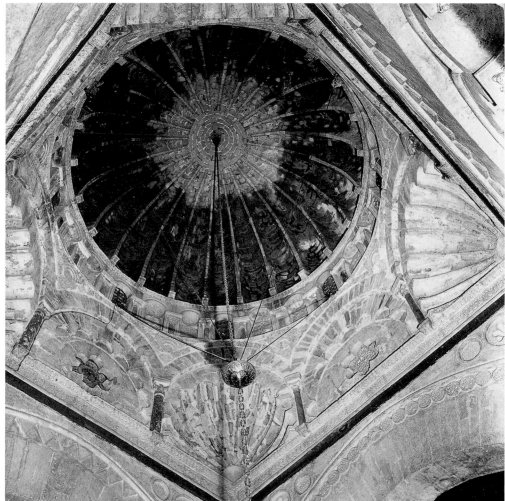

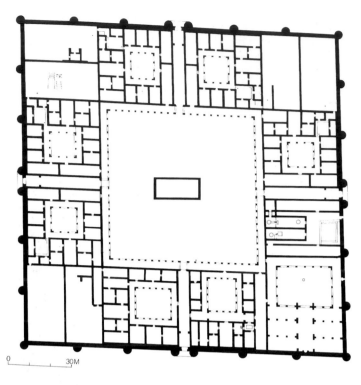

36. Qasr al-Hayr East, early eighth century, plan of large enclosure

Marçais astutely brought to light a second significant feature.[72] He showed that the bays opening on to the court are of three sizes: the central one largest, the bays on each side of it and the last one at each end smallest, the other eight of equal and intermediary size. In addition, he demonstrated that the mosque has three axes of symmetry: one through the middle of the axial nave which serves both the whole façade and the equivalent of a triple gate into the covered area, and two lateral axes which pass through the third supporting block of columns from either end. The bays on each side of the central nave can be seen as part of either of the compositions centred on these axes, and serve thereby as a 'relay' between interlocking parts of the façade.

Qayrawan illustrates two ninth-century Abbasid characteristics also present in the mosques of Samarra and Fustat. The first is the attempt to organize formally the hypostyle plan almost fortuitously created in the early mosques of Basra, Kufa, Fustat, and probably Baghdad. Second, while the ornamentation of certain parts of the building is intensified, decorative themes are almost totally subordinated to structural forms and often originate with them, and serve mainly to emphasize architectural lines.

SECULAR ARCHITECTURE

The eighth and ninth centuries are unusual in the Middle Ages for the astonishing wealth of their secular art, especially architecture. This is largely due to the peculiarities of the Muslim settlement in the Fertile Crescent. In Palestine, Syria and Transjordan, the Muslims, and most particularly the Umayyad aristocracy, took over quite extensive irrigated and developed lands whose Christian owners had left for the

Byzantine empire.[73] Furthermore, the conquest transformed the Syrian steppe, the middle Euphrates valley, and the western edges of Iraq from frontier areas into major centres of commercial and administrative communication and at times into zones of agricultural development. The Muslim leaders became landlords, and the Umayyad state initiated, especially in the middle Euphrates valley (the Jazira of medieval geographers), various programmes of economic development such as swamp drainage, irrigation, and transfers of population. The Abbasids continued this investment in a zone which was to them the main staging area for military operations against Byzantium and founded several cities there, notably Raqqa and its satellites. But their primary effort was concentrated in central and southern Iraq, where the foundation of Baghdad and, then, of Samarra required the maintenance and development of land for agriculture.

Over the past decade a large number of explorations, surveys, soundings, and excavations have been carried out, especially in Syria and Jordan, which constantly alter the knowledge we possess of these centuries.[74]

UMAYYAD CITIES AND PALACES

Most of what we know of Umayyad secular architecture comes from the unique socio-economic setting of the Syro-Jordanian countryside. The urban palace in Damascus, al-Khadra ('the green one' or 'the heavenly one', as has been proposed recently),[75] is gone and even the soundings being carried out in the area where it stood are unlikely to bring out much of its character; its Iraqi parallel in Wasit has never been excavated,[76] although the *dar al-imara* or Government House in Kufa has been explored and published in part.[77] Other urban examples of Umayyad buildings are known in the complicated cases of the citadel in Amman and of the unfortunately partial remains excavated in Jerusalem.[78] By contrast, dozens of country or steppe foundations are avail-

37. Qasr al-Hayr East, early eighth century, plan of small enclosure

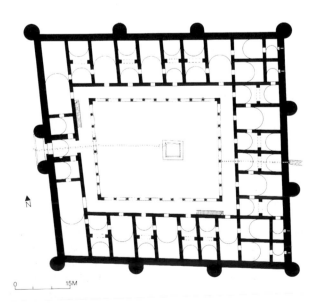

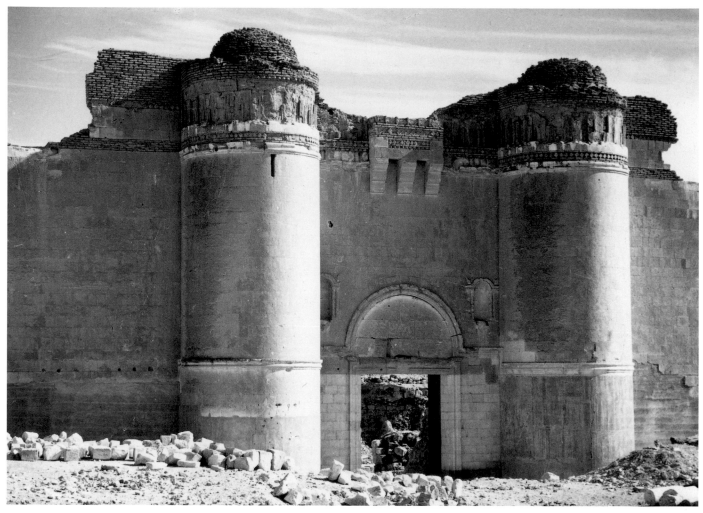

38. Qasr al-Hayr East, early eighth century

able.[79] Their interpretation in the past as reflections of an Umayyad bedouin taste was based on western romanticism about Islam[80] and it is true that in one or two cases – Qusayr Amra, for instance – something has remained of an Arabian aristocratic taste, as we shall see below. In fact these many settlements fulfilled a number of different functions within a new ecological setting.

A most unusual example is Qasr al-Hayr East [36, 37, 38].[81] A hundred kilometres northeast of Palmyra at the intersection of the main roads from Aleppo to Iraq and from the upper Euphrates to Damascus, it consisted of a large (7 by 4 kilometres) walled enclosure probably for animals and agriculture, the earliest known caravanserai in Islam, a large bath, and a 'city' (*madina*, as is specifically mentioned in an inscription, now lost) consisting of six large dwellings, a mosque, and an olive oil press. A few more primitive houses were scattered around. The whole ensemble may well have been the Zaytuna of the caliph Hisham. It was probably begun in the early decades of the eighth century and received major royal funding celebrated by an inscription dated 728. It was probably never finished according to its planned scale and continued as a living, although small, city well into the ninth century. To the archeologist, the historian of technology (especially for water and for construc-

tion), and the social historian, Qasr al-Hayr is a document of considerable importance. For the art historian, two points are particularly noteworthy. First, the forms and techniques used (large square buildings with towers filled with rubble, high gates framed by half-towers and decorated with stucco or brick, organization of space around a square porticoed court, whether the large space of a whole city or the small space of a house, introduction of brick within predominant stone, highly polished skewed wall surfaces, and skewed vaults) originated in the architectural vocabulary of Late Antiquity, for the most part from the Mediterranean. There is no technical or formal invention here, but there is a different use of these forms, in many ways just as in the mosque of Damascus. For instance, three of the four gates of the 'city' were walled almost immediately after construction, because the available type of a square with four axial gates was not adapted to the city's purpose. Moreover, while the central authority, probably the caliphate, created the infrastructure of foundations, water channels, and basic layout of nearly everything, the completion was much more haphazard, at times even in contradiction to the original plan.

The second point also derives partly from Roman architecture: utilities such as waterworks or inns are given a striking monumentality. One can only hypothesize about the

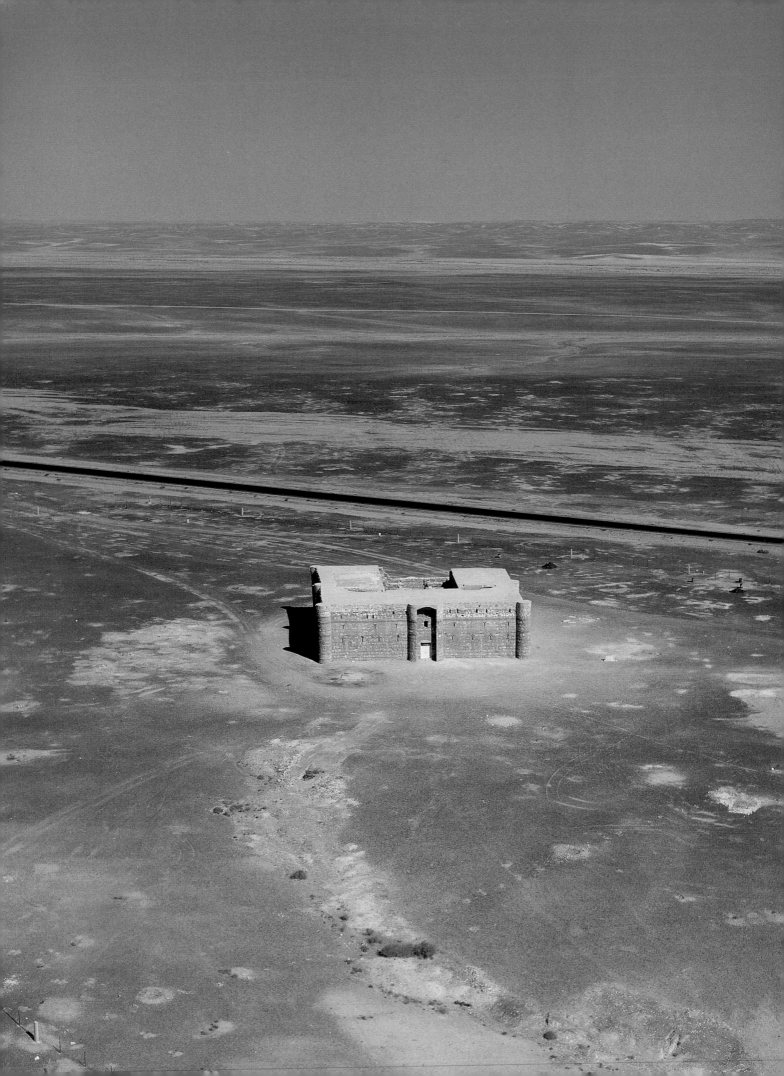

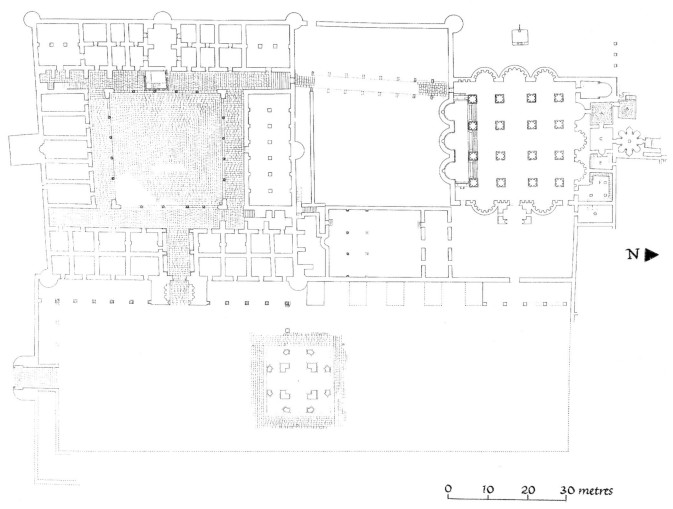

0 10 20 30 metres

41. Khirbat al-Mafjar, eighth century, plan

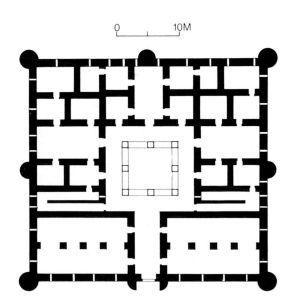

0 10M

40. Qasr Kharana, c.710, plan

39. Qasr Kharana, c.710, exterior

historical and human conditions which created Qasr al-Hayr, but undoubtedly the exterior monumentality of its buildings served the purpose of demonstrating wealth and the power of a new empire. Similar conditions of economic, ideological, and political purposes were behind other idiosyncratic layouts, like those of Anjarr in the Beqaa valley in Lebanon which looked almost like a prototypical Roman military city, and of the citadel in Amman in Jordan, where ancient ruined dwellings were reused for a significant Umayyad establishment, whose exact functions are unclear, but which is remarkable for a massive entrance pavilion with many problematic details and a problematic date.

Yet another unusual example of Umayyad architecture is Qasr Kharana [39, 40],[82] wonderfully preserved on top of a waterless knoll in the Jordanian steppe. Small in size (35 by 35 metres), it has a single entrance, a court, and two floors of halls or rooms, some arranged in apartments and decorated with stucco. Its fortified look is misleading, as the arrow slits turn out to be purely decorative. The technique of construction (rubble in mortar) is unusual in the western part of the Fertile Crescent, and the ornament clearly derives from Iraqi–Iranian sources. Date and purpose have been widely

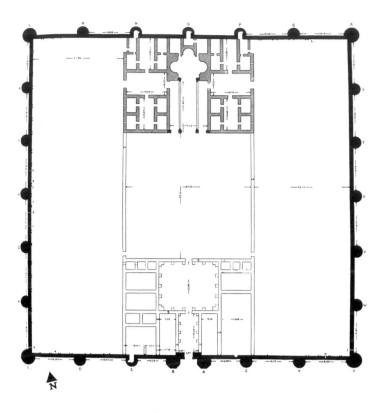

42. Mshatta, eighth century, plan

43. Mshatta, eighth century, air view from the west

discussed. A graffito indicates that the building was standing by 710, and the general consensus is that this date is close to its foundation. Its function is more puzzling; location and internal arrangements give no clue, and recent soundings confirmed the nearly total absence of shards or other traces of regular life. In all likelihood, this was a meeting place of some sort, within the complicated pattern of relationships that existed between the ruling princes and tribal confederations.

These examples are unusual within our present state of knowledge. The fact, however, that we can provide them, even hypothetically, with a social significance within the emerging Muslim world suggests that they were in fact more typical than has been believed, and that each one was a local answer to the needs of a new society in an old land.

The best-known Umayyad palatial monuments are a group built with one exception as places of living, rest, or pleasure for Umayyad landlords. The most important are Kufa (the one urban exception), Jabal Says, Rusafa, Khirbat Minya, Qasr al-Hayr West, Mshatta, Qusayr Amra, and Khirbat al-Mafjar,[83] the last four particularly remarkable for their copious sculpture, paintings, and mosaics.

Khirbat al-Mafjar [41], the best studied one, can be used as a basis for discussion. It consists of three separate parts – a castle proper, a mosque, and a bath – linked by a long porticoed courtyard with a most spectacular fountain. With variations, these elements are found in most palaces. The

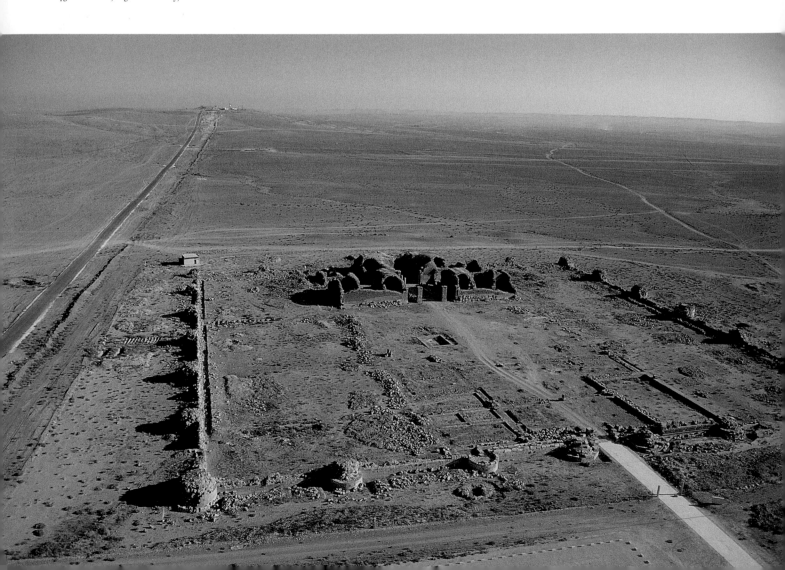

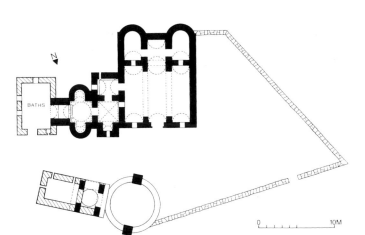

44. Qusayr Amra, eighth century, plan

castle always has an entrance, generally quite elaborate, and along the walls full towers often arranged in apartments (*bayts*) of three or five rooms. There was often a second floor with official apartments, throne rooms, and so on. In addition, Khirbat al-Mafjar's castle has a small private mosque on the south and a small underground bath on the west. Within the same framework, Mshatta [42, 43], the most ambitious of all, although unfinished has a slightly aberrant interior with a large entrance complex (with mosque), a courtyard, and a throne-room complex opening on the court, all set on an axis independently from the living quarters. These differences from typical Syrian constructions and plans can be explained by the impact of Umayyad architecture in Iraq, as we know it in Kufa. The origins of the fortress-like plan, improper for defence, lie in the forts and palace-forts which started on the Roman frontier of Syria and spread to Roman imperial palace architecture elsewhere. The construction – both stone, the most common material, and brick, used in Mshatta and in some parts of other palaces – follows the traditional methods of Syria, with the addition of a few Mesopotamian and strictly Constantinopolitan features. We know less about the ceremonial rooms, since in most instances they were on the second floor over the entrance. However, the remaining examples at Mshatta and Khirbat Minya used the ubiquitous basilical hall of the Mediterranean world which at Mshatta had an appended dome area and triconch.[84]

An important feature of these establishments is their baths; in the case of Qusayr Amra [44] a bath is still standing alone in the wilderness.[85] All have small hot-rooms, which follow in all practical respects the heating and water distributing techniques of Roman baths. But while the heated rooms shrank, a significant but variable expansion took place in what corresponds to the Roman *apodyterium*. At Khirbat al-Mafjar it is a large (slightly over 30 metres square) hall, with a pool at one side, a magnificently decorated entrance, and a luxurious small domed private room at one corner (marked X on the plan [41]). The superstructure is more uncertain: there were sixteen huge piers, and clearly a central dome; whether we must assume something like two ambulatories around it, as was suggested by R. W. Hamilton

[45],[86] or some other system is less certain. The effect was certainly grandiose, especially if one adds the splendid mosaics, the carved stucco, and the paintings which decorated walls and floors. The bath at Qasr al-Hayr East had a simple basilical hall.

The function of such a room is more difficult to define. It has already been pointed out that its size and decoration, as well as the two entrances – one public to the east, one princely and private to the southwest – are fully appropriate for the relaxation generally associated with medieval baths.[87] It was certainly not an *apodyterium* in the strict sense of the word: instead, it must have been a place for official royal entertainment, as practised by Umayyad princes. It may even have had a complex mythical meaning connected with the legends surrounding the Prophet-King Solomon.[88] Its pre-modern equivalent would be the ballroom of a rich residence, serving at the same time for pleasure and as a symbol of social status; for the bath always had the connotation of well-being (hence, for instance, the importance of astrological and astronomical symbols in baths, as in the domed room at Qusayr Amra), and royal entertainment (*lahwa*) increased well-being. Furthermore, to the Arabs from Arabia a bath building was indeed one of the higher forms of luxury.

In other Umayyad baths, the large hall had a different shape and fulfilled slightly different functions. At Qusayr Amra it looks like a throne room with a tripartite basilical hall followed by an apse and two side rooms with floor mosaics.[89] Whether it was really a throne room is debatable and depends on the interpretation of the frescos, to which

45. Khirbat al-Mafjar, eighth century, reconstruction

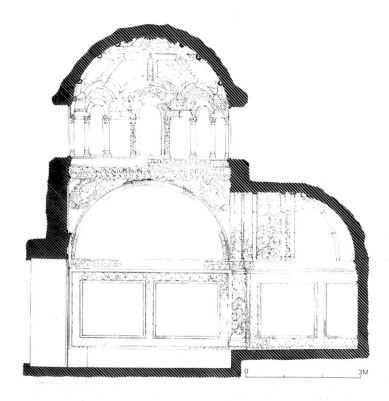

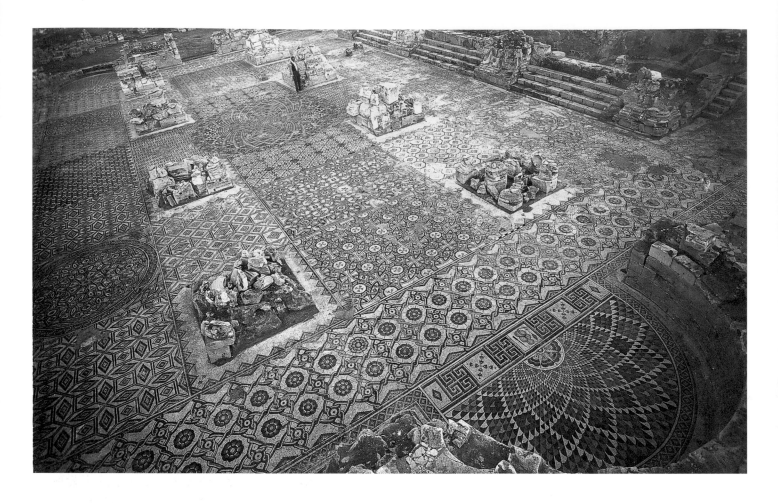

46. Khirbat al-Mafjar, eighth century, bath, mosaic pavement

47. Khirbat al-Mafjar, eighth century, divan, mosaic of lion hunting gazelles under a tree

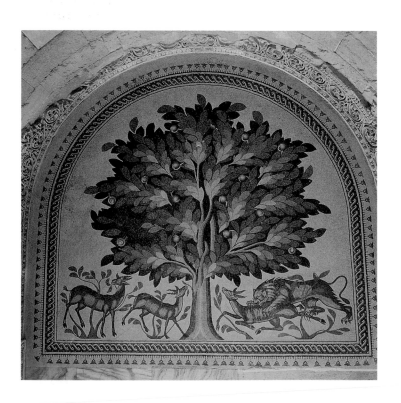

we shall return presently. At Qasr al-Hayr West, which had a nearby palace with a throne room, the large hall was probably a dressing room.

In summary, the Umayyad châteaux, varying in size and wealth, transformed the fortress and the bath into places for gracious living, according to the norms of the time. In all specific aspects – shapes of rooms, methods of construction, size, techniques – the Umayyads followed the traditions of Rome and early Byzantium, and in Iraq and Palestine dependence on precise pre-Islamic monuments and types is clear.[90] But, at the same time, the bringing together of these features and their new use for early Muslim princes, as well as their location outside great urban centres, bestow upon them a specifically Umayyad character.

In addition to their architectural meaning, these secular buildings have yielded an extraordinary amount of evidence for other aspects of Umayyad art. At Qusayr Amra, Khirbat al-Minya, and Khirbat al-Mafjar, there were many tessellated floors. The most spectacular mosaics are at Khirbat al-Mafjar [46], where the bath hall was entirely covered with thirty-one different abstract designs, all related to classical themes, but with a decorative, rug-like quality not usually found in pre-Islamic mosaics. These very same characteristics appear at Khirbat al-Minya, where one panel in particular has the colour pattern arranged so as to give the impression of woven threads.

The small private room off the bath at Khirbat al-Mafjar has preserved the best-known of Umayyad floor-mosaics,

showing a lion hunting gazelles under a tree [47]. Here again the tassels around the panel suggest a textile imitation. The delicacy of the design, the superior quality of colour-setting in the progressively lighter tones of the tree, and the vivid opposition between the ferocious lion, the trapped gazelle still on the run, and the two unconcerned gazelles nibbling at the tree make this panel a true masterpiece. Its location in the apse of a semi-official room suggests an allegory of Umayyad power, since earlier examples had such a meaning,[91] but recently Doris Behrens-Abu Sayf has proposed an erotic explanation based on the images of contemporary Arabic poetry.[92] The stylistic antecedents are to be sought in the Mediterranean world, but the theme is an ancient Near Eastern one.

The techniques of painting and sculpture in Umayyad palaces are not much different from those of preceding centuries: fresco painting in the Roman manner, and stone-carving as had been practised for centuries in Syria and Palestine. More important, both for its implication of oriental influences and for its impact on architecture, is the large-scale use of stucco sculpture.[93] Its cheapness and rapidity of execution permit the easy transformation of an architectural unit into a surface for decoration, a tendency common enough in the Sasanian world, and readily apparent on a façade like that of Qasr al-Hayr West [48], where an

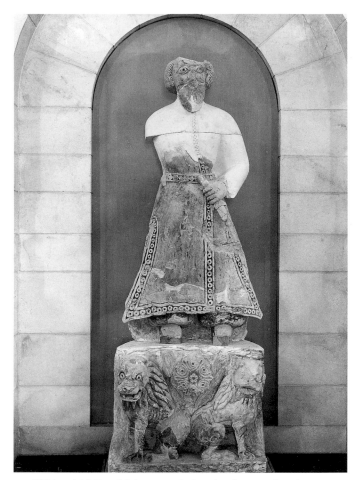

49. Khirbat al-Mafjar, eighth century, bath, painted statue of a prince

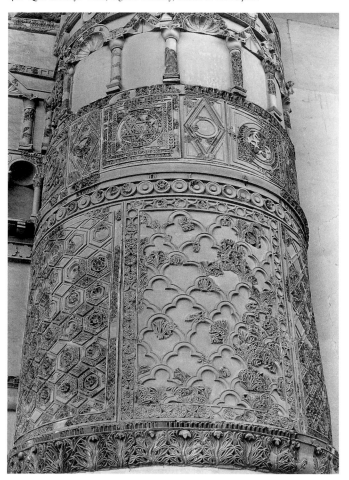

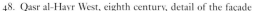

48. Qasr al-Hayr West, eighth century, detail of the façade

essentially classical composition was covered with ornamental panels which tended to obliterate or at least minimize and modify the basic architectural form. But the important issue is why the first Muslim dynasty revived an art of sculpture in the round or in high relief which had all but disappeared. One explanation may be the purely visual impact of the classical monuments which covered most of the Roman world and which would have appeared to the Umayyads as characteristic prerequisites of an imperial life.[94]

Out of the great number of painted or sculpted subjects remaining from Umayyad palaces, the most original are figural representations, which form the majority of paintings at Qusayr Amra and include many fragments from Qasr al-Hayr West and Khirbat al-Mafjar. The subject matter is not always easy to determine, nor is it always simple to distinguish from among the great wealth of identifiable themes, most of which existed in pre-Islamic times, those which were adapted to new Umayyad meanings, and those which were merely used for their decorative value or because they reflected ideas and modes of life taken over by the Arab princes. Various levels of iconographic interpretation exist for the sculptures and paintings which deal with courtly life. Four royal figures remain; whether they were caliphs or not is uncertain. The first, at the gate to the bath of Khirbat al-Mafjar, is a prince standing on a pedestal with two lions [49]. He wears a long coat and baggy trousers in the

50. Qusayr Amra, eighth century, painting of an enthroned prince with attendants

51. Qasr al-Hayr West, eighth century, standing prince

52. Qasr al-Hayr West, eighth century, seated prince

53, 54. Qusayr Amra, eighth century, painting of the Six Kings, and detail

Sasanian manner and holds a dagger or a sword. The second, at Qusayr Amra, is an enthroned and haloed prince in a long robe under a dais [50]. An attendant with a fly-whisk stands on one side, a more richly dressed dignitary on the other. In front, a Nilotic landscape completes the composition. The other two representations are at Qasr al-Hayr West: on the façade, a standing crowned man in another typical Sasanian outfit [51]; in the court, a seated figure [52] more closely related to a Mediterranean prototype as at Qusayr Amra. In all these instances, position as well as iconography imply an official glorification of the prince.

The considerable variations between these images borrowed directly from Sasanian and Byzantine princely representations indicate that, with the exception of a few details,[95] the Umayyads did not develop a royal iconography of their own; this is confirmed by the vagaries of early Islamic coins[96] [95]. It is, however, important that official representations derived almost exclusively from Sasanian or Byzantine types, for it indicates the level at which Umayyad princes wanted to be identified. An excellent example is the well-known Qusayr Amra painting of the Six Kings [53, 54],[97] where an Iranian theme of the Princes of the Earth is adapted to the Umayyad situation by the introduction of Roderic of Spain, a prince defeated by the Muslims. It is likely that there were other images with iconographic meanings catering specifically to the ideology or myths associated with the Umayyads, but the first attempts at such explanations, however intriguing, have not been entirely persuasive.[98]

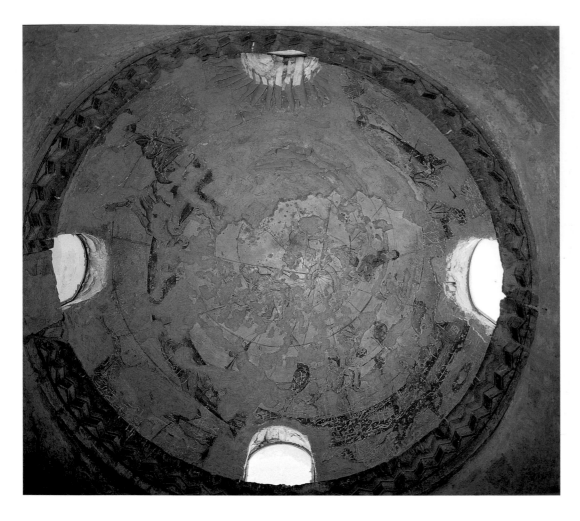

55. Qusayr Amra, eighth century, astronomical ceiling

56. Khirbat al-Mafjar, eighth century, divan, dome with six heads in a flower

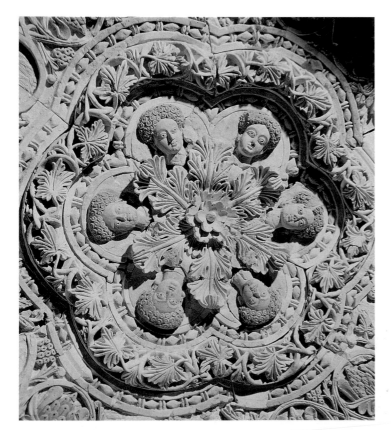

These subjects emphasize the strength and power of the Arab princes. The same theme is implicit in a number of other representations, at Qusayr Amra, for example, in the astronomical ceiling [55] with its connotations of cosmic well-being.[99] Again, in the small room in the back of the main bath hall at Khirbat al-Mafjar [56], the striking six heads in a flower on a dome supported by four winged horses and a procession of birds may have had some kind of cosmic symbolism, although here once more a peculiar ambiguity exists between decorative value and specific symbolic or other meaning.

A second royal theme is of particular interest for three reasons: it was almost exclusively borrowed from the Ancient Orient through the Iranian kingdoms conquered by the Muslims; it corresponded to a certain extent to Umayyad practices; and it remained a constant in later Islamic princely art and practice. The theme is the royal pastime. It includes male and female attendants [57], dancers, musicians, drinkers, acrobats, gift-bearers, and activities such as hunting, wrestling, bathing, and nautical games (the latter two shown clearly only at Qusayr Amra). In most instances a prince is the focus, and an idealized court is represented; but as usual there are modifications inconsistent with the official character of the imagery and which illustrate two further aspects of Umayyad art: its decorative value and its earthiness. At Khirbat al-Mafjar, the

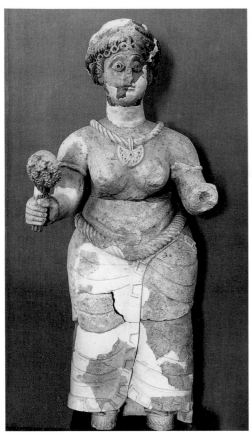

57. Khirbat al-Mafjar, eighth century, female attendant

58. Khirbat al-Mafjar, eighth century, dancing figure in a pendentive

use of four acrobats or dancers in pendentives [58] either means a confusion between the court theme and the old motif of Atlantes (mythical figures holding up world), or, more likely, serves simply to cover the surface of the wall. At Qusayr Amra the rather crude disembowelment of animals introduces an unfamiliar note to the traditional hunting cycle.

It is not clear why a few non-courtly themes appear: at Qusayr Amra some badly faded erotic scenes and a series of personifications (History, Poetry) with legends in Greek; at Qasr al-Hayr a curiously classical painting of the Earth, probably to be related to the general theme of royal power,[100]

and a sculpture of a prone man with a seated woman reminiscent of Palmyrene funerary sculpture; at Khirbat al-Mafjar, as well as at Qusayr Amra or Qasr al-Hayr West, numerous remains too fragmentary to be fully interpreted.[101] Human beings also occur in a decorative context, especially at Khirbat al-Mafjar. Whether painted and fully integrated with a vegetal design, or sculpted and projecting from the decoration [59], their origins are probably to be sought in textiles.

Because of the fragmentary state of remains, one can only hypothesize about the existence of an iconographic programme at Khirbat al-Mafjar and Qasr al-Hayr West.

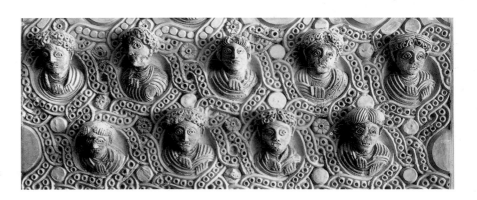

59. Khirbat al-Mafjar, eighth century, frieze of heads in interlace

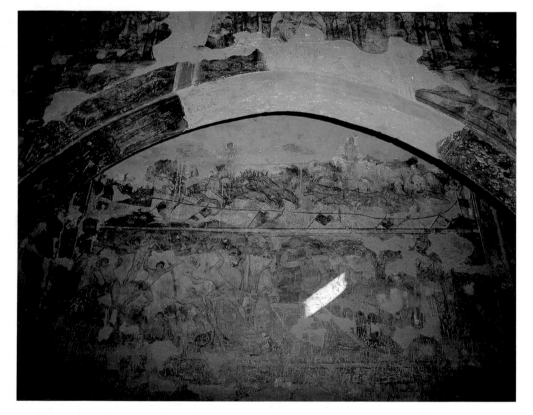

60. Qusayr Amra, eighth century, bath, detail of interior

61. Qusayr Amra, eighth century, bath, painting of animal round-up

62–64. Qusayr Amra, eighth century, bath, painting of nude and clothed dancers

Matters are quite different at Qusayr Amra [50–55], where removal of soot and dirt from the wall of the bath has brought back to light nearly all the paintings discovered at the turn of the century by Alois Musil.[102] The first investigators concluded that at least the main hall had a formal programme depicting the court and ideology of an Umayyad caliph, either al-Walid I or, more probably, the rather libertine al-Walid ibn Yazid, who is known to have lived in that area before his brief rule as caliph in 744.

However, neither the size of the building nor its remote location point to its being anything other than a private pleasure domain. Its most singular characteristic, apparent as one enters, is that the paintings are so numerous [60], so closely packed, that none of them, not even a theme, dominates the rooms. It is as though one has penetrated into the tight coexistence of a prince enthroned in state with a very local round-up of animals [61], rather lascivious nude dancers with a formally dressed one [62–64], carefully and

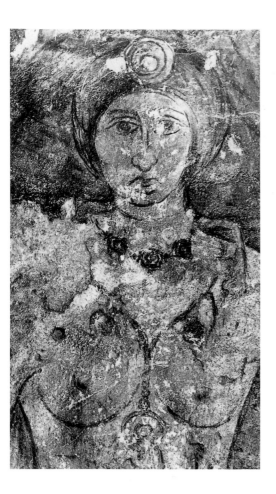

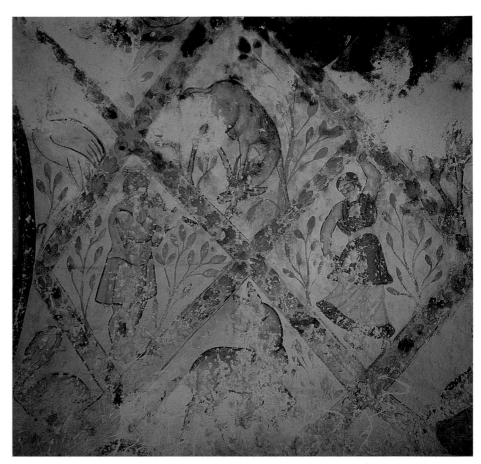

vividly drawn figures or animals with miserable drawings, clear topics next to obscure ones, highly private images of nude figures next to the formal Kings of the Earth. All this shows that Qusayr Amra was a rare medieval example of a private work of art, a combination of themes from many sources – from princely typology to personal whim to local events – which makes sense only from the point of view of a specific patron. What emerges is much less the official statement of a prince than the fascinating personality of someone known only through his private photograph album.[103]

The style, quality, and origins of these paintings and sculptures vary considerably. In most instances the paintings can be related to common Mediterranean traditions, but, although a certain loveliness was occasionally achieved, on the whole most figures have thick outlines, hefty bodily configurations, and lack of subtlety and proportion in the use of shadowing or in composition.

At first glance the sculptures are not of very great quality either, as in the crude eroticism of the Mafjar female figures. The decadence of sculpture in the round, hardly peculiar to Islamic art at this time, is clearly shown by the fact that the more successful and impressive figures are those in which heavily patterned clothes hide the body. The Umayyads achieved more remarkable results only in a few faces with rough planes and deep sunken eyes reminiscent of what prevailed in the Mediterranean world during the fourth and fifth centuries. The background of this sculpture is still unclear. Its main source of inspiration must be sought in Iran, perhaps even in Central Asia; but there is some trace

also of the local Syro-Palestinian pre-Christian styles of such Nabatean sites as Khirbat al-Tannur[104] or of Palmyra, although we cannot yet tell why these sculptural styles were revived several centuries after their apparent abandonment. Finally there are instances of simply copying classical figures.

In addition to human beings, Umayyad painters and especially sculptors represented animals. Most of them are found at Khirbat al-Mafjar: rows of partridges or mountain goats below the bases of domes, winged horses in pendentive medallions [65], and an endless variety of monkeys, rabbits,

65. Khirbat al-Mafjar, eighth century, winged horse in a pendentive

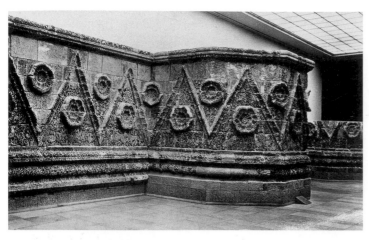

66, 67. Mshatta, eighth century, carved stone triangles, Amman, Department of Antiquities and Berlin, Staatliche Museen

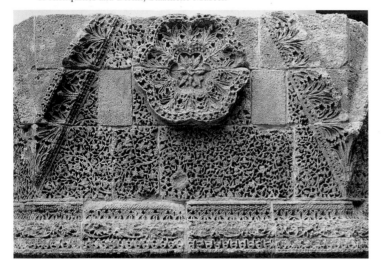

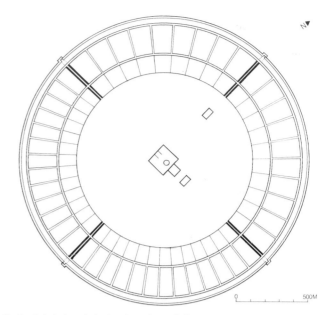

68. Baghdad, founded 762, plan of round city

and pig-like animals in vegetal scrolls. The significance of these fragments is twofold: on the one hand, practically all of them derive from Persian and Central Asian models;[105] on the other, they show a far greater imagination and vivacity than the representations of human figures, as is clearly shown in images of wild onagers at Qusayr Amra.

Altogether the representations of humans and animals in paintings or sculpture can hardly be called great art, however interesting they may be, and they do not compare in quality with the mosaics from the great mosques or from Khirbat al-Mafjar and Khirbat al-Minya, nor even with the ornament to be discussed shortly. This oddity can be explained in two ways. The artisans responsible for the mosaics may have been more skilled than those practising painting, where local provincials predominated, or sculpture, which was an artificial revival. In addition, the stylistic source of both paintings and sculptures may have been objects, textiles, ivories, silver gathered by the Umayyads all over western Asia. The process of magnifying small models may have led to their frequent formal awkwardness.

Umayyad palaces have also preserved purely decorative fragments, mostly carved in stone or stucco and in a few instances moulded in stucco. The greatest number come from the palaces of Qasr al-Hayr West and Khirbat al-Mafjar, but the most elaborate single unit is the facade at

Mshatta [43] with its superb twenty triangles of carved stone [66].[106] The variety and complexity of this extraordinary accumulation of material is bewildering. Early attempts to explain it are unsatisfactory because the more recently discovered palaces of Qasr al-Hayr West and Khirbat al-Mafjar have provided a different context for Mshatta, and because they gave a great deal of emphasis to stylistic origins and the division of the twenty triangles into regionally related groups. One example illustrates the unrewarding character of many of these studies. A great deal of discussion has centred on the fact that almost all the panels on the left of the entrance have animals [66], whereas those on the right have no living beings [67]. This led to varying conclusions about the place of origin of the artists, if not about the symbolic significance of the panels. A later study proposed that the most likely reason for the lack of living things to the right of the façade was that this was the back wall of the palace mosque, which could not be decorated in any other way.[107] If valid, this explanation would indicate a high degree of consciousness in the cultural and religious values of representational art. Whether such an awareness was likely in the middle of the eighth century remains to be seen.

Several characteristics of Umayyad sculpted ornament can be defined, albeit tentatively. First, with the exception of capitals and of certain niche-heads, especially at Khirbat al-Mafjar,[108] it follows the mosaics of the Dome of the Rock in developing on its own, unrelated to the architecture. This is true of the large triangles of Mshatta and most of the panels at Khirbat al-Mafjar and Qasr al-Hayr West. Second, except for a few border motifs, the Umayyad artists created their designs within simple geometrical frames – squares, rectangles, triangles, even circles – which occur both on a large scale (for example the triangles of Mshatta or the rectangles of Qasr al-Hayr West) and on a small scale within the single panel. This point is important in explaining the operation of an Umayyad construction site. Such a tremendous mass of work was accomplished in such a short time only by means

of a large corvée-created labour force. Some master-mind probably planned the basic outlines and then gave free rein to individual gangs for the details; thence derives the unity of organization as well as the multiplicity of detail.

The third characteristic of Umayyad decoration is the tremendous variety of its themes and motifs. They can be divided into two major categories: geometric ornament, used for borders and frames, but also for such features as the balustrades, parapets, lintels, and windows of Khirbat al-Mafjar (similar to the Damascus ones); and the more frequent vegetal ornament, from the luxurious naturalistic vine of Mshatta to the highly stylized artificial palmette of the Qasr al-Hayr West panel. In between we find almost all the themes and styles prevalent in the Mediterranean, Sasanian, and Central Asian worlds of the sixth, seventh, and eighth centuries. It is not yet known whether this eclecticism was due to mass migrations of workers or, as is more probable,[109] to the greater impact, especially in the last decades of the Umayyad period, of people, objects, and impressions from the huge eastern world. The fact remains that the Umayyads provided a sort of showplace and incubator for the decorative arts of all conquered areas. Of course, there are individual characteristics. At Mshatta we have mostly plants of classical origin, in a fairly natural style, with animals from west and east, and, on certain triangles, the superposition of a geometric rhythm of circles. Qasr al-Hayr West has the most stylized decorative motifs, Khirbat al-Mafjar the greatest variety of themes of different origins and in different moods, but none relies on one source only: all express a catholicity consonant with the size of the empire. In addition, many different techniques are drawn on, with a curious predominance of textile patterns. This cheap and rapid reproduction of motifs from expensive sources (the point applies less to Mshatta than to the other palaces) also illustrates something of the *nouveau riche* side of the new civilization.

All this may explain the origins and wealth of Umayyad designs. But is it possible to define the ornament as such? One of its principal features is its cultivation of contrasts. A panel from the façade of Khirbat al-Mafjar contains geometric division of space, highly stylized palmettes symmetrically set in a circle, and a handsomely luxurious double trunk, ending on one side in a fairly natural bunch of grapes and on the other in a geometricized vine leaf. On the Mshatta triangles a vigorous and lively movement of stems, leaves, and bunches contrasts with geometrically perfect, static series of circles with artificial pearl borders. At Qasr al-Hayr West the artificiality is more apparent, but even here a simple geometric design appears next to lively palmettes. In every case the background has wellnigh disappeared. All is decor at Khirbat al-Mafjar and at Qasr al-Hayr West, whereas at Mshatta only dark voids remain, giving the impression of filigree work. It is the opposition between intensely naturalistic and completely stylized features, the tendency to take over the whole surface of the wall, and the presence of so many different elements alongside one another that define Umayyad ornament. The latter does not yet have the sophistication and cleverness which were later to characterize Islamic decoration, but it has already separated itself from the traditions of the Mediterranean and of

Iran, even though individual units and motifs and the general conception of a decorative programme partly independent from architecture derive directly from one or the other. In a curious way which, for the time being, defies explanation, much in this art bears comparison with nearly contemporary Irish and northern European art. Since there could not have been artistic contacts between these areas during the Umayyad period, the parallelisms must be structural and require an eventual theoretical rather than historical explanation.

ABBASID CITIES AND PALACES

Nothing remains of the most important Islamic monument of the second half of the eighth century, al-Mansur's Baghdad founded in 762, but it is sufficiently well described in written sources to lend itself to detailed analysis.[110] Officially called 'City of Peace' (*Madina al-Salam*), it was conceived in true imperial style as the navel of the universe, and al-Mansur called engineers and labourers from all parts of Islam to build it. Special bricks were made, and the foundations were begun at a time chosen by two astronomers. It was perfectly round [68] (about 2000 metres in diameter), a plan by no means new, although Muslim writers considered it so. In the outer ring, as reconstructed by Herzfeld and Creswell, were houses and shops protected by heavy walls and cut by four long streets covered with barrel-vaults [69].

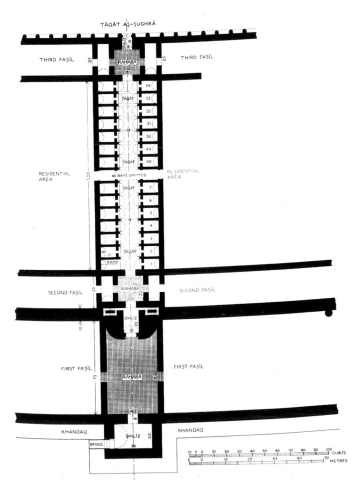

69. Baghdad, founded 762, street plan

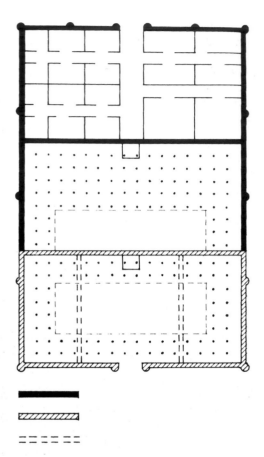

70. Baghdad, mosque of al-Mansur, *c*.765, with additions to the late ninth century, reconstructed plan

71. Drawing of automaton rider with lance on the Green Dome, Baghdad, founded 762

Each street opened on the outside through a magnificent two-storeyed gateway and a complex system of vaults and passages over moats. On the second floor of the gateway, accessible by a ramp, was a domed reception hall (*majlis*), probably to be connected with a Mediterranean imperial tradition, for it was found in Rome and Byzantium and transmitted to the Muslim world by the Umayyads. The entrances were symbolic rather than defensive; indeed, three of the doors were actually taken from older cities, including one attributed to Solomon. The idea behind them was a statement of repossessing the ancient traditions of the area.

The extent of the outer ring is uncertain, but the central area was clearly large and, originally at least, mostly uninhabited. At its heart lay a palace and a mosque [70]. The mosque, which has already been mentioned, was at the same time the royal mosque attached to the palace and the congregational mosque for the whole population of the city. The palace was arranged around a court, an *iwan* of unknown shape, and two domed rooms, one above the other, all probably deriving from the Sasanian tradition already adopted in Umayyad buildings in Syria and in Iraq. At the centre of the whole city was a higher dome, the Green (or Heavenly) Dome, surmounted by a statue of a rider with a lance [71].[111]

The interest of Baghdad is twofold. First, it is rare in being conceived and planned with the cosmic significance of the centre of a universal empire. Ironically, it remained in its ideal shape for only a few years, for economic necessity pushed it out beyond the walls, and caliphs or major princes abandoned their palaces in the centre for the quietude and security[112] of suburban dwellings whose names only have remained. Second, many features derived from the architectural tradition of palaces, for example both the gates and the domed throne room as well as the overall design with four gates for royal audiences. The Abbasid city was thus a magnified royal palace rather than the rich industrial, administrative and commercial centre that it later became.[113]

Since nothing is left of the round city of al-Mansur, it is difficult to say whether new methods of construction or architectural forms were introduced. We have only two other early Abbasid monuments to compare it with. One, the complex of cities in the middle Euphrates area known today as Raqqa,[114] is mostly buried. To this Abbasid city founded in 772 supposedly on the model of Baghdad (it is

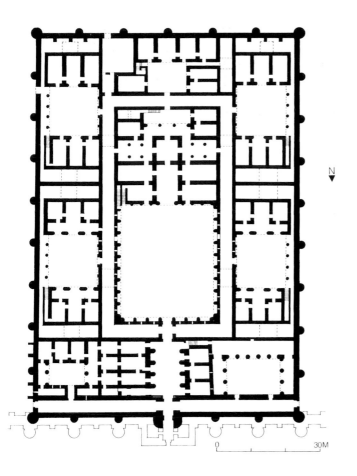

probably the horseshoe-shaped city still visible today), Harun al-Rashid added after 795 a number of further constructions. All that remains above ground is a much restored mosque; possibly the location of walls and gates also corresponds to the original Abbasid plan. In addition, Syrian and German excavations, mostly still unpublished, in and around the city proper have brought to light large private villas which are interesting for the decoration found in them (such as elaborate stucco panels and glass floors, possibly trying to suggest pools) and as our only illustration of the growth documented in literary sources of private palaces inside cities or in their suburbs.

More or less contemporary with Baghdad is the palace of Ukhaydir [72, 73], in the desert some 180 kilometers to the south. Creswell related its construction to events in the caliph's family and dated it around 778;[115] the date at least is reasonable. Its location and fortified exterior relate it to the Umayyad palaces of Syria, but its size (175 by 169 metres for the outer enclosure) and much of its construction are

72. Ukhaydir, probably c.778, plan

73 (*below*). Ukhaydir, probably c.778, general view

74 (*right*). Ukhaydir, probably c.778, vaulted hall at entrance

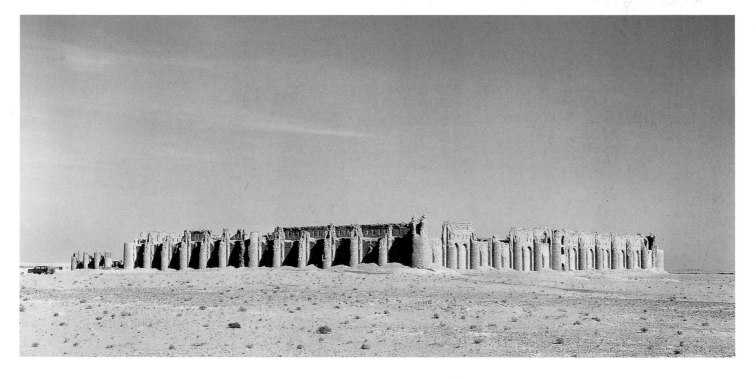

75. Samarra, founded 836, air view

76. Fustat, Nilometer, 861

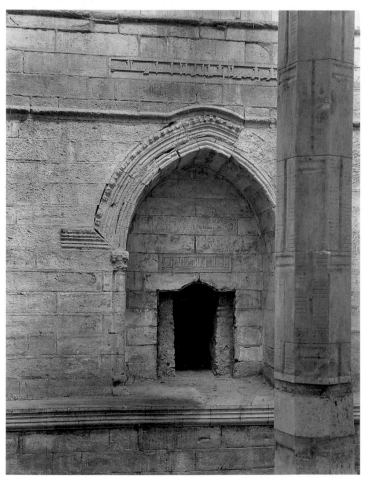

quite different. The technique (rubble in mortar covered with stucco and brick for vaults), the heavy pillars making up arched recesses on the side of long vaulted halls, the pointed curve of the vaults, and the use of blind arches for the decoration of large wall surfaces all show the persistence of Sasanian methods. In plan, the entrance complex on several floors preceding a domed room followed by a long vaulted hall [74], plus the central official group of court, *iwan*, and dome, correspond on a small scale to the textual descriptions of Baghdad. Thus Ukhaydir confirms that in plan Baghdad relied on palace architecture, and in technique on Sasanian methods.[116] In addition, even though the reasons for its location remain obscure, Ukhaydir illustrates the continuation of the Arab aristocratic tradition of building outside the main cities.

Abbasid architecture of the ninth century shows significant changes. First, in 836, the caliph al-Mu'tasim founded a new capital, partly because of difficulties between the Turkish guards and the Arab population of Baghdad, partly to express anew the glory of his caliphate. The chosen site was Samarra, some sixty miles up the Tigris from Baghdad. Until 883, when it was abandoned as capital, every caliph added to al-Mu'tasim's city, creating a huge conglomeration extending over some fifty kilometers [75]. After it declined to a smallish town of religious significance only, the Abbasid city remained in ruins or buried underground, and recent excavations as well as photogrametrical surveys remain only partly published with very preliminary interpretations.[117] From texts we know of major Abbasid constructions in most cities under their rule except in western Syria (as opposed to the valley of the Euphrates) and Palestine, but recent arche-

77. Samarra, Jawsaq al-Khaqani palace, *c*.836, plan

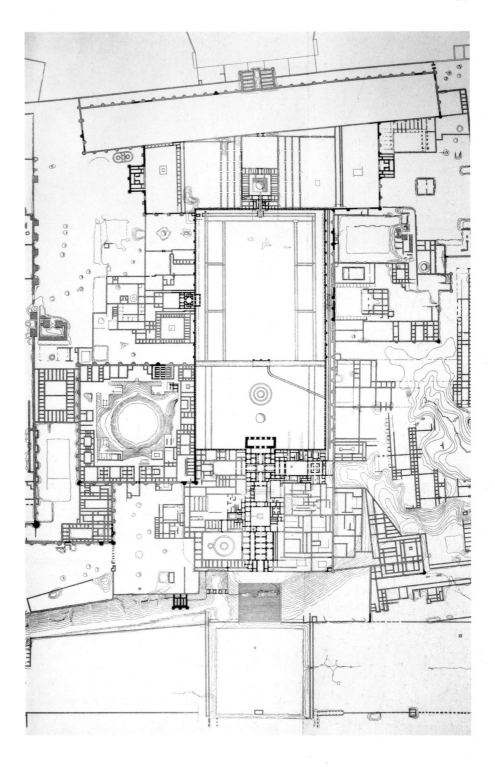

ological investigations may well challenge this conclusion. Tantalizing information exists on the quarters added to Fustat in Egypt by the Abbasid governors of the early seventh century and then by Ahmad ibn Tulun, who ordered the creation of a large open area (*maydan*) with fancy gates near his palace.[118] Urban architecture is also represented by a series of major public works mainly to do with water conservation and utilization: canals in Samarra, cisterns at Ramla in Palestine and in Tunisia, and the extraordinary Nilometer at Fustat (861) [76],[119] with its magnificent stonework and relieving arches.

Finally, there are the palaces, of which those at Samarra are the most important, though none has been totally excavated. Examination of the available information about the Jawsaq al-Khaqani [77], the Balkuwara, and the Istabulat[120] leads to a number of conclusions. Their most striking feature is their size. All are huge walled compounds with endless successions of apartments, courts, rooms, halls, and passageways, whose functions are not known. From a city in the shape of a palace, as Baghdad was, we have moved to a palace the size of a city. Second, each has clearly defined parts. There is always a spectacular gate: at Jawsaq al-Khaqani, an impressive flight of steps led up from an artificial water basin to a triple gate of baked brick, in all

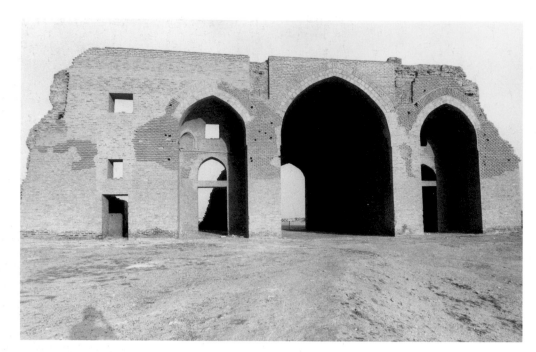

78. Samarra, Jawsaq al-Khaqani palace, 'Bab al-Amma', c.836

probability the Bab al-Amma, the 'main gate', of so many texts [78]. Gates and gateways also appear inside the palaces, and in the Balkuwara a succession of impressive doorways emphasized passage from one court to the other. On the axis of the main entrance a series of courts generally leads to the main reception area, which is cruciform. A central domed room opens on four *iwans* which, in turn, open on four courts. At times, mosques, baths, and perhaps private quarters filled the areas between *iwans*. Textual and archaeological sources indicate that this cruciform arrangement of official rooms derives from eastern Iran.[121] The only other clear feature of these palaces is the appearance in and around them of large gardens and parks, carefully planned with fountains and canals, game preserves, or even racing tracks,

as is suggested by a rather extraordinary area in the shape of a four-leaf clover discovered through air photographs near the Jawsaq al-Khaqani.[122] Ancient Near Eastern and Hellenistic traditions of the royal 'paradise' were adopted by the Abbasids and sung by their poets.

Not much can be said about structural technique: baked and unbaked brick, natural in Iraq, was the usual material and, so far as we can judge, vaulting the prevalent mode of covering. The real importance of these buildings lies in their conception of a royal palace, totally new to Islam, although not unknown in previous civilizations. It is a hidden and secluded world, completely self-sufficient. The fact that its splendour was barely visible from outside sparked the imagination of story-tellers and poets, who began at that time to develop the theme of secret marvels familiar to readers of the *Arabian Nights*. From Samarra this conception, if not always the scale of execution, spread to the provinces, as we can see from the description of the palace which Khumarawayh ibn Ahmad ibn Tulun built in Egypt.[123]

A last group of Abbasid monuments are neither mosques nor obviously secular constructions. Their background and significance are not always easy to establish, and they demonstrate how much is still unknown about the period: the octagonal Qubba al-Sulaybiyya in Samarra [79],[124] for instance, may be either a mausoleum built for one of the caliphs by his Greek mother or the earliest remaining sanctuary for a Shi'ite *imam*.[125] An entirely different type of building is the *ribat*, a military monastery developed in early Islamic times on the central Asian, Anatolian, and North African frontiers from which specially trained men engaged in battle against the infidels. Unfortunately it is impossible to say whether the Tunisian examples[126] at Monastir [80] and Susa – small, square fortified buildings with a central court, rooms and oratories on two floors around the court, and a high corner tower – were peculiar to North Africa or not.

79. Samarra, Qubba al-Sulaybiya, 862, plan

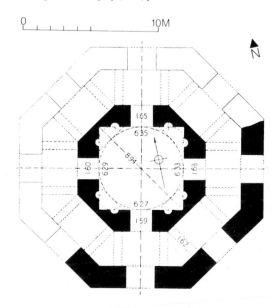

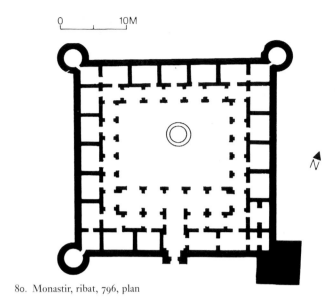

80. Monastir, ribat, 796, plan

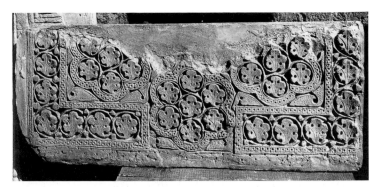

81. Samarra Style A, ninth century, Berlin, Staatliche Museen

82. Samarra Style B, ninth century, Berlin, Staatliche Museen

ARCHITECTURAL DECORATION

By and large Abbasid mosques were decorated very soberly. At Samarra there is almost no applied ornament, and in the mosque of Ibn Tulun stucco is used only to emphasize the major architectural lines. At Qayrawan and in the Aqsa Mosque in Jerusalem – if the latter's fragments are indeed Abbasid[127] – the painted or carved designs on wooden ceilings involved the medium of construction itself. The same subservience to architectural forms or materials appears in the stone decoration of the dome at Qayrawan [35], where even the floral designs of the niches and windows of the drum do not detract from the essential sturdiness and massivity of the construction. In other words, much of the architectural decoration of the Abbasid period, especially in mosques, is still quite Late Antique in spirit, even though the themes may have changed. The two major extant exceptions are the *qibla* wall at Qayrawan, where ceramic tiles and marble panels (on which more below)[128] have almost totally transformed the effect of the *mihrab* area, and the secular buildings of Samarra. The former involve the arts of objects, and will be discussed later; here we shall concentrate on the decoration of the palaces and houses of the ninth-century capital in Iraq where, in fascinating contrast to religious buildings, the walls of almost every house and every room in the palaces were covered with decorated and painted stucco (in addition to occasional marble panels), in continuation of Iranian and Umayyad practice.

Most of the material from Samarra was published by Herzfeld, who discovered and studied it in detail;[129] Creswell suggested certain alterations in chronology.[130] Both agreed that, with few exceptions, the Samarra stuccoes can be divided into three basic styles. Their order of appearance cannot be determined, for the archaeological evidence, however limited, clearly indicates that all three existed, if not always simultaneously, at least throughout the period of Samarra's greatness in the ninth century. Furthermore, they often overlap both on the wall and in treatment of motifs, and any attempt to distinguish them should not obscure the fact that, in spite of some preliminary studies,[131] many problems concerning their origins and relation to each other are far from being solved.

Style A [81] tends to develop within identifiable frames, most commonly in long bands (at times T-shaped), but sometimes in simple rectangles or polygons. Its characteristic feature is the vine leaf, its parts always sharply outlined, with four deeply sunk 'eyes' and often with incised veins. The striking and effective contrast between the theme itself and the deeply carved void of the background can be explained by the peculiar technique of execution *ex situ* on specially prepared mats. Both vocabulary and treatment are related to the vine ornament, already used by the Umayyads, which prevailed throughout the eastern Mediterranean in Late Antiquity. However, by the ninth century the same few formulas are being dully repeated, and Samarra is not comparable with the façade of Mshatta. Style B [82] was usually carved freehand, with a greater variety of themes, motifs, and shapes. The motifs develop within much more diversified frames, from all-over patterns to many different polylobes and polygons. Moreover the contrast between subject and background is much less apparent than in the first style, because the design takes over almost the whole surface, and is heightened by the deep grooves around individual motifs. Also, while the vegetal origin of most of the themes is clear,[132] the surface of the individual leaf or flower is almost totally covered with small notches and dots, and its outline has been simplified into an almost abstract shape which acquired its significance only in relation to other units of decoration and to a pre-established

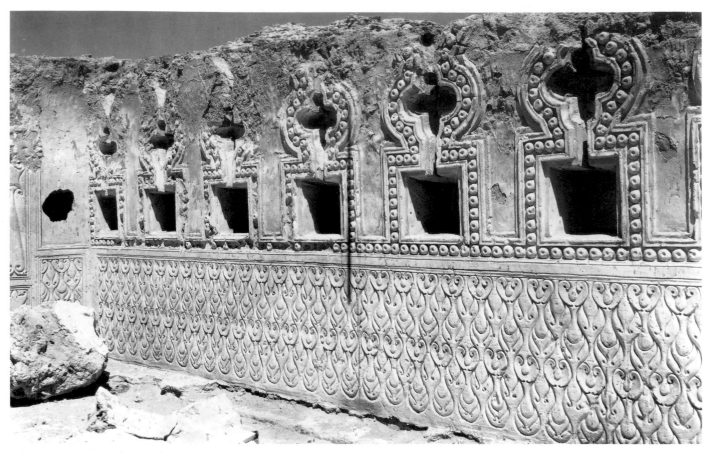

83. Samarra Style C, ninth century, Berlin, Staatliche Museen

pattern. While perhaps not very beautiful, this style is peculiarly appealing because in the best examples its symmetrically arranged patterns constantly contrast an inner tension and movement with the rigidity of geometric frames. An Indian origin has been proposed,[133] but neither the historical context nor other known works of art fully justify it, and the style can best be understood as a further modification of Late Antique ornament, perhaps to contrast with the exuberance of Umayyad palatial ornament; for the central characteristics described above were already present in the stuccoes of the great Umayyad palaces, and no new and external impetus has yet been identified.

While the first two Samarra styles are related to the tendencies of the first Islamic century, Style C [83] introduces something quite new and far-reaching in its implications. Its first characteristic results from its technique: the design was moulded, and consists of endless rhythmic repetitions of curved lines with spiral endings, at times with additional notches, slits, pearl borders, or other identifiable elements. Moreover, throughout, the lines were 'bevelled' – i.e. they meet the surface obliquely – so that the wall surface has a strongly plastic quality. Next, the style is identifiable not through specific units of design but rather through a certain relationship between lines, notches, and planes; in other words, the unifying factor is no longer the elements themselves but rather their relationship to each other. Furthermore, none of the traditional geometric, vegetal, or animal themes is used, and the background has disappeared,

so that in effect the whole surface of the wall is ornament. The final characteristic (at least in stucco) is symmetry on a vertical axis; but (except where the exact size of the wall surface is known, or where the decorator has introduced a geometric unit) the axis is not self-evident from the design, but can vary from place to place.

Thus, the major characteristics of the third Samarra style are repetition, bevelling, abstract themes, total covering, and symmetry. Its significance goes beyond Abbasid architectural decoration, for it is the first, and in certain ways the purest and most severe, example of the 'delight in ornamental meditation and aesthetic exercise'[134] which has been called the arabesque. Its impact was immediate, for it appears in the stuccoes of the mosque of Ibn Tulun and in many small objects, and it remained in use for several centuries [99].

The questions of the origins of Style C and of the exact date of its appearance are more complex. With respect to origins, close analysis reveals possible vegetal patterns of trefoils, palmettes, even cornucopias or vases in the background of many an interplay of line and plane. A series of capitals found in the area of the middle Euphrates, near or in Raqqa, shows an evolution from vegetal ornament which leads almost to the Samarra pattern,[135] and the third style, like the second, could be another systematized variation on earlier decorative principles which was given striking effect through the use of an original technique and the impact of metal or wooden moulds. However, the eastern Syrian capi-

tals are not datable with any degree of accuracy; they may be later than Samarra, and therefore perhaps indebted to it. Another explanation, first proposed by Kühnel[136] and amply supported by later archaeological discoveries, is based on the fact that Central and even Inner Asian wood work and metalwork from nomadic areas show a very similar technique and fairly similar transformations of vegetal designs.[137] The difficulty lies in assuming that Turkic soldiers of Central Asian descent created a style of decoration based on their memory of their homeland, or on objects brought from it. Samarra's Style C should probably be explained as a moment in an evolutionary process simplifying forms of Antique origin to the point of total abstraction, because of a willed or repressed avoidance of living beings in publicly accessible monuments. Its quality of abstraction may explain its impact in the rest of the Muslim world.

A few words must, finally, be said about the many fragments of large mural paintings brought to light in the dwellings and bath houses of Samarra and, most particularly, in the domed central hall and the private quarters of the palace of Jawsaq.[138] The classical strain still predominant in Umayyad figural representations was overshadowed in Samarra by what may be called a pictorial style in the old Persian tradition. Lively animals in full movement, drawn in the Hellenistic manner, still occurred, and one of the more imposing frescos of the palace consisted of powerfully composed rinceaux with branches like cornucopias, inhabited by human and animal figures, a theme common in late classical art. The bulk of the paintings, however, represent nearly static, heavily built, expressionless human figures and animals with close parallels in Sasanian silverware, and a few contemporary textiles; also similar is the treatment of the motifs as patterns and the lack of interest in landscape and the *mise-en-scène*. Comparable material has been found in frescos from Central Asia and Chinese Turkestan.[139] The physiognomy and coiffure so common in Samarra occurred in Turfan, and frescos excavated at Varakhsha and Panjikent, though in many respects quite different, also exhibit some related features.[140] As Herzfeld, original excavator of the Samarra material and the foremost writer on the finds, already clearly saw, these paintings have to be seen as a mixture of strongly orientalizing versions of Hellenistic themes on the one hand, and motifs and modes of representation derived directly from the Ancient Orient on the other. The use of both three-quarter and frontal views of the human face clearly demonstrates this dichotomy. Some marked differences are also apparent. There is, for instance, a pronounced preference for the female figure, which was already manifest under the Umayyads, while in early and middle Sasanian art it played a very minor role. Unfortunately the finds were too limited to allow much generalization about favoured themes, but obviously the pleasures of the court – the hunt, dance, and the drinking of wine – are frequently represented. Other subjects may be of a more symbolic nature or intended simply to produce rich surfaces; written sources even tell of a painting showing a monastic church, and one fragment came from a bottle with the representation of a Christian monk.[141]

A typical example of this art is the scene of a huntress from the private part of the palace and reproduced here after

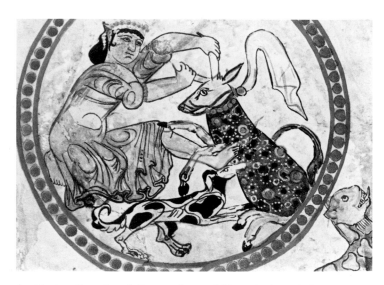

84. Huntress fresco (copy), Samarra, Jawsaq al-Khaqani palace, ninth century

Herzfeld's reconstruction [84]. The main figure has often been compared with the huntress Diana, but the face has a distinctly oriental cast, with its long hooked nose and fleshy cheeks, as has the bunch of black hair at the back and the slender curl on the temple. She seems animated, as do her prey and the dog, but the movement is both petrified and exaggerated, an effect further accentuated by the expressionless gazes of both huntress and prey. The decorative spots on the animal and the patterned fall of the huntress's garment contribute to the unrealistic quality of this skilfully composed work. All the Jawsaq paintings were designed by Qabiha, mother of the caliph al-Mutazz, then covered with whitewash by his puritanical successor al-Muhtadi. At least so it is reported in a much later story.[142]

Like the other arts, the paintings from Samarra were apparently influential elsewhere in the caliphate. The Tulunids of Egypt even went one step further: the second ruler of the dynasty, Khumarawayh, whose role as a patron has already been mentioned, had painted wooden statues of himself, his harem, and singing girls put in his palace,[143] a most unorthodox artistic display yet one that, in its presentation of the courtly pleasures, fitted well into the general picture of themes known to have gratified many of the ruling princes of this period.

THE ART OF THE OBJECT

The decorative arts produced during the Umayyad period have remained the least explored within the discipline of Islamic art history. If the production of *objets d'art* during the first one hundred and twenty-five years of Muslim rule is discussed at all it is usually with the suggestion that the material culture changed very little during the first century and a quarter after the Muslim conquest; or it is defined under the rubric 'post-Sasanian' with the same implication as the above hypothesis but with more specificity – the pre-

85. Sheet-metal tie-beam covering in the Dome of the Rock, Jerusalem, completed 691

fix 'post' being added to signify that the object in question was thought to have been produced after the arrival of the invading Muslim armies.[144]

In fact, a detailed study of the decorative arts created in the central lands of the Muslim world during this seminal period is essential to the comprehension of most later artistic production in the Islamic world. Furthermore, a close look – especially at the dated and datable works from this epoch and/or at those with an unequivocal provenance – sheds light not only on the origins of this art but also on

86. Stone window grille in the Great Mosque, Damascus, founded 706

the time and place of its tentative beginnings. Such an examination helps to inform us as to what was immediately acceptable to the new Muslim patrons – how the Greco-Roman and Sasanian elements that were present in the various areas which came under Muslim domination and those elements which the Arabs themselves contributed from their own pre-Islamic culture were accumulated, sorted and redistributed in a new way.[145] The resulting novel combinations of old forms and techniques were to become inherent characteristics of Islamic art in general. Indeed, an exhaustive study of the subject will show that the majority of the seeds of the plants to be reaped during the next one thousand years were sown at this time and, no matter how these plants were grafted and trained in the centuries to come, their origins in this highly complex and challenging formative period are obvious. We shall see that this cycle of adoption, adaptation and innovation was to be repeated in other parts of the Muslim world as well during this creative epoch and that it was this cyclical repetition, more than anything else, that was to set Islamic art on its particular and unique course for the next millennium.

Undoubtedly we are safe in assuming that in most geographical areas and in all the various media the new rulers and their entourage, not to mention their subjects, at times simply adopted the art of earlier times. However, it is not these objects that will be considered here. We shall be occupied with those works of art which exhibit adaptations of the newly adopted pre-Islamic elements as well as those that break new, creative, ground.

Fortunately, at this juncture in the study of Islamic art, the decorative arts of the Umayyad period can be positively identified in a number of different media, and these can be used as firm anchors around which other similar works can be confidently gathered. Three tools have been very useful in this regard: the large number of dated or datable architectural monuments from this era; dated or datable objects themselves; and archeological excavations, all of which have helped us to establish a vocabulary of Umayyad ornament – a vocabulary based on four elements: abstract vegetal forms, geometric patterns, calligraphy, and figural decoration.

As has been mentioned earlier, the Dome of the Rock incorporates an octagonal arcade consisting of eight piers and sixteen columns with a continuous band of tie-beams separating the capitals of the columns and the shafts of the piers from the spandrels. These wooden beams are covered

87. Wooden soffit from Aqsa Mosque, Jerusalem, 86 × 46 cm. Rockefeller Archeological Museum, Jerusalem

with continuous vegetal motifs popular during the Umayyad period[146] but so also were a multitude of geometric designs. One of the latter was created in stone during the reign of al-Walid I to serve as a window grille in the Great Mosque of Damascus [86]. Geometric design elements were adopted from the late Greco-Roman tradition, and from the beginning these patterns were adapted and developed, becoming vehicles for great diversity and ingenuity in the hands of the artists working under Muslim rule. In fact, no other culture used geometric repeat patterns in such inventive and imaginative ways. During the period covered here, we shall witness both the perpetuation of such designs in general throughout the Islamic world as well as the vogue for geometric window grilles in particular not only in the central Islamic lands but in the further Muslim lands as well.[147]

Vertically as opposed to horizontally oriented vegetal designs were also very popular in the central Islamic lands during the Umayyad period. The wooden soffit from the Aqsa Mosque [87] and the carved stucco window grille from Qasr al-Hayr West [88] each contain a palmette tree with its trunk positioned axially and giving rise to symmetrically arranged pairs of branches each scrolling to enclose a highly stylized leaf or grape cluster.[148] In each example a stylized, linear, vegetal element frames the panel. This so-called tree of life motif had its origin in the late classical candelabra tree which was part of the Late Antique heritage of early Islamic art.

The decoration executed in both carved stucco and wood during this period, as exemplified by the examples just discussed, has a highly ornamental character betraying a decided preference for floral designs, usually executed in a fanciful and luxuriant manner.[149] Unlikely botanical combinations occur, such as vine leaves with pomegranates or cone-shaped fruits. This tendency towards the exuberant is held in check by a strong sense of rhythm and symmetry: the rich floral forms often riot within the framework of simple geometric figures – a circle, ellipse, diamond, a set of spi-

on their undersides and outer faces with repoussé sheet metal (a copper alloy) fixed by large nails [85]. The layout of a central band bordered on each side by a narrower band bearing a repetitive pattern is to be found on all such coverings of the arcade. However, this particular example exhibits motifs that will be repeated often in many versions and media throughout the period not only in the central Islamic lands but in the eastern and the western as well with echoes also in the subsequent medieval Islamic period. The stylized rinceau emerging from each side of a central, ribbed, tazza bears, alternately, a six-petalled rosette and a cluster of grapes. This band is flanked on either side by an arcade alternately filled by two differing vegetal designs. A pearl border outlines the entire element as well as its central band. All of the raised areas are gilded, with the central area painted black and the outer, arcaded, borders green.

We shall see that not only were such decorative bands

88. Stucco window grille from Qasr al-Hayr West. Datable between 724 and 727, Ht. 1 m. 34 cm. Syrian National Museum, Damascus

89. Glazed earthenware storage vessel Basra, Iraq, Ht. 43.6 cm. D. 34.3 cm. Syrian National Museum, Damascus

90. Earthenware pouring vessel, Gurgan, Iran, Ht. 36 cm. L. A. Mayer Memorial Institute of Islamic Art, Jerusalem

rals, or possibly an arch on columns. Quite a few bone carvings show the same tendencies in more limited measure, as they are smaller and were made for a humbler clientele.[150]

Only two types of pottery of esthetic merit have been attributed to the Umayyad period with any certainty. The first is executed in a buff, well-levigated clay that is covered with a white slip and painted with geometric and stylized vegetal designs. This ware has been found at a number of sites in Palestine, including Rujm al-Kursi west of Amman and Khirbat al-Mafjar. Although the place of manufacture of this ceramic type is currently unascertainable, its dating seems to be more secure. It appears that it was current at the very end of the Umayyad period and that its production continued for the remainder of the century.[151] The second type of pottery definitely attributable to this epoch is the group of moulded and predominately unglazed oil lamps some of which bear as an integral part of their ornamentation the name of their place of origin (Jarash – in present-day Jordan), the name of the potter or of the owner and often the date of their manufacture. The earliest dated lamps of this type extant fall into the first half of the eighth century.[152]

It seems safe to assume that the latter, moulded ware would also have been produced in forms other than lamps and, therefore, that some of the extant vessels exhibiting this technique should be attributed to the same period. This ought to be especially true of those objects bearing designs and motifs closest to those found on the Roman *terra sigillata* ('moulded earthenware') out of which the early Islamic pottery type grew. One such vessel that may be attributable to the Umayyad period is a large, mould-decorated, green glazed jar [89], with mustard-yellow finials on its three handles that bears an inscription around the base of its neck stating that it was made for the governor of al-Hira

by Yahya ibn Umayya in Basra – an important port and manufacturing centre in lower Iraq founded in 635.[153]

An unglazed pouring vessel [90] that bears an identical moulded decoration on both its flattened faces is another candidate for a pre-Abbasid date. The fine angular inscription encircling the central bosse calls this object a *kuz* and states that it was made in the *tiraz* of Gurgan, southeast of the Caspian Sea.[154] Finally, al-Hira in southern Iraq is mentioned as the place of production of a moulded and unglazed bowl made for 'the Amir Sulayman son of the Prince of the Believers' found in Raqqa, Syria. Assumed to have been made for the son of the Abbasid caliph al-Mansur (*r.* 754–75), this object helps to make the transition from Umayyad to Abbasid mould-decorated ceramic wares.[155]

The ornament on most of these early moulded ceramic objects is organized in a series of bands. These are filled with arcades, tightly executed and organized minute vegetal designs, a small-patterned diaper, and rinceaux or with jewelled borders consisting of repetitions of concentric circles, half circles, rosettes, and pearls. The decorative technique itself imbues the designs with a particular crispness, making the overall effect not unlike that on the covering of the tie-beam in the Dome of the Rock [85].

Another type of pottery in use in the Islamic world before the ninth century has eastern prototypes and bears stamped, incised, or applied decoration and, like the mould-decorated group discussed above, is also found in either glazed or unglazed versions.[156]

The metal ewer [91] was part of a cache of objects discovered near a mausoleum in the Fayyum in Egypt, and is traditionally ascribed to the last and then fugitive Umayyad caliph, Marwan II (*r.* 744–50).[157] A series of arches circumscribes the body of the vessel. Each arch was originally set

with a row of circular inlays and filled with a multi-petalled rosette with a round inlay at its centre. This principal chased and originally inlaid decoration, to which secondary chased motifs were added above and below the arcade, echoes that in mosaic at the base of the drum in the Dome of the Rock.[158] The shoulder and long neck of this vessel bear a textile-like design – with Sasanian prototypes – of chased, and sometimes inlaid, rosettes (see textiles depicted on the kings [53, 54] and those bearing the name of Marwan II discussed below); and the applied sculptural spout and handle and the ajouré and inlaid rim all exhibit motifs to be found in the inherited Antique repertoire.[159] However, unlike luxury metal objects of the pre-Islamic period for a Sasanian or Syrian grandee, and even more one for a king or governor that would have been of silver or gold, this vessel is a copper alloy.

A second, earlier and simpler, copper-alloy ewer is inscribed with the date of 69/688–89 and the name of the newly founded town of Basra [92].[160] Since this is the second object mentioned here that bears not only the artisan's name – in this case Abu Yazid – but also the information that it was made in Basra, we must assume that even at this early period being able to afford an object made in this southern Iraqi city was a status symbol, and can further speculate that the craftsmen working there may have had more of a social standing than was originally thought.[161]

The lidded ivory pyxis in [93] bears an Arabic inscription in angular script stating that it was made in Aden to the order of al-Amir ʿAbdallah ibn al-Rabiʿ who served as governor of Madina from 762 to 764.[162] Executed as a series of drill holes, this calligraphic decoration bears close comparison to that on a stone lintel from Qasr al-Milh dated 109/727.[163] The remaining, geometric, motifs decorating

91. Copper-alloy ewer, Ht. 41 cm. Museum of Islamic Art, Cairo

92. Copper-alloy ewer, Basra, Iraq. Dated 69/688–89, Ht. 64.8 cm. Museum of Arts, Tiflis

93. Ivory pyxis, Aden, Yemen. Datable between 762 and 764, Gr. ht. 17.5 cm. St Gereon, Cologne

94. Wool fragment. Datable between 744 and 750, 49 × 12.5 cm. Textile Museum, Washington, D.C.

95. Gold coin, obverse and reverse. Dated 77/696–97, diam. 19 mm. On loan to the American Numismatic Society, New York, from the University of Pennsylvania Museum of Art and Archaeology

this object are related to those we have seen not only on the moulded pottery discussed above but also on the ewer attributed to Marwan II. Arranged in a series of bands, this decoration includes five framing borders of concentric circles, three of pearls and two of contiguous semicircles that form an arcade-like design with each arch bearing a frieze of dots.

The textile [94] belongs to a rare group of tapestry-woven woollen textiles generally believed to have been made in Iraq. They characteristically bear an all-over repeat pattern consisting of stacked rows of variously decorated roundels. Prototypes for the layout of these early Islamic fabrics can be seen in the patterned textiles represented on the rock reliefs at Taq-i Bustan in western Iran generally attributed to the Sasanian ruler Khusrau II (r. 591–628).[164] The influence of the artistic tradition of this pre-Islamic dynasty on the art of the Muslim world is particularly strong as regards textiles and was to remain so throughout the period covered by this volume. This example of the early Islamic group, bearing as it does the name

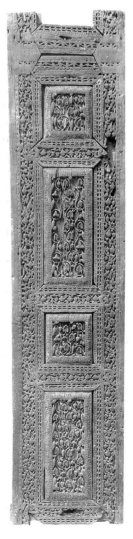

96. Wood panel from door or *minbar*, Ht. 1.79 m. Metropolitan Museum of Art, New York

97. Wood panel from chest or cenotaph, 32 cm × 1.92 m. Museum of Islamic Art, Cairo

of Marwan II (r. 744–50), is the earliest surviving datable product of an imperial textile workshop (*tiraz*), which for centuries supplied enormous amounts of fabric for the caliph's household. It is decorated with confronted roosters circumscribed in large roundels framed with three concentric borders bearing a diaper pattern, contiguous half-circles and a stylized vegetal design. The interstices contain rosettes. These workshops also produced the many robes of honour which the ruler alone could give to his high officials, following an age-old custom of the area attested by Pharaonic history and the Bible (Genesis 41:42). The immediate prototype for this tradition was undoubtedly Sasanian court procedure, although the custom of inscribing patterned textiles with religious texts or with the place of origin was also well established in Coptic Egypt.[165]

Marwan's name occurs also on a silk fabric, four fragments of which are preserved in museums in Brooklyn, Brussels, Manchester, and London. It bears a design consisting of rows of roundels containing a four-petalled rosette circumscribed by two concentric bands with a similar rosette or half-rosette in the interstices, and pearl, jewel, and heart motifs in the border. Unlike the first fragment bearing this ruler's name, however, this inscription was embroidered on to (and not woven into) the textile, and it is believed that it was probably added in Egypt or North Africa as opposed to where it was woven.[166]

A paradigm of the way in which pre-Islamic artistic elements were accumulated, sorted and redistributed in new ways during the Umayyad period is provided by the coinage of this dynasty. When the Arabs first began their conquests, not having coinage of their own, they made use of existing currency. In the east they adopted the Sasanian silver *drahm* and in Palestine, Syria, and Egypt the Byzantine gold *solidus* or *denarius aureus* and the copper *folles*, in addition to the *drahm*. However, within a very short time they adapted these coins to their own needs. The earliest examples of what has become known as Arab–Sasanian coinage had the portrait of a Sasanian emperor and a Zoroastrian fire altar plus inscriptions in Pahlavi and a pious phrase in Arabic in the margin. The first Arab–Byzantine coins exhibited adaptations of imperial imagery such as standing figures and a column surmounted by a globe on a four-stepped pedestal as well as Arabic and/or Greek or Latin inscriptions.[167] It was not long, however, before this imagery was replaced by a completely original Islamic design. In the seventy-seventh year after the Hijra (696–97) during the reign of ʿAbd al-Malik, a totally new coinage was invented which bore Qurʾanic inscriptions as its sole decoration except for the date and mint name [95a, b]. The layout

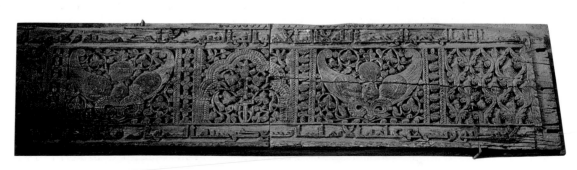

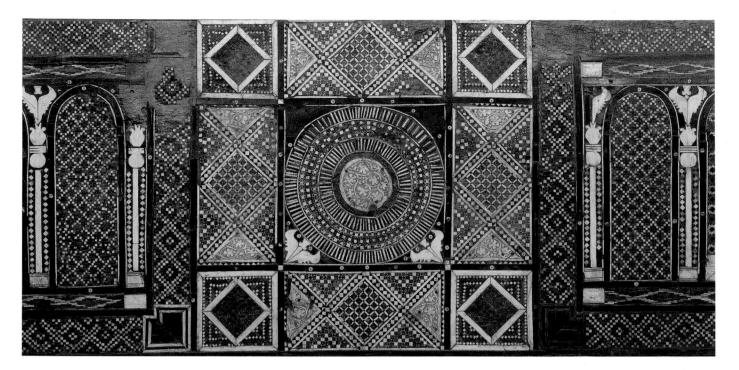

98. Detail of Marquetry panel from chest or cenotaph, 47.6 × 194.3 cm.
Metropolitan Museum of Art, New York

devised for this new coinage remained almost canonical on Islamic coins of the caliphate until the thirteenth century, as did most of the original inscriptions.

Our knowledge of contemporary gold and silver jewellery objects can, unfortunately, only be deduced from pictorial and sculptural representations. As has been discussed elsewhere, the earrings and pendants depicted at Khirbat al-Mafjar [51, 57] and the various types of necklaces as well as breast and waist ornaments found in the frescoes of Qusayr Amra [62, 63] are often very close in style to their presumed models from pre-Islamic times.[168] Thus, we can assume that the jewellers' art was no different from that, for example, of the metalworker or potter in that the goldsmiths and silversmiths also adopted earlier forms and techniques and gradually recombined them in a new way. In the case of this medium, however, since the study of Sasanian and early Byzantine jewellery is still in its infancy it is possible that to some extent the apparent scarcity of early Islamic jewellery may be due to our lack of knowledge and that many of the pieces now classified as Roman, Byzantine, and Sasanian have been 'misfiled' and are in fact Islamic.[169]

We have clearly seen that the Umayyads did, indeed, take their forms – architectural or decorative – and much of their iconography from the world they conquered;[170] and that they did not only adopt from their Syrian provinces, where most of the known Umayyad works are found; their art reflected the full scope of their empire. The traditions which were to shape Islamic art throughout the ages – mosque forms and parts, secular iconography and the conscious abandonment of religious imagery, new patterns, a tendency towards stylization and non-naturalistic treatment of vegetal forms – were established during this

period. The Umayyad world borrowed according to its own tastes and aims and adapted these elements and styles to suit its own needs. In brief, it was a feverish workshop from which classic Islamic art emerged.

The decorative arts produced under the succeeding, Abbasid, dynasty continued the pattern of adoption and adaptation – a pattern that permeated all media, as it had in the prior period. Building on the vocabulary of Umayyad ornament as seen, for example, at Mshatta [66, 67], the carved panel from a door or *minbar* [96] shows, especially in the central square and rectangular sections, how the Late Antique vine scroll gradually evolved into a pattern so highly stylized that with very little adjustment it could become an infinite repeat pattern like that seen executed in stucco later in the period at Samarra [81].[171]

The rectangular carved panel [97] that originally functioned as one of the sides of a large chest or cenotaph not only illustrates the progressive stylization of adopted and adapted Greco-Roman motifs, it also shows the purely Sasanian wing motif being superimposed on a Late Antique vine scroll.[172] The designs drawn from the two traditions are no longer seen side by side as in, for example, the Dome of the Rock but are seen combined here in a manner that can be considered only as 'work in progress'.

This transitional phase gave way to a new manner of combining the designs and motifs from these two cultures that can be seen in the rectangular wooden panel [98].[173] Here the motifs and designs from two seemingly diverse traditions have been integrated and blended into a successful whole. The very time-consuming technique employed – known as marquetry and employed earlier by the Romans – in which thousands of pieces of light and dark woods and bone were fitted together and which required highly skilled

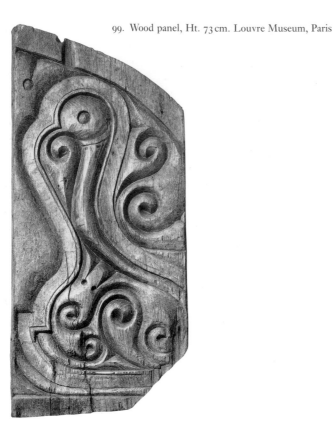

99. Wood panel, Ht. 73 cm. Louvre Museum, Paris

especially the former, rendered wholly or in part [99]. Keeping within the general character of the style, they are abstract, yet can be clearly recognized as related to the floral or vase motifs from Samarra stuccoes moulded in the bevelled style.[179] Their arbitrary and unnatural character is further underscored by the fact that certain parts, for instance the beak, can turn into floral forms. These fanciful creatures are no mere freaks: the zoological element was preserved and further developed in the subsequent period.

A characteristic metal object of the Abbasid period is the copper-alloy pouring vessel in the shape of a bird of prey [100], which is clearly related to a series of earlier Sasanian zoomorphic censers and pouring vessels.[180] With its massive symmetrically shaped body, broad stylized wings, and ill-boding head, this piece, which is dated 180/796–97 and signed by Sulayman, combines a high degree of formalization with an astute characterization of species. At the same time the creature's viability is negated by the purely ornamental designs on the chest and neck consisting of floral patterns and the already mentioned Arabic inscription which have no obvious connection with the bird. With its stress on a design applied to a plain ground and at variance

100. Copper-alloy pouring vessel. Dated 180/796–97, Ht. 38 cm. Hermitage, St Petersburg

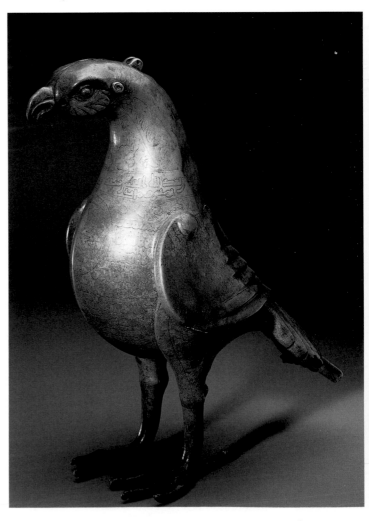

craftsmen to execute properly, was to have a long life in Egypt and the Maghrib.[174]

The next step in the evolutionary process we have been following *vis-à-vis* Early Islamic woodworking is to be seen on those objects exhibiting the so-called bevelled style. Its earliest beginnings in Iraq have already been discussed in connection with a type of stucco wall decoration utilized at Samarra – beginnings that are associated with the origins of the arabesque as well.[175] Quintessentially Islamic, the formalization known as the arabesque is created when a vegetal design consisting of full palmettes and half palmettes becomes an unending continuous pattern – which seems to have neither a beginning nor an end – in which each leaf grows out of the tip of another. Found in the Abbasid heartland during this early period not only in stucco but also in wood and stone, this convention soon spread to Tulunid Egypt. That it can be found in numerous Muslim countries at least until the fourteenth century attests to its popularity not only with the early Muslim art patrons but with their successors as well.[176]

Most of the motifs on the earliest wood carvings in the bevelled style from Tulunid Egypt were identical with those of their Iraqi prototypes, although some tendencies became more pronounced.[177] At times there was a marked effort to break up the rather broad sculptured masses into smaller elements and to add secondary surface decoration in the focal areas. Certain small units were frequently used, and a rounded leaf seen from the side became a stereotyped motif. A few features had no counterpart in Samarra, at least so far as is known. The designs, especially in small narrow panels, thus appear as free, asymmetrical compositions.[178] Other new elements were bird and animal motifs,

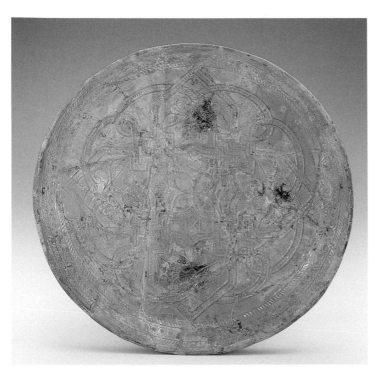

101. Glazed earthenware dish, D. 28cm. Freer Gallery of Art, Washington, D.C.

commonly covered with a yellow or green lead glaze.[182] Not only are the shapes of these objects imitative of metal vessels but a similarity to metalwork is apparent also in the decoration itself, which resembles that executed in repoussé [101]. At one time it was believed that this apparent imitation of precious metal objects resulted from religious puritanism but, as contemporary sources speak of the extensive use of gold and silver in the caliph's palace[183] and as the foremost patronage of art emanated from that court, this theory now seems unlikely. Rather, these pieces were cheap substitutes for more precious objects,[184] and this economic aspect appealed to a wide clientele. This pottery type was found not only in the palaces but also in the private houses of Samarra, an indication of the eagerness with which the city-dwellers accepted it. It has also been found at Susa and at Fustat; and, in fact we know – from a condiment dish in the British Museum – that the same general type of relief ware was being produced in Egypt by an artisan from Basra.[185]

One type of pottery was popular, especially in its unglazed version, during the Umayyad period and remained in vogue under the early Abbasids with only minor changes [102]. Unlike that on the moulded category just discussed, the vari-

102. Glazed earthenware vessel, Ht. 25.7cm. Los Angeles County Museum of Art, Los Angeles

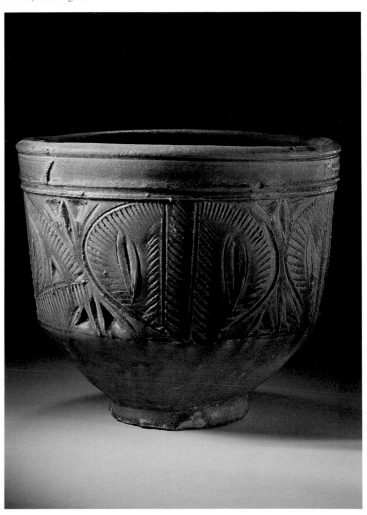

with the object itself, this piece is an early example of a tendency already noted in the surface decoration of the Dome of the Rock, Mshatta, and Khirbat al-Mafjar as well as on the metal ewer [91] where the arcade which requires verticality is quite non-tectonically applied to a globular body. Like the latter vessel from the Umayyad period, this pouring vessel was also inlaid; in this case traces of both silver and copper are found. These two objects are among the first efforts of the Islamic period to revive the much earlier technique, which later took on enormous importance, of inlaying metal with another metal, usually copper, to create a chromatic effect and to stress certain parts of the design.[181]

Pottery production during the first century and a half of Abbasid rule exhibited several trends. Certain popular types manufactured under the aegis of the new dynasty were simply continuations of, or developments upon, those in vogue during the prior, Umayyad, period. Another trend, however, which consisted of painting a decoration on the surface of a ceramic vessel using several different techniques was to have far-reaching implications not only for later ceramic production in the Islamic world but for that in China, Europe, and America as well.

As was implicit in the discussion of pottery production during the Umayyad period, the vogue for decorating an earthenware surface by working malleable clay into a carved, unglazed and fired ceramic mould – the method of ornamentation we have seen being employed on objects bearing the names of such pottery manufacturing centres as Basra, Gurgan, Hira, and Jarash [89, 90] – continued under the Abbasid dynasty. The most common shape for vessels executed in this technique during the later period was a shallow, flat-bottomed, rimless dish, and these are most

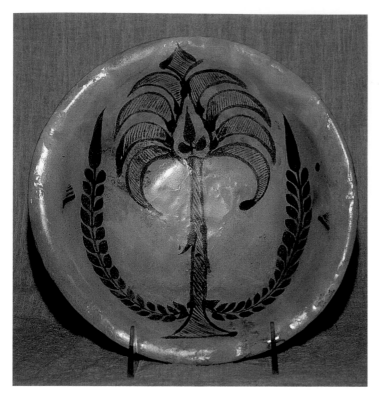

103. Glazed and inglaze-painted earthenware bowl, D. 24.2 cm. Los Angeles County Museum of Art (M.2002.1.34)

104. Glazed and lustre-painted earthenware tiles on *qibla* wall in Great Mosque, Qayrawan. Datable between 856 and 863

as secondary colours. The second method entailed decorating an already fired opaque white-glazed vessel with one or more metallic oxides and then refiring the object in a reducing kiln. It has been shown that, contrary to all earlier literature on the subject, both methods of decoration seem to be exclusive to Basra at this period.[188]

The bowl [103] is representative of the first method of ornamenting this group and exhibits one of the two main categories of decoration to be found on such ware, that consisting solely of vegetal motifs.[189] This type of opaque white-glazed ware is the first occurrence, in the universal history of ceramic production, of blue designs on a white background, a combination later to be exploited in every possible way by Yuan, Ming, and Ching potters and their European imitators.[190] This ware with such ornamentation appears to have been very popular during the ninth century and fragments of it have been found throughout the length and breadth of the Abbasid empire. It was also widely copied in the provinces as well. These imitations, lacking the finesse of the wares made in Basra, were produced in regions – such as what is today Spain, Tunisia, and Algeria as well as eastern Iran – that looked to Baghdad as the cultural capital of the period [141, 142, 182]. The palette for such objects was typically green and aubergine.

ety of decoration found on this group has eastern prototypes. The design is created by both carving and incising the vessel, in a technique known as *Kerbschnitt* (literally, chip-carving), after which the object was covered with a turquoise glaze and fired. This rare, large, utilitarian vessel can be dated to *c.*900.[186]

The most innovative pottery produced during the first one hundred and fifty years of Abbasid hegemony is a series of types with decoration painted on a glazed surface belonging to what has been termed the Opaque White-Glazed Group – a group exhibiting a unique and highly creative combination of three distinct influences. The glaze utilized was adopted and adapted from the pre-Islamic pottery tradition prevalent under both the Sasanians and their immediate predecessors, the Parthians; the most predominant bowl shapes (which are the most common pottery form at this time) are strongly imitative of the profiles of much-admired and apparently prestigious Chinese porcelaneous white wares which began to arrive in western Asia around the middle of the eighth century;[187] and the method of decoration is purely of the period and area under discussion here.

Two ways of ornamenting this group are of particular interest here as the resulting products constitute the most luxurious Abbasid glazed ceramics ever produced. One method consisted of painting vegetal, geometric or calligraphic designs (or combinations of two or more of these) with cobalt-pigmented blue glaze on to the opaque white-glazed surface of a vessel and subsequently firing the object. Cuprous-pigmented green or, less commonly, manganese-pigmented purple glazes are sometimes used on this group

The second method of ornamenting this group consisted of using silver and copper oxides, each mixed with a medium, to paint designs on an already fired opaque-glazed surface. During a second firing in a reducing kiln, oxygen was drawn out of the metallic oxides, leaving the metal suspended on the surface to refract light and create a lustrous appearance. A technique that was first used to decorate glass,[191] lustre-painting as employed by ninth- and tenth-century potters in Basra left a permanent imprint on the ceramic industry in general since the closely guarded trade secret of the recipe for the production of lustre-painted pottery spread from Iraq to Tunisia, Algeria, Egypt, Syria, Iran, Spain, Italy, England, and eventually to America.

Sharing with the blue-painted group its most common, Chinese-inspired, shape, the lustre-painted variety provides us with the only, up to now, reliable means of dating the production of both of these highly important opaque-glazed pottery types. Abu Ibrahim Ahmad, an Aghlabid amir who ruled from Qayrawan between 856 and 863 under the aegis of the Abbasids, had ceramic tiles imported from Baghdad for a reception room he was planning to build. To prove his piety after having been branded a sinner by important religious leaders of his Ifriqiyan capital, he decided instead to use the imported tiles to face the *mihrab* in the Great

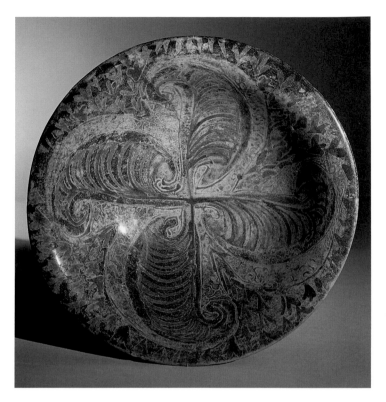

106. Glazed and lustre-painted earthenware bowl, D. 29 cm. Al-Sabah Collection, Kuwait

105. Glazed and lustre-painted earthenware tile, Ht. 28 cm. Museum für Islamische Kunst, Berlin

Mosque in that city [104].[192] Since the imported lustre-painted tiles would have been made to order and thus new at the time of their purchase and as their designs and colour schemes very closely resemble those found on three-dimensional objects in the same technique, the window during which these tiles must have been imported can also serve as a specific time-period around which the Basra production of both the blue-painted and the lustre-painted opaque-glazed ware should be clustered.[193] In addition, the multitude of designs on this large quantity of beautifully preserved tiles can serve as a pattern book of precisely datable motifs as well. The most common designs on the three-dimensional polychrome lustre-painted objects are to be found among those on the polychrome lustre-painted Qayrawan tiles. Some of the secondary motifs on both the tiles and the bowls are indebted to those on objects executed in other techniques such as millefiori glass.

We shall probably never know whether lustre-painted tiles of the type discussed above were made for local use as well as for export. To date, no such tiles have been discovered in Iraq. The tiles in this technique found in the Abbasid heartland are of a very different type. Square tiles bearing the design of a cock in a wreath-like roundel with elaborate palmettes in the corners were among the glazed ceramic architectural decoration excavated at Samarra.[194] These were bordered by elongated hexagons, decorated in the same technique, which the excavators felt formed a continuous wall pattern [105].[195] The tiles found at Samarra and those in Qayrawan's Great Mosque should be considered the earliest Islamic use of such decoration, and it is no acci-

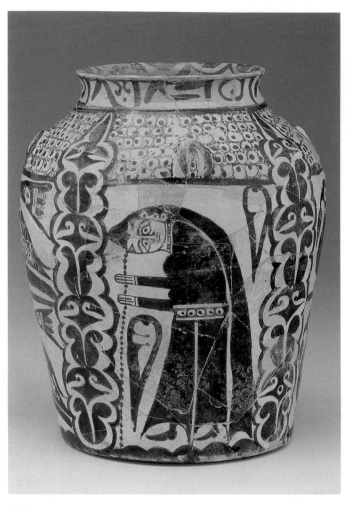

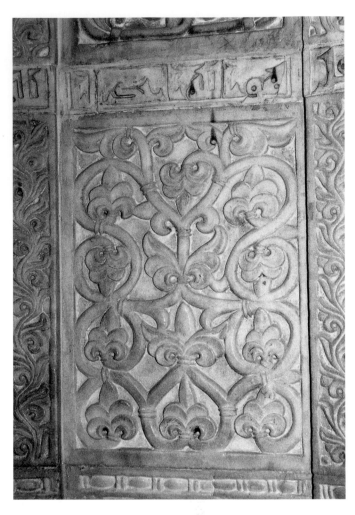

107. Glazed and lustre-painted earthenware jar, Ht. 28.2 cm. Freer Gallery of Art, Washington, D.C.

108. Marble panel of *mihrab* in Great Mosque, Qayrawan. Datable between 856 and 863

dent that this revival began in Iraq, which had had such a glorious pre-Islamic tradition of glazed ceramic architectural decoration in places such as Assur, Khorsabad and Babylon. The skilful combining at Samarra of two different shapes – interlocking octagons formed from units of polygonal tiles framing a square tile – would soon be successfully taken up again in the Maghrib [451] and later in twelfth- and thirteenth-century Iran.[196]

In addition to polychrome lustre, an extremely rare variety of lustre-painted pottery was produced at this time consisting of a combination of only two lustre colours, gold on a ruby-red ground [106] – a variety which is thought to have been a simplification of the polychrome lustre-painting process. It was the yet simpler monochrome version [107], however, that was much longer-lived than either the polychrome or ruby lustre, as it was more certain of success since only one lustre colour was involved.[197] It was the latter variety that was imitated in the provinces and which was to spread from Iraq to other pottery centres in the Muslim world, Europe, and America. Among the popular decorative motifs found on this lustre-painted type were not only palmette-based vegetal elements but also human and animal designs.[198]

Monochrome lustre-painted decoration was at times

applied to opaque white-glazed vessels already adorned with cobalt blue designs, clearly demonstrating not only that the two methods of ornamenting this group emanated from the same workshop but, more importantly, that monochrome lustre-painting and cobalt-pigmented painting were contemporary.[199] We shall see that this combination was taken up again more than three centuries later, with great success [280, 411].

Another method of decorating the opaque white-glazed pottery group in Iraq during the Early Islamic period was adopted from the *sancai* three-colour ware of the Tang Dynasty in China, which was imported to the Muslim world in the ninth century and has been found at both Samarra and Fustat where its dots and splashes in green, yellowish-brown, and purple on a white ground made a great impression. The type was at once extensively imitated. The ceramists working under the Abbasid aegis attempted to control and organize the coloured pigments and, as far as the rather unmanageable materials allowed it, to create simple patterns, in particular radial ones.[200]

The same Aghlabid amir who had had lustre-painted tiles imported to Qayrawan from Baghdad and placed in the Great Mosque also assembled a *mihrab* in that great sanctuary that was brought from the Abbasid heartland in the form

of panels of marble.[201] When one compares the beautifully executed vegetal design on one of these panels [108] with those on the soffit from al-Aqsa Mosque and the window grille from Qasr al-Hayr West [87, 88] from almost a century and a half earlier, the progressive stylization in the early Abbasid period of adopted and adapted Greco-Roman motifs is, once again, clearly evident.

When one turns to the glass produced during the early Islamic period, the *leitmotif* of adoption, adaptation, and innovation runs through this medium as well. Glassmaking under the Muslim aegis was greatly indebted to the Roman imperial glass industry, and glass manufactured during the early Abbasid period, in particular, shows a perpetuation of Roman practices in its shapes and decorative techniques. The bottle [109] continues the earlier tradition of decorating thinly blown, clear glass vessels with fine spiralled and pinched threads in the same, or as here a contrasting, colour. This glass type did not inspire Islamic adaptations, but only adoptions such as this. The vogue for such decoration in the Muslim world did not continue much after the eighth century, nor does it appear to have extended beyond the

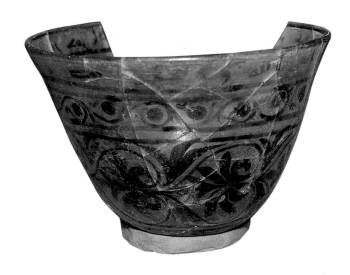

110. Glass bowl of a goblet with lustre-painted decoration. Datable to 773, Ht. 9.5 cm. Museum of Islamic Art, Cairo

109. Glass bottle with thread decoration, Ht. 18.6 cm. Metropolitan Museum of Art, New York

111. Glass ewer with mould-blown decoration, Baghdad, Ht. 11.1 cm. Metropolitan Museum of Art, New York

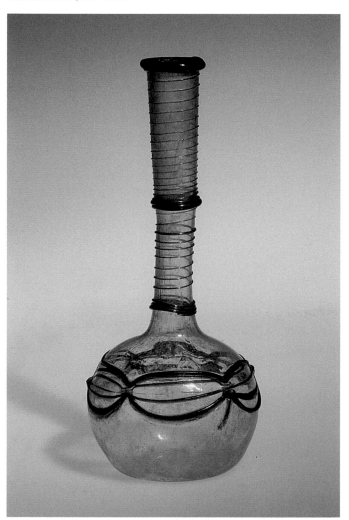

112. Silk fragment with gold, 39.5 × 47 cm. The Textile Museum, Washington, D.C.

113. Linen and wool fragment, 25 × 38 cm. The Textile Museum, Washington, D.C.

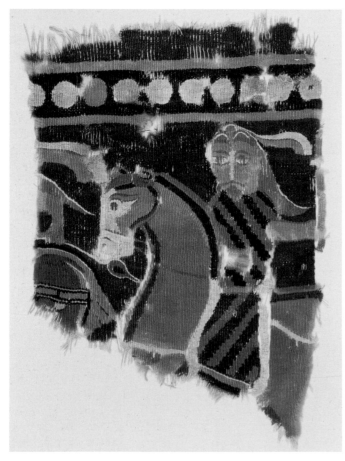

ilarly decorated glass vessels were found in the excavations in Fustat, Egypt, in an undisturbed pit that was very carefully bracketed in time by, at one end, a coin weight bearing the date 750 and, at the other, a fragmentary glass measuring vessel datable to between 762 and 774.[202]

While this bottle looks back to pre-Islamic times, the lustre-painted bowl of a fragmentary goblet datable to 773 [110] looks forward. As was mentioned above in connection with Abbasid lustre-painted pottery, this technique that began as a means of decorating glass was to have a long and glorious history not only in the Muslim world but in Europe and America as well.[203] Although the decorative technique is quintessentially Islamic, the vegetal designs found here were inherited from the Late Antique repertoire and in their adaptations are reminiscent of those found among the vocabulary of Umayyad ornament.

The technique of inflating the gather of metal – or viscous and extremely ductile melted batch of ingredients – in a mould bearing a counter-sunk pattern was another one adopted from the Roman imperial glass industry. Like the moulds used by Roman glassblowers, those employed in the Muslim world were usually made of clay or wood. The ewer [111], which was made in a two-part, full-size piece mould, bears as its principal design an Arabic inscription containing the name of its maker[204] and the place of its manufacture, Baghdad. Until the initial publication in 1958 of the group of ewers to which this vessel belongs, the existence of a glass industry in Baghdad was known only from contemporary writings.[205] The shape of this nicely proportioned piece with its pear-shaped body has numerous parallels in the early metal ewers of the central Islamic lands [92] which, in turn, grew out of a form of pouring vessel current in the eastern Roman empire during the fourth and fifth centuries.[206] Thus, both the shape of this container and its decorative technique were drawn from the Late Antique repertoire.

Any discussion of textile production in the central Islamic lands during this period should be prefaced with the information that this activity was the single most important industry in the Mediterranean basin during the period covered by this work. Not only did it produce items of clothing but those used for household furnishings as well. The exquisite silk and gold fabric [112], decorated with a series of cocks each of which is enclosed in an octagonal element of the overall diaper pattern (in a manner strongly reminiscent of the tiles from Samarra seen above), is probably a fragmentary garment woven in Iraq. The wool and linen tapestry woven fabric from Egypt [113] is from a curtain. Although one does not know exactly where and how such items were used, their mention in contemporary texts indicates that they were a ubiquitous domestic article.[207]

As regards the occurrence of these draperies, *sutur*, in Egypt during this period, it has been stated that in the highly important documents of the Cairo Geniza (literally, a repository of discarded writings)[208] they 'formed so profuse and costly an item in the outfits even of middle-class brides that one wonders what purposes they served'.[209] The curtains of Bahnasa in the Egyptian Fayyum were particularly famous and are mentioned by many contemporary writers, including Ibn Hawkal, who says that the draperies from this city are 'made with wool, linen and dyes that do not fade,

eastern shore of the Mediterranean. This example with its so-called 'spectacle pattern' decoration is so close to its prototypes that it must be seen as a beautiful echo of ancient glass in the Muslim world. It might even have been classified as a pre-Islamic object except for the fact that two sim-

114. Reed mat, Tiberias, 2.33 × 1.156m. Benaki Museum, Athens

115. Double folio of a Qur'an manuscript. Ink on parchment. Folio size: 30 × 20cm. British Library, London

and colours in which you can see figures, [ranging from] the gnat to the elephant'.[210]

Another type of furnishing is illustrated by the mat [114]. This is a very fine example of a type of floor covering often referred to in the Geniza documents and thus one that must have been quite popular in the eastern Mediterranean during the period covered here.[211] Woven in the private *tiraz* in Tiberias, Palestine, during the first half of the tenth century, it was made from a fine reed grown in the Jordan valley.[212]

THE ART OF THE BOOK

As was discussed in Chapter 1, one of the four most important contributions to the formation of Islamic art between the Hijra (622) and the death of Muhammad ten years later was the establishment of the Qur'an as the most precious source for Islamic knowledge and the Arabic language as the vehicle for the transmission of this knowledge. The greatest possible care was taken in copying and transmitting the divinely directed Book, and during the early Islamic period the writing of this language began to develop from its plain and purest form into beautiful and artistic scripts. This process, which continued for the next millennium, was a highly innovative one that was to result in an almost unprecedented number of transformations and the designation of calligraphy as the greatest of all the arts. The earliest of these calligraphic styles were soon incorporated into the vocabulary of Umayyad ornament and are to be found not only in mosaic decoration and on stone, metal and other media but also in the art of the book.

Since there appears to be a total lack of parchment manuscripts bearing colophons which place them firmly in the Umayyad period, we are at a great loss when considering this material. To glean what knowledge we have about Qur'an codices produced during this formative era, scholars have been largely dependent upon two different methods of attributing undated parchment folios of the Qur'an to this period.

The first, and oldest, method consists of matching contemporary descriptions of various scripts with those on extant leaves. While this has proved, for the most part, to be an exercise in futility owing to the summary manner in which contemporary authors discussed these scripts, there does seem to be agreement on the identification of one of the early styles mentioned by Ibn al-Nadim, the tenth-century Baghdadi scholar, in his bibliographical work, the *Fihrist*. This style was renamed *hijazi* because of Ibn al-Nadim's attribution of it to Mecca and Madina, and it is ascribed to the seventh and early eighth centuries. The double folio [115] belongs to what is thought to be the earliest *hijazi* group – that with a vertical format and a script that exhibits a verticality as well as a slanting to the right.[213]

The second, and considerably more recent, method of attributing undated parchment folios of the Qur'an to the Umayyad period is to compare their illuminations to closely related decorative elements on dated or datable buildings. It appears that chapter (*sura*) headings were rather ambitious in scope from quite an early date.[214] A complex vegetal

116. Frontispiece of a Qur'an manuscript. Colours and gold on parchment. Dar al-Makhtutat, Sana'a

117. Folio from the same Qur'an manuscript as Fig. 116. Ink, colours, and gold on parchment

design that projected into the margin soon became an important feature of the narrow decorative bands with a textile-like character that were the first such devices. Derived either from the Late Antique or Sasanian repertoires, the idea of combining such projecting vegetal designs with rectangular bands may have come from Roman inscription tablets with flange-like projections (*tabulae ansatae*).

The group of folios from a sumptuously illuminated, beautifully calligraphed, and unusually large Qur'an that was found above the ceiling in the Great Mosque in Sana'a, Yemen, permits a close comparison of this type [116, 117].[215] It has been shown that these vertically oriented pages incorporate motifs that are very similar to those used to decorate the Dome of the Rock, Qasr al-Hayr West, the Hammam at 'Anjar, Khirbat al-Mafjar, and the Great Mosque of Damascus. Using such a method, the time of production of the leaves in question has been narrowed to the second half of the Umayyad period and more specifically to between 691 and 743. Further securing such a dating is the fact that the angular calligraphy employed on these folios is very similar to that used in the Dome of the Rock [10]. This seemingly unique manuscript is the only lavishly illuminated Qur'an codex extant that can be securely placed in the Umayyad period. Its decoration consists either of bands that separate one chapter from another or border text pages and of designs that cover a full page. This illumination provides us with further examples of Umayyad ornament such as multiple rows of arcades, vegetal scrolls, rosettes and arches decorated with a frieze of dots that we have seen on other objects discussed in this chapter. The double frontispiece (the left half of which is seen here) exhibiting an architec-

tural design also provides us with rare representations of an Umayyad prototype for later hanging and standing glass lamps.[216]

While the most common format for manuscripts of the Qur'an during the Umayyad period appears to have been vertical, in the early Abbasid era horizontal codices of the Holy Book took precedence. It is not known precisely when this peculiar format began to be used or why; but, once in vogue, it was to remain popular at least until the tenth century. Possibly the scribes were following a religious injunction to differentiate the sacred book from other texts,[217] and also from the Hebrew scrolls of the Pentateuch or the vertical Greek Gospel codices; or the fashion could have had a purely aesthetic basis – to accommodate the early Abbasid angular scripts in which the horizontal letters are drawn out giving them an 'extended' appearance. The Abbasid calligraphers continued the Umayyad practice of writing Qur'an manuscripts exclusively on parchment probably until the tenth century, when the earliest dated Qur'an codex on paper occurs.

The folio [118] is part of a Qur'an manuscript that was given as a religious endowment (*waqf*) to a mosque in Tyre in 875–76 by the Abbasid governor of Damascus, Amajur. This is one of several dated or datable copies of the Qur'an from the ninth and tenth centuries.[218] In addition to its beautifully calligraphed leaves lavishly consisting of only three lines per page, illuminated folios with both geometric and vegetal decoration survive as well.[219]

We have seen, especially in [116], that very early in the Islamic period there was a desire to beautify the sacred text. We have further seen [117] that the ornament also per-

118. Folio of a Qur'an manuscript. Ink on parchment. Datable before 875–76, 12.7 × 19.3 cm. Museum of Turkish and Islamic Art, Istanbul

119. Frontispiece of a Qur'an manuscript. Ink, colours, and gold on parchment. Folio size: 10.2 × 17.1 cm. Metropolitan Museum of Art, New York

formed the functional task of separating verses (*aya*s) and, particularly, chapters (*sura*s). These decorative tendencies continued during the Abbasid period and certain of them became canonical.

In this period as in the Umayyad, the illuminator lavished most of his attention on the full-page frontispiece, or on that consisting of two leaves with similar large-scale compositions confronting each other; occasionally such pages also occurred at the end of the book. As in [119], the overall design was usually subdivided into two or three sections, or given a wide frame; unity was achieved by means of an elaborate system of interlacing. Geometric motifs prevail, with floral patterns used only as fillers. Certain parts of the design consist of dots, so that they resemble panels of mosaic and *opus sectile* (a technique of floor and wall decoration typically employing marble plaques and inlays). The frontispieces, like the *sura* headings, carry large composite floral arrange-

ments in the outer margins that already seem to have become an indispensable feature of all rectangular decorative panels in a book.[220] The Qur'an section that this frontispiece embellishes is beautifully written in an early angular script that characteristically effects a wonderful balance in the placement of the letters on the page. This calligraphy is very close to that used for the Amajur Qur'an and its illumination is very similar as well. The layout of the decoration on the folio illustrated here appears to have derived from *tabulae ansatae*, Roman inscription tablets with projections like handles. Its rectangular section incorporates motifs reminiscent of some of those of Hellenistic inspiration on the marquetry panel [98]. The two triangular areas are ornamented with a large palmette flanked on each side by a smaller leaf executed in sepia. These areas can be related in both design element and function to the triangular bone insets decorated with vine scrolls in the central section of the marquetry panel.[221]

120. Leather bookbinding. Datable before 883–84, Ht. 7.6 cm. W. 12 cm. Dar al-Kutub, Cairo (after Marçais and Poinssot)

Concerning the function of these frontispieces in a Muslim context it is possible only to speculate.[222] They were probably testimonials to religious piety, showpieces of conspicuous wealth, or, like the 'carpet pages' in Hiberno-Saxon manuscripts of the seventh and eighth centuries, had some religious significance. The early illuminators of the Qur'an, by attempting to limit themselves to lines and abstract forms, not considering the many decorative possibilities of Arabic script, and relying on the brilliant yet insubstantial qualities of thinly applied gold, revealed an uncompromising striving towards the spiritual and the absolute. As their artistry was devoted to a task of almost unequalled sacredness, their vocabulary provides insight into what may be called basic Muslim forms of expression. Among them is a tendency to provide a clear, solid, yet interlocked surface organization, and to create within each larger unit a series of co-ordinated symmetrical compartments whose contents, though distinctive enough on closer inspection, play only a secondary role. Furthermore, there is no intimate relationship among these motifs, which appear rather indistinct and are subordinated to a general impression. Moreover, these secondary features have a vibrant quality which contributes to the dissolution of the two-dimensional composition by extending it subtly in depth; though the precise range of this spatial addition remains undefined, the artist has actually broached the third dimension. This physical and optical play with spatial forms creates an inner tension that counteracts what would otherwise be a static composition. All these phenomena seem to be more than limited early manifestations of a specific art form, for many of them recurred in later Muslim works of art.

The general organization of such pages is related to that of contemporary bookbindings. The example [120] (together with the first *juz'* of a Qur'an that it once contained) was given as a religious endowment (*waqf*) to the Great Mosque of Damascus in 883–84 and thus serves as a rare, early, datable representative of this craft that was to have such an illustrious history not only in the Islamic world but, under the direct influence of this tradition, in Europe and America as well.[223]

In these central lands of the Muslim world near the end

of the Early Islamic period – more specifically in Baghdad before 940 – the vizier to three Abbasid caliphs, Abu ʿAli Muhammad ibn Muqla, brought about a momentous development in the art of Arabic calligraphy. Through his genius and knowledge of geometry, Ibn Muqla revolutionized the art of writing by devising a system of proportional cursive scripts that could successfully parallel, if not compete with, the highly refined angular ones.[224] The rules he laid down for the chancery (in contrast to Qur'anic) scripts based on geometric principles were followed by two of his pupils who, in turn, taught Ibn al-Bawwab, who perfected and beautified Ibn Muqla's letters in the 'six pens' or cursive calligraphic styles. The only surviving manuscript that seems to be securely attributable to this most famous Arab calligrapher, who was working in Baghdad under the aegis of the Buyids, is a Qur'an executed in that city in 1000–01 that exhibits a number of revolutionary changes. Not only does it reveal a format that is now vertical instead of horizontal but also a radically new attitude towards the composition of full-page illuminations [121].[225] Instead of a tripartite composition with the centre field composed of interlacings with small, dense braided designs filling the surrounding space and a margin containing the traditional floral palmette, a layout that was an early favourite [119], here there is a large-scale arrangement, imbued with so much dynamic force that it seems to burst its frame. The old softly drawn, rounded lines are replaced by sharply delineated geometric forms in which the painted edges are just as important as the circular motifs. In addition, instead of a rather indistinct and uniform pattern in the field we have a variety of clearly defined floral and geometric designs, all with a specific function in the interplay of parts. Furthermore, unlike the former two-dimensional rendering, movement appears to occur on more than one level, and the patterns themselves are plastically conceived. This interrelation of the various sections, their inner movement, and the three-dimensional aspect of the whole combine to give the page its lively, sparkling appearance. This effect is also emphasized by the more varied colour scheme, in which sepia and dark blue, formerly used only sparingly in combination with gold, are supplemented by brown, green, crimson, and white. Indeed, only the marginal palmette, though here more articulated and more refined in detail than those on the earlier codices, could be called the umbilical cord connecting this composition with those of the past; otherwise this page, like the others in this Qur'an, points entirely to the future.

Like the slightly earlier Isfahan Qur'an discussed in Chapter 4 [207], Ibn al-Bawwab also wrote his codex on paper. However, this eminent calligrapher also executed this Qur'an completely in cursive scripts – *naskhi* for the text and *thulth* for the headings – a form of writing which had existed from the beginning of Islam but had previously been confined exclusively to secular documents [122].[226] With so many transformations in one manuscript, scholars are, of course, all the more appreciative of the colophon, which, as

121. Illuminated folio from a Qur'an manuscript. Colours and gold on paper. Baghdad. Dated 1000–01. Folio size: 13.5 × 17.8 cm. Chester Beatty Library, Dublin

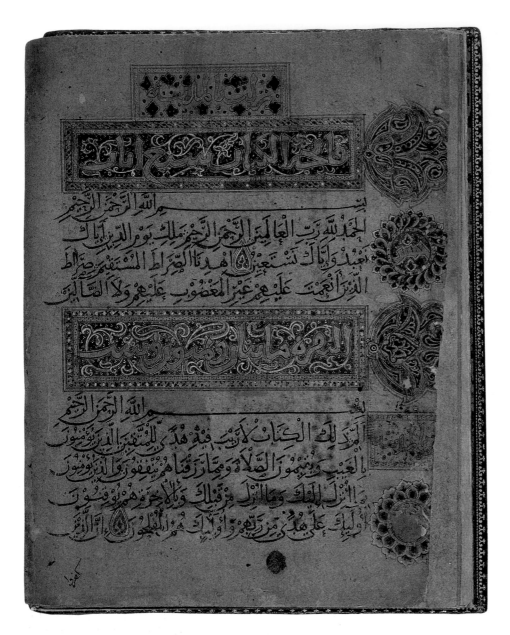

122. Folio from same Qur'an manuscript.
Ink, colours, and gold on paper

we have seen, gives both the date and place of origin. Unfortunately, however, one cannot be sure that this evidence is correct, since there is ample literary proof of early and later forgeries (the writings of Ibn al-Bawwab, in particular, were imitated soon after his death), and although, for intrinsic reasons, this manuscript has a better chance than any so far discovered of being genuine it could date from a few decades after the scribe's death in 1022.[227]

CONCLUSION

Traditionally, the arts of the seventh to eleventh centuries in the central lands of the newly formed Islamic world have been divided into two periods defined by the ruling dynasties and, to a smaller degree, by the areas over which they governed. There is, thus, an Umayyad art (661–750) centred on Greater Syria and an Abbasid art (750–c.1000) centred in Iraq. In the former, the wealth and enthusiastic patronage of the ruling class gave rise to mosques and residences which exhibited simultaneously a sense of state and an exuberance

of life and which reflected many different artistic sources and a broad range of tastes. The art created during the rule of the Umayyad dynasty seems to have been, as Ernst Herzfeld proposed in a seminal article published nearly a century ago, an art of adaptation and of juxtaposition. The rich vocabulary of forms current in the Late Antique world was adopted and adapted to the service of whatever new or old functions were required, and a myriad of motifs and ideas drawn from the entire area under Umayyad rule and even from beyond were creatively juxtaposed.[228] Thus, new combinations of common structural elements were designed for the mosque, representations of living things became restricted to the secular realm, the simplification or geometrization visible in the decoration of some walls coexisted with an exuberant explosion of forms with many subjects. A new geography of art came into being, in which Syria and Iraq are the pre-eminent centres of patronage and inventiveness (with the former predominating) and in which Central Asian themes can be found in Palestinian monuments or even on those in Egypt. In other words, the new art of the Umayyads reflected the

full scope of the new empire and, at times especially in the more private world of country villas and palaces, something of the *nouveau riche* taste of patrons suddenly provided with enormous resources.

Abbasid art, with a few exceptions in the courtly art of Samarra, can be characterized as a purification and simplification of the Umayyad inheritance. There is, at first glance, an austerity and a severity to most Abbasid decorated walls, wooden panels, and objects of all sorts. Figural representations are few and far between, and it has been argued in the past that Abbasid art, like Abbasid culture in general,[229] marks the end of the line for the great 'Hellenistic' vision which had dominated the Mediterranean and western Asia since the fourth century B.C.E. More recent scholarship, at least in fields like cultural history, has seen early Abbasid culture, especially that of the ninth century, in more positive and more creative ways, and these could be used to explain the evolution of the visual arts. Two very remarkable new phenomena can be singled out. One is the growth, around the establishment of the caliphs in Baghdad and Samarra as well as in the older cities of Basra and Kufa, of centres of cultural and artistic production and consumption which affected all layers of society in Iraq and, by extension, those in Ifriqiya and al-Andalus in the west and Khurasan and Transoxiana in the east. Scientists and translators made available ancient learning from the Mediterranean or from India and developed all fields of knowledge in the newly available Arabic language; their concerns extended to all aspects of physical matter and cultural life, as we owe to these times theories of grammar or of poetry as well as transformations of Euclidian mathematics or Ptolemaic astronomy. By the year 900 there had emerged from the urban world of Iraq a complete and coherent world view, with many internal nuances no doubt, but with a cohesion of shared ideas accepted by a majority of the learned elite. The other phenomenon is the full growth of an Islamic culture with the formation of theological and legal schools, heterodox movements, mysticism, philosophy, history, morality, and many other avatars of a self-conscious acceptance of an Islamic ethos rooted in the Scripture and in the life of the Prophet.

The difficulty lies in relating formal changes in the arts or the appearance of a new technique to the profound cultural transformations which affected first Iraq and then the whole Muslim world. The works of historians such as Mas'udi, litterateurs such as Jahiz, raconteurs such as Tanukhi or poets such as Abu Nuwas are replete with stories, anecdotes, and fantasies which can bear on the arts, once they have been gathered in some systematic fashion. As independent documents they are individually tendentious and difficult to interpret.[230] Yet there are areas where a direct impact of the new faith and of its social as well as ethical requirements on the arts can be proposed. One such area is the transformation of the common activity of writing into an iconophoric message, that is to say a carrier of meaning independent of its form, or into a subject worthy of the most elaborate ornamentation, or even into an end in itself, in short a work of art. Another one is the complex set of modifications called simplification, abstraction, and stylization. The effect of these modifications has been subsumed under the term 'arabesque,' a word invented during the Italian Renaissance

and adopted by eighteenth-century German writers on aesthetics, used to mean a formal arrangement of vegetal ornament into an endless succession of scrolls as well as the concept of an infinitely repeated motif.[231]

The special position taken by or given to writing and the arabesque, whether the latter is meant as a form or as a concept, could be understood as direct or indirect reflections of the brilliant intellectual life of Iraq in two ways. One is that both form and concept reflected or expressed the formalization of a legal structure, the prevailing legal order for making decisions or for passing judgments. Legal structure (*usul al-fiqh*) was, like ornament, logically constructed and could be extended to any personal and social need. It is this order, accepted by most of the elites, that can explain the ease with which new techniques and new motifs were carried from place to place and adapted to local conditions. The other way is through the permeation of all Muslim societies with ideas, Muslim or not in origin, which gave these societies a distinctive character of their own. Such is the notion of God as the exclusive Creator and, therefore, the vanity of all visible things and the possibility of unexpected combinations of details which appear to the modern eye as stunning inventions. This procedure has been called atomism and has often been used to explain the originality of early Islamic art.[232] A third way is geometry, whose investigation has been fashionable during the past decades and which was indeed one of the more remarkable developments of ninth- and tenth-century Muslim thought.[233] Geometry, like Ibn Muqla's standardization of writing, was a technique with straightforward and clear rules; it may thus have acquired the additional ideological component of reflecting Abbasid order. The full impact of geometry on the arts belongs in reality to the following centuries, although, as we shall see, some curious beginnings took place in northeastern Iran in the tenth century.

Yet, to see these centuries in terms of two clearly defined periods of artistic performance is probably to misunderstand the role played by the arts in society and to give undue importance to major political changes. It is probably more appropriate to consider the period that began with the Dome of the Rock (691) and essentially ended with the fall of Baghdad to a heterodox Shi'ite leader (945) as a time when several processes took place according to rhythms which are still impossible to disentangle: new shapes fashioned for the practice of the faith, princes seeking to remain good Muslims *and* be like the great kings of old, tradesmen and artisans discovering new markets and new products, religious leaders and intellectuals formulating the distinguishing parameters of Islamic theology and knowledge, and even at times individuals seeking to create for themselves a means for their own salvation and serenity. All of these processes, public or private, visible or secret, are reflected in the arts and material culture of the central Islamic lands during this seminal period. They created a mood of intense activity out of which coherent styles of the earliest Islamic art eventually emerged. In and under the influence of Baghdad, these styles, if not necessarily the mood that inspired them, were transmitted throughout the world of Muslim communities, the *umma*, the Islamic equivalent to the *koiné* of ancient times. They have been the foundation of the arts of the Islamic world ever since.

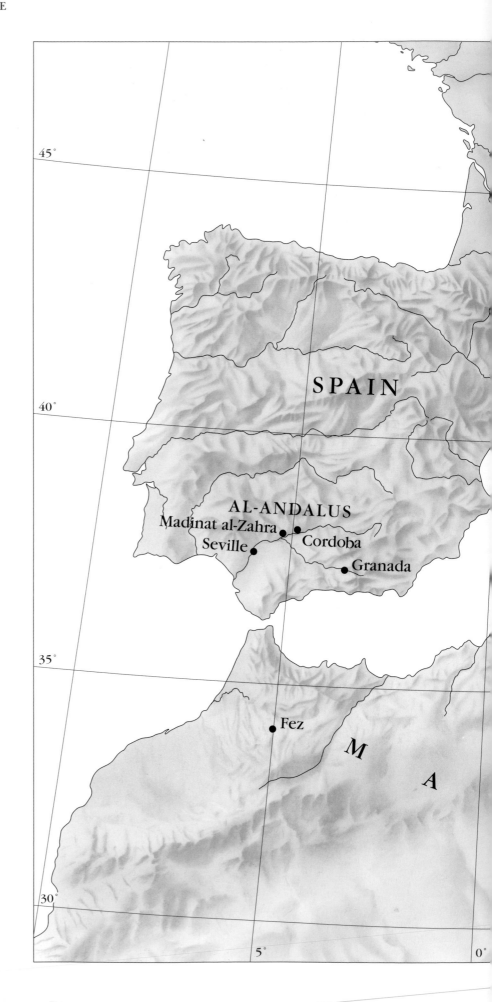

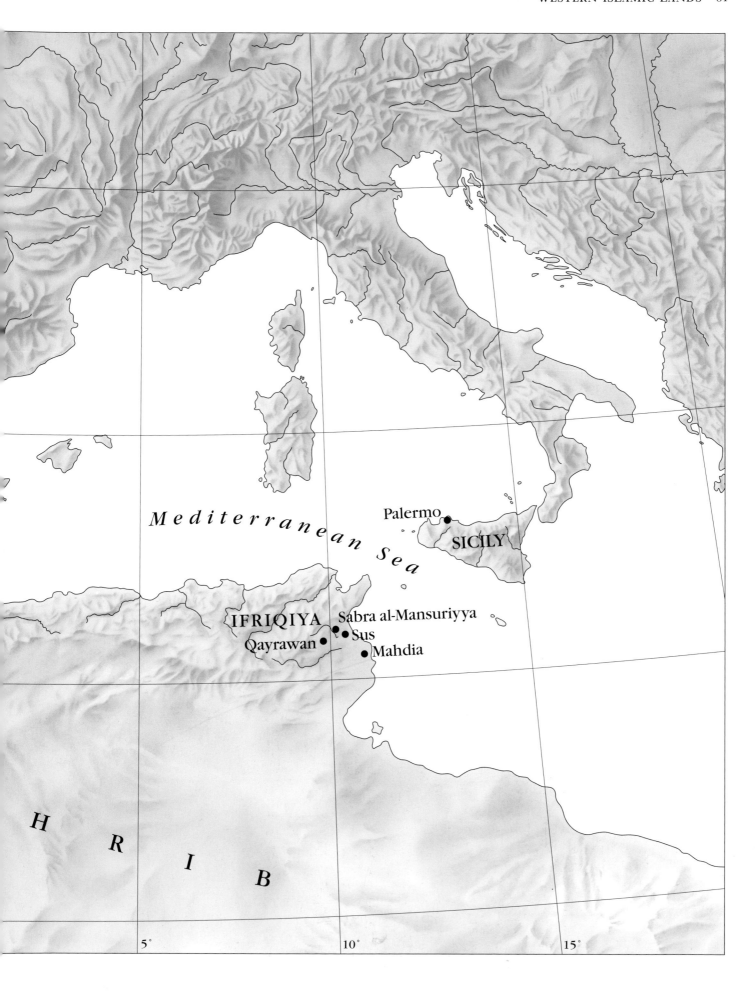

M e d i t e r r a n e a n S e a

Palermo

SICILY

IFRIQIYA Sabra al-Mansuriyya

Qayrawan Sus

Mahdia

H

R

I

B

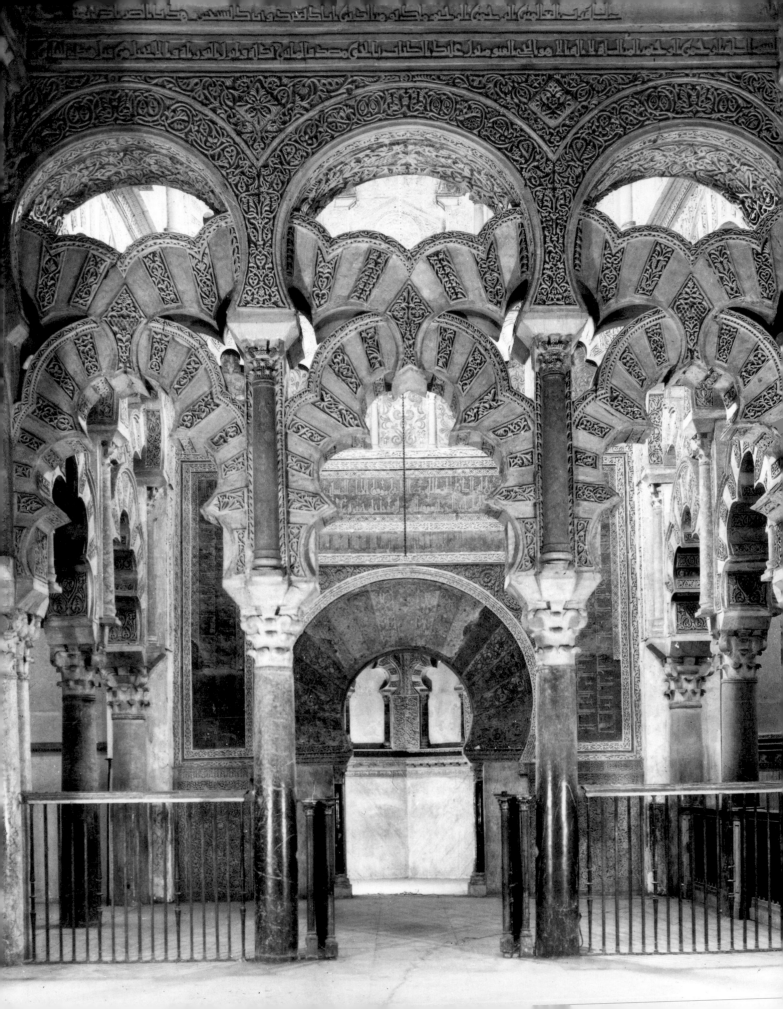

Western Islamic Lands

During the early centuries of Islamic rule the cultural history of western Islamic lands was concentrated in two areas. One is the province of Ifriqiya under the rule of the Aghlabid dynasty of governors, with its new capital of Qayrawan and its fortified coastal cities like Sus (modern Sousse). The other is al-Andalus, the generic name given to all parts of the Iberian peninsula under Muslim rule. The former was still very much of a cultural satellite of the caliphate in Syria and in Iraq, and we dealt with its architecture in a previous chapter. The latter, however, created a culture and an art which were strikingly original. Between the two, the fledgling dynasty of the Idrisids had founded the city of Fez and had fully established itself in what would be now northeastern Morocco and northwestern Algeria. But the region was mired in internal struggles, even though the dynasty itself welcomed Andalusian settlers in the ninth century. Its artistic, and even archeological, importance will appear only late in the tenth century and will be considered in Chapter 7. Sicily had been conquered in the ninth century, but almost nothing is known about its art or material culture under direct Muslim rule.

The only survivor of the Abbasid massacre of Umayyad princes in 750 was ʿAbd al-Rahman ibn Muʾawiya, who escaped to al-Andalus. There, thanks to the large number of pro-Umayyad Syrian settlers and to their equally numerous North African Berber clients, he succeeded in becoming an independent governor. Until 1009 his descendants ruled the nearly three-quarters of the Iberian peninsula which were controlled by the Muslims. Theirs was not an easy and peaceful rule, as they had to contend with Christian kingdoms to the north and with streams of revolts within their own realm. By the time of ʿAbd al-Rahman II (r. 833–52), a significant Muslim cultural life had developed in and around the southern cities of Seville and Cordoba or in the old Visigothic capital of Toledo. The reputation of Baghdad led to the importation of high Abbasid culture symbolized by the person and personality of one Ali ibn Nafiʾ. Known as Ziryab, a singer by profession, he was a man of many talents (or many talents were attributed to him by later historians) who is supposed to have introduced taste and refined manners to an uncouth Muslim Far West. Umayyad power reached its apogee in the tenth century, under ʿAbd al-Rahman III and his son al-Hakam (r. 912–76). At that time the Umayyads of Spain assumed the title of caliphs and their capital, Cordoba, became one of the wealthiest and most brilliant cities of the medieval world. Not only were its poets known throughout Islam, also influencing the budding secular poetry of the Christian West, but in many other ways the Umayyad caliphate of Spain was the single most powerful cultural centre of Europe, with a strong impact on the large Christian and Jewish populations within and without al-Andalus.

ARCHITECTURE AND ARCHITECTURAL DECORATION

THE UMAYYADS OF SPAIN: 750–1000

The most remarkable monument of the Umayyads in Spain is the Great Mosque at Cordoba [123]. Today it is a rectangle 190 by 140 metres of which about a third is occupied by a courtyard planted with orange trees and surrounded on three sides by a much restored portico. On the fourth side is

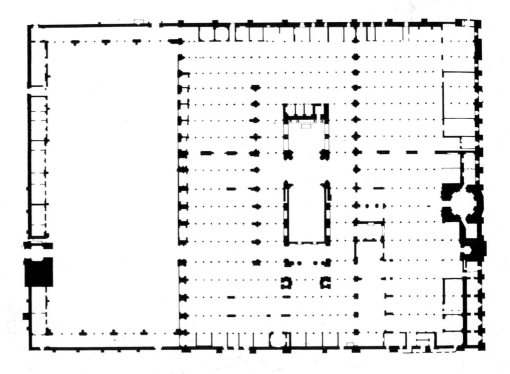

123. Cordoba, Great Mosque, *maqsura*

124. Cordoba, Great Mosque, plan

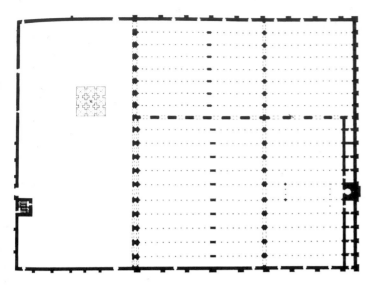

125. Cordoba, Great Mosque, sequence of construction, 784–6, 833–52, 961–76, 987

a long hall of seventeen naves on sixteen arcades running south west–north east, incorrectly thought to be in the direction of Mecca. The naves are thirty-two bays deep and 7 metres wide, except for the sixth from the southwest, which is 8 metres wide. In the middle of the hall is a whole Gothic cathedral built in 1513 against strong opposition, and there are Gothic or later chapels elsewhere from the

thirteenth century onwards. The outer walls are much restored, heavily buttressed, and pierced by eleven ornamented doors.

This rapid description makes clear that the monument was not built all at once. The Muslim work can be divided into four periods [125] distinguished (except in a few details)[1] by literary and archaeological documents. The first mosque, built in 784–86, probably on the site of an older Christian church,[2] consisted of nine or eleven twelve-bay naves, the central one wider than the others, at right angles to the *qibla* wall. ʿAbd al-Rahman (r. 833–52) made the first additions, possibly widening the hall by two naves and certainly lengthening it by eight bays.[3] The second expansion, the most remarkable of all, is attributed to al-Hakam II (r. 961–76). He lengthened the mosque by another twelve bays, and, on the axis provided by the central nave of the first building, erected a spectacular group [124] beginning with the dome (the present Villaviciosa Chapel[4]) and ending with three more domes in front of a richly decorated *mihrab* [126] in the shape of a nearly circular, but in fact seven-sided, room.[5] The area in front of the *mihrab* was separated from the rest of the mosque, constituting a *maqsura*. In 987 al-Mansur, the minister of the caliph Hisham, made the third addition [127]: an eight-nave widening towards the north-east[6] which consciously used the earlier methods of construction[7] and gave the completed work a more traditional ratio of width to length, but destroyed the axial symmetry. Other ninth- and tenth-century additions were made by var-

126. Cordoba, Great Mosque, *mihrab*

128. Cordoba, Great Mosque, polylobed arch

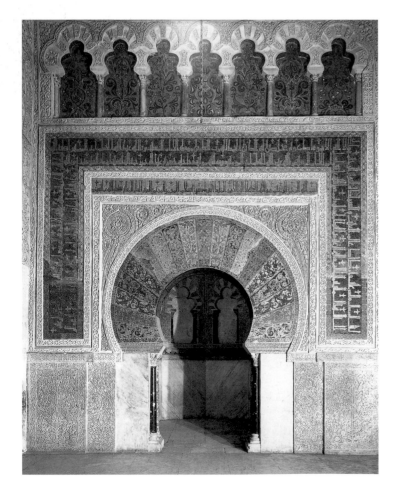

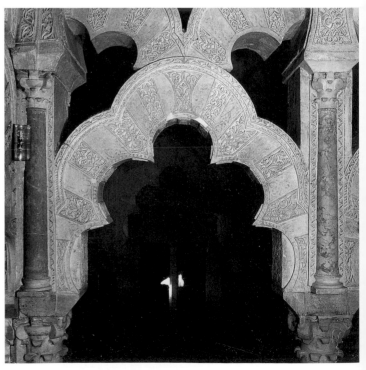

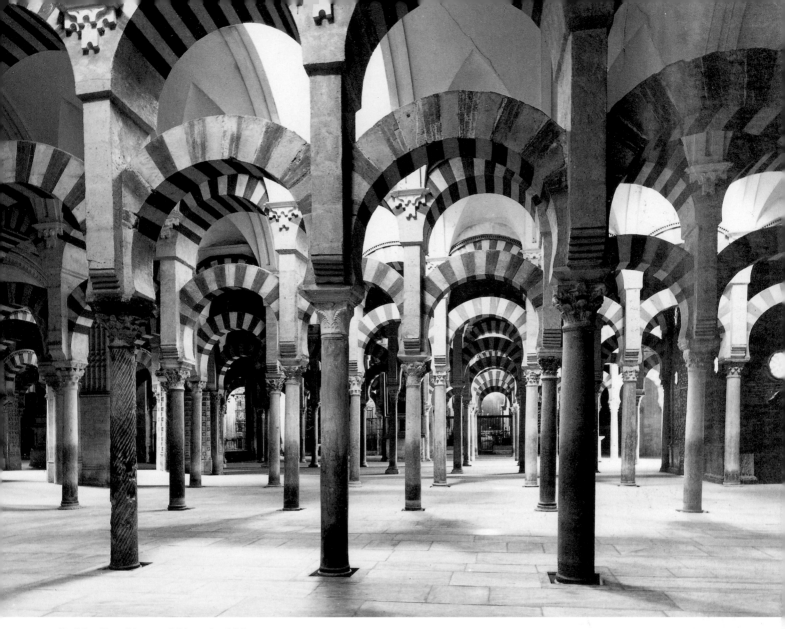

127. Cordoba, Great Mosque, al-Mansur's addition

ious Umayyad princes;[8] most of them are secondary except for the striking minaret erected in 951–52, whose significance as a symbol of Umayyad power confronting the rise of the Fatimids in Ifriqiya has been argued recently.[9]

The mosque of Cordoba, like so many other early hypostyle mosques, reused elements (especially columns and capitals) from pre-Islamic buildings. However, a number of major innovations transformed it into one of the great monuments of medieval architecture. The first, found in the original mosque and maintained in all succeeding additions, consists in raising the height of the building by erecting two tiers of arches, the lower supported by regular columns, the upper by long and narrow piers inserted between the lower arches and resting on the columns. Spain could not provide the monumental columns so characteristic of Syria, and the available ones were too small to allow for a large hypostyle area. The result was this highly developed and impressive superstructure over numerous but short supports, creating the most original visual effect of an elaborate ceiling, further strengthened by the alternation of colours in the stone and brickwork of the arches.

The second innovation involves the arches, the domes, and the *mihrab* of al-Hakam's addition. The slightly returned semicircular arches of the first building become polylobed [128]; instead of maintaining the single arch as a completed unit, the architects broke it up into small parts which, in turn, created a complex pattern of interlocking arches used both as supports in the construction and as decorative designs for wall surfaces and for gates.

The third innovation concerns the four domes. The main dome in front of the *mihrab* preserves the traditional octagon based on the squinch, but is carried on eight large ribs resting on small columns fitted between the sides of the octagon [129]. It is thus shortened, and its base has a staggered shape formed by twenty-four mosaic-covered centripetal ribs. The other three domes provide variations on the same theme, the most interesting occurring in the Villaviciosa Chapel, where the ribs transform a rectangle into a square.

The structural significance of these innovations is difficult to assess, but one point is quite clear. Changes in the construction of arches and in the appearance of domes led to

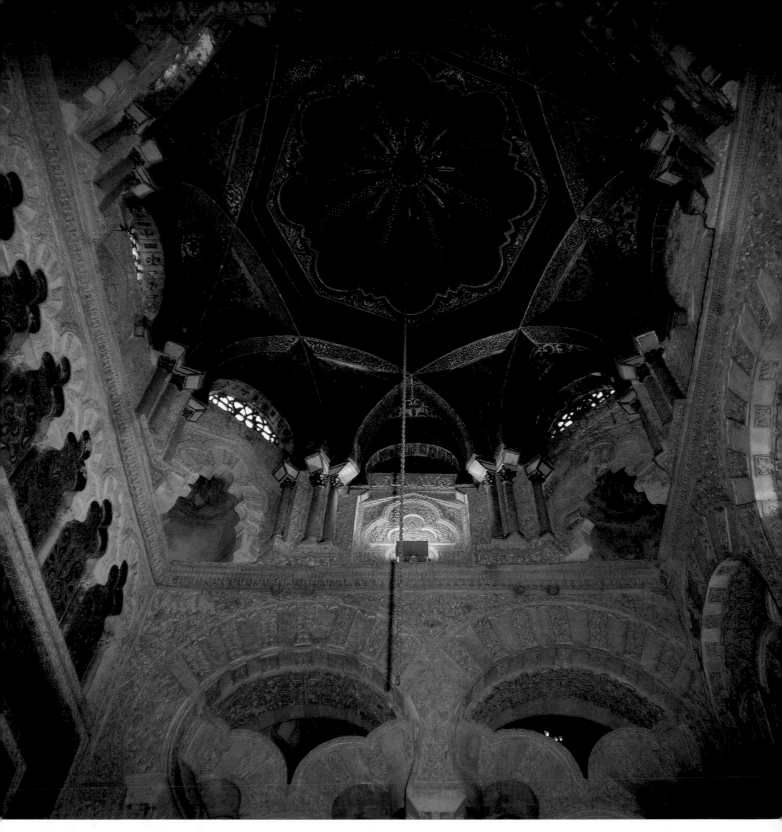

129. Cordoba, Great Mosque, dome in front of *mihrab*

a great increase in the decorative and expressive value of
both; originally simple architectural forms and lines are
transformed into complex ones and broken up into smaller
units, each of which in turn becomes a decorated surface or
shape, for instance every single stone of the arches or the
newly created triangular areas between the ribs supporting
the domes. The straightforward forms of the classical dome
have developed into infinitely complicated combinations of
lines and shapes, almost all of which derive more or less
directly from specific units of construction. The Muslim

130. Toledo, Bab Mardum,
general view

131. Toledo, Bab Mardum, dome

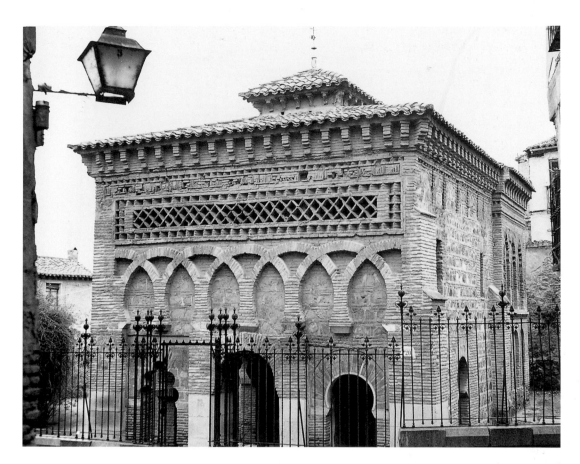

architects of Spain recognized the decorative significance of the Cordoba innovations, as shown by the small mosque known as Bab Mardum in Toledo [130, 131] (now the church of Cristo de la Luz). It is datable around 1000; its plan belongs to a pan-Islamic type which had appeared already in Abbasid times and which has been discussed earlier (pp. 28, 29); its originality lies in its nine small domes decorated with structurally useless ribs arranged in different patterns.[10]

The ribs of Cordoba have often been compared to those of later western Christian architecture; they have also been related to ribs found in Armenian churches[11] and to certain features of Sasanian and later Iranian dome construction.[12] An oriental origin has also been assigned to the polylobed arches, which indeed occur in the decorative niches of certain Abbasid buildings (palace of al-Ashir in Samarra, mosque of Ibn Tulun in Cairo). Most of these hypotheses are still uncertain. However, the example of the Villaviciosa Chapel, where the masonry of the dome has been examined,[13] shows that the architects of Cordoba were not fully aware of the structural possibilities of the rib in permitting lighter vaults; nor does later Islamic architecture in the West seem to have noticed that such ribs had a structural potential; they probably had nothing to do with the development of vault construction in the Christian world.

The question of origins is a difficult one. Although the history of Iranian methods of construction in the first Islamic centuries is almost totally unknown, the late eleventh- and early twelfth-century monuments with which Cordoba is compared show a similar attitude towards forms rather than the same architectural and decorative motifs.

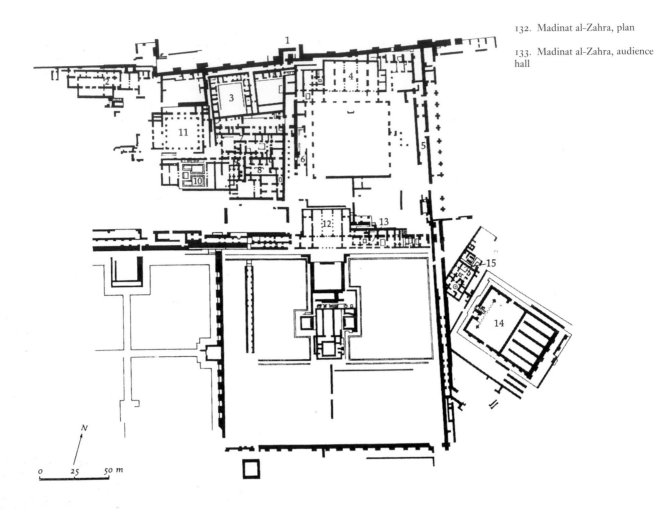

132. Madinat al-Zahra, plan

133. Madinat al-Zahra, audience hall

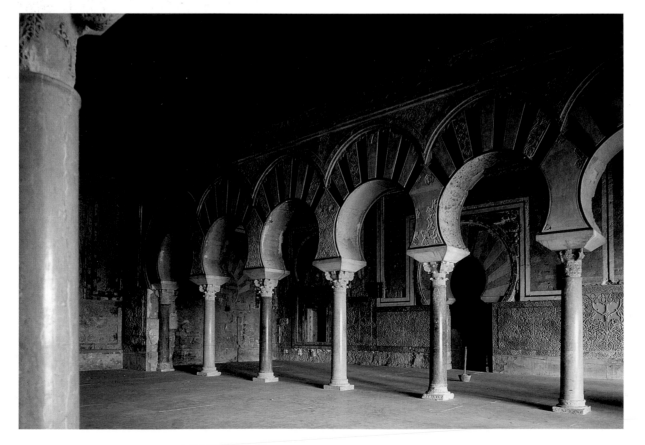

With respect to the polylobed arches, it is logically questionable whether Spanish builders would have transformed oriental decorative shapes into forms of construction, since in most instances the evolution runs in the opposite direction. Therefore the arches and vaults of Cordoba are more likely to be local Spanish developments. They began with the double tiers of arches in the mosque of 784, possibly inspired by large Roman engineering masterpieces like the aqueduct of Merida located north of Cordoba. On the other hand, the relationship between construction and decoration finds equivalents in other parts of the Islamic world.

The last important points about the mosque of Cordoba concern the *mihrab*. Its shape of a whole room is unusual, and its original effect must have been either that of a darkened opening into another world or, if a light was put into it, of a beacon for the faithful. Its numerous inscriptions, almost entirely Qur'anic,[14] include the proclamation of divine glory on the cupola, statements about ritual obligations, and references to royal rights [129]. Perhaps under the influence of the surrounding Christian world, the *mihrab* of the mosque appears to have acquired a precise liturgical, ceremonial, and religious meaning usually absent elsewhere in the Muslim world, at least in these early centuries. Unusual rites were performed in this one mosque like the carrying in procession of a copy of the Qur'an.[15] This liturgical and symbolic aspect of the *mihrab* and its relationship to royal ceremonies may well explain why the horseshoe shape within a rectangular frame was used for gates, and most specifically, as early as 855, for San Esteban, one of the main gates into the mosque from the adjoining palace.[16] Without being always as fully charged with meaning, this formal ensemble will remain characteristic of most of western Islamic architecture.

In spite of its disturbed and irregular plan, the mosque of Cordoba, then, is a most extraordinary monument in which the fascination of early Islamic patrons and designers for a perfect blending of architecture and decoration finds one of its first and most brilliant expressions. The tenth-century architects of al-Hakam developed structural and decorative forms which, like those of Samarra and Qayrawan, provided the hypostyle building with a new order and a new emphasis; the spectacular display of arches and domes on tiny and insignificant columns is, however, characteristically Spanish Islamic. It is a monument of architectural art as it combines an economy of means with a powerful effectiveness of contrasts between light and shade, fulls and voids, clear foci and an infinite spread in all directions.[17]

The secular architecture of Umayyad Spain is known through some public works[18] and particularly through the large and still mostly unexcavated expanse of Madinat al-Zahra, a few kilometres from Cordoba. It is the palace which ʿAbd al-Rahman III transformed into a city, and it became eventually, and for a short period of time, the capital of the Umayyad caliphate in Spain. Work on it began in 936 or 940 and it is likely that it was never completed, assuming that its design was based on some sort of master plan rather than the result of a more or less haphazard succession of buildings connected to each other by ceremonial or behavioural patterns.

From surveys, partial excavations, and numerous written references one can reconstruct a huge walled space (roughly 1506 metres by 800) on a sloping hill. More or less in the centre of its northern boundary, a complex of palatial buildings has come to light [132], which includes service areas, a bath, a mosque, several formal halls on a basilical plan of three or five aisles preceded by a long foreroom facing a courtyard, and thousands of fragments of stucco and other decoration. Much is still unclear about this ensemble, which was certainly inspired by whatever was known in Cordoba of Abbasid Samarra. A similar sense of extensive, if repetitious, luxury pervades much of the site, as though there were no restrictions on available space nor funds for construction. An exception to this general impression may have been the two fountains erected in the gardens of the palace. One of them, according to a rather late source, was adorned with twelve gold sculptures of animals, both real and imaginary.[19]

For the history of architecture, Madinat al-Zahra exhibits several significant features. One is the artful way in which it engages the surrounding landscape through a highly original system of miradors or viewing places.[20] A second one is the technical precision and formal quality of its horseshoe arches [133] set on slender columns. The third is that an unusual number of its capitals (many are in museums all over the world) are signed by the artisans who made them. The exact social and perhaps economic implications of this

134. Cordoba, Great Mosque, marble fragment from *mihrab* area

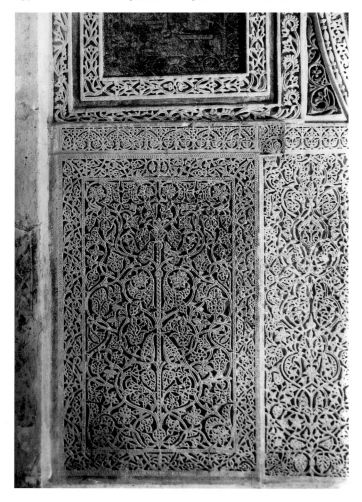

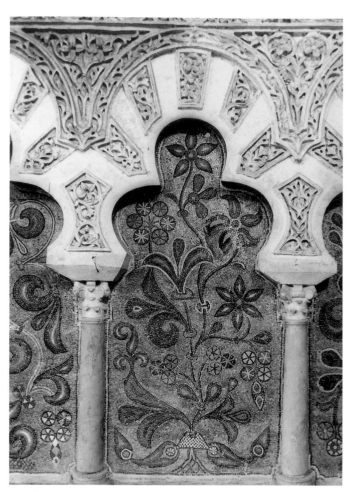

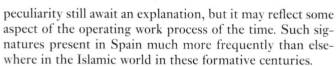

135. Cordoba, Great Mosque, mosaics in the *mihrab*

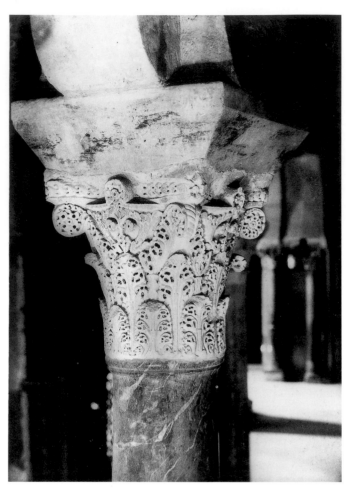

136. Cordoba, Great Mosque, capital

peculiarity still await an explanation, but it may reflect some aspect of the operating work process of the time. Such signatures present in Spain much more frequently than elsewhere in the Islamic world in these formative centuries.

Finally a word must be said about Umayyad Spanish architectural decoration, although little has so far been done on classifying themes[21] or tracing their evolution. The mosque of Cordoba [134] and especially the palaces of Madinat al-Zahra [133] abound in mosaics, marble sculpture, carved stone and stucco, and carved or painted wood. In the mosque the decoration of capitals, brackets on the piers supporting the upper tier of arches, alternating stones of polylobed arches, and cornices and ceilings is largely subordinated to the forms created by the architects. Only in the *mihrab* and on some of the gates did the need for special visual effects lead to the composition of panels, mosaics, carved marble, and moulded stucco independent of architecture. But even then – for instance, in the way the mosaic patterns follow the complex lines created by the architect [135] – the wealth of ornament serves chiefly to heighten the dramatic effect of the construction. In the palaces, on the other hand, perhaps following the traditions established in Umayyad Syria, decorative panels seem to have covered most of the walls of the main halls, and, even though (unlike at Khirbat al-Mafjar and Qasr al-Hayr West) there is a lack of completely preserved or even securely restored rooms, one

should probably imagine the same simple or complex geometric frames enclosing a luxurious tapestry-like decoration.

The morphology of this ornament as defined in recent years by Ewert, Pavón Maldonado, and others need not be spelled out in detail, but certain peculiarities stand out in comparison with ninth-century Samarra or Qayrawan. First, in spite of some geometric or figural ornament,[22] vegetal elements predominate, in the form of endless variations on the vine and acanthus of antiquity; this classical element may derive from local Roman or post-Roman tradition, a continuous Byzantine impact (as through the importation of mosaicists), or the very eclectic usage of the first Umayyad art of Syria. Second, the ornament of Cordoba and of Madinat al-Zahra is much subtler than at Qayrawan and even than in much of Syria (except at Mshatta). It refines infinitely upon the same basic themes. On certain capitals, for instance [136], and in a superb marble panel to the side of the *mihrab* of al-Hakam II, it introduces a fascinating movement of stems and leaves around a rigid axis, in which the basic symmetry is contradicted by the asymmetry of the details, and constant changes in the place relationships of separate units contrast with the primary effect of an opposition between the plane of the design and the invisible background. Finally, this ornament is conservative; it does not reflect the revolutionary designs of the Samarra stuccoes but relies on interlace and the same few floral shapes, all probably derived from Late

Antiquity. Its quality lies in the inventiveness of its modulations rather than in the discovery of new themes.

THE ART OF THE OBJECT

Up to now and with the exception of al-Andalus,[23] the arts created during this formative period in the western lands of the Islamic world, the Maghrib,[24] if they are mentioned at all have usually been discussed as part of either the Abbasid or the Fatimid traditions. However, the geographical and chronological subdivision followed in this particular study of the history of Islamic art, as opposed to the conventional approach based on a dynastic one, has allowed for a more comprehensive and accurate presentation of what might be called classical western Islamic art of the early period, i.e. the art of the Maghrib between 650 and *c*.1000. Only by approaching the subject in such a way can the objects produced in this area of the Muslim world be seen for what they truly are: new departures for the Islamic west and thus pieces of the mosaic that is early Maghribi art. When they are not evaluated in such a context, the Early Islamic products of Tunisia, Morocco, and Sicily as well as certain of those from Spain either tend to be completely omitted in works surveying the history of Islamic art or are greatly overshadowed by better-known, more avant-garde or, at times, more beautiful works of art.

Indeed, a discussion of the full range of Maghribi objects from this period is needed not only to flesh out the history of Islamic art in its first three hundred and fifty years but to help explain the later chapters of this history as well.

The cycle of adoption, adaptation and innovation we have been following in the decorative arts created in the central Islamic lands during this early period was echoed in various contemporary artistic centres in the western reaches of the Muslim world. The art that evolved in the Maghrib during this formative epoch owed a great debt to three different sources. The first of these was the Greco-Roman, a heritage common to all the Islamic countries on the shores of the Mediterranean. Having been the prevailing tradition in the area at the time of the Arab conquests, in the early Islamic period many of its features were adopted and gradually adapted for the new patrons.

The second source was the artistic styles and traditions that developed under the aegis of the caliphates ruling from Damascus and Baghdad. More specifically, the rulers who governed the Maghrib during the early Islamic period were constantly attempting to emulate and even surpass the life styles of the Umayyads and Abbasids and because of the prestige of these two houses the artistic production of their capital cities and/or artistic centres created vogues and subsequently spawned imitations or variations in the principal urban centres of the Islamic west. The same effect was achieved when techniques and styles, newly developed in the heartland, were carried to other areas by migrating craftsmen who were seeking work or were summoned by more prosperous patrons. Thus, the major centres within the central Islamic lands during this period should be viewed as at the hub of a wheel. The spokes of this wheel radiated to the furthest reaches of the Muslim world bearing kernels of the newly evolving art form known today as Islamic. Once having been adopted in these 'further' lands, the cycle was repeated with the local inhabitants adapting the styles from the heartland to suit their own needs by adding elements familiar to them and thus eventually creating a western (and an eastern) version of classical early Islamic art.

The last major indebtedness was to the contemporary 'Mediterranean society' itself. It has been stated that 'the Mediterranean has always been a unifying force for the countries that surround it; it is a commonplace that the spread of Greek and Roman culture depended largely upon it. And yet, in studies of Islamic art, this fact tends all too easily to be forgotten.'[25] In fact, the material culture found in each of the many Islamic countries bordering this sea can be understood only when viewed from this perspective, and any study of the art of this area that is not predicated on this unity will fail to identify the multitude of threads in the rich cultural tapestry of the particular early or medieval Islamic state being discussed and thus to comprehend its civilization fully.

The important role played by imperial Umayyad artistic styles and traditions in the formation of Islamic art in the Iberian peninsula (that occupied by Spain and Portugal) cannot be sufficiently stressed. The marble doorjamb from Madinat al-Zahra – a new Umayyad city founded in the third or fourth decade of the tenth century some five kilometres

137. Marble doorjamb from Hall of 'Abd al-Rahman III, Madinat al-Zahra. Datable between 953/4 and 956/7, 104 × 50 cm. Museo Arqueológico Provincial de Córdoba, Cordoba

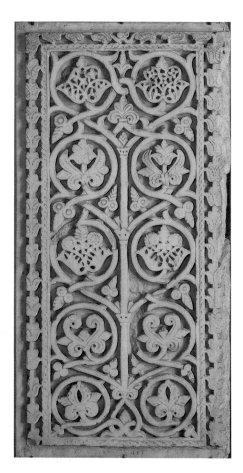

138. Marble window grille 177 × 98.5 cm. Museo Arqueológico Provincial de Córdoba, Cordoba

139. Marble relief, L. 53 cm.; Ht. 35 cm. Musée National du Bardo, Tunis

this early period – both in the Iberian peninsula and in Ifriqiya. Among these is the carved and inlaid marble relief [139] from Mahdiyya (in present-day Tunisia) that must have once graced a secular building in this Ifriqiyan capital. It depicts an imbibing ruler being entertained by a musician playing a flute-like instrument. Contemporary architectural fragments similarly inlaid with black stone have been found also in al-Andalus.[28]

An early type of pottery produced in Umayyad Spain – made of clay covered with a slip and painted with calligraphic and geometric designs – is represented by the ewer [140]. The group to which this pouring vessel belongs imitates closely those late imperial Umayyad and early Abbasid objects discussed above that can be dated to the eighth century.[29]

east of Cordoba – is an excellent example of the strong dependence of the art of al-Andalus on the earlier products of Greater Syria [137]. The so-called tree of life decoration – which had its origin in the late classical candelabra tree – is highly reminiscent of the depictions of the same motif on a number of stucco window grilles from Qasr al-Hayr West and on several wooden soffits for the Aqsa Mosque [87, 88]. The imperial and Andalusian Umayyad examples also each exhibit a border of small, interconnected and repeated vegetal designs. The tree of life motif proved to be a particularly popular one in al-Andalus, especially for architectural decoration; and its variations are legion. Not only is it found in the secular as well as religious architecture [134] of Umayyad Spain but it was popular also in the later, *taifa* period.[26]

The vogue in al-Andalus for stone or stucco window grilles decorated with geometric repeat patterns [138] also stemmed from their popularity in the imperial Umayyad realms [86].[27] Their appeal reflected not only their attractiveness but their functional qualities as well; in the hot Mediterranean climate, they maintained privacy while permitting visibility from indoors, diffused sunlight, and provided ventilation while inhibiting the movement of insects through the variously sized openings.

In addition to the exquisitely carved stone objects that exhibit vegetal and geometric designs, others with figural decoration occur as well in the western Islamic lands during

140. Painted earthenware ewer, Max. ht. 47 cm. Conjunto Arqueológico Madinat al-Zahra, Cordoba

141. Inglaze-painted earthenware tile, Gr. W. 30 cm. Musée National du Bardo, Tunis

142. Inglaze-painted earthenware dish, D. 35 cm. Museo Arqueológico de Granada, Granada

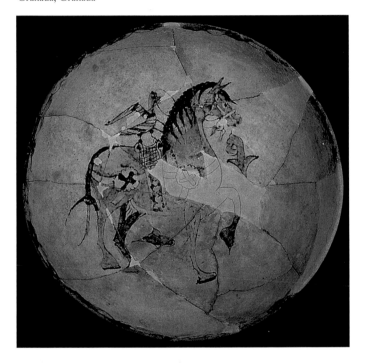

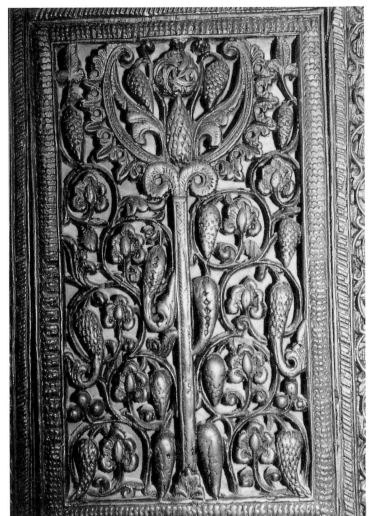

143. Detail of wood *minbar* in Great Mosque, Qayrawan. Datable between 856 and 863

The most prevalent glazed ceramic objects in the western Islamic lands during this period were those that imitated the opaque white-glazed group manufactured in Basra, Iraq, under the Abbasids, specifically that variety ornamented with designs painted mainly in cobalt blue.[30] Unlike the Iraqi prototypes, however, the palette of the wares produced in the provinces was typically green and aubergine, and in Ifriqiya figural representations predominated over the vegetal, geometric, or calligraphic designs so prevalent in the heartland [141].[31] The Andalusian version, on the other hand, exhibits a popularity for both figural and non-figural decoration and includes among its profiles the one most commonly found on the Abbasid originals, namely that imitative of Chinese white wares and proto-porcelains – a shape not encountered in Ifriqiya at all [142].[32] Thus, once they had been adopted, the local artisans and, presumably, the patrons themselves adapted the styles from the heartland to suit their own needs and tastes by adding elements familiar to them and thus cre-

ated a western version of one of the two most luxurious Abbasid glazed ceramic types ever produced. In both Ifriqiya and al-Andalus, three-dimensional objects as well as wall tiles were produced in this technique.[33]

Because of the very close stylistic and iconographic as well as technical resemblance between the inglaze polychrome painted ware from these two western Islamic lands, it can be assumed that they were contemporary. The approximate date of the Andalusian production is provided by the moulding decorated in this technique that embellishes the dome in front of the *mihrab* in the Great Mosque of Cordoba that was added to the building by al-Hakam II in 965–68.[34] Therefore, these two pottery types should be placed in the second half of the tenth century. Since it is not yet known precisely when the production of cobalt-pigmented painting on opaque white-glazed wares began in Basra, Iraq, and for how long it continued to be manufactured in that centre, there is no way of determining the time

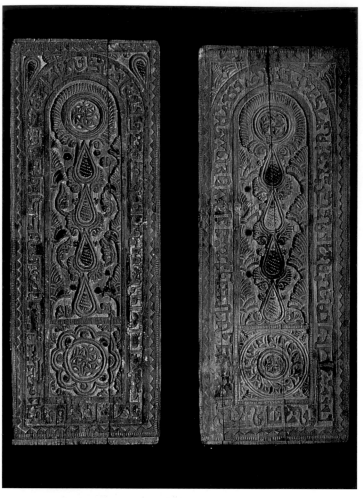

144. Panels of wood *minbar* from Mosque of the Andalusians, Fez. Dated 369/980. Right panel: 55 × 20.7 cm. Left panel: 56 × 20.5 cm. Musée du Batha, Fez

lag in the spread of this technique from the lower reaches of the Euphrates to the southern and western shores of the Mediterranean. Such diffusion can take years, thus ensuring the longevity of certain styles as well as the presence of international conventions.

A major work of this period in the western lands of the Islamic world is the wood *minbar* in the Great Mosque of Qayrawan [143]; crafted between 856 and 863, it is the oldest surviving pulpit in the Islamic world.[35] It has the simplest possible shape, only two triangular side walls framing the stairs and a platform on top, but the function of the side walls is entirely overshadowed by the intricacy of the thirteen vertical rows of rectangular panels on each, exhibiting a rich variety of designs directly based on Umayyad work.[36] The more numerous geometric patterns are ultimately related to such schemes as those in the window grilles of the Great Mosque of Damascus [86], whereas the more significant floral compositions go back to the carvings at Mshatta and other sites, except for some new Abbasid stylistic tendencies now being more pronounced. All concern for natural growth and botanical veracity has disappeared, to be replaced by an emphasis on abstract floral fantasies. Trees, leaves, and fruits of diverse species are shown on the same

plant; branches twist in odd, even geometric shapes or have been left out altogether; and familiar forms turn unexpectedly into others. Although purely decorative elements are comparatively rare, their richly sculptured surfaces stand out effectively against the deep shadows of the background, and the same elements appear in different compositions. Such versatility bears witness to rich imagination and inner dynamic force, but the piling up of forms, the unexpected combinations, and the ever-changing juxtapositions, as well as the lack of any close relation between the geometric and floral panels, betray an endeavour that was still unfocused. Although outwardly the artisans had their designs in admirable control, the balance, even spacing, and formal unity in each thematic group show that they were still groping for both the syntax and the vocabulary of the newly developing decorative language. The only definite conclusion that can be drawn is that artistic expression tended to be achieved through non-naturalistic and abstract motifs.

In the past, scholars have assumed that these panels were carved in Baghdad; but the early eleventh-century text previously referred to[37] states clearly that the teak beams had been imported from that city for the purpose of fabricating lutes but that the reformed Aghlabid amir used them, instead, to make the *minbar* destined for Qayrawan's Great Mosque. Objects such as the door or *minbar* panel [96] – unearthed in Iraq, perhaps even in Baghdad itself[38] – with similarly decorated sections bearing designs built on the vocabulary of Umayyad ornament, must have served as the prototype for the Aghlabid masterpiece. Although the *minbar* was made at a time when Samarra was the Abbasid capital, the style of its carvings reflects none of the tendencies towards abstraction of the Samarra stucco Styles B and C, and the floral panels lack entirely the hackneyed quality of Style A. Therefore we must assume a cultural time lag, which is easily understandable in so distant a region as Tunisia belonging to the Mediterranean world of artistic forms rather than to that of western Asia as Samarra did. This remoteness and distinct cultural tradition explain why, at a time when some artisans of the capital were half-heartedly following old traditions and others had already experimented with new ideas, their fellow-craftsmen in a Mediterranean centre were employing the ancient vocabulary with renewed vigor.[39]

More than a century after this pulpit was carved in Ifriqiya, another was produced in Fez [144]. It was ordered in 980 for the Mosque of the Andalusians in that city by the Fatimid client Buluggin ibn Ziri. As was the case with the earlier *minbar*, this one also drew its inspiration from the artistic styles and traditions that had developed under the aegis of the Umayyad caliphate ruling from Damascus. The two carved panels seen here, still retaining traces of their original paint, each bear as the principal decoration a highly stylized palmette tree set within an arch and circumscribed by an angular, foliated inscription.[40] Because the vegetal motif itself (adapted from the late classical candelabra tree) was part of the Late Antique heritage of early Islamic art, a precise answer to the route this design took to Morocco and the time of its arrival and incorporation into the iconographic repertoire there remains elusive. It could have passed into the repertoire of the artisans of Fez directly from

Greater Syria just as easily as from Greater Syria via al-Andalus or from Baghdad via Ifriqiya.

Carved ivory objects from al-Andalus that survive in substantial quantity must be regarded as among the finest products of the period, fully commensurate with the stately and imaginative opulence revealed by the architectural monuments of Umayyad Spain.[41] Fortunately, many are inscribed with the names of the royal personages or court dignitaries for whom they were made, and dates are usually given, ranging from about 960 to the middle of the eleventh century. Most are either pyxides with a hemispherical lid or rectangular containers with a flat or hipped cover.

The earliest pieces carry only rather loosely spaced, wiry vegetal designs. Their special quality lies in the ingenious manner in which leaves and branches grow and curl around one another so that the designs are full of inner movement, reflecting a refined sculptural sense.[42] The same quality, as well as the generally restricted vocabulary of motifs, characterizes slightly later pieces, which, however, exhibit more ambitious decorative programmes. In the pyxis made in 964 for al-Hakam II's celebrated concubine Subh, the mother of the future caliph Hisham II,[43] the vegetal forms, inhabited by peacocks, doves, and antelopes, are somewhat richer than before and the opulent ornamental design is endowed with lively movement. Equally important is the artist's sense of structure, which resulted in a clear organization of the surface. The branches form geometric compartments which serve both as skeletons for the composition and as frames. Geometric and vegetal motifs are thus harmonized not by mere juxtaposition but by integration, a solution that the earlier wood-carvers of Qayrawan had not yet achieved. This type of arrangement also characterizes the sculptured marble panels flanking the *mihrab* of the Great Mosque in Cordoba [134], but in a delicate ivory box the result is more subtle and effective.

The same organizing tendency found expression in an even richer pyxis made in 968 for al-Mughira, the younger son of 'Abd al-Rahman III.[44] Here human and animal figures are enclosed in large, eight-lobed medallions formed from continuous interlace, while other figures and plant forms fill the spandrels [145]. This piece provides the first conscious organization of a complex decorative scheme into major and minor scenes within a unified whole. It is also the first appearance on a Spanish ivory of a cycle of royal themes. In one of the medallions the prince himself appears with a goblet or bottle in his right hand and a long-stemmed flower in his left; he is seated in the company of his fan-bearer and his lutenist while falconers stand outside the medallion frame. Other motifs representing royal might, like the lions below the throne platform and the symmetrical arrangement of lions attacking bulls in a second medallion, can be traced to Mesopotamian or Persian origins. Still other designs are simply decorative.[45] As many of the motifs on this pyxis occur in pairs flanking axial trees, Islamic or Byzantine textiles showing an ultimately Sasanian organization may have served as models, but the originally flat patterns have now been successfully transformed into richly modulated reliefs. Furthermore, the sculptural quality is enhanced by the now greater density of the designs. Both the function of such ivories and the degree to which they were appreciated can be

deduced from the inscription on a pyxis with purely vegetal designs.[46] Carved in angular script around the base of the domed lid are the following verses in a classical Arabic metre:

> The sight I offer is of the fairest, the firm breast of a delicate maiden.
> Beauty has invested me with splendid raiment that makes a display of jewels.
> I am a receptacle for musk, camphor, and ambergris.[47]

On al-Mughira's pyxis the main themes are differentiated only by the lobed frames and the larger size of the figures in two of the four medallions. The division is clearer on a large rectangular casket made in 1004/05 for 'Abd al-Malik, the son of Hisham II's all-powerful vizier, al-Mansur.[48] Here, on the more important long sides, similar polylobed frames enclose boldly rendered royal scenes, which stand out clearly against the density of the small-patterned spandrel areas. This piece bears the signatures of a number of carvers who ornamented it, thus attesting to a collaborative effort. In spite of this organization – or perhaps because of it – the decoration bears no integral relation to the structure and shape of the casket. Similarly, on an ivory pyxis made sometime between 1004 and 1008 for 'Abd al-Malik,[49] the arches, in even sharper contrast to tectonic principles, form loops at their apexes as frames around little birds, giving the general impression of a sculptured shroud that envelops the piece. The combination of a richly patterned surface and simple form became standard for the Muslim architect and craftsman, to the degree that the shape often counted for little in

145. Ivory pyxis. Dated 357/968. Ht. 15cm. Musée du Louvre, Paris

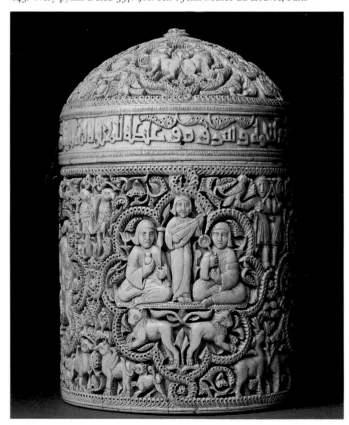

146. Ivory casket, Sabra-al-Mansuriyya. Datable between 953 and 975, 42 × 24 × 20 cm. Museo Arqueológico Nacional, Madrid

comparison with the decoration, and the ornament usurped some of the aesthetic functions of the underlying form.

As we have observed concerning objects in other media that were produced during this period in Ifriqiya and al-Andalus, the prototypes for the decoration preferred in the prolific ivory carving industry in Cordoba/Madinat al-Zahra were, likewise, not those currently in vogue in Baghdad or Samarra. The phenomenon of a time lag in the spread of a fashion from one area to another is a common one.

The only extant ivory object known to have been made in Ifriqiya during this period is the casket [146]. The top of its flat lid is circumscribed by an angular inscription informing us that it was made for the early Fatimid ruler al-Muʿizz (r. 953–75) in his capital al-Mansuriyya by an artist with the nisba al-Khurasani.[50] A feature of this inscription – the hesitant use of stylized leaf forms attached to the letters –

147. Gilded silver casket with niello decoration. Datable to 976, 27 × 38.5 × 23.5 cm. Tesoro de la Catedral de Gerona, Gerona

was, although employed here in a highly tentative manner, destined to become very popular in the early medieval period under the rubric 'floriated'. Whether this, earlier, foliated angular script gradually developed into that known as floriated or the latter was suddenly created in Fatimid Egypt and can be seen as having no antecedents, the calligraphic decoration on this casket is representative of the restrained beginnings of an ornamental transformation in inscriptions, which from this time on were to play a greater and more vital role in Islamic decorative schemes.[51] The casket is constructed of wood and covered with plaques of ivory. The method of decorating the plaques – that of staining the ivory with various colours after the design had been lightly outlined – is not found at all in the famous Umayyad Andalusian industry just discussed but is closely related to that employed on the group of ivories thought to have been produced in Sicily during the eleventh and twelfth centuries.[52] The flat, as opposed to a hipped, lid is more commonly found on the latter group and is also seen on a mid-eleventh-century silver casket from Fatimid Egypt [339]. Thus, unlike the imitative tendency so often met with up to now, this Ifriqiyan object – unique for the period in its decorative technique and exhibiting the tentative beginnings in the western Islamic lands of an ornamental transformation in inscriptions – appears to look more forward than backward.

Although there are numerous references in Umayyad, Abbasid, and Fatimid texts to spectacular three-dimensional objects executed in precious metals being used by various rulers and members of their courts or being given as gifts of state, few such pieces have survived to corroborate these sources. A casket [147], though of an unusual kind, helps to substantiate these descriptions, so long thought to be highly exaggerated.[53] Datable to the year 976 by means of the inscription surrounding the lower edge of the lid, this receptacle is the sole extant example of a type of silversmiths' work current in al-Andalus in the tenth century, one that from a technical as well as from an iconographical point of view appears to be both retardataire and avant-garde. The rectangular shape with its hipped lid and the vegetal decoration itself should, by now, be very familiar to the reader. However, the basic construction of wood to which have been attached the repoussé, gilded and overlaid silver plaques is closer to that on the contemporary painted ivory casket from al-Mansuriyya, as is the restrained foliation of the angular inscription. The method seen here of adorning precious metal objects with independently formed decorative units inlaid with niello (and in other cases with cloisonné enamel) is an early example of what was to remain a popular ornamental device in al-Andalus at least until 1492.[54]

The technique of repoussé employed to decorate the silver plaques covering this unique casket was used to adorn contemporary jewellery items in al-Andalus as well. In fact, it was to remain a favoured decorative technique for gold and silver ornaments from Andalusia for more than five hundred years. The gold diadem [148] is part of a hoard that included coins dating between 944 and 947, thus allowing us to date this head ornament as well as the other jewellery items found with it before the latter date (a date which serves as a terminus ante quem for the hoard as a whole).[55] In addition to the repoussé decoration, the diadem is also adorned with glass

148. Gold and glass diadem. Datable before 947, 4.6 × 21.6 cm. Museo Provincial de Jaén, Jaen

149. Detail of fragmentary silk, linen, and gold thread textile. Datable between 976 and 1013, 18 × 109 cm. Real Academia de la Historia, Madrid

cabochons,[56] filigree and small sheet-constructed hemispheres. It would have been held in place by a cloth band drawn through the two end rings and tightened.

The *tiraz* system first discussed here in connection with its earliest extant datable product – the textile [94] – spread from the central Islamic lands where it had been a distinctive element of Umayyad, and later Abbasid, court life first to Ifriqiya and then to al-Andalus. The fragmentary textile of Andalusian (probably Cordoban) manufacture executed in silk, linen, and gold thread [149] exhibits a layout especially typical for contemporary Fatimid *tirazes* woven in Egypt [335]. A wide, decorative, band (in this case bearing a series of pearl-framed octagons each containing a quadruped, a bird, or a human figure) is bordered above and below by a single bold band of calligraphy in foliated, angular script that informs us that this textile was made for Hisham II (*r.* 976–1013). Elements of the design itself, specifically the bird-filled octagons, are reminiscent of those on the Abbasid silk [112] and on the ceramic architectural decoration from Samarra [105]. Thus, not only did the artistic styles and traditions that developed under the aegis of the caliphates ruling from Damascus and Baghdad strongly influence the textile industry in Spain but the close similarity with contemporary Egyptian textile production is illustrative of the important influence the vogues within the various member-countries of the 'Mediterranean society' had on others in the group.

In the previous chapter we have seen that copper-alloy pouring vessels in the shape of birds of prey were characteristic of the Abbasid period and grew out of a long tradition which became well established in the Muslim world during that and the preceding, Umayyad, period. This vogue for small and large copper-alloy bird and animal sculpture, with its roots in earlier Sasanian zoomorphic censers and pouring vessels, subsequently spread to the Maghrib via the by now well known route that so many of the decorative motifs and traditions discussed here have taken. This fashion persisted in the western lands of the Islamic world at least until the end of the eleventh century. The copper-alloy stag from al-Andalus [150], found among the ruins of Madinat al-Zahra, and its companion piece (the hind now in a private collection) originally formed part of a fountain – the water spewing forth from the open mouth of the animal after having

been funnelled through the pipe protruding from the sculpture's base.[57] A closely related quadruped from Ifriqiya was most probably the prototype for these two fountainheads as well as for two other similar animals since it shares with all of them not only its stance but also the treatment of the eyes and the manner in which the horns are attached.[58]

We have descriptions of two tenth-century Andalusian fountains, one in Cordoba itself and the second at Madinat al-Zahira, with water emanating from the mouth of lions. According to these accounts, the former feline is golden

150. Copper-alloy stag, Ht. with plinth: 61.6 cm. Museo Arqueológico Provincial de Córdoba, Cordoba

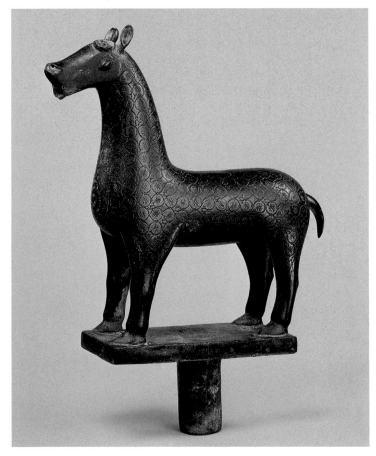

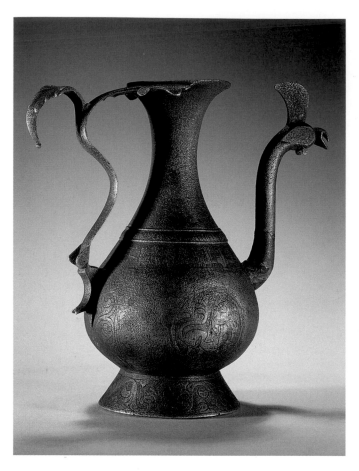

151. Copper-alloy ewer, Ht. 22 cm. The David Collection, Copenhagen

centuries that had ultimately derived from the imperial Roman version popular in Italy.[63] The spout terminating in a cock's head is reminiscent of that on the so-called Marwan ewer [91] and on the group of ewers to which the Marwan ewer belongs.[64] However, the style in which the incised feline, circumscribed in a circle on the body, is executed, the repeated inscription *al-mulk li-llah* ('sovereignty is God's') in an angular script which completely fills the band below the torus moulding, and the style of the cock's head are typically Andalusian.[65]

THE ART OF THE BOOK

One of the most sumptuous extant manuscripts of the Qur'an copied in the western Islamic lands during this period is the so-called 'Blue Qur'an' [152].[66] Unlike the Qur'an manuscript illustrated earlier [116, 117], it is neither the illumination nor the calligraphy nor the size of its folios that puts this codex into a special category but the materials on which and with which it was copied. It is written in gold on blue-dyed parchment with silver ornamental devices to indicate groups of verses.[67] This highly unusual combination may have been inspired by imperial Byzantine documents and manuscripts of purple-dyed parchment which were calligraphed in gold and silver. We know that such material was presented by Byzantine embassies in Umayyad al-Andalus, and it is a safe assumption that contemporary embassies to Ifriqiya could have proffered similar documents. However, purely Islamic in inspiration is the codex's horizontal format – one which, we have seen, took precedence for manuscripts of the Qur'an in the central Islamic lands during the early Abbasid period.

This codex was probably copied in Qayrawan, which in the ninth century became one of the principal cultural centres of Islam, with the Great Mosque at its heart. Numerous copies of the Qur'an were executed here, many of which were exported and carried to all regions of the Islamic world. An inventory of the library of this mosque compiled in 1293 mentions a Qur'an in seven sections of similar large format, written in gold on blue-dyed parchment and with ornamental devices in silver, thus suggesting that, at the end of the thirteenth century, this very manuscript was still in the city where it had most probably originated.[68] As to the date of this manuscript, the *tabula ansata* with the linear stylized rinceau terminating in a delicately executed but equally stylized palmette tree bears, especially in the depiction of its *ansa*, strong parallels with the palmette tree [143] and other vegetal designs on the Qayrawan *minbar* as well as that painted on the nichehead of the *mihrab*.[69] Thus, a date as early as the latter half of the ninth century would be possible for this codex.[70]

The folio [153] is another from the Qur'an manuscripts belonging to the library of the Great Mosque in Qayrawan. Although it is a certainty that not all of these were written in that important cultural centre, it is not unlikely that this particular copy of the Qur'an, the oldest dated codex (295/907–08) among those found in the Great Mosque, was copied in Aghlabid Qayrawan. Calligraphed by a certain al-Fadl, the freedman of Abu Ayyub Muhammad, almost forty years after that commissioned by Amajur [118], the angular

with eyes set with jewels and the latter is of black amber and is adorned with a pearl necklace.[59] The copper-alloy fountainheads we are discussing here must have been used as a pair or together with other similar animals as part of a basin or pool or, singly, for two separate, paired, fountains. Small basins and ornamental pools played an important role in the architecture of both the eastern and western Umayyad caliphates and the Umayyad amirate as well as in that of Aghlabid Ifriqiya. This vogue continued in Ifriqiya under the Fatimid and Zirid dynasties and in the Hammadid capitals of Qal'at Bani Hammad and Bougie.[60] The similarity of such features and their enduring popularity in the western Islamic lands attests not only to the influences moving between the northern and southern shores of the Mediterranean during the period,[61] but to the importance of water in the Islamic culture in general owing to the arid nature of so much of the area under Muslim control.

A typical feature of the extant copper-alloy utilitarian objects from al-Andalus is their dependence on imperial Umayyad and Abbasid prototypes.[62] The ewer [151] is no exception. Its shape (including the heavy torus moulding at the base of the neck) and the handle, with its acanthus-shaped thumb stop, terminating at the bottom in a highly stylized head of a gazelle, both have numerous parallels in the early ewers of the central Islamic lands which, in turn, were strongly influenced by a form of pouring vessel current in the eastern Roman empire during the fourth and fifth

152. Folio from a Qur'an manuscript. Gold on blue-dyed parchment. Folio size: 31 × 41 cm. Musée des Arts Islamiques, Qayrawan

153. Folio from a Qur'an manuscript. Ink, colours, and gold on parchment. Dated 295/907–08, 16.7 × 10.5 cm. Library of the Great Mosque, Qayrawan

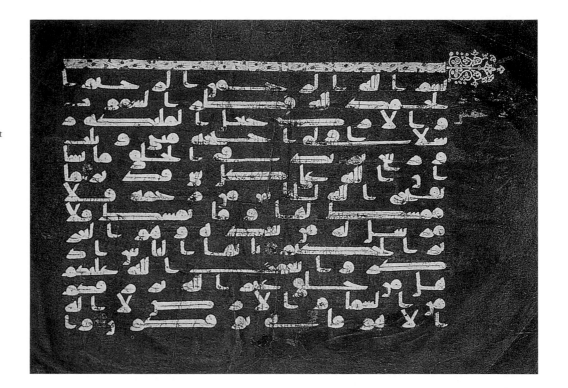

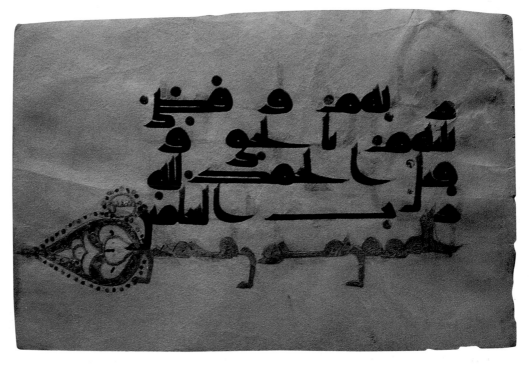

script is remarkably similar to that employed in the earlier manuscript, as is the illumination[71] and the lavish use of parchment. Such conservatism is attributable not only to a time lag, such as we have seen previously between the same vogues in the heartland and in the provinces, but also to the role of traditionalism in the copying and illuminating of Qur'anic codices resulting in this period in what could be considered an international style.

The latest copy of the Qur'an to be discussed in this chapter is that finished in Madinat Siqilliyya (Palermo) in 372/982–83 [154]. It is also the first in this work exhibiting

a type of script belonging to a group that has been termed the 'New Style'.[72] This category of scripts grew out of a long tradition. It was first employed for secular documents and gradually, at the end of the ninth or very beginning of the tenth century, came to be used for Qur'anic codices. While in other areas of the Islamic world the 'New Style' appears to have continued in use for such manuscripts until the thirteenth century, as regards the Maghrib its vogue has continued until today. For some time copyists of the Qur'an used both the 'Early Abbasid' or angular scripts as well as the 'New Style' scripts (for examples of the former in this

154. Folios from a Qur'an manuscript. Ink, colours, and gold on parchment. Madinat Siqilliyya. Dated 372/982–83. Folio size: 17.6 × 25 cm. The Nasser D. Khalili Collection of Islamic Art, London

155. Leather bookbinding for a Qur'an manuscript. Datable before 378/988, 19.9 × 13.8 cm. Library of the Great Mosque, Qayrawan

chapter see [152, 153]. However, the latter group of scripts finally emerged victorious, owing, presumably, to the relative ease with which it could be read, and written, as opposed to the various angular scripts. This is the earliest Qur'an manuscript known to have been copied in Muslim Sicily. While it is avant-garde in its adoption and adaptation of the 'New Style' script, it is *retardataire* in its continued use of parchment and in its employment of a horizontal format which is much better suited to the angular scripts with their exaggerated, horizontally drawn out, letters.[73]

The inventory of 1293 for the library of the Great Mosque of Qayrawan referred to above also includes a description of the binding for the Qur'an on blue-dyed vellum. It tells us that it was 'covered in tooled leather over boards, lined with [. . .] silk'.[74] Unfortunately, none of the bindings for any of the seven sections of this spectacular codex appears to be extant. However, many bindings for Qur'an manuscripts housed over the centuries in the same library have survived. Two of them can be securely placed in the period being discussed here as they were given as a *waqf* to the mosque. The earliest of these, its manuscript no longer extant, dates to the Aghlabid period (800–909), having been given as an endowment by a princess of this ruling family.[75] More or less contemporary with the binding [120], it shares its format (which seems to have been a very popular one during this period) of a rectangular field filled with a large-scale geometric interlace design circumscribed by a series of borders or guard bands with smaller repeat patterns. The binding crafted around 988 (or about a century after the Aghlabid example), for the ninth volume of a ten-volume Qur'an, is rather exceptional in its decoration [155].[76] Both of these horizontally oriented bindings were most probably made in Qayrawan.[77]

As to the arts of the book in al-Andalus during this period, although texts mention the libraries of 'Abd al-

Rahman II (*r.* 822–52), Muhammad I (*r.* 852–86), and especially the huge library of al-Hakam II (*r.* 961–76), only one manuscript from the latter library appears to have survived.[78] In addition to the interest of these rulers in amassing such collections, the medieval author Maqqari tells us that al-Hakam fostered the making of books as well, having ateliers built in Madinat al-Zahra for copyists, binders and illuminators. Unfortunately, with the one possible exception noted above, nothing remains of this production.[79]

CONCLUSION

Early Islamic art in North Africa and Spain can be understood in several different ways. When viewed geographically and chronologically, al-Andalus – and, more specifically, Cordoba and its surroundings in the tenth century – dominated this period. Nearly all media, except for the art of the book, are represented and in many instances, as with ivories, there is a critical mass of works which should allow for reflections and conclusions on classical art historical topics such as sources, styles, subject matter, and expression. Relatively little has been done in this regard,[80] but two broad conclusions can be proposed.

One is the high quality of the concepts and designs and the superior craftsmanship involved in making mosques or palaces, or objects such as ivories and textiles. A high level of workmanship is to be expected with the wealthy patronage of the caliphal court, which sponsored most of the works and which had access to the best available artisans from the whole Mediterranean area, Byzantium and Italy in particular, as well as from the Islamic East. However, external sources are probably not sufficient to explain original features like the innovations in the superstructure of the Mosque of Cordoba, the ribs in Toledo's small mosque, the animals represented on objects or sculpted in metal, or the compositions on the ivories. It is particularly curious to witness the appearance, so suddenly and at such a high level of quality, of an art of sculpted objects, especially ivories. To be sure, Byzantium never abandoned ivory carving and the Carolingians, in the ninth century, revived it in the Christian West. But, in a small number of masterpieces, the artisans of al-Andalus managed to explore the detail of each subject and to set personages or animals in ways unseen since Late Antiquity. Whether, as has been argued by some,[81] this was a true renaissance, a conscious act carried through the memory of Umayyad practices in Syria or a specifically Iberian one, or whether it should be considered in terms of innovation rather than revival, are questions for further debates. It is, however, important to contrast the vocabulary of the mosque of Cordoba, the impact of which will continue to be felt for centuries, with that of the tenth-century ivories which remain a unique and iconographically, if not typologically, unexplained phenomenon, even though suggestive directions have been provided recently.[82] Thus, the second broad conclusion about Umayyad art in Spain is that, while all aspects of that art were strongly developed, those which were available to a broad segment of the population, like architectural decoration, practices of construction, and textile deign, made a continuing impact. By contrast, those which were restricted to the court of the caliphs, even to individuals within the court, may have carried richer messages but left fewer traces.

While tenth-century al-Andalus can be defined through a striking cluster of major works of art, other areas of the Muslim West before 1000 are difficult to illustrate by more than a few items. It is clear that there were artistic activities in Spanish cities other than Cordoba and Toledo, in Fez in northern Morocco and in Sicily, but the examples involved are few and do not lend themselves to easy generalization. A more serious case can be made for Ifriqiya, where there was a significant ninth-century architecture (discussed in the previous chapter) and where, in other arts, a specifically Aghlabid style seems to have become operative. In the following century, this style had an impact on a small number of architectural monuments and objects associated with the dynasty of the Fatimids, whose rule began in 909. We shall deal in Chapter 6 with their few architectural monuments in Ifriqiya as well as with the bulk of their other arts, because their major monuments are in Central Islamic lands and most of them are later than 1000. But it is proper to note here that one aspect of the Fatimid phenomenon, in the footsteps of a more elusive Aghlabid one, was that it transformed North Africa. This transformation is still very difficult to detect in visual terms. The so-called 'blue Qur'ans' are a wonderful example of works of art which partake of a pan-Islamic concern for beautiful writing, of ideological purposes associated with a specific time, and of some relationship, through colour, with ways to honour a text and a patron that have Late Antique roots. Whether there was a North African or indeed Ifriqiyan (not to say, anachronistically, Tunisian) visual identity by the year 1000 or whether such monuments as remain are more logically related to the art of al-Andalus or to the dynastic art of the Fatimids, are questions for further discussion. By including the appropriate documents in different chapters we have avoided dealing with these broader issues in the expectation that they will some day be resolved.

Instead of focusing on internal regional idiosyncrasies, another way of looking at the art of the western Islamic lands could be to define and explain their formal identity and to identify their own peculiar character. Three clearly visible strands stand out in the creation of these forms. One is the vast vocabulary of Antique and Late Antique construction and decoration which was available in Spain and in most of North Africa. Another strand is the memory of, at times nostalgia for, the Umayyad world of Syria, even though the actual forms of Syria are less clearly visible than the idea of these forms, as is so apparent in Syrian names given to Andalusian sites and buildings. What are missing there, in spite of written sources to the contrary, are the ways of ninth- and tenth-century Baghdad. Or, perhaps, scholarship does not quite know yet how to distinguish Baghdadi features in the concentrated body of tenth-century monuments from Cordoba. Finally, there is the impact of the various regions of the Mediterranean society of the early Middle Ages, whose components are only beginning to emerge.

Possibly, in line with current thinking on these matters, we should simply argue that the iconographic idiosyncrasies and the formal virtuosity of Umayyad art in Spain were created by locally available materials and competencies, a locally acquired wealth, and an equilibrium between a very private art of objects and a public display of architecture, even of mosques with their newly acquired fancy entrances. It was the creation of a very unique society that was run by Muslim Arabs, arabicized Berbers, and Hispanic converts, but which also included a vital Christian component with strong and continuing connections with the Christian north of Spain.[83]

During the same ninth and tenth centuries, the art of Ifriqiya, including Sicily, was slowly formulating its own ways within the broad umbrella of Abbasid art; in Morocco, the first steps of a new architecture begin to appear. These are all places where the historian can observe the rarely available phenomenon of artistic tradition in the making. An interesting and unusual example of local variations on common themes occurs in the buildings and stucco decoration of Sedrata, a small, heterodox, settlement in southern Algeria from the ninth and tenth centuries, whose exploration had barely begun half a century ago.[84]

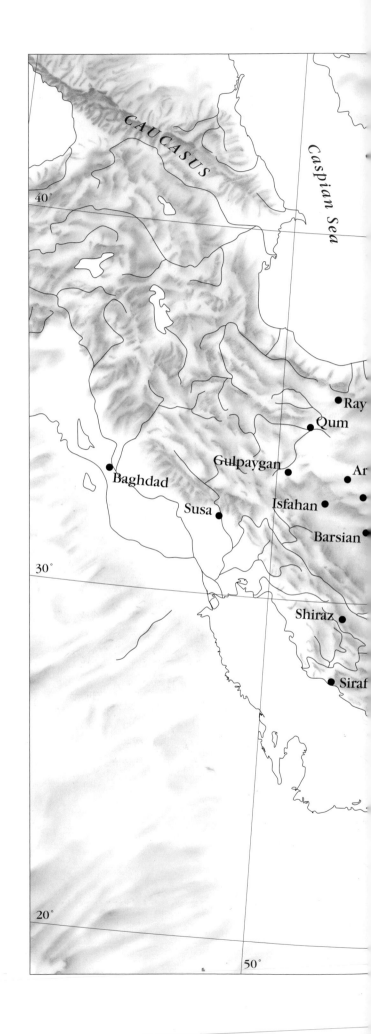

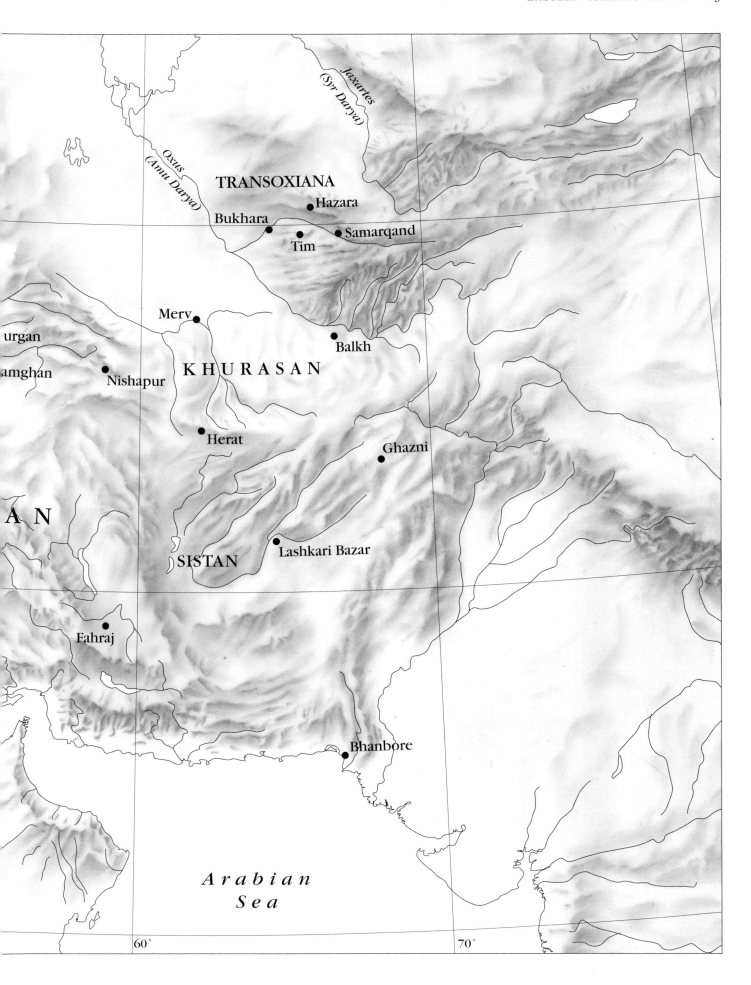

TRANSOXIANA

Hazara

Bukhara

Tim • Samarqand

Oxus
(Amu Darya)

Jaxartes
(Syr Darya)

urgan

amghan

Merv

KHURASAN

Balkh

Nishapur

Herat

Ghazni

SISTAN

Lashkari Bazar

A N

Fahraj

Bhanbore

*Arabian
Sea*

60° 70°

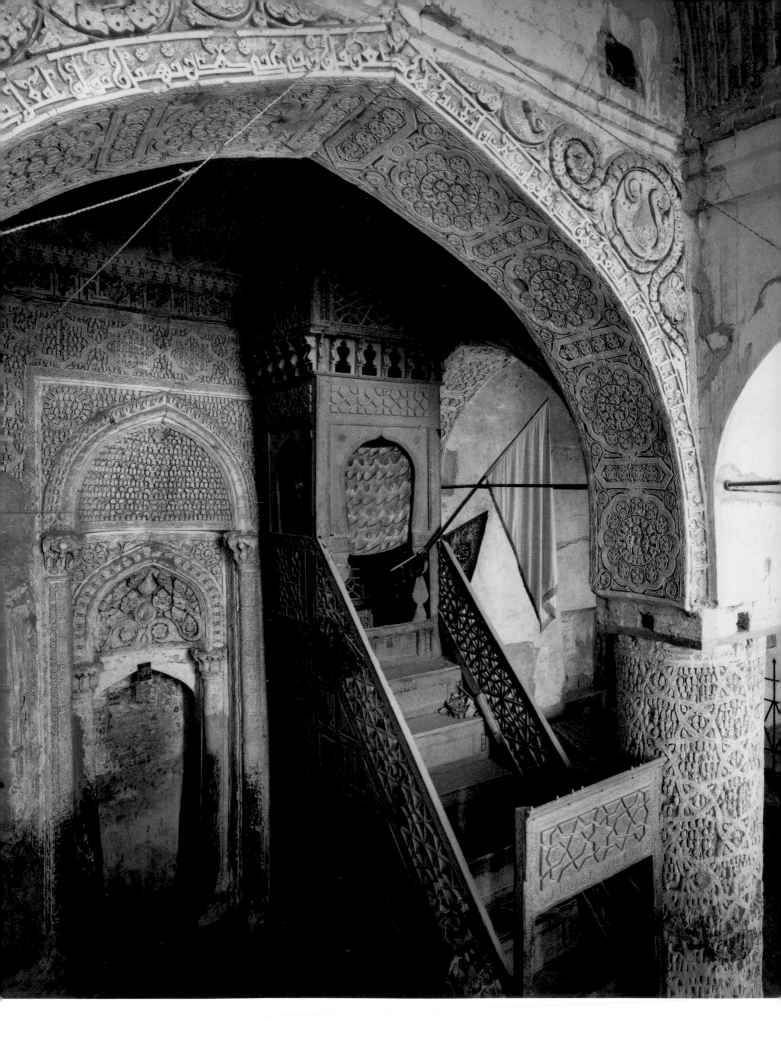

Eastern Islamic Lands

The history and culture of Iran and central Asia during the first centuries of Islamic rule are difficult to sketch succinctly and clearly. Nominally, this vast area consisted of several provinces ruled by governors appointed in Baghdad. From the ninth century, however, dynasties of governors, such as the Arab Tahirids (821–73), the native Iranian Samanids (819–1005) descended from pre-Islamic nobility, and the more populist Saffarids (867–963), exercised effective control over large areas without neatly established frontiers. For most of this period only a few important Muslim cities were in western Iran, like the future Isfahan or Qum, the latter having acquired quite early a holy association with Shi'ism. The main Muslim centres were in the huge province of Khurasan, with its four great cities of Nishapur, Merv, Herat, and Balkh, and in the frontier area of Transoxiana, with Bukhara and Samarqand, the heartland of pre-Islamic Soghdian culture. Several minor local dynasties flourished in the mountains of northern Iran, and out of one of them emerged the Buyid dynasty (932–1062), which occupied Baghdad itself in 945 and relegated the caliphs to be mere figureheads.[1] A crucial role at the crossroads between all these areas was played by Rayy, near modern, Tehran, which was for several centuries the main administrative and political centre of Iran. Excavations were carried out on the site which have never been published.[2]

Cultural life was dominated by two partly contradictory trends, whose presence remained for centuries characteristic of Iran. One is a pan-Islamic Arabic culture, closely tied to that of Baghdad, as practised in the major philosophical, religious, and scientific centres of the northeast by thinkers of considerable originality and of universal importance such as al-Farabi (d. c.950), al-Razi (d. 925 or 935), Ibn Sina (Avicenna, d. 1037), al-Biruni (d. 1048), and al-Jurjani (d. 1078). Most of these were attached to local courts and often were passed on, like treasures, from one ruler to the other. They all wrote primarily in Arabic, even if a Persian dialect was their native tongue and Turkish the language in which they communicated with those in power. The other cultural trend of these times is specifically Iranian, for the very same regions witnessed the birth of modern Persian. A new Persian poetry made its appearance then, and the epic tradition of Iran was written down in Ferdosi's *Shahnama* (c.1000). In all likelihood most contemporaries participated in both of these trends, thus creating an amalgam of ethnic awareness and Muslim allegiance.

This cultural blend continued for several centuries. But the social, ethnic, and political structure of northeastern Iran was further complicated by the large-scale migration of Turkic tribes and Turkish soldiers into Iran, beginning in the tenth century. Turkish dynasties arose rapidly after the Ghaznavids (977–1186) in Afghanistan and northern India, and their power culminated with the Saljuqs, who captured

Baghdad in 1056. The period of adaptation of Islam to Iran and of experimentation with new forms and new purposes more or less ended by the first decades of the eleventh century. Art and especially architecture can by then be more easily related to what followed, and will be considered in Chapter 5.[3]

ARCHITECTURE AND ARCHITECTURAL DECORATION

MOSQUES

The large cities were all provided with congregational mosques. Some, such as those of Nishapur, Bukhara, Qum, and Shiraz, are known only through literary references.[4] The archaeologically retrieved mosques at Susa and Siraf, technically in Iran, have already been considred since they belong geographically to the central lands of Iraq. At Isfahan[5] [156] the size, the complexity of the later history of the building, and several obscure texts[6] have made the task

156. Isfahan, Great Mosque,
plan as in the tenth century

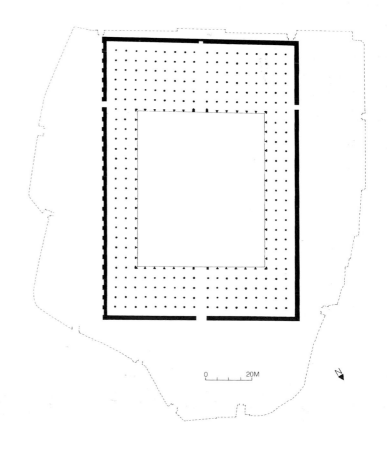

0 20M

159. Nayin, mosque, view towards *qibla*

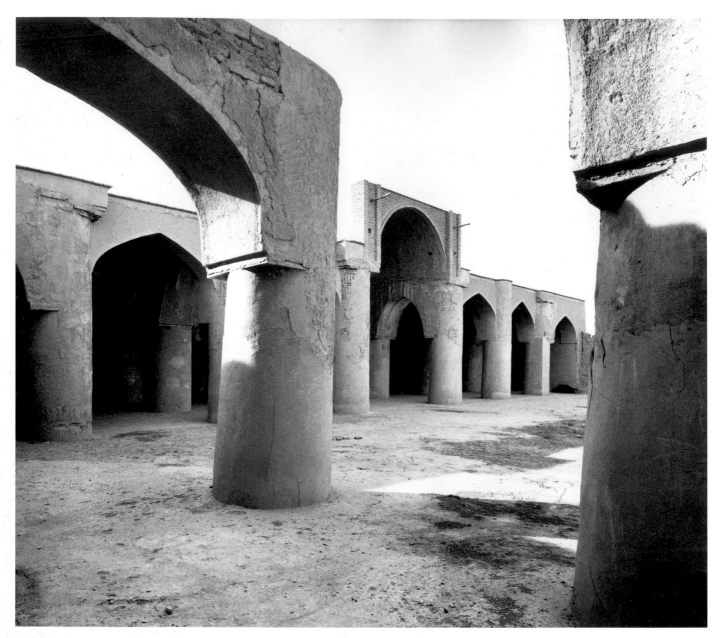

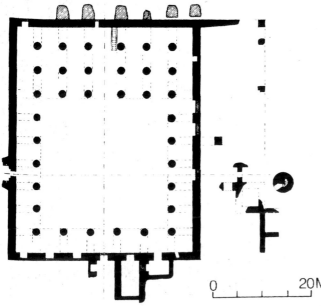

157. Damghan, mosque, court

158. Damghan, mosque, plan

of reconstructing the early Islamic mosque particularly dif-
ficult. It seems clear, however, that a large (about 140 by 90
metres) hypostyle mosque was built, possibly in the ninth
century, and that in the tenth, probably under the Buyids, an
additional arcade was constructed around the court with the
bricks of the piers arranged so as to make simple geometric
designs into strongly emphasized variations in planar depth.

It is probably no accident that the mosques of the large
emporium of Siraf and of the major political centre of
Isfahan underwent the same change of an arcade added to
the courtyard in the ninth and tenth centuries respectively.
Just as in contemporary Qayrawan, the explanation may lie
in a concern for the visual and aesthetic autonomy of the
court, and these may well represent the first steps towards

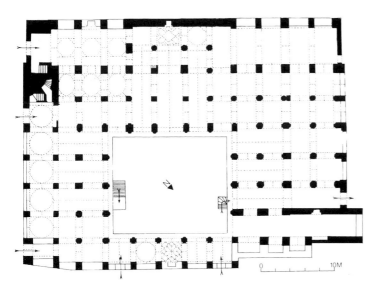

160. Nayin, mosque, plan

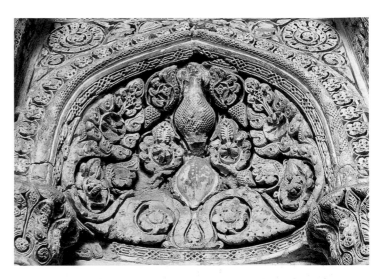

161, 162. Nayin, mosque, details of stucco work

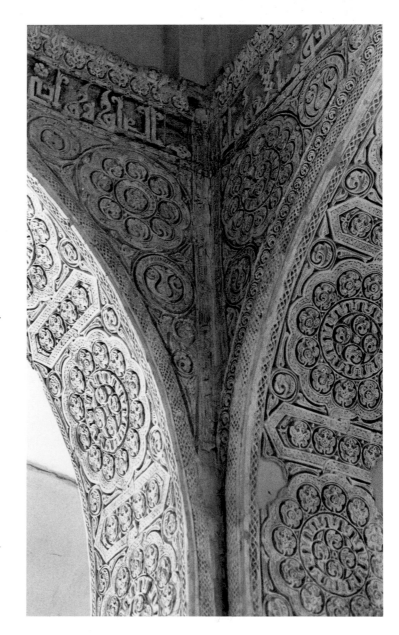

one of the major achievements of Iranian architecture: the court façade.[7] But other early mosques, known only through partial and much redone remains, such as those of Yazd or Shiraz, were certainly hypostyle.

What is more difficult to visualize is the nature of the problems faced in creating a new type of building and in developing new technical or other solutions. Three smaller mosques on the Iranian plateau, at Damghan [157, 158],[8] Nayin [159, 160],[9] and Fahraj,[10] all undated and much restored, suggest some answers. The first two are hypostyle, but covered with vaults. The third has five barrel-vaulted compartments at right angles to the *qibla*; the three central ones are cut short in order to provide for a court. Nayin has three domes in front of the *mihrab*.[11] These three mosques illustrate the problem of adapting an architectural tradition based on long barrel-vaults, often by then pointed in section, to the need for a large space with a minimal number of supports. One solution was to build closely set, heavy, and often ungainly brick pillars of varying shapes, whose rich stucco decoration (at least at Nayin [161, 162]) served to mask the squatness of the architecture and to emphasize the *qibla*. Interesting though they are for the history of architecture, these buildings can hardly be called successful in visual or functional terms.

We do not know whether all early congregational mosques in Iran were hypostyle. An undated small mosque at Hazara, near Bukhara, is certainly archaizing, if not archaic.[12] It consists of a square hall with a central dome on squinches with vaults on all four sides, and four small domes on the corners [163, 164]. Domes and vaults are carried by thick walls and four heavy brick pillars with curiously shaped arches. The central plan is similar both to that of certain Iranian fire-temples and to a whole tradition of east Christian architecture, but neither can be justifiably brought to bear on Hazara. This example, like many fragmentary ones brought out in recent publications on Central Asia,

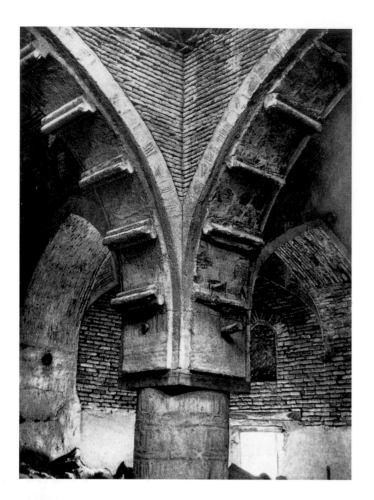

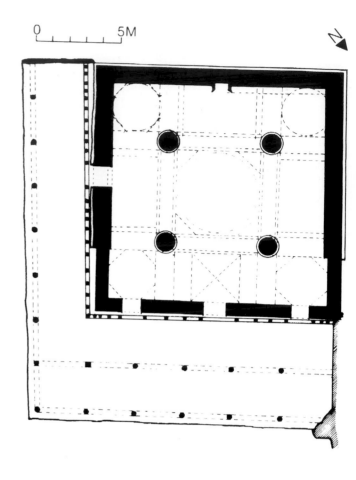

163. Hazara, mosque, view of interior

164. Hazara, mosque, plan

165. Balkh, Masjid-i Nuh Gunbadh

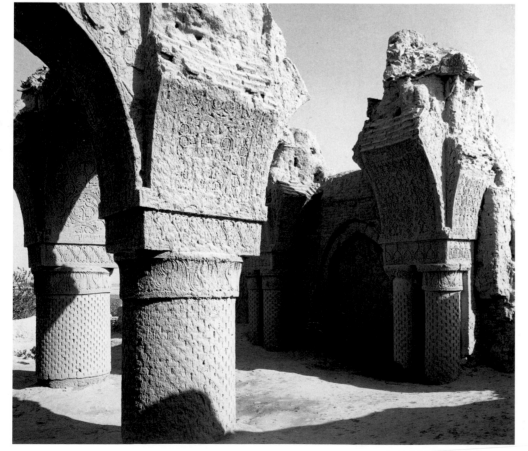

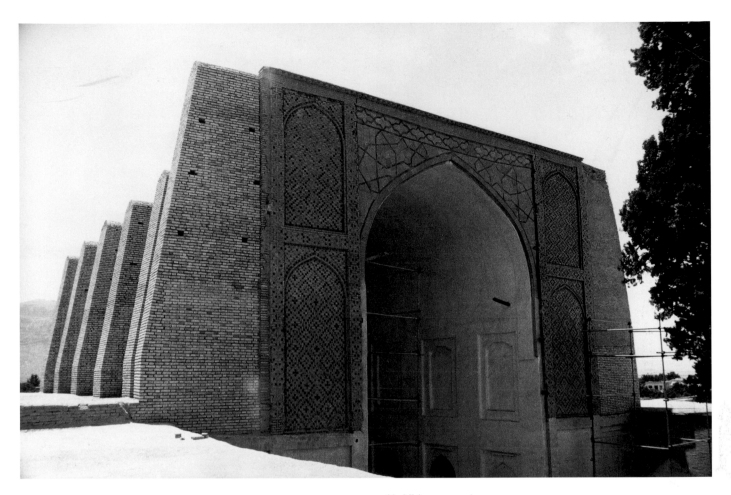

166. Niriz, mosque, *iwan*

167. Niriz, mosque, plan

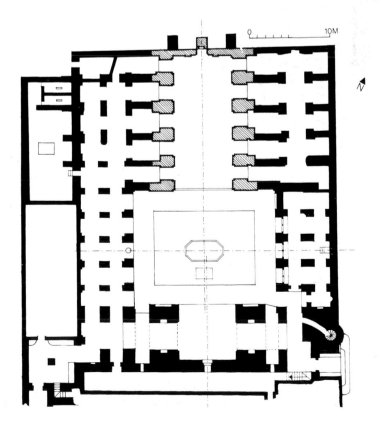

serves to make two points: the still considerable originality of local answers to new needs and the insufficient exploration of a vast area likely still to bring out many surprises. A better-preserved small nine-domed ninth-century mosque near Balkh, known as Masjid-i Nuh Gunbadh [165],[13] may be related to a secondary type of sanctuary found in Egypt, Arabia, and Spain which was discussed earlier, and should probably be dated in the ninth century.[14]

Some significant hypotheses proposed in the 1930s by A. Godard,[15] which have found their way into many general accounts, are based on the fact that in many congregational mosques of later times (Isfahan, Ardistan, Gulpaygan, Barsian, etc.) there stands on the *qibla* side a large domical room of a period different from the rest of the mosque. At Niriz [166, 167], instead of a dome, there is an *iwan* extending from the court to the *mihrab* and towering above the rest of the mosque; an ambiguous inscription dates the earliest construction there to 973. Godard therefore put forward the thesis that, in addition to a number of hypostyle mosques, there was in early Iran a type consisting of a single domical room, like the ancient fire-temples, or even of a single *iwan*. An open area in front, perhaps marked off in some simple way, would have served as the main gathering area until, after the eleventh century, more complex and complete constructions were erected. Attractive as it may be in providing a link between the pre-Islamic and later Seljuq uses of domes and *iwans* in monumental architecture, this hypothesis cannot at the moment be accepted, except in regard to

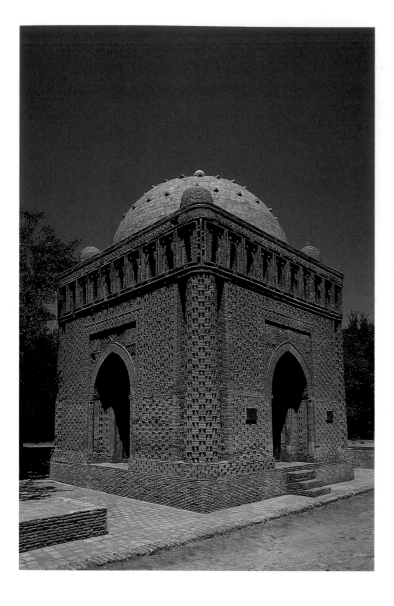

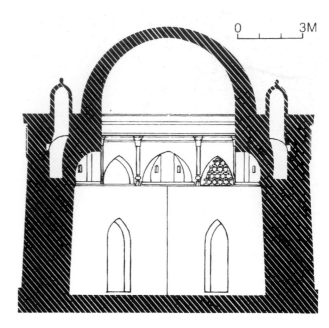

168. Bukhara, Samanid mausoleum, section

169. Bukhara, Samanid mausoleum, exterior

170. Bukhara, Samanid mausoleum, interior

the few early cases, such as in Yazd-i Khwast on the road from Isfahan to Shiraz, where a pre-Islamic sanctuary was actually transformed into a mosque.[16] None of the adduced examples of domes can be dated before the end of the eleventh century, and in no instance is it possible to maintain that a dome alone preceded the present one.[17] It is simpler to conclude, for the time being, that the hypostyle congregational mosque was adapted to Persian techniques of construction, and that other types belong, in ways yet to be understood, to a range of local variants known elsewehere within the Muslim world.

MAUSOLEUMS

Why the earliest consistent group of Islamic mausoleums should appear in tenth-century Iran[18] is not altogether clear. Dynastic pretensions, heterodox movements worshiping the burial places of descendants of Ali,[19] and attempts to attach a Muslim meaning to traditional pre-Islamic holy sites must all have played a part in a phenomenon which may well have spread westward from Iran (where it took permanent root), especially to Fatimid Egypt.[20] Or perhaps early examples

which may have existed in Iraq or in Arabia have been destroyed because of later opposition to monumental tombs.

Of the two remaining types of mausoleums, the first, of which examples remain throughout the Iranian world, is the canopy tomb, a domed cube generally open on all sides, like the first constructions in Najaf and Kerbela over the tomb of Ali and his descendants. Some may be as early as the tenth century; only two can be securely dated, however, and these happen to be remarkable monuments of architecture.

Recently discovered epigraphic, literary, and archaeological evidence suggests that the mausoleum of Isma'il the Samanid in Bukhara was used for more than one prince, and that it was built a little later than hitherto believed, perhaps under the Samanid prince Nasr (r. 914–43).[21] This slightly tapering cube, about ten metres to the side, is entirely of excellent baked brick, covered by a large central dome with four small domes on the corners [168, 169]. In the middle of each face is a monumental recessed arched entrance within a rectangular frame; a circular, partly engaged, full pier serves to soften the corners and to provide an upward movement to the whole monument. A gallery runs all around, although no access to it exists. Inside [170], the most strik-

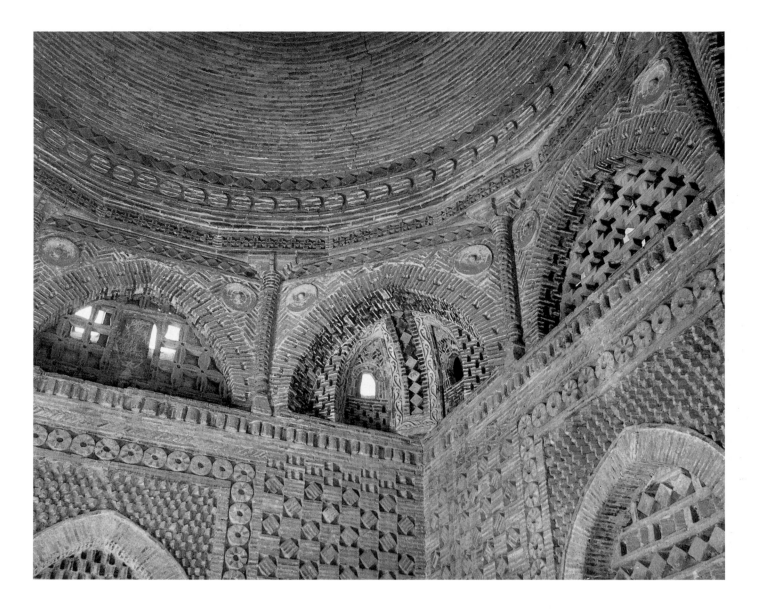

ing feature is the transition from square to dome: the squinches are framed within an octagonal flat arcade on brick colonnettes, and, above, a narrow sixteen-sided zone smooths the passage to the base of the cupola. The squinch itself consists of two arches parallel to each other and buttressed by a perpendicular half-arch – almost a sort of rib – which abuts the gallery, thereby permitting the opening up of the areas on each side of the half-arch and the lightening of the building. To use E. Schroeder's happy expression, the thrust of the dome is carried on a sort of tripod.[22]

This building has three major peculiarities. First, the corner pillars, the gallery, and the small domes are all structurally completely unrelated, although they are understandable as elements in the decorative composition of the façade or of the roof. A similar point can be made about the multiplication of features marking the transition from square to dome, and about the lack of relationship between inner and outer forms. These apparent contradictions can be explained only as reflections of several architectural traditions in which all these features played some part: they illustrate an architect's keen eye for surface composition rather than for clarity in construction.

The second peculiarity of the Bukhara mausoleum is the unusual use of brick. Almost every visible brick is at once an element of construction and part of a decorative design. The designs vary. On the main wall surfaces the two types, one inside, the other outside, serve primarily to provide a woven effect, a chequerboard of light and shade. At the entrances and in the zone of transition a greater variety of motifs creates a deeper intensity of decoration without changing the medium or the technique.

The third peculiarity of the mausoleum of the Samanids is its asthetic quality. Its harmonious and largely irrational proportions were achieved through carefully drawn designs. And the similarity of all four of its walls suggests that the monument must have been seen or meant to be seen from all sides, possibly within the setting of a garden. It can be imagined as a mausoleum in a cemetery and as a pavilion in a palace.

Although individual themes or motifs of the Bukhara mausoleum may be related to aspects of pre-Islamic art, the reason for their congregation here at this time is unclear. The plan, though akin to some, is not exactly like that of any known fire-temple. It might of course derive from Late

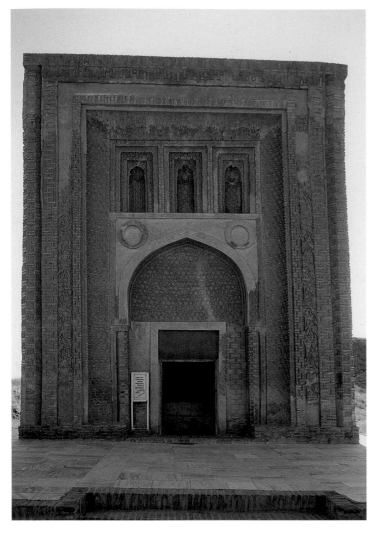

171. Tim, mausoleum, façade

172. Tim, mausoleum, cross section

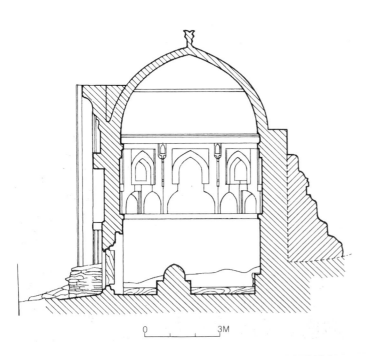

Antique *martyria* (Sanctuaries commemorating holy men or events), but it is difficult to explain how such Mediterranean forms could have reached Central Asia. Nor is it altogether in the tradition of later Iranian mausoleums. Since it was a princely foundation, its plan and decoration may well have derived from secular building. Even though none has survived, domical pavilions were common in Muslim palace architecture; such a structure, with several features similar to those of the Bukhara mausoleum, is shown on a celebrated Sasanian or early Islamic salver in the Berlin Museum.[23] Another possibility is that the building derived from smaller portable domical objects, biers or ossuaries, such as those represented on the Soghdian frescos of Pyanjikent, where they have a clearly funerary significance.[24]

A second canopy mausoleum of even greater significance for the history of architecture, the *mazar* (holy place) Arabata at Tim in the area of Samarqand [171, 172], is dated 977–8.[25] Square inside (5.60 by 5.60 metres) it is extended on the outside (8 by 8.70 metres) by a splendid, fully developed single façade, a feature long believed to have appeared only in the following century. The barrenness of the brickwork throughout contrasts with the decorative wealth of this

173. Tim, mausoleum, transition to dome

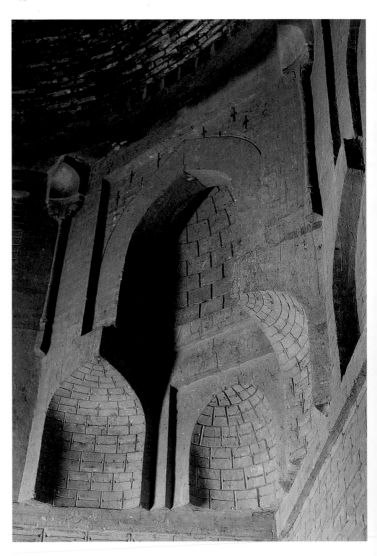

façade, many of whose themes – such as the three recessed arches – are closely related to those of the outer faces of the Samanid mausoleum, as is the general composition. The presence of stucco for decorative designs between layers of brick, however, announces the techniques of the following century. Finally, the Tim mausoleum introduces a type of transition from square to dome also destined to have a brilliant history in later Iranian architecture, which may be called the 'articulated squinch' [173]. The squinch proper shrinks, and is framed by two sections of domes, one on each side, and by a high arch above, producing a characteristic profile which is then reproduced as a flat arch between the corners, thereby giving the octagonal zone of transition a unified and proportioned aspect. The small purposeless column remaining in each angle, the clumsy framing of the new expedient within rectangles, and the overall heaviness of the system suggest that the device is related to the older type of squinch arrangement found at Bukhara, modified by a new technical concern to which we shall return shortly. Although best preserved, the Tim mausoleum was not the only one to have developed façades or a new type of squinch. Another example is that of Baba Khatun, not far from Bukhara and undated.[26]

Several tower mausoleums also remain. The most spectacular is the Gunbad-i Qabus [174, 175], built by the Ziyarid prince Qabus ibn Vashmgir in 1006–7 near Gurgan, southeast of the Caspian Sea. Circular inside and shaped like a ten-pointed star outside, it dominates the landscape. As no trace of a tomb was found, the coffin may have been suspended inside, as a medieval chronicler related.[27] The tightly packed brickwork is distinguished from that of the Samanid mausoleum by the intense purity of its lines and

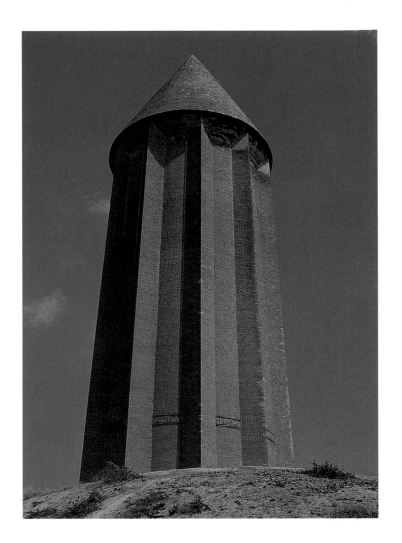

174. Gunbad-i Qabus

175. Gunbad-i Qabus, detail

176. Muqarnas niche from
Nishapur, Metropolitan Museum
of Art, New York

177. Painted stucco wall panel
with eyes and hands, Nishapur,
Metropolitan Museum of Art,
New York

178. Polychrome muqarnas niche
with eyes and floral design, Iran,
Metropolitan Museum of Art,
New York

179. Painted stucco wall panel with human head, Nishapur, Metropolitan Museum of Art, New York

shapes. Two inscriptions and a small decorative border under the roof are the only features which break up the solid mass of brick. A totally different aesthetic is present here. The origin of the Gunbad-i Qabus is no clearer than that of the Bukhara monument. Since it was built by a member of a family recently converted to Islam from Zoroastrianism and still connected with pre-Islamic traditions (as indicated by the use of a solar as well as of a lunar calendar on its inscription), we may very tentatively suggest that its background may be sought in some Mazdean commemorative monument or in the transformation into permanent architecture of a transitory building such as a tent.

SECULAR BUILDINGS

Most of the great palaces and public works of Iran at this time are known only through texts. Both the Samanids and the Buyids had magnificent establishments with gardens, pools, and pavilions. An American expedition to Nishapur may have uncovered significant sections of the city. For the history of architecture, the information is limited to segments of buildings, a small mosque, a bath, and a large number of architectural elements like piers or walls.[28] In one of these buildings, painted niche-shaped panels of stucco were found which could be arranged in groups so as to form three-dimensional wall surfaces later known as *muqarnas* [176]. Moreover Russian exploration of areas allegedly devastated by the Mongols in the thirteenth century and not inhabited since has brought to light quite a number of smaller châteaux,[29] similar in purpose to Umayyad castles and preserved for the same fortuitous reasons. Residences of the feudal aristocracy or *dihqans* who owned and cultivated most of the land, they all had the outward semblance of massive donjons; the upper part of the walls consisted of a series

of adjoining semicircular towers giving the appearance of silos. Some had a central courtyard surrounded by living quarters, others a central domical room with vaulted halls on the sides. In all instances, vaults and domes were very well developed, and in a few cases the builders laid their bricks so as to create a patterned effect.

Most mud-brick buildings were covered with decorated stucco. Excavations at Nishapur, Rayy, and elsewhere, as well as stray finds, have brought to light many fragments of mural paintings and carved stucco [177–180], mostly to be dated in the tenth century, as are the fragments covering some of the columns and part of the *qibla* wall of the Nayin mosque in Iran.[30] In Afrasiyab (the pre-Mongol ruins of Samarqand) the stucco covering of an entire domed room, possibly part of a Samanid palace, has been reconstructed; the interior probably gave the effect of a brilliant, if overwhelming, museum of designs.[31]

The division of the wall surface into geometrically defined areas, the patterning of practically the whole field, the vegetal decoration bent into the geometric frames, and the covering of leaves and flowers with dots and notches are all features which relate this Iranian stucco ornament to Samarra's Style B. Occasionally, however, it shows a freshness and nervous vivacity which contrast with the somewhat jaded Abbasid style, while a few examples introduce purely geometric constructions or all-over patterns hitherto unknown. Until the fragments are completely published or new and clearly dated ones come to light, it is impossible to say whether these indicate a vitality of experimental variation on the art of Samarra or an independent evolution from earlier models.

The architecture of Iran in the ninth and tenth centuries is thus elusive. We must draw conclusions from a few monuments whose contemporary significance and often original shape are almost impossible to evaluate. Nothing illustrates these uncertainties better than the so-called Jurjir Mosque

180. Painted stucco wall panel with falconer (copy), Iran Tehran, Iran Bastan Museum

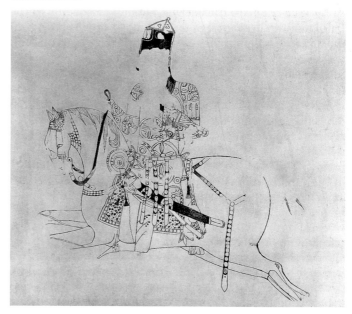

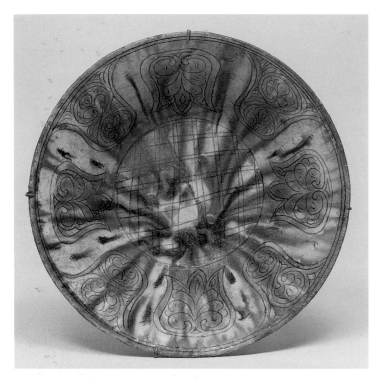

185. Earthenware bowl with coloured and colourless glazes, D. 26 cm.
Metropolitan Museum of Art, New York

186. Buff ware earthenware bowl, D. 38 cm. Iran Bastan Museum, Tehran

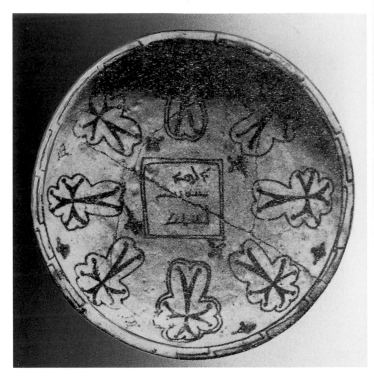

187. Buff ware earthenware bowl, D. 27.3 cm. Iran Bastan Museum, Tehran

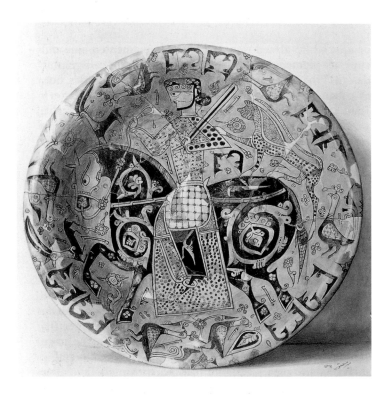

China represented a second source of inspiration. As in contemporary Iraq, Egypt, and Syria, ceramists in eastern Iran and Transoxiana attempted to imitate the *sancai* three-colour ware of the Tang dynasty with its dots and splashes in green, yellowish-brown, and purple on a white ground.[40]

The artisans in the eastern Islamic lands combined coloristic effects from the original wares with underlying sgraffiato patterns [185]. The production of Nishapur was distinguished by the delicacy of its floral designs.

The last, but by no means the least important, source of inspiration was the art of Sasanian Iran. In one large group falling in this category – which came into being exclusively in Nishapur and owes its inspiration to Sasanian royal art, especially the designs on silver plates – portrayals of the noble warrior, alone or in the company of a friend or of boon companions, mounted for the hunt carrying his sword and shield are the common theme [186].

This design, rendered in a manganese-purple slip on a white engobe and stained with yellow and green glazes – and at times even incorporating red slip – for details, does not, however, exhibit any of the single-minded dedication to the royal theme that characterized the original pieces; there is no sign of excitement while the animal is being hunted nor of any dramatic impact in the heroic moment. Out of a *horror vacui* the motifs – including not only human figures and animals but also floral designs, and bits of script – are crowded into dense and often uncoordinated all-over designs with only enough background showing to permit the distinguishing of individual elements.

Another unexpected aspect of this ware is the occasional use of a Christian motif.[41] Mostly it is a cross, and on one bowl in the Iran Bastan Museum [187] there is an additional religious inscription in Syriac. These Christian objects, of unpretentious size and ordinary function, were obviously made for simpler people. This fact, together with the existence of a great mass of pleasant yet artistically modest pieces, seems to indicate that pottery had become the

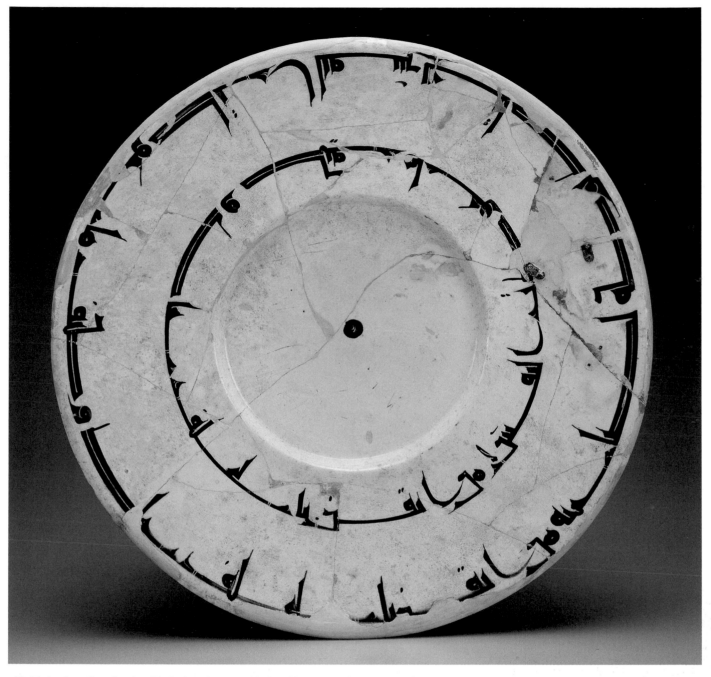

188. Underglaze slip-painted and incised earthenware dish, D. 46.8 cm. Freer Gallery of Art, Washington, D.C.

favourite medium of the middle and possibly even the lower classes, who insisted on ornamentation, even of a complex kind. It also suggests the vulgarization of the original royal or noble motifs, which had declined to a level where they were used in a less discriminating, though more demonstrative, manner.

The effective adaptation and transformation, both artistic and technical, of foreign and indigenous influences speaks for the originality and resourcefulness of the tenth-century Khurasani potters. It is therefore not surprising that they developed several ceramic types that owe nothing to outside models. Among them none is more attractive than the large platters and bowls decorated solely with bold angular Arabic inscriptions, most often executed in manganese-purple slip

on a white engobe, usually applied in circular fashion around the wall of the vessel: a formal stately manner is typical of Samarqand, whereas the Nishapur epigraphic style is more rapid but less refined. The texts include proverbs and adages such as 'Magnanimity is at first bitter to the taste but in the end sweeter than honey'; 'He who talks a lot, slips a lot'; 'Planning before work protects you from regret'; 'Be modest, for this is an attribute of the noble'; and 'He who is confident of being rewarded will be generous and one becomes accustomed to whatever one endeavours to accustom oneself to' [188];[42] and so on. These inscriptions reflect mostly a practical worldly wisdom which suggests that this art was mainly secular, apparently destined primarily for customers in an urban milieu. Given the fine workmanship

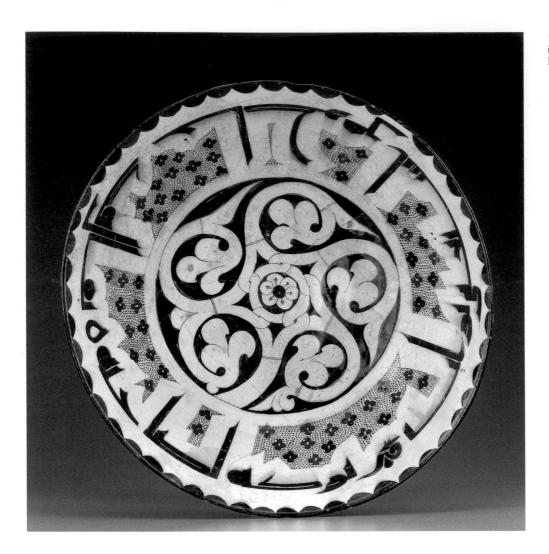

189. Underglaze slip-painted and incised earthenware bowl, D. 39.3 cm. Freer Gallery of Art, Washington, D.C.

and the often large size of these vessels, they must have been made for a discriminating, educated clientele, probably the urban middle class such as wealthy merchants. Here we have the first reflections in art of a contemporary literary effort, for collections of Arabic proverbs had been made by noted litterateurs from the eighth century on,[43] and indeed these vessels are among the earliest surviving 'manuscripts' of this genre of writing.

In some instances, the decoration on inscribed bowls achieved a contrapuntal effect by means of additional ornamentation in the centre – sometimes no more than a dot, but at the other extreme assuming such large proportions that it overshadowed the inscription [189]. In either case the colour range could be enlarged, especially by the addition of a contrasting red slip, which appeared in this period for the first time in Islamic pottery.[44]

Occasionally, in place of the chaste, gracefully attenuated, but otherwise unadorned angular inscriptions, the characters have been transformed into zoological shapes, particularly long-beaked, long-necked water fowl.[45] They are the first zoomorphic inscriptions in Islam, which, again, underscores the secular nature of this production. It was a precocious appearance, for this type of writing was not taken up again until two centuries later, during the great flowering of the secular arts in the urban centres of the twelfth and early

thirteenth centuries – and even then, in contrast to parallel developments in Europe, on a limited scale.

Another small group within this category of slip-painted ware, although avant-garde in its technique, is *retardataire* in its ornament exhibiting only a few very minor motifs like 'wreaths' of hearts [190] or combinations of three dots[46] – that is, motifs that had originally been used in pre-Islamic Iran as framing devices or as decorative patterns on textiles and metalwork.

Yet another type of design, curiously, had never before been applied to pottery, though it had a great vogue otherwise. It consists of the formalization known as the arabesque, created from full and half palmettes, which had been characteristic of the bevelled style so popular at Samarra and which now appeared on bowls made in Samarqand [191].

In this period, especially in the region just south of the Caspian, there appeared a new variety of pottery, even with a new kind of design: sketchily drawn birds in red, brown, and green on a white ground [192],[47] or similarly drawn floral stalks. Although these rather crude pieces in no way measure up to the high standards of the eastern Iranian examples, they at least indicate that decorative household articles had become common at the lower levels of society, even in border regions.

190. Underglaze slip-painted earthenware bowl, D. 12 cm. Iran Bastan Museum, Tehran

191. Underglaze slip-painted earthenware bowl, D. 26.7 cm. Metropolitan Museum of Art, New York

192. Underglaze slip-painted earthenware bowl, D. 19.7 cm. Metropolitan Museum of Art, New York

193. Fragmentary incised glass dish. Datable before 874, D. 28 cm. Metropolitan Museum of Art, New York

195. Copper-alloy bowl, D. 26 cm. Los Angeles County Museum of Art (M.2002.1.623)

194. Gilded silver shallow bowl with niello decoration, D. 10.3 cm. Hermitage, St Petersburg

196. Gilded silver vessel, Ht. 15.2 cm. Hermitage, St Petersburg

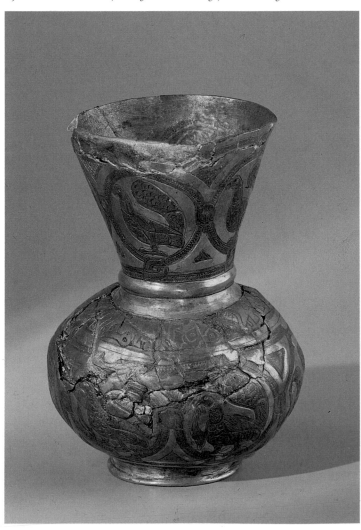

As regards glass production in the eastern Islamic lands, the difficulties of attribution are great, for although a great deal of material has come to light, especially in recent years, most of it offers no ground for specific association with a particular country, let alone a city, and, even when the provenance of objects is known, there is no guarantee that they were made in the place in which they were found.[48] Scientific examination of the glass itself may eventually lead to greater certainty; so far, however, the range of objects to be put to the test has not been sufficiently wide to provide definite clues. Finally, no dated Iranian pieces are known. Thus, practically all scholarly deductions are based on style, on analogies with objects in better-documented media, and on a few other datable associations. One such association allows us to suggest that it is quite possible that the cobalt dish excavated at Nishapur [193] was produced in the eastern Islamic lands before 874. In that year, six very similar dishes were placed by the Tang emperor Xizong in the crypt of a *stupa* (Buddist shrine) in the Famen Temple in China. The latter are so close to the dish from the Khurasani centre that they must all have been made in the same place and at the same time.[49] The incising technique utilized here was another that was adopted from the imperial Roman repertoire. However, glassmakers in the Early Islamic period preferred metal-coloured manganese-purple and various shades of blue to the colorless variety favoured by the Romans. The technique itself caused the designs to appear as white. Although at this juncture in our knowledge we do

not know when this technique was first utilized to decorate Islamic glass, as was previously stated we can be rather certain that the object illustrated here was made before the last quarter of the ninth century.

Not enough Iranian metalwork of precious or base materials survives from the Early Islamic period to permit precise temporal or spatial attributions. What does exist, however, is important, not only for its intrinsic qualities but also because it forms the foundation of an extensive production in the area during the high Middle Ages.

One category of metal objects produced in Greater Iran during this period betrays a strong Sasanian influence. In adapting the pre-Islamic iconographic features and designs, however, many of these were reshaped and progressively flattened, especially in the silver examples. There are still instances of 'royal' iconography in the old tradition, but, as has been seen on the pottery, the repertory often tends to be restricted to minor Sasanian motifs. The small silver bowl [194] is decorated with a common Sasanian scene: the representation of an enthroned ruler between two standing attendants. However, elements of the costumes such as the courtiers' two-horned caps and type of footgear, both of

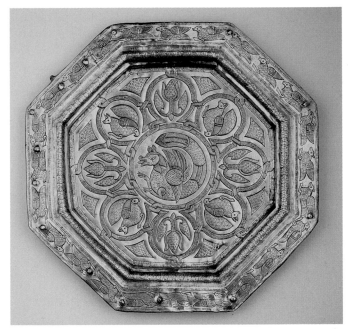

198. Gilded silver tray, D. 35.8 cm. Museum für Islamische Kunst, Berlin

197. Silver ewer, Ht. 18 cm. Hermitage, St Petersburg

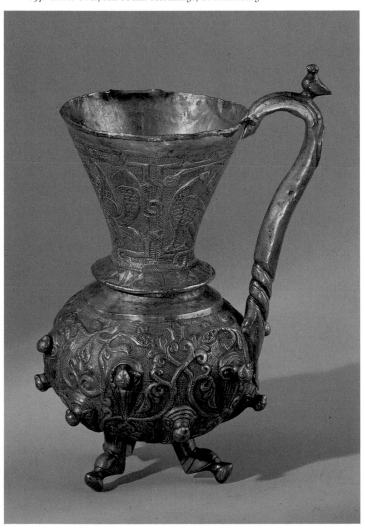

which were in vogue during the Ghaznavid period, and the Turkic facial features of the ruler himself as well as other details of the design point to a date of production in the late tenth or very early in the eleventh century.[50]

The adoption and adaptation of pre-Islamic artistic traditions is apparent also in the copper alloy vessels of this period, which are generally decorated more simply than those in silver, usually with animal or floral patterns. A Sasanian source of inspiration is particularly evident in the hemispherical bowl [195] bearing as its principal decoration a chased depiction of a crowned and haloed king hunting on horseback.[51] Surrounding this *retardataire* ornamentation is a bold, angular, Arabic inscription that circumscribes the inner rim. A second such inscription, framing the exterior rim of the bowl, states that the maker was an artist originating in Sistan, a province in southeastern Iran. This is the sole, tenuous indication of one region where these bowls of Sasanian type might have been made, though it does not preclude the possibility of other centres as well.[52]

From the evidence provided by a second category of metal objects produced in Greater Iran during the early Islamic period, however, it is clear that, in addition to those we have just discussed that looked to the past, there were others that indicated that a new, Muslim orientation was taking shape in Iranian art, which soon made itself felt throughout the Islamic world. This process, with experimental variations, can be clearly followed in a series of silver vessels with animal, avian, and vegetal designs. The vase [196], exhibiting a shape later to be used for glass mosque lamps, marks a convenient starting point.[53] The vessel's chased decoration consists of an angular Arabic inscription on the shoulder bearing the name of its owner and on both the body and neck of the vase more or less identical peacock-like birds – each grasping a leaf in its beak – set in interlaced bands. The patterns still stand on an undecorated ground,

just as they had done in Sasanian times, but the compartmentalization of the flat, linear design and its rather repetitive character reflect a different aesthetic attitude. Owing to a slightly different approach, the shape of the ewer [197], though basically the same, is more attenuated, the decoration more varied, and a handle and three feet have been added. Furthermore, the silhouette of the vessel is interrupted by the heads of highly stylized birds, which protrude from it. In a newly emerging differentiation of designs, the neck here is decorated with various birds in diverse poses within compartments of interlace derived from lettering, whereas the body is covered by an overall vegetal pattern around the protruding birds. As was the case on the vase [196], this vessel also bears the name of its owner in an angular Arabic script, here on the flange at the base of the neck. These decorative elements of the most varied derivation are skillfully combined. Another innovation consists of the punchmarks that fill the background.

200. Silver amulet case with niello inlay, L. 7.3 cm. Iran Bastan Museum, Tehran

199. Silver pouring vessel with niello inlay, Ht. 25.5 cm. Museum of the Gulistan Palace, Tehran

201. Copper-alloy ewer, Ht. 31.7 cm. Victoria and Albert Museum, London

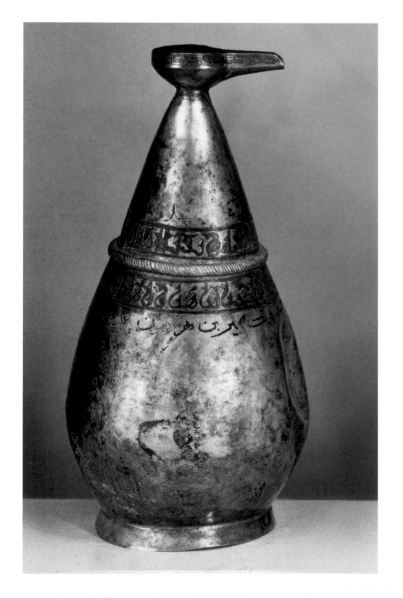

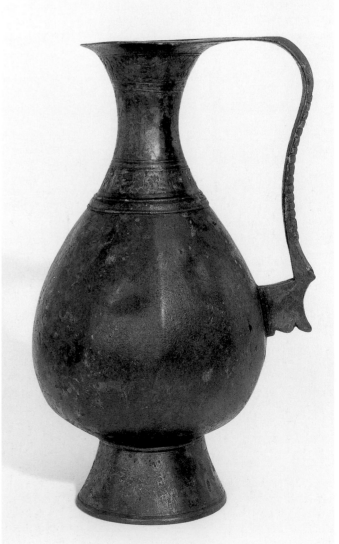

202. Detail of fur-lined silk caftan. Total length about 140 cm. Hermitage, St Petersburg

A third tenth-century silver object, the flat octagonal platter [198], is also covered with chased, increasingly stylized, decoration in which simurghs alternate with floral patterns in interlaced bands around another such mythical lion-headed bird in the centre.[54] The motifs are again rather Sasanian, but the design is stiffer and harder in execution than that of the vase [196], suggesting another workshop, possibly in a different region.[55]

Most definitely in the new Islamic manner is a set of silver vessels decorated solely with encircling bands of Arabic inscriptions in foliated script ornamented with niello inlay. Unlike the ceramic objects from Nishapur or Samarqand [188], these inscriptions do not preach worldly wisdom but invoke divine blessings for their noble owner, whose name and high princely titles are given [199].[56] The well-established and long-current figural imagery in the Sasanian royal tradition has thus given way to verbalizations of princely aspirations. Indeed these silver pieces, though secular, show the impact of the revealed word, and more specifically the literary character of Islamic civilization and the all-important place of language in it. Unfortunately, the owner of this set of vessels is not identifiable, but his rather unusual name occurs at the end of the tenth century in northwestern Iran, which suggests that it was current there. His title, which also appears on the vase [196], went out of

use in the middle of the eleventh century so that a *terminus ante quem* is provided for these two objects.

One of the earliest extant objects of personal adornment that can be placed, by means of its calligraphic style, in an historical context is a silver amulet case excavated in Nishapur [200]. Inscribed, with *sura* 112 of the Qur'an, in a beautiful angular script inlaid with niello against a punched ground, such a jewellery item could have been worn by either a man or a woman.[57] Since the unique ornament under discussion here and the equally singular contemporary ewer [197] invite stylistic and technical comparisons with the casket made in al-Andalus before 976 [147], one wonders whether all three of these objects might not have been inspired by a common, now lost, Abbasid prototype or prototypes. We have seen, repeatedly, how provincial governments in the western as well as the eastern Islamic lands looked to Baghdad and the life it nurtured for artistic and cultural direction. Another example of this is the copper alloy ewer [201] which, like the contemporary Andalusian vessel [151], exhibits a form that was adopted and adapted from imperial Umayyad [92] and Abbasid prototypes.[58]

If we turn to textile production in the eastern Islamic lands during this period, undoubtedly one of the most spectacular extant objects is a fur-lined silk caftan discovered (in the late 1960s) in a tomb in the northern Caucasus [202].

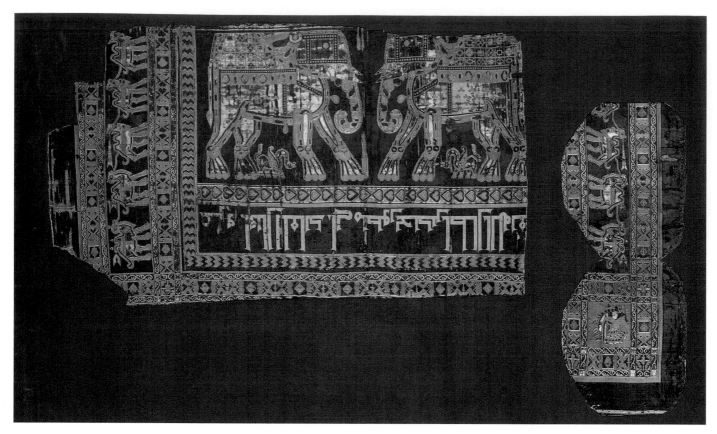

203. Detail of fragmentary silk textile. Datable before 961. Largest fragment 94 × 52 cm. Louvre Museum, Paris

204. Fragmentary silk textile, 58.5 × 34.5 cm. The Textile Museum, Washington, D.C.

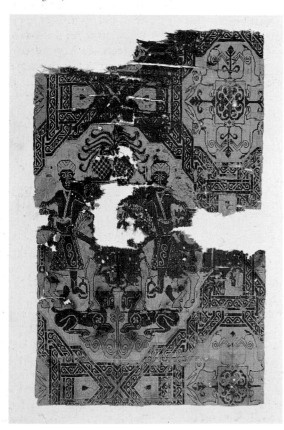

Attributable on the basis of archeological, iconographic, and stylistic evidence to eighth- or ninth-century Iran, this weft-faced compound twill or samit bears an overall design of rows of contiguous and interlocking pearl-bordered roundels each ornamented with a right-facing simurgh. The interstices are filled with a single symmetrical vegetal design. Representations of textiles decorated with this mythical lion-headed bird are found at the late Sasanian site of Taq-i Bustan and also in post-Sasanian Afrasiyab. Thus, an indigenous prototype for this patterned silk is indisputable.[59] The style of this garment – long-sleeved, wrapping to the left and closing with braid-like clasps – is not unlike that being worn by the three figures on the bowl [194] and those depicted in the textile [204].

In the later (tenth-century) textiles from the eastern Islamic lands, the powerful influence of Sogdian or Sasanian art is still apparent, but it is evident, as in all the other media discussed, that the earlier patterns were being adapted to fit the taste of the period.[60] The technical exigencies of the craft further contributed to this stylistic transformation. All the designs became more rigid, symmetrical compositions on either side of a real or imaginary central axis. The elements are piled one on top of the other to fill every possible empty space. Although the preserved specimens were made in different regions, they all reflect these tendencies, varying only in the manner in which the parts of the design are combined.

The decoration and the organization of the motifs of the famous textile from the church of Saint-Josse near Caen

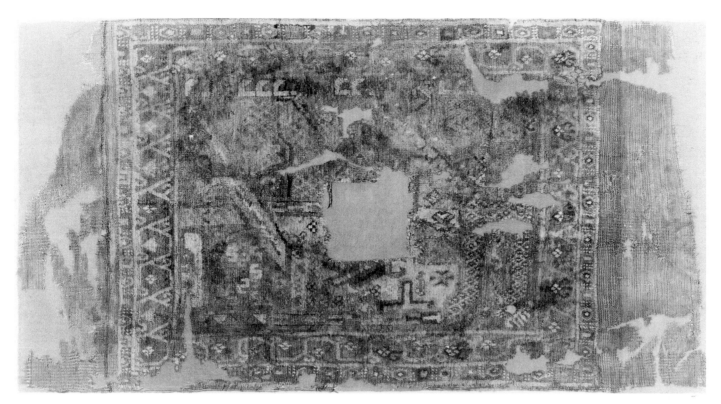

205. Wool pile rug, 89 × 166 cm. Fine Arts Museum of San Francisco, San Francisco

[203] reflects the angular stylization, even to the framing devices, which are all rectangular. Only the peacocks in the corner squares, the border of hearts, and the long ribbons floating from the necks of the camels betray an ultimately Sasanian derivation. The procession of camels ought to introduce a certain amount of movement, but their stylization is so rigid that they are hardly less static than the large patterned elephants in the field. Thanks to the custom of including the caliphal imprint and other historical data in the *tiraz*, textiles woven in the eastern Islamic lands – like those we have seen earlier from other parts of the Muslim world – carried inscriptions that help us to date and localize them. The *terminus ante quem* for this piece is provided by the name of an amir of Khurasan, a certain Qa'id Abu Mansur Bukhtakin (d. 961), who is mentioned in both of the inscription bands.[61]

The main theme of a fabric preserved in the Textile Museum in Washington, D.C. [204], and the Detroit Institute of Arts is more ambitious: framed by bands of geometric strapwork, turbaned falconers on horseback flank a tree.[62] Owing to the absence of purely ornamental features, this design is particularly striking in comparison with other, more dynamic Sasanian-inspired hunting scenes. According to its inscription, the piece was made for an anonymous 'Isfahabad', a title held in princely families south of the Caspian Sea, that is, in an area, closed off by high mountains from the rest of Iran, that had avidly preserved many aspects of its Sasanian heritage. Apart from the stylization, the new framing device, as well as the garments of the falconers and even such a detail as the stirrups, suggests a tenth-century date.[63]

The earliest complete rug extant from the Islamic period

[205], found in a burial context in Fustat, Egypt, is attributed to the eighth or ninth century. Its knotted-pile structure and design layout – that of multiple borders framing a field pattern – are both present in the earliest-known carpet created more than a millennium before and found in a frozen burial site at Pazyryk in Siberia as well as in later rugs from the Islamic world, including the first large group extant, the so-called Konya carpets which are beyond the scope of this work. Although a unique object at this juncture in our knowledge of the history of Islamic textiles, this floor covering, decorated with a highly stylized lion with fero-

206. Detail of stucco panel, 95.3 × 234.6 cm. Metropolitan Museum of Art, New York

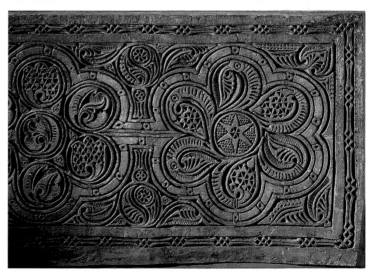

207. Folio from a Qur'an manuscript. Ink, colours, and gold on paper. Isfahan, dated 383/993. Folio size: 23.9 × 33.8 cm. The Nasser D. Khalili Collection of Islamic Art, London

cious claws, may have been only one of many such rugs manufactured during the Early Islamic period. Its technical features permit us to determine that this lone representative of the carpet industry during this formative age was imported into Egypt, most probably having been made in Greater Iran and, more specifically, in what is today Armenia.

Stucco decoration in the eastern lands of the Muslim world during the latter part of the Early Islamic period appears to follow the same evolutionary cycle distinguishable in other areas during this formative era. Prototypes for many of the motifs found in profusion on the interior of the small mosque at Nayin [159, 161, 162] are to be found executed in various media within the central Islamic lands during the eighth and ninth centuries. Those found gracing the façade of the Jurjir Mosque at Isfahan [181] are highly reminiscent of those in the so-called bevelled style in wood, stucco, and stone to be seen in ninth-century Abbasid Iraq and Tulunid Egypt. The ornamentation of the panel excavated at Nishapur [206], however, while recalling Samarra Style B, exhibits a flattening and geometricizing of the vegetal design not found on the prototypes. In addition, some of the leaves now end in birds' heads, a playful variation seen

earlier in the wood panel from Egypt [99] and one which will be further developed in the subsequent period.

THE ART OF THE BOOK

In the tenth century what has been called an 'intense evolution' was taking place as regards the arts of the book in general and calligraphy in particular. Two Qur'an manuscripts, incorporating not only the dates of their execution but also the names of the cities in which they were copied, are illustrative of this evolution, being representative of both the innovative as well as the conservative trends discernible in the arts of the book at the end of the Early Islamic period. One of these codices, that known as the Ibn al-Bawwab Qur'an, was discussed earlier in Chapter 2.[64] The second is a four-volume Qur'an that one Muhammad ibn Ahmad ibn Yasin finished copying in Isfahan in 383/993 [207]. The latter, like that executed seven years later in Baghdad, was done on paper instead of parchment. The secret of paper-making had been wrung from Chinese prisoners captured in Turkestan in the course of the decisive Arab victory in 751, and the industry soon became important in the Islamic world, paper replacing papyrus and parchment as the primary writing material.

Already at the very end of the eighth century it was in use in the caliphal chancery, and from the ninth century on there are references to books on paper; the earliest so far discovered was written in 866.[65] It was only natural, however, that the calligraphers were more conservative in their choice of a medium to transcribe the Divine Word, and the earliest dated Qur'an on paper so far found was not executed until 972, more than one hundred years after the earliest extant dated secular writings on paper.[66] The Isfahan Qur'an is an important transitional object as not only does it look forward in its utilization of paper as well as in its use of what Deroche has termed the 'New Style' of script[67] but it is also *retardataire* in its retention of the older, oblong format and type of vocalization system. The *tabula ansata* form of its sura headings and their tripartite decoration are also strongly reminiscent of earlier illuminations. The larger, central section of this heading contains the name of the *sura* and the verse count in an angular script in gold on a gold ground bearing a textile-like pattern and the two, smaller, square sections are filled with a gold geometricized vegetal design. The *ansa* itself retains the long-popular palmette form.

At least one secular codex can be associated with this period: a treatise on the fixed stars that the Buyid sultan ʿAdud al-Dawla asked his teacher, ʿAbd al-Rahman al-Sufi of Rayy, to compile about 965. It continued the astronomical researches of the ninth century, which in turn were based on classical writings, particularly Ptolemy's *Almagest*. All copies show the constellations in mnemonic configurations, usually derived from classical mythology or from the animal world. The illustrations are ultimately based on al-Sufi's holograph: one of the oldest surviving copies, probably dated 1009, was made from the author's own manuscript by his son.[68] Their unique linear style reflects the fact that these figures were made after designs traced from celestial globes; the constellation pictures also betray their scientific origin in their stress on the stars, which are indicated by both dots and written labels, a deliberately astronomical aspect that had often been lost in late classical renditions. The figures themselves represent reinterpretations of classical themes which were no longer understood at the time. They were also given a more Islamic aspect; thus Andromeda is no longer either half-nude or clothed in a *chiton*, with outstretched arms, chained to rocks on either side,[69] but a bejewelled dancer in the pantaloons and skirt of the contemporary performer, that is in a role consonant with hands outstretched as necessitated by the position of the stars [208]. The type of beauty, the embellishments, and the drawing of the folds are all related to Samarra paintings. But, although the Samarra style lingered on throughout the twelfth century in border areas (Sicily and Spain), the images drawn for al-Sufi's treatise had a much longer life: manuscripts written as late as the seventeenth century continued to follow the established tradition both in the Islamic forms of the constellation figures and in their linear treatment. Just as Qur'an illumination remained conservative owing to its sacred nature, so the illustrations of al-Sufi's codex and all other scientific texts tended to be archaic and rather static, closely following the 'correct' prototypes to allow easy identification of specific natural phenomena. Although, as we have discussed earlier, the number

208. Folio 165 from manuscript of al-Sufi's treatise on the fixed stars. Dated 1009–10, Ht. of figure: 21 cm. Bodleian Library, Oxford

of extant jewellery items from the Early Islamic period throughout the Muslim world is extremely small, this manuscript as we shall see in the forthcoming chapter has proved to be most useful in helping us to corroborate and also deduce contemporary jewellery vogues.

CONCLUSION

Just as for the Islamic west, the arts of the eastern lands of the newly created Muslim world can be understood geographically, chronologically, and formally.

The two most active and innovative areas during these centuries were clearly that of Khurasan, the vast and diverse northeastern province which is shared today by Iran, Turkmenistan, Tajikistan, and Afghanistan, and of Transoxiana, beyond the Amu Darya (Oxus), to the loosely defined and porous frontier between the old Iranian world and the northern steppes of Asia, the Altai mountains, and western China which was, at that time, essentially Buddhist. Little remains of the area's large buildings like mosques or palaces, and it is only tentatively and hypothetically that its

urban structure has been reconstituted by a team of Russian scholars.[70] But, thanks to a new, and possibly locally developed, technology of baked bricks, both the construction and the decoration of small buildings, especially the newly developed funerary ones, acquired a hitherto unknown geometric intricacy illustrating once again what has been called 'the draped universe' of Islamic art.[71] The *muqarnas*, while probably not invented in Khurasan, became in that province a much-used new architectural device. Falling somewhere between an element of construction and ornament, it was destined to enjoy a very rich future in Islamic architecture everywhere. Thanks to a few relatively well-controlled excavations in Nishapur and the suburb of Samarqand known as Afrasiyab and to many clandestine ones, a rich array of glass, ceramics, and even metalwork is available, with imaginative new decorative designs. The best documented fragment of silk from this period is also from Khurasan. Most of the techniques employed, especially those used by ceramicists, are new, and the vast majority of the designs appear as visual novelties rather than as continuations of older Soghdian practices. It seems reasonable to conclude that several independent types of taste had developed in these northeastern outposts of the Muslim world.

By contrast, western and northern Iran are poorly known, the authenticity of many objects attributed to these areas has been questioned, and it is difficult to draw a coherent picture of the arts which prevailed there. Even though such conclusions are hazardous, it does seem that both in architecture and in the arts of objects, especially metalwork, pre-Islamic, Sasanian, or even earlier, practices and motifs had been maintained, especially if the later date proposed for Sarvistan is accepted,[72] or revived, as may be concluded from the interest in the vast ruins of Persepolis demonstrated by the Buyids, who associated it with Solomon as well as with the mythical Iranian ruler Jamshid.[73]

The contrast between these two primary regions of the Iranian world will remain for centuries, each region eventually acquiring additional subdivisions following new patterns of settlement and urban growth as well as a modified political structure. Many of the novelties created in northeastern Iran, especially in architecture but also in aspects of the art of ceramics like the use of writing as decoration, will later spread westward to the whole of Iran. Some of them may well have derived from Abbasid achievements in Iraq, although it is curious, for instance, that the technique of lutre-painting on pottery was imitated, but not reproduced, in eastern Iran.

What led to these striking developments? One possibility could be the patronage of the Samanid rulers, the dominant political power of the eastern Islamic lands in the tenth century. These rulers were largely independent from Baghdad and relatively uninvolved in Abbasid politics. Their wealth resulted from their being at the crossroads of Asian trade with connections extending all the way to Scandinavia, where hoards of Samanid coins were uncovered. They were apparently devoted to the revival of Persian literature and sponsored Persian poets as well as translations from Arabic and from Sanskrit. The practical operation of their patronage of the arts still escapes us, but their collecting habits are made clear in the account of the display of wealth the ruler Nasr ibn Ahmad allegedly ordered around 940 to impress Chinese envoys. Unique objects or striking quantities of expensive items of all sorts were shown alongside tamed and wild animals.[74] The landowners and merchants from the dozen or so large centres of northeastern Iran such as Nishapur, Balkh, Herat, Merv, Samarqand, or Bukhara probably accounted for the development of a second source of patronage. A great deal is known about the social structure of some of these cities with their mix of Arabs, western Persians who had fled the Muslim invasion, Soghdians, many varieties of Turks, Jews, and Jacobite or Nestorian Christians from Syria. The cities were primarily Muslim, and Arabic probably dominated as a common language, a fact that would explain the absence of Persian on the objects of that time. Princes, most of the time Turkic, usually sponsored an intellectual and scientific flourishing which involved almost every field of learning, but the thinkers, scientists, and philosophers themselves came out of the urban mix of the area and provided an Islamic cultural flavour to the courts. A late twentieth-century school of thought developed in Tashkent attributed to this brilliant array of thought the formation and growth of a coherent system of geometric principles for architecture and possibly for other arts as well.[75] It appears in a more subdued form in the works of S. Khmelnitski. How well these theories will withstand the test of further research remains to be seen, but it is reasonable to argue that northeastern Iran did rival Baghdad and central Iraq in brilliance and originality. Yet, whereas Iraqi learning was concentrated in a small number of centres relatively close to each other, distances between cities are enormous in northeastern Iran. And it remains difficult, at this stage of historical knowledge, to imagine the mechanisms for a continuity of intellectual, social, and by extension artistic contacts. Perhaps, as is beginning to come to light through the variations in ceramic use and production found in different cities, there were in the arts many more local distinctions than we know how to disentangle.

Medieval Islamic Art and Architecture
(c.1000–1250)

Islam by their conquests. Their first major dynasty, that of the Ghaznavids (962–1186), started under the wing of the Samanids, established its capital in Ghazni in present Afghanistan, conquered much of northwest India, and controlled most of eastern Iran. More important were the Great Saljuqs (1037–1157), who rose to power in northeastern Iran, moved westwards, took Baghdad in 1055, expelled the Buyid Shi'ite dynasty of Iraq, sponsored the conquest of Anatolia after the battle of Manzikert (1071), and finally gained ascendancy over northern Syria. However, political control over so vast an area could not be maintained and, especially after the death (1157) of Sanjar, the last great prince in the direct line of succession, other Turkic dynasties took over: members of the Saljuq family in Anatolia and southwestern Iran, Zangids in northern Mesopotamia and eventually Syria, Artuqids in the mountains and valleys of the upper Euphrates area, and Khwarazmshahs in northeastern Iran. In addition to providing military and feudal leaders, Turkic tribes continued or initiated the total or partial Turkification of Iranian Central Asia, Azerbayjan, and Anatolia.

The Turks appear everywhere east of Egypt, but several more localized marginal ethnic groups also entered Muslim history at this time. From the mountains of Afghanistan came the Ghorids, of moot ethnic origin, who ruled over an area extending from Herat to India. The Kurds left their mountains, divided today between Turkey, Iran, and Iraq, entered the service of Turkic masters, and eventually created their own dynasty, the Ayyubids, whose greatest prince was Saladin (d. 1193). Based in Syria and later in Egypt, the Ayyubids finally succeeded in destroying the heterodox Fatimid caliphate in 1171 and the Latin hold on Jerusalem in 1187. The Fatimid world itself had been rejuvenated in the latter part of the eleventh century by the actions of a remarkable Armenian convert to Islam, Badr al-Jamali; another Armenian convert was the great prince of Mosul in the middle of the thirteenth century, Badr al-Din Lu'lu'. In the western Islamic lands the two Berber dynasties of the Almoravids (1062–1147) and the Almohads (1130–1269) came out of the mountains of Morocco to purify and thereby revive Muslim presence in Spain, but failed ultimately to contain the Christian *reconquista*.

Invaders were repulsed in Asia and the Islamic frontiers enlarged with the help of Turkic, Ghorid, Kurdish, Armenian, and Berber military and political leaders. Their assumption of power – symbolized, among other things, by the new title of *sultan* (literally 'power'), first restricted to the lord nearest the caliph, but rapidly widened to include almost any prince – did not mean, however, that the whole area was taken over by hitherto alien cultures. On the contrary the new princes adopted, fostered, and developed the indigenous Persian and Arab traditions. For example, Ferdosi dedicated his Iranian national epic, the *Shahnama*, to the Ghaznavid Turk Mahmud; the great Persian scientists and poets Ibn Sina (Avicenna), al-Farabi, Omar Khayyam, Anvari, and Nizami lived and prospered under Turkic rule; Nizam al-Mulk, the Iranian vizier of a Saljuq prince, wrote the main ideological statement of the period, the *Siyassat-nama*. In effect then, wherever their conquests took them, the Turks, or at least their princes, carried a

largely Persian culture and Persian ideas, even the Persian language. The greatest Persian mystic poet, Jalal al-Din Rumi, lived and wrote in Konya in central Anatolia.

Arabic and the Arabs did not make the same cultural impact on the new military elites. In the west, to be sure, the rude mountain Berbers of the Almoravid and Almohad dynasties were soon captivated by the refinements of Andalusian princely courts, and the Ayyubid Kurds became the champions of their subjects, most of them Arab. Throughout the Islamic world, intellectual and religious works were still generally written in Arabic. But, on the whole, contemporary Arabic literature had a more restricted impact than its Persian counterpart. The best known Arabic productions were the tales called *Maqamat*. The most celebrated, by al-Hariri, were later illustrated, but the stories are not so important as their abstruse linguistic and grammatical pyrotechnics, accessible only to highly cultivated readers. Appearing at the same time as many histories of individual cities, the *Maqamat* bear witness to a withdrawal of the Arabic-speaking world into its own fold, especially when contrasted with the tremendous growth and spread of Persian. Thus the first significant change of these centuries involves not only the rise to prominence of newcomers from the frontiers of the Muslim world but also a new relationship of prestige and importance between the two major linguistic and ethnic groups which had been part of the Islamic system almost from the beginning.

The partial list of dynasties in the eleventh, twelfth, and thirteenth centuries given above introduces the second major change of the time. Authority was carried down from the caliph and, at least at the beginning, a sultan directly associated with him, through a complex chain of personal and family allegiances, until, at the lowest level, it was vested in a local ruler. As a result the number of princely courts increased enormously; not only was there a revival in power and prestige of such older centres as Merv, Isfahan, and Damascus, but small or abandoned cities were suddenly transformed into capitals, sometimes ephemeral, as in the case of Dunaysir (modern Koçhisar in southern Turkey). All were also manufacturing centres, transit trade depots, and markets for outside products. Princes depended on the support of merchants and artisans often belonging to some official or informal organization. For, parallel to the official level of a military aristocracy with its internal quarrels so carefully recorded by the chroniclers, there was an expanding transregional trade by sea and by land. Caravans enriched more than the military rulers who protected them; they permitted the growth of private sponsorship for monuments and works of art, and led to new kinds of monumental architecture (inns known as *khans*, bazaars, caravanserais, roads, bridges, and so forth) and to a very varied taste in objects.

The last transformation concerns the religious climate. In all instances, the new conquerors – Turks, Kurds, and Berbers – were dedicated Sunnis and felt it their duty to extirpate heresies and to reinstate true Sunni orthodoxy. The defeat of Shi'ism was accomplished both by force of arms and by a systematic attempt at forming religious elites through the institution of the *madrasa* (literally 'school'), in which orthodoxy was redefined by including some of the

new religious trends like Sufism; a largely rejuvenated Islam, with many variations under a common mantle, became the main source of religious teaching.[4]

To sum up, then, the eleventh, twelfth, and thirteenth centuries are characterized by three essential features which influenced the development of the arts: a new balance between ethnic and linguistic groups; without abandoning the notion of a single unifying caliphate, a fragmentation of political authority leading to a tremendous growth of urban centres and urban activities; and a revivified orthodoxy whose implementation was seen as a responsibility of the state and of the individual, but in whose margin Sufism maintained a powerful appeal to individuals and social organizations.

The end of this period is much easier to define than its beginning. The brutal Mongol invasion penetrated into eastern Iran in the second decade of the thirteenth century and advanced westwards, destroying Baghdad and the Abbasid caliphate in 1258, only to be stopped in southern Syria in 1260 by the Mamluks of Egypt, a new power rising from the collapse of the Ayyubids. In Anatolia the Saljuq regime lasted until the end of the thirteenth century, when a period of political fragmentation began, out of which emerged the great power of the Ottomans. In the West, after the disaster of Las Navas de Tolosa (1212) at the hands of a coalition of Christian princes, Almohad power declined and was replaced in North Africa and Spain by smaller, locally formed dynasties.

Thus, on the whole, this brilliant era – coeval with the Romanesque and early Gothic in the West and with the Sung emperors in China – disappears brutally. Everywhere but in Spain and Sicily it had been successful in meeting both internal and external challenges because it managed to make new and meaningful syntheses from the many features which made up the contemporary Islamic world, a world which in many ways still conceived of itself as a unit, whereas in the following centuries the Islamic West, the Arab Near East, the Turks, Iran, and Muslim India were to develop their own separate destinies.

We have divided the presentation of the arts of these times according to the same three geographical categories as in the first part of the book, but in a different order. Before providing our reasons for doing so, it is important to note that, far more than for the earlier period, this one has been affected by scholarly trends and a bibliographical apparatus into which has crept a high degree of specialization. For instance, our knowledge of Iran and Afghanistan has been revolutionized by many large-scale explorations and excavations carried out in the 1960s and 1970s, many of which have never been published. Systematic surveys and excavations organized by various Soviet institutions from Tashkent, Baku, or Moscow all over Muslim Central Asia and the Caucasus or Azerbayjan have modified the interpretations to be given to these areas particularly rich in monuments. Egypt, Anatolia, and the Fertile Crescent had already been better surveyed in the past, but there as well, especially thanks to Turkish scholars in Anatolia and to a recent growth of interest in Muslim Syria and Palestine at the time of the Crusades, the mass of new interpretations and of new data is rather overwhelming.

Two additional difficulties complicate matters even further. Both are methodological in nature. The fascinating peculiarity of this rich period is that our knowledge of it is based on a great variety of information – descriptions of nineteenth-century travellers, complete archeological surveys, partial descriptions, undocumented reconstructions, recent restorations – and of such recent vintage that any generalization is bound to be modified by subsequent research. The other difficulty is that the secondary literature is not very accessible, partly because it is often hidden in rare periodicals and series, partly because it occurs in an unusually broad spectrum of languages, each with its own specialized vocabulary. And then the numerous written sources have been very unevenly surveyed for their pertinence to the arts: fairly well known for the Arab world and especially for Syria and Baghdad, they have hardly been touched for Iran and Anatolia, and even inscriptions are less easily available than for Early Islamic times.[5]

Eventually, no doubt, there will be separate histories of each province or even city during these two and a half centuries and some such studies already exist or are in active preparation. In the meantime we decided to begin with Central Asia and Iran (including the little that is pertinent about India), because major changes there preceded those of the areas to the west of the Zagros mountains and because it can be demonstrated that, in many cases, both ideas and techniques moved from east to west. A survey of eastern Islamic lands is followed by those of the central core, essentially the feudal dynasties of Turkic and Kurdish origin, but also the weakened Abbasid caliphate in Baghdad which witnessed a fascinating cultural revival in the first half of the thirteenth century. But we have included as a separate section a full discussion of Fatimid art centred on Egypt, even though it clearly began in the previous period. The reasons for this decision were two. One is that it seemed illogical to divide the reasonably coherent history and culture of that dynasty into two periods because of major changes elsewhere. The other reason is that there is much in Fatimid art that precedes developments elsewhere, even though the connection between apparent Fatimid innovations and similar ones farther east, if it existed, eludes us so far. The Muslim west, partly isolated from the momentous changes in the eastern Islamic lands, continues in many ways its own independent path.

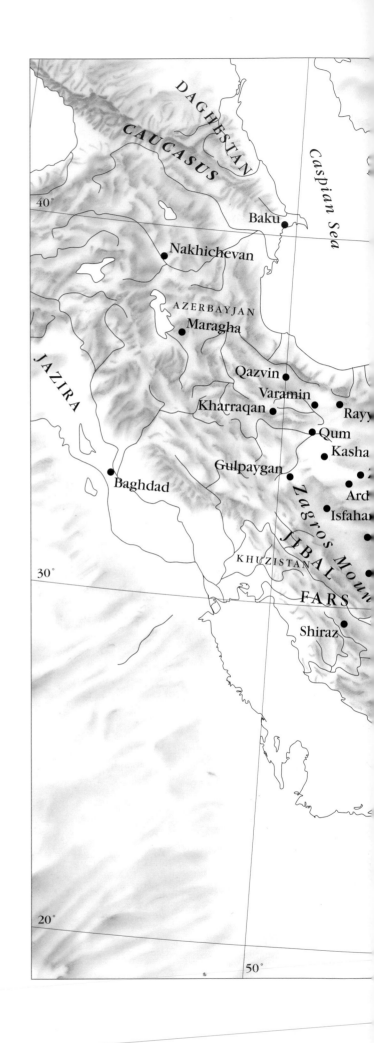

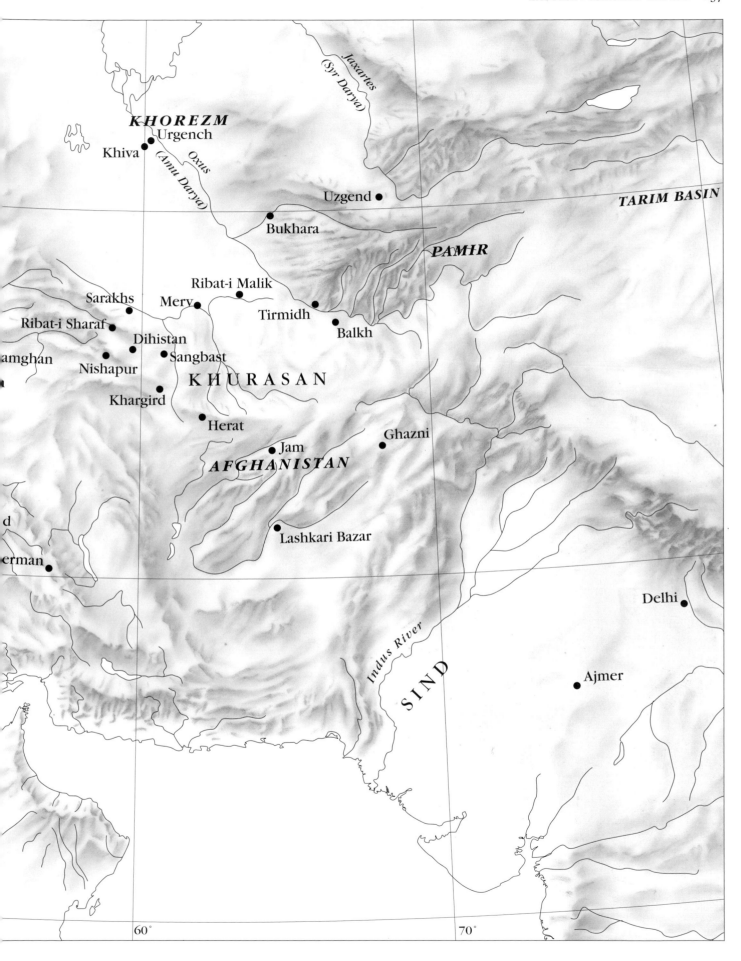

KHOREZM

Urgench

Khiva

Jaxartes (Syr Darya)

Oxus (Amu Darya)

Uzgend

TARIM BASIN

Bukhara

PAMIR

Ribat-i Malik

Sarakhs

Merv

Tirmidh

Ribat-i Sharaf

Dihistan

Balkh

amghan

Nishapur

Sangbast

KHURASAN

Khargird

Herat

Ghazni

Jam

AFGHANISTAN

Lashkari Bazar

erman

Delhi

Indus River

SIND

Ajmer

60°

70°

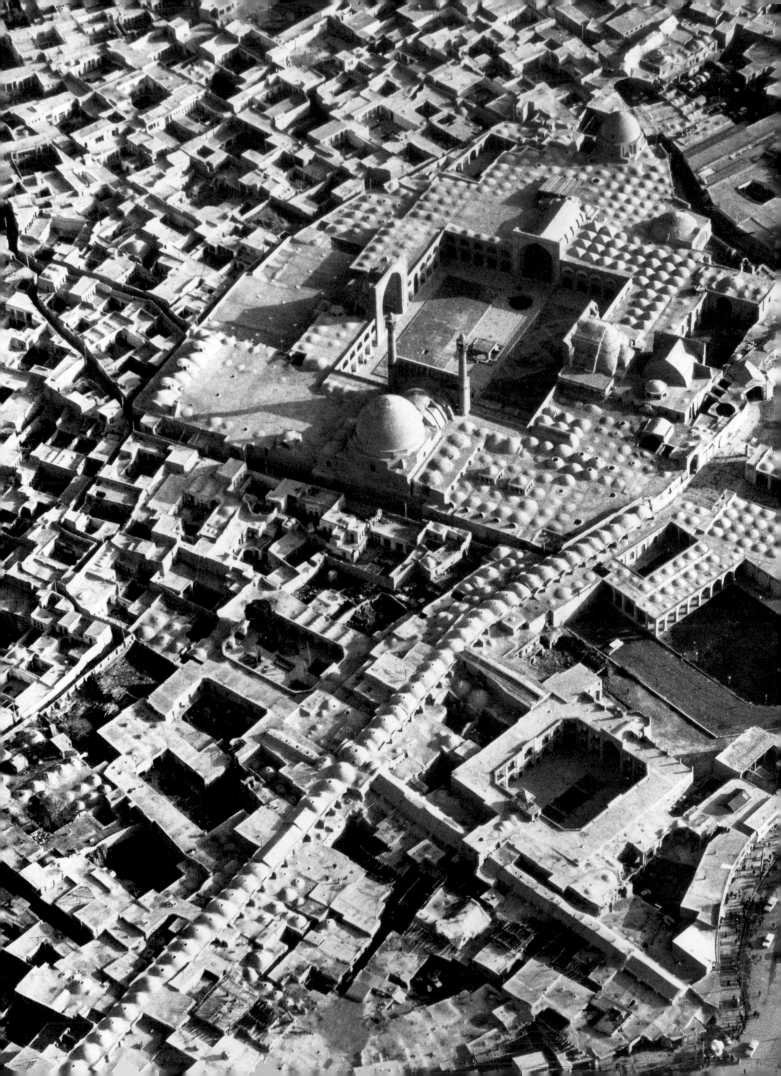

CHAPTER 5
Eastern Islamic Lands

ARCHITECTURE AND ARCHITECTURAL DECORATION

The area involved, from the Mesopotamian valley and the eastern Anatolian or Caucasian mountains to the Tarim basin in western China or the rich valleys of northern India, is vast and diverse in climate, range of architectural activities, and innovative trends. It will eventually be presented in terms of individual provinces such as Fars or Jibal in western Iran, or the Bukhara oasis in the east. Preliminary attempts in this direction have already been made, especially for Azerbayjan and Central Asia. But it is also reasonable to argue that enough features are shared by the buildings of these two centuries in the lands of eastern Islam that their common characteristics can be defined with some precision. To do so requires an awareness of buildings which are themselves very unevenly known. For these reasons the presenta-

tion of the monuments with their individual problems precedes an attempt at identifying common traits of construction and design which best characterize the architecture of a remarkably rich period.

THE MONUMENTS

Mosques

The edge of the Iranian desert in the centre and west of the country boasts a remarkable and coherent group of more or less contemporary mosques: Isfahan, Ardistan, Barsian, Gulpaygan, Zavareh, Burujird, with Qazvin and Qurva farther to the north.[1] In addition, in the same general area, at Yazd, Kerman, Shiraz, and probably Rayy, many other mosques were constructed or reconstructed, though later restorations have often obliterated the earlier work. This

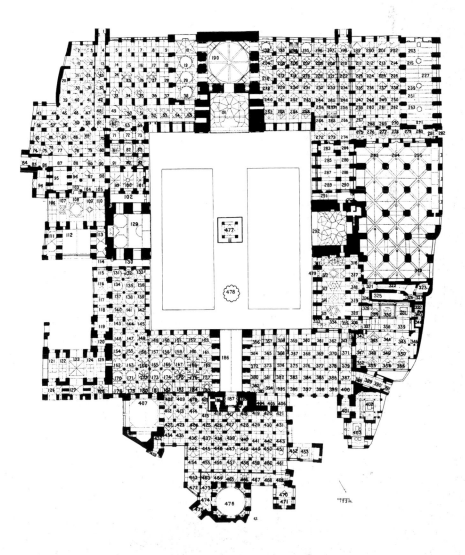

209. Isfahan, Great Mosque (Masjid-i Jumah), eighth–seventeenth centuries, air view

210. Isfahan, Great Mosque (Masjid-i Jumah), plan

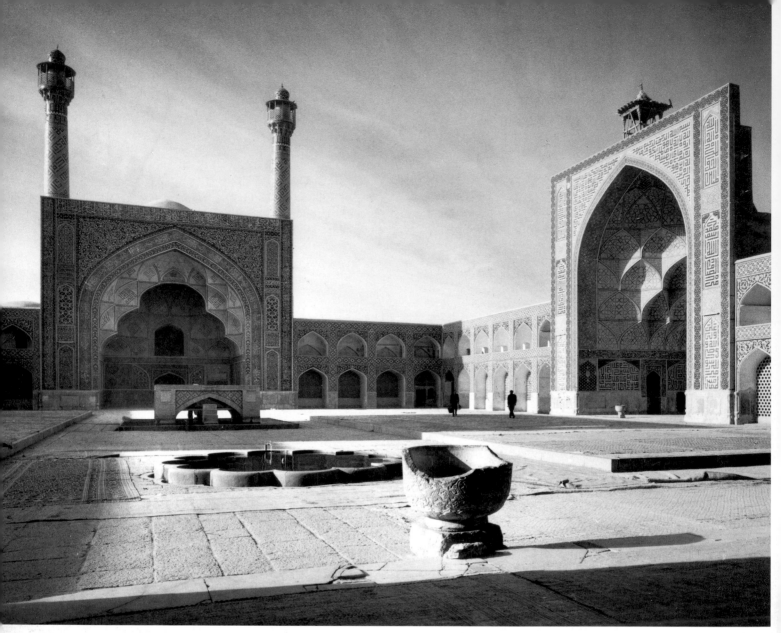

211. Isfahan, Great Mosque, court, eleventh and twelfth centuries, facing west

group belongs essentially to the period of the Great Saljuqs, with the earliest dated construction in 1088 (northeastern dome at Isfahan) and the latest in the eighth decade of the twelfth century (Qurva). Unfortunately our information on mosques built elsewhere in the Iranian world is so limited as to make it almost useless. In Herat,[2] in Lashkari Bazar,[3] in a small town near Merv,[4] in Bukhara,[5] Damghan,[6] Khiva,[7] and Baku[8] there is evidence for major religious buildings, but either no trace is left or the monuments have not been properly published or even studied, or else they are small, traditional, hypostyle constructions of little artistic merit. It is therefore partly by default that a consideration of mosque architecture is centred on west central Iran. The area was in fact a favourite of the Great Saljuqs both for residence and for patronage, and its mosques can be seen as paradigmatic for a twelfth-century Iranian type.

The most remarkable and celebrated of these monuments is the great Masjid-i Jomeh of Isfahan [209, 210]; it is also extremely complex and, in spite of several studies and

partially completed and published excavations,[9] still far from being clearly understood. Like Chartres, with which it has often been compared, it is unique, and thus cannot be adduced to define a period; yet the period cannot be understood without a full awareness of its character. For this reason we shall begin with an analysis of the structure as it now stands, and then single out those of its features which clearly belong to our period.

It is a large, irregular aggregation of buildings whose northeast–southwest axis is 150 metres, with 476 separate vaults, mostly domes. The core is the rectangular courtyard of the tenth-century hypostyle mosque discussed earlier[10] into which were introduced four *iwans*, of which two are almost square halls ending in a blank wall [211, 212]. The *iwan* on the *qibla* side is also squarish but related to a large room, 15 metres square, covered with a dome. The fourth on the opposite side, to the northeast, is much longer and narrower, in a more traditional rectangular pattern, and ends in two massive blocks recalling the towers of a gate, at

least in plan (in elevation[11] so much of it is masked by later decoration that it is difficult to ascertain its original shape). The *iwans* occupy only a fraction of the façade on the court; the rest is taken up by forty-two rectangular panel-like units of two superposed tiers of arches. It is uncertain whether this double arrangement is a relic of the first façade. Each panel leads to an aisle of square bays covered with domes, except where there was later rebuilding, for example on either side of the northwestern *iwan*.

Within this area there is only one approximate date: in the lowest part of the *qibla* dome [213] an inscription names its builder, some time between 1072 and 1092, as the great Nizam al-Mulk himself. Three areas outside the earlier rectangle, however, bear dates in the late eleventh and early twelfth centuries. First, on the main axis of the mosque, some 23 metres beyond the northeastern *iwan*, a square domed room (10 metres to the side) [214] is precisely dated to 1088 by an inscription which names Taj al-Mulk, Nizam al-Mulk's enemy and competitor, as its founder. The area which separates this domed room from the northeast *iwan* is covered today with later additions, but it is generally assumed that it was originally free from buildings. Second,

a gate [215] outside the main rectangle to the east of the northeast *iwan* is inscribed as 'rebuilt after the fire of 1121–22'[12] – in all probability the one recorded by chroniclers during a local revolt in 1120.[13] Finally, the area beyond the limits of the rectangle in the southern corner of the present mosque exhibits not only a remarkably archaic mode of construction but also fragments of religious inscription whose epigraphical style is hardly likely to be later than the end of the eleventh century.[14]

There are three features – a dome in front of the *mihrab*, a second dome to the north and presumably outside the perimeter of the mosque, and a somewhat eccentric gate – which are clearly dated to the late eleventh and early twelfth centuries. They imply major transformations of the Buyid mosque in several stages which are largely confirmed by recent excavations. First would have been the large dome in front of the *mihrab*, sponsored by the vizier Nizam al-Mulk. It was not in itself a novelty, but its size and majesty are unusual, perhaps reflecting the old tradition of a large *maqsura* in mosques.[15] It is reasonable to interpret this as a reserved princely area, but it is still unclear how the dome was connected with the remaining hypostyle. One of its

212. Isfahan, Great Mosque, court, eleventh and twelfth centuries, facing northeast

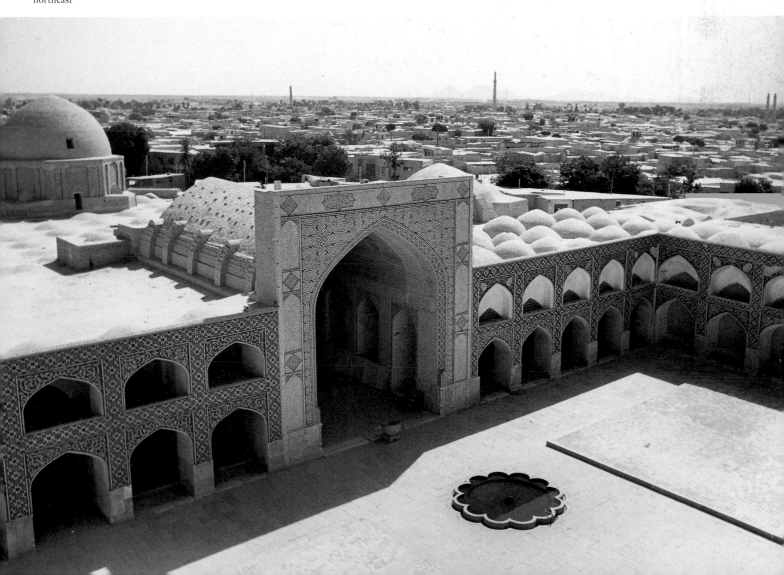

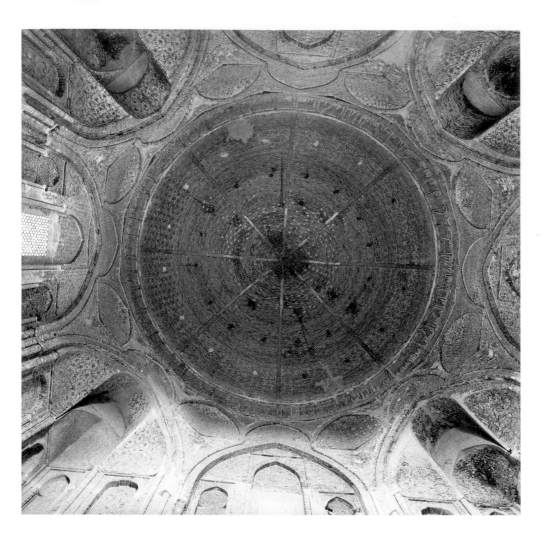

213. Isfahan, Great Mosque, south dome, 1072–92

214. Isfahan, Great Mosque, north dome, 1088

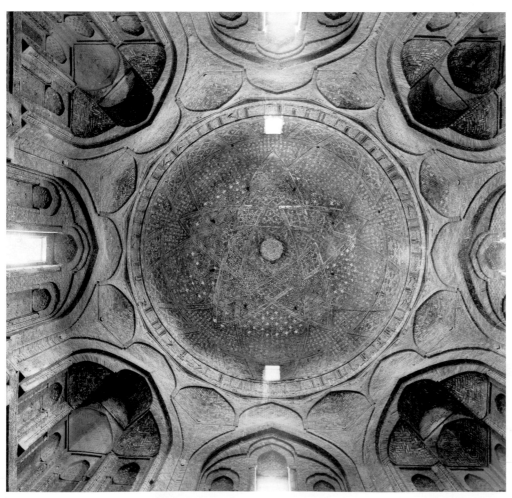

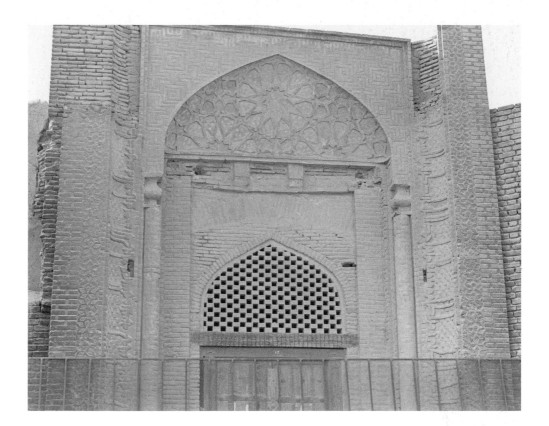

215. Isfahan, Great Mosque, gate, rebuilt after 1121–22

most striking features is that it was initially standing alone [216] with fragments of a Qur'anic inscription on its north-western side which was eventually covered up by later constructions.[16] The outside north dome built in 1088 by Taj al-Mulk also had some royal function – perhaps the prince changed his clothes there before he entered the mosque,[17] as its Qur'anic quotation (7:54) is rarely found in mosques and emphasizes the 'royal' character of God. Its asymmetrical openings further indicate that it served some ceremonial function of passage. The gate of 1121–22 is more difficult to explain because of its eccentricity, but several rather cryptic textual references to built areas adjoining the mosque and functionally related to it[18] suggest an earlier expansion or addition which would have been formally incorporated into a single building. It is to this last phase that the four *iwans* are usually attributed, although there is no archaeological, epigraphic, or literary proof.[19]

We cannot define the mosque's outer limits because it is not known whether the many fourteenth- and sixteenth-century additions were on newly acquired areas or displaced Seljuq or even earlier constructions. Its most characteristic feature was a core of a courtyard with four *iwans* and a dome behind the *qibla iwan*, all fitted into a plan imposed by an earlier building.

All other mosques of central Iran were built or transformed in the first decades of the twelfth century. Moreover, even though at Ardistan and Barsian an older hypostyle and a number of local peculiarities[20] gave rise to unusual features, basically a standard plan type was used throughout. Its fully dated occurrence is in the small town of Zavareh in 1136 [217, 218].[21] Within a rectangle is a courtyard with four *iwans* and a dome behind the *qibla iwan*. The areas between

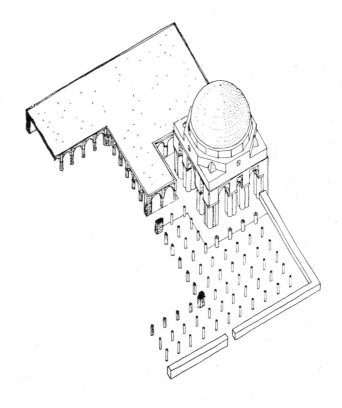

216. Isfahan, Great Mosque, plan as in Seljuq times (after Galdieri)

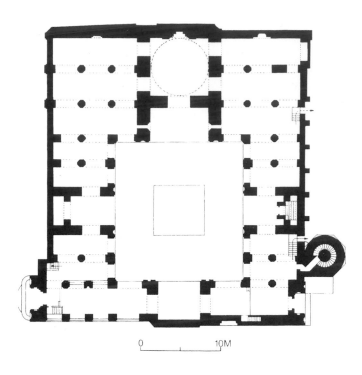

217. Zavareh, mosque, 1136, plan

218. Zavareh, mosque, 1136, interior

are covered with pointed barrel-vaults on heavy piers,[22] and a symmetrically planned court façade of arches frames the *iwans* and connects with the vaults. There is an entrance to the side of the main axis of the mosque, and a minaret usually outside of the frame of the rectangle. With only minor variations this type was imposed on the remains of the hypostyle mosque of Isfahan.

What is the origin of this plan, and why was it adopted at this time and place? Individually, of course, neither the *iwan* nor the *iwan*-dome combination, nor even the court with four *iwans* is new – all can easily be related to pre-Islamic traditions in Iran and Iraq. The innovation lay in combining a court with a side entrance and giving it four *iwans*, the size of each depending on its position in the liturgical orientation of the building and on the large dome behind the *qibla iwan*. In other words, existing forms were adapted to the liturgical, functional, and symbolic purposes of a congregational mosque.

It is much more complicated to determine the reasons why this plan was so readily adopted at this time. An older theory was that the court with four *iwans* and a side entrance is a characteristic of the eastern Iranian private house, which would have had an early impact on monumental secular architecture, as we shall see later.[23] To explain how and why

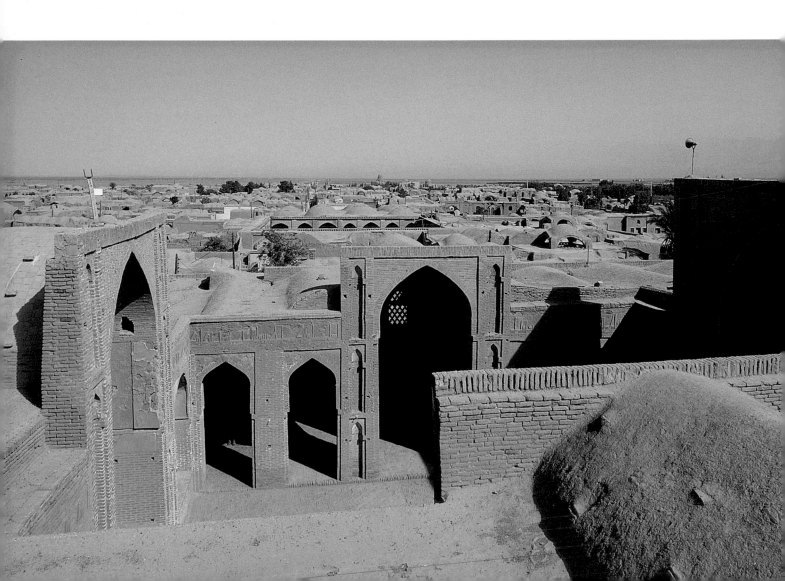

a house plan from eastern Iran came to be used in newly built congregational mosques of central Iran, Max van Berchem, followed later by E. Herzfeld and A. Godard,[24] evolved what may be called the *madrasa* theory. Its starting point is the accepted fact that, after the occupation of Iran and Iraq by the Saljuq Turks, *madrasas* were constructed for the ducation of the Muslim masses in the principles of orthodoxy. Some *madrasas* were sponsored privately, others built by the Saljuq princes and their advisers, sometimes at their own expense, but all as instruments of the state. The most celebrated were the Nizamiyas built in Iran and Iraq by Nizam al-Mulk himself, of which the most remarkable was in Baghdad. It has not been preserved, and the existing descriptions are of no help towards a reconstruction.[25] While it was only under the Saljuqs that the government began to sponsor such institutions, privately founded *madrasas* existed already in northeastern Iran, in most instances in houses transformed for the purpose. These facts led to two assumptions: that the Saljuq *madrasas*, because of the nature of their sponsorship and the rapidity of their construction, tended to be of a standard type; and that the type originated in the private houses of eastern Iran already adapted for such use. It was then concluded that the four-*iwan* house plan spread throughout the area of Iran and Iraq and was adopted for congregational mosques merely because it was convenient and popular.

Simple and coherent through it may be, this hypothesis cannot be fully maintained. The first argument against it is an argument *a silentio*: nothing is known of the physical shape of the *madrasa* before the second half of the twelfth century, and no early *madrasa* is known in Iran at all; the often-quoted one at Khargird consists of architectural remains so indistinct as to be useless.[26] It is true, as we shall sce later, that Syrian and Anatolian examples generally have but few typological variations, suggesting that the *madrasa* indeed possessed precise characteristics of plan and construction: but even so, is it likely that twelfth-century architects would have applied systematically to all new or rebuilt mosques of one area a plan identified with a precise and limited function in another? In any case, we shall not ascertain the original form of the *madrasa* until an early example has been excavated.

The stronger objection to the theory is, however, that the four *iwans* with courts are hardly ever found in later *madrasas*, but became standard for many constructions – secular and religious – in the twelfth century, in Iran and beyond, suggesting a much more powerful force behind the plan than a new religious institution about which we know so little. It may well have been an indigenous western Iranian or Iraqi form which received a monumental shape in local mosques. It is a curious fact – and one that should lead to considerable care in drawing conclusions on this whole question – that, of all the major mosques of eastern Iran and Central Asia that date from before the Mongol conquest, only one, of the early thirteenth century, at Dihistan (modern Mashhad-i Misriyin)[27] has an *iwan*-dome in front of the *qibla*.

To sum up, in the early decades of the twelfth century a remarkable group of congregational mosques with a similar internal arrangement – even when (as at Isfahan) compli-

cated by local factors – appears in west central Iran. This can be explained by the historical circumstance that these were the major centres from which the Great Seljuqs and their vassals ruled over much of the Islamic east. But the formal origins of the new plan and the degree to which this central Iranian development can be assumed at that time for the rest of the eastern Islamic lands are problems which, so far, we lack the information to solve. Even though the prevalent theory of an eastern Iranian origin cannot be maintained on archaeological or logical grounds, the literary and architectural documentation in our possession does not suggest a more adequate explanation. In any case, the combination of forms thus created became the basis for all subsequent developments of Iranian mosque architecture. Ultimately, its most important achievement was aesthetic. Like the Parthenon in Athens, the paragon of classical architectural creativity, Iranian mosques like the one in Isfahan were meant to be seen and experienced from the open air, but in this case from the very centre of the building, in an open court. There, as on a stage, a simple, self-sufficient façade created a backdrop for functions enacted inside.

Mausoleums

As we have seen earlier, the first Islamic mausoleums were erected in the tenth century, presumably for the glorification of princes and the celebration of Shi'ite imams. In Iran they were either towers or square buildings covered with cupolas on squinches, but with the arrival of the Turks and the subsequent triumph of Sunnism they were transformed in function and in shape. Instead of descendants of Ali, it was holy men, legendary Companions of the Prophets, and often Old Testament figures who were accorded true *martyria* (Arabic *mashhad*, 'place of witness'; in Iran often called *imamzade*, 'son of the imam'). These became focuses of popular piety and related activities, and their growth should be examined in relation to two important pietistic characteristics of the time: the search for personal salvation through the intercession of a holy man or a holy event, and attempts by guilds and Sufi organizations to relate themselves to holy personages. The cemetery became, in some cities at least, a proper place for meditation and gathering in the proximity of long-gone virtuous men. At the same time the development of a feudal order of military lords maintained the need for the commemoration of wealth and importance or for the establishment of dynastic or personal shrines.

Like the mosques, the remaining Iranian mausoleums pose a number of unresolved problems. Is it accidental that by far the largest number from this period are found in the north along a line from Urgench, almost in the Pamir, across Balkh and Merv, in and around the mountains south of the Caspian Sea, and into Azerbayjan? Why is it that in the extreme northeast and the extreme northwest there are groups from the second half of the twelfth century and a few earlier ones, while in the area south of the Caspian Sea many dated examples exist from the second half of the eleventh century and the first half of the twelfth? In the absence of adequate regional or cultural investigations, which alone could provide answers to these questions, these mausoleums are discussed in purely typological fashion.

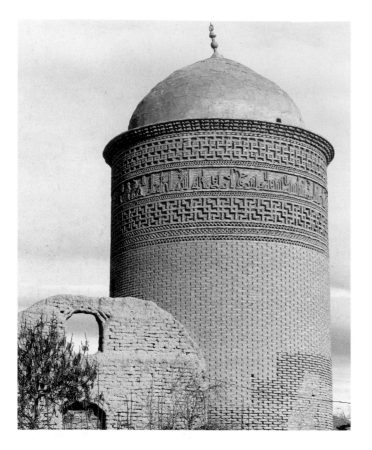

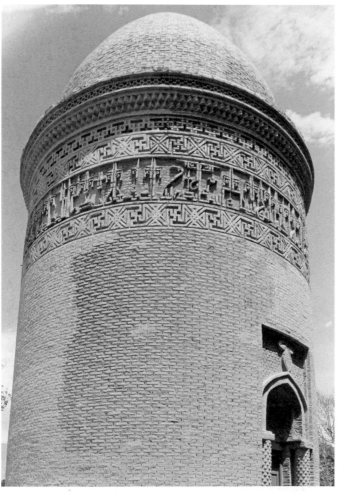

First, the tower tomb is still present. There are two examples (1026–27 and 1054–55) at Damghan [219, 220],[28] round and squat, of brick, with a pointed dome. The brickwork is simple everywhere but on the upper part of the shaft, where it is heavily decorated. At Rayy (1139)[29] is a much restored star-shaped tomb, which, like Gunbad-i Qabus, has very little ornament beyond a small area along the cornice below the dome; the striking elegance of the earlier monument has, however, deteriorated into the heavy semblance of a water tower. In southern Iran the tower tomb is represented at Abarquh (1056).[30]

The most interesting and ultimately more far-reaching development occurred within the second type: the square or polygonal canopy-like mausoleum.[31] It appears in small villages of Central Asia and elsewhere,[32] and in large towns like Sangbast and Yazd,[33] in many variants which, at this stage of research, escape easy classification. I shall limit myself to a brief discussion of the Kharraqan tombs, the mausoleum of sultan Sanjar, and the Azerbayjan group, and to the growth of the *pishtaq*, a notable feature which appears in many of them.

The two Kharraqan tombs (dated 1067–68 and 1093) [221–224] and the related mausoleum at Damavend are in northern Iran, southeast of Qazvin and east of Tehran respectively.[34] All three are octagonal inside and out and about 13 metres high; each side is about 4 metres long, with heavy semicircular corner buttresses. Inside on a zone of squinches is a dome, double in the case of the second of the Kharraqan buildings, the earliest double dome in Iran. All are remarkable for their brickwork, a series of most elaborate panels, to which we shall return. One of the Kharraqan mausoleums also has painted decoration which may, however, be later. The Kharraqan towers were built by one Muhammad ibn. Makki al-Zanjani, and the patrons were probably non-princely Turks or Iranians.

The mausoleum of sultan Sanjar in Merv (c.1152)[35] was part of a large complex including a palace and a mosque directly attached to it [225, 226]. It is thus the first dated instance of the mosque-mausoleum, later to become common; the palace on the other side, however, relates it to a much more ancient tradition, illustrated, for instance, by Diocletian's ensemble in Spalato, where tomb, palace, and temple are all part of the same conception. In plan it is square, 27 metres to the side, with two entrances facing each other. Inside is a square domed room (17 by 17 metres). The plan is thus not very original, except for its size, but the elevation is. Remarkably deep and strong foundations support a thick brick wall which goes up to a height of about 14 metres without any major decoration inside or outside. The zone of transition is hidden outside by a gallery, in the manner of the Samanid mausoleum in Bukhara, and above it soars the superb dome, 14 metres high, which has unfortunately lost much of its outer brick. It appears to be on a high

219. Damghan, tower tomb, 1026–27

220. Damghan, tower tomb, 1054–55

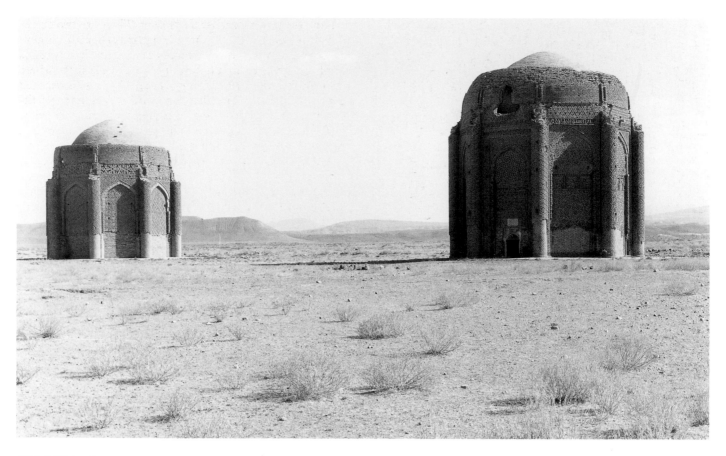

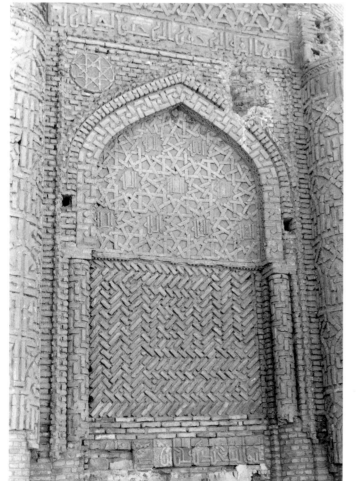

221. Kharraqan, mausoleums, 1067–68 and 1093

222. Kharraqan, mausoleum, 1067–68, façade

223. Kharraqan, mausoleum, 1093, plan and section

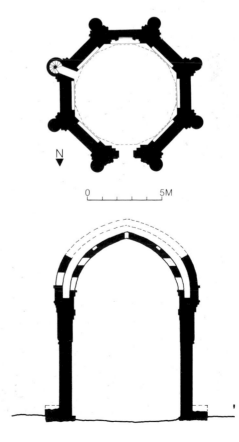

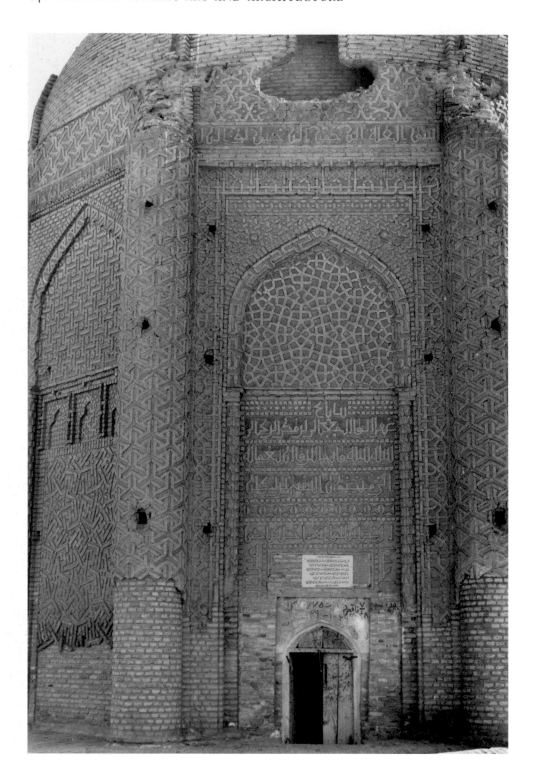

224. Kharraqan, mausoleum, 1093, entrance façade

drum, whereas originally it had the high-crowned shape of a typical Persian arch. We shall return to the elements of construction, especially the double dome and the octagon, meanwhile noting that, although the largest and most spectacular of Saljuq mausoleums, its plan and basic formal elements are quite simple and traditional.

A third group stands out both for its originality and because it incorporated many of the features developed in earlier mausoleums elsewhere in Iran. It is in the northwest of the area, more or less coinciding with present

Azerbayjan,[36] especially at Maragha and Nakhichevan, and dates from 1147–48 (the 'red' mausoleum at Maragha) to 1197 (Gunbad-i Qabud [227], also in Maragha). Circular, square, or polygonal, at times in stone, the tombs derive as much from the tower as from the canopy. They all have crypts, a novelty in Iran, and in almost all the façade is differentiated from the other sides by its shape or the extent of its decoration. Furthermore, many have preserved the names of their builders in official inscriptions.

A major innovation in Iranian mausoleums of the time is

225. Merv, mausoleum of Sanjar,
c.1152, general view

226. Merv, mausoleum of Sanjar,
c.1152, section

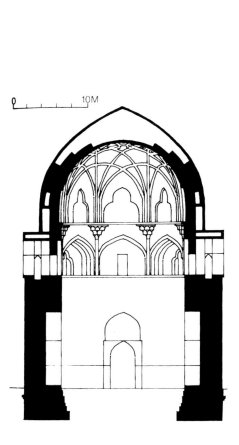

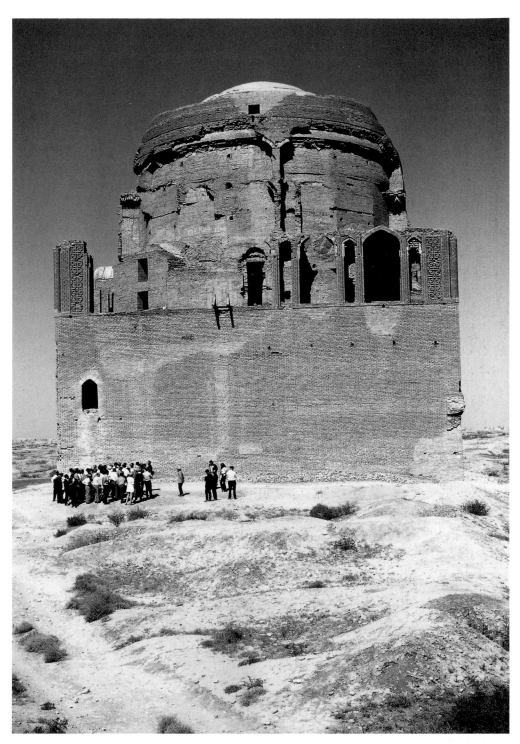

the *pishtaq*, the high and formal gateway which gives a single façade to the building. It seems to have had a Central Asian origin, since at Sarakhs [228] and Mehne in southern Turkmenistan such façades were added to mausoleums as early as the mid eleventh century [229].[37] It consists of two dissimilar projecting towers creating a sort of shallow *iwan* with a characteristic arch framed in a rectangle, at times serving to mask stairways to reach the gallery. At Mehne and Sarakhs the decoration is sober on all four sides, but later, for example at Uzgend (1152 and 1186) [230] and Urgench,

the growing complexity of mouldings and decorative designs accentuates the contrast between façade and side walls.[38] We can only speculate as to whether the façade-gateway was an aesthetic, ceremonial, or symbolic development; it may be related to a general increase in external ostentation which pervades much of this period.

The *pishtaq* illustrates what seem to be the essential issues of the Iranian mausoleums of the eleventh and twelfth centuries. The distinction between tower and canopy, so clear in previous centuries, tends to become blurred; but the differ-

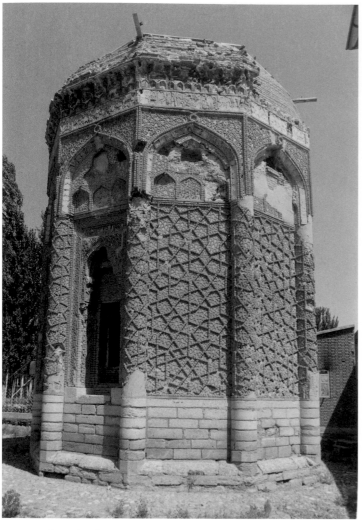

entiation between sides, their elaborate and varied orna-
mentation, and their range of structural complexity imply
that their architectural and aesthetic development is related
to that of contemporary building in general, while their
social and contextual meaning must be sought in religious
and cultural history.

Towers and minarets

Apart from congregational mosques and from mausoleums
(which are partly secular in character), most of what we
know of religious architecture in Iran derives from texts; no
madrasa, *khangah* (communal dwelling for mystics), or *ribat*
can be reconstructed. However there remain, from Bukhara
to Baku, Isfahan, and Afghanistan,[39] many unusually well
and carefully built tall towers, most standing alone [231, 232,
233], but some known to have been attached to mosques.[40]

The overwhelming majority consist of a simple cylindri-
cal brick shaft, at times on a square base; except for their
magnificent brick and stucco decoration (on which more
below), these thin towers could sometimes be confused with
modern factory chimneys. Anomalous types are found in
Afghanistan: the star-shaped *minaret* of Ghazni (early
twelfth century) [233], and the extraordinary one at Jam
[234] built by the Ghorid prince Ghiyath al-Din
(1153–1203),[41] where three cylindrical shafts of decreasing
diameter are crowned by a sort of small belvedere, the whole
reaching a height of some 60 metres.

None of the hypotheses proposed to explain the shape
and purpose of these structures is totally satisfying. Clearly,
many served for the call to prayer and were attached to
mosques, although their large number, heavy decoration,

227. Maragha, Gunbad-i Qabud, 1197

228. Sarakhs, mausoleum, twelfth century (?), plan

229. Sarakhs, mausoleum, twelfth century (?), section

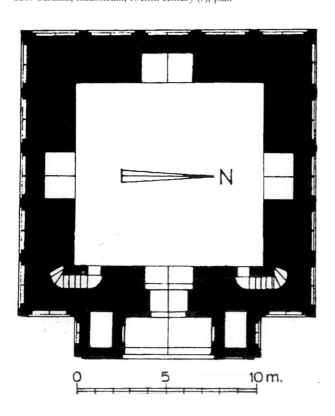

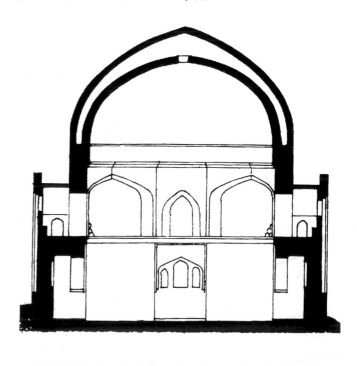

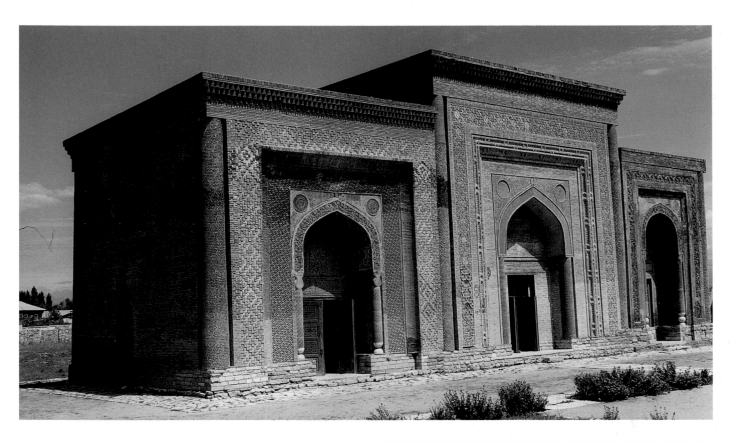

230. Uzgend, mausoleum, twelfth century

231. Bukhara, Kalayan minaret, 1127

232. Damghan, minaret, mid-eleventh century

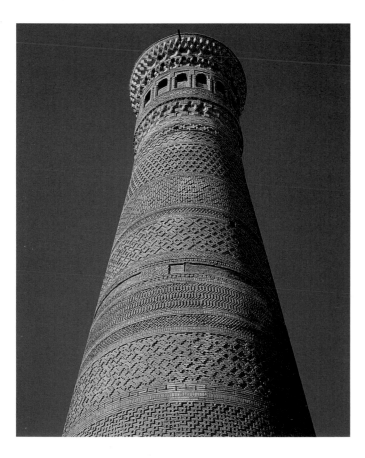

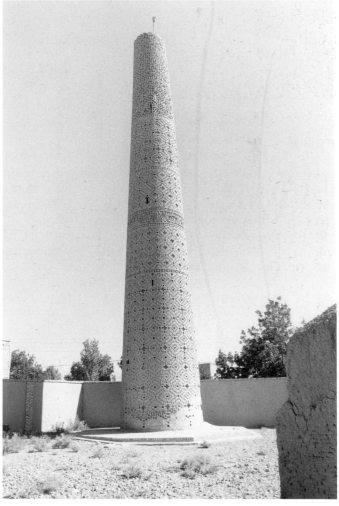

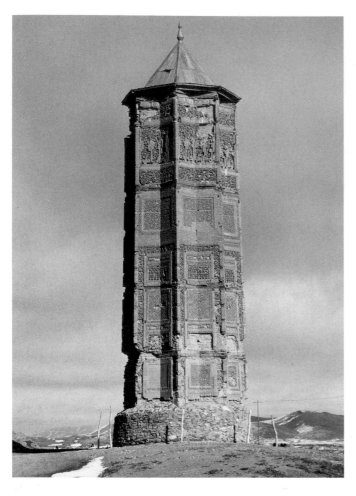

233. Ghazni, *manar* of Masud, early twelfth century

234. Jam, *manar* of Ghiyath al-Din, 1153–1203

height, and epigraphic emphasis on the piety of their patrons suggests that, like medieval chapels in western cathedrals, they may also have served as monumental expressions of individuals' devotion, or, like Italian campanili, as symbols of a certain family or quarter in town. In other instances, in particular at Jam, the setting excludes the possibility of a mosque near the minaret, and the rather unusual choice of Qur'anic quotations for the inscriptions suggests instead that the *manar* was a memorial to a prince and to his faith – perhaps indeed a victory tower. Others may have been simple landmarks, literally lighthouses (which is what the Arabic word *manar* means) built by the prince for the convenience of the traveller. This is the likely explanation for the towers on major roads such as those at Khusrawgird and Semnan in northern Iran; even the grand Kalayan minaret at Bukhara (1127) [231] could well be the beacon announcing the oasis from afar.

There is altogether something very puzzling about these towers, which spread to a few places in north and central Mesopotamia. Considerable effort was expended on them, their striking visual power has long been recognized, and yet their purpose is still obscure. Perhaps in fact a multiplicity of meanings were given the same form. Whence did that form come? The star-shaped towers could have had a pre-Islamic or non-Islamic origin,[42] but the thin or thick cylindrical tube on one or more levels may well have been an invention of the eleventh century.

Secular architecture

Compared with religious or partly religious monuments, secular structures are poorly preserved and badly known. Pugachenkova and other Russian scholars have attempted to reconstruct the main features of the great contemporary urban centres such as Merv,[43] with its central walled city (*shahristan*), its citadel (*arq*) astride a section of the walls, and its extensive suburb (*rabad*). Undoubtedly these and the traditional square (*maydan*) in front of the fortress appeared in other Iranian towns, but archaeological and textual research is still needed to find out how the better-known Central Asian examples were translated into western and central Iranian terms.

Central Asia also furnishes most of our information about private dwellings,[44] generally centrally planned square buildings. The governor's palace at Merv seems to have been rather small (45 by 39 metres), with a central court sur-

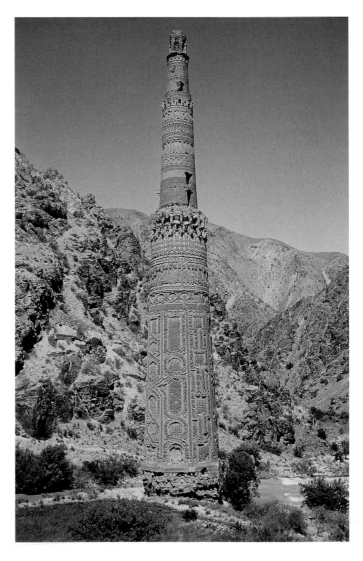

236. Ribat-i Malik, *c.*1068–80, reconstruction

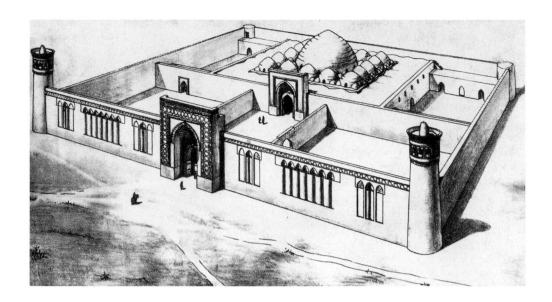

235. Lashkari Bazar (Qalah-i Bust), palace, eleventh century, plan

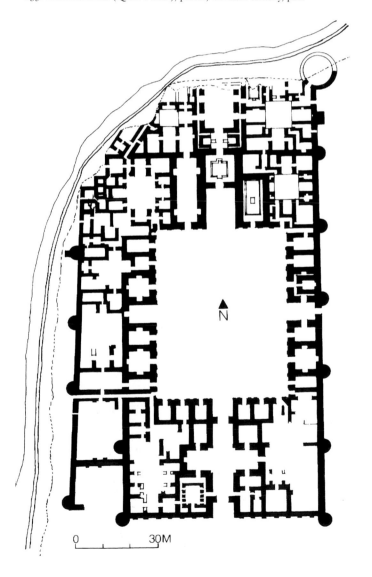

0 30M

rounded by four *iwans*. During extensive surveys at Lashkari Bazar in Afghanistan several villa-type buildings were identified, but in the absence of excavations they cannot be discussed in any detail.[45]

More is known about three very remarkable palaces, one at Tirmidh, datable to around 1030,[46] the second built by the Ghaznavids at Lashkari Bazar in the eleventh century, and the third at Ghazni itself.[47] None of these excavations has been published in its entirety. All three palaces are extremely important for the paintings, sculptures, and objects found in them, but the architecture of Lashkari Bazar is the best preserved and most easily accessible [235]. It is a large rectangle (100 by 250 metres) with additions on the north and west. Like older Islamic palaces such as Mshatta and Ukhaydir, it consists of an entrance complex (here cruciform), a courtyard, an audience complex on the entrance axis (here *iwan* and dome), and then a superb *iwan* turned towards the north overlooking the river, as, for instance, in the third-century palace at Dura-Europos on the Euphrates. A series of self-contained dwelling units with *iwans* were grouped around courts. Outwardly it resembles a fortified enclosure. Its decorative arches and recesses, and its basic divisions, continue older traditions – as does the peculiar throne room at Tirmidh with its two halls at right angles to each other, known at Samarra or in western Islamic palaces. The principal innovation in the plan of Lashkari Bazar is its systematic use of four *iwans* – one directly opposite the entrance – opening on courts, proving that secular monumental architecture had fully realized the planning and aesthetic possibilities of this arrangement as early as the eleventh century. Such palace compositions might perhaps be the source of the features which, at this time, came to characterize the new large congregational mosques.

The last group of secular monuments from the eleventh and twelfth centuries consists of caravanserais. Their appearance as a major architectural type is in itself an

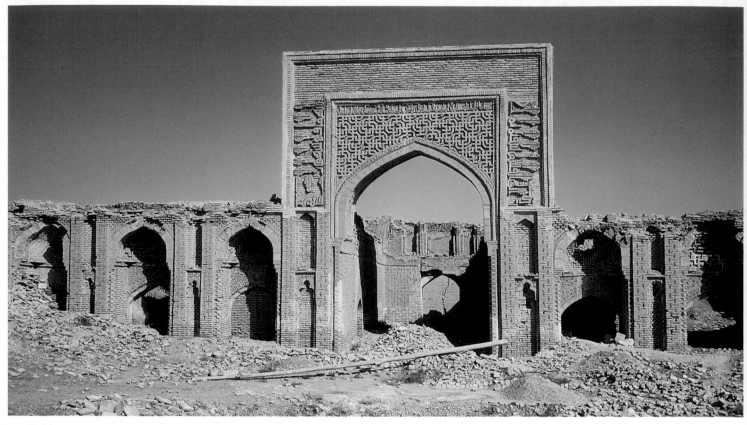

237. Ribat Sharaf, twelfth century

important testimony to the social and economic changes of the time. Of the earliest extant example, the superb Ribat-i Malik (*c*.1068–80) in the desert of Central Asia, a wall and a magnificent portal remained until quite recently. Its reconstructed plan [236] shows a domed pavilion at the back of the courtyard which is fascinating, but the evidence for which is lacking so far.[48] Its spectacular external wall surface, composed of half-cylinders surmounted by recessed brick arches, no doubt grew from earlier local practices.

Two other caravanserais should be mentioned: Daya-Khatun, of the late eleventh or early twelfth century,[49] and Ribat Sharaf [237], definitely of the twelfth.[50] Both are

almost square (Ribat Sharaf has an additional forecourt), with a superb monumental portal, a courtyard with a portico interrupted by an *iwan* on each side, and long vaulted or square domed rooms along the walls, at times arranged in small apartments. The significance of these buildings for the history of architecture is not only that they use the four-*iwan* plan found in mosques and palaces but also that in construction and decoration they show a variety and quality (about which more will be said below) which exemplify the care and importance given at this time to buildings dedicated to trade.

MATERIALS AND TECHNIQUES OF CONSTRUCTION

This survey of the major buildings of the huge area extending from the frontiers of China and India to Anatolia seems to suggest that the most active construction period in Iran began about 1080 and ended about 1160. The comparatively large number of buildings which have survived from a limited period leads to some tentative conclusions on techniques and methods of construction – tentative because, with a few exceptions,[51] no truly monographic studies have been undertaken, nor have repairs and restorations been catalogued, even for so central a monument as the mosque at Isfahan, whose 476 domes and vaults have not yet been properly published. Yet, for the history of the art of building, it is important to separate construction from the buildings themselves.

238. Ribat Sharaf, twelfth century, detail of decoration showing imitation brickwork

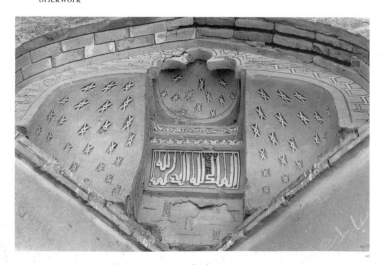

239. Ardistan, mosque, dome, eleventh and twelfth centuries

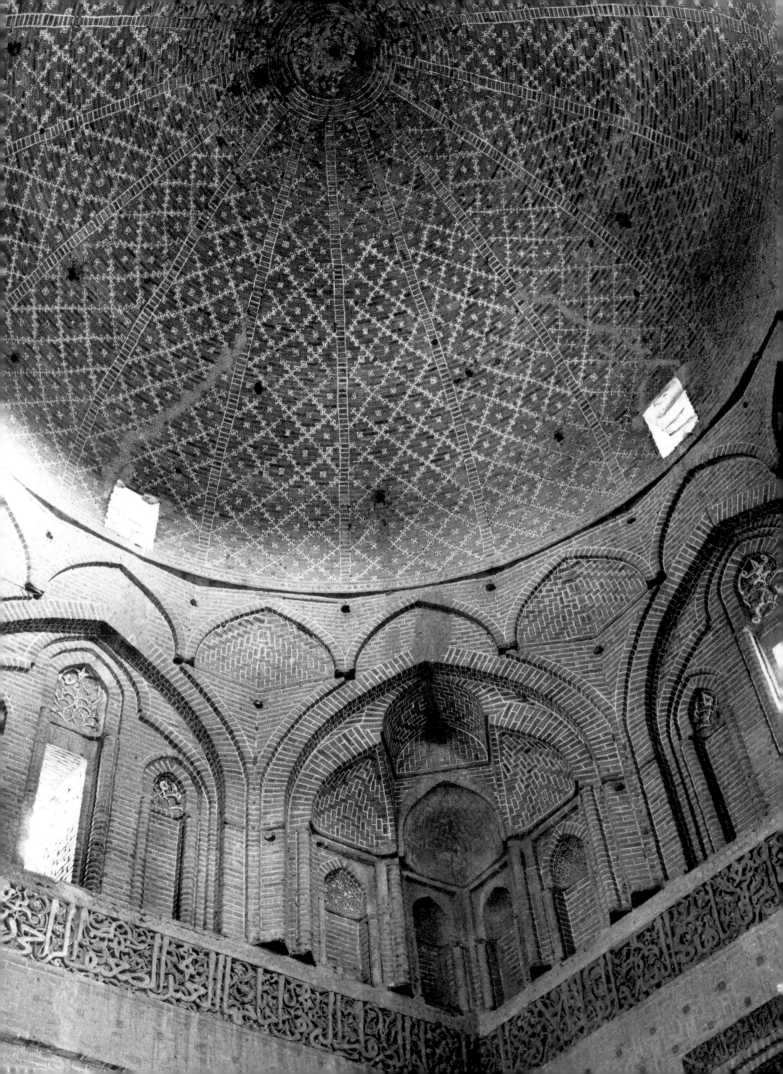

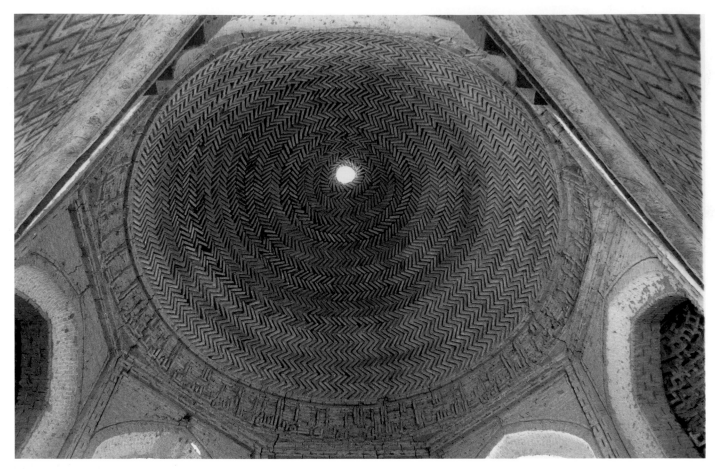

240. Sangbast, tomb, c.1028, dome

Materials

Ubiquitous as a material is high-quality baked brick. To be sure, unbaked brick, stone, and pisé are still used, but either in specific areas (for example stone in parts of Azerbayjan) or in rustic buildings and secondary parts of major monuments, particularly secular works. Elsewhere baked brick occurs throughout, in walls, vaults, and decoration. It is significant for its appearance even in areas such as central and western Iran, where it has hitherto been rare, but chiefly for the fascinating variety of its uses. At one extreme the outer walls of Ribat Sharaf and the mosque of Isfahan show quite simple patterns of horizontal layers whose variations enable one to distinguish the practices of masons from different provinces. The brick simply follows the lines and forms imposed by the architect and lends sobriety and strength. At the other extreme, on portals, on walls and vaults, on many mausoleums, and on some of the minarets, brick provided a rich and luxurious wall surface. At times, it gives a sense of constantly moving lines and forms partly, at least, independent of the lines suggested by the architecture. At other times, as in Damghan [232] or Bukhara [230], brickwork divides the building up into sections, each one with a different geometric design. These results were achieved in several different ways, but the brick used for decorative effect and to modify the impression of the wall is always the very brick used for construction. At Ribat Sharaf the stucco covering of the brick wall is carved with a motif imitating brickwork [238]. Even the interstices between bricks have played their part in defining the brick wall. They were left free, thereby creating a surface pattern of light and shade. Or they were filled with stucco and contributed a decorative effect of their own.

It is not clear why brick became such a favourite. Was it a revival of Sasanian techniques, as they had existed especially in Iraq and parts of Iran? Had the brick architecture known from as early as the tenth century in the northeastern provinces now spread across the whole of Iran? Or was it best suited to the need, especially in the west of the area, for the rapid erection of permanent religious buildings and for formal and technological experiments? Did some technical invention make brick cheaper to manufacture than before? There probably is no one explanation for the fact that from the eleventh century onwards baked brick became the most characteristic material of monumental construction in Iran. The forms it made possible were frequently translated into other media.

Supports and domes

Supports are comparatively simple. Columns as such are almost non-existent; piers, circular or polygonal, are more common, frequently so massive that they come close to being sections of walls. Similarly, the connecting arches

241. Sangbast, tomb, c.1028, squinch

242. Yazd, Duvazde Imam tomb, 1037, squinch

more often than not amount to small vaults. At times recesses relieve the piers or sections of walls, especially on court façades, but very rarely (as in a few exceptional *iwans* and in the northeastern dome of the mosque at Isfahan) do they represent a serious attempt to relate the form of the pier to the main features of the superstructure.

The heaviness and size of the supports are easy to explain if one considers that brick vaulting was the most common, if not the only,[52] mode of roofing. Barrel-vaults, usually pointed in section, covered rectangular spaces such as *iwans*; domes covered square ones. Of interest here are both the transition from square to dome and the actual means of construction. The first problem was solved in a bewildering variety of ways – five different ones at Ribat Sharaf alone,[53] at least three at Daya-Khatun.[54] These variations, whether they are the result of constant experimentation or of a virtuosity based on a mastery of basic principles, almost all depend on the squinch,[55] i.e. the arch or niche transforming the square into an octagon [239]. In many cases (e.g. Sangbast [240, 241], Qazvin) a simple traditional squinch arch is used, differing from earlier examples mainly in its greater size. But the most important modifications of the squinch are constructional and aesthetic. Two examples may serve to introduce what turns out to be a major innovation of Iranian architecture: the squinches of the northeastern dome of Isfahan, which are substantially similar to those of the southwestern dome in the same mosque and of most western Iranian domes [213, 214],[56] and those of the mausoleum of Sanjar at Merv.

At Isfahan there are two types of squinch, one a traditional high-crowned, four-centred arch, the other with three lobes corresponding to three sections of vaults: a central barrel-vault perpendicular to the arch, and two quarters of domes. Each section is carried down to the level of the square, the sides through a flat niche framed in a rectangle, the central one through a secondary niche over two flat niches. Instead of being a sort of half-dome in the classical tradition, the squinch now becomes a symmetrical combination of flat niches and sections of vaults which seem to buttress each other. This *muqarnas* system is not new – we have seen it in the second half of the tenth century at Tim in Central Asia.[57] The units of the composition are similar at Isfahan, but the rather flat, decorative, and uncertainly balanced Tim squinch has become a deep, architectonically meaningful, and perfectly poised and composed, element. The relationship to Tim is a clear indication of the eastern origin of the theme, but the question remains whether it was architects in eastern or central Iran (where the earliest instance of a *muqarnas* squinch known so far is in the Duvazde Imam tomb at Yazd [242], dated 1037),[58] which first transformed the awkward Tim form into a structurally meaningful one which gives the impression of a logical division of weight into five points on the square. It is unlikely that the dome was so heavy that it necessitated a division of the thrusts: rather, the *muqarnas* was a decorative feature in which architectural forms were so artfully used that they made sense as elements of construction as well as of ornament. In any case, the *muqarnas* squinch seems to have been a transformation of an originally northeastern decorative development which became popular in western Iran.[59]

The Isfahan zone of transition does not stop at the squinch. Above the octagon proper is a sixteen-sided area for which the name of squinch-net has been proposed.[60] A further step before the base of the cupola is logical enough in domes as large as Isfahan's; more interestingly, this sixteen-sided zone blends with the octagon because it is directly connected with a pendentive-like unit filling the spandrels of the squinches. The difference in plane between the eight recesses over units of the octagon and the eight over the spandrels gives a certain relief to this part of the wall and also serves to distinguish the octagon's units from each other.

The extremely logical organization of the zone of transition in Isfahan's northeastern dome was repeated in many other Iranian monuments of the time. The Isfahan room is remarkable because every single element of the construction of the transitional zone is carried down to the bases of the

piers through a system of articulation reminiscent of later Gothic piers. This involvement of the whole of the room in the logic of one part – not the dome proper but the area below it – is unique in contemporary architecture. In contrast to what has been argued, it is, sometimes, less important to search for possible relations with western forms of a century later than to explain why the device was never repeated in Muslim architecture.

The zones of transition in the west of Iran contrast remarkably with those of the northeast, where – as at Merv – the Samanid order of decreasing arches with a narrow window was still in use. There is a *muqarnas* at Merv, but in the spandrels of the octagon's arches, where it supports an atrophied sixteen-sided zone and can be related, at least genetically, to the column and capital of Tim and Bukhara. Here the themes of the transitional zone are much more traditional than at Isfahan, and the *muqarnas* is more strictly decorative. Elsewhere in Central Asia the same conservatism prevails, with occasional attempts at new formulas. It is this conservatism which may well have led to the frequent preservation of the gallery around the zone of transition, transforming domical constructions into two superposed masses, a cube and a dome, whereas in western Iran the zone of transition tends to be visible from the outside.

The methods of construction of the dome proper and of vaults in general pose more complex problems, for, in spite of a preliminary attempt by Godard,[61] much information is still lacking. The most important novelty, first encountered at Kharraqan, is the double dome in brick in which the two shells are not quite of the same profile and are connected by intermittent brick ties. Ultimately, the double dome probably derived from wooden architecture, but it has also been connected with the nomadic tents of Central Asia. The lightening of weight opened up new possibilities for the outer shape, and paved the way for the spectacular domes of the Timurid period.

Godard's study and M. B. Smith's careful examination of the Barsian and Sin domes confirm the visual impression produced by the domes of Merv, Isfahan, and Ardistan, and the barrel- and cross-vaults in some of the smaller mosques of western Iran. Lack of wood prohibited the systematic use of centring, so the masons created a network of brick ribs – generally covered up on the outside – which was slowly filled with bricks laid in a different direction. In the smaller domes the ribs were probably erected first, but in the larger ones they were constructed and filled in at the same time. Here two essential points must be made. First, the ribs are not functional because, once the vault is completed, their mass is integral with that of the rest of the dome, even when, as at Merv, they are in relief; they are meant for construction, not for support. Second, while sometimes the network of ribs is simple and straightforward, leading from the base of the dome to its apex, in other cases it forms decorative patterns of varying complexity. The masterpiece among complex domes is Isfahan's unusual northeastern pentagram [214].

Although their construction was simpler, the smaller domes of Isfahan, many of them redone in later times, and smaller vaults and domes in other contemporary monuments were usually built on the same principles as large

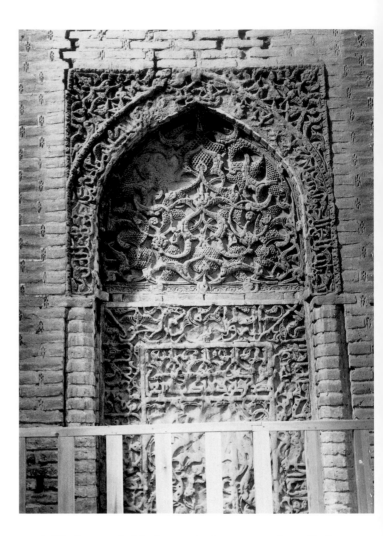

ones. Their remarkable feature is the great variety of minor modifications that the builders introduced into a few basic procedures standardized throughout the whole area.[62]

It is probably premature to draw definitive conclusions, but one thing seems incontrovertible: whatever the earlier history of vaults and domes in Iran and regardless of eccentric monuments like the Samanid mausoleum in Bukhara, the second half of the eleventh century is the earliest demonstrable time for the formation of a uniquely differentiated, highly original, and stylistically coherent (though extraordinarily varied) development of an Iranian architecture of brick domes and vaults.

There developed in fact an aesthetic of the dome, which alone among major forms – whether over a mausoleum or the *qibla* room of a mosque – was conceived primarily from the interior. Even though the introduction of the double dome portends change, and even though our contemporary taste leans toward the pure, undecorated lines of the exterior of Isfahan's mosque, undoubtedly architects at the time devoted most of their energies to the interiors, with their vibrant logic, their mathematical combinations, their decorative effects, and their *muqarnas*. A mere landmark from the outside, inside the Iranian dome is a haven from the brilliance of the sun; small wonder that it became accepted as the symbol of the most holy, the direction to prayer (the *qibla*) and the holy place (the *mashhad*). It thus joins a most ancient tradition of domical sanctuaries, but not before the

243. Ardistan, mosque, *mihrab*

244. Lashkari Bazar (Qalah-i Bust),
arch, early eleventh century

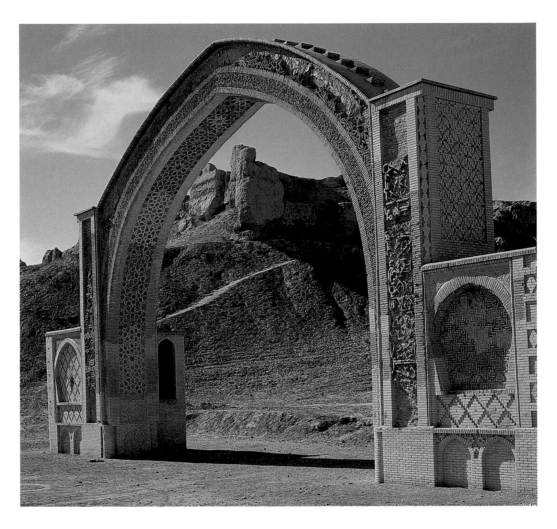

evolution of the faith and of its practice had led to it. One of these domes, the northeastern dome at Isfahan, may well have had more secular than religious purposes. The rare refinement of its composition and its decorative patterns indicate a designer of genius who was inspired by standard forms to create a work of art based on the most advanced and most inventive geometric reasoning. It has recently been suggested that it was the result of intellectual discussions directed by the great poet and mathematician Omar Khayyam.[63] His vision was not followed, either because contemporary technology was not equal to its complexity or because its private function did not make it available as a model until much later, when other tastes had emerged.

ARCHITECTURAL DECORATION

The architectural decoration of the eleventh and twelfth centuries is unusually abundant, varied, and difficult to interpret. The greatest monuments, like the domes of Isfahan, achieved a remarkable balance between architecture and decoration. Others, like some of the mausoleums and minarets, tended to subordinate architectonic values to ornamental effects, while the secular buildings of Central Asia and Afghanistan had rooms entirely covered with ornament. It remains to be seen whether there were regional or functional explanations for this variety of treatment, or whether there was simply an explosion of building activity.

As to the meaning of the decoration, the analyses of Bulatov and the school of Tashkent seem to have elucidated the complex geometric principles behind some of the designs, although very recent research has been critical of their results.[64] The complete or partial publications of Kharraqan, Jam, Tirmidh, Lashkari Bazar, and Ghazni has shown that, through writing or representations, certain ideas were expressed.[65] It is still uncertain whether the latter were exceptions, and whether the link between geometric design and mathematical thought was purely technical and mechanical or had more profound cultural implications. In short, the task of interpreting architectural ornament is still fraught with uncertainty and I shall limit ourselves to a traditional discussion of techniques and themes.

Techniques

The most original technique derives from the actual building materials. The most common is brick, which in Isfahan and in other mosques of western Iran provides some of the main decorative effects and about which much has already been said.

Painting was used both for its own sake, as at Lashkari Bazar, and to add colour to other media. In Khorezm especially, the decoration was in wood, either inserted carved wooden panels or wooden columns and capitals covered with designs. But the most significant technique of applied

245. Zavareh, masjid-i Pamonar, *mihrab*

ornament was stucco, the *gach* of Persian builders (usually *ganch* in Tajik, hence also among historians trained in the former Soviet Union). It appears everywhere, with considerable variations in quantity, purpose, and type. In the south-western dome of Isfahan [213] and in the southern *iwan* of Ardistan, the stucco on the brick spandrels of the octagon is a sort of veil thrown over the surface. At Ardistan [243], Lashkari Bazar [244], Zavareh [245], Merv, and elsewhere, on the other hand, the architects or decorators selected the *mihrab*, a composition of niches, a frieze, or a gate for isolated stucco covering. Finally at Ribat Sharaf, Tirmidh, and Jam there are walls where the stucco ornament virtually obliterates the architecture proper.

Thus the two main techniques, one relying on the brick construction itself, the other on the stucco covering to provide the ornament, seem to represent opposite approaches, although they often occur together in the same building. It seems odd that one, stucco, should have had a long history in pre-Islamic and Islamic art, while the other, brick, began in the tenth century and came to its full flowering in the eleventh. A comparison of the use of brick at Bukhara or of stucco at Nayin with the same techniques in the eleventh or twelfth centuries shows that, without sacrificing ornamental values, the Seljuq monuments in Iran more effectively subordinate their decorative effects to architectural ones. Of course this point is more obvious with respect to brick, but it suggests once more that in the eleventh and twelfth centuries architectural impulses were generally more powerful than ornamental ones.

One last category of applied decoration involved units prepared in advance and then set either in relief or more often as a sort of mosaic on the surface of the wall, between or over bricks, or on a bed of stucco. They were sometimes of terracotta, as on one of Isfahan's larger domes, on some of the towers from Afghanistan, and most commonly in Central Asia and Azerbaijan. The most interesting variants, however, are applied glazed tiles or bricks. The tiles are known today as *kashi*, a term which has been applied to the technique as a whole. The use of glazed ceramics in archi-

tectural decoration was to become one of the great characteristics of later Islamic art, especially in Iran but also in Anatolia and elsewhere. In Iran it certainly began in medieval times, but exactly where and in what form is less certain. The evidence studied so far[66] indicates that glazed faience, mostly turquoise-blue, was used as early as the eleventh century at Damghan and Kharraqan, and most spectacularly in the Azari mausoleums of Maragha and Nakhichevan. However, except for a number of magnificent *mihrabs* found in museums all over the world and of bands of inscriptions executed in glazed tiles, this new dimension of colour was still used in a very subdued manner and aimed simply at emphasizing certain decorative lines, not yet at transforming the whole wall surface.

Themes

In the absence of monographs dealing with individual monuments,[67] it is idle to try to enumerate the themes of decoration used in Iran in the eleventh and twelfth centuries, to identify their source, or even to discuss the principles of architectural ornament as a whole. Of the few attempts at generalization so far made, some merely analyse a small number of individual monuments, and others treat only restricted aspects of the decoration or deal with very limited areas.[68] The few which have attempted broader conclusions have usually done so in an ahistorical context.[69]

Much of the decoration, especially in mosques, followed the lines of the architecture or filled wall spaces provided by the construction. The first type consisted either of long straight bands separating one part from another or of curved lines following arches or vaults. The second covered spandrels, tympani, units of *muqarnas*, or square and rectangular panels, and was on the whole related to the architecture. Sometimes, however, motifs develop independently of any structural necessity; for example, each of the cylindrical units of the brick minarets is decorated separately, and the Jam minaret – simple in itself – is almost entirely covered with complex ornamental brick and, especially, stucco.

In mosques and other religious buildings there are two areas which traditionally merited spectacular decoration: the *mihrab* and the newly developed *pishtaq*. Both had several planes and recesses, and the decorative composition was probably expected to suggest something of the movement of the architecture. Finally, in palaces and in some other buildings both secular and religious a flat wall would be entirely covered with decorative designs; usually, as for instance at Tirmidh,[70] the decorator preferred to divide the area into polygonal units.

The great variety of available shapes ultimately resolves itself into two groups: long bands whose width, length, and direction are either imposed by the lines of the architecture or (as in the minarets) serve to subdivide the larger decorated areas, and the surfaces so outlined. The bands mainly consist of simple geometric patterns, or of inscriptions in brick and stucco. On the larger surfaces writing is used more rarely, but there are more complex figural elements as well as geometric and vegetal ones. Most of the decorative vocabulary, however, and the main principles of composition apply to both types of surface.

246. Tirmidh, stucco of monster

247. Court official, thirteenth century. Painted stucco relief. Detroit Institute of Arts, H. 101.6 cm

The overwhelming principle of decoration is geometric. In its purest form it appears on the superb brick minarets and mausoleums, but it is present also in the stuccoes of Tirmidh and in the vegetal compositions of the Jam minaret and most *mihrabs* in western Iran. According to the painstaking work accomplished by L. Rempel and M. S. Bulatov, the key figure is the circle. All polygonal figures are related to each other through the circles inscribed in or circumscribing them; in other words, by means of a ruler and compass the motifs can be reduced to a geometric network whose points of intersection are determined either by the complex rules of division of the circumference of a circle or, on certain occasions, by the Golden Mean, although the conscious use of the latter has been questioned by investigations into the practice of architects and mathematicians.[71] Once the geometric network is established, the artisan uses other themes to fill in the spaces or to introduce more flexibility and suppleness. At times the geometric line itself is broken so as to create a star at the centre of the composition, but usually it is vegetal forms that impart movement and life. Themes of Abbasid origin were still used or revived (especially Samarra Styles B and C), but the most common, as in the Ardistan *mihrab* [243], is an arabesque of stems and leaves (usually half-palmettes) of varying degrees of elegance. The arabesque always has a clearly defined axis of symmetry, but the best develop on several repeatedly intersecting levels, thus creating movement in depth. Furthermore, the vegetal forms themselves, especially in the bands, may bear a network of geometric designs[72] as decorative supports for inscriptions. Their stylistic evolution has

not yet been charted, except in the case of a few of the Ghaznavid and Ghorid monuments.[73]

Thus, the architectural decoration of the monuments of the eleventh and twelfth centuries could perhaps best be defined as a dialogue between the basic geometry and the lively movements of a vegetal arabesque. Moreover, as with a Chinese box, analysis produces several different levels of motifs, from the first axis of symmetry to the last single dot of a punctured leaf. Consistent with principles already developed in Samarra's third style, the composition consisted of an abstract relationship between lines, notches, and planes; the dynamism of motifs controlled by an unexpressed modular system gives visual force to the best designs. An equilibrium is created between the living models from nature and the abstraction of human geometry. The extent to which this contrast was intellectually realized at the time is still unknown,[74] but it is probably not an accident that it was the age of the popularization in practical manuals of the high mathematics of the eleventh century. Few periods can offer in one region the contrast between the clear patterns of the brick style of the Damghan minaret [232], the geometric sophistication of the Bukhara minaret [231], and the overwhelming wealth of decoration of the *mihrabs* at Ardistan and Zavareh [244, 245].

Figural themes occur exclusively in secular art. At Tirmidh [246] looms an extraordinary monster with a single head and two bodies, whose origin may perhaps be traced to older images of Central Asia, but whose treatment here as a symmetrical composition recalls contemporary arabesque designs. A large number of almost life-size stucco sculptures

248. Delhi, Qutb Mosque, thirteenth–fourteenth centuries, view towards the sanctuary

249. Delhi, Qutb Mosque, thirteenth–fourteenth centuries, plan

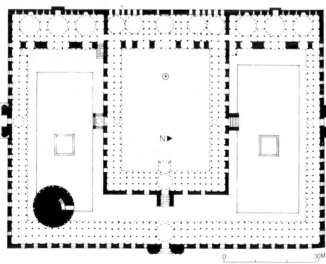

of individuals [247] – usually princes or princely attendants – and of scenes of courtly life have also been generally attributed to the Saljuq period of Iran, and more particularly to Rayy.[75]

The last decorative motif to be mentioned is writing. Ubiquitous, it appears in all techniques and in several styles relatable to the styles of script developed at the same time in other media and discussed in a following section of this chapter. Two aspects of writing are directly pertinent to architectural decoration. One is its use as a compositional device at the base of domes or around ornamental panels. The other is its varied semantic function: in the Jam minaret it proclaims the mission of Islam and thus gives a concrete meaning to the tower. In many mausoleums and minarets it identifies a patron, or indicates a date; at Qazvin it comprises a long *waqf* document about properties endowed for a pious purpose, and at Ghazni it is in Persian and provides the text of an epic poem.[76] Proclamatory, indicative, or informative, writing has now become the most specific vehicle for the transmission of at least some of the meanings and uses of architecture.

It is difficult to draw conclusions in the present state of our knowledge of eastern Islamic, primarily Iranian, architecture in the eleventh and twelfth centuries. Building energy was intense, and tremendous numbers of mosques, mausoleums, palaces, and caravanserais were erected, from the steppes of Inner Asia to the Caucasus and the Zagros, illustrating both the wealth and growth of Iran, and the range of new social needs as Islamization was completed. Innovations are more significant than the reuse of elements from preceding centuries. Predominant are the court with its four *iwans*, the monumental gate, new techniques of construction, baked brick, the spread of the round minaret, the new and logical *muqarnas*, the 'brick style' of the decoration, the double domes, the ornament and its new tensions between geometry and vegetal themes, and a reappearance of figural sculpture – all of which left a permanent imprint on later Iran and on contemporary architecture elsewhere.

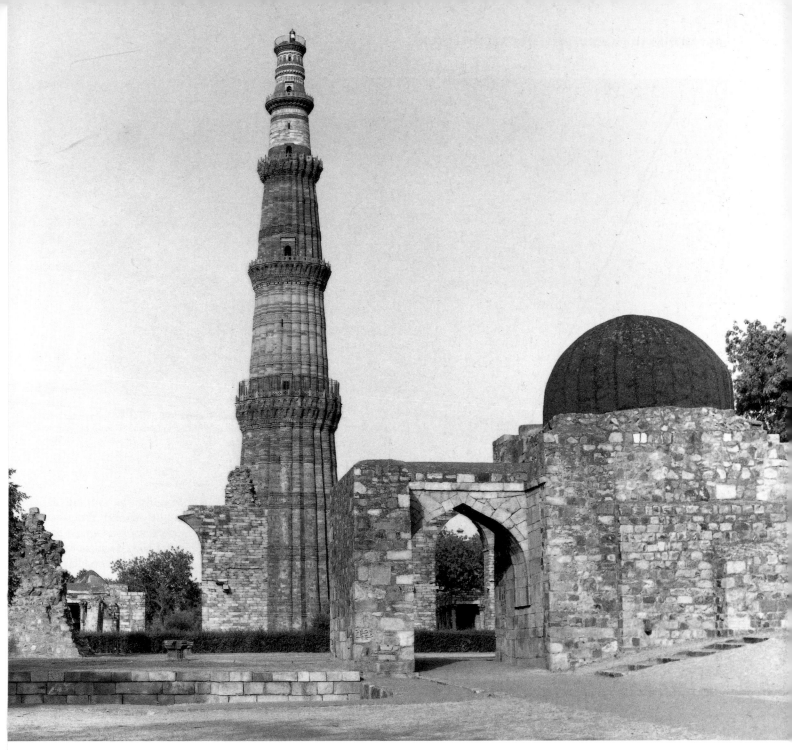

250. Delhi, Qutb Mosque, *manar*, 1201–early fourteenth century

The great mosque of Isfahan, the mausoleum of Sanjar, the minaret of Jam, the decorative designs of the Haydariya at Qazvin and at Ardistan and Tirmidh, and the mausoleums at Kharraqan are masterpieces in which a fascination with decorative effects went hand in hand with a remarkable ability to create new forms from available material. The unremitting search for new formulas, higher domes, and a more significant decoration is to a certain extent comparable to contemporary activity in western Europe. This is an architecture in full movement that will be restrained somewhat by internal political dissensions in the late twelfth century which affected the availability of patronage, and then will be halted by the Mongol conquest.

INDIA

Muslim conquerors reached the Indian subcontinent as early as the first decades of the eighth century, and the province of Sind, at the mouth of the Indus river, has remained Muslim ever since. Between 1001 and 1026 the Ghaznavid Mahmud led several expeditions to establish Muslim rule in northern India. The major centres of the Ghaznavids, however, and of the Ghorids who followed them, were in Afghanistan, and India was mostly a source of booty and wealth to enrich their constructions and collections there, as is amply demonstrated by the objects excavated at Ghazni.[77] Indian monuments were systematically

ondary interstitial design often of a vegetal nature, but sometimes consisting of small animals. The stark, monumental grandeur of the early Iranian silks [202] has, however, given way to a much denser, small-patterned arrangement. There are often more than the traditional one or two animals in the centre of each circle, and, in addition, vegetal forms serve as central axes and as background fillers [251]. Calligraphic decoration consisting of one, or occasionally two, lines of fine angular script often plays an important part as well [252].[85] In addition to the popular organization into roundels we have been able to follow from early in the Islamic period, extant medieval Iranian silks also exhibit the detailed and sophisticated patterns for which they were so renowned arranged within geometric strapwork.[86] So far it has not been possible to assign any Iranian

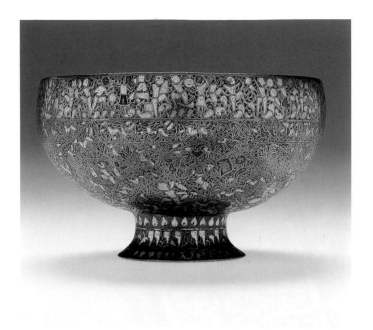

253. Copper-alloy ewer with traces of silver inlay, Ht. 29.5 cm. Metropolitan Museum of Art, New York

254. Copper-alloy footed bowl with silver inlay, Ht. 26.7 cm. Cleveland Museum of Art, Cleveland

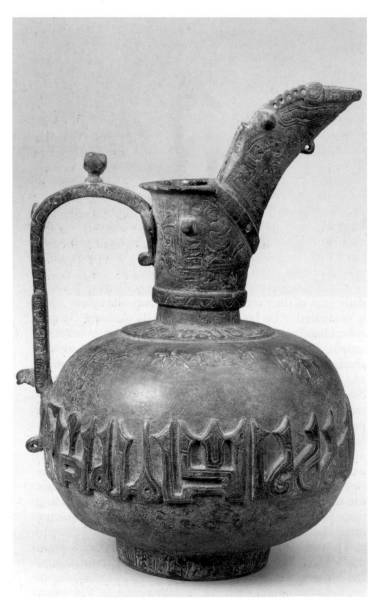

textiles of this period to a specific locality, except for *tiraz* fabrics on which the city of manufacture is mentioned; this is all the more regrettable in that the medieval sources mention many such centres.

Although a very large number of metal objects, especially those in silver and gold, have been destroyed by corrosion, melting down, and other abuses, many more objects in this medium have survived from the eastern Islamic lands during this period than in that of textiles – the latter medium being even more perishable and easily cut up as well. The quantity of well-preserved vessels and utensils in a myriad of differing shapes is impressive: bowls, caskets, boxes, inkwells, penboxes, buckets, ewers, flasks, bottles, jugs, rosewater sprinklers, and strong boxes. Then there are trays and mirrors, as well as objects as diverse as keys, locks, lamps, lampshades, candleholders, incense burners, mortars, tray stands, bottle supports, pumice-stone holders, astrolabes, and celestial globes, as well as more unusual types, like animal-shaped incense burners and aquamaniles. Although they must have existed, the arms of this period such as helmets and swords, and the body and horse armour, unfortunately also seem to have all but disappeared,[87] along with braziers, window grilles, and drums.

Copper alloys were the most common materials, by far. Silver vessels with parcel gilding and designs in niello have also been preserved. When coinage is excluded, gold – with very few exceptions – survives only in jewellery, though, to judge from literary references and from the number of personal names incorporating the designation 'goldsmith', its use must have been fairly common.

The most remarkable aspect of the metalwork from the eastern Islamic lands during this period is the variety of decoration, even on a single piece. It has been suggested that this is attributable to the growth at this time of a strong

bourgeoisie in northeastern Iran that created a more varied patronage – one that sought to express many more social, personal, ethnic, literary, sectarian or other needs than did the more consistent and traditional patronage of princes. In other words, the middle class in this part of the Muslim world rose to a level of affluence and cultural power that permitted it to impose new forms and subjects on the arts. Lucrative commercial activities had given rise to a wealthy urban merchant class whose members showed a proclivity for purchasing manufactured goods. This, in turn, lead to high levels of production that spawned a wealthy artisan class as well, for these items were comparatively expensive. The large quantity of objects extant starting from around the middle of the twelfth century has been attributed to the impact of a 'bullish' economic situation which brought

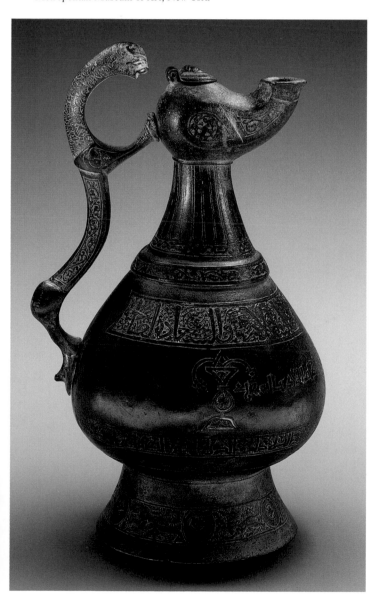

255. Copper-alloy container with copper and silver inlay, Ht. 18.4 cm. Metropolitan Museum of Art, New York

about what has been called an 'artistic explosion'.[88]

For the next century or so, considerable changes are manifested in the art of the object. Not only did the quantity of objects vastly increase but the surfaces of utilitarian objects were literally transformed by animated decoration that is generally well spaced and perfectly suited to the underlying shape. The motifs are organized according to simple rhythms or in bands of almost equal size and importance. Prominent among these designs are animals, framed singly or in friezes; after the middle of the twelfth century human figures appear also in individual scenes or in elaborate friezes of revels and hunting. Only on a few deliberately showy pieces such as the bath bucket [257, 258] is the decoration crowded, but there the intent was to impress the viewer specifically with the wealth and density of the motifs.

Inscriptions occur on nearly every object. They usually consist of a sequence of anonymous wishes, but sometimes they provide important information about patrons, makers, and dates – though hardly ever about places – of manufacture.[89] They are mostly in an angular script [253],[90] including the very complex plaited variety that is often difficult to decipher, but some are in simple *naskh* or are of the novel anthropomorphic and zoomorphic kind [254].[91] Inscriptions are usually given the same emphasis as the other types of decoration. Geometric designs were also popular and are found either as individual motifs or – as can be seen on the so-called Wade cup [254] – as narrow strapwork often framing and connecting individual motifs.

Chasing was the most common technique used for decorating copper alloys, particularly before the middle of the twelfth century. Openwork was popular for such pieces as the bases of candleholders and tray stands, and for incense burners it was imperative. Relief, achieved mainly by means of casting in moulds, and often combined with chasing, was the usual technique for mirrors and mortars. Another, less common technique which offered additional variety was the solid casting of animal figures to serve as handles or decorations for handles [255], lids and spouts and as feet for small dishes and other utensils.[92] Repoussé was limited primarily to friezes of lions, fantastic animals, or birds and to the fluting and faceting on a group of late twelfth-century candleholders and ewers made in Herat – in that part of Khurasan that is now in western Afghanistan [256].[93]

This last object is also a beautiful example of another technique, which came to the fore about the middle of the twelfth century, namely the inlaying of metals with silver, red copper (which appears to have been discontinued about 1232), and, after 1250, gold.[94] It had been used early in the Islamic epoch [91, 100], but it appears not to have been common in the intervening period.[95] Its sudden reappearance on a grand scale was apparently a result of the new affluence in the large mercantile cities of northeastern Iran already discussed, and it reflected the urge for conspicuous consumption among the *nouveaux riches*. Indeed, one of the showiest early pieces, a bucket [257, 258], was made in 1163 by two artisans, a caster and a decorator, in Herat as a gift for a merchant. As such vessels were used in the public baths, the happy owner must have had ample leisure to study its elaborate decoration and to show it off to his friends.[96] The technique involved more than simple incrustation with silver

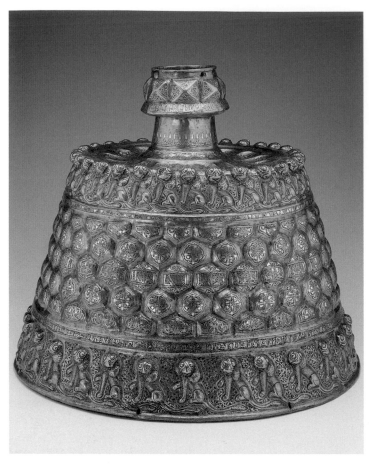

256. Copper-alloy candlestick with inlay of copper, silver, and black organic material. Datable to last quarter twelfth century, Ht. 40.3 cm. Freer Gallery of Art, Washington, D.C.

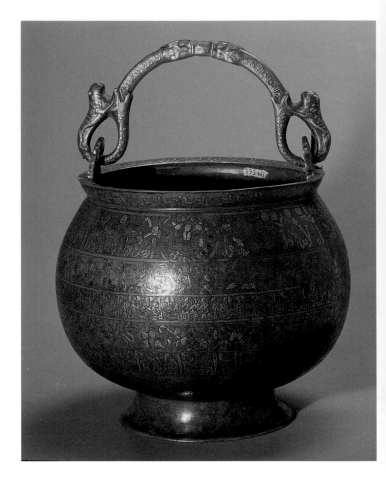

257. Copper-alloy bucket with copper and silver inlay, Herat. Dated 1163, Ht. 18 cm. Hermitage, St Petersburg

258. Detail of Figure 257

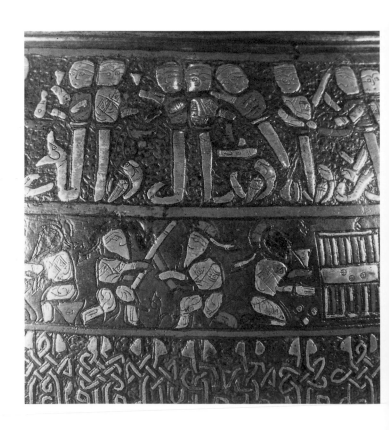

wires or pieces of sheet, however; the latter were also carefully chased with the finer details of the design, such as facial features and garment folds. As on this bucket, a number of metal objects made during this period were signed by the artisans who made them and, upon occasion, more than once. At this juncture, we are unable to ascertain the reasons for the strong feelings of self-importance, pride, and esteem such signatures would connote.[97]

In spite of the wealth of surviving material, which includes a limited number of dated pieces, it is still not possible to give a detailed account of the stylistic development *vis-à-vis* metalworking in the eastern Islamic lands during the Medieval period. As in other media, bolder designs and a sparser use of the available surface for decorative purposes generally reflect an early stage. The advent of inlay work, however, gradually led to more tightly packed all-over designs on a reduced scale, resulting in densely textured surfaces reminiscent of textiles [259].[98]

There was also a conservative undercurrent, best seen in a unique copper-alloy sculptural group made in 1206, apparently for an Iranian lord [260].[99] It represents a zebu cow nursing a calf; a diminutive lion has leapt on to the cow's back to serve as a handle. The main group is reminiscent of Sasanian aquamaniles as well as those made in the central Islamic lands during the Early period [100]. It is not

259. Copper-alloy lidded inkwell with silver inlay, Ht. 14.6 cm. Metropolitan Museum of Art, New York

260. Copper-alloy aquamanile with silver inlay. Dated 1206, Ht. 31 cm. Hermitage, St Petersburg

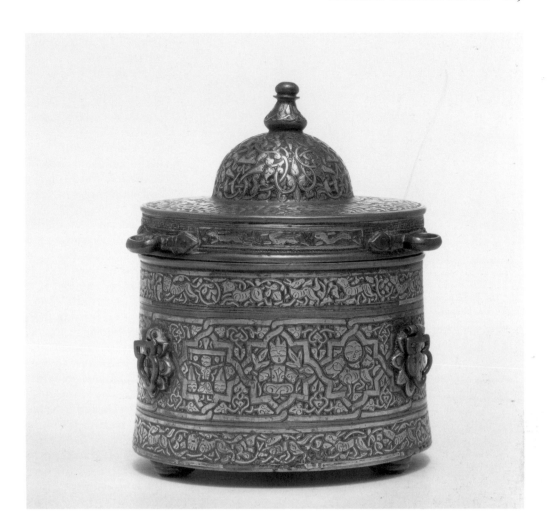

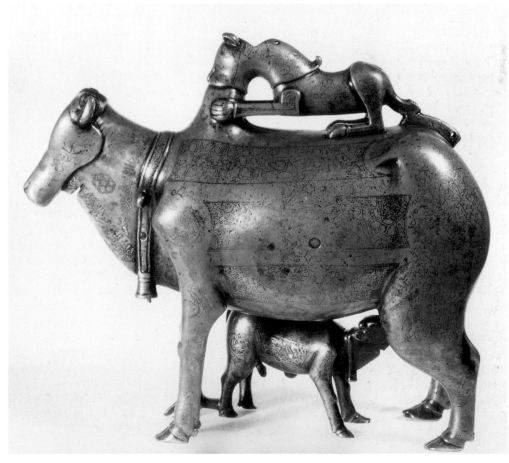

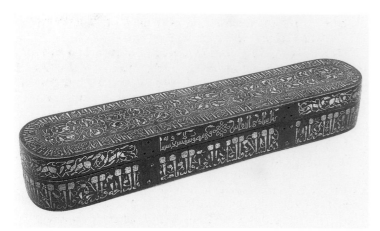

261. Copper-alloy pencase with silver inlay. Dated 1210, L. 31.4cm. Freer Gallery of Art, Washington, D.C.

262. Parcel-gilt silver bowl. Datable between 1198 and 1219. The Keir Collection, London

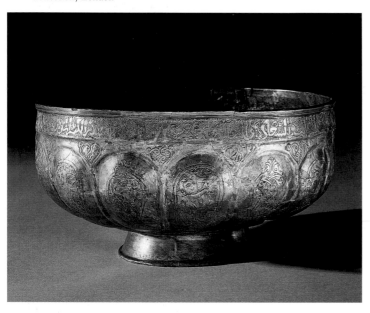

clear whether such an object is the result of a simple continuation of Sasanian metal traditions in the area or shows an attempt to emulate the long-admired and often-adopted or often-adapted Abbasid traditions. The motif of the lion attacking the bovine is even older. It may have been an astronomical symbol in prehistoric times; by the Achaemenid period, or perhaps somewhat earlier, it had been adopted as an emblem of royal power.[100] The seemingly awkward disproportion of the two animals and the transformation of the original bull into a nursing cow demonstrate on the one hand a weakening of these old traditions concomitant with a reduced sculptural sense, as witnessed by the use of figural inlay work in silver on the body of the cow, negating its basic form, and the stirrings of a greater realism on the other.[101] The persistence of such traditional forces in the eastern Islamic lands, even at the end of the Medieval period, is in stark contrast to the overwhelming majority of well-integrated, fully harmonious pieces in which these conflicting historical forces have been successfully fused. The end result was a novel style whose development was interrupted

at a critical moment in Iran itself by the Mongol invasion; we shall see in the following chapter, however, that in the Jazira and in Syria it was to reach its full flowering.

Khurasan was the main early production centre for metalwork in Iran; as we have seen above, Herat is specifically mentioned on the *hammam* bucket. It is also found on a ewer produced twenty years later, in 1181.[102] The *nisba* 'Haravi' ('of Herat') occurs as well in the artist's signature on an inkwell of about 1200. There are pieces with the signatures of masters from Isfarayin and Nishapur, also in Khurasan, and the pencase of 1210–11 may have been made in Herat [261].[103] Herat, Nishapur, and Merv were sacked by the Mongols in 1221 and Herat again in 1222; other northeastern centres suffered a similar fate.[104] These disasters brought about the flight of many artisans to western Iran and particularly to the Jazira, where their designs and techniques contributed to the development of a new style of inlaid metalwork which, in turn, had an important impact on that executed in Syria and Anatolia.[105]

The Iranian copper-alloy objects made before the Mongol invasion were apparently destined for a broad clientele, who must have gone to the bazaars to buy anonymous works inscribed with general eulogies.[106] Courtly pieces, as for instance the silver-inlaid pencase of 1210–11 made for the grand vizier of a Khwarezmshah in Merv just discussed [261], seem to have been hardly superior in artistic quality and technical finesse to those made for the merchant classes. Indeed, a footed cup with purely epigraphic decoration made for another eastern grand vizier is a rather modest, though dignified, piece, entirely lacking the splendour of many anonymous objects.[107] That the finer pieces were highly regarded, however, can be assumed both from their self-laudatory inscriptions (such inscriptions being common on Persian objects but not on those from other areas of the Muslim world) and from the frequency with which craftsmen signed their works. One – not even the best – is inscribed with no fewer than four stanzas, including the following lines:

> Nobody can find anything to match this ewer
> Because there is nothing like it . . .
> All the seven heavenly bodies, however
> Proud they may be,
> Protect him who makes an object of this kind.[108]

Besides the numerous copper-alloy objects, a considerable number of silver vessels have also survived, comprising jugs, rosewater sprinklers, cups, bowls, spoons, trays, boxes, and incense burners. In form and decoration there are obvious connections with work in copper alloy, but in some aspects they are unique, reflecting relations with other luxury media. The shapes of long-necked rosewater sprinklers, for example, echo those of contemporary facet-cut and bevel-cut glass versions, whereas rectangular covered boxes may be connected with earlier containers made of ivory. Occasionally, just as in pottery and in the base metals, there was a deliberate use of Sasanian motifs, reflecting a particularly strong traditionalism in silver work. The bowl from western Iran datable between 1198 and 1219 [262], on the other hand, is reminiscent in its shape of slightly earlier footed bowls from the Byzantine realms.[109] As was the case

263. Gold armlet. Datable to first half eleventh century, Ht. at clasp: 50.8 mm. Metropolitan Museum of Art, New York

on copper-alloy objects, chasing was the most important decorative technique, but niello also played a major role, analogous to that of inlay on objects of baser metals; further colouristic enrichment was achieved by partial gilding. Repoussé and cast ornamentation were rather rare.

Niello occurs also – but rarely – on gold jewellery, of which much has been preserved; it is found, more often, on silver items of adornment, considerably fewer of which are extant. The major decorative techniques for jewellery of the Medieval Islamic period, however, were granulation and – especially for openwork – filigree. Bracelets [263], rings, earrings, necklace elements, hair and headdress ornaments, and pendants are known, as are amulet cases.[110] The vogue in the eleventh century for such ornaments is corroborated by the colored drawings in the early copy of al-Sufi's *Book of the Fixed Stars* discussed and illustrated in the previous chapter. As many jewellery items depicted in this manuscript can actually be identified among those pieces that have survived, it should be safe to assume that many of those items represented of which no extant examples exist can also be considered to be actual depictions of ornaments in vogue in the early years of the medieval Islamic period, thus considerably broadening our knowledge of the art of personal adornment during this period.

Another medium which aids us in filling the gaps in our knowledge of the art of personal adornment and costume of the medieval period in the eastern Islamic lands is stucco, namely, the group of reliefs with painted decoration – one of which was seen earlier [247]. Each of these figures serves to flesh out for us the picture of the dress and accoutrements of the elite military corps serving as the sultan's personal guards in the eastern Islamic lands during the early medieval period. Another such relief [264], that still retains much of its polychromy, provides a particularly clear depiction of the bejewelled scabbard, the headdress and the jewelry items at both the neck and ears of this young warrior; and, the details of his yoked overgarment exhibiting side edges decorated

with pearls and square gems and *tiraz* bands on the sleeves are carefully delineated as well.

The objects executed in the ceramic medium in the eastern Islamic lands during the medieval period constitute the richest and most extensive of all the surviving array of production in this area at this time, their numbers running into the thousands. They also differ from the preserved specimens of other media in that they reflect a broader clientele.

At one end of the spectrum are vessels made for royal patrons and inscribed with the full panoply of official titles, though sometimes the owner's exalted status is implied only by the deluxe technique and the iconography of princely leisure activities or heroic exploits.[111] The architectural decoration executed in this medium is also outstanding. Since it was intended for the mansions of the well-to-do and for mosques and mausoleums endowed by wealthy patrons,

264. Painted stucco figure, Ht. 1.194m. Metropolitan Museum of Art, New York

In shape and decoration such ware is closely related to a type of lustre-painted ware which exhibits what Oliver Watson has, for good reason, termed the monumental style. As was suggested above, there are strong arguments for proposing that this first important lustre production in the eastern Islamic lands – concentrated in the pottery-producing centre of Kashan in central Iran – arose from the influx of potters from the declining court of the Fatimids, where both lustre-painted designs and motifs reserved from the lustre ground were known (see Chapter 6).[120] Decorated with bold and spirited designs of animals or princely figures, which, together with large arabesques, were reserved in white from a deep lustre background [269], the scale of these early pieces, as well as their vigorous draughtsmanship and real or potential movement was never again to be equalled.

Most probably contemporary with the lustre-painted objects in this monumental style are those in what Watson has called the miniature style. The ceramists who created the majority of the pieces in this category appear to be less in control of their medium than those working in the same city who executed objects in the monumental style. The inspiration for this group's small-scale motifs – arranged in a series of panels and friezes – is provided by manuscript illustrations and the scale and repetitive nature of the designs together with the bichrome colour scheme gives the decoration a rather untidy or confused appearance [270]. A

269. Glazed and lustre-painted composite-bodied bowl, D. 20.3 cm. Metropolitan Museum of Art, New York

270. Glazed and lustre-painted composite-bodied dish. Dated 1191, D. 38 cm. Art Institute, Chicago

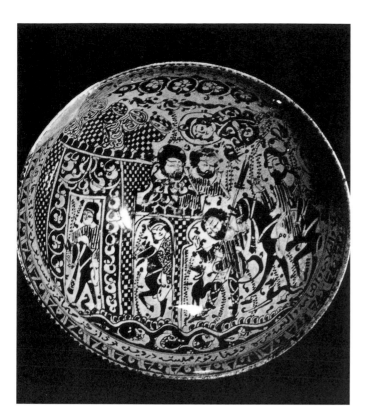

271. Glazed and lustre-painted composite-bodied bowl, Kabul Museum

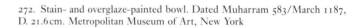

272. Stain- and overglaze-painted bowl. Dated Muharram 583/March 1187, D. 21.6cm. Metropolitan Museum of Art, New York

rare, and usually finer, sub-group of this category exists that Watson has termed the large-scale miniature style. The representative bowl [271] bears an as yet unidentified scene of a dignitary entering a town accompanied by two mounted attendants and one on foot armed with spears. What appear to be two saluki dogs are part of this procession, which is viewed from a gate by two men and four veiled ladies. Perhaps the scene depicted on this extraordinary bowl should be seen as an example of what has been called a private image.[121] Such vignettes serve in much the same way as family photographs. They are souvenirs of an occasion familiar to a small group. The dated objects in this miniature style category as a whole range from 1179 to 1194.

This miniature style was employed also for many of the objects decorated in the so-called *mina'i* technique, the myriad of colours used on this ware greatly aiding the resolution of the detail. Single images and larger-scaled motifs are also found on these vessels, which are probably the most luxurious of all types of ceramic ware produced in the eastern Islamic lands during the medieval period. The large-scale miniature-style bowls in particular are closely related to a group of *mina'i* bowls designated 'Muharram' bowls owing to the occurrence of the name of this Islamic month on three of their five dated examples [272].[122] The fact that the lustre-painting and *mina'i* decorative techniques were contemporary is proved by the existence of ceramic objects that are decorated with both.[123] The *mina'i* technique was developed in an attempt by some Iranian potters to increase the number of colours in their palettes. Stable colours were stain-painted in a lead glaze opacified with tin and, after a first firing, less stable colours were applied and the object was refired at a lower temperature. This technique enabled the artist to paint in a greater variety of colours with complete control. Whether for economic or aesthetic reasons, this method was relatively short-lived.

In addition to the more formal figural compositions usually applied to pottery, genre scenes appear; there are even subjects inspired by, and possibly copied from, book paintings, especially episodes from the *Shahnama*, including, for instance, the proofs of Bahram Gur's marksmanship, and a whole series of consecutive scenes such as the victory procession of Faridun and the love story of Bizhan and Manizha [273].[124] Subjects drawn from literature such as these are considerably more common on pottery objects than on those of metal. Approximately three dozen works in both media are extant with figural images that are distinctive for the specificity of their iconography.[125]

On one large plate [274] is a battle scene like a fresco representing an attack on a fortress by a large army of horsemen, foot soldiers, and elephants. All the main figures are labelled with Turkish names, which has made it possible to identify the battle as one in which an Assassin stronghold was attacked by a petty Iranian prince and his troops.[126] The painting is remarkable for its large scale and precise detail; equally noteworthy is the uncommon portrayal of a contemporary event which, unlike the *Shahnama* subjects, was not readily recognizable. The labels were thus necessary, and, furthermore, the historical event itself evoked the legends of the past, which were recalled in appropriate parallels of heroic exploits on the plate's exterior [275]. Perhaps this is another example of a private image or souvenir of a specific event.[127]

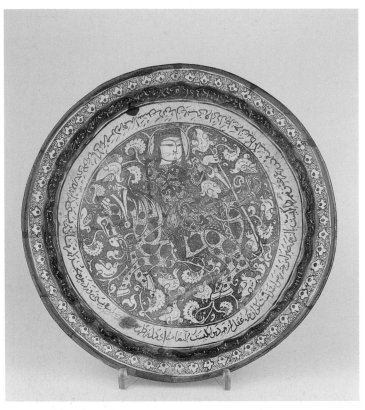

279. Glazed and lustre-painted composite-bodied dish. Dated 604 / 1207, D. 35.2 cm. Victoria and Albert Museum, London

haloes stand out [279].[132] Various stylistically related vegetal arrangements of a more formal nature were used for the star and cross tiles in the dados of mosques and mausoleums.

More restrained in their decorative repertory, but on a grandiose scale and imposing in their overall effect, are the *mihrab* ensembles [280]. A graduated series of flat niches is encapsulated one within the other, the whole framed by a strong projecting cornice. The component slabs are mostly articulated by inscriptions in large *naskh* and, to a more limited degree, in an angular script, which stand out boldly in relief in dark blue against the dense lustre ground. The centre of the composition usually consists of a large pentagonal slab dominated by a symmetrical arabesque motif in relief against the typical Kashan foliage in the background. As with the vessels and tiles, the *mihrabs* were often signed and dated by the ceramists; indeed, from such pieces it has been possible to trace one family of *mihrab* makers through several generations.[133]

Although many of the various types of pottery produced in the eastern Islamic lands during the medieval period may have been manufactured in one of several ceramic centres, there appears to have been only one city in the area during this period that produced lustre-painted pottery – of either the two- or three-dimensional variety – and that was Kashan.[134] There was a large intra-Iranian market, which extended into the Caucasus and Central Asia, for the lustre-painted ceramic architectural decoration produced in this centre. This fact is proven by the number of *mihrabs* and wall tiles made in Kashan from this and the succeeding

period that have been found in, for example, Baku, Damghan, Mashhad, Qum, and Veramin. As regards the three-dimensional lustre-painted objects from this central Iranian city, they have been discovered as far east as Afghanistan and as far west as Syria.[135]

The relief-cut glass produced in the central Islamic lands during this period brought the technique of wheel cutting to a consummate level, as we shall see in the succeeding chapter. Greatly admired and highly prized, it is not surprising that vessels decorated in such a manner were imitated not only in the centres in which they were created but also in the provinces. The ewer [281] illustrates one way in which glassmakers in the Medieval Islamic period attempted to imitate relief-cut designs in less time-consuming techniques. The principal decoration, executed in trailed threads, is suggestive of the undulating, stylized vegetal scrolls often executed in the more difficult, relief-cut, technique. The series of horizontal rings on the neck and body are also paralleled on relief-cut glass ewers [329]. Imitations of relief-cut beakers, decorated in the same trailed-thread technique as the adaptations of relief-cut ewers, also survive. The handle of this ewer is built up from a series of individual handles closely resembling those on Roman funerary

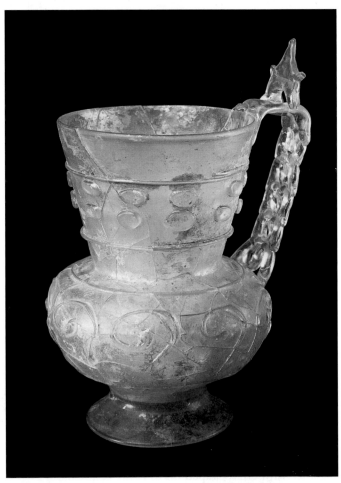

281. Glass ewer with applied decoration, Ht. 15.5 cm. Al-Sabah Collection, Kuwait

280. Underglaze- and lustre-painted composite-bodied *mihrab*. Dated 1226, Ht. 2.84 m. Staatliche Museen, Berlin

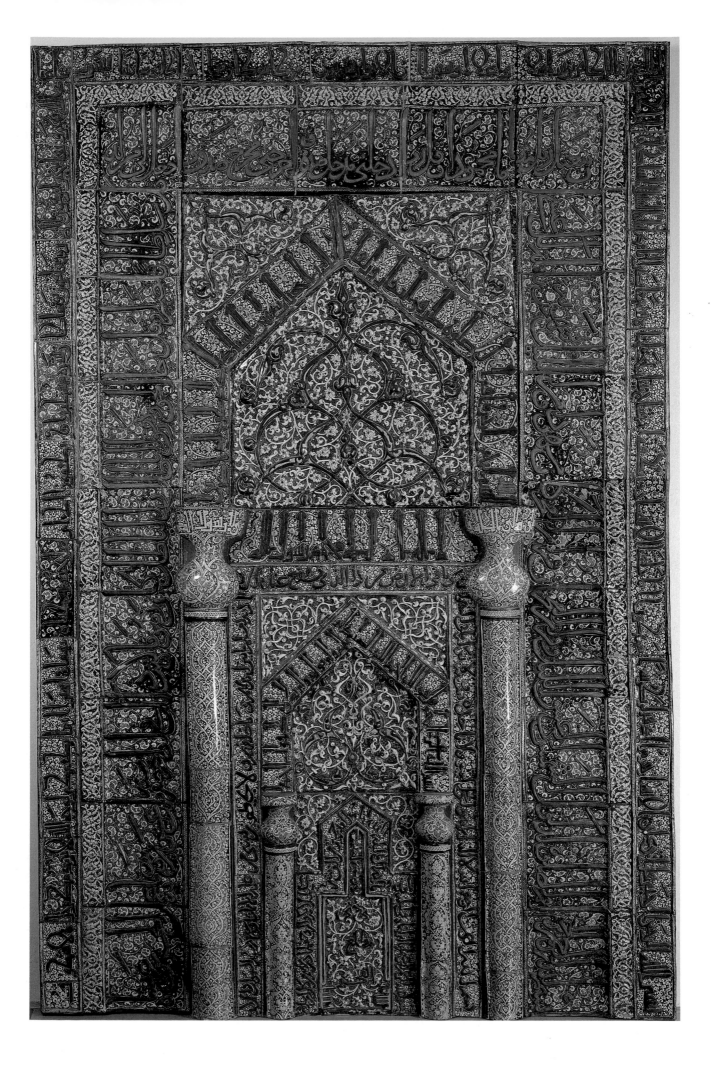

urns that are here 'stacked' to create a chainlike composite handle with close parallels in rock crystal [331]. A *terminus ante quem* for this vessel and others closely related to it is provided by a similar ewer unearthed in China in 1986 in the tomb of Princess Chenguo of the Liao dynasty who died in 1018.[136]

The art of bookbinding was rather conservative during this period. However, a few fragmentary stone moulds, employed for pressing designs into items of leather, shed light on an industry in the eastern Islamic lands at this time which was on an artistic level equal to that in any of the media we have previously discussed. The designs on these leather tools connect them especially with those on stucco and metalwork. The most elaborate floral scrolls or strapwork enlivened by real or fantastic animals and even human figures provide clear evidence that the leather craft had reached such a high point that, if complete pieces had been preserved, they would no doubt be among the period's finest decorative specimens [282]. Rare though they be, these moulds serve to corroborate as well as visually supplement the tantalizing medieval accounts of exquisite saddles and shields. In fact, one of these extant moulds is signed 'work of Bandar the saddlemaker'.[137]

282. Stone mould for pressing leather, L. 30.2 cm. Metropolitan Museum of Art, New York

283. Double opening folios of the tenth *juz'* of a Qur'an manuscript. Ink, colours, and gold on paper. Dated 1073–74, 26 × 20.5 cm. Imam Riza Shah Shrine Library, Mashhad

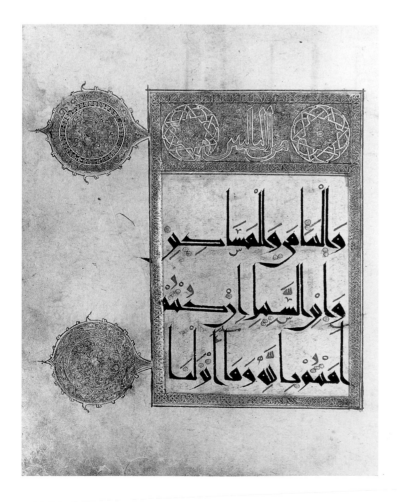

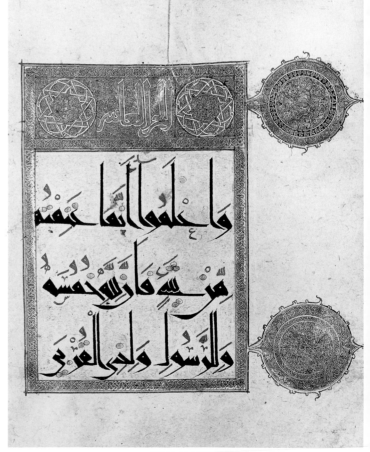

284. Folio of a Qur'an manuscript. Ink, colours, and gold on paper. Dated 1186, 43 × 31.5 cm. Chester Beatty Library, Dublin

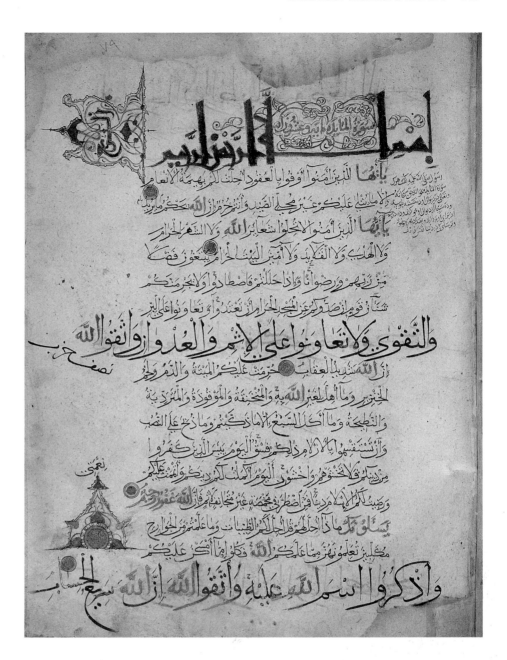

THE ART OF THE BOOK

One important group of Qur'an manuscripts copied in the eastern Islamic lands during the medieval period continued to employ the New Style of script. Usually each page contained only three or four lines of this boldly conceived calligraphy, and thus the ample remaining space could be devoted to delicately drawn vegetal, geometric or calligraphic designs or a combination of one or more of these [283]. The grandeur of the writing is often further enhanced by contour lines, which echo the forms of the letters and function as a kind of *cordon sanitaire*, sharply segregating the sacred script from the decoration.

A second novel type of composition probably reflects specifically Iranian ingenuity. The example [284] displays a bewildering array of four different scripts.[138] The scale of the several scripts employed for three lines, at the top and bottom and across the centre of the leaf, is large and serves to demarcate two areas of text written in yet another script in a smaller scale. There have been two interpretations put for-

ward to explain such pages. One sees the organizing lines functioning in the same manner as the horizontal boards of wooden doors between which the carved panels are set, and this type of composition as an early endeavour to break the monotony of, as well as to enliven, the evenly written page. The second explanation sees the use of differing scripts, scales, and ink colours on the same leaf as a manipulation or modulation in the service of interpreting the text.[139] Perhaps the reason for such transformations lies somewhere between these two theories. Decorative framing bands and verse markings also helped to turn text passages into remarkable and varied compositions.

In addition to the often exquisitely rendered calligraphy, many Qur'an manuscripts were adorned with spectacular illuminations. Chapter headings and verse indications in the text, as well as the markers in the margins, are drawn in the most sophisticated manner, often in gold with designs outlined in white and sometimes set against red-washed (or possibly red-burnished) backgrounds or blue areas painted

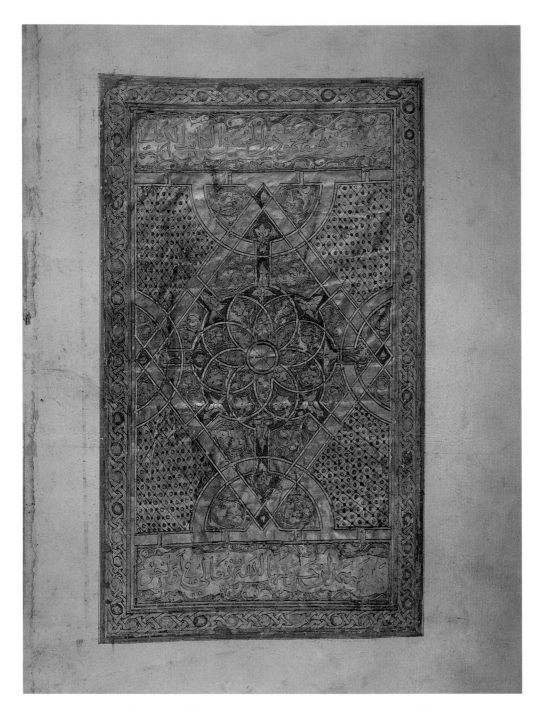

285. Frontispiece of a Qur'an manuscript, Hamadan. Dated 1164, 41.5 × 28.5 cm. University Museum, Philadelphia

with powdered lapis lazuli. The arabesques and floral patterns are highly formalized and handled with consummate skill.

The finest decorations of all are the large 'carpet pages' at the beginning of the codices (and sometimes at the end as well). It can be argued that the sombre and subdued bookbindings of the period alluded to above are the low-keyed overtures to such dazzling spectacles with their bold compositions consisting mainly of arabesques and sometimes also of geometric designs. Similar decorative themes are lightly touched upon on the bindings, but there seems to have been no intention to compete with the main creations, which burst forth as transfiguring experiences. The 'carpet page' [285] shows its indebtedness to the example executed

more than one hundred and fifty years earlier – from the Qur'an copied by Ibn al-Bawwab [121] – which was to become a paradigm for subsequent large-scale, dynamic full-page Qur'an illuminations.

CONCLUSION

From the new Isfahan domes in the last decades of the eleventh century to the destructive Mongol onslaught in the third decade of the thirteenth, the arts of the eastern Islamic lands underwent major changes in nearly all respects. These changes are, first of all quantitative. The two most common and usually best preserved media are architecture and ceramics. Both are represented by large numbers of exam-

ples (thousands if one counts shards formally excavated or picked on the surface of ruins or archeologically retrievable fragments of living quarters or other built establishments) remaining from nearly every region of this huge area and fulfilling a wide variety of functions. At this stage of investigations their number and, most importantly, their density is probably inferior to what is known from central Islamic lands, not to speak of western Europe, during the same centuries, but the difference is striking compared to the previous centuries in the same lands. There occurred what may be called a critical creativity with two significant results. One is that much of the eastern Iranian world came to share in the same, or at least comparable, outbursts of construction, manufacture, and decoration. Major variations existed no doubt between the Central Asian provinces, the western Iranian ones, Azerbayjan, the central Iranian land, and the valleys of Afghanistan. But, at least at this stage of research, it is important to stress how often similar ceramic types are found in areas far away from each other or how ubiquitous is the fascination with brickwork or with domes. The other result of these outbursts is that the further developments of architecture and of ceramics in the Iranian world have almost always reacted to the achievements of these two centuries. A few indications involving lustre ceramics and metalwork suggest that artisans moved from place to place and, eventually, probably spread their technical competencies around, but the ways in which the dispersion of technical knowledge took place still remain a mystery.

What were these techniques? In architecture they were primarily the manipulation of baked brick, the structure of domes with a unique *muqarnas* squinch, the first steps in the use of colour for decoration, the four-*ivan* court, the portal. Each of these elements had its own history, but, in the aggregate, they do not so much define a style as identify a set of competencies allowing for considerable individual variations. Something similar happened in ceramics with a large range of available shapes, ways of covering surfaces, and means of decoration. Many of these techniques had as their primary aim to fix colour on ceramics and, therefore, to allow for complicated and sophisticated surface designs such as elaborate cursive inscriptions or complex representations. Similar results could be achieved with the rejuvenated technique of inlaying bronze with silver or copper, an apparent novelty first seen in Herat shortly before the middle of the twelfth century. We are less well informed on other media, but the reappearance of an art of representational sculpture would be another instance of a hitherto neglected, if not even condemned, medium at the service of new tastes.

It is difficult to identify the components of that taste, for it is only in architecture that the sponsorship of monuments can often be ascertained. There is clearly a princely or aristocratic and courtly component, as many of the examples given above, even in mosques, were meant to enhance the power or the reputation of a ruler or else illustrated, literally or metaphorically, his way of life. With the so-called Bobrinski bucket [257, 258] and the Hermitage pencase, among many examples in bronze and in ceramics, an urban patronage of merchants and artisans makes its appearance. At times the patrons used both Arabic and Persian and some inscriptions on objects have both languages present. But the vast majority of the inscriptions on ceramic objects were in Persian, often from well-known literature, and it is scenes from Persian epic poems or romances that can usually be identified on objects with a narrative decoration. It is only hypothetically, and in part under the impact of the better-known social structure of central Islamic lands, that we propose to attribute much in this new medieval taste of the eastern Islamic lands to the full crystallization of an Iranian entity within Islamic culture and to locate primarily in cities its patronage of the arts. Next to the princely and the urban, it may be possible to identify a religious patronage in the organization of space in mosques to reflect a newly recognized variety in pious practices and allegiances, in copying the Qur'anic text with particular elegance, in the rich decoration of mosques, especially of their *mihrabs*, or of ceramics, and, possibly, in the appearance on some objects of a pietistic tone associated with mysticism and mystical imagery.

The specific styles of medieval eastern Islamic art are quite varied, and it is difficult, if not impossible, to find common strands which served different patrons and probably very different tastes. One such strand, obvious in the best-quality architecture and occasionally found on objects and in decoration in general, is what has been called 'geometric harmonization', that is to say the presence of a sophisticated geometrically determined grid in the design of works of art. How this characteristic is to be related to the mathematical and scientific thinking of the time remains an open question. A second strand is the consistent presence of several levels of meaning for forms. The point is most obvious on objects which can be understood as simply decorated for the pleasure of users and viewers as well as carriers of complex iconographic messages or conducive to personal meditation. And, finally, the most important strand is that, however it is defined and explained, something visually original and idiosyncratic appeared in the arts of the eastern Islamic lands, something which will eventually form the basis of that Iranicate culture which survives to this day in many more places than the country of Iran proper. The cultural matrix that made this possible still eludes our understanding.

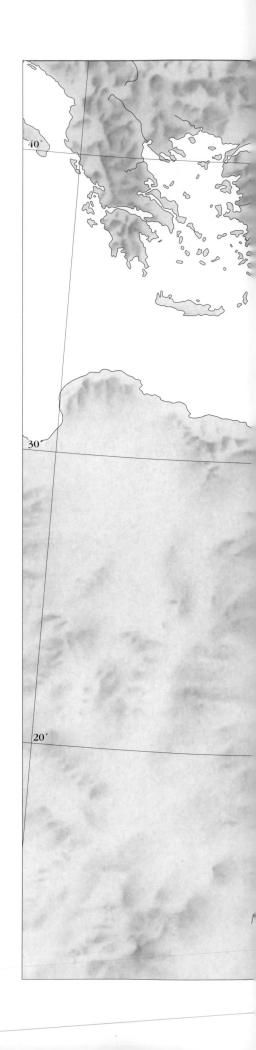

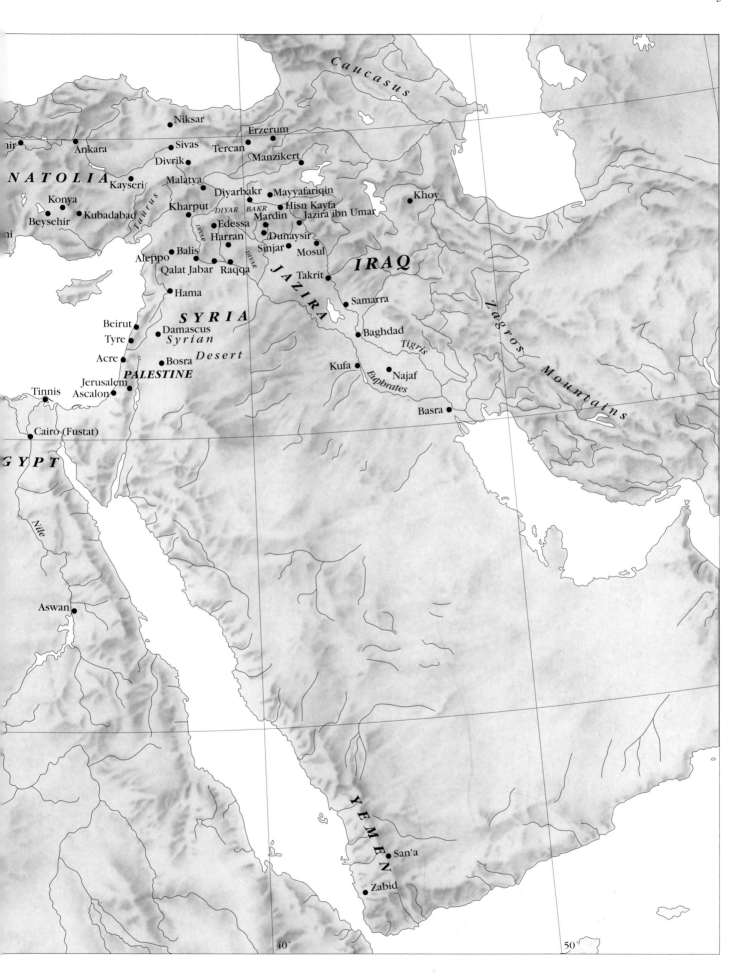

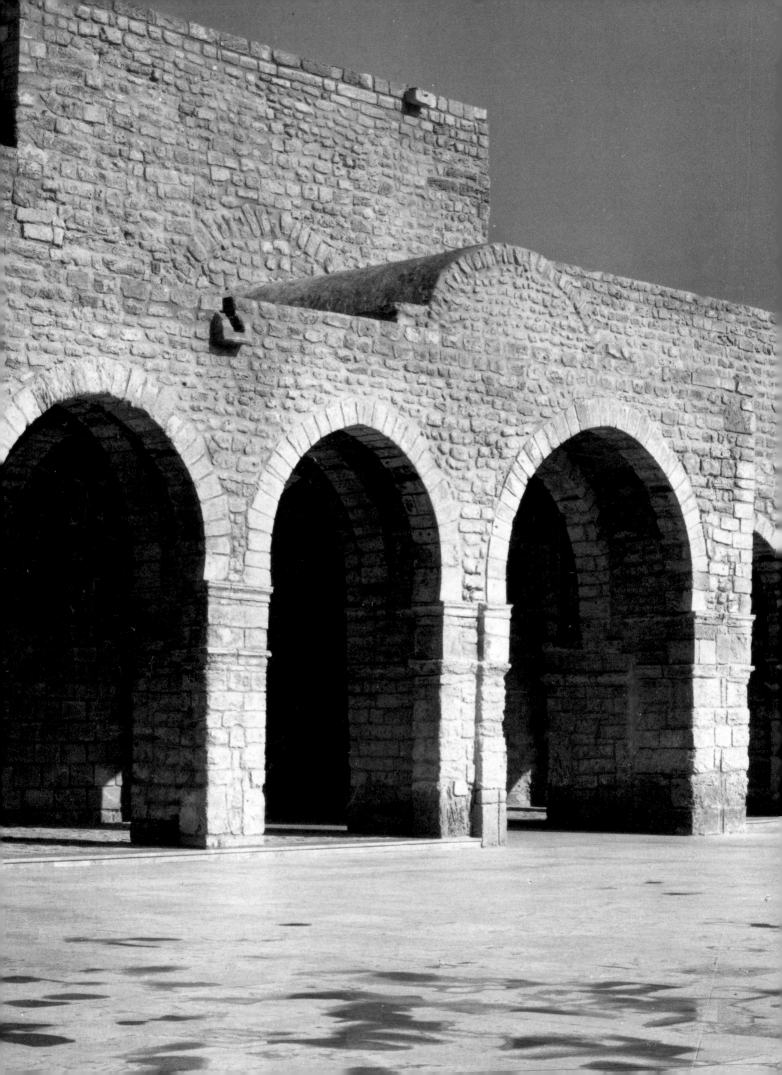

CHAPTER 6

Central Islamic Lands

For reasons provided in the Prologue to Part II of this volume, the presentation of the medieval arts in central Islamic lands has been divided into two sections.

The first section deals with the rule of the Fatimid dynasty, which began in Ifriqiya (present-day Tunisia) around 908, moved its capital to Egypt in 969 under the leadership of the brilliant caliph al-Mu'izz, and ruled from there an area of shifting frontiers which, at its time of greatest expanse, extended from central Algeria to northern Syria, the middle Euphrates valley, and the holy places of Arabia. Its very diminished authority, affected by internal dissensions and by the Crusades, was eliminated by Saladin in 1171. The dynasties dependent on them vanished from North Africa by 1159, while Sicily had been conquered by the Normans in 1071.

The second section focuses on the art of the whole area in the twelfth and thirteenth centuries (at least until 1260), but only on its eastern part, essentially the Mesopotamian valley, in the eleventh. Several interlocking dynasties were involved in struggles and competitions which were as constant as they are difficult to describe and to recall. The lands of Iraq, the Jazira, Syria, Anatolia, Palestine, Egypt, Arabia, and Yemen were a mosaic of feudal rules enriched by the overall prosperity of the area, much involved in the elimination of the Crusaders' states, and largely committed to the revival of Sunnism and the destruction of what they considered to be a Shi'ite heresy. Although ideological opponents of the Fatimids, these feudal rulers shared with them both taste and material culture, and the visual distinctions between the arts of the two realms is not always easy to demonstrate.

PART I

The Fatimids in Egypt, Palestine, and Syria

The arts of this period of some 250 years are difficult to define on account of regional differences and of the growing complexity of Fatimid contacts with the rest of the Muslim world, the Christian West, Byzantium, and even India and China. The Fatimid era is North African, Egyptian, Syrian, and Arabian; but it is also Mediterranean and pan-Islamic.[1]

Politically, and in many ways culturally and artistically, Fatimid power and wealth were at their highest before the middle of the eleventh century. Shortly after 1050, however, in the middle of the long reign of the caliph al-Mustansir (1036–94), financial difficulties, famines, droughts, and social unrest led to two decades of internal confusion out of which order was not re-established until the 1070s. At the same time, in North Africa, an attempt by local Berber dynasties to shake off Shi'ite allegiance led to a new invasion by Arab tribesmen and to a thorough change of economic

and political structure,[2] as Tunisia and western Algeria lost much of their agricultural wealth and entered by the twelfth century into a western rather than eastern Islamic and Mediterranean cultural sphere. During the last century of their existence the Fatimids controlled hardly anything but Egypt. Whether the major changes in Islamic art which they had earlier set in motion were the result of their own, Mediterranean, contacts with the classical tradition or of the upheavals which, especially in the eleventh century, affected the whole eastern Muslim world remains an open question.

ARCHITECTURE AND ARCHITECTURAL DECORATION[3]

NORTH AFRICA

The Fatimids founded their first capital at Mahdiyya on the eastern coast of Tunisia.[4] Not much has remained of its superb walls and gates or its artificial harbour, but surveys and early descriptions have allowed the reconstruction of a magnificent gate decorated on both sides with lions, of parts of the harbour, and of a long hall or covered street similar to those already found at Baghdad, Ukhaydir, and even Mshatta.[5] The parts of the palace so far excavated[6] have yielded two features of interest [286]. First, there was a curious entrance complex, consisting of a triple gate, its centre set out within a large rectangular tower. As one proceeds inwards, however, this gate ends in a blank wall. Two narrow halls on each side of the central axis lead into the court; the side entrances, on the other hand, proceed directly into the interior. The purpose of this odd arrangement could hardly be defensive; perhaps the four entries were to accommodate some of the extensive processions which, at least in later times, characterized Fatimid court life.[7] Second, we cannot determine whether the decoration of some of the rooms with geometric floor mosaics sprang from memories of Umayyad palaces or imitated the many pre-Islamic mosaics of Tunisia.

A much restored mosque also remains from Fatimid Mahdiyya [287, 288].[8] It was initially a rectangular

286. Mahdiya, founded 912, palace, plan

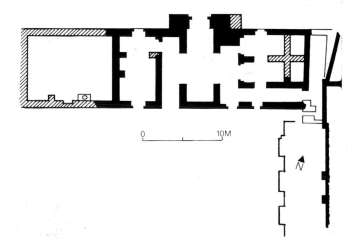

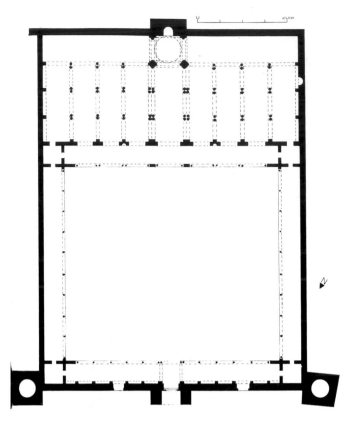

287. Mahdiya, founded 912, mosque, plan

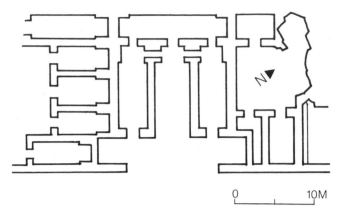

289. Sabra al-Mansuriya, throne room

hypostyle with a covered hall of prayer consisting of nine naves at right angles to the *qibla*. An axial nave led to a dome in front of the *mihrab*, and a portico in front of the covered hall served as a transition between open and covered areas and as part of a court with four porticoes. But the most significant novelty is the monumental façade, involving the whole of the north western wall of the mosque. It consists of two massive salients at each corner, which emphasize and control the limits of the building, and three symmetrically arranged gates, the central one set within another salient decorated with niches. This earliest known instance of a composed mosque façade gives a sense of unity not only to the outer wall but also to the building as a whole. Its origins should probably be sought in royal palace architecture, where such compositions were known as early as the Umayyad period.

From the second capital built by the Fatimids in North Africa, Sabra-al-Mansuriyya near Qayrawan, we know so far only of a very remarkable throne room [289] which combines the eastern *iwan* with the characteristic western Islamic unit of two long halls at right angles to each other.[9]

The last two major monuments from North Africa to be attributed to the Fatimid cultural sphere are (if we except certain minor utilitarian structures) rarities in that geographical area. The first is the palace of Ashir, in central Algeria, where, under Fatimid patronage, the Zirid dynasty founded a capital around 947.[10] It is a rectangle (72 by 40 metres) with towers of varying sizes [290]. The single outer gate of the complex is transformed into two entrances into the palace proper. On one side of the court is a portico. The presumed throne-room complex comprises a long hall with

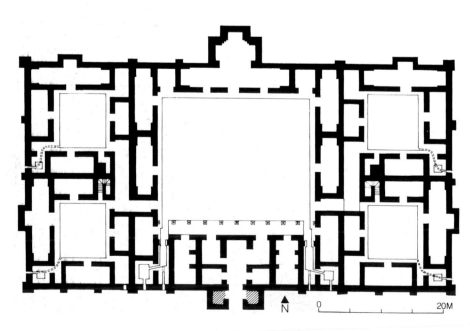

290. Ashir, founded c.947, palace, plan

291. Qal'a of the Beni Hammad, begun c.1010, plan

292. Qal'a of the Beni Hammad, begun c.1010, tower

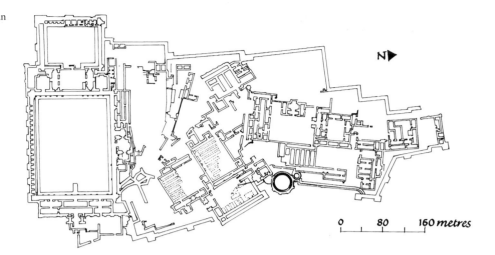

three entrances and a squarish room extending beyond the outer line of the wall and no doubt dominating the land-scape. On each side of the central official unit, lining a court-yard, are two residential buildings consisting mostly of long halls. This symmetrical organization of living quarters around official areas recalls Mshatta or Qasr al-Hayr rather than the sprawling royal cities of Samarra and Madinat al-Zahra. Moreover, the palace is remarkable for its great sim-plicity: limited design, no columns, probably simple vaults, and very limited applied decoration. Though but a pale reflection of the architecture created on the Tunisian coast, Ashir is nevertheless precious for the completeness and preservation of its plan.

The second monument is the Qal'a of the Beni Hammad [291] in central Algeria, begun around 1007 by a Berber dynasty related by blood to the Zirids and also under the cultural impact of the Fatimid centres of Tunisia.[11] It was a whole city, with an immense royal compound comprising a huge tower with pavilions at the top [292], a complex of buildings crowded around a large (67 by 47 metres) artificial pool in which nautical spectacles took place, a bath, a mosque with a superb *maqsura*, and a series of individual houses and palaces. Neither the chronology nor the ceremo-nial or symbolic meaning of these buildings is clear; typo-logically, however, the Qal'a belongs to the succession of Samarra's or Madinat al-Zahra's sprawling ensembles, but with the emphasis on a setting for leisure and pleasure. A celebrated poem describing a lost palace of the eleventh cen-tury in Bijaya (Bougie) in present-day Algeria elaborates on this luxury and describes an imagery charged with heavenly and secular topics.[12] It was possibly this ideal of luxury that inspired the twelfth-century architecture of the Norman kings of Sicily, about which more will be said in Chapter 8.

One group of fragments of unusual importance from the Qal'a of the Beni Hammad is a series of long ceramic paral-lelepipeds with grooves at one end; they must have pro-jected unevenly from a ceiling or a cornice, looking like stalactites of a particularly unusual kind [452].[13] Other plas-ter fragments were certainly more typical *muqarnas* transi-tions. The origin and inspiration of these features is still unresolved. They could have been local inventions or, a more likely hypothesis, local interpretations of forms and

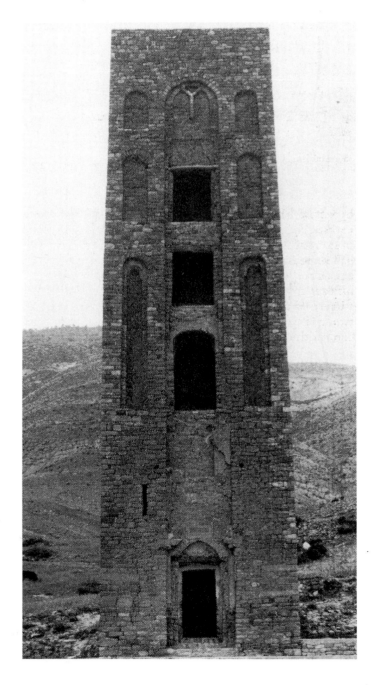

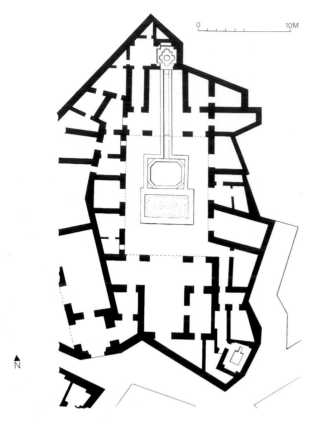

293. Fustat, plan of house

ideas from the east, and prepared the way for the later vaults of Morocco and of Norman Sicily, especially the large ceiling of Roger II's Cappella Palatina at Palermo.[14] Nearly all these examples occur in secular architecture, suggesting that the *muqarnas* may have been transmitted through the medium of private dwellings. But this matter also is not resolved, and we shall return to these very same fragments in Chapter 7.

EGYPT UNTIL 1060

After their conquest of Egypt in 969, the Fatimids embarked on a truly grandiose program of building, some of which survives; much more has been recorded by later Egyptian compilers such as the invaluable al-Maqrizi.[15] These accounts in turn led, already before the first World War, to a series of very important, although not complete, topographical surveys by members of the French School in Cairo,[16] supplemented by a study of epigraphical material by Max van Berchem and Gaston Wiet[17] and Creswell's monumental work. Both archaeological and interpretive concerns are ongoing activities in Egypt[18] and, thus, for once in the study of Islamic art, both original documents and scholarly studies are numerous.

The centre of the Fatimid world was the imperial and military city of Cairo (al-Qahira, 'the triumphant').[19] Nothing has remained of the first foundation, inaugurated in great pomp in the presence of astrologers with the purpose of controlling the older Muslim town of Fustat and its communications with the east. Yet its size is known (almost a square, about 1000 by 1150 metres), as are its north–south, almost straight axial street (the present Mu'izz al-Din street), its two huge palaces more or less in the middle of each side of the cental street, with a wide open space for parades between them. It was provided with eight irregularly set gates (two on each side). Even the sites and names of the quarters assigned to the military groups permitted to share the city with the caliph have been recorded, because so much of the later topography and toponymy of Cairo is based on that of the town built between 969 and 973. Thereafter, little by little, the whole area to the south and southwest was transformed so that by the year 1000 Cairo, with the old city of Fustat, had become one of the largest and most cosmopolitan urban complexes of the medieval world, with its markets, mosques, streets, gardens, multi-storeyed apartments, and private houses. Fatimid urban developments elsewhere are less well known, except for Jerusalem, Mecca, and, to a smaller degree, Ascalon on the Palestinian coast. In most of these instances, religious considerations dictated new constructions, but it is probably justified to believe that the establishment of Fatimid authority included transformations in the urban fabric of all the cities controlled by the dynasty.

The buildings of the early Fatimid period can be divided into three groups. Of the first, the palaces, nothing has remained, but the lengthy compilation of al-Maqrizi and the on-the-spot descriptions of Nasir-i Khosrow (1047) and al-Muqaddasi (985), as well as archaeological data brought together by Herz,[20] Ravaisse,[21] and Pauty,[22] allow for a a few remarks about these palaces. Most remarkable was the Great Eastern Palace, whose main Golden Gate opening on the central square was surmounted by a pavilion from which the caliph watched crowds and parades.[23] Inside, a complex succession of long halls led to the throne room, an *iwan* containing the *sidilla*; this was 'a construction closed on three sides, open on the fourth and covered by three domes; on the open side there was a sort of fenced opening known as a *shubbak*'. Painted scenes, probably of royal pastimes since we know that they included hunting scenes, constituted much of the decoration.[24] For all its brilliance, the Eastern Palace seems to have been comparatively rambling in planning; the Western Palace (c.975–96, rebuilt after 1055) was smaller but more regular, centred on a long court with halls and pavilions on both axes.

Fatimid secular architecture can be characterized by two further features. The first (an apparent novelty in Islamic palaces) consisted in the royal pavilions spread all over the city and its suburbs.[25] To these, for amusement or for ritual purposes, the caliph repaired in the ceremonial processions which brought the practices of the Fatimid court so close to those of Byzantium.[26] Their shape is unknown, but most seem to have been set in gardens, often with pools and fountains, very much like the remaining twelfth-century constructions of the Normans in Sicily. The second feature is the layout of a number of private houses excavated in Fustat [293]. They abut each other in very irregular ways, and the streets on which they are found are often both narrow and crooked. But the interior arrangement of the larger ones is often quite regular and symmetrical. In almost all instances, open *iwans* or else two long halls at right angles to each

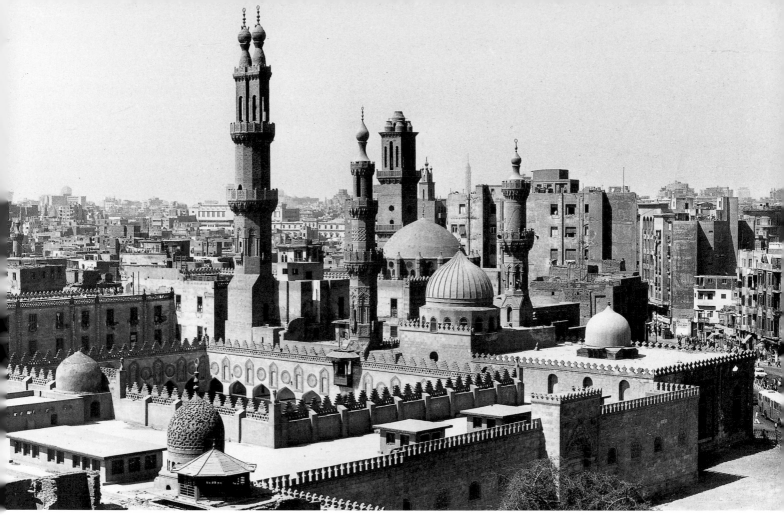

294. Cairo, Azhar Mosque, founded
969/73

295. Cairo, Azhar Mosque, founded
969/73, court façade

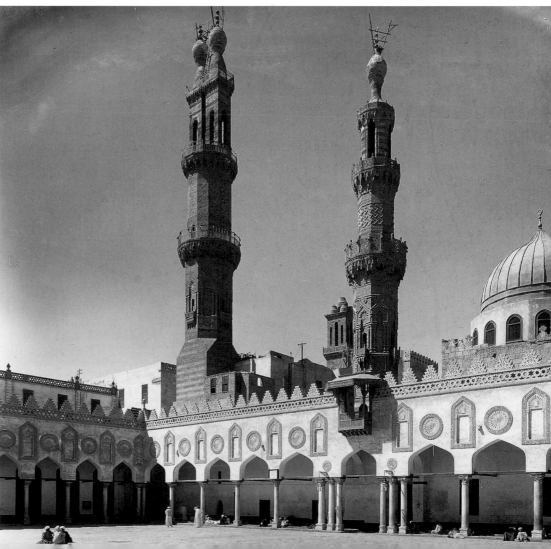

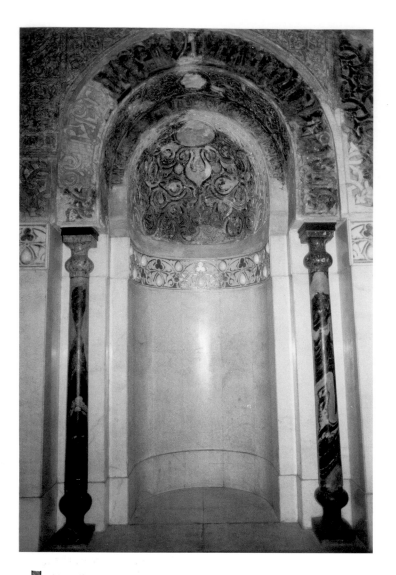

other, or even both, surround a central court.[27] The forms themselves often recall palatial ones, and the quality of most construction and the sophistication of the civil engineering are at times quite amazing.

There also remain from the early Fatimid period in Cairo two large congregational mosques. The celebrated al-Azhar ('the splendid') was founded together with the city to serve as its main place for ritual gathering. Because it grew slowly into a great centre of religious learning, it has undergone frequent alterations (the court façade, for example [294, 295, 296], is later, although still Fatimid). The original mosque can be reconstructed as a simple hypostyle (85 by 69 metres) with a prayer hall of five aisles parallel to the *qibla* wall and porticoes.[28] The hall of prayer was bisected by a wide axial nave leading to a superb *mihrab* decorated with stucco [296];

296. Cairo, Azhar Mosque, founded 969/73, mihrab

297. Cairo, Azhar Mosque, founded 969/73, early plan

298. Cairo, al-Hakim Mosque, 990 and 1013, plan

299. Cairo, al-Hakim Mosque, 990 and 1013, drawing

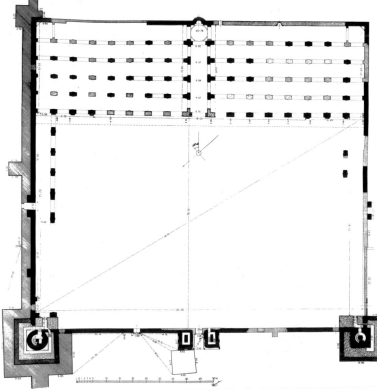

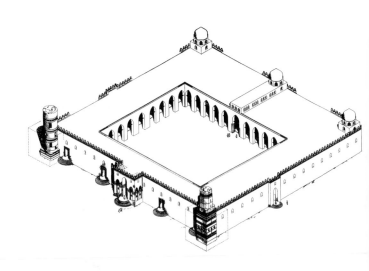

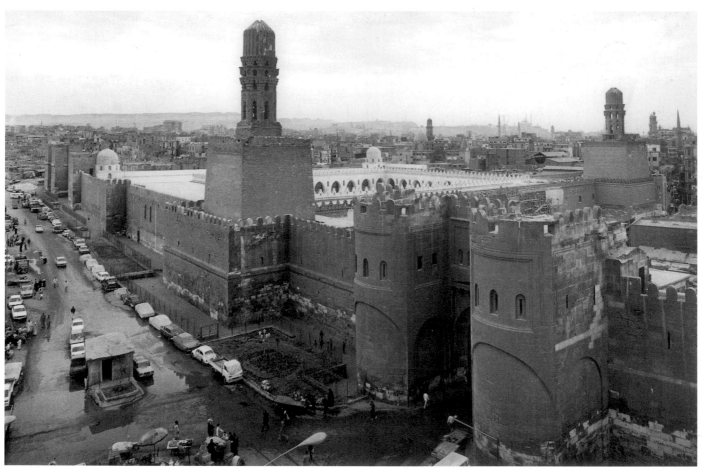

300. Cairo, al-Hakim Mosque, 990 and 1013, general view, and city walls, 1087

in front of the *mihrab* was a dome, probably with two other domes framing it.[29] The remaining dome now in front of the axial nave, built between 1130 and 1149, recalls, by its position, the one introduced in the mosque of Qayrawan. Throughout the mosque the supports were columns, single or double, often spoils from older and abandoned buildings. A great deal of decoration – mostly stucco – remains in the spandrels of the axial nave, on the *qibla* wall, and elsewhere. To its themes we shall return later; its position seemed to emphasize the main directions and lines of the building. The Fatimid exterior has not been preserved. Al-Maqrizi relates that there were royal pavilions and that a number of official ceremonies took place which were probably reflected in architecture. Without these accessories, the first Azhar Mosque appears almost as simple as the first hypostyles with axial naves known in Islam [297].

The second early Fatimid mosque in Cairo, the mosque of al-Hakim, redone and inaugurated by that caliph in 1013, was begun by his father in 990. Its original purpose is not evident, for it was outside the city walls to the north, in a sparsely populated area. Clarification is provided by a long passage in al-Maqrizi.[30] Until 1266 (when it returned to the Azhar), the first and most splendid of a cycle of long and elaborate ceremonies of caliphal prayer, including the *khutba* or allegiance to the sovereign, took place here, to be followed on successive Fridays in Cairo's other large three mosques

(early mosque of Amr, Ibn Tulun, al-Azhar). We may, then, interpret this building as an imperial foundation, whose primary function was to emphasize the religious and secular presence of the caliph and to serve as a setting for the ceremonial pageantry of the dynasty.[31] While no doubt related to earlier mosques such as those of Damascus, Baghdad, and Cordoba, in all of which the nearby presence of the ruler played a part, the al-Hakim Mosque had a more restricted purpose as a royal sanctuary some way away from the city proper, not far from the mausoleums of the Fatimid family, and illustrating the very complex nature of Fatimid kingship. The private oratory in one of the minarets, and a possible mystical explanation of some of the decorative motifs like stars and a pentogram found on the masonry,[32] lend credence to the idea of the building's special character.

The mosque of al-Hakim was a large and slightly irregular rectangle (121 by 131 metres) [298, 299]. At the west and south, on the corners of the façade, are two minarets now partly enclosed in later constructions, a feature obviously related to Mahdiyya's mosque. The minarets are remarkable for their decoration and for being of different shapes, one cylindrical, the other square. Between them in the main façade [300] is the monumental (15 by 6 metres) entrance; four more doors with flat arches and a very classical moulding complete the composition, and there is a further gate on each side of the mosque. The interior hypostyle combines

301. Jerusalem, Aqsa Mosque, mosaic

son is all the more justified since – except for the epigraphical borders rarely found in Iraqi palaces – the shapes of the panels, the motif of constant interplay of leaves and flowers around symmetrically arranged rigid stems, and the techniques of outlining, notching, and dotting are all certainly related to the art of Samarra, probably through the impact of the latter on Tulunid Egypt.[33] However, the floral element is more pronounced and more clearly recognizable, and the background again plays an important part. After the Samarra-inspired experiments, therefore, the Azhar stuccoes seem to indicate a preference for an earlier and more natural treatment of vegetal motifs. The inscriptions of the Azhar have been chosen to proclaim the ideological bases of the Fatimid dynasty.

The decoration of the al-Hakim Mosque is quite different. Flat ornamental panels are rarer; when they exist, as on certain niche-heads of the entrance or on the windows of the domes, they consist of symmetrical designs of stems and

302. Jerusalem, Aqsa Mosque, mosaic

features from the mosque of Ibn Tulun [25–27] (five-aisled sanctuary parallel to the *qibla* wall, large brick piers with engaged columns, single arcade on the other three sides) with innovations from North Africa (higher central nave, dome in front of the *mihrab* with two corner domes on squinches and drums). Thus, compared to the Azhar Mosque, al-Hakim's is much more carefully thought out, blending several architectural traditions and drawing especially on its North African roots. But it is still in most aspects traditional, and its most expressive features are the domes, whose outer appearance (square, octagon, cupola) is one step removed from the inside (octagon, drum, cupola), and the façade, whose symmetry is so curiously broken by the different shapes of the minarets which frame it.

Both the Azhar and Hakim mosques are remarkable for their architectural decoration, although themes and style differ considerably. At the Azhar the stucco panels on the wall spaces provided by the arches and the *qibla* aim, like those at Samarra, to cover the whole surface. The compari-

303. Aswan, mausoleums, probably early eleventh century

leaves or of more complex arabesques, always set off by a visible background. Most of the decoration is of stone and is concentrated in a series of horizontal and (more rarely) vertical bands which emphasize the minarets and the gateway block. The designs include vegetal as well as geometric and epigraphical motifs, almost always in relief leaving the stone background visible. As already mentioned, it may be that some of the devices, such as pentagrams or the heavily decorated medallions which occasionally replace the horizontal bands, had a symbolic significance.[34] There is no doubt that the inscriptions of the mosque were meant to proclaim an ideological message of caliphal power, and the striking originality and novelty of the al-Hakim example is that this message occurs on the outside of the building in direct and immediate contact with all the inhabitants of the city rather than being restricted to those permitted to pray inside.[35] The al-Hakim decoration as a whole, however, is most notable, especially when compared to the Azhar, for its sobriety. Both the sobriety and the complex composition recall North Africa rather than the East, although it is possible that the ubiquitous classical background of the Mediterranean was wilfully employed by the Fatimids both in the simplicity of ornamentation and in the revival of more naturalistic themes of design.

A last point about early Fatimid decoration is that it was not limited to stucco or stone. Wood was common, although little has remained *in situ*. Mosaics were also used, which we know mostly from texts and from the superb decoration of the large dome in front of the *mihrab* of the Aqsa Mosque in Jerusalem (early eleventh century). The mosaics of the drum [301] probably copy much earlier Umayyad work,[36] but those of the triumphal arch and of the pendentives are original Fatimid compositions [302], and their technical

quality indicates that the older traditions picked up by the Muslim world in Byzantium were not yet totally lost or that, especially in Jerusalem, the Fatimids were reviving Late Antique techniques they knew as Umayyad.

The last group of monuments datable to the first Fatimid decades in Egypt consists of mausoleums, whose erection is attributable both to the Fatimid sense of imperial pomp and to their Shi'ite veneration of the descendants of Ali.[37] The earliest royal and religious mausoleums are known through texts only, but two major early groups remain, a small one near Cairo,[38] and another sixty-odd-strong in the great Aswan cemetery in southern Egypt [303].[39] None is dated, but the indirect evidence of texts and certain details of construction indicate that they probably belong to the early decades of the eleventh century. By then the mausoleum was no longer either a royal prerogative or a place of religious commemoration, but a widely available form of conspicuous consumption. The social and pietistic conditions of the time suggest that the new patrons of architecture in this field were women and the middle class of merchants and artisans. There is, for instance, the very curious case of the Qarafa Mosque, sponsored by two noble women in 976 in the southern cemetery of Cairo; it shows that, quite early in Fatimid times, the place of the dead became a site for the expression of piety by another patronage than that of rulers.[40]

The mausoleums are simple squares with openings on one, two, or three sides. Built in brick or stone in mortar, or in combinations of the two methods, most of them probably had whitewashed walls with little decoration. All were covered with domes on simple squinches with an octagonal drum whose purpose was to give greater height and more light. Some of the mausoleums had over twelve windows,

Altogether, the later Fatimid period witnessed an extension of architectural patronage reflected in the growth of smaller monuments, the development of the *mashhad*, the use of the *muqarnas* in architecture and decoration, and a partial return to stone. Whether or not these features are of local origin is often still a delicate problem; but most of them are also characteristic of Muslim architecture elsehere, strongly suggesting that, despite its heterodoxy, the Fatimid world fully partook of the pan-Islamic changes of the eleventh and twelfth centuries. In some cases, it is even possible to compare Fatimid architecture, especially in its second phase, with that of contemporary, more particularly western, Christianity.

THE ART OF THE OBJECT

The Fatimid period is of singular importance as the era when Egypt reached an outstanding position in the Muslim world, not only as the focal point of vast trading activities extending as far as Spain in the west and India in the east (as well as outside the Islamic regions) but also as a great manufacturing centre. The arts and crafts were so highly specialized during that epoch that it has been possible to establish no fewer than 210 different categories of artisans, compared to 150 in ancient Rome.[54] Production for the lower and middle class was on a very large scale.[55]

Our most vivid and also most sumptuous picture of this period is provided by historical accounts, both contemporary and later, reporting on an event during the reign of al-Mustansir (r. 1036–94). In 1067–68 the great treasury of the Fatimids was ransacked when the troops rebelled and demanded to be paid. The stories of this plundering mention not only great quantities of pearls and jewels, crowns, swords, and other imperial accoutrements but also many objects in rare materials and of enormous size.[56] Eighteen thousand pieces of rock crystal and cut glass were swiftly looted from the palace, and twice as many jewelled objects; also large numbers of gold and silver knives all richly set with jewels; valuable chess and backgammon pieces; various types of hand mirrors, skilfully decorated; six thousand perfume bottles in gilded silver; and so on. More specifically, we learn of enormous pieces of rock crystal inscribed with caliphal names; of gold animals encrusted with jewels and enamels; of a large golden palm tree; and even of a whole garden partially gilded and decorated with niello. There was also an immensely rich treasury of furniture, carpets, curtains, and wall coverings, many embroidered in gold, often with designs incorporating birds and quadrupeds, kings and their notables, and even a whole range of geographical vistas.[57] Relatively few of these objects have survived,[58] most of them very small; but the finest are impressive enough to lend substance to the vivid picture painted in the historical accounts of this vanished world of luxury.

There is no exception to the pattern we have been following up to now in our investigation, namely the cycle of adoption, adaptation and innovation, as regards the objects created for the Fatimids after their conquest of Egypt in 969. At first the artists working under the aegis of this dynasty seem to have continued to explore the possibilities inherent in forms long current in Egypt or more recently

313. Wood door. Dated 1010, Ht. about 3.25 m. Museum of Islamic Art, Cairo

imported from the East. Only gradually do they seem to have introduced new decorative elements which had begun evolving in the western Islamic lands during the previous, Early Islamic, period under Umayyad, Abbasid, and indigenous influences. Once this innovative phase began, artistic problems were approached in an entirely new spirit.

As regards wood, treasured in Egypt because of its scarcity, early in the Fatimid period we can witness the continued popularity of the bevelled style first encountered in the Abbasid heartland and later in Tulunid Egypt [99]. The carved decoration on a tie-beam in the mosque of al-Hakim, dated 1003, is still based on the true Samarra Style C but it is also illustrative of a further development of that style in that the lines delineating the rather restricted number of motifs are wider, thus giving quite a different impression. Unlike the prototype, here the distinction between pattern and interstitial spaces is clearly defined.[59] This feature is even more pronounced on the panels of a wooden door dated 1010, also inscribed to the caliph al-Hakim [313],[60] where the individual bevelled patterns stand out clearly from a dark background. The major design elements are themselves decorated with small-scale surface patterns. The resulting textures, along with the contrast between light and dark, produce more varied, lively, and accented compositions than earlier on.[61]

By the third quarter of the eleventh century, however, a

314. Wood panel from door. Datable to
c.1058, Ht. 34.9 cm; W. 22.9 cm.
Metropolitan Museum of Art, New York

315. Detail of wood panel. Datable to
c.1058, L. 3.45 × Ht. 30 cm. Museum of
Islamic Art, Cairo

316. Detail of wood panel. Datable to
c.1058, Ht. 31.5 cm; W. 143 cm. Museum
of Islamic Art, Cairo

further evolution is discernible. The bevelled elements are reduced to thin, spiralling stems against a deeply carved background, and figural and animal designs begin to come to the fore. The early stages of this innovative trend are well illustrated by the panel [314]. Although the vegetal and figural designs can here be interpreted as being given equal treatment, the former motifs are beginning to be relegated to the background, and pride of place is moving toward the zoomorphized split palmette. Instead of starkly abstract, static, and purely sculptural qualities, there is now a dramatic interplay between abstract and more realistic parts, between elements conceived three-dimensionally and purely linear ones, and between light and shadow. In addition there is a new sense of movement.

This panel and another in the Museum of Islamic Art, Cairo, are closely related to those comprising a fragmentary door believed to have come from the Western Fatimid Palace, built by the caliph al-ʿAziz and completely renovated by al-Mustansir in 1058.[62] Destroyed by the Ayyubid conqueror Salah al-Din (Saladin) in the late twelfth century, it was bought in 1283 by the Mamluk sultan Qalaʾun, who then proceeded to build his great complex consisting of a school, mausoleum, and hospital. These were completed in fifteen months, and in this hasty project the amir in charge of the project took advantage of the already existing woodwork and other material on the site. Were it not for this medieval recy-

cling, this beautiful panel and many others – some of which will be discussed presently – would probably have been lost to posterity.

Particularly important among these is a series of horizontally oriented carved wooden boards – some with decoration organized in interlaced cartouches containing designs of animals and human figures all carved against a background of formalized vine scrolls in lower relief [315] and others with a symmetrically arranged animal decoration [316].[63] The horse protomes seen on the contemporary door panel discussed earlier, because their outline was made to conform to that of a split palmette, appear very stiff when compared to the liveliness of the varied motifs on these friezes and the realism conveyed by them. Human figures predominate now, and the rich repertory of subjects includes a number of male and female dancers portrayed in animated postures. In keeping with the new taste for scenes from everyday life, a woman peers out through the open curtains of a palanquin on the back of a camel, which is escorted by a man. In another compartment a drinking party is in progress. Two turbaned figures grasp goblets, one of them pouring from a bottle. From one side a servant approaches carrying a large vessel, presumably in order to replenish the bottle. Although the roughness of execution means that details are not as clear as those on similar representations in other media, traces of red and blue pigment suggest that specifics of facial

317. Marquetry panel, Ht. 22 cm; W. 41 cm. Museum of Islamic Art, Cairo

features, costume, implements, etc. may have been precisely delineated in paint. Similar wood-carvings, more refined in workmanship but reflecting even more strongly the late Fatimid taste for observation from life, are to be found in a Christian context in Cairo, in the Coptic convent of Dayr al-Banat.[64]

Probably dating from about the same time is the fragmentary panel [317], decorated with a bird of prey attacking a hare, which must have originally functioned as one of the sides of a chest.[65] This is a simpler but equally beautiful example of the technique known as marquetry that had a

318. Ivory plaque, Ht. 12.5 cm. Museo Nazionale, Florence

319. Glazed and lustre-painted dish. Datable between 1011 and 1013, D. 41 cm. Museum of Islamic Art, Cairo

320. Glazed and lustre-painted bowl. Datable to c.1000, D. 25 cm. Museum of Islamic Art, Cairo

321. Glazed and lustre-painted bowl. Datable to last quarter of eleventh century, D. 22.5 cm. Originally built into wall of Church of S. Sisto, Pisa; now, Museo Nazionale di San Matteo, Pisa

long life in Egypt [98]. Both the latter, more intricate, version of this art and the particular adaptation seen here were to be adopted later by the Almohads in al-Andalus and the Maghrib.[66]

Although the earliest extant datable woodwork with figural decoration from Muslim Egypt is from the third quarter of the eleventh century, architectural elements with such ornamentation were being utilized in Fatimid Ifriqiya more than one hundred years earlier. The fact that the capital Sabra al-Mansuriyya, founded in 947, contained buildings adorned with carved wood decorated with birds and stucco sculpture in human, bird, and animal form may indicate that early Fatimid structures in Cairo which no longer survive were similarly decorated.[67] Thus, the vogue for carved wooden architectural elements with figural decoration may have been concurrent with that for the vegetal decoration that was evolving from the bevelled style.

Ivory carvings attributed to Fatimid craftsmen show close parallels in style and iconography to wood, but here the workmanship demonstrates the greater refinement appropriate to so expensive a material. The openwork plaque [318] that apparently once sheathed a casket or other small object repeats a long-common motif: the scarf dancer, skipping, her draperies swirling about her twisted body, her arms gesturing sinuously.[68] Particularly noteworthy on this panel is the grace of the performer, her weight convincingly distributed, her headdress precisely knotted. The naturalism of all the figures on such plaques is heightened by the refined technique. Although there are two main levels of relief, as on the wooden boards, here the frames and figures are so delicately modelled that they appear fully rounded as if they were actually emerging from the vegetal scrolls that constitute the background.[69] A device that contributes to this three-dimensional effect is undercutting. Furthermore, the leaves project forward from the vine scrolls in the background so that the two planes of the carving seem interconnected. These ivories are distinguished by the care lavished on detail, for example in the rendering of textile patterns, the texturing of animal fur and bird feathers, and the veining of leaves.

Because of their highly developed style, these ivories and comparable pieces in Berlin and Paris have been dated to the late eleventh or early twelfth century. However, there appears to be no reason why they could not be contemporary in date with the carved wooden panels from the Western Fatimid Palace [315, 316], i.e. datable to c.1050. When the paint was intact on the latter decorative elements, these panels could have been as highly developed in detail as the ornament on the ivories.

The stylistic development we have been able to follow in the carved decoration of wood during the Fatimid period can be observed also in the ornamentation of lustre-painted pottery. Early in the period the designs adorning ceramic objects are often based on the bevelled style, but the motifs that took on sculptural qualities in carved wood had here to be rendered two-dimensionally. The earliest datable lustre-painted object so decorated is a fragmentary dish [319] bearing the name of a commander-in-chief of the caliph al-Hakim who held the title for only two years – November 1011 to November 1013.[70] At this time as well, we know that

322. Glazed and lustre-painted bowl. Datable to second half of eleventh century, D. 21 cm. Freer Gallery of Art, Washington, D.C.

this particular type of vegetal decoration was sometimes combined with figural designs. A fine example of such a transitional work is the bowl [320] signed by Muslim ibn al-Dahhan, a very productive artisan whose period of artistic output is known to us by means of a fragmentary dish in the Benaki Museum bearing an inscription stating that it was made by the above-named ceramist for a courtier of al-Hakim (r. 996–1021).[71] The winged griffin in the centre of the bowl illustrated here is rendered basically in silhouette, but parts of its body structure are clarified and emphasized by keeping certain interior articulations free of the overglaze lustre paint. This attention to naturalistic detail represents a further departure from the caricature-like quality of the animals and human figures on the Iraqi monochrome lustre-painted pottery vessels of the Early Islamic period [107], as do the greater grace and innate movement in the griffin's body.

Although there are numerous lustre-painted bowls from Fatimid Egypt that bear figural designs as their principal decoration, there is only one such vessel known to us which can be securely dated [321], employed as a bacino in the Church of San Sisto in Pisa, Italy, dating to the last quarter of the eleventh century. We can be certain that the style of decoration exhibited on this bowl was current at this time since it must be assumed that this and the many other bowls from Egypt and elsewhere that once graced or still adorn the façades of Romanesque churches and/or campaniles in Italy were installed at the time of the construction of these buildings.[72] Two other bacini, in one instance adorned with an animal and in another with calligraphic designs, can be used to date another group of lustre-painted pottery [322]. On the basis of the evidence provided by these two bacini, this group, which has long been associated with Fatimid Syria,

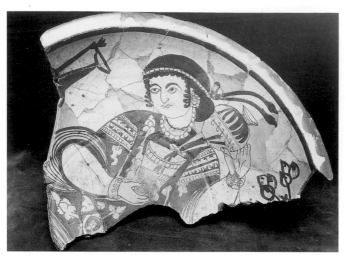

323. Glazed and lustre-painted fragment. Maximum dimension 34 cm. Museum of Islamic Art, Cairo

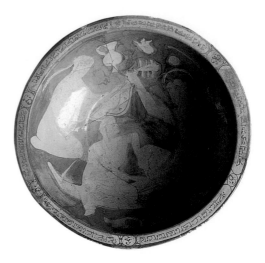

324. Glazed and lustre-painted bowl, D. 30 cm. Museum of Islamic Art, Cairo

325. Slip-painted, carved, incised, and glazed earthenware bowl. Datable to first half of eleventh century. Max. d. 29.7 cm. Bodrum Museum, Bodrum, Turkey

more specifically with Tell Minis – a village in the central part of the country – and dated to the middle of the twelfth century, must now be placed in the second half of the eleventh.[73]

The firmly datable bowl [321], however, appears to exhibit a somewhat different figural style from that found on the majority of the extant lustre-painted bowls with such decoration from Fatimid Egypt which are ornamented in a style closer to that found earlier at Samarra and in Ifriqiya. A dated or datable example of this latter category would be necessary before we could ascertain whether this type was contemporary with that exemplified by the *bacino*, or whether it preceded or succeeded that production.

Although the rendering of most of the faces and the coiffures on these so far not clearly datable vessels betrays descent from the Abbasid figural style – especially the large, round face, the staring eyes and small mouth, as well as the side curls – the animation of the body and exaggerated gestures of the limbs are illustrative, however, of an approach quite different from the frozen monumentality of even the most active figures in the wall paintings from Samarra [84]. As was the case *vis-à-vis* Fatimid woodwork from Egypt, the influence of the artists working under the aegis of this dynasty in Ifriqiya must be seen as an important inspiration for the new trends that can be documented in Egyptian pottery, foremost among them being an intensified interest in naturalistic representation of the human figure, which was always greater in the areas bordering the Mediterranean than in the eastern parts of the Islamic world.[74]

Whenever this innovation occurred on Egyptian ceramics, the craftsmen of this undated and so far not datable pottery group managed, by means of a number of devices, to achieve naturalistic effects quite far removed from the two-dimensional stylization of Mesopotamian lustre-painted designs, and even from the rather static vegetal and animal motifs [319, 320]. Among these devices were the use of an energetic line, off-balance poses, and dramatic gestures to convey a sense of movement and animation. In addition [323], greater attention was devoted to realistic details of costume, jewellery, and vessels. Furthermore, the ceramist

of this bowl managed to accentuate the fullness of the arms, the grip of the fingers, and even the dissipation of the eyes.[75] This group also explored the episodic nature of a theme, a convention we have already seen in the tile from Sabra al-Mansuriyya [141]; instead of human figures and animals presented singly or serially, some bowls in this category illustrate groups engaged in particular activities [324]. Here a lady with two female attendants reclines on a couch and the main protagonist seems to be taking up her lute or relinquishing it to the servant. In contrast to the ceremonious quality of courtly scenes on Spanish ivory boxes [145], the Fatimid pottery examples have the informal flavour of an event observed from daily life.[76]

Although the pottery decorated with lustre-painting was the most luxurious of the kiln production of Fatimid Egypt, it was not the only ceramic type manufactured during this period. The bowl [325] belongs to a type of pottery known as *champlevé* that until very recently was generally dated to the late twelfth or early thirteenth century and usually attributed to Iran. However, following the excavation of ten

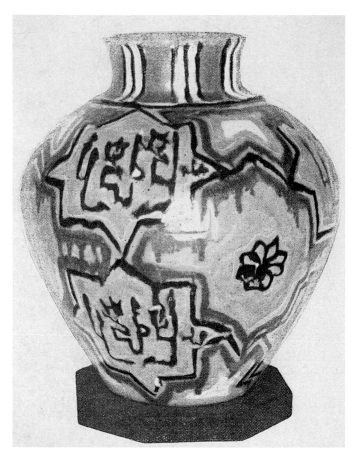

326 (*left*). Glazed and splash-decorated earthenware vase, Ht. 30.5 cm. Museum of Islamic Art, Cairo

327. Incised and glazed composite-bodied deep bowl, Ht. 13 cm. Victoria and Albert Museum, London

328. Carved and glazed composite-bodied dish, D. 41 cm. Staatliche Museen, Berlin

vessels of this type from a shipwreck in Serçe Limani, a small natural harbour on the southern Turkish coast just opposite Rhodes, we can now confidently date this category to *c*.1025 and place its production either in Fustat, Egypt, or in a manufacturing centre somewhere in the Fatimids' Syrian province.[77] The decoration of such wares was created by first applying a slip of light-coloured clay to the interior and part of the exterior surfaces. When dry, the slip was partially carved away to leave the desired design in relief. Details were then incised in the slip and the vessel was finally covered with a transparent, clear or coloured, lead glaze.[78]

The second type of glazed pottery found in this shipwreck was a variety of splash-decorated ware. It, too, was previously vaguely dated – in this case as early as the ninth to as late as the twelfth century. Thanks to this chance find, at least wares in this category with similar designs and shapes can now be given a secure time frame as well as place in the history of Islamic pottery.[79] The vase [326] seems not only to be a variant of this splash-painted type but also to be representative of the Egyptian version of a category that was so popular in the western Islamic lands during the Early Islamic period. This was the type that imitated the opaque white-glazed group manufactured in Basra, Iraq, under the Abbasids [141, 142].[80]

The potters working in Egypt and Syria during this period also produced monochrome glazed carved and/or incised ceramics, decorative techniques previously met with on pottery produced during the Early Islamic period [102]. The Egyptian version [327] is much closer to its boldly decorated antecedent than are representatives of the group

made in Syria and associated with Tell Minis.[81] The latter appears to exhibit for the most part a more delicate decorative style which seems to lead directly into that produced slightly later in Iran [265].[82] The Tell Minis carved and/or incised category is datable to the middle of the eleventh cen-

329. Cameo-glass ewer, Ht. 15.5 cm. Corning Museum of Glass, Corning, NY

tury by means of a *bacino*.[83] Since the so-called *lakabi* ('glazed') type of pottery [328] shares not only principal decorative motifs but body profiles as well as a peculiar rim design with the Tell Minis variety, this group must be attributed to the same period in Syria as well.[84]

Near the end of the first millennium or at the very beginning of the second, Islamic glassmakers in the central Islamic lands[85] inaugurated a second period of innovation[86] that brought them increasingly further from Roman imperial glass and culminated in superb relief-cut vessels. Without question, the most beautiful Islamic object of this type extant is the cameo-glass ewer [329]. The artisan initially formed a clear-colourless glass blank around which was blown a gather (or viscous and extremely ductile melted batch of ingredients) of turquoise-blue glass. The surface was then selectively cut away with a wheel, leaving the design in relief, with the highest point of the decoration representing the original, in this case turquoise-blue, surface. Considering the difficulty of working with such thin and brittle material, high-relief glass cutting is a remarkable achievement and often – as here – a real *tour de force*.[87]

Unlike its highly creative technique, a commonly found earlier shape was adopted for this vessel [92].

Another fine and famous example of the relief-cut technique is the bowl [330] executed in opaque turquoise-coloured glass and obviously meant to imitate a bowl carved from a mineral,[88] further supporting the hypothesis that the flowering of the craft of cut glass – especially relief-cut glass – was an offshoot of the technique for working precious or semi-precious stones, be they turquoise, emerald, or rock crystal. The close relationship between cut glass and cut stone, especially rock crystal, had been fully understood by medieval Muslims, for they are repeatedly listed together in reports of the Fatimid treasures in Cairo; and, we are told by a medieval Iranian author that Syria and the Maghrib were known for a type of green glass used to imitate emeralds.[89]

The ewer [331], bearing the name of the early Fatimid caliph al-ʿAziz (r. 975–96) and exemplifying the finest quality of workmanship possible at the time, belongs to a group of highly important rock-crystal objects, several of which are firmly datable.[90] This vessel and several others in the group share not only the same traditional shape with the cameo-

330. Relief-cut glass bowl. Diam. without mount 17 cm. Treasury of S. Marco, Venice

331. Rock crystal ewer. Datable between 975 and 996, Ht. without stand about 20.5 cm. Treasury of S. Marco, Venice

332. Wheel-cut glass beaker. Datable to first half of eleventh century. Bodrum Museum, Bodrum, Turkey

glass vessel just discussed but also many iconographic and stylistic features. However, whether the relief-cut glass objects led up to, were contemporary with, or were made in imitation of the rock-crystal ones is yet to be determined.[91] In addition to this *tour de force*, the five other very similar extant pouring vessels,[92] and a small group of objects of comparable calibre in other shapes, there are a good many non-epigraphic and non-figural rock-crystal objects with decoration in the bevelled style. Were these also made near the turn of the millennium for a more conservative clientele? Or was there an extended earlier development in this difficult medium leading to the accomplished style of the inscribed works – a hypothesis supported by some pieces decorated in the Samarra Style C, which reached European church treasuries in the period from 973 to 982?[93] An overlapping of styles is possible, but it is more likely that a slow, unilateral growth led up to the climax of this art in the eleventh century, a development following fairly closely that which we have already outlined in this chapter *vis-à-vis* the decoration of wood, ivory, and lustre-painted ceramics.[94]

Very shortly after the technique of wheel cutting reached its Islamic zenith in the relief-cut glass just discussed, its gradual simplification began. It was not long before a totally bevel-cut decoration often with no foreground or background had evolved, a stage beautifully exemplified by the vessel [332], decorated with finely executed lions, which was found in the Serçe Limani shipwreck previously mentioned in connection with the *champlevé* bowl [325] and is, therefore, firmly datable to the first half of the eleventh century.[95]

333. Glass cup. Datable to first half of eleventh century. Bodrum Museum, Bodrum, Turkey

The simplification of this lapidary technique as applied to glass was to reach its logical conclusion in totally plain but beautiful vessels with bodies faceted like gemstones.[96]

In addition to experimenting with wheel-cutting techniques, which could be employed after the glass had cooled, the glassmakers in the Medieval period continued to adapt techniques applicable only to a hot gather (viscous and extremely ductile portion of molten glass 'gathered' for use in glass-blowing) or parison (glass bubble): mould blowing and thread or coil trailing. The latter decorative device is beautifully exemplified in the Fatimid period by the cup [333] also excavated at Serçe Limani. The less time-consuming technique of thread trailing employed here in a boldly contrasting colour to set off the rim of the drinking vessel was often used at this time as well to imitate relief-cut designs.[97]

Glass products and glassmakers themselves moved from country to country. Documents from the Cairo Geniza mention that in the eleventh and twelfth centuries glassmakers from Greater Syria, fleeing the almost permanent state of war there, came to Egypt in such masses that they

334. Lustre-painted glass vessel, Ht. 9.6 cm. Staatliche Museen, Berlin

were competing with local artisans. Further, in a document dated 1011 it is noted that thirty-seven bales of glass were sent from Tyre, presumably to Egypt. Such emigrations and importations make precise attributions risky and international styles more likely. However, it is generally assumed that the ill-fated ship that sank in Serçe Limanı took on its cargo at a port at the eastern end of the Mediterranean, thus indicating a Greater Syrian provenance for its contents.

The vessel [334] continues the tradition of lustre-painting on glass that we first met with in Egypt during the early Abbasid period [110].[98] While considerably simpler than the decoration found on Fatimid lustre-painted pottery, the style of the rinceau and the convention of setting off the ornamented bands with double (or single) plain lustre fillets, not to mention the shape of the vessel itself, are all familiar elements in the repertoire of the period.

Ample evidence for the importance of textiles during the Fatimid period is provided by the detailed descriptions of the dispersal of the imperial treasury in 1067–68 as well as by reports of contemporary geographers. These invaluable texts inform us as to the quantities and diverse origins of the numerous types of textiles being stored in various areas of the palace at the time of the catastrophe and the different types of textiles being woven in various parts of the Fatimid realm. We learn not only that this dynasty imported stuffs of many different kinds from al-Andalus, Mesopotamia, and Persia as well as from Byzantium, but that locally made products were also very highly valued both within and outside Egypt.[99] The *tiraz* [335] was probably the back of an over-garment similar to a modern *'abaya* and belongs to a rare and deluxe group of Fatimid textiles datable to the reign of the caliph al-Mustali (*r.* 1094–1101) and to the factories of Damietta in the Delta.[100] The decorative bands and ornamental roundels are tapestry woven in coloured silks and gold file (silk core wrapped with a gold wire) on a fine linen. This group has been associated with a type of textile called *qasab* described in 1047, by the medieval Persian traveller Nasir-i Khosrow, as being woven in Tinnis and Damietta for the sole use of the ruler.[101] While the gazelles and prancing sphinxes reflect a figural style with which we have become familiar on other objects of this period executed in many different media, the layout as well as the style of the garment itself were adopted from the fashion of the Copts in pre-Islamic Egypt.

For the most part earlier and considerably more plentiful than the deluxe group just discussed were the group of Fatimid textiles adorned solely with epigraphic and narrow decorative bands [336]. This veil is particularly sumptuous and not only bears the name of the caliph al-'Aziz and the date of 373/983–84 but also informs us that it was made in the private *tiraz* in Tinnis. Its epigraphic ornamentation shows a continuation of the style begun under the last Abbasid ruler of Egypt, al-Muti' (*r.* 946–74), in which the *hastae* (vertical stems) of the letters of the large silk tapestry woven inscription bands end in very graceful half palmettes.[102] These *tirazes*, like the group from the period of al-Musta'li just discussed, closely followed not only the layout and content of the decoration found on the textiles produced in pre-Fatimid Egypt but the styles of the earlier garments as well.

335. Detail of silk, gold, and linen fragmentary garment. Datable between 1094 and 1101, 74.3 × 71.8 cm. Metropolitan Museum of Art, New York

336. Detail of silk and linen fragmentary veil. Dated 373/983–84, L. 143 cm. Metropolitan Museum of Art, New York

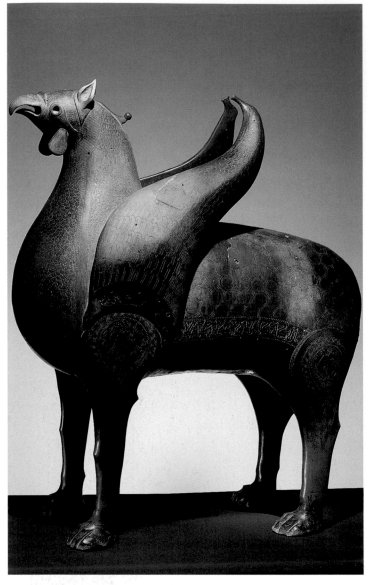

orginal function of which is unknown) everything is formalized: not only the body and its parts but also the engraved decoration, which consists of roundels, inscriptions, and designs of small animals – none of them detracting, however, from the grandiose impression that this object, more than one metre high, makes on the beholder. Made under the Fatimid aegis most probably during the eleventh century, this object could very well have been part of the large booty taken by the Pisans after their successful invasion of the Zirid capital, Mahdia, in the summer of 1087.[105]

It is not yet possible to assign precise dates to these sculptures, and therefore it is not known whether or not the small, more realistic, copper-alloy hare [338] – which most probably served as a fountain spout – was contemporary with or made before or after the griffin.[106] Whatever the style, the Fatimid works are impressive as animal sculptures. Furthermore, they seem to have served as prototypes for Romanesque pieces.[107]

Although we are informed that the Fatimid treasury contained silver articles with niello decoration, until recently we were at a loss as to the appearance of any of these items as none of them seemed to have survived. The box [339], therefore, bearing the name of a vizier of al-Mustansir who served only for three years – 1044–47 – fills an important gap. As Geniza documents support the idea that large quantities of silver vessels were exported to the Maghrib and India from Egypt in the Medieval period, we can assume that this small container – most probably used as a box to keep jewels – was made in that country.[108]

Not only did Fatimid craftsmen excel in the making of objects of fine silver, as can be judged from contemporary sources and the above-mentioned object, but their goldsmiths' work was of the highest quality as well. The elements comprising the necklace [340], especially the biconical and two spherical beads near the centre of the ensemble that are totally fabricated from gold wire and decorated with granulation, were of a type known to have been

337. Copper-alloy griffin, Ht. about 1 m. Museo dell'Opera del Duomo, Pisa

338. Copper-alloy hare, Ht. 15 cm; L. 15 cm. Private Collection

Growing out of a long tradition established during the Umayyad and Abbasid periods [100, 150], the vogue for small and large copper-alloy animal sculpture persisted in Egypt and the Maghrib at least until the end of the eleventh century. Representing griffins, stags, gazelles, lions, rabbits, eagles, and other types of birds, they were used as aquamaniles, incense burners, fountain spouts, padlocks, and possibly vessel supports, and they share not only a high degree of stylization, which, however, never impairs effective recognition of the subject, but also such secondary features as frequent all-over decoration and zoomorphic handles.[103] The most famous as well as the most beautiful and monumental example of this tradition in the central Islamic lands is undoubtedly the celebrated so-called Pisa griffin [337], the immediate precursor of which is a quadruped from Ifriqiya.[104] On this copper-alloy object (the

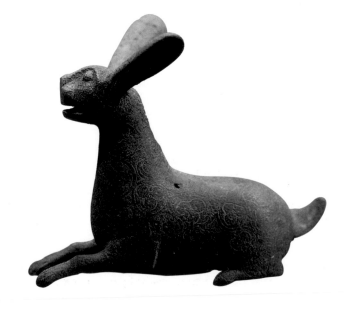

339. Gilded silver and niello casket. Datable between 1044 and 1047, 7.5 × 12.4 × 7.9 cm. Real Colegiata de San Isidoro, Leon

340. Gold necklace elements. Datable to first half of eleventh century. Width of central biconical element 50.8 mm. Israel Museum, Jerusalem

of wood, ivory, and lustre-painted ceramic objects during the Fatimid period reflected developments that occurred first in painting.[110] Unfortunately, only a few fragments of wall and ceiling painting and not many more drawings on paper survive from this era, none of which is dated or datable [341–3]. Therefore, it is impossible at this juncture of our knowledge to prove or disprove this suggestion.[111]

THE ART OF THE BOOK

As to the drawings on paper from this period, the tattooed female figure [341] is perhaps the most accomplished picture that has come down to us. It shares with the undated and so far undatable lustre-painted pottery group, discussed above [323, 324], the new Fatimid imagery, exhibiting greater animation and interest in the naturalistic representation of the human figure. However, the rendering of the face and the coiffure still betrays a dependence on the figural style at the temporary Abbasid capital at Samarra.

Also exhibiting the new trends is the drawing [342]. This bears very close comparison to the decoration on tiles from Sabra al-Mansuriyya [141]. Such similarity provides proof

executed during the first half of the eleventh century in either Greater Syria or Egypt and may very well have been of the variety described by the eleventh-century author Ibn Zubayr as 'unusual, very beautifully fashioned gold jewellery' that was sent to the Byzantine king Romanos I Diogenes in 1071.[109]

It has been suggested that the new imagery with its animation and fully realized observation of the details of everyday living that we have seen especially in the ornamentation

341. Drawing of female figure, 28.5 × 18 cm. Israel Museum, Jerusalem

342. Drawing of battle scene, 31.5 × 21 cm. British Museum, London

343. Manuscript leaf with illustration of rabbit, Gr. Ht. 15.7 cm. Metropolitan Museum of Art, New York

heavy body, long and large ears, snub nose, and short tail closely resembles those seen earlier in this chapter executed in the marquetry technique and in metal [317, 338]. However, this illustration shows an animal drawn even more realistically – owing, perhaps, to the medium – checking his flank before hopping along. The verso of this folio is adorned with a lion.[112]

Other than the few drawings on paper, virtually no arts of the book produced in Egypt during the Fatimid period have up to now been identified. Because of the heightened interest in the human figure during this period to which so many of the decorative arts bear witness, it is difficult to imagine that the art of miniature painting was not highly developed. However, apparently no illustrated manuscript or fragment of one has survived. In fact, none has even been attributed to this period. We learn from the eleventh-century report by Ibn Zubayr of the dispersal of the Fatimid treasury during the reign of al-Mustansir that

> the number of libraries (within the palace) was forty, including 18,000 books on ancient sciences. The books included also 2,400 complete copies of the Qur'an [kept] in Qur'an boxes. They were written in well-proportioned calligraphy of the highest beauty, and adorned with gold, silver, and other [colours]. This was besides [the books] kept in the libraries of Dar al-'Ilm in Cairo.[113]

None of these appears to be extant.[114] The meagre knowledge we have of the arts of the book in the Fatimid realm, other than that found in texts, is that gleaned from those manuscripts produced under the aegis of this dynasty in Sicily [154] or under that of their governors in Ifriqiya [471]. This total lack of Fatimid Egyptian manuscripts has never been satisfactorily explained. The fact that none has been positively, or even seriously, identified after more than eight hundred years might indicate that all of them, even the Qur'an manuscripts, were methodically destroyed in the Sunni revival that followed the fall of this heterodox dynasty – the fulfilling of a duty to extirpate heresies and reinstate true orthodoxy and thus part of the systematic attempt at reeducation undertaken by the Sunnis. The solution to this puzzle has so far not presented itself.

CONCLUSION

The most striking feature of the arts under Fatimid rule was the establishment of Egypt, and more particularly of the newly created city of Cairo, as a major centre for artistic activities. The latter involved the construction of many buildings, their decoration in many techniques, the establishment of a brilliant art of lustre-painting ceramics and glass, carving ivory, rock crystal or wood, chasing and engraving (but apparently not inlaying) metalwork, and an elaborate art of textile weaving. Cairo also became a consumer for foreign goods, silks and ceramics from China, gifts from Christian rulers farther north. Expensive curios from many places were brought to the city as parts of an extremely active international trade in items that must have been considered works of art. All these things were available to a wealthy middle class best known through its Jewish component which left so many documents of private and

of the important inspiration for the new imagery to be found in the output of the artists working under the aegis of the Fatimid dynasty in Ifriqiya.

The manner in which animals are depicted in this medium is no exception to the new sylistic trends we have been following from this period not only in the art of the book but also in that of the object. The hare [343] with its

professional life.[115] Or else they were kept in an imperial treasury whose variety is demonstrated by the lists made after the looting in the middle of the eleventh century.[116] Some of these sources even imply the existence of an art market, where new and old objects, sometimes outright frauds like the saddles attributed to Alexander the Great, were peddled by otherwise unknown dealers.[117] Cairo became a major employer of artisans and technicians, and it is, for instance, to the importation of stone-cutters from Armenia and northern Mesopotamia that some of the novelties in late eleventh-century construction techniques have been attributed.

But beyond these economic and technical considerations, the detailed evolution of which still needs investigation, a more important and particularly original feature of the arts under the Fatimids is the blurring of the boundaries between public and private art. Many of the new artistic developments, especially the buildings in the city of Cairo but also the lustre ceramics, were made to publicize and to display power, ideology, wealth, taste, or whatever else a patron or an owner wished to proclaim. This novelty is particularly visible in the importance assumed by inscriptions, the 'public text' identified by I. Bierman,[118] on the outside of buildings, by individualized images on ceramics, and in the colourful restoration of great sanctuaries like those of Jerusalem.[119] Nasir-i Khosrow, the Persian traveller and propagandist for the Fatimids, was allowed to visit the imperial palaces in Cairo and described at great length their elaborate decoration.[120]

While it is easy enough to demonstrate the artistic vitality of Fatimid Cairo and some of the social and ideological functions of individual monuments or objects, it is much more difficult to identify and explain the characteristics of the art itself. Three of these may help to define the paradox of Fatimid art.[121] One is the possibility of demonstrating a progression away from the dry and severe formalism of ninth-century vegetal decoration, as in the stucco ornament of the mosque of Ibn Tulun in Cairo and in many related pieces of woodwork, to a much more lively arabesque with highly naturalistic features in the eleventh century, and, eventually, in the twelfth, to an elaborate geometry with its own formalism. Whether an evolution which is apparent in woodwork and stucco ornament is true for all media remains to be seen. A second characteristic is the frequent appearance of representations of people and animals in almost all media. Sometimes hidden in vegetal ornament, animals and personages also appear as the motifs decorating *muqarnas* niches and lustre-painted ceramics. The motifs represented in the latter are quite varied both in style and in originality, but the essential point is that their range goes from traditional scenes of royal pastimes to very lively images of daily life. Stretching a point slightly, R. Ettinghausen even talked of 'realism' in this Fatimid art.[122] It is unfortunate that we are not yet able to date accurately the appearance of these representations, but there seems to be little doubt that it preceded by almost a century the same phenomenon in Iraq, in Syria, and especially in the eastern Islamic provinces. It could be connected to a renewed awareness of Late Antique art and, in general, to the artistic explosion of the whole Mediterranean area in the eleventh century rather than to some uniquely Islamic developments, but the matter still requires further reflection.[123] And, finally, the art of the Fatimids reflected and satisfied the needs of a stratified society. It is, at times, difficult to decide whether a given object, or even a building, should be attributed to a royal, aristocratic, or middle-class patron or user, or whether he or she was a Christian, a Muslim, or a Jew. But all these possibilities are open.

Thus, and therein lies the paradox, the art of the Fatimids is more difficult to explain than to describe or to define. Should it indeed be considered a Mediterranean art which may have picked up certain features from eastern Islamic lands, but which developed largely independently within a different context of civilization? Or was it the precursor and even possibly the inventor of changes, like the appearance of representations or the growth of a public art, which were soon to become common? There are as yet no answers to these questions which illustrate the second paradox of Fatimid art within the broad context of medieval Islamic art. It exhibited an aesthetic vitality which seems absent from the rest of the Islamic world during the same period. Is it an accident? Does it have something to do with the doctrines of Isma'ili Shi'ism and the ways in which they were applied to the rich and complex society of Egypt and of the provinces, like Ifriqiya or Syria and Palestine, under its domination in the eleventh century? Or, perhaps, Fatimid art and culture were an original phenomenon hatched in tenth-century Ifriqiya by a brilliant leadership around the caliph al-Mu'izz, which would have created its own synthesis of Islamic doctrines and practices with Mediterranean art and culture.[124]

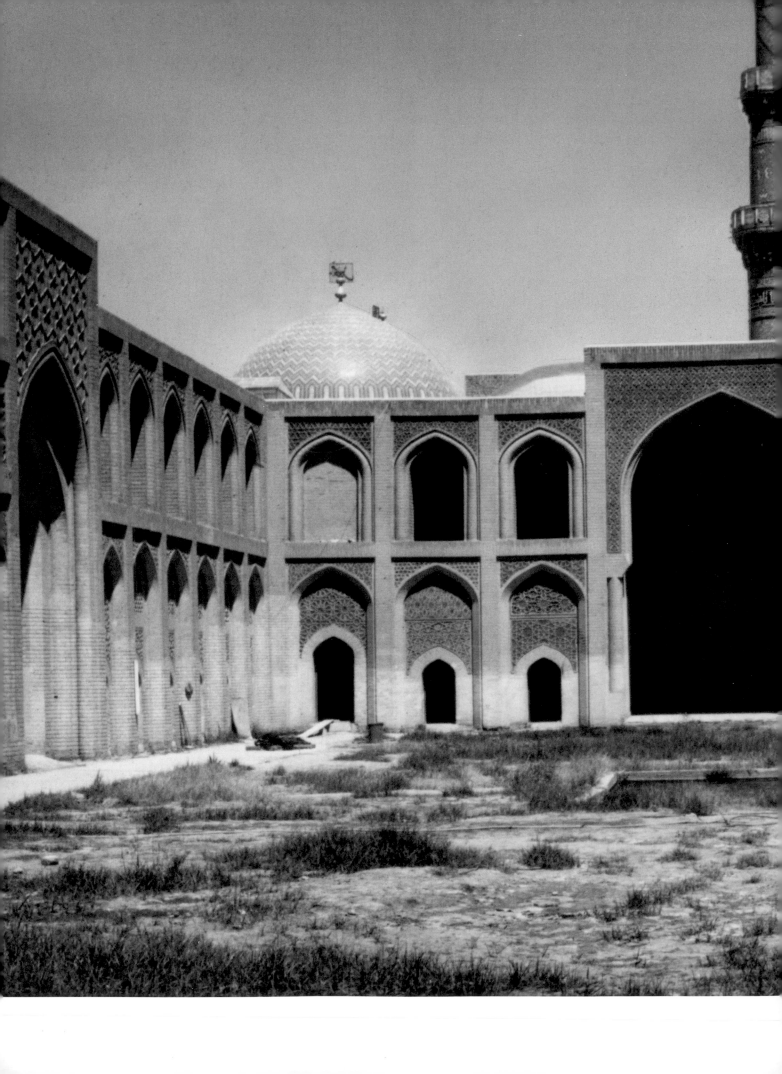

PART II

The Saljuqs, Artuqids, Zangids, and Ayyubids in Iraq,
Anatolia, Syria, Palestine, and Egypt

ARCHITECTURE AND ARCHITECTURAL DECORATION

In contrast to early Islamic times, it is not possible, at the present stage of research and interpretation, to provide a single, continuous, chronological account of medieval (eleventh to thirteenth centuries) architecture in the central Islamic lands which were not under Fatimid rule. Two approaches could be proposed. One is dynastic and political; it would identify monuments and architectural characteristics according to definable areas of shared power and culture. Seljuq rule in Anatolia or Ayyubid control of Egypt and the Levant led to an architecture with recognizable forms of its own. But it is difficult to identify an independent set of forms associated with the Zangids of the Jazira and Syria, the Artuqids in northern Jazira, or Abbasid rule in Baghdad. Therefore, we have preferred a second approach, which is to present these lands in terms of four geographical regions with partly interlocking dynastic histories: Iraq; Jazira; Syria with Palestine and Egypt as well as a brief foray into Yemen; Anatolia. Chronological sequence will suffer no doubt, but it is possible to argue that, during a politically complicated period such as this one, architectural consistency lies in lands rather than in rulers.

IRAQ

The history and development of Iraq, defined here in the medieval sense as the lower part of the Tigris and Euphrates valleys, were somewhat overshadowed by the momentous events taking place in Anatolia, Palestine, and Syria. Nevertheless, the orthodox Abbasid caliph resided in Baghdad and in spiritual and intellectual power the city was as great as ever. Nizam al-Mulk, the celebrated vizier and ideological guide of Saljuq rulers, founded his most important *madrasa* there. The tombs of Ali and Husayn, the tragic

heroes of Shi'ism, and of the great founders of Sunni schools of jurisprudence were in Baghdad, Kufa, Kerbela, and Najaf; they all became centres of large religious establishments for pilgrims and other wayfarers; their impact was as wide as the Islamic world.[125] The port city of Basra in the extreme south was still one of the major Muslim gates to the Indian Ocean, and travellers such as the Muslim Ibn Jubayr and the Jew Benjamin of Tudela continued to be struck by the wealth and importance of most Iraqi cities. Iraq's political significance, on the other hand, had shrunk, to revive briefly in the first decades of the thirteenth century, when the caliphs al-Nasir and al-Mustansir asserted themselves as more than figureheads.[126] In 1258 the last caliph was killed by the Mongols and the city sacked.

Few monuments survive from this period. Of those mentioned in texts, mostly chronicles,[127] many were reconstructions of, or comparatively minor additions to, older buildings. The vast complex of the Mustansiriya in Baghdad, inaugurated in 1233 by the caliph al-Mustansir,[128] stands out both ideologically and architecturally [344, 345, 410]. The first recorded *madrasa* built for all four Islamic schools of jurisprudence, it reflected the idea of the caliphate as the sponsor of an ecumenical Sunnism, a strong feature of the new guidance that the later Abbasids attempted to provide. Built along the Tigris, the Mustansiriya is a huge rectangle (106 by 48 metres) with a large central court (62 by 26 metres). It had three *iwans* opening on the court, one of which served as an oratory. Between *iwans* and oratory lay long halls at right angles to the court, and various other halls and rooms extended to the north and south, probably equally divided between the four official schools of Islamic law, according to Sunni practice.

Extensive reconstructions and long use of the Mustansiriya as a customs house have greatly altered the internal aspect of the building, but two points about it are of some significance. First, although, with its two superposed arches in rows symmetrically arranged on either side of larger single arches, it was clearly influenced by the Iranian court with four *iwans*, it differs in that one of the *iwans* was transformed into an oratory whose function separated it from the rest of the building. This function was emphasized by a triple entrance on the qibla side of the court [346], bal-

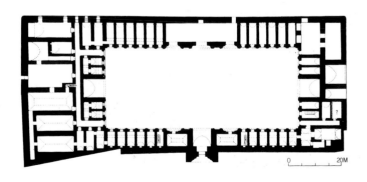

345. Baghdad, Mustansiriya, founded 1233, interior

344. Baghdad, Mustansiriya, founded 1233, plan

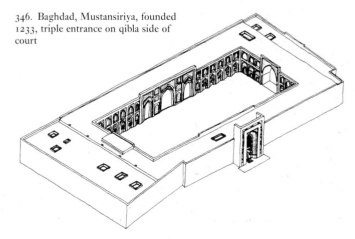

346. Baghdad, Mustansiriya, founded 1233, triple entrance on qibla side of court

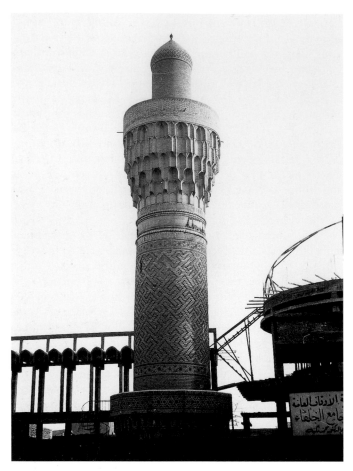

347. Baghdad, Suq al-Ghazi minaret, probably twelfth century

either have been altered beyond recognition of their early appearance or have never been available for scientific analysis. Two less holy ones which have been studied are the Imam Dur (or Dawr), near Samarra, datable around 1085 [348, 349], and the so-called tomb of Zubayda in Baghdad, datable around 1152, and very much restored in recent times.[130] In both instances the individuals originally commemorated in these mausoleums are unknown. Their plan is quite simple: a polygon or a square covered with a dome. The curious development occurs in the dome: over an octagon, five (at Imam Dur) or nine (in Baghdad) rows of niches lead up to a very small cupola. The dome has been transformed into a sort of *muqarnas* cone. In detail the two monuments vary considerably: the Baghdad one is drier and more obviously logical in its construction than Imam Dur, where there is a much more complex combination of geometric forms, particularly inside. In both domes, however, great height was achieved through a geometrically conceived multiplication of single three-dimensional units of architectural origin. This type remained quite popular in the Persian Gulf,[131] and its impact elsewhere has been well documented. Although the full documentation of the point is difficult to make, recent and forthcoming works are very suggestive in proposing that the type identifies the Baghdadi version, if not invention, of the *muqarnas* as an ideological statement of Sunnism.

348. Samarra, Imam Dur mausoleum, *c.*1085, exterior

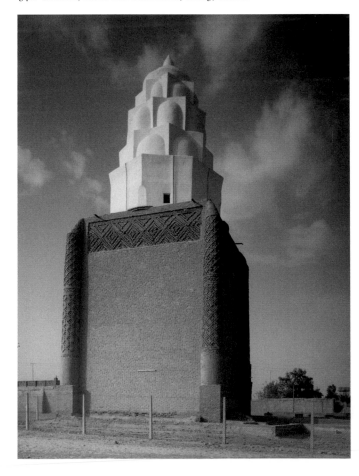

anced by a totally artificial triple façade on the opposite (entrance) side. Thus the openings on the court do not correspond with the same clarity as in Iran to the purposes and forms of the covered parts behind them; from being a meaningful screen, the court façade has become a mask or a veil, perhaps aiming to provide an eastern Islamic effect to a Baghdadi building and being, thus, the expression of social taste. Second, the ratio between length and width, the multiplication of long vaulted halls, and the peculiar separateness of the oratory are all anomalous features, at least from the point of view of an Iranian model. They could be due to the location of the Mustansiriya in a bazaar area where previous constructions and an urban rhythm of life imposed peculiar forms on the new buildings; on the other hand they may derive from earlier developments in Iraq in the eleventh and twelfth centuries of which as yet we have no knowledge. In any case the originality of the ecumenical function of the Mustansiriya is indubitable.

A second Baghdadi monument, probably of the twelfth century,[129] the minaret in the Suq al-Ghazi [347], uses the brick technique and decoration of Iranian minarets. Stucco decoration on one side shows that it was once attached to some larger construction.

The mausoleums erected in Iraq during this period are particularly novel and original among the funerary buildings seen so far. Many of the most celebrated, such as those of al-Hanafi and the Shi'ite ones in Kufa, Najaf, and Kerbela,

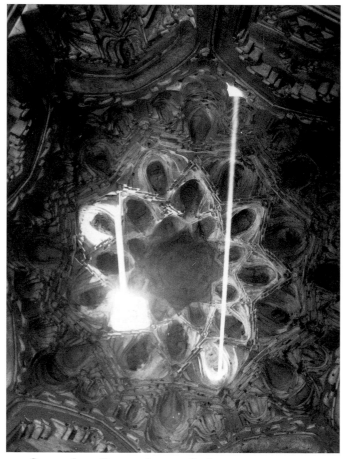

349. Samarra, Imam Dur mausoleum, c.1085, dome

Secular architecture is represented by a few fragments from thirteenth-century palaces in Baghdad (now much restored and transformed into museums),[132] with *iwans* and porticoed courts and rich stucco decoration covering most of the walls, and by two gates to the city. The more interesting, the Gate of the Talisman, was blown up in 1918.[133] Built by the caliph al-Nasir in 1221, it was remarkable for the sculpted figure of a small personage pulling the tongue of two dragons, possibly a symbol of the caliph destroying the heresies threatening the empire, or perhaps a more general, apotropaic talisman, as was fairly common in the popular culture of the Fertile Crescent at that time.

THE JAZIRA (NORTHERN MESOPOTAMIA)

The middle and upper parts of the Tigris and Euphrates valleys and the mountains and semi-deserts between the two rivers and their affluents, known as the Jazira ('island') in medieval times, consisted of three parts: the Diyar Mudar, essentially the middle Euphrates valley, more or less coinciding with present eastern Syria; the Diyar Rabiʿa, the middle Tigris valley, corresponding to the present northern Iraq; and the Diyar Bakr, including the more mountainous regions of the upper Tigris and Euphrates, now almost totally in Turkey. Great mountains – the Tauric chains, the Armenian knot, the Zagros and the Kurdish ranges – surround the Jazira on the east, north, and northwest. To

the west and southwest lies the Syrian desert; to the south, Iraq. For centuries the main battleground between Mediterranean and Iranian empires, northern Mesopotamia was conquered by the Muslims in the first years of their expansion. For several hundred years thereafter it remained an area of transition, a passageway from Baghdad to Syria through Raqqa and Aleppo for trade and armies guarding the Anatolian frontier against the Byzantines. At least in the Euphrates valley, an area of major agricultural settlements had developed in the shadow of fortified towns such as Raqqa, Harran,[134] and Diyarbakr.[135] Prosperity declined considerably in the tenth century, as nomadic incursions threatened trade and weakened agriculture.

In the twelfth and thirteenth centuries enormous social and political changes took place. The conquest of Anatolia, the Crusades, Turkish and Kurdish population movements, the necessity of providing for large armies marching against Christians and Fatimids led to the transformation of the Jazira into one of the liveliest regions of the Muslim world. Old towns were revived, small villages transformed into major centres.[136] As the danger from the nomads in the desert was checked, agriculture developed around some of the more important settlements. From impregnable fortresses enterprising feudal rulers or robber barons exacted taxes and tribute from passing caravans and armies. The cities of Mosul, Sinjar, Diyarbakr, Mayyafariqin (modern Silvan), Mardin, Hisn Kayfa (modern Hasankeyf), Jazira ibn Umar (modern Cizre), Harran, and many others suddenly hummed with power and activity. Armenian, Nestorian, and Jacobite Christians fully participated in the wealth and growth of northern Mesopotamia, and the building of new churches and monasteries is almost as remarkable as that of forts and mosques.

Prosperity did not last long, however; the Mongol invasions came and, as the destinies of Iran, Anatolia, and Syria moved in different directions in the following centuries, the Jazira reverted for the most part to an impoverished and largely deserted region of a few strongholds separated by menacing wastelands. Such it remained until the twentieth century. This fate, as well as its modern divisions between remote regions of three different countries, explains why its numerous monuments are still very little known and, with exceptions in present-day Turkey, unrecorded and little studied. Yet the interest and significance of the Jazira in the twelfth and thirteenth centuries, both for Syria and for Anatolia, cannot be overestimated. The Zengids and the Ayyubids, future rulers of Syria and Egypt, came from this area and, in the middle of the twelfth century under Nur al-Din and in the second quarter of the thirteenth under Badr al-Din Luʾluʿ in Mosul, the Jazira was one of the truly great centres of Islamic economic and political life. Builders were busy, as a list of Nur al-Din's constructions proves,[137] but limited investigation so far allows only for the identification of some of the more significant monuments and a suggestion of their importance.

New congregational mosques were constructed and older ones rebuilt. In Raqqa the old Abbasid mosque was redecorated and largely rebuilt in 1146–47, 1158, and especially in 1165–66.[138] In Mosul almost all of the mosque built in 1148

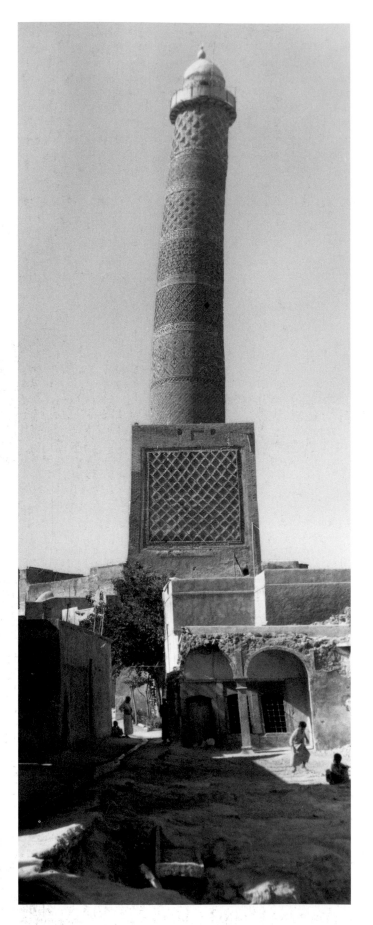

350. Mosul, Great Mosque, minaret, perhaps 1170–72

under Nur al-Din (rebuilt in 1170–72) to replace an early Islamic shrine has disappeared or been redone; Herzfeld reconstructed it as a hypostyle with vaults in the Iranian manner.[139] All that remains from the early construction, a superb minaret [350], cylindrical on a square base and curiously leaning, shows the impact of Iran in both construction and decoration. It may not date from the time of Nur al-Din, for another minaret certainly sponsored by him at Raqqa[140] is a simple round structure, hardly showing an Iranian impact; or possibly the western part of the Jazira was slower to adapt new fashions than the eastern, for the earliest minaret in the middle Euphrates area clearly to show such brick influence is the one erected in 1210–11 at Balis (modern Meskene).[141]

One of the most remarkable congregational mosques of the period, begun in 1204, is at Dunaysir (modern Kochisar) [351].[142] All that remains is the prayer hall, a rectangle 63 by 16 metres divided, like the mosque of Damascus, into three naves parallel to the *qibla* – a Syrian–Umayyad plan to which was added a feature of undoubted Iranian origin: a huge dome in front of the *mihrab* which takes up two of the aisles. Also Iranian in origin is the squinch arch filled with *muqarnas* and the decoration of the spandrels of the squinches [352]; but the superb stone piers and brick vaults are in the pure classical tradition of Late Antiquity and of Byzantium. Equally classical is the traditionally moulded lintel gate, but the luxurious and monumental *mihrab* with its complex geometric, floral, and epigraphic designs reflects oriental influence [353], while the rather strange interlace motif of the façade recalls Armenian or Georgian themes and hardly fits with the decorative imagery of the Islamic Near East. The minaret was square, just like the one of 1211–13 farther west at Edessa (modern Urfa).[143]

The mosques of Malatya (1247–48, restored 1273–74),[144] Mayyafariqin (1157–1227),[145] Kharput (1165),[146] Mardin,[147] and a number of other cities of the area, though by no means yet thoroughly studied, plainly share the stylistic feature of characteristics drawn from various sources. The *muqarnas* squinch at Malatya is an almost perfect copy of a central Iranian type; indeed inscriptions confirm that there were Persian builders there. All exhibit a fascinating variety of decorative themes, from the 'brick style' and incrustation in the Persian tradition to portals with half-*muqarnas* domes of an Iraqi type here translated into stone, writing carved on an arabesque background, and rude but striking geometric themes also carved from stone. At Harran, even classical ornament was literally copied on capitals and friezes. Nowhere is this relation to a pre-Islamic world more apparent than in the mosque of Diyarbakr (ancient Amida). Quite close to Damascus in plan and proportions, its most remarkable feature is its court façades [354], at first glance an extraordinary jumble of antique and medieval elements. Undoubtedly the mosque was, in its main parts, erected in the twelfth century,[148] adding new decorative motifs to elements of construction from older ruins, so that Late Antique vine rinceaux appear next to Islamic arabesques and Arabic writing. The result is less appealing aesthetically than it is fascinating as one of the most remarkable instances of the catholicity of taste which characterized the period and the area.

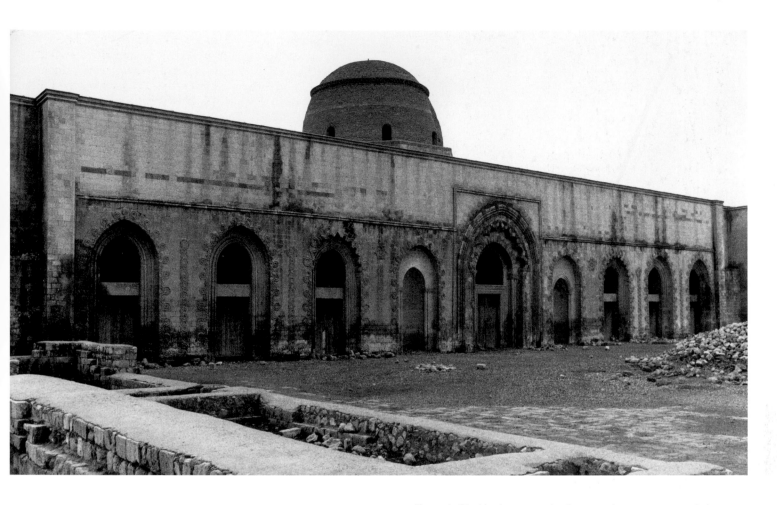

351. Dunaysir (Kochisar), congregational mosque, begun 1204, general view

352. Dunaysir (Kochisar), congregational mosque, begun 1204, wall beneath dome in front of *mihrab*

353. Dunaysir (Kochisar), congregational mosque, begun 1204, *mihrab*

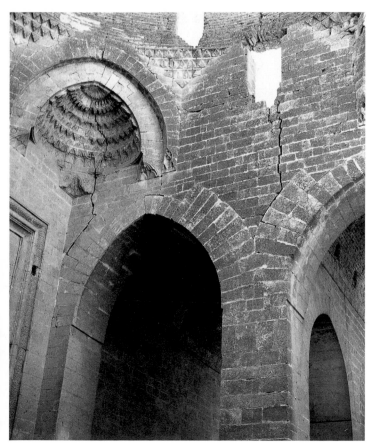

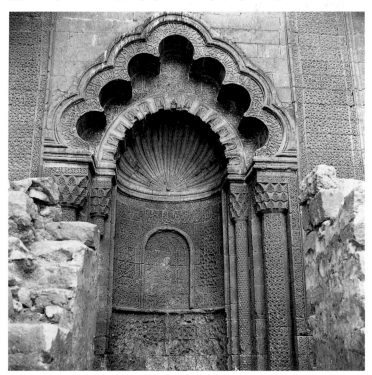

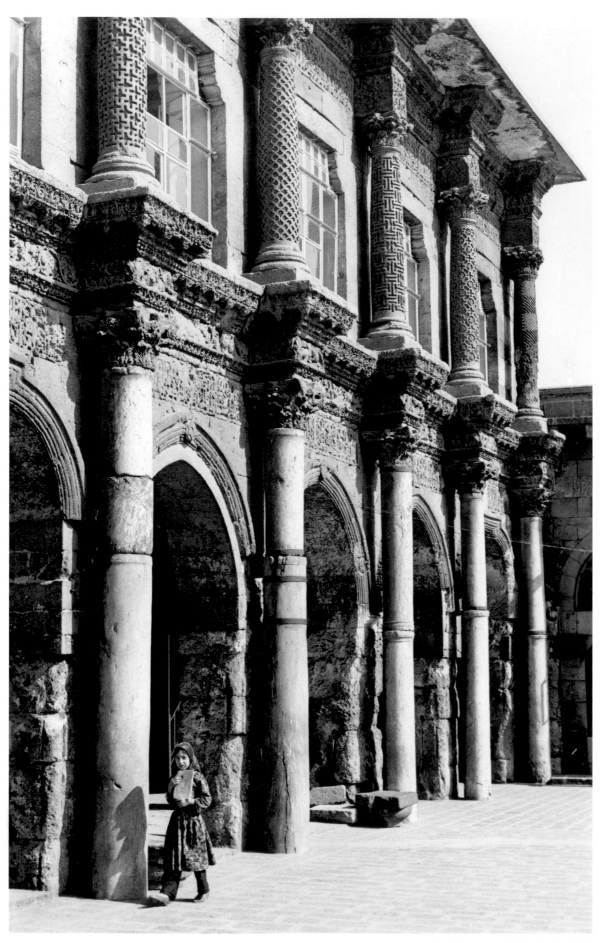

354. Diyarbakr, mosque, mainly twelfth century, court façade

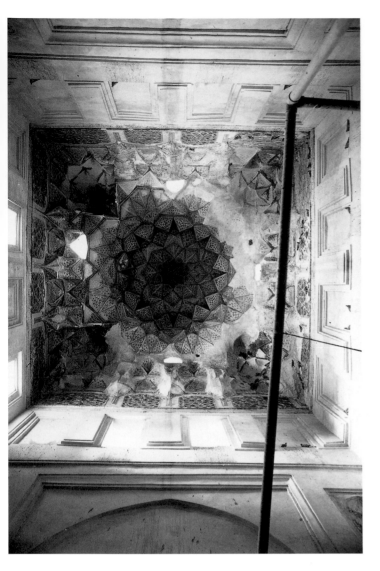

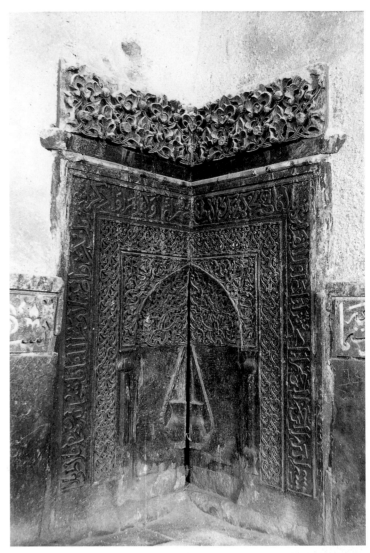

355. Mosul, Mashhad of Awn al-Din, dome, 1248–49

356. Mihrab from Mosul, thirteenth century *Baghdad Museum*

Besides congregational mosques, the cities of the Jazira boasted many smaller religious buildings. *Madrasas* – none of which remains in its original form – are known from Mosul (seventeen of them),[149] Diyarbakr,[150] and most other cities. Some were attached to the tomb of the founder – the first instance of the combination of the mausoleum with some endowed public function which later became so popular in Syria and Egypt. Still standing in and around Mosul are a considerable number of sanctuaries dedicated to saints, prophets, and holy men,[151] including Jonah and St George as well as medieval Muslims, indicating that ancient holy places were often taken over by the predominant faith. Their central feature was always a domed room, often conical or pyramidal on the outside, and the more elaborate ones frequently had an inner *muqarnas* dome (often in stucco, as in the *mashhad* of Awn al-Din [355], dated 1248–49) in complex polyhedral shapes related to Iraqi types, and handsomely carved *mihrabs* [356]. Christian churches took this form as well.[152] In mosques the entrance proper is framed by interlaced polylobed niches filled with decorative designs, in churches by figures. The few known mausoleums and sanc-

tuaries in and around Mosul are no indication of the numbers erected in the Jazira: a guidebook to places of pilgrimage written in the late twelfth century lists many more.[153] Several are visible on the cliffs which border the Euphrates in Syria, and others could probably be found along the roads of the upper valleys of the two rivers.

The great sanctuaries of Edessa and Harran remain uninvestigated. These sanctuaries differ from known Iranian and Iraqi buildings in two ways. First, instead of being only tombs, they are usually associated with constructions dedicated to some cultic, philanthropic, or ceremonial purpose. Second, the architectural qualities found in Iranian mausoleums are not as consistently displayed in the Jazira. This may be because some of the best examples have disappeared, although it is more likely to be a reflection of a wider social basis among patrons and users in the Arab countries of northern Mesopotamia: the long and complex history of Arab cities – with their many religious, economic, and tribal components – might easily have led to greater differentiation in patronage and function than was likely in the constantly shifting and more ephemeral cities of Iran.

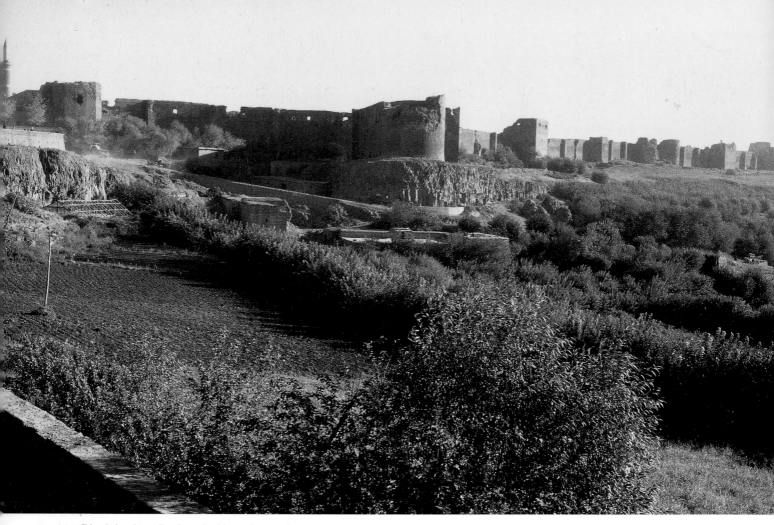

357. Diyarbakr, city walls, eleventh–thirteenth centuries

The secular architecture of the Jazira is equally varied and even less well known. The area became studded with castles, fortresses, and citadels. They occur along the Euphrates, as at Qalʿa Jabar,[154] Qaʿla Najm.[155] At Diyarbakr [357] the striking black basalt wall and massive round towers built over older foundations and often decorated with curious examples of animal sculpture.[156] At Harran, strong walls and towers with long vaulted halls and impressive gates are still standing.[157] And the celebrated Baghdad Gate at Raqqa [358] with its intricate decoration of brickwork clearly belongs to this period, as has recently been demonstrated.[158] Other remains have not yet been systematically studied. Only small fragments remain of palaces. At the Qara Saray in Mosul,[159] generally identified with the thirteenth-century residence of Badr al-Din Luʿluʿ, only a few mud-brick walls remain from what must have been a great pavilion on the Tigris; the only interest of the building now is its stucco decoration of interlaced niches with figures, as already encountered in religious architecture. The most significant feature of the single remaining caravanserai, al-Khan near Sinjar,[160] is its two façade sculptures of a bearded man transfixing a snake-like dragon [359]. Of several surviving bridges, most of them ruined, the most interesting is at Jazira ibn Umar (modern Cizre), with its astronomical

sculptures on the piles.[161] Further explorations and occasional excavations will certainly bring to light other bridges, as well as standard monuments of secular architecture like caravanserais and bazaars so far known only from texts.

SYRIA, PALESTINE, AND EGYPT

The Zangid and Ayyubid princes who assumed control in Muslim Syria from various petty local dynasts first succeeded in ejecting the Crusaders from Edessa in the Jazira (1146), then took over Egypt (1171), and finally pushed the Crusaders back until, by the time of the Mongol invasion in 1258–60, only a few fortresses remained in Christian hands in Syria and Palestine, and a constantly diminishing Armenian kingdom barely subsisted in Cilicia (now south central Turkey). The changes in Fatimid Egypt after the middle of the eleventh century have already been discussed; this section concentrates on Syria and Palestine under Seljuq, Zangid, and Ayyubid rulers, and on Egypt after its conquest by the Ayyubid Saladin. Brief mention will be made of Yemen, remote and isolated from the main stream of central Islamic lands, but where a branch of the Ayyubid family established itself after the end of Fatimid rule.

These were memorable centuries for Islamic architecture

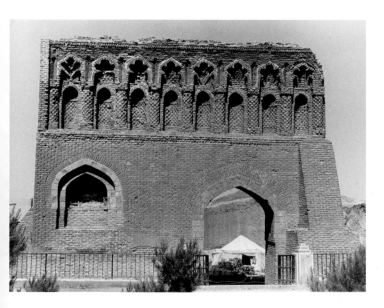

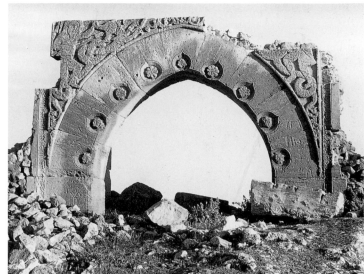

358. Raqqa, gate

359. Sinjar, al-Khan, façade sculpture

360. Sarha, mosque, thirteenth century, ceiling

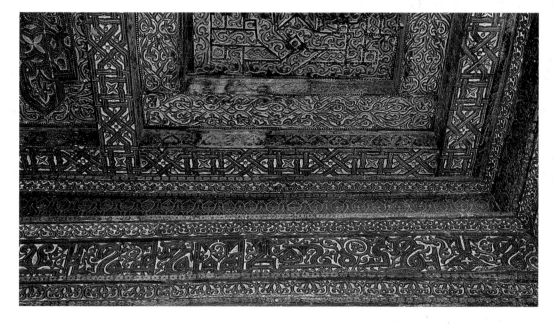

in Syria. The two old cities of Aleppo and Damascus were totally revitalized,[162] and small and at times almost abandoned towns and villages were transformed into major centres.[163] It was a period of intense architectural activity which is finally drawing the attention of scholars and, most interestingly, of architects and urbanists involved in the rehabilitation of old cities and the restoration of their monuments. Enough material exists to justify, as was the case with eastern Islamic lands, a presentation of monuments separately from observations and considerations on techniques of architecture.

The monuments

Few congregational mosques were built, since most towns had had them since the first Muslim century, when Syria was the centre of power. But the old establishments in

Aleppo,[164] Damascus,[165] Busra,[166] and Jerusalem after the reconquest,[167] were refurbished or repaired, increased or modified. At Aleppo, for example, while the plan and setting of the mosque are Umayyad, the porticoes (1146–47), courtyard, and minaret (1090) are from the Medieval period. But, as in late Fatimid Egypt, large institutions are rarer than smaller *masjids* or less ambitious congregational mosques serving either one of the many suburbs which sprang up at the time or some precise social or symbolic purpose. Such are the Hanbalite mosque in the Salihiya suburb of Damascus (before 1215–16),[168] the Mosque of Repentance in a formerly ill-famed part of the same city,[169] and various similar institutions in Aleppo known from texts or inscriptions.[170] They are usually traditional hypostyles based more or less directly on the early model of the mosque of Damascus.

Several mosques were built or rebuilt in Yemen at this

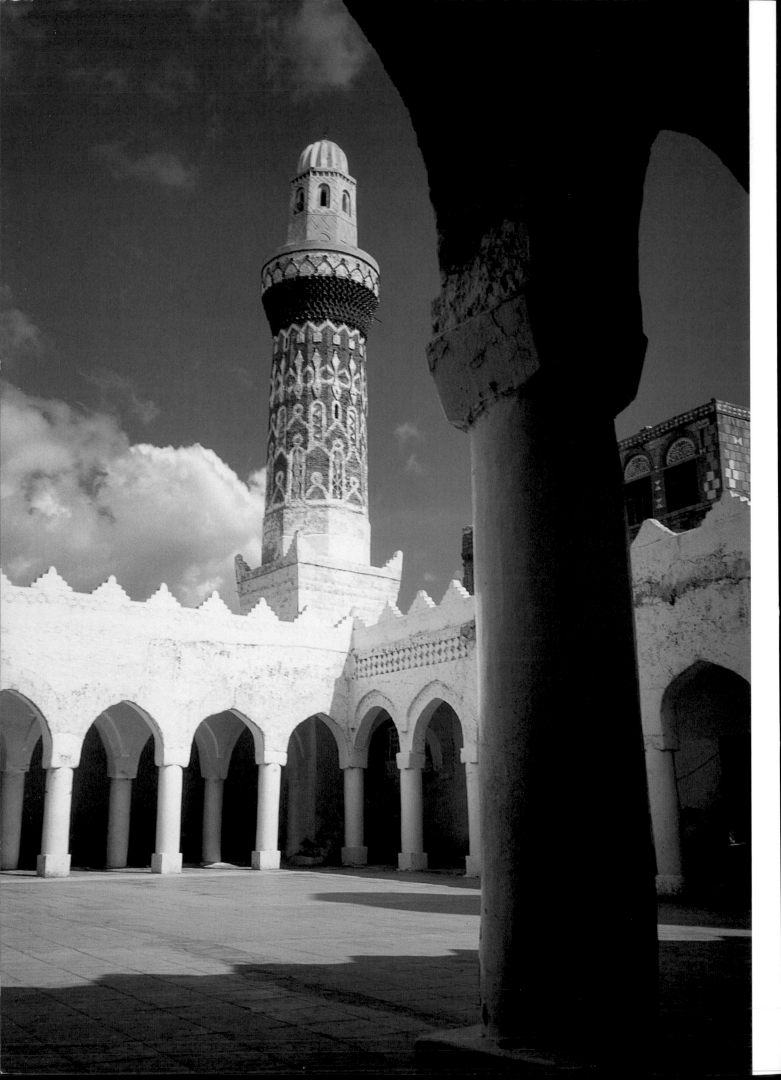

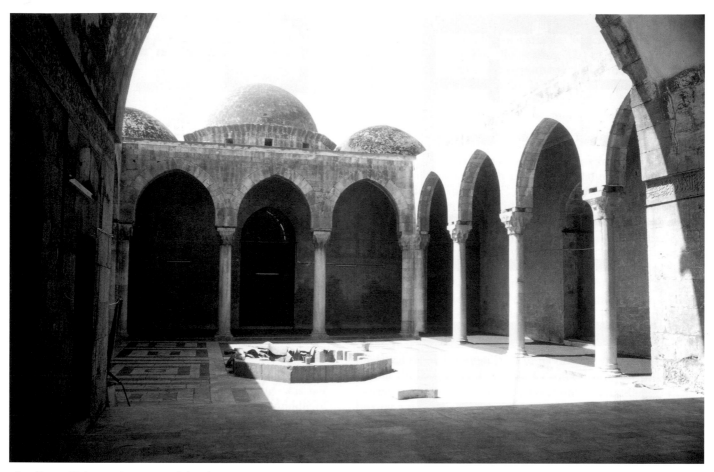

369. Aleppo, Firdaws *madrasa*, 1235–36, interior

time. Some, like the mosque of al-Abbas at Asnaf (1126) or that of Sarha (thirteenth century) are closed chambers without windows, with a single entrance and, often, with beautifully decorated carved and painted ceilings [360]. Others are hypostyle buildings, like the mosque, founded by a woman, of Arwa bint Ahmad in Jibla (1088–89) with a courtyard and an axial nave reminiscent of Fatimid architecture in Cairo [361]. Monumental minarets and portals were added in the twelfth century to the mosques of Zabid and San'a.[171]

Of greater interest and importance are the institutions of Islamic learning sponsored by the new masters of Syria and Egypt. Most were *madrasas* for one or, more rarely, two of the four Sunnite schools of jurisprudence. At the Salihiya in Cairo,[172] built in 1242, however, as at the Mustansiriya in Baghdad and probably under its influence, all four rites were united. In addition to *madrasas* there were several *dar al-hadith* for the expounding of Traditions;[173] in many cases these also included the tomb of the founder or of a member of his family. The number of these schools is quite staggering. Later texts record the construction of forty-seven in Aleppo, eighty-two in Damascus, nine in Jerusalem, and nineteen in Cairo around the twelfth and thirteenth cen-

361. Jibla, mosque of Arwa bint Ahmad, 1088–89

turies. They were the most popular form of piety at the time, fulfilling more than a simple teaching function. While undoubtedly their systematic construction by great leaders such as Nur al-Din and Saladin reveals political, ideological, and religious intentions,[174] many *madrasas*, especially in the thirteenth century, with large endowed properties attached to them, were also examples of conspicuous consumption and a way of restricting private fortunes to the same families.

In contrast to those in Iran, these institutions were usually small, especially in Damascus, squeezed between other buildings in older parts of cities, often with only a narrow façade to the street but spreading out at the back. This apparent constriction, at times avoided by building in the suburbs, arose from the power of the landowning bourgeoisie in Arab countries,[175] which made urban sites far more expensive in Syria than they were further east.

In spite of considerable variations in plan, and of differences both within one city and from one city to another, almost all these buildings are related, as can be seen by an analysis of six of them: the *madrasa* in Busra of 1135 [362], the earliest known in Syria; Nur al-Din's *dar al-hadith* (1171–72) [363] and *madrasa* (1167–68) [364] in Damascus; the Adiliya (1123) [365, 366] in the same city; and two of the greater Aleppo *madrasas*, the Zahiriya (1219) [367] and the Firdaws (1235–36) [368, 369]. All are rectangular structures around a central court often with a pool; at Busra, however,

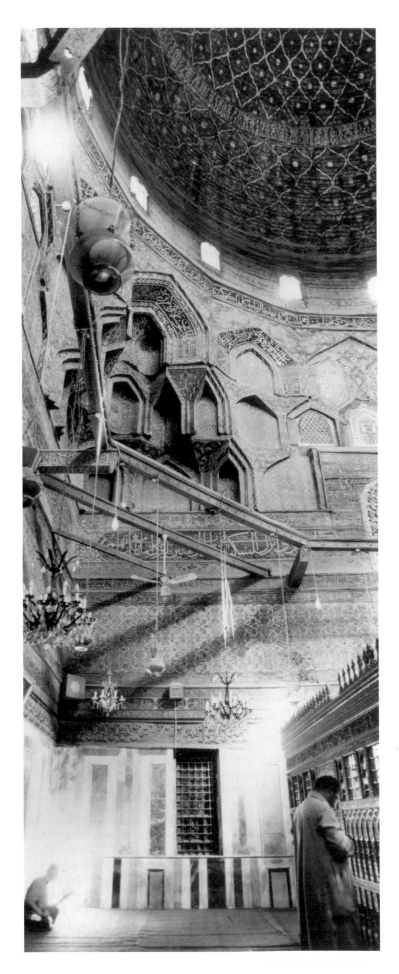

371. (*left*) Cairo, mausoleum of al-Shafi'i, 1217

370. (*above*) Damascus, Adiliya, 1123, façade

373. (*below*) Damascus, hospital of Nur al-Din, 1154, plan

372. Damascus, hospital of Nur al-Din, 1154, façade

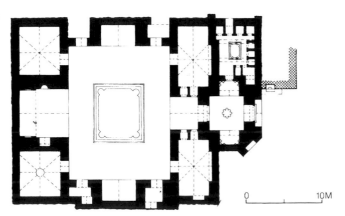

0 10M

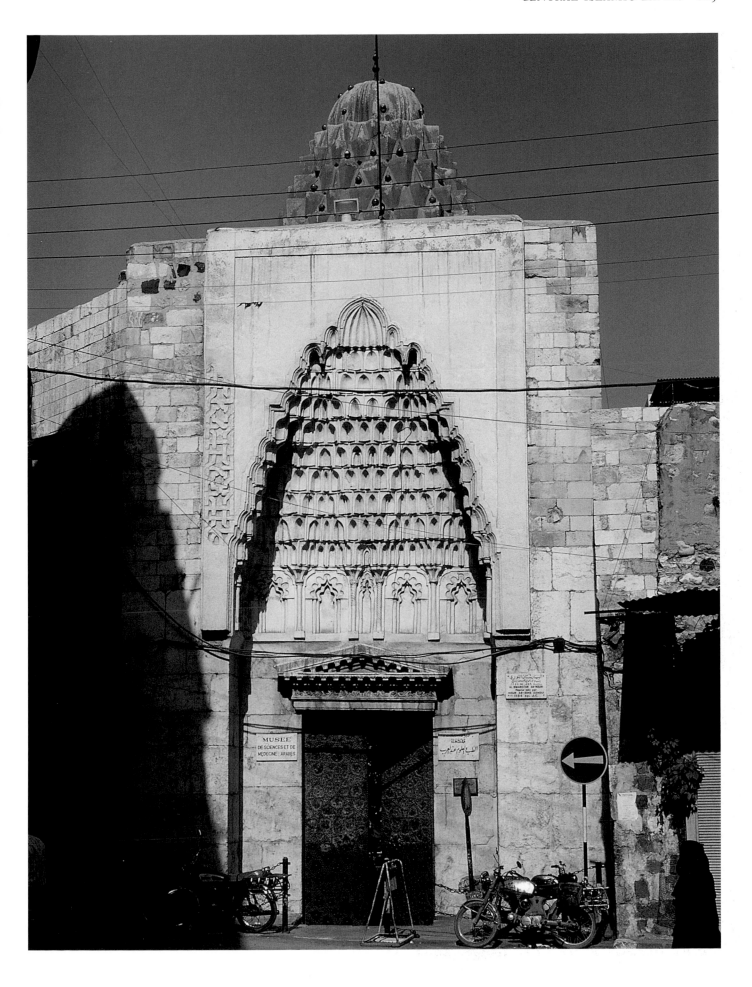

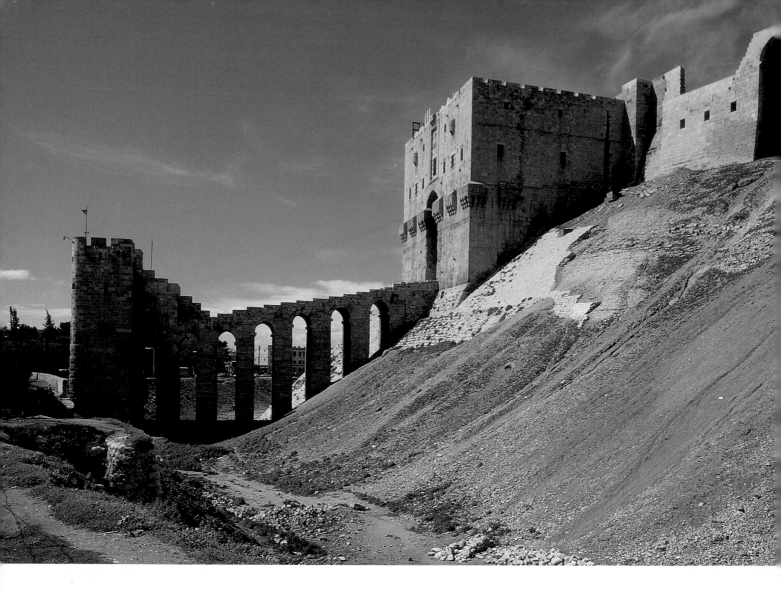

374. Aleppo, citadel, early thirteenth century

375. Aleppo, citadel, early thirteenth century, sculpture at gate

often-repaired *qal'a* on a hill overlooking Cairo has been throughly analysed by K. A. C. Creswell.[187] The one at Busra grew up round an ancient Roman theatre and thus succeeded in creating one of the most stunning contrasts in architectural design, as the sombre, vaulted, frightening halls of a basalt-built fortress lead to the brilliantly lit trabeated marble of the theatre.[188]

The interiors of these citadels, later rearranged, were probably rather monotonous, as in most military architecture, with long halls, narrow openings, various devices for defence, courts, stables, and originally austere living quarters. Yet some of the details from the citadel in Aleppo show considerable care given to details and a sober but effective masonry decoration. The gates were the most impressive feature, at times bearing figurative symbolic sculptures [375], always with magnificent inscriptions which were symbols both of possession and of the power and prestige of the individual sultan. It is unlikely that the often ephemeral rule of constantly warring princes gave rise at that time to any significant ceremonies inside the citadels, nor even to any elaborate cultural life, as happened at the same time in the Muslim West (see below, Chapter 7). There does not seem to have been much of an architecture of pleasure and comfort in most of them. But, since the later quite luxurious

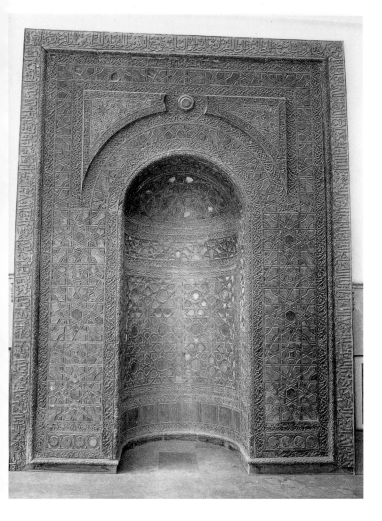

376. Aleppo, Halawiya Mosque, twelfth century. Mihrab

377. Aleppo, Firdaws mosque, detail of masonry

baths and halls in the citadels of Aleppo and Cairo were built over earlier palaces about which we know a little from texts,[189] careful archeological investigations may yield many surprises.

Construction and decoration

Much work has been done on the methods of construction and decoration in Egypt and Syria. Consequently quite fine distinctions can be drawn between the individual architectural idioms of Cairo, Aleppo, and Damascus. At the same time, constant influences and movements of craftsmen and ideas from one city to another contributed many variations.[190]

Materials are traditional: stone in Syria, with brick fairly common for vaults in Damascus, basalt in the Hauran, brick and stone in Egypt; wood throughout for limited purposes. Unexpected techniques that appeared occasionally, such as the use of wood in the *dar al-hadith* of Nur al-Din in Damascus (between courses of stone, a feature common in brick, but in stone serving only to weaken the wall),[191] indicate a new dependence on northern Mesopotamia or Iraq. But, in general, the masonry is simple, except on certain façades and arches where joggled voussoirs and the *ablaq* technique of alternating stones of different colours are used. Rubble in mortar – both inexpensive and quick – was fairly common in vaulting in caravanserais and citadels.

The supports consisted of traditional columns with capitals (sometimes utilizing new *muqarnas*-based designs) and of piers carrying arches. But, more and more, heavy walls, often pierced by bays, appear in new buildings, as they did in Iran. This is largely due to the spread of vaulting, which came about partly through the penetration of themes from the north and east, partly because often wood could not be used (particularly in military architecture) for fear of fire. A few *masjids* and the oratories of some *madrasas* have old-fashioned wooden ceilings, but barrel-vaults, often of simple semicircular section, as well as cross-vaults are usual on rectangular spaces and are especially typical of the long galleries of military architecture. Flat arches, usually in combination with relieving ones, are also occasionally revived.[192]

Domes and zones of transition are of almost unbelievable variety. The large wooden dome and the *muqarnas* zone of transition of the mausoleum of al-Shafi'i in Cairo date from the fifteenth century. Elsewhere in Egypt, as in the tomb of the Abbasids, the Ayyubid models simply transformed the Fatimid *muqarnas* squinch into a composition covering the whole zone of transition. The citadel of Cairo and most Syrian monuments use the squinch and pendentive alone or combined with *muqarnas*. The mosque of Busra may have had a corbelled zone of transition, in line with the corbelled roofing of the pre-Islamic Hauran, but it is still unclear whether a dome covered the centre of the *madrasa*. The Iraqi and northern Mesopotamian technique of high domes on rows of *muqarnas* did not reach Egypt in Ayyubid times, but became fully acclimatized in Syria with the first Zengid monuments. Translated into stone, it provided some of the most effective domes over tombs and entrances and half-domes on façades, probably endowing them at the same time with a rather cold and dry mathematical quality.

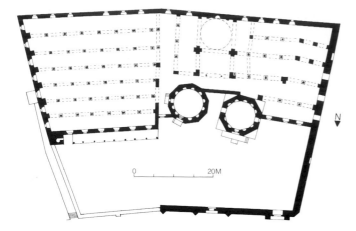

378. Konya, mosque of Ala al-Din, 1156–1220 and later, plan

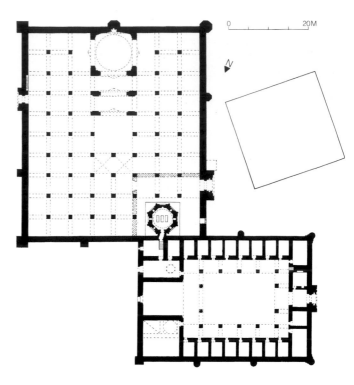

379. Kayseri, mosque of Khuand Khatun, 1237–38, plan

380. Kayseri, mosque of Khuand Khatun, 1237–38, façade

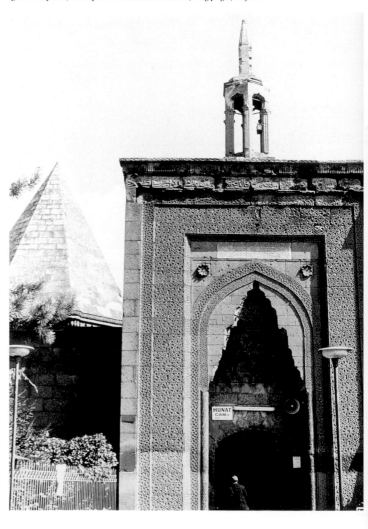

Decoration in Syria and Egypt was on the whole remarkable for its sobriety and simplicity. It was limited to gates, where single sculpted panels were often put on the walls around the entrance; to plaques and bands of writing, using Qur'anic quotations or established formulas to point up the purpose of the building and the glory of its founder; to the elaborate stone or stucco grilles of windows and oculi; and to *mihrabs* in wood, stone, stucco, or the peculiarly characteristic new technique of marble incrustation. Themes were traditional, including arcades (as in the minaret of the Great Mosque in Aleppo), classical and early Christian motifs reused from older buildings, or further developments on the Fatimid geometry based on star patterns []. Three newer features are particularly significant. The first is a motif of interlacing heavy lines, varying in the complexity of their geometry and in the relationship between right angles and curves. It occurs most commonly in *mihrabs* [376] – more specifically, in the rectangle framing the nichehead – and also in gates, creating a strong and immediate visual effect. The motif reflects a simpler and ruder tradition and taste than the minute arabesques of Fatimid times, but its influence was to be quite strong in Anatolia and in Mamluk Egypt. The second characteristic theme is writing, often used in conjunction with floral motifs. Like contemporary objects, architecture bore both angular, somewhat artificially archaizing inscriptions and the more common cursive ones. Like contemporary sculpture in western cathedrals, the epigraphy both illustrates the purpose of the building and emphasizes its main axes and lines, fulfilling the function of a moulding in classical architecture as well as reflecting the expressive value and meaning of a monument. A most striking example occurs in the Firdows Mosque in Aleppo [377], where the mystical imagery of the inscriptions sets the tone for the peaceful and otherworldly atmosphere of the building.[193]

The third motif involves the windows and medallions used on *qibla* walls,[194] domes, and façades, geometric in Syria, but often incorporating magnificent floral arabesques of leaves and stems. Related though they are to Fatimid or

Iranian themes, the main quality of these complex designs – as can be seen for instance in the Abbasid mausoleum in Cairo[195] and the Maydaniya in Damascus[196] – is their remarkable clarity, which enables the eye to catch the major lines of the movement without being bored with endless repetition. Such arabesques do not have the wealth of their Iranian or Iraqi counterparts, but they make up for the consistent simplicity of their designs by their elegance and restraint.

Two more original techniques are those of mosaic and of representational sculpture. Mosaics occur in some *mihrab* niches in Egypt[197] and in Saladin's reconstructions in Jerusalem, in particular in the Aqsa Mosque. Saladin probably used mosaics in a conscious attempt to revive the decorative methods of the first conquest of Jerusalem by the Muslims in early Islamic times. The actual quality of the workmanship is not very high, but its presence attests to the major task of rehabilitating the Haram al-Sharif.

The second technique, representational sculpture, was applied chiefly to secular architecture, most interestingly at Aleppo, where intertwined dragons and lions guard each of the three gates to the citadel. Their iconography and their simple but effective style relate them to similar images in Iraq and northern Mesopotamia, and their prophylactic aim is confirmed by several texts,[198] but their origin and their application to contemporary Aleppo are unclear.

Zangid and Ayyubid Syria was the second of the Muslim regions after Iran to evolve a great medieval architecture. Although the citadels of Aleppo and Cairo are the only monuments to rival some of those farther east in size and in the complexity of their history, Syria must nevertheless be singled out for the variety of its constructions, the growth of military architecture, the incorporation of motifs and techniques from the east and from the north, the importance of cities in determining the sizes and types of buildings, and the transformations given to the *muqarnas*. Many of these features reflect the religious and cultural needs of the time and illustrate phenomena wider than either Syria or the Arab world, most particularly that great Sunni revival which became the mission of many of the region's rulers. The simplicity and clarity of construction, excellence of workmanship, successful use of stone, the sobriety of decoration, fondness for geometric lines and for clear surfaces all reflect, wilfully or accidentally, some of the qualities of the rich heritage of Late Antiquity. Some scholars have even talked about a classical revival.[199]

ANATOLIA

The battle of Manzikert opened Anatolia (known in medieval Islamic sources as al-Rum) to Islam in 1071, but it is not until the turn of the thirteenth century that the Saljuqs of Rum, a few minor dynasties related to them, and many relatives of ruling princes or government officials were sufficiently established to engage in major building activities. Only indirectly affected by the Mongol conquests, except for the refugees from Iran and Iraq who poured into Anatolia, the Saljuqs of Rum did not disappear from the scene until the beginning of the fourteenth century, when internal dissensions gave rise to a number of more or less

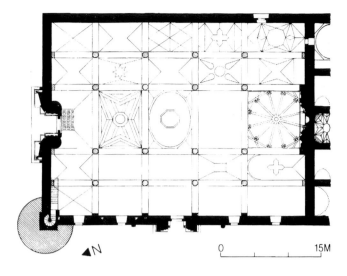

381. Divrik (Divrigi), mosque, 1228–29, plan

383. Divrik (Divrigi), mosque, 1228–29, gate

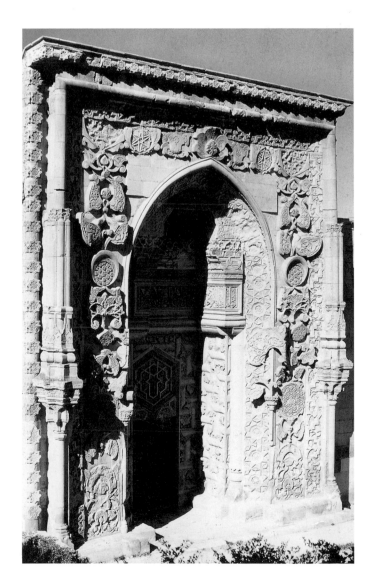

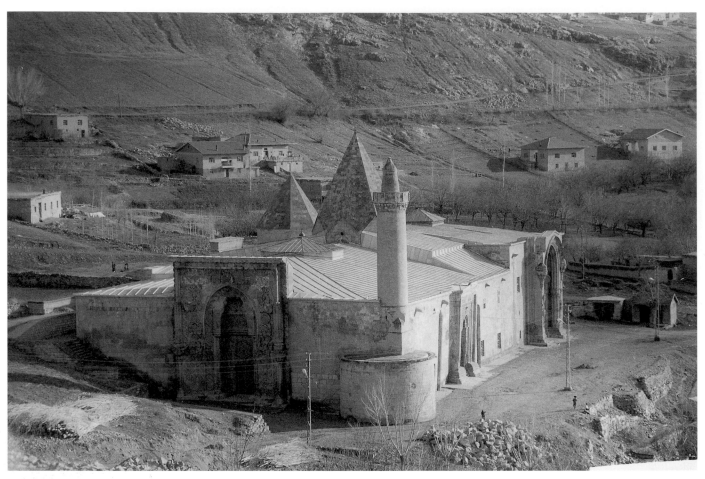

382. Divrik (Divrigi), mosque, 1228–29, exterior

independent principalities. Thus Anatolian Muslim architecture developed mostly after the main features of Iranian and Syrian medieval architecture had been established. A further peculiarity of Saljuq Rum was its cultural, social, and ethnic make-up. As a newly conquered Islamic province, it counted many non-Muslims and recent converts, with the twin consequences of eclecticism and of a wide range of cultural components, especially from the Christian Caucasus. As a frontier area it attracted Muslim militants, from *ghazi* (militant) warriors to the adherents of mystical Sufi orders. Just as in Syria, the large number of preserved monuments and the absence of monographic studies devoted to any one of them justifies a presentation which separates comments on the buildings from the processes of construction and idiosyncrasies of styles.

The monuments

Being in control of a newly Muslim area, the Saljuqs of Anatolia had the task of erecting all the buildings which had by then become characteristic of Islamic civilization. The most important was the congregational mosque. An early one at Mayyafariqin (perhaps of the eleventh century) was a simple rectangle (65 by 61 metres) with a court and a hall of prayer of eleven naves at right angles to the *qibla*; pillars and arches carried a flat wooden roof.[200] The mosque of Ala al-

Din in Konya [378] (built between 1156 and 1235 with later additions) is historically more complicated because it was not built at one time and because it was included within the palace area and also served as a place of burial for princes. In spite of this, its last addition in 1235 was a simple hypostyle in an early Islamic tradition even to the point of using columns and capitals from older buildings.[201] A number of other such simple hypostyles, for example at Beyşehir and Afyon, lacked courts, and several were almost entirely of wood, reflecting both its availability in the mountains of Anatolia and, perhaps, the impact of Central Asian tradition.

More original plans occur in the much restored Ulu Cami at Kayseri,[202] and in the mosques attached to philanthropic and religious institutions, such as the Khuand Khatun complex of mosque, *madrasa*, and tomb at Kayseri (1237–38), and the mosque and hospital at Divrik (1228–29).[203] The courts have all shrunk to simple central squares. The naves of the Ulu Cami are at right angles to the minuscule court (later domed). In front of the *mihrab* is a large Persian-style dome. The mosque of Khuand Khatun [379, 380] is divided into square bays, plus a sort of axial nave of two wide bays and a large dome. At Divrik (Divriği) [381–383] it is a five-aisled basilical hall with a wider central aisle, the naves consisting of rectangular bays except for the square one in front of the *mihrab*. All three mosques have three entrances, one

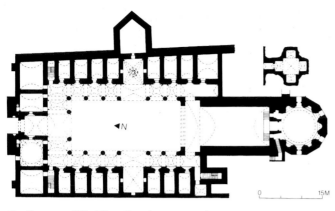

384. Erzerum, Cifte Minareli *madrasa*, 1253, plan

385. Erzerum, Cifte Minareli *madrasa*, 1253, interior

on each side other than the *qibla*, symmetrically arranged only in the Ulu Cami. As can be expected in a newly conquered area with an old history, aberrant types exist as well, for example the three-aisled mosque of the castle at Sivas (1180–81),[204] and the Iplikci Mosque (1182–1202) with its three rows of seven square bays with the *qibla* on one of the long sides and three domes leading from the front door to the *mihrab*.[205]

Madrasas were also common. They are of two types. The first, exemplified by the Saraj al-Din (1238–39), Khuand Khatun, and Sahibiya (1267) *madrasas* at Kayseri,[206] the Gök (1271) at Sivas,[207] and the Sircali (1242–43) at Konya,[208] is closely related to the Syrian and farther eastern types. On a court with porticoes open varying numbers of *iwans*, of which one is always connected with the entrance. The tomb of the founder is usually by the entrance or on the side opposite it. The interior consists of long halls at right angles to the court. Different from Syrian prototypes are the protruding *iwan*-like entrances, sometimes framed, as in the Gök *madrasa*, by two high minarets. The most monumental and remarkable variant of this type, a transformation of an Iranian tradition, is the Čifte Minareli *madrasa* at Erzerum (1253) [384–386]. Here is one of the earliest instances of a

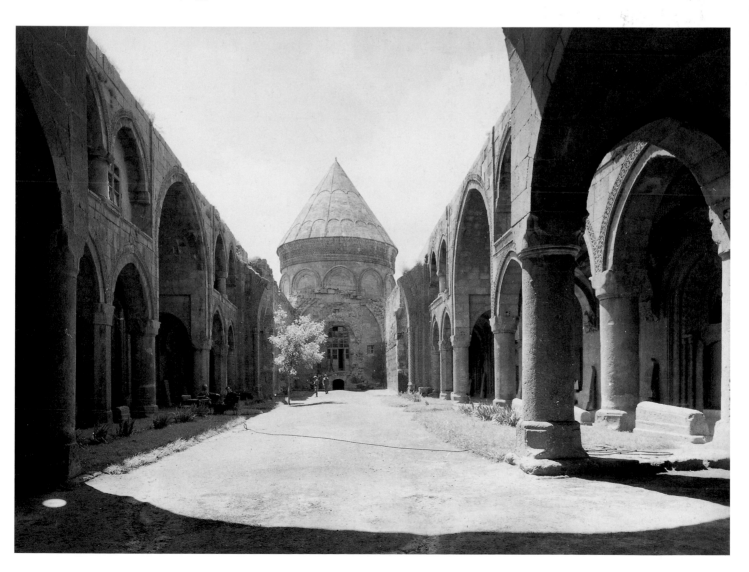

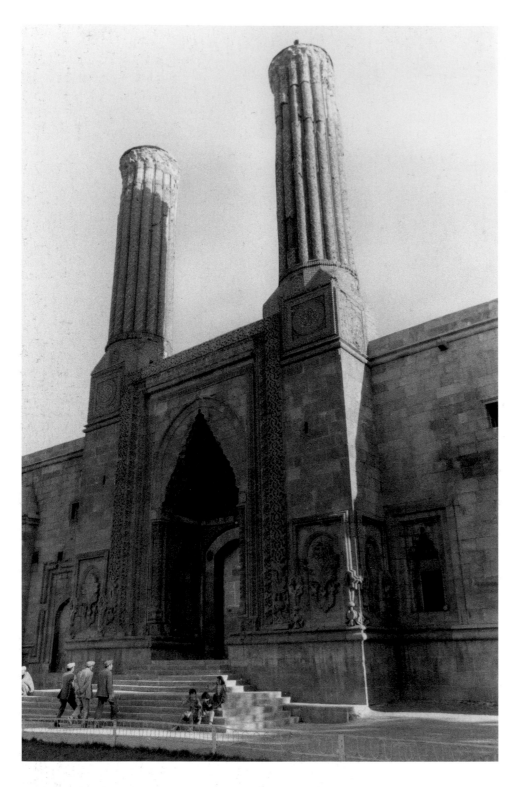

386. Erzerum, Cifte Minareli *madrasa*, 1265, façade

façade with two minarets. The circular mausoleum is on the axis of the building at the back of a long *iwan*, and the *iwans* have two-storey arcades.[209]

The main centre of the second group, which is more peculiar to Anatolia, is Konya, the capital of the Saljuqs of Rum. There, in the Karatay (1252) [387–388] and Ince Minareli (1258) *madrasas* [389–391],[210] the single *iwan*-like feature, the long halls, the domed rooms on either side of the *iwan*, and the magnificent façades are clearly connected with earlier traditions. However the court has been replaced by a

dome and the buildings are understandably smaller, a development related of course to the similar abandonment or diminution of the court in congregational mosques, without any major modification of the rest of the building. This change, generally explained as a consequence of the rigorous climate on the Anatolian plateau, had a far-reaching formal significance, especially for the *madrasa*, for the characteristically Iranian monumental inner court façade based on the *iwan* was replaced by a building with a large outer façade, planned around a central dome. Probably, beyond climatic

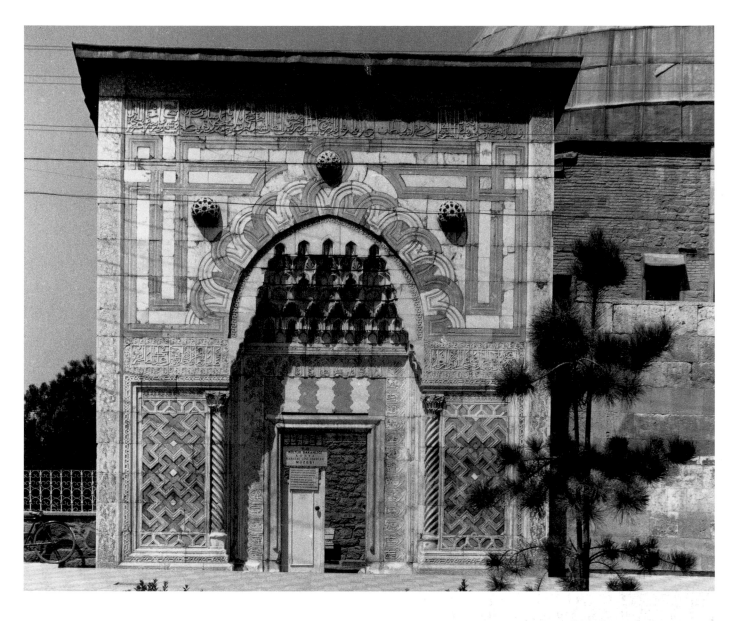

387. Konya, Karatay *madrasa*, 1252, façade

388. Konya, Karatay *madrasa*, 1252, plan

389. Konya, Ince Minareli *madrasa*, 1258, detail of façade

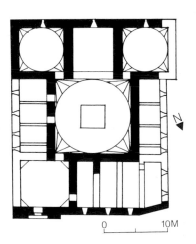

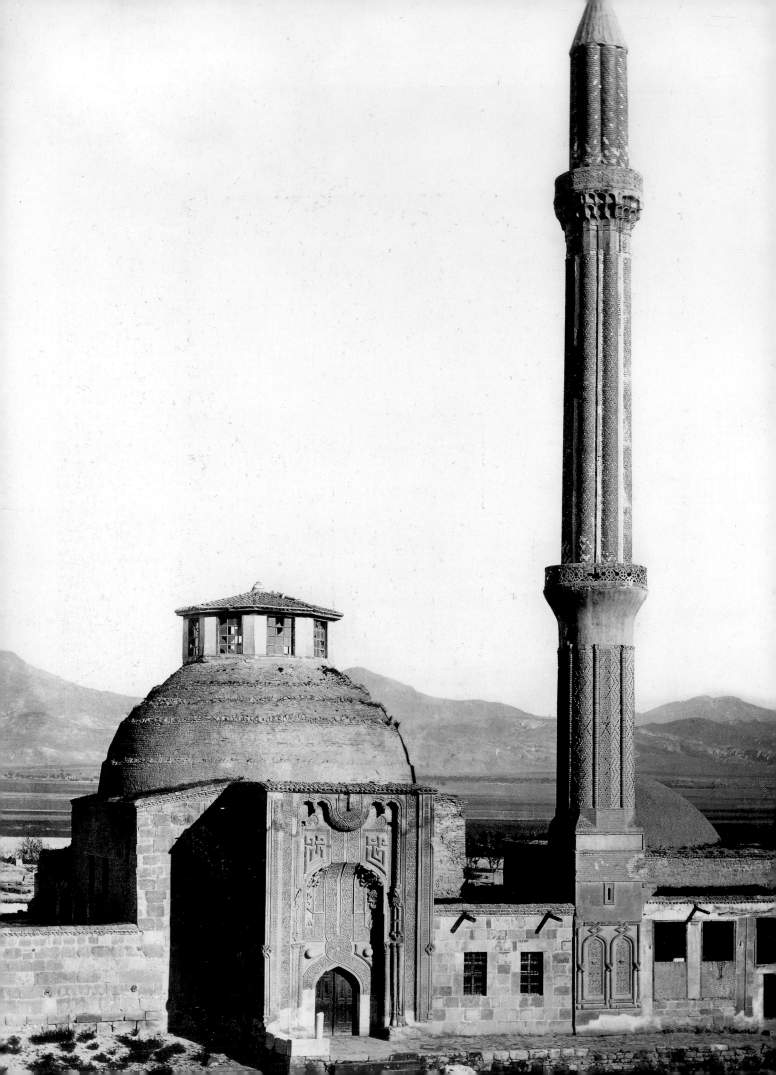

390. Konya, Ince Minareli *madrasa*, 1258

391. Konya, Ince Minareli *madrasa*, 1258, interior

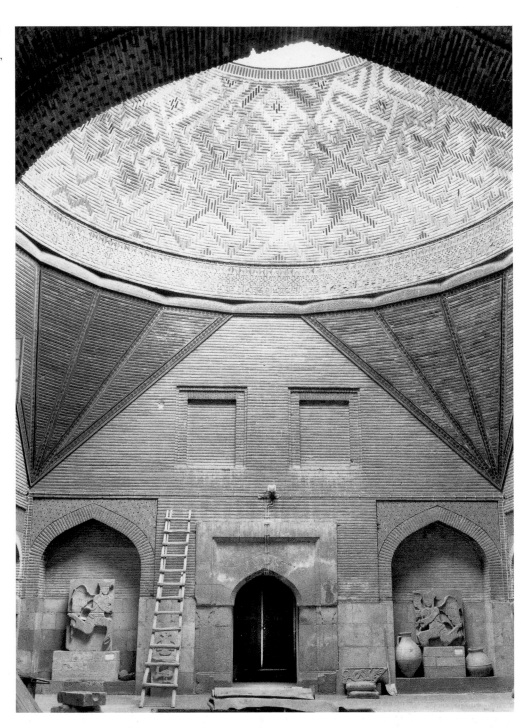

reasons, the Christian architecture of Armenia and Byzantium, which consisted wholly of such centrally planned buildings, affected Muslim architects.[211]

Just as in Iran and Azerbayjan, the single mausoleum, generally known in Anatolia as a *türbe*, was much more common than in Syria. A few were square,[212] but the vast majority were polygonal or circular, on high bases, usually with a crypt and a domed interior, with pyramidal or conical roofs, and richly decorated façades. At the curious Mama Hatun mausoleum at Tercan, a circular enclosure surrounded the *türbe* like an ancient *temenos*. In central Anatolia there also existed a so-called *iwan*-tomb with a prayer chamber open at one of its ends and with vaults covering both crypt and main chamber; such are the tombs of Haci Cikinik at Niksar (1183) and of Sayid Ghazi in Eskişehir (1207–08). These tombs are most closely related to those of Azerbayjan, but local traditions may have been involved as well. Oddly enough, funeral architecture was influenced primarily from the Iranian world, whereas mosques and *madrasas* apparently often arrived through Syria and the Jazira.

As to secular architecture, remains exist of hospitals, for example the one at Divrik whose plan is so similar to that of a *madrasa*; there were others, for instance the four-*iwans* one of Gevher Nesibe Hatun in Kayseri and the recently excavated one of Izzedin Keykavus in Sivas; Saljuq Anatolia was known for its great medical schools. Many of the hospitals

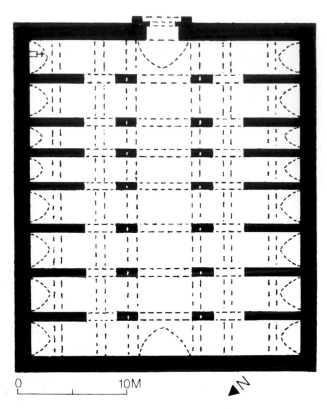

0 10M N

392. Zivrik Han, plan

393. Sultan Han, 1232–36, interior

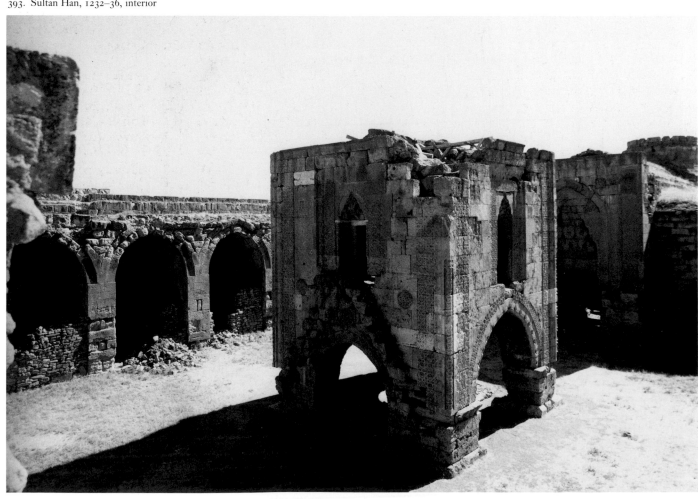

were attached to mosques, mausoleums, *madrasas*, and other socially pious buildings. Anatolia in the thirteenth century witnessed the appearance of complexes containing both pious and useful functions, often supported by an endowment, a kind of development which will find a spectacular expansion in later Ottoman architecture.[213]

Of the great palaces of the Saljuqs, whose wonders are related by the chroniclers,[214] only a few walls have remained in Konya, although previous travellers saw more.[215] A huge palatial complex at Kubadabad, near Lake Beyşehir, has been partly excavated and belongs to the grand tradition of early Islamic palaces. K. Erdmann identified as Saljuq a widespread number of small structures which he called *Seraibauten*[216] – perhaps hunting lodges or bases for agricultural exploitation, as had existed in Central Asia and Umayyad Syria. Of numerous remains of Saljuq fortifications many were destroyed in the twentieth century to make way for new towns.[217]

By far the most spectacular constructions of Saljuq Anatolia are the superb caravanserais, nearly two hundred and fifty of them from the thirteenth century.[218] There are three basic plans. The first is comparatively rare and, like the Syrian examples mentioned earlier, consists of a rectangular or even square building with a central court from which open halls of varying sizes. The second, exemplified by Zivrik Han [392],[219] is square or rectangular and lacks a

court. The best examples have a central nave abutted by others at right angles, often with a central dome for light and air. The third plan – that of the two Sultan Hans, one near Kayseri[220] – is the most remarkable [393, 394]. A court with halls at right angles to its sides precedes a long covered building with a central nave and others at right angles. Superb portals led often to an oratory (at times a separate pavilion in the middle of the court) and to a bath. While their monumentality and construction are peculiarly Anatolian, the last two plans are related to earlier ones in Iran and Central Asia and may well be pan-Islamic. But it is probably more appropriate to consider them as reflections of functional objectives and practical uses in detail which cannot, at this stage of investigation, be reconstructed or even imagined.

Why did chains of caravanserais of such quality emerge so suddenly? Sponsored by the ruling princes themselves, they are in all likelihood a rare attempt to capture international trade at a time of shifting directions for commerce and of constantly moving populations; but how they fit within the economic policies and activities of the time remains to be investigated.

Construction and decoration

By far the most common material for monumental buildings was stone, though brick was used for secular vaults and also in cities such as Konya. Wood also was sometimes employed, occasionally for entire buildings. Rubble in mortar was common for simpler vaults and walls.

Most structures were vaulted. Supports might consist of long and solid walls, especially in the *madrasas*, where the Iranian *iwan* had imposed its plan and elevation. A more common and original type, however, used piers and columns, ranging from borrowed older columns to new ones with *muqarnas* capitals, from polygonal, round, or even cross-shaped low piers carrying high and wide arches to the superb high piers and arches of the caravanserais. The

arches are usually carefully outlined, even when bonded with the masonry. Like the piers and columns, they are an interesting revival of Late Antique and early Christian practices in the Near East.

Vaults display an equally fascinating variety. The most common system of roofing a long space, for instance in the *khans*, was by means of tunnel-vaults, often divided by transverse arches. Small rectangular areas, as at Divrik, show endless variations on the simple theme of the cross-vault, with a multiplication of decorative rather than structural ribs. Domes were usually on pendentives, at times with *muqarnas*, although squinches are also known. At Konya an original mode of transition is the 'Turkish triangle' [391], a rationalization of the pendentive into simple geometric forms. Sometimes a combination of several long triangles gave greater, but still very angular, movement to the passage from square to dome.

Seljuq architectural decoration reflects the same multiple influences as building construction and design.[221] The portals of the Ala al-Din mosque in Konya and of the Karatay *madrasa* are typically Syrian in style, while other mosques and caravanserais use the *muqarnas* half-dome of Syria and Iraq. At Divrik, Kayseri, and in the Sultan Hans, stone carvings on façades and along the major lines of the architecture reflect the brick decoration of Iran. Apparently more original is the use of mosaics of glazed tiles, not merely as an element of emphasis but completely to cover large wall surfaces. The best-preserved examples are at Konya, in the *iwan* of the Sircali *madrasa* [417] and in the zone of transition of the Karatay *madrasa*. The technique originated in Iran, but it first occurs independent of other decorative devices in Anatolia.

However, the most spectacular results were achieved in stone-carving and on façades. Almost every monument warrants a detailed study, for each presents peculiar problems. Of the two groups which define the most striking characteristics of this decoration, the first comprises certain monuments of Konya. The impact of Syria is obvious, but, on the portal of the Ince Minareli *madrasa* [389–390], the reserve of the Karatay façade [387] has given way to an odd composition of columns, recesses, and mouldings. Architectural elements transformed the elevation into a non-architectural combination of thick interlacing epigraphic bands and geometric or floral designs in both very low and very high relief. The arches of the portal are absurdly composed, and the architectural elements do not lead into an architectural composition. In addition the constant opposition between kinds of relief and the lack of appropriate proportion between such diverse elements as a column and an epigraphic band contribute to the fascination of the façade, but also to the general impression it gives of being a sort of collage.

The second and much more spectacular group includes the façades of the main buildings of Sivas [395] and Divrik [382].[222] The whole wall is involved in the composition. Highly developed corner towers frame it, while two tall thin minarets emphasize a huge central portal. The portal at Divrik is even splayed. The decoration includes both the traditional Islamic epigraphy and geometric or floral arabesques and fantastic combinations of vegetal and even animal forms which, in their tortured violence, recall Celtic

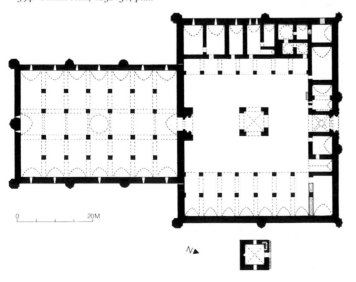

394. Sultan Han, 1232–36, plan

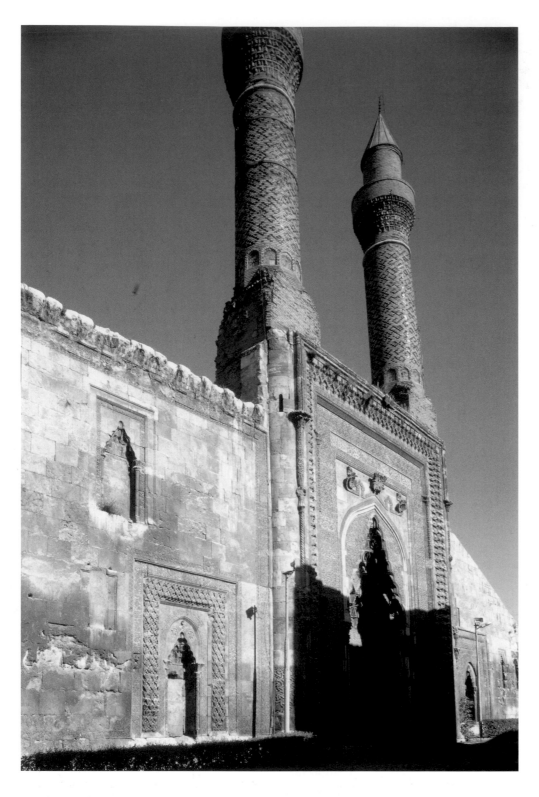

395. Sivas, Gök madrasa, 1271, façade

miniatures and Romanesque façades. An actually Romanesque origin can possibly be proposed for a portal in the hospital at Divrik. Even the geometric designs, like the ones on the Sultan Hans [396], are not always of the Islamic symmetrical and organized type but recall the endless meandering of northern, so-called barbarian, ornament. In now disappeared secular buildings, figural sculpture was often used:[223] dragons, lions, elephants, fantastic animals, astronomical figures, princes and court and attendants. At times crude, this sculpture seems to reflect a visual awareness of the artistic wealth of the Anatolian past and perhaps the memory of ancient pagan beliefs from Central Asia.`

Medieval, so-called Saljuq, architecture of Anatolia was a highly original achievement. The last Islamic province to develop in the Middle Ages, it took its inspiration from Iran, Syria, and the Jazira, drawing also on the strong indigenous Christian and even earlier traditions of Anatolia and conscious of the grand architecture of Christian Europe. The

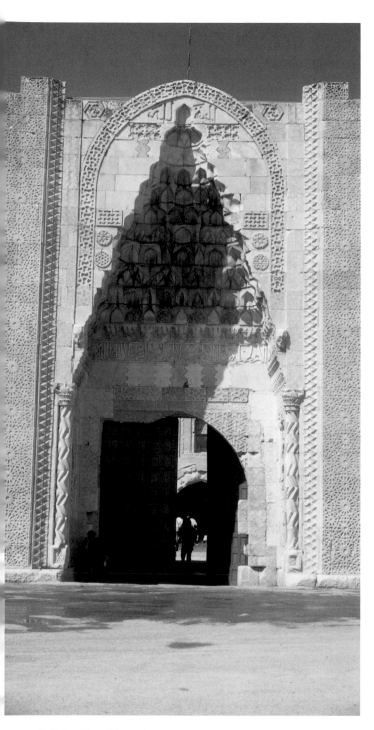

396. Sultan Han, thirteenth century, entrance

great achievement of this architecture was that it drew together so many disparate elements to create monuments which may at times seem awkward and strangely composed, but which always express the powerful spirit of the conquerors and a passionate need for expression through buildings. This complexity in the process of architectural creation is demonstrated, among many other arguments, by the presence of many signatures of builders on the monuments.[224] The relationship between patrons and builders became in Anatolia much more elaborate and much better documented than elsewhere in the medieval Islamic world.

THE ART OF THE OBJECT

Although during most of this period the once omnipotent Abbasid caliphate was only a shadow of its former self and, for all intents and purposes, virtually powerless, the textiles of Baghdad were both highly esteemed in medieval Europe and also much in demand there; indeed, European languages have been enriched by terms drawn from their names. From Baldacco, the Italian designation for Baghdad, is derived the term *baldacchino* for luxury textiles, especially those used for canopies; in England the fabrics of Baghdad were called *baudekin*, or *baldachin*. Matthew Paris, the English monk and historian (d. 1259), mentioned that Henry III wore a robe *de preciosissimo Baldekino* at an investiture at Westminster Abbey in 1247. Inventories of St Paul's Cathedral from 1245 and 1295 indicate that these baudekins were patterned with roundels containing griffins' heads and diminutive lions, double-headed birds with wings displayed, elephants, men on horseback, archers, and 'Samson the Strong'.[225] Most of these textiles we know only through literary references, which are, however, not precise enough to permit definite identification with preserved fabrics.[226]

Happily, however, there are two textiles that, though manufactured in Spain, do give some clue as to the appearance of these costly fabrics, namely a fragment in Leon and the silk [458].[227] Although, in the inscriptions on both, Baghdad is claimed as the city of origin, technical features as well as paleographic details reveal that the silks are actually Spanish copies of Iraqi originals. Their compositions, based on a series of roundels framing pairs of animals or fantastic creatures in symmetrical arrangements, represent medieval paraphrases of Sasanian textile designs and are thus closely related to contemporary Iranian silks [251]. Such circumstantial evidence is corroborated by the statements of the twelfth-century Arab geographer al-Idrisi and the early seventeenth-century Maghribi author al-Maqqari mentioning that 'attabi fabrics (named after the 'Attabiyya quarter of Baghdad) were made at Almeria in Spain.[228] There are many other such references to the copying of textile patterns in distant parts of the medieval Muslim world, and this testimony helps to explain the difficulty of distinguishing between the products of different regions.

In the thirteenth century, Mosul in the Jazira was also an important centre of textile manufacture,[229] as is again attested by words still current in European languages: *muslin*, *mousseline*, *muselina*, and *mussolina*. It has not yet, however, been possible to isolate this type of fabric from among those that have come down to us.

Among the textiles being produced in contemporary Syria under the rule of the Ayyubids, one [397] – the decoration on which bears close comparison with the figural and vegetal ornament filling the interstitial area on the fragment [252] – illustrates clearly how the tremendous displacement of artisans during the Mongol era resulting in an enforced migration from east to west contributed greatly to an eventual blending of styles. The same phenomenon is witnessed in the textile [398], probably belonging to the Rum Saljuqid sultan Kayqubad ibn Kaykhusraw (r. 1219–37). In gold on a crimson ground, two addorsed lions in roundels form the main design with the ever-popular arabesques filling the

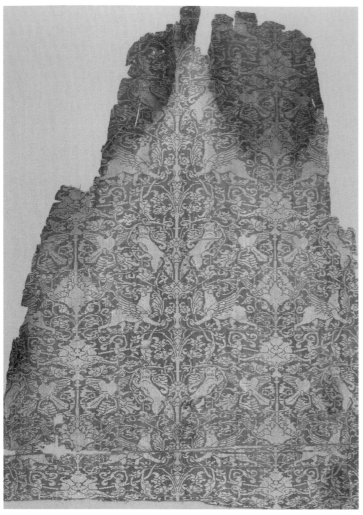

397. Silk fragment, Ht. 43 cm; W. 31 cm. Metropolitan Museum of Art, New York

398. Silk fragment. Datable between 1219 and 1237, Ht. 102 cm; W. 74.5 cm. Musée Historique des Tissus, Lyon

space within and between the circular frames. Once again the general layout, juxtaposed animals, and interstitial configurations betray distant Sasanian origins, but a new elegance and lightness permeate this design, which can also be found on a few extant and approximately contemporary fabrics woven in eastern Iran.[230]

The dearth of surviving metalwork from the later twelfth century in the central Islamic lands is partly made up for by a wealth of objects from the first half of the thirteenth century. The rise of artistic patronage under various Turkic groups including the Artuqids, Zangids and Rum Saljuqs as well as the Kurdish Ayyubids caused a sudden flowering of the local artistic tradition. This burgeoning seems to have been advanced, just as in the textile industry, by an influx of refugee metalworkers from Iran, whose presence can be deduced from the *nisba* of one of them,[231] as well as from stylistic evidence.

Proof that Artuqid metalworking centres specialized in casting is abundant from the material extant. A large copper alloy talismanic mirror made in the mid-thirteenth century for Artuq Shah, a member of that dynasty, is adorned on its flat back with an heraldic bird in high relief in the centre and a long princely inscription framing its outer edge [399].

The intermediary space bears two interconnected decorative bands, one with twelve contiguous interlaced roundels each ornamented with a zodiacal sign with its planetary lord, and the other with a second inscription interrupted by 'classical' busts of the seven planetary gods. This dependence upon classical or Byzantine prototypes and emphasis on propitious heavenly bodies is reflected also in contemporary copper coins issued in the Jazira and helps to define the iconographic preferences in that area.[232]

Another category of cast metal objects for which the Jazira is known during this period is that of copper alloy door fittings. Although purely utilitarian in nature, both their bold yet intricate arabesque designs [400] – often on many levels and thus a *tour de force* of the caster's art – and the sinuous yet realistic fantastic animal forms are not only paradigms of Jaziran style and iconography but also illustrative of how that area in general and Mosul with its great wealth in particular served as a bridge between Iraq and Syria and thence to Anatolia under the Saljuqs of Rum.[233]

Not only did the metalworking centres under the artistic patronage of various Turkic dynasties cast outstanding works in copper alloys, they worked in other metals as well [401]. This mirror is cast in steel and inlaid with gold. It

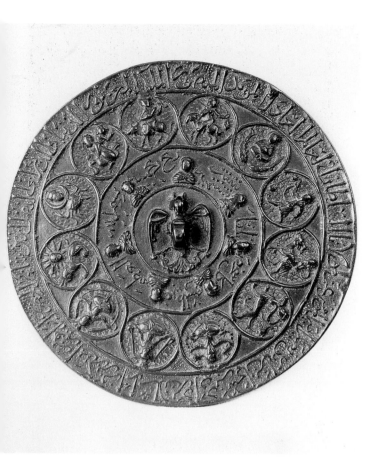

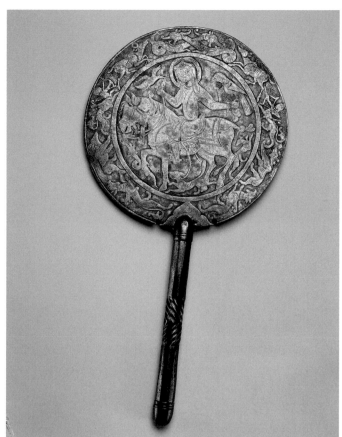

399. Copper-alloy mirror, D. 24 cm. The David Collection, Copenhagen

400. Copper-alloy door fittings, Ht. 37.5 cm; W. 17.1 cm. Museum of Islamic Art, Qatar

401. Steel mirror with gold inlay, Ht. 41 cm; D. 20 cm. Topkapi Sarayi Muzesi, Istanbul

402. Copper-alloy drum, Ht. 65 cm. Museum of Turkish and Islamic Art, Istanbul

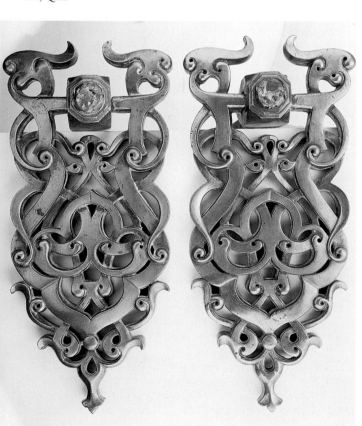

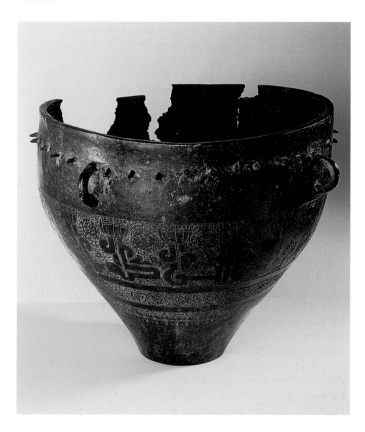

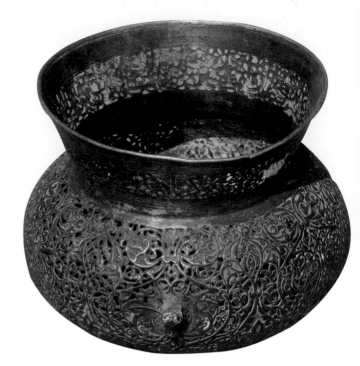

403. Detail of gilded silver belt fittings. British Museum, London

404. Gilded copper-alloy mosque lamp. Dated 1280–81, Ht. 20 cm; D. at rim 18 cm. Ankara Ethnographic Museum

405. Copper-alloy ewer inlaid with silver and copper. Dated 1232, Ht. 30.4 cm. British Museum, London

incorporates decorative motifs and stylistic conventions we encountered earlier in this section and shall continue to see on many other media produced in this area.[234]

The metalworkers in this region also lavished great care on the musical instruments they crafted such as the large drum [402]. This was probably part of the issue of a military band accompanying an Artuqid ruler into battle or on ceremonial occasions. The principal decoration on this rare survival consists of a playful animated angular inscription that incorporates both human and dragon heads, the latter very similar in style to those on the door handles from the Ulu Cami in Jazira ibn 'Umar (modern Cizre) referred to above.[235]

On a totally different scale are the gilded silver belt fittings [403]. These elements originally adorned a type of flexible belt from which were suspended short straps, also bearing fittings, that had been popular in pre-Islamic Iran and continued in use in early and medieval Islamic times until it was largely superseded around 1400 by a new type that remained in vogue for centuries to come. Such ornaments and another, slightly later and datable, group give us a tantalizing glimpse of the splendour of personal adornment in the Jazira and Syria during this period.[236]

Belonging to the tradition that created these fine groups of fittings is the particularly splendid gilded copper alloy mosque lamp known from its inscription to have been made at Konya in 1280–81 [404].[237] On its body are graceful arabesques in repoussé, a technique rare on copper alloy objects of this period. The principal decoration on the neck is a Qur'anic passage from the Sura of Light, 24:35,[238] refer-

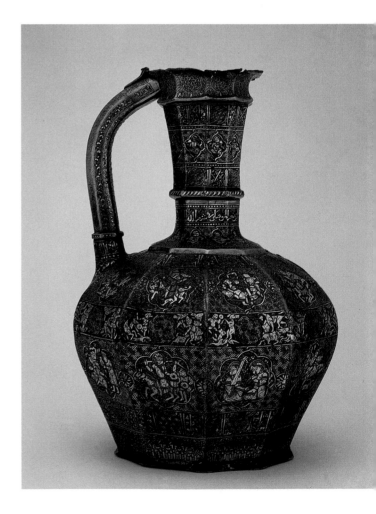

ring to the ineffable presence of the deity himself, in the form of a glass lamp suspended in a niche or arch. The entire surface of the Konya lamp is pierced to allow light to shine forth from a glass container within, casting intricate and beautiful shadows. Three bulls' heads serve to attach the (now lost) suspension chains.

As regards this area's important metal objects inlaid with silver, the earliest dated example from the Jazira is a miniature box of 1220. Production of such pieces, however, must have begun around the turn of the century, for the maker of the dated container, Isma'il ibn Ward, was a pupil of an already practising master called Ibrahim ibn Mawaliya.[239] Both artisans ended their signatures with the generic 'al-Mawsili', 'of Mosul' – a designation used on at least twenty-eight objects[240] (one from as late as 1321) by twenty metalworkers – thus implying metal production in that city; but only one craftsman, Shuja' ibn Man'a, stated specifically that he made his object, a ewer, in Mosul in 1232 [405]; a second named Damascus, and five others Cairo. In other instances names of the owners suggest that Mosul itself was not the city of origin. Indeed, only six pieces, besides the one by Shuja', can be said with certainty to have come from Mosul, for they were ordered by the local ruler Badr al-Din Lu'lu' (r. 1237–59) or by members of his court.[241] Many

406. Copper-alloy ewer inlaid with silver. Dated 1223, Ht. 38 cm. Cleveland Museum of Art

407. Detail of Figure 406

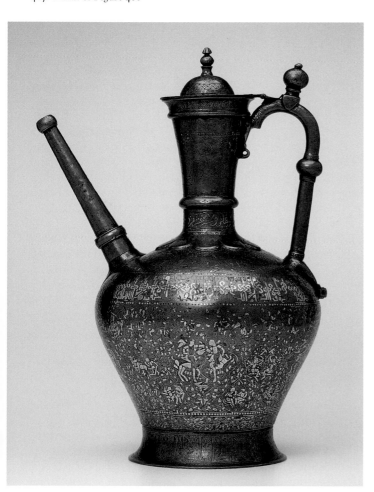

Mawsili artists worked in styles quite different from those attested by these six pieces, and in the work of one single artist there are stylistic differences that may imply various locales.[242] This pattern reveals how difficult it is to make attributions of metal objects from this period when historical inscriptions are lacking.

There are, however, certain features that do distinguish the metalwork of the Jazira, including that of Mosul, from contemporary Iranian production. First, representations of princes, still rather rare in Iran, are frequent, which is only natural in view of the high percentage of pieces known to have been ordered by royal patrons. Indeed, the princely theme is the keynote of these works, and in certain cases it is developed into an all-encompassing royal ambiance. On the other hand, genre scenes extend well beyond the stock Iranian motifs of revellers, hunters, and polo players, and their composition is more sophisticated. Their variety is astonishing as well: gardeners with spades and mattocks, peasants ploughing with pairs of oxen, a flute-playing shepherd in the shade of a tree surrounded by his flock and faithful dog, boys shooting at birds with blowpipes, a relaxed youth reclining on a couch with his cupbearer and *sommelier* in attendance, a noble lady admiring herself in a mirror while a servant girl stands by with a box of toiletries, and so on [406, 407].[243] Even the more formal royal images are set outdoors and are connected with merrymaking and hunting. Like the ceramic decorators of Iran, the rich repertory of the Mosul metalworkers often shows an indebtedness to the inventiveness of manuscript illustrators. The fundamental importance of the painting styles of Iraq, the Jazira, and

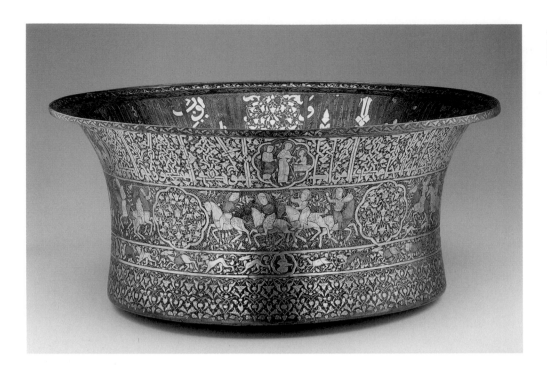

408. Copper-alloy basin inlaid with silver. Datable between 1239 and 1249, D. at rim 50 cm. Freer Gallery of Art, Washington, D.C.

Syria in this period as sources of imagery for the art of the object can be observed again and again, even though it is not always possible to distinguish the style of one specific area from that of another (see discussion of manuscript painting, below). Finally, the shapes themselves show greater variety.

More surprising still is the novel organization of themes. Whereas parallel bands, unfolding without interruption, and differently shaped spaces filled with closely packed motifs of equal importance, are typical of Iranian work, in the Jazira they were replaced by sequences of vignettes, some of them relatively large, some small. Avoiding a sampler-like display of individual motifs, the craftsmen organized vessel surfaces by connecting the frames around the images and by using smaller ornaments as links. In addition the vessels are encircled at various levels by bands that tie the compositions together. Furthermore, to prevent monotony, the even flow of main elements is punctuated at intervals by secondary motifs. Even the spaces between the vignettes have an artistic function. Instead of being left undecorated and thus neutral, as on Iranian works, they are covered with delicate webs of arabesques or interlocking fret patterns based on swastikas or Ts,[244] which lend tension to the surfaces and serve as foils for the main features. By these means the monophonic co-ordination of equal parts has been replaced by a polyphonic form, of graded subordination, in which the many different parts of a complex composition are made to interact and interrelate. As a result both aesthetic and intellectual requirements are fully satisfied. No wonder, then, that metalworkers of Mosul origin were in demand in the highest places everywhere: their works 'were exported to kings', according to a contemporary Spanish Muslim,[245] and that is why they signed their products with the name of the town from which they hailed.

We have seen above how Mawsili artists migrated to other major cities outside the Jazira including Damascus. Thus, it is not surprising that the distinction between Jaziran and Syrian inlaid pieces is often hard to draw.[246] The stylistic differences are more subtle and the borrowings more wholesale than, for example, those between Persian and Jaziran work. The complex 'polyphonic style' of the latter continued, including the fretted backgrounds, but in Syria the work was in general drier and more meticulous; representations such as throne scenes became more formal and the arabesque spirals in the background more pronounced. Nevertheless, the short Ayyubid period (1171–1250) is commemorated by some remarkable and varied pieces of inlaid metalwork, often with novel features. Foremost among them is the use of Christian motifs, including New Testament scenes and, within arcading, figures of ecclesiastics and saints testifying to the relationship between the Latin states and the Ayyubids or to the presence of Christians in high positions at the Sunni Muslim court. One example is the so-called Arenberg Basin made for the Ayyubid Sultan of Cairo and Damascus al-Malik al-Salih Ayyub (r. 1239–49) [408].[247] Another fine example of the type is the anonymous canteen in the same collection which, like the basin, combines Christian subjects with scenes depicting mounted horsemen including Crusader knights.[248] Another feature that makes its debut in Syria is gold inlay, which was used on a basin made in 1250 by another Mosul metalworker, Dawud ibn Salama.[249]

An even better aid to attribution than stylistic and iconographic clues, however, are inscriptions, which give the dates and original – usually royal – owners of many distinguished objects. The earliest inlaid piece with an Ayyubid association, a ewer made in 1232 by Qasim ibn ʿAli of Mawsili origin,[250] has a unique decorative scheme that would be difficult to place without the evidence of the inscription. Both body and neck are covered, not with the usual figural designs, but exclusively with fine arabesques

enclosed in a network of ovoid compartments – the first occurrence of the all-over, purely abstract vegetal patterns on metalwork which was to be more common in subsequent periods.

Mosul, like Sinjar and Takrit, was renowned at this time also for its large unglazed water jars called *habb*s, the ornamentation of which attained a particularly high artistic level in response to the demands of affluent consumers. Unglazed pottery household vessels account for a high percentage of the total ceramic output of the Islamic world during the period covered by this volume. However, most of this large production was not as ambitious as, and considerably less refined than, the profusely and finely decorated ewer [90] and the *habb*s being discussed here. Because of their basically utilitarian function – liquids stored in them were kept cool by the evaporation that occurred through their porous walls – these storage jars were popular for centuries, their antecedents predating the arrival of Islam in the area and their descendants continuing in use down to the modern period. All their surfaces except for the rounded bottoms (which were set into the ground or placed on stands) are covered with relief decoration, adroit combinations of moulded, incised, carved, pierced, and barbotine work – a

410. Cut brick from the Mustansiriyya *madrasa*, Baghdad, founded 1233, Gr. Ht. 17.8 cm; Gr. W. 24.2 cm. Los Angeles County Museum of Art (M.2002.1.670)

411. Underglaze- and lustre-painted basin, D. 27 cm. Fundação Calouste Gulbenkian, Lisbon

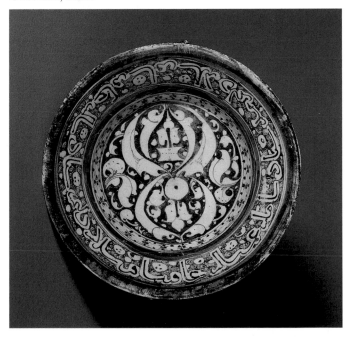

409. Unglazed earthenware *habb* (water storage vessel). Baghdad Museum

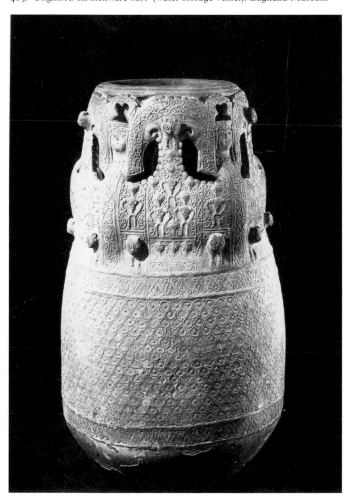

technique in which rolled strips and circles of clay were applied to the surface and, sometimes, decorated [409].[251] The motifs constitute a fascinating potpourri of ancient gods and their sacred animals juxtaposed with the latest images of princes, musicians, revellers, and court officials. The popularity of such designs throughout the whole central Islamic area during the medieval period is witnessed by the fact that they can be found on so many different media in Iraq, the Jazira, Syria, and Anatolia at this time – exhibiting the very same style as on the unglazed *habb*s. The now destroyed Gate of the Talisman in Baghdad, stone architectural elements from the Jazira [426], a gateway in the Aleppo citadel [375], and wooden doors from Anatolia [424] – to mention only a few examples – testify to the veracity of this statement.[252]

The beautiful arabesque decoration on the cut brick from the Mustansiriyya in Baghdad [410], founded in 1233 and discussed earlier in this chapter, is a testament to the con-

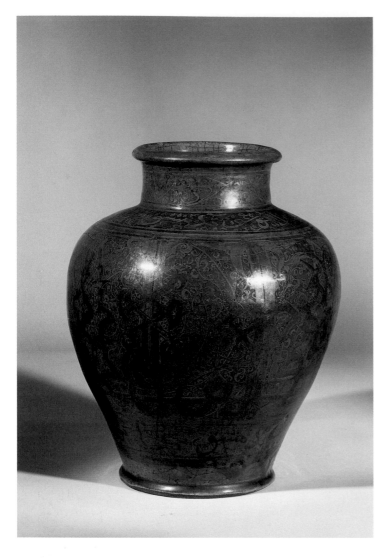

412. Glazed and lustre-painted vase, Damascus, Syria. Ht. 26 cm. Al-Sabah Collection, Kuwait

tinuation in Iraq of this striking style up to the end of the Abbasid period. As was the case with the figural and animal designs, such vegetal motifs also seem to have had universal appeal in the central Islamic lands at this time and can be seen in the Jazira [400] and Ayyubid Syria [411] as well as in contemporary Saljuqid Anatolia [423].

Turning now to the glazed pottery produced in these areas during this period, it appears that we have two parallel and interconnected ceramic traditions. One was located in an as yet unknown Syrian production centre[253] and the other most probably in or near the Anatolian city of Konya. As regards Ayyubid Syria, the production of lustre-painted ceramics was most probably a continuation of and a further development upon the earlier so-called Tell Minis ware [322] – the first pottery produced in that country to be decorated in this technique. It is generally assumed that the art of lustre-painting on pottery entered the repertoire of the Syrian potters from Egypt, brought by migrating ceramists during the decline of the Fatimid dynasty in the latter half of its hegemony. The basin [411] is a paradigm of Ayyubid

Syrian lustre-painted pottery, bearing as it does the characteristic chocolate-brown lustre combined with underglaze-painted blue, the organization (with its abundant metal prototypes) of the various calligraphic, geometric, and vegetal designs into a series of concentric bands that in other examples are sometimes interrupted by medallions; and a background of tightly coiled spirals reminiscent of engraved or chased scrolls on contemporary metalwork as well. The shape of this particular vessel and of other lustre-painted objects from this centre also echoes those in metal.[254] Another, considerably less common, variety of Syrian pottery in this technique is represented here by the jar [412]. Unlike the other various Ayyubid pottery types discussed whose centre of production has not yet been isolated, both of the cursive inscriptions on this storage vessel bear witness to the fact that Damascus was producing exquisite lustre-painted ware in the thirteenth century, stating that it was made for Asad al-Iskandarani by a certain Yusuf in that city. The principal decoration on this vessel is a bold angular calligraphic design in lustre on a deep cobalt-blue ground.[255]

Such a design was also popular on carved and monochrome glazed or glazed and lustre-painted vases from Syria.[256] The decorative technique employed on the latter ware must have developed from the incised so-called Tell Minis ware, which, in turn, owed a great debt to the monochrome sgraffiato ware so popular in Egypt during the Fatimid period [327]. The same Syrian kilns must also have produced the moulded and monochrome glazed objects

413. Underglaze-painted bowl, D. 26 cm. Metropolitan Museum of Art, New York

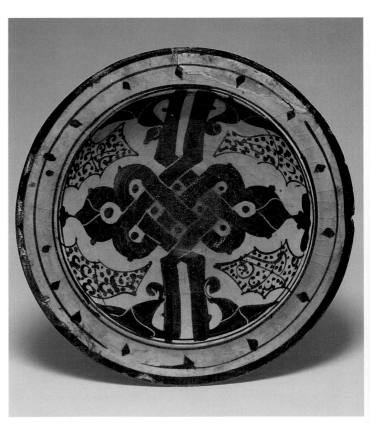

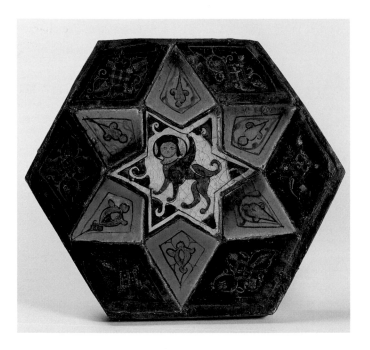

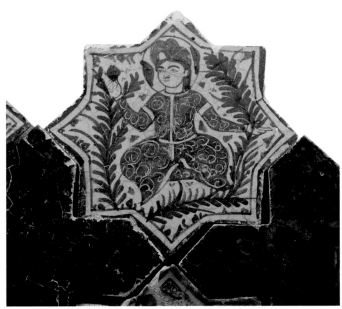

414. Underglaze and overglaze painted and leaf gilded tile assemblage. Datable between 1156 and 1192, D. 22.7 cm. Metropolitan Museum of Art, New York

415. Detail from glazed and lustre-painted tile panel from Kubadabad, founded 1227, Ht. of star tile: 22 cm. Karatay Madrasa Museum, Konya

416. Detail from underglaze-painted tile panel from Kubadabad, founded 1227, Ht. of star tile: 23 cm. Karatay Madrasa Museum, Konya

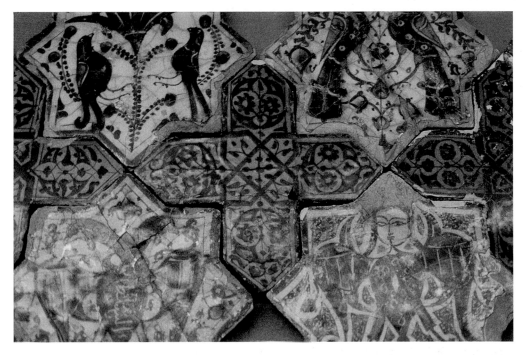

among which we find shapes borrowed from other media, such as the low triangular, square, rectangular, and octagonal tables with relief decoration or ornamentation derived from turned wooden originals. Other examples are pierced mosque lamps imitating metal prototypes.[257]

Another technique employed in Syria at this time was that of underglaze painting, either in black under a clear colourless or turquoise-blue glaze [413] or a variety in which red, black, and blue designs were painted under a clear colourless glaze.[258] Derived from calligraphy, the decoration on this bowl, so popular at the time, bears close comparison to that on the lustre-painted vase made in Damascus [412].

Lustre-painted as well as monochrome and polychrome underglaze-painted pottery was likewise produced in or near Konya. As was the case with their architecture, the Saljuqs of Rum also emulated their Syrian neighbours vis-à-vis their ceramic production and, consequently, some of it exhibits strong Ayyubid influence.

Structures that stand to this day in central Anatolia as well as those revealed during excavations attest to the Saljuq fondness for covering the walls of their buildings with tiles arranged in geometric patterns. The hexagonal grouping [414] which probably came from the palace of Qilich Arslan II (r. 1156–92) at Konya exhibits the technical and iconographical influence of Syrian objects in the star-shaped underglaze-painted tile with the sphinx and the technical

influence of Persian *minaʾi* ware on both types of the four-sided tiles [272]. The tiles [415] belong to those from a somewhat later royal residence, Kubadabad on Lake Beyşehir, founded by ʿAlaʾ al-Din Kayqubad I in 1227. Both types of lustre-painted tiles comprising the panel betray their dependence on the so-called Tell Minis variety of Syrian pottery [322] *vis-à-vis* the iconography and style employed as well as the convention of incising details through the lustre and lustre-painting on a coloured ground. As regards the underglaze painted tiles from this complex seen comprising the panel [416], on the other hand, both the examples painted in black under a transparent turquoise glaze and those polychrome-painted under a clear colourless glaze are definitely related to those Syrian productions represented here [413].²⁵⁹ All of these examples point to the fact that the building tiles in Anatolia were produced with the help of imported or migrant craftsmen.

We must assume that tiles were not the only objects produced in these central Anatolian kilns; it would be surprising if the same kilns were not also manufacturing bowls, and perhaps other objects, exhibiting various decorative techniques.²⁶⁰

It would seem, therefore, that while the unknown centre or centres in northern Syria mentioned above were producing pottery that developed to a large extent from that manufactured in Egypt during the Fatimid period, the main influences on the ceramic production of contemporary

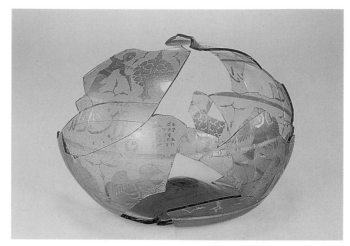

418. Fragmentary gilded glass vessel. Datable between 1127 and 1146, W. 15.7 cm. British Museum, London

Anatolia appear to have come both from Iran and from Syria. The Mongol invasion forced artisans working in the former country to seek new patrons. It is well documented that some of them found their way to Anatolia, and thus the possibility of Persian potters influencing Anatolian production in general is quite plausible. For example, we know – concerning ceramic architectural decoration – that a master potter from Tus in Khurasan was working in Konya. The building providing this information is the Sircali *madrasa*, in the central Anatolian Saljuq capital, founded in 1242; it is the earliest surviving dated example in the Islamic world of a total surface decorated with glazed tiling [417]. It may therefore be assumed that such colourful assemblages were already known in eastern Iran.²⁶¹ As regards the influence from Syria on Anatolian production, the seeming interdependence discernible in so many instances has not yet been fully explored. Although there was most definitely an international vogue for certain types of pottery in this period, for the most part that produced in the various areas can be easily differentiated by such elements as style, iconography, and profile.

The Fatimid tradition of lustre-painting on glass exemplified by the diminutive vessel [334]²⁶² appears to have led directly into gilded and/or enamel-painted decoration on the surface of the glass vessel. The earliest datable gilded object is the fragmentary vessel [418] bearing an inscription containing the *laqab* of ʿImad al-Din Zangi, Atabeg of Mosul and Aleppo (r. 1127–46).²⁶³ Its figural ornamentation bridges the gap between that found on objects of the Fatimid and that of the late Ayyubid and early Mamluk periods. This flask was probably made in Syria, as were the three earliest datable enamel-painted glass objects, a beaker bearing the name of sultan Sanjar Shah (r. 1180–1209),²⁶⁴ the flask in the name of the last Ayyubid ruler of Damascus and Aleppo, al-Malik al-Nasir II Salah al-Din Yusuf (r. 1237–59)²⁶⁵ and the dish [419] with the names and titles of Ghiyath al-Din Kaykhusraw II (r. 1237–46),²⁶⁶ the son of the imperial founder of Kubadabad in central Anatolia. The design on the outer wall of the dish in particular clearly shows an indebtedness to the decoration on lustre-painted objects, as it is drawn from the same repertoire.

417. Tile mosaic *mihrab* in the Sircali *madrasa*, Konya, founded 1242

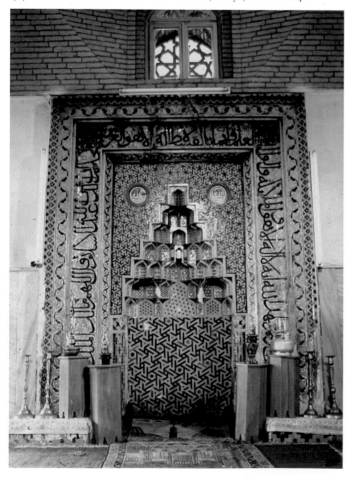

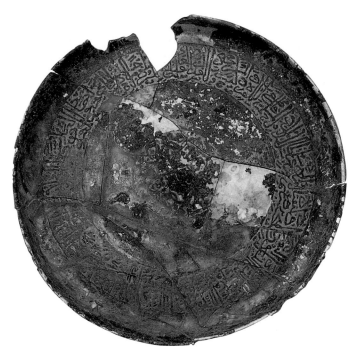

419. Enamel-painted glass dish. Datable between 1237 and 1246, D. at rim: 30 cm. Karatay Madrasa Museum, Konya

420. Enamel-painted and gilded tazza, Ht. 18.2 cm. Metropolitan Museum of Art, New York

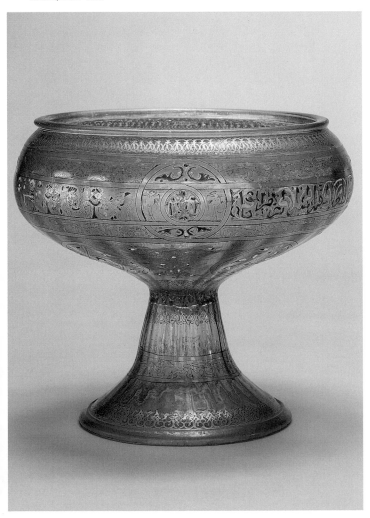

The gilded and enamelled tazza [420] exhibits both techniques combined in a masterful, yet tentative, manner bearing an abundance of gilding and the almost experimental application of enamel colours in a highly varied palette (red, blue, yellow, green, white, and black). The style, scale, and rich decorative vocabulary of designs (including entertainers, geometric patterns, arabesques, virtual bestiaries of both real and fantastic animals, and secular inscriptions) displayed in the horizontal bands of varying widths are typically found on various media from the first half of the thirteenth century. However, it is in metalwork that the closest parallels are encountered.

Tapering beakers with outward-curving rims were the most popular shape for enamelled and gilded glass at this time. However, other characteristic forms include rosewater sprinklers (Arabic *qumqum*) with tall tapering necks, straight-sided mugs, and basins. The production of enamelled and gilded mosque lamps with high, wide, flaring necks also began during the period under discussion here, reaching its peak in the fourteenth century.

The popularity of enamelled glass among the Frankish invaders of the Holy Land is attested not only by fragmentary vessels found in the ruins of their châteaux and by objects brought back for deposit in European churches but also by the fact that this deluxe technique is one the Franks seem to have copied from the Muslims while they were in Syria: an example of this is the beaker in the British Museum signed by Magister Aldrevandin.[267]

Unquestionably such glass products also greatly influenced those of Venice, the foremost European glass-manufacturing centre – especially those from the formative years of its industry. The mystique of these vessels continued to enthrall the West long after the Middle Ages, as is evident from Ludwig Uhland's poem 'Das Glück von Edenhall' and Henry Wadsworth Longfellow's English version of it.[268] The 'Luck of Edenhall' was shattered; but fortunately the enamelled Syrian beaker that inspired the poems exists today in perfect condition.[269]

Another decorative technique, known as marvering and combing, which appears to have been very popular for ornamenting glass especially during the Ayyubid period, has a long pre-Islamic history in the area; its ultimate origins lie in Egyptian core-formed vessels of the Eighteenth Dynasty. This type of decoration was executed by winding a thread of contrasting colour around the object and subsequently marvering, or pressing the thread into the surface by rolling the vessel on a flat stone slab. A comblike tool was then utilized to create the featherlike design. The beautiful lidded bowl [421], executed in red glass with opaque white threads, is unique for the type, being the only container so ornamented that still retains its original lid.[270] We know from the Cairo Geniza documents that red (manganese-coloured) glass was a specialty of Beirut. As the provenance of the Metropolitan Museum object is reported to have been nearby Sidon, Greater Syria (and perhaps even Beirut itself) can be suggested as the place of manufacture. Its shape is echoed in both the underglaze-painted and the underglaze- and lustre-painted pottery associated with this area as well.[271]

Many outstanding carved wooden objects are extant or known from the central Islamic lands during this period.

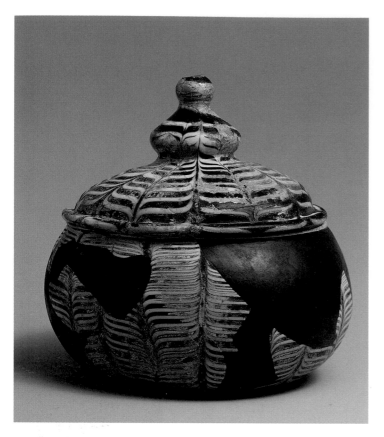

421. Marvered and combed glass bowl with cover, Ht. 20 cm. Metropolitan Museum of Art, New York

and intersecting stems, all of the same width. In their clarity and formality these coiling stems, which produce few leaves or flowers, are remote from natural forms. They cross and recross the arched configuration of the fillet 'which is no longer a boundary but a melody running through a fugue'. This apt description emphasizes the innate musical quality of the design.[275] The closest stylistic parallels are the carvings on a stone *mihrab* in Mosul executed by a Baghdadi artist during the reign in al-Jazira of Nur al-Din's brother Sayf al-Din Ghazi I (*r.* 1146–49). A more developed version of the same type can be seen on a wooden door of 1209 donated by the reigning caliph al-Nasir (*r.* 1180–1225) to a sanctuary in Samarra.[276]

The most important example of the wood-carvers' art crafted in the central Islamic lands during this time, however, was the (now destroyed) *minbar* Nur al-Din ordered for

422. Wood *minbar* in Aqsa Mosque, Jerusalem (now destroyed). Datable between 1168 and 1174

One of the chief production centres seems to have been Aleppo, where several masters signed their works, and we know of at least one son following his father in making mosque furniture – a parallel to the family of potters producing *mihrab* tiles in Kashan.[272]

Using dated examples as our guideposts, we can follow the craft from its archaizing phase – exemplified by a *maqsura* dated 1104 – to an austere, almost abstract style found on a *minbar* of the Zangid ruler Nur al-Din Mahmud (*r.* 1146–74), dated 1163 and partially preserved in the Great Mosque at Hama, Syria. The latter is an appropriate reflection of the age of Islamic scholasticism, dominated by this puritan, even ascetic ruler, who devoted his life to waging 'war against the enemies of his faith', as he claimed in his *minbar* inscription, and to leading the *jihad* against the Crusaders.

The dated *maqsura*, or screen, probably intended as an enclosure for a tomb in a cemetery at Damascus,[273] clearly reflects the pivotal position of Syria. By incorporating both certain principles of the abstract Style C of Samarra with elements met with on Fatimid wooden pieces, Syria's function as a bridge between the East (particularly Iraq and the Jazira), on the one hand, and Egypt and the western Islamic lands, on the other, can be clearly discerned.[274] The *minbar* of Nur al-Din, which was crafted sixty years later than the screen, was also executed to some extent in the purely linear Style C; other sections, however, were deeply carved to produce a carefully planned lacework of spiralling, bifurcating,

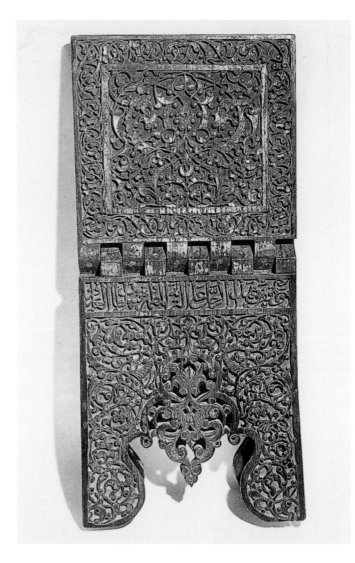

423. Wood Qur'an stand. Dated 1279, Ht. 94.5 cm. Konya Museum

The wood-carvers' art is also beautifully represented in Saljuq Anatolia. An outstanding example is the folding wooden Qur'an stand (Turkish *rahle*) made, according to its elegant cursive inscriptions, in 1279 for the tomb of the mystic poet and saint Jalal al-Din Rumi in Konya.[279] The four outer surfaces, all originally painted and gilded, are each carved with a rhythmic arabesque composition which exhibits an indebtedness to earlier Artuqid vegetal designs [400]. On the two upper surfaces is a twice-repeated design – executed in gold, black, red, and blue – of a double-headed bird of prey on a field of arabesque scrolls inhabited by fourteen lions. On three similarly decorated doors – one from the Haci Hasan Mosque in Ankara,[280] another from the public soup kitchen (Turkish *imaret*) of Ibrahim Bey in Karaman and the third now in the Museum für Islamische Kunst in Berlin from an unknown building [424],[281] the basic repertory of arabesques and inscriptions is enriched by an infinite repeat pattern in the large central medallion; in addition, despite the religious and public settings of the doors, there are bold representations of confronted lions and addorsed griffins, as well as of paired dragons and frontally

424. Wood door, Ht. 168 cm; W. 102 cm. Museum für Islamische Kunst, Berlin

the Aqsa Mosque in Jerusalem, begun in 1168 but not finished until 1174, after the donor's death [422]. The *minbar* was to be a thank-offering for the reconquest of the holy city, which Nur al-Din did not live to see; in the meantime it was kept in the Great Mosque at Aleppo, the city where three carvers had produced it under the guidance of a master 'unequalled in the perfection of his art', in the words of the historian Abu Shama (1203–68). After Jerusalem was finally taken in 1187, Nur al-Din's successor as leader of the *jihad*, the famous Salah al-Din (Saladin), placed the *minbar* in its destined home.[277]

It is clear that this style could hardly have been developed further. A pair of wooden doors dated 1219 in the citadel of Aleppo reflects a different tendency, namely towards geometric configurations related to those developed in Egypt after the middle of the twelfth century. Nevertheless, the Syrian craftsman's mastery is still amazing, however, and the composition of eleven-pointed stars interlaced with twelve- and ten-pointed stars has been described as an 'almost unsolvable problem' and the 'most complicated design ever produced by that branch of art'.[278]

oriented human figures that are also highly reminiscent of decorative motifs seen or mentioned earlier in both Iraq and the Jazira.

The Early Islamic vogue for adorning the interior walls of palaces or private homes with either moulded or carved stucco decoration which we have discussed as regards Abbasid Samarra and Samanid Nishapur continued in the subsequent period and seems to have been particularly popular in Anatolia during the reign of the Saljuqs of Rum. The example of this art [425] was excavated in Kubadabad on Lake Beyşehir, where it formed part of a wall of recessed cupboards not unlike that found in Samarra [83]. The buildings in this complex (the summer palace of 'Ala' al-Din Kayqubad – r. 1219–37) when newly completed must have been quite dazzling with their minutely decorated stucco

425. Stucco cupboard from Kubadabad, founded 1227, Ht. 74 cm; W. 57 cm. Karatay Madrasa Museum, Konya

426. Detail of stone niche, Max. Ht. 4.20 m; Max. W. 2.70 m. Iraq Museum, Baghdad

427. Stone relief from the citadel of Konya, Ht. 159 cm; W. 99 cm. Ince Minareli Madrasa Museum, Konya

428. Carpet pages from a Qur'an manuscript. Datable between 1198 and
1219. Nasser D. Khalili Collection of Islamic Art, London

panels and colourful lustre- and underglaze-painted tile
assemblages [415, 416]. The style exhibited here, especially
of the peacocks, as well as on other stucco panels from this
residence and from contemporary palaces and pavilions in
Konya, is related to that used for the animals, birds, and
human figures depicted on the unglazed ceramic water stor-
age jars (*habb*s) made in the Jazira [409] – a direct line of
influence we have been able to follow here on objects in
many media other than stucco.[282]

The fashion for ornamenting buildings in Iraq and the
Jazira with figural decoration has already been mentioned,
and the stone niche from the latter area [426] is a striking
example of this vogue. Although it incorporates the shape as
well as the design layout that is typical for *mihrab*s from this
area, the array of courtiers depicted in many of the inter-
connected niches of this architectural element preclude its
use as the focal point of a *qibla* wall and another function,
perhaps that of a fountain or a throne niche,[283] must be
sought. It is the tradition of figural architectural adornment
not only in the Jazira but also in Iraq that helped give rise to
the Rum Saljuqid proclivity for ornamenting the walls of
their palaces and private residences with such decoration in
various media. The stucco cupboard and the wooden doors
discussed above and the stone relief [427], with a winged
and crowned figure moving spiritedly to its left – one of
many such reliefs in the citadel in Konya itself – are only a
few examples of this prevalent vogue.[284]

THE ART OF THE BOOK

The carpet pages [428] comprise the initial double-page
illumination from the twenty-eighth *juz'* of a Qur'an made
for the library of a Zangid prince who ruled Sinjar, Khabur,
and Nisibin in the Jazira from 1198 to 1219.[285] This section
is one of five extant parts of the only Zangid Qur'an from the
Jazira known to have survived; and, it is the only *juz'* pro-
viding information about the provenance and date of this
manuscript. The calligraphic, vegetal, and geometric deco-
ration lavishly executed in gold is closely related to that
found adorning a number of the objects that were produced
in the same area or in realms with close ties to this branch of
the Zangid dynasty. The symmetrical arabesque designs on
this frontispiece, for example, are particularly reminiscent of
those on contemporary metal, ceramic and glass objects as
well as those on textiles and wood [398, 400, 411, 415, 416,
420, 423].

Thanks to the identification of five sections of the Qutb
al-Din Qur'an, it is possible to begin to follow the evolution
of the art of book illumination in the Jazira. Since each
extant *juz'* is fully illuminated, the decoration within these
five codices can be used like a pattern book for manuscript
illumination around the year 1200 in the Jazira, about which
we previously knew almost nothing.[286] The ornamentation
of these folios helps us to understand better the tradition
that was soon to give rise to the superb illumination found
in the earliest surviving copy of the *Masnavi* of Jalal al-Din

429. Carpet page from a manuscript of the *Masnavi* of Jalal al-Din Rumi. Dated 1268–69, Ht. 49.5 cm; W. 32.5 cm. Mevlana Museum, Konya

Qur'an are very commonly found on the group of Syrian lustre-painted pottery exemplified by the basin [411] as is the outlining of the script itself.

As regards the art of manuscript illustration in the central Islamic lands at this time, that practised in Iraq, the Jazira and Syria was so closely related in theme, style, and iconography that it seems best to treat it under a single heading. Thematically the material falls into two or perhaps three major groups: illustrations of technical and scientific subject matter which served as visual aids to ensure proper identification and to facilitate explanation; illustrations accompanying works of *belles-lettres*; and possibly, as a third group, illustrations for philosophical treatises.

The first category consists mainly of self-contained pictures accompanying works by authors such as al-Sufi, Ibn al-Ahnaf, Ibn Bukhtishu, al-Zahrawi, and al-Jazari, as well as the anonymous writers known as Pseudo-Aristotle and Pseudo-Galen. Arabic translations of works by Dioskorides and Heron of Alexandria were also copied and illustrated.[289] The subjects depicted range from personifications of constellations to animal representations, illustrations of veteri-

430. Leaf from a Qur'an, Ht. 33 cm; W. 24.6 cm. Topkapi Sarayi Library, Istanbul

Rumi most probably produced in Konya and now in the Mevlana Museum in that city. Consisting of six splendidly bound volumes comprising a total of 613 folios, this manuscript is dated 1268–69 and was calligraphed by ʿAbd Allah ibn Muhammad al-Konyali and illuminated by Mukhlis ibn ʿAbd Allah al-Hindi. Each volume opens with a double-page composition illuminated in gold of such exquisite execution that the manuscript has been called 'one of the finest – if not the finest – illuminated Islamic manuscript of the thirteenth century' [429].[287]

The illumination of the so-called Qarmatian Qur'an [430] – its original volumes are still in Istanbul but many of its leaves are scattered around the world – shares certain features with the ornamentation of the two Qur'an manuscripts just discussed as well as with the decorative motifs employed on other media produced in the central Islamic lands at this time.[288] To cite just two examples, the bold arabesque design gracing the lower border of the leaf illustrated here is strikingly similar to that filling the illumination from the *Masnavi* [429]; and the background of tightly coiled spirals which characteristically completely fill the spaces between the lines and letters of the folios of the so-called Qarmatian

The text of al-Hariri's *Maqamat* consists of fifty picaresque tales narrated by al-Harith ibn Hammam, each set in a different part of the Muslim world. In every story a group of people is so overwhelmed by the astounding eloquence and erudition of an aged stranger, Abu Zayd of Saruj, that in the end they amply reward him with money, which he as often as not spends improperly. The real purpose of the book is to demonstrate the most elaborate linguistic fireworks; and, therefore, only the barest indications of action and setting are given. Nevertheless, several copies are enriched by a series of imaginative compositions in appropriate, often quite detailed, settings in which the characters express by attitude and gesture the liveliest interest and even active participation in the events depicted. The wealth and variety of scenes – often depicting several episodes in one story – is astonishing, and varies from manuscript to manuscript.[292] There are episodes on land and sea; in towns, villages, and deserts; indoors and outdoors; involving human beings, animals, or both. Scenes in mosques and palaces occur, but those of everyday urban life constitute the characteristic settings. Keen insight into the psychology of

431. Leaf from a *Kalila wa-Dimna* manuscript, 12.5 × 19.1 cm. Bibliothèque Nationale, Paris

432. Leaf from a manuscript of Dioskorides' *De materia medica*. Dated 1229, 19.2 × 14 cm. Topkapi Sarayi Library, Istanbul

nary procedures, medicinal plants, surgical instruments, and automata. Episodic action is relatively rare and reflects the influence of the next thematic category.

This second group consists primarily of illustrated copies of two books that were very popular during the medieval period. The first, *Kalila wa-Dimna*, was a compendium of fables named after the two main characters, a pair of jackals. Allegedly composed by the wise Brahmin Bidba (or Bidpai), it belongs to the literary genre of 'mirrors for princes' which embodies precepts for rulers regarding good governance – here made more palatable by the animal guises of the characters. These stories originated in the Indian *Panchatantra*, of which a Middle Persian version had been translated into Arabic under the title *Kalila wa-Dimna* in the eighth century.[290] The second 'best seller' belongs to the literary genre called *maqamat* ('assemblies' or 'entertaining dialogues'), an indigenous Muslim creation. The first of its kind was written in Arabic by the Iranian al-Hamadhani (968–1007). However, the one authored by the Iraqi al-Hariri (1054–1122) was the most popular of the type, and it was his *Maqamat* that was most frequently copied and lavishly illustrated during this period.[291]

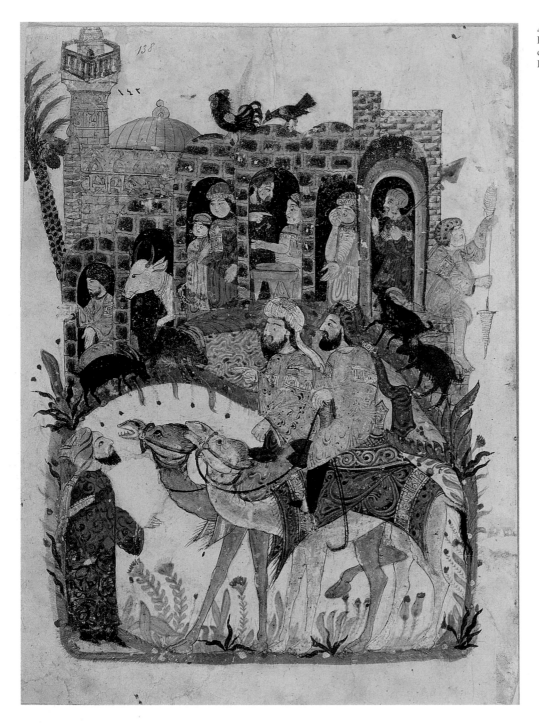

433. Leaf from a manuscript of al-Hariri's *Maqamat*. Dated 1237, Ht. 35 cm; W. 26 cm. Bibliothèque Nationale, Paris

situations and personality types is the hallmark of this art. Also noticeable is a tendency towards satire, directed against the Turkic ruling class,[293] which reveals sentiments apparently shared at that time by much of the Arab population of the area. Indeed, these miniatures provide a unique mirror of contemporary civilization.

The panoramic view of a village [433] is representative of the close attention paid in the *Maqamat* paintings to details of quotidian existence in the multifaceted Arab mercantile society, a characteristic that makes these illustrations highly reflective of this specific milieu. The unusually detailed vignettes punctuating several extant copies of this manu-

script inform us better than those in any other medium about contemporary daily life in the Arab world. As has been stated earlier in this work, the inventiveness of the illustrators of manuscripts such as these influenced the rich repertory of Jaziran metalworkers.

A special kind of painting, common to both thematic groups of miniatures, is the frontispiece. There seems to have been no hard and fast rule, but scientific treatises are generally introduced by 'author portraits', while works of *belles-lettres* frequently include idealized 'portraits' of rulers, sometimes of the patrons of the books.[294]

The not well represented and therefore vaguely defined

third group – illustrations for philosophical treatises or wisdom literature – exhibits most features of the second group in addition to the introductory 'author portraits' of the first.[295]

Three major stylistic categories can be established in the art of manuscript illustration at this time, which to some extent cut across the boundaries of the thematic groups and occasionally, it would seem, reflect regional origins. At present, however, the number of manuscripts and the historical data they contain are too limited to permit further, more precise classification.

In the first stylistic category there is heavy reliance on Byzantine prototypes such as scientific works and bibles, gospels, and lives of saints.[296] Although the human figures are shown in turbans and caftan-like garments, quite often their postures and even groupings derive from Greek manuscripts. Identical copies of whole compositions, feature by feature, are rare; usually specific elements have been adapted and rearranged, and motifs from other sources as well as contemporary additions are incorporated. Most important from an artistic point of view is the frequent 'humanization' of the figural scenes: personal relations exist between figures, usually between a speaker and a listener; and, compared to the Greek models, the action has far greater immediacy and relevance.[297] On the other hand, vegetal forms are more stylized, and the treatment of animals more varied: sometimes they are conventionalized, but often they take on human traits [431]. The influence of Greek originals is especially clear in the three-dimensional modelling of figures by means of shading and the relatively natural fall of garment folds.

In this category are to be found many of the illustrated scientific texts that have survived from this period, of which the finest are two manuscripts of Dioskorides' work on the pharmacological properties of plants, *De materia medica* – one dated 1224, the other 1229 [432].[298] Of several al-Sufi manuscripts, the most spirited are in Istanbul, Paris, and London, the first dated 1130, the last two undated but of the thirteenth century.[299] Some literary works, primarily a 1222–23 copy of al-Hariri's *Maqamat*, also belong to this group.[300] The Dioskorides copy of 1224 and a Pseudo-Galen of 1199[301] also incorporate features from the second stylistic category to be discussed below, pointing up the cross-fertilization that occurred in much of the art of this period. The colophon of the 1229 Dioskorides contains expressions in Syriac, perhaps indicating an origin in Syria or the Jazira; furthermore, some of the architectural details in al-Hariri's *Maqamat* of 1222–23 and two related copies of *Kalila wa-Dimna* are characteristic of the area of Aleppo.[302]

The second stylistic category, apparently without a single firm tradition, is basically original to this period and area.[303] This group is best represented by three fine manuscripts of al-Hariri's *Maqamat*: an undated one in St Petersburg, probably executed between 1225 and 1235; a second painted by Yahya ibn Mahmud al-Wasiti in 1237 [433]; and, possibly the most elaborate but unfortunately also the most desecrated by iconophobes, a copy made during the reign of the last Abbasid caliph, al-Muʿtasim (1242–58).[304]

The emphasis here is on action and on realistic detail. Instead of moulding the body, garments swirl around it

434. Frontispiece to volume 17 of *Kitab al-Aghani* manuscript, Ht. 30.6 cm; W. 22 cm. Millet Kutuphanesi, Istanbul

under the impetus of rapid motion, and this effect is underscored by energetic gesture and lively facial expression. Despite the originality of this 'Iraqi action style', medieval artists in the Muslim world, as in Europe, customarily worked from earlier models, so that related or parallel sources probably furnished catalysts, if not prototypes; the most likely are the brightly coloured figures and evocative scenery from the shadow plays, to which there are many references in contemporary Arabic and Persian literature.[305] Whatever their sources, these *Maqamat* miniatures must be regarded as outstanding pictorial creations of the period and the finest ever produced in the Arabic-speaking world. Indeed, the Iraqi action style had so much vitality that it survived the sack of Baghdad by the Mongols in 1258 and the collapse of the ruling caliphate. A double frontispiece with 'author portraits' in the same animated manner appears at the beginning of a copy of *Rasaʾil Ikhwan al-Safaʾ* (*The Epistles of the Brethren of Sincerity*) of 1284.[306] Even as late as 1297 or 1299 the same style enlivened eleven miniatures depicting mammals in the first part of a Persian copy of *Manafiʿ al-Hayawan* (*Beneficial Uses of Animals*) by Ibn Bukhtishu, painted in Maragha in northwestern Iran.[307] After this the style disappeared.

435. Detail of leaf from *Warqa wa-Gulshah*, Ht. of folio 27.7 cm; W. of folio 21.3 cm. Topkapi Sarayi Library, Istanbul

A third, stylistic category, instead of characterizing all of the illustrations in a given manuscript, comprises two specific types of miniatures. The first is the 'princely frontispiece', where the enthroned, frontally rendered, ruler is flanked by attendants standing stiffly at attention or ready to serve – the latter being depicted in a smaller scale than the potentate himself. These compositions are akin to the royal representations on Sasanian rock reliefs, which were also adapted to various early Islamic scenes [194]. They occur particularly in manuscripts attributable to Iraq, including several volumes of one copy of *Kitab al-Aghani* (*The Book of Songs*) probably made for a prince of Mosul in the second decade of the thirteenth century [434] and the *Maqamat* of al-Hariri dated 1237 and discussed previously.[308] The second type is the antithetical scene, especially as found in *Kalila wa-Dimna* illustrations,[309] in which pairs of animals flank central trees or plants.[309] This device, too, is known from Sasanian and early Islamic silver, stuccoes, and silks. The fact that these two types of miniatures occur in manuscripts attributable to several different regions of the Muslim world attests to the thoroughness with which earlier traditions had been absorbed into the arts of the medieval Islamic world.

Let us turn, finally, to the illustrations of an undated copy of the romantic Persian poem *Warqa wa-Gulshah*,[310] consisting of scenes in a kind of ribbon format, wider than it is high, with the figures usually extending over much of the height between the lower and upper edges of the picture band [435]. The cultural climate in which this manuscript was created was not unlike that in which so many of the objects seen in this section were produced. Consequently, it is not surprising to see the effect in this medium as well of the tremendous displacement of artisans at this point in the history of the medieval Islamic world. We have already discussed how an enforced migration from east to west contributed greatly to an eventual blending of styles in the art of the weaver, the potter, and the metalworker. That of the miniaturist was no exception.

Thus, although certain Persian influences are discernible in this manuscript, the coloured backgrounds, ribbon format of the scenes, type of vegetation, and figural style are also all quite closely related to depictions in manuscripts probably produced in the Jazira in the middle of the thirteenth century.[311] The particular type of arabesque filling the background on the miniature illustrated here and on others in the codex is to be found not only on early thirteenth-century Kashan pottery [280] but also decorating the draperies, thrones, tents, pillows and garments in two manuscripts of al-Hariri's *Maqamat*, one dated 1237 and the other datable to some time between 1225 and 1235 as well as in the Paris Pseudo-Galen of 1199 probably copied in the Jazira (all of which were mentioned earlier) and in Anatolian Qur'an illumination.[312] One encounters the same figural style in miniature painting from the Jazira as well as in the polychrome overglaze- and underglaze-painted ceramics discussed earlier [272–275, 414, 416] from both Anatolia and Iran. Furthermore, stylistic comparisons can be made with inlaid metalwork from the Jazira and northern Syria.

Because of the blending of styles seen here, the provenance of this unique codex has long been debated. However, several representations and biographical information on the painter seem to tip the balance in favour of the central Islamic lands as the place of origin – a general provenance reinforced by a number of the comparisons discussed above. Not only is the pre-Islamic ruler depicted as a Turkic military leader but Crusader foot-soldiers, armed with a type of weapon common in medieval Europe, and Christian knights

436. Leather bookbinding. Datable to 1182 or earlier, Ht. 17.4 cm; W. 13.5 cm. Preussische Staatsbibliothek, Berlin

are represented in some of the paintings.[313] Since one of the pages is signed in large letters by the painter ʿAbd al-Muʾmin ibn Muhammad, whose family originated from Khoy, Azerbaijan, and settled in Kastamonu north of Ankara, and since we know that the painter witnessed the deed of endowment for the Karatay *madrasa* in Konya in 1252–53, perhaps we can be even more specific. It might be safe to assume that he was living and working in the capital at that time and to suggest further that he illustrated the manuscript there some time during the middle decades of the thirteenth century.[314]

The number of precisely dated or datable leather bindings extant from the period covered by this volume is extremely small. The two previously discussed examples of this art [120, 155], dating from the end of the ninth and end of the tenth centuries respectively, both exhibit the horizontal format common during the early Islamic period. The example [436], datable to 1182 or slightly earlier, and thus approximately two hundred years later than the binding [155], exhibits several new characteristics which were to dominate the art of bookbinding in the Islamic world for

centuries. The first of these is the three-part construction of the binding, consisting of an upper cover (missing here), lower cover, and, attached to the fore-edge of the latter, a pentagonal envelope flap. Thought to have made its first appearance in the eleventh century, this classic type was to remain an intrinsic feature of Islamic bindings at least until the eighteenth century, when the influence of those from Europe brought about a slow disappearance of the traditional fore-edge flap.[315] Another new characteristic seen here is the vertical format that was to be so universally popular from the medieval period onwards. That this is an early example of the new orientation is seen in the fact that the only clue to the vertical format on the binding itself is the lack of a central border at the sides of the back cover, thus rendering the design higher than it is wide. Finally, we see here an early example of the use of triangular corner designs in the central rectangle, a convention that was to remain popular not only for Islamic bindings but for those of the Renaissance as well.[316] This tooled binding can be attributed to Damascus on the basis of two notations in the binding's manuscript.[317]

CONCLUSION

The medieval arts of Iraq, the Jazira, Syria, and Anatolia do not lend themselves to simple and easy generalizations. Because of its historical and ideological associations, the patronage of the Abbasid caliphs in Baghdad still had wide repercussions all over the Islamic world, but the rest of the area was governed by the twin powers of feudal military rulers loosely organized into dynastic families and by an urban middle class of merchants and landowners. Both groups invested heavily in the building of what may be called Sunni 'Islamic' cities, with many mosques, *madrasa*s, and other establishments reflecting the social piety of the times. Non-Muslims were part of the picture, especially Christian communities, which witnessed a considerable artistic revival (to be sketched in Chapter 8). Princes also built citadels, usually better preserved than palaces, while rulers as well as the middle class profited from a network of fancy *khan*s or caravanserais for local and international trade.

Both groups of patrons were served by an inlaid metalwork with nearly identical iconographic programmes, while the most original book illustrations of the *Maqamat* were restricted to the literate Arab middle class. In objects and manuscripts as well as in architecture, there was a fair amount of ostentation. Frontispieces in books or ornate portals in buildings are both instances of a concern for display, possibly illustrating rivalries between patrons and artisans. Families and even dynasties of artisans, best known among metalworkers, probably travelled from city to city or court to court, wherever there was an opportunity for lucrative commissions. In general, while, thanks in part to archeological work, it is possible to identify some of the regional differences in the arts of the object, it is the similarities that seem to overwhelm, especially in the art of inlaid metalwork and in the art of the book. But these preliminary conclusions must be tested against further research. In short, there was a distinctive patronage within central Islamic lands and a shared supply of craftsmanship as well as a common vision of a structured urban environment and of the implements needed for a satisfying life.

When we move to forms, matters become more complicated. Syria (including Palestine in the thirteenth century) and Anatolia are two well-defined artistic spaces, comparable to but different from each other. The comparison is particularly striking in architecture. The same pious or secular functions are translated into buildings, primarily in stone, utilizing the same vocabulary of structural and decorative forms (portals, *iwan*, court, portico, etc.). Syria exhibits an almost classical sobriety and purity in the treatment of stone, with a sharply defined geometry of decoration, and a preference for elegant but restrained ornament and writing. Anatolia, on the other hand, shows much more variety, more inventiveness in ways to build and decorate, and fewer inscriptions. Some of the portals exhibit a baroque virtuosity and probably illustrate individual experiments or reflections of some unique circumstances. Brick occurs as well as stone, and Syrian forms cohabit with Iranian ones. Anatolian peculiarities can be explained by the fact that it was a newly Islamized province at a major frontier between Islam and the Christian world, with many non-Muslim or recently converted groups, with a fluid society of immigrants from many parts of the rest of the Muslim world, even with sectarian communities at the edge of Muslim orthodoxy. Most of the Anatolian development is also later by a generation or two than the Syrian one and depended in part on the latter's achievements. Some scholars have also sought to explain Anatolian art through the introduction of practices and ideas brought by Turks from Central Asia. Less clearly delineated than their Syrian counterparts, objects made in Anatolia illustrate most of the techniques found elsewhere, with a possible tendency to greater complexity in design.

The two remaining provinces comprising the central lands – Iraq and the Jazira – remain, with one exception, less clearly focused. Their architectural monuments are not well preserved, and whatever remains can easily be related to those in Syria or Iran. The spectacular 'Mosul' school of metalwork is a relatively late phenomenon and could be interpreted as reflecting the needs of a social class – the feudal rulers and the wealthy patricians – more readily than the practices of a region. Only the art of book illustration seems to have appeared in these provinces much more frequently than elsewhere, for reasons which are not really clear. It is possible that, just as geography has divided the Jazira into many discrete independent zones, so the arts of this area will eventually be defined through the study of smaller and physically separate regions.

But there is yet another way to look at the arts of the central Islamic lands and of defining their character and their evolution. Following a pattern begun by Turkish scholars dealing with Anatolia and, to a smaller degree, by other scholars involved with Syria, one can argue in primarily dynastic terms. One could thus identify an Artuqid art (primarily in the first half of the twelfth century) centred in the northern Jazira, with features borrowed from many surrounding areas and with relatively less formal cohesion in architecture than in other arts. A late Abbasid flowering occurred around Baghdad in the thirteenth century, identifiable simultaneously by the Mustansiriyya, the calligraphical systematization attributed to Yaqut al-Mustasimi, and the illustrations of the *Maqamat*. Zangid art could be seen in the area of Mosul in the middle of the twelfth century and then in Syria at the time of Nur al-Din, an art that led directly into that of the Ayyubids, with many major accomplishments in Palestine, Arabia, and Egypt after the defeat of the Fatimids and of the Crusaders. The rich memory of Late Antiquity in Syria was adapted to new functions and new tastes. Finally, the Saljuqs of Anatolia, as well as a few secondary Anatolian dynasties established in the area, created an unusually original art in a newly Muslim area, bringing together functions and forms from Syria, Iraq, or Iran and mixing them with the rich heritage of Byzantium, Armenia, and Georgia, not to speak of an Anatolian Late Antique.

There was, of course, much that all these dynasties shared, ideologically as well as in terms of taste, and all of them profited from the accrued wealth of urban trade and manufacture, but there were many differences between them. The latter are most visible in architecture, because architecture has been better studied than other arts, but it

should be apparent as well in ceramics after the many archaeological enterprises have put their information together, and in metalwork or the art of the book. It should be added that Muslim patronage was never alone. There was a significant Christian component within the Muslim empire, but, more importantly, this was a time of constant contacts with the Christian worlds of the Crusaders and of Byzantium or of other eastern Christian realms. It was a time when the Christian and Jewish population of Syrian and Anatolian cities profited from the general prosperity. Altogether, just as with the Fatimids (although perhaps less obviously), it may well be a common *Zeitgeist* which inspired the astounding creativity of the times.

Finally, it is worthwhile to ponder about the art of these centuries throughout the Muslim world between Central Asia and India to the east and present-day central Algeria to the west. This vast area, united by comparable social, political, linguistic, cultural, ideological, and political changes, was also connected by the functions and forms of its arts. However blurred the distinctions between them may be, a patronage of cities coexisted throughout with that of princes. Everywhere, but at different rhythms, representations appeared on objects and in books; an iconographic language came into being to illustrate or to adorn ambitions at many levels of society. The Arabic language still dominated, but Persian became a major vehicle for expression, and the writing of both acquired a sophistication of form which was hitherto unknown. But perhaps the most important achievement of these centuries was to have created social and economic conditions as well as a creative energy which led to the invention and spread of technical means to produce a true art of objects in all media and accessible to large segments of the population.

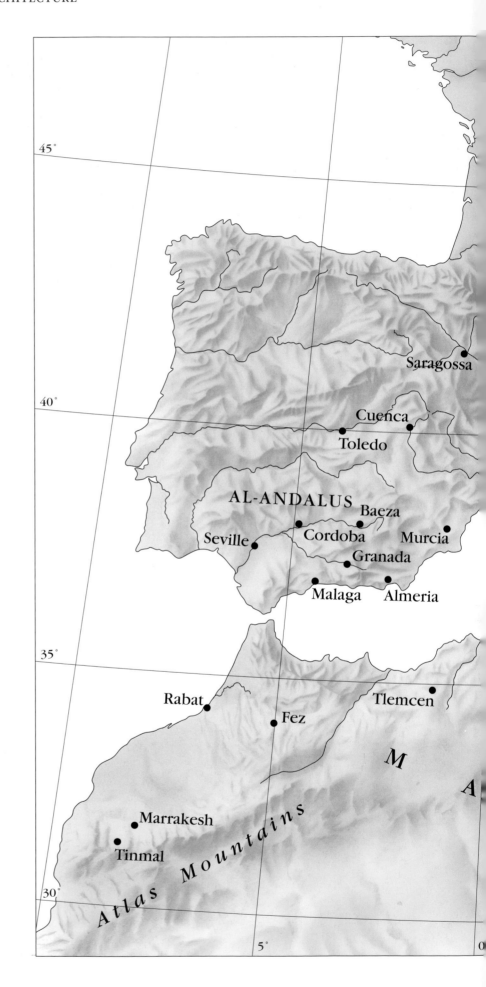

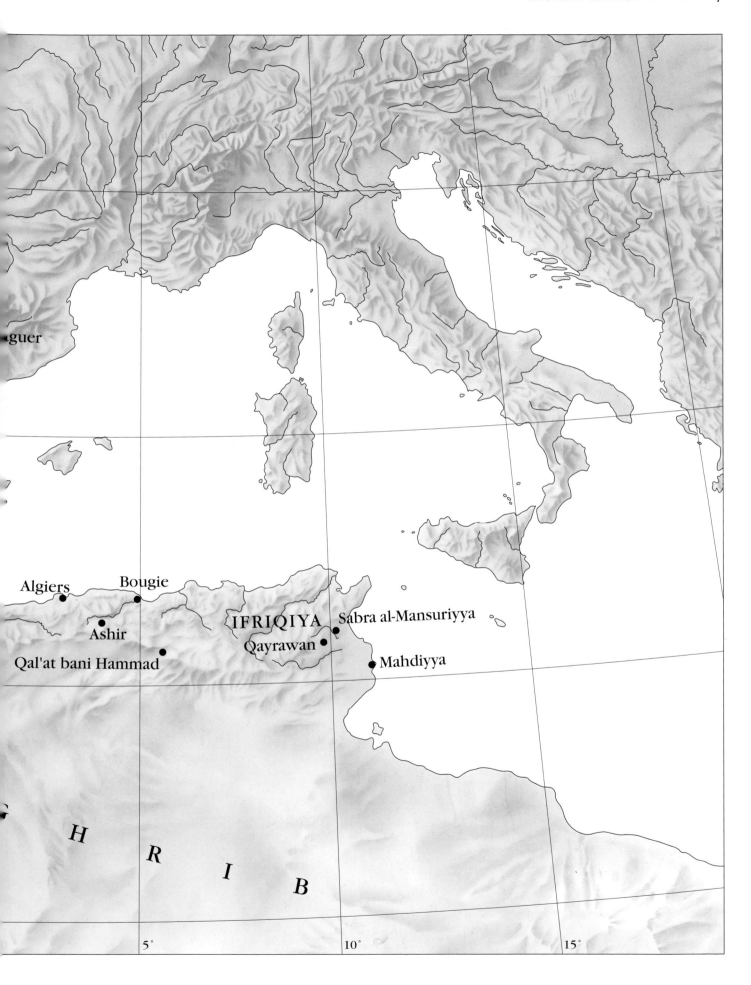

guer

Algiers

Bougie

Ashir

Qal'at bani Hammad

IFRIQIYA

Sabra al-Mansuriyya

Qayrawan

Mahdiyya

H

R

I

B

5°

10°

15°

CHAPTER 7

Western Islamic Lands

ARCHITECTURE AND ARCHITECTURAL DECORATION

The most important religious monuments of the area in medieval times are closely related to the creation of new cities, especially in the western part of North Africa more or less corresponding to modern Morocco and central or western Algeria, and to the growth of older cities in al-Andalus, Muslim Spain. A second impetus was the desire, by the initially highly rigorous Sunni Berber dynasties – the Almoravids ('al-Murabitun', 'those who dwell in frontier settlements', 1062–1147) and the Almohads ('al-Muwahiddun', 'those who proclaim God's unity', 1130–1269) – to proclaim their presence and their control. Tinmal in central Morocco (c.1035), Algiers (1096), Tlemcen (1136), Fez (the so-called Qarawiyyin Mosque, around 1135), Marrakesh (the so-called Kutubiyya, 1146–96), Rabat (1196–97), and Seville (1171) all acquired new or completely rebuilt congregational mosques.[1] They varied in size from the comparatively small one in Tinmal (48 by 43 metres) [437, 438] to that of Rabat [439], which was immense.[2] Their simple plans continue the early so-called T-hypostyle type, but a special emphasis is given to the central nave and the *qibla* wall. Rows of domes highlight both of them, or else three aisles are set parallel to the *qibla* and separate the latter from the main hall for the faithful. In Rabat, twenty-one perpendicular naves abutted on these aisles; the mosque was so large that two additional small courtyards were set in the midst of the covered area. In Tinmal, in addition to a central axial nave, there was a wide aisle along three of the four walls, as though framing the mosque. No function has been proposed so far for this unusual arrangement, but it was certainly a carefully thought-out one, as Christian Ewert has demonstrated the attention given in this mosque to every detail of composition and design. Following the earlier Cordoban practice, the *mihrabs* are deep and, usually, extensively decorated. Frequently, they also project beyond the outer walls; a possible explanation for this unusual feature lies in the need for a space to put the movable *minbars* still common at that time in or near the *mihrab* niche.[3] The minarets, of which the most celebrated are the three at Seville [440], Rabat, and Marrakesh, are traditional square buildings, sturdy and tall signals, minimally decorated, of the presence of a rejuvenated Islam.

Almost nothing is known of other types of religious architecture, except for a few mausoleums in Ifriqiya[4] and the still unexplained so-called Qubbat al-Baradiyin or al-Ba'adiyin in Marrakesh [441, 442]. The latter, datable by an inscription to 1117, has the unusual form of a small rectangle (7.30 by 5.50 metres) covered by a dome. There are no known parallels for its shape and dimensions, except perhaps the Ka'ba in Mecca, which is also rectangular, yet considered as a square. Its most amazing feature is the passage from rectangle to dome [442]. It is a most peculiar combination of high inventiveness, classical geometry, and possibly even plain fudging, as individual units of composition vary in dimension, apparently being adjusted to this specific building during construction rather than designed according to some carefully thought-out geometric logic. It is not a *muqarnas* dome, but it is likely that its designers knew something about this new architectural device. The most puzzling feature of the building is the uncertainty of its function. It could have been a place for a fountain for ablutions, whose architectural history is still quite unclear.[5] It could have been a religious commemorative building recalling some remote sanctuary like the Ka'ba. But it could also have been a royal pavilion attached to a mosque, something akin to the north dome of the Isfahan mosque discussed earlier. What is, however, certain is that it recalls, in a new Maghribi capital, shapes and expressions reminiscent of Baghdad and of Mecca, perhaps of both, and then decorated with interlaced arches common in the Islamic west.[6]

Finally, a word must be said about secular constructions. Many fortresses survive in part in Morocco and Spain,[7] and the Almohad gates of Marrakesh and Rabat [443], with their wide and heavy horseshoe arches on low supports, establish the basic lines for all later western Islamic gates.[8] The palaces of central Algeria seem, at this stage of research, to be more closely tied to central and eastern Mediterranean architecture and have been discussed in the preceding chapter. Relatively recent archeological investigations and various programme of restoration, mostly in Spain, have brought to light many partial and heavily restored or reused remains of private houses and of palatial establishments from the eleventh and twelfth centuries. Such is the *castellejo* of Murcia datable to 1146–71 or a fortified palace in Balaguer.[9] The most important and most available of these establishments is the Aljaferia in Zaragoza [444] bearing the name of one Abu Ja'far Ahmad ibn Sulayman of the Bani Hud, a king from one of the many minor dynasties which ruled Spain in the eleventh century (1049–83). The Aljaferia has been much redone in later centuries, although its massive exterior with round towers does recall earlier Umayyad palaces as well as fortresses built all over the Mediterranean. Its most interesting feature is its rectangular courtyard with two pools connected to each other by a channel, and a brilliantly decorated arcade [445] about which more will be said below. It has recently been proposed that this courtyard served as a space for the gathering of poets around the prince and his companions, in a sort of sensuous festival of drinks, food, music, and words.[10]

Western Islamic construction continued in nearly all ways the traditions of the past. Supports, columns, and piers are clearly related to earlier practices. The roofs of many mosques were flat and wooden, often, as in the Kutubiyya in Marrakesh, with remarkable visual effects. Of greater interest are the arches, either simple horseshoes or, more often, variations on the polylobes of Cordoba. It is possible

437. Tinmal, congregational mosque, *c*.1035, plan

438. Tinmal, congregational mosque, *c*.1035, general view

440. Seville, 'Giralda' minaret, twelfth century

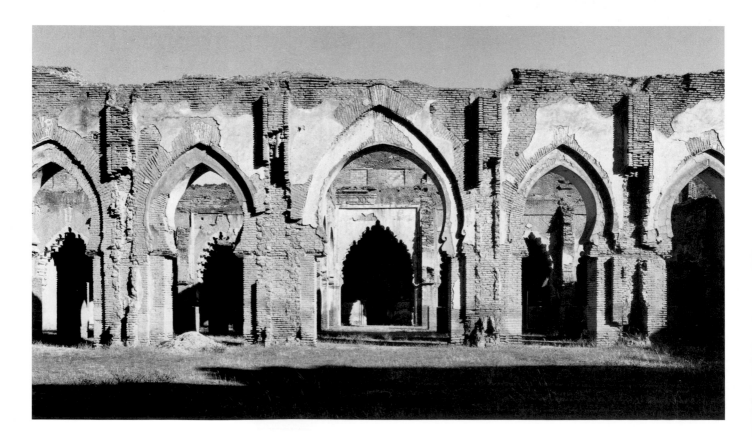

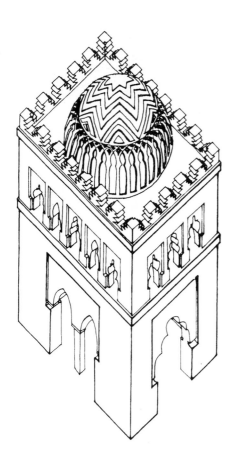

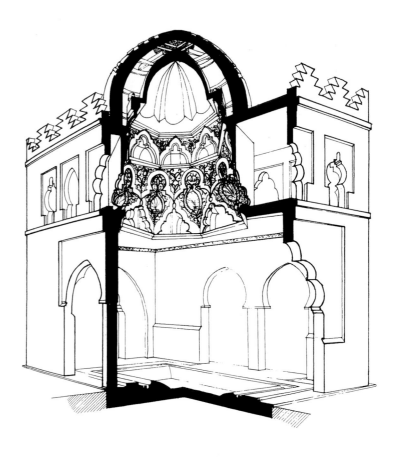

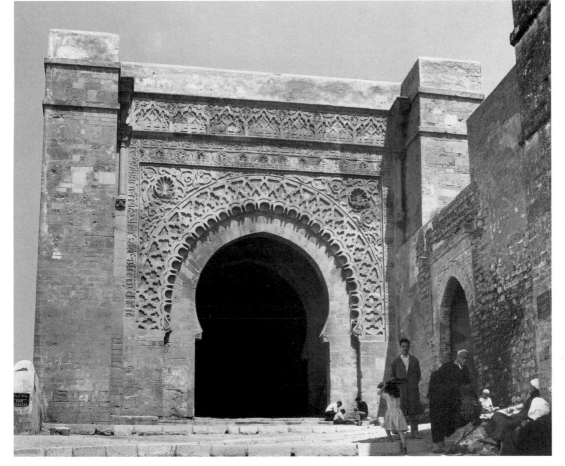

441. Marrakesh, Qubba al-Burudiyin

442. Marrakesh, Qubba al-Burudiyin, drawing, transition zone, dome

443. Rabat, Oudaia Gate, Almohad

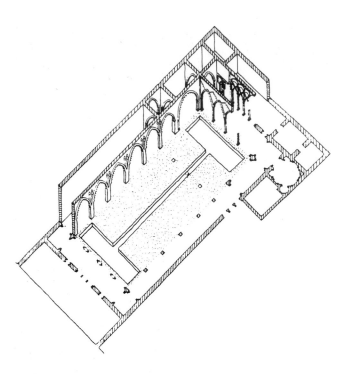

444. Saragossa, Aljaferia, sketch elevation

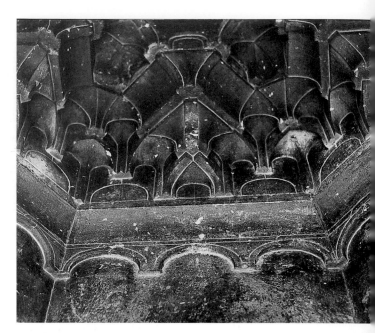

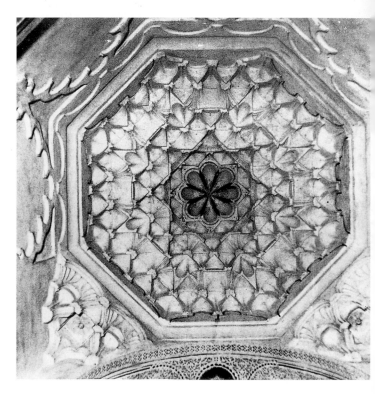

that further investigations and analyses will explain these variations in terms of a continuous discourse of generations of patrons and artisans elaborating on the work of their predecessors and honing in sophistication the Cordoban examples. But the needed studies are still lacking, and the preliminary impression is of the earlier architectural idiom being continually perpetuated. The use of plaster for the lobes permitted an increased number of profiles for the shaping of the interior; thus, at Tinmal, the importance of the aisles is indicated by the degree of development of the arches, with the most spectacular ones around the dome in front of the *mihrab* [446].

The two most important aspects of the western Islamic monuments are the appearance and development of the *muqarnas* and the variety and use of decorative designs. In the twelfth century the dome on ribs tends to disappear, and the dome on modified squinches, as in the Qubbat al-Baradiyin in Marrakesh, is rare.[11] Both are usually replaced by a *muqarnas* dome, first fully developed in eastern Islamic lands and probably imported from there. The *muqarnas* of North Africa is certainly derivative from models developed elsewhere, but none the less original in many ways. It was used on rectangular as well as square planes; it is usually not structural, but a plaster screen of architectural segments hiding the actual vault or ceiling. Some of the plaster *muqarnas* of Fez [447], Tlemcen, or, in a particularly spectacular way, in the Cappella Palatina of Palermo (see below, Chapter 8) were intricate indeed and required considerable sophistication in planning and design, in particular in the identification of minute units of composition – usually curved panels stretched like membranes and held together by a network of small columns – which could be

adapted to any architectural space. But, whatever geometric complexity they express, they also came to reflect a successfully honed and often repeated ornamental routine.

Concerning architectural decoration, two points can be made. First, in eleventh-century Spain (stemming from the art of Cordoba), it tended to be more complex than it was at first in North Africa. It is enough to compare the stucco panels from the Aljaferia in Zaragoza [455], with their wild breaking-up of Cordoban themes, and the simple and severe geometric and architectural designs framing the niche of the *mihrab* in Tinmal [446].[12] Much of the history of western Islamic architectural decoration consists in the interplay with these two tendencies, one austere and conservative, the

445. Stucco doorway from the
Aljaferia, Saragossa, eleventh century.
Madrid, Museo Arqueologico
Nacional

446. Tinmal, congregational mosque,
c.1035, dome in front of the *mihrab*

447. Fez, Qarawiyin mosque, mostly
1135, muqarnas dome

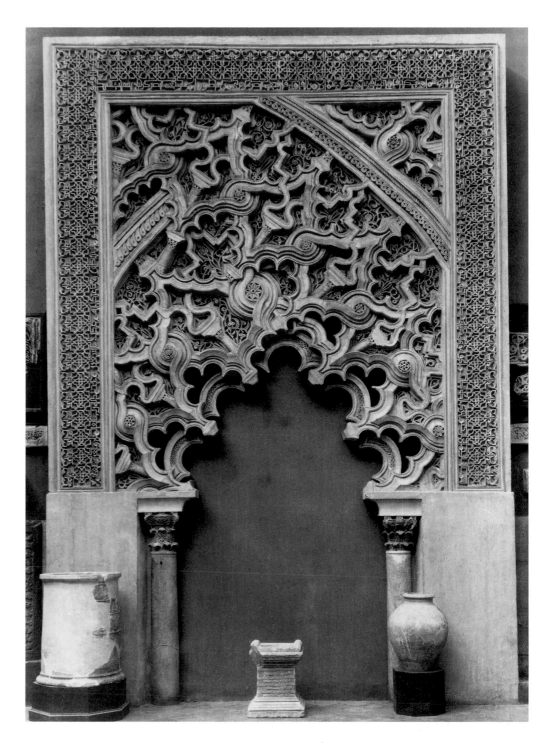

other one inventive and imaginative. Second, plaster was the
most common medium of decoration; its comparative inde-
pendence from construction allowed the decorators consid-
erable latitude in the development of themes and the motifs
were probably painted as well.

Most designs derived from architecture. This was true of
the *muqarnas*, but also of the decoration of minarets, espe-
cially the celebrated trio of Seville, Rabat, and Marrakesh,
where fairly traditional intersecting polylobed arches were
woven into a tapestry covering as much of the surface of
the wall as was deemed necessary. Otherwise, writing, geo-
metrical combinations, and floral arabesques continued to
be employed, emphasizing the spandrels or arches or the

sides of *mihrabs*, or else adding some new dimension to the
muqarnas, as on many panels of the Qarawiyyin domes. The
acanthus, palmette, and vine which had existed in western
Islamic art since Umayyad times continued to be present.
While something of the wealth of detail and fascinating
interplay of light and shade typical of the best works of the
caliphate is occasionally present, the designs, especially in
Morocco, are more rigid and repetitive, the leaves are dry,
and, in particular in later Almohad monuments such as the
Kutubiyya in Marrakesh, a sturdy decoration replaces the
elegant refinement of Cordoba. Although an earlier scholar-
ship saw these changes in terms of decline from an idealized
tenth century, it may be more appropriate to argue that they

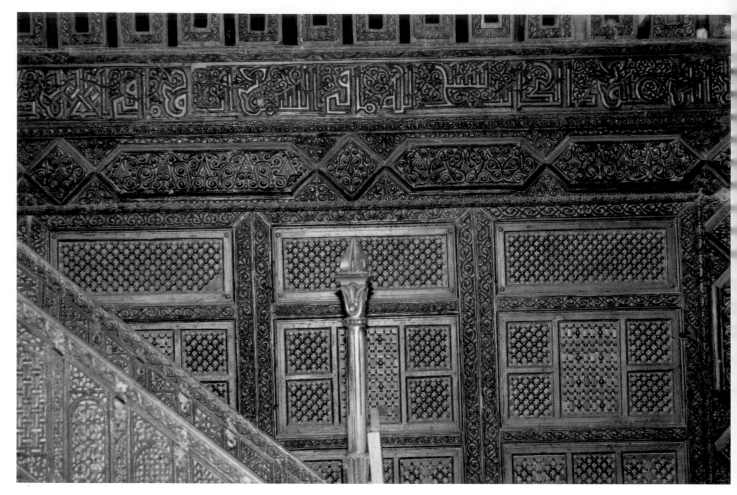

448. Detail of wood *maqsura* in the Great Mosque, Qayrawan. Datable between 1016 and 1062

illustrate the new taste of Berber dynasties transforming through their own ascetic puritanism the heritage of Umayyad Spain and suggesting an effective power of persuasion, or at least of presence, especially on the walls of mosques and of city gates. It has been possible also to suggest a deeper meaning than that of mere ornament in such secular instances, as with the Aljaferia, when a cultural context of socially oriented poetry readings can be demonstrated.[13] In a sense, the true investigation of the medieval decorative forms of western Islamic architecture is only beginning, for it had to relieve itself of the burden of constant comparison with the tenth-century caliphate.

THE ART OF THE OBJECT

When the Fatimids conquered Egypt, founded Cairo, and made it their capital in 973 (see Chapter 6), they designated Buluggin ibn Ziri their governor in Ifriqiya.[14] Once in Egypt the Fatimids began paying less and less attention to the Maghrib, confident in Buluggin. Soon it became apparent that an autonomous dynasty – the Zirid – was emerging, one that was to inaugurate a three-century-long era of almost exclusive Berber rule in the western Islamic lands. In its attempt to imitate their overlords – a practice that Buluggin's father, Ziri, had initiated long before his son

became governor – this ruling house took over the North African capital of the Fatimids, Sabra al-Mansuriyya, less than a mile south of Qayrawan.

One of the most beautiful works attributable to the Zirid dynasty is the *maqsura* made for the Great Mosque of Qayrawan [448, 449].[15] Ordered by the Zirid ruler al-Muʿizz ibn Badis (r. 1016–62), who according to Ibn Khaldun enjoyed the richest and most flourishing reign ever seen in the Maghrib, this wooden protective enclosure is adorned with exquisitely carved and turned decoration. The former consists of a continuous band of bold, angular script on a vegetal ground bordered above by crenellations. Below this calligraphic band is another band decorated on several planes with a series of arabesque designs many of which betray their ultimate indebtedness to the bevelled style first seen in Samarra and later in Egypt [83, 99].

Most likely attributable to the patronage of the same ruler are the planks and beams composed of single pieces of wood surviving from the ceiling of this mosque [450].[16] Owing to the ravages of time and man, very few wooden ceilings of the hypostyle mosques in the central and western Islamic lands from the period covered by this book are extant. However, the types of ceilings current at a particular time, the ornament preferred, the coloration in vogue and the decorative techniques employed can be ascertained to a certain extent

449. Detail of Figure 448

450. Detail of wood beams with painted decoration from the Great Mosque, Qayrawan. Datable between 1016 and 1062, width ca.15 cm. Qayrawan, Tunisia

by means of the relatively small number of ceiling elements that have survived. Those extant from Qayrawan's congregational mosque provide not only the answers as regards all of these questions *vis-à-vis* the Zirid period in Ifriqiya but also indications as to its prototypes in the central Islamic lands. The vegetal design seen on this beam, polychrome painted on a red ground, betrays its pre-Islamic heritage in its hints of classical cornucopias and Sasanian pearl borders. However, the bifurcations and number of secondary shoots place its prototype firmly in the early Islamic period. These eleventh-century beams from the ceiling of the Great Mosque should therefore be seen as reflective of earlier ceilings of which only a few elements seem to have survived.[17] Since some of the contemporary ceiling beams from the Fatimid restoration in 1035 of the Aqsa Mosque in Jerusalem have come down to us, we can further – and not surprisingly – state that the Zirid elements belong to the same tradition albeit seemingly less developed.[18]

In 997 one of the Zirid amirs gave his uncle, Hammad ibn Buluggin, the governorship of Ashir and Msila in present-day Algeria, an appointment that not only led to the founding of the Hammadid dynasty in the central Maghrib in 1015 but also caused the amir's great-uncle, Zawi ibn Ziri, to revolt and subsequently, in 1002, to flee to Andalusia, where he and his relatives proclaimed an independent principality in 1012 with Granada as its capital. Thus, by the second decade of the eleventh century, the Zirids in the Maghrib were divided into three branches: one in Ifriqiya; one in the central Maghrib; and one in al-Andalus.

The capital of the Hammadid dynasty, Qalʿat Bani Hammad, was founded in 1007–08, and this fortress city enjoyed an unexpected surge of prosperity as well as a population increase when, after the Banu Hilal and the Banu Sulaym devastated Qayrawan in 1053, Ifriqiyans in general and citizens of Qayrawan in particular sought refuge in the Hammadid capital. Scholars, students, artisans, and merchants came from far and wide because of the great opportunities that al-Qalʿa offered to those who cultivated the sciences and the arts as well as to those involved in commerce – with caravans from Iraq, the Hijaz, Egypt, Syria,

and all parts of the Maghrib being attracted to the city.[19]

The buildings gracing this seat of government were often elaborately and finely adorned. It is not surprising, given the emigration mentioned above of Ifriqiyan craftsmen to this mountain capital, that much of this ornamentation as well as many of the objects made for the Hammadid rulers and their subjects exhibit an indebtedness to Aghlabid, Fatimid, and Zirid Ifriqiya and ultimately to Abbasid Mesopotamia. One of the materials employed for this architectural decoration was carved and painted stucco – the fashion for such adornment spreading from the Abbasid heartland not only eastward [206] but also westward, via Ifriqiya. The stucco ornamentation of the buildings at Qalʿat Bani Hammad, especially that giving a tapestry-like effect such as the infinitely repeating geometric designs, appears to have ultimately given rise – through the intermediary of such buildings as the Aljaferia in Zaragoza [445] – to the tradition in Nasrid al-Andalus that produced the exquisite stucco tracery on the walls of the Alhambra and other related buildings.[20]

Another vehicle utilized for adorning the edifices of this Hammadid capital was glazed ceramic decoration – all of which seems to have been locally produced. It is tempting to speculate that the lustre-painted cruciform tiles [451] – which were found combined with monochrome turquoise

451. Lustre-painted and monochrome glazed tiles. Datable between 1068 and 1090–91, greatest width of each tile ca.24 cm. Musée Stefan Gsell, Algiers

452. Monochrome glazed architectural element, each segment 16 × 4.6 cm. Setif Museum, Setif, Algeria

or green eight-pointed star tiles – should be attributed to the immigrating artisans mentioned above who would have brought this technique with them and either executed the tiles themselves or trained local craftsmen to do so.[21] Forty-nine such tiles were excavated in Qal'at Bani Hammad, in both Qasr al-Mulk and Qasr al-Manar dating from between 1068 and 1090–91 – a time frame that supports this hypothesis. As was the case in Ifriqiya, this luxury technique seems to have been reserved almost exclusively for architecural decoration. The motifs found on these tiles are epigraphic, vegetal (mostly palmettes), and geometric (mainly ogives and guilloches).

Although, as we have seen, ceramic architectural decoration played a role in the adornment of buildings in both the central and western Islamic lands during the Early Islamic period, we are totally unprepared for the proliferation of this ornament found at the Hammadid capital, not just in terms of sheer quantity but in terms of the forms this decoration takes as well.[22] Many new shapes were employed in addition to the simple squares, disks, stars, crosses, and hexagons or combinations of these which we have seen in Samarra and the various Ifriqiyan capitals.[23] One finds here, for the first time, glazed ceramic architectural elements. Particularly important and unique are the series of partially glazed objects (square in cross-section with a groove in the centre of each side running two-thirds the length of the tile and a small concavity in the centre of the bottom) [452] mentioned above[24] that were thought to have been inserted under the ceiling either as denticles, as small corbels, or placed at dif-

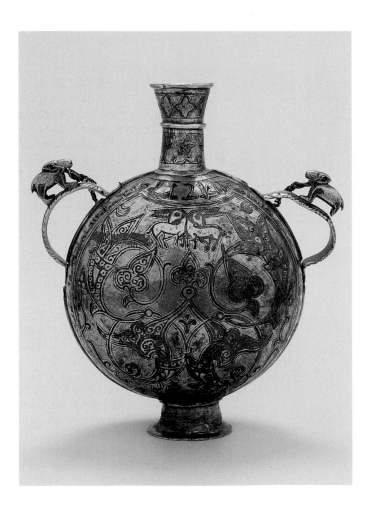

454. Gilded silver perfume flask with niello inlay. Datable before 1044 – by 1103, Ht. 15.6 cm. Museo Provincial de Teruel, Teruel, Spain

453. Ivory casket. Dated 441/1049–50, 23 × 34 × 23.5 cm. Museo Arqueológico Nacional, Madrid

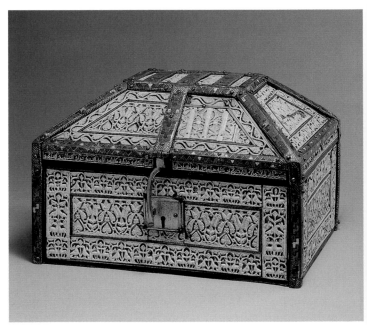

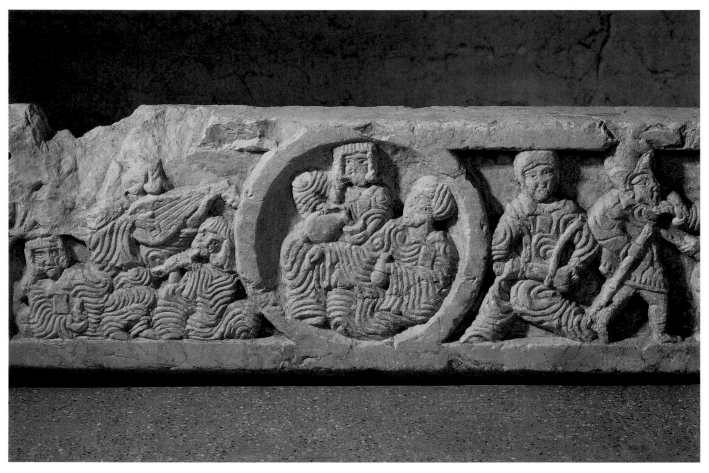

455. Detail of marble basin, 42 × 170 × 67 cm. Museo del Almudín, Játiva, Spain

ferent levels forming a cornice of stalactites.[25] Since they could not have carried any weight, they had chiefly an aesthetic function.

Nowhere in the Islamic world up to this time had glazed ceramic architectural decoration played as large a role as at Qal'at Bani Hammad. Not only do we see earlier ceramic architectural decoration serving as inspiration but we also find here many forms translated into the ceramic medium which had previously appeared in stucco, brick, paint, or stone. From here and the subsequent Hammadid capital on the Mediterranean coast, Bougie (Arabic Bijaya), the vogue for this type of architectural decoration spread not only to Spain and Morocco, where it was to become a hallmark of the architecture of those countries, but also to Europe.[26]

For most of the eleventh century in al-Andalus (both during the dissolution and after the complete collapse of the Umayyad dynasty in 1031), the area formerly under the rule of the Cordoban caliphate was governed by a number of independent sovereigns known as the *muluk al-tawa'if* or Taifa kings, the most powerful among them being those ruling from Granada, Saragossa, Seville, and Toledo. We have seen during the early Islamic period how the cycle of adoption, adaptation, and innovation in the art of the object in the central Islamic lands was echoed in the various contemporary artistic centers in the western Islamic lands. Those works produced in the Maghrib during the subsequent

medieval Islamic period are no exception to this pattern. The western version of classical early Islamic art that had developed in al-Andalus and North Africa prior to the year 1000 was further developed in the following two and a half centuries.[27] In effect, and as regards al-Andalus in particular, not only was the influence of the peninsula's own special version of classical Islamic art evident in that created for the various party kings and their subjects but, in addition, there was the even greater influence of the versions created in Egypt and North Africa. These latter sources were particularly influential during the period under discussion here since trade as well as family connections kept the petty kings in close contact with the ruling houses on the southern coast of the Mediterranean.

The provincial centre of Cuenca continued producing handsome and decorative carved ivory objects after the royal workshops of Cordoba and the palace precincts of Madinat al-Zahra ceased the manufacture of these luxury containers during the decline of the Umayyad dynasty. The casket [453], made under the aegis of the Taifa kings of Toledo, illustrates very clearly the influence of the earlier caliphal artistic style; however, the designs have become flatter and more repetitive [145].[28]

The diminutive gilded silver perfume flask decorated with niello inlay [454], on the other hand, shows not only local influences but those from outside the peninsula as

456. Stone lions. Datable to the third quarter of eleventh century. In situ, Alhambra, Granada

well.[29] Its ornamentation of a bold, symmetrical, arabesque design betrays a dependence on both the Late Antique and Sasanian heritage of early Islamic art and reminds us of the adaptation of this design on Ifriqiyan ceiling beams [450] and on contemporary Fatimid door panels.[30] The way in which the leaves themselves are decorated is also reminiscent of contemporary Ifriqiyan and Egyptian conventions. Comparisons of this detail on the flask with that on the Qayrawan *maqsura* [449] and on the contemporary casket made for the Fatimid vizier Sadaqa ibn Yusuf [339] are particularly striking.

The basin [455], which probably functioned as a fountain and is known as the Pila de Jativa, also seems to betray a strong Fatimid influence, especially in the realism conveyed in some of the vignettes in the decorative band completely encircling the object as well as in certain of the motifs themselves.[31] Although figural iconography is not uncommon in medieval Spain especially on the Umayyad ivory boxes, highly informal poses which enjoyed great currency in Egypt have been substituted for the hieratic representations more usual in al-Andalus.

The Zirids of Granada, considered the wealthiest of all the *muluk al-tawa'if* and closely related to rulers in Ifriqiya and the central Maghrib, were responsible for the twelve stone lions that now lend their name to the Patio de los Leones in the Alhambra [456] and those at the edge of the Partal Pool in the same palace complex. Presumably made for the Palace of Yusuf ibn Naghralla, minister of the Zirid prince Badis (r. 1037–76), these felines must originally have been used in much the same way as those made for a Hammadid palace in contemporary Bougie. The latter is described in two different medieval poems as having a pool bordered by marble crouching lions with water streaming from their mouths back into the basin.[32] We have already seen the important role played by large basins of water in the architecture of both the eastern and western Umayyad caliphates, the Umayyad amirate as well as Aghlabid Ifriqiya. This fashion continued in Fatimid and Zirid Ifriqiya and in both Hammadid capitals. Although a number of copper-alloy fountainheads in the form of quadrupeds have survived [150], very few are extant in stone.[33]

The succeeding dynasties in North Africa and al-Andalus, namely the Almoravids and the Almohads, despite their rather puritanical beginnings soon became renowned for the brilliance of their courts, where some of the most original intellects of the day found a welcome and where the taste for luxury stimulated craftsmen to new peaks of achievement. Like many of the *muluk al-tawa'if*, both of

457. *Minbar* of bone and various species of wood from the Kutubiyya Mosque, Marrakesh, begun 532/1137, 3.86 × 3.46 × 0.90 m. Badiʿ Palace, Marrakesh

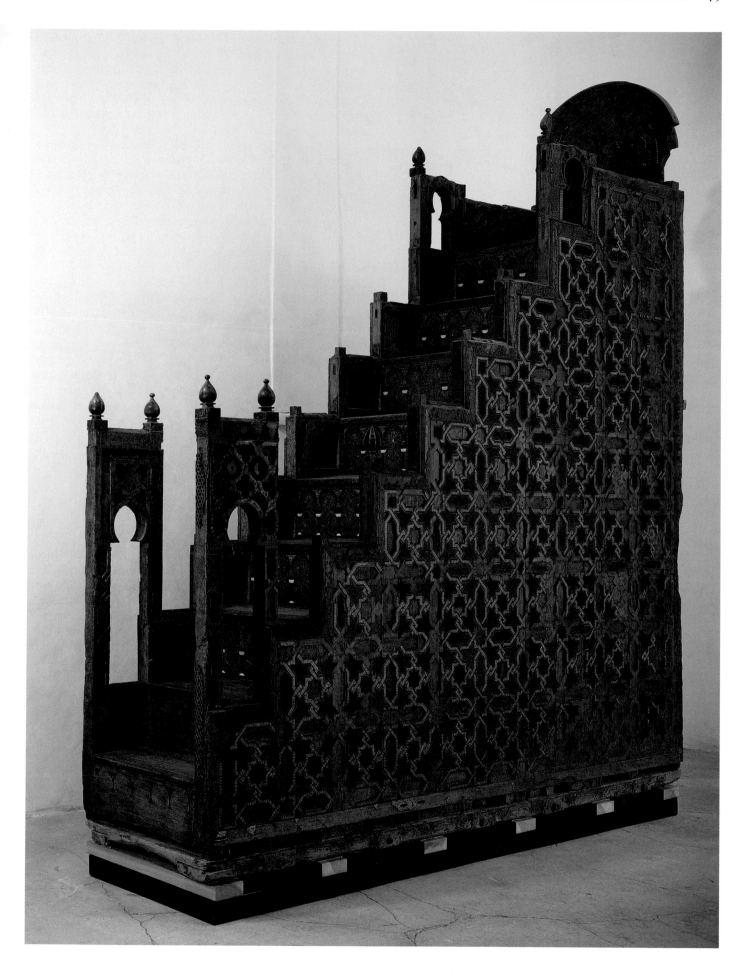

458. Silk and gilt membrane fragment, 45 × 50 cm. Museum of Fine Arts, Boston

these ruling families were Berber; and in fact, this entire chapter is devoted to a large extent to the art created under the aegis of members of this North African group between *c*.1000 and 1250.

Owing to a sequence of outstanding dated or datable objects, it is possible to follow in detail the evolution of carved as well as carved and inlaid wooden *minbar*s made during the rule of these two Berber dynasties.[34] Following common Maghribi practice, all of these *minbar*s are on wheels so that they can be brought out into the mosque on Fridays and moved into a special storage chamber for the rest of the week.[35]

The earliest, in the Great Mosque of Algiers, was finished in 1097. Its composition is similar to that of the much earlier *minbar* in the Great Mosque of Qayrawan [143] and like the latter is ornamented solely with carved decoration. However, the motifs, though also vegetal and geometric, are more unified and subtle.[36]

The *minbar* from the Kutubiyya Mosque in Marrakesh [457], begun forty years later, is the next in the chronological and evolutionary sequence of these Maghribi pulpits; it is also the most illustrious and by far the finest of the extant group.[37] According to one of its inscriptions, this masterpiece was begun in 1137 during the reign of the Almoravid ruler ʿAli ibn Yusuf (*r.* 1106–43) and it was made in Cordoba for the congregational mosque in Marrakesh, the dynasty's capital. This piece of information is especially valuable because the fabled *minbar* of the Great Mosque of Cordoba, commissioned by the Spanish Umayyad caliph al-Hakam II (*r.* 961–76), is no longer extant. We know from contemporary texts that the latter pulpit was decorated with marquetry, making it the earliest object of its type known to have been so adorned.[38] Such polychromy, composed of bone and various species of wood, is found on that from the Kutubiyya Mosque as well, forming a myriad of designs and motifs. It is utilized for the strapwork outlining the geomet-

ric pattern, on the stair risers and frames, and on the backrest. In addition, wooden panels intricately carved with a delicate vegetal design are inlaid between the strapwork outlining the infinite repeat pattern, engendered by a series of precisely located eight-pointed stars, on the triangular sides of the *minbar*. All the components of this staggeringly complex composition are beautifully balanced.

By contrast, the only slightly later Almoravid pulpit in the Qarawiyyin Mosque in Fez (completed in 1144) exhibits an infinite repeat pattern which is less spirited than that made for the congregational mosque in Marrakesh, and the marquetry and the carving of the polygonal inlaid panels is less intricate.[39] In the closely related *minbar* of the mosque of the Kasbah in Marrakesh, ordered between 1189 and 1195 by the Almohad Abu Yusuf Yaʿqub al-Mansur, the interlaced geometric configurations have been developed on a larger scale but in a smaller area, creating a heavier appearance.[40] Marquetry is used both for the geometric bands and as part of the filling patterns, so that the total effect is extremely sumptuous. Under the later Almohads this style became less inspired, as can be seen in the *minbar* of the Mosque of the Andalusians in Fez (1203–09),[41] which is devoid of marquetry and has less delicately carved panels. However, a portal – a feature apparently given up after the 1097 *minbar* in Algiers – has been here reintroduced and crowned with a scalloped horseshoe arch on slender columns, which gives the *minbar* a more ceremonial appearance.

459. Detail of chasuble composed of silk fragments. Datable between 1107 and 1143. About 1.25 × 5 m. Parochial Church Quintanaortuño near Burgos

Given the excellence of the craftsmanship found on these objects executed for religious buildings, it can only be assumed that the woodwork executed for use in secular settings in the western Islamic lands during the medieval period was equally fine.

Several groups of Almoravid and Almohad woven silk textiles, which were much appreciated not only at the Muslim courts themselves but also throughout Europe, have survived, largely because they were used for Christian clerical vestments and for wrapping the relics of saints. According to the business records found in the Cairo Geniza, al-Andalus under the aegis of these Berber dynasties was the leading textile-producing country, both for raw materials and for finished products. Almeria especially 'had the most extensive relations with the rest of the Muslim world', and 'it also had a station for Christian ships'. It boasted no fewer than eight hundred looms for the weaving of silk garments and precious cloaks, a thousand for splendid brocades, and the same number for various other types of textiles, some of which showed 'patterns of circles', while other designs were supposed to have originated in Baghdad or in Gurgan or Isfahan in Iran. Further Spanish textile centres were Murcia, Malaga, Granada, Baeza, and Seville.[42]

As regards those Andalusian fabrics with designs originating in Baghdad, a large number of them have come down to us. All of these share a distinctive technique known as brocaded lampas, a colour scheme consisting of orange-red and blue or green on an ivory ground supplemented with gold brocading and a decorative style consisting of a series of roundels bearing hieratic designs. Two among them serve to firmly anchor the design and its layout to the Abbasid capital and a third textile provides the dating for the group. In our earlier discussion of medieval Abbasid textile production, we mentioned two Spanish fabrics – a fragment in Leon and the silk [458] – both of which provide unequivocal evidence of direct influence from Baghdad on the textile art of al-Andalus, bearing as they do decorative motifs that incorporate an Arabic inscription in angular script that states they were made in that city when in fact they were woven in Spain, probably in Almeria.[43] *Vis-à-vis* the fabric illustrated here, each roundel contains a pair of addorsed sphinxes flanking a central tree and is bordered by a frame divided into four sections by four smaller medallions with the inscriptions, each with a crouching figure grasping the forelegs of a pair of griffins.[44] Were these textiles made as fakes of the actual Baghdad silks to trick the Andalusian consumer or were they rather simply a copy of the epitome in silk fabrics of the time? Although their message is clear, we may never know how such textiles were perceived in medieval al-Andalus, nor will we ever know their value.

The datable textile belonging to this group is a chasuble composed of silk fragments inscribed with the name of the Almoravid prince Ali ibn Yusuf ibn Tashufin (r. 1107–43), thus making it possible to date the entire group to the first half of the twelfth century.[45] This fabric, woven for the ruler who commissioned the splendid *minbar* from the Kutubiyya Mosque [457], is patterned with large, slightly elliptical, medallions each enclosing a pair of addorsed lions flanking a stylized tree [459]. Beneath the lions' feet is a pair of small animals; paired sphinxes flanking a plant form are arranged

460. Silk fragment, Ht. 34.9 cm. Cooper Hewitt Museum, New York

sequentially around the medallion frame between beaded borders. The interstices between the medallions are filled with bilaterally symmetrical palmettes.

Some silks in this group show variants of the basic hieratic design within a medallion. On one famous piece, for example, the composition is similar to those already discussed, but the central tree has been replaced by a frontal warrior figure, his arms wrapped around the necks of the flanking lions, which seem to dangle in the air as if he were strangling them.[46] The basic design found on all these Almoravid textiles must already have been known in France at the time of Philippe-Auguste (r. 1180–1223), for it provided the model for the painted ceiling in the crypt at the cathedral of Clermont.[47] As was previously mentioned, the manufacturing centre for these fabrics may well have been Almeria, which is known to have produced silks with circle patterns during the twelfth century.[48]

Probably from another centre are the tapestry-woven silks of a second, less hieratic group, where rows of small medallions usually frame musicians, drinkers, or other courtly figures.[49] Particularly striking is the 'drinking ladies' silk [460].[50] In each medallion two female figures face each other in profile, one holding out a goblet, the other a bottle.[51] In

461. Silk and gilt parchment banner. Datable between 1212 and 1250, 330 × 220 cm. Patrimonio Nacional, Museo de Telas Medievales, Monasterio de Santa María la Real de Huelgas, Burgos

that produced in Egypt and Syria under the Fatimids. The pair of earrings [462] betrays a total dependence on the earlier, eleventh-century, examples not only in the construction itself but also in the decoration of these items of adornment.[53] However, the primacy as regards the materials used is reversed. The predominant feature of the prototypes is the goldwork of filigree and granulation, for which the Fatimids were justly famous (see Chapter 6, pp. 210, 211 and [340]), with the cloisonné cup (in one case adorned with paired birds) serving to fill only a small area on one face. The Almohad craftsman, on the other hand, employed the goldwork simply as a very narrow and simple frame that encircles the four faces, each of which is set with a large cloisonné plaque bearing the first two verses of *sura* 112 of the Qur'an executed in a cursive script that is characteristically Maghribi. This change in emphasis was also noted in the weavers' art and is characteristic of much of the artistic production under this reforming Berber dynasty. While the Alhomads gradually succumbed to the luxury arts of their predecessors in the Maghrib, their austerity tempered the extent to which they embraced all aspects of this longstanding royal tradition. The late twelfth-century ornaments [463] are, likewise, both adoptive and adaptive. The technical and stylistic indebtedness to the art of Fatimid goldsmiths is clearly seen here as well, but the Almohad craftsmen have simplified the construction by forming the ornaments of gold sheets decorated with filigree instead of laboriously fashioning them solely with wire. The prototype for the configuration of the earrings is to be found in those manufactured in Arab Crete before the Byzantine conquest

462. Pair of gold earrings set with cloisonné enamels, Ht. with earwires 4.8 cm. Al-Sabah Collection, Kuwait

the relative spontaneity of the composition and attention to such details as fold patterns and hairstyles, these scenes seem to suggest the freedom of manuscript painting adapted to the more rigid technical requirements of weaving.

Ibn Khaldun relates that the earliest Almohad rulers did not adopt the *tiraz* institution, eschewing silk and gold stuffs so as to follow the simple life taught by the founder of the dynasty, Ibn Tumart. It was only at the end of their rule that they reinstated the institution.[52] Their textiles, while very sumptuous and of high quality, incorporate little figural decoration. The banner [461], datable to the years 1212–50, is therefore more characteristic of Almohad weaving than the 'drinking ladies' silk just discussed – being adorned solely with geometric, vegetal, and calligraphic decoration. The style of script seen here is very characteristic not only for Almohad textiles but for other arts of the period as well.

The same cursive script can be found also decorating the exceedingly rare products of the jewellers' art crafted under the aegis of this dynasty. As was the case during the *muluk al-tawa'if* period [454], work in fine metal under the Almohads (and presumably under the Almoravids as well although nothing from this category of objects can as yet be attributed to the latter dynasty) continues the tradition of

in 961. Both the Andalusian and Cretan examples share the same semicircular profile, the triangular protrusions from the outer edge of each ornament and Arabic inscriptions. However, the scripts are different – the Almohad pair substitutes the by now familiar cursive Maghribi script for the angular type seen in the earlier examples.[54]

Judging from the extant copper-alloy objects from the Almoravid and Almohad periods, the craftsmanship in this metal was equally as fine as that in gold. The door fittings [464] from the Qarawiyyin Mosque in Fez were part of a group that originally completely covered the plain wooden leaves of the door called Bab Jana'iz. The layout of these fittings, consisting of an infinite repeat pattern outlined with strapwork and highlighted with calligraphic and arabesque designs, is reminiscent of that on the *minbar* from the Kutubiyya Mosque [457] commissioned by the same ruler, ʿAli ibn Yusuf, and on a number of pulpits from the succeeding Almohad Dynasty.

The fashion for such door fittings continued under the latter house and, as was the case on the earlier examples, the leaves were opened and closed with the aid of handsome ring handles such as that seen here [465],[55] which is still gracing its original door[56] on the Almohad Mosque in Seville. It is cast in the form of a massive arabesque enclosed within a contoured band bearing a cursive inscription.

Earlier in this chapter we discussed the production of lustre-painted ceramics, especially tiles, at Qalʿat Bani Hammad in present-day Algeria.[57] From here and the subsequent Hammadid capital, Bougie, the technique spread to al-Andalus. A group of more than sixty bowls so decorated

464. Copper-alloy door fittings from the Qarawiyyin Mosque, Fez. Datable to 531/1136, Ht. 75 cm. Musée du Batha, Fez

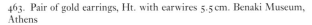

463. Pair of gold earrings, Ht. with earwires 5.5 cm. Benaki Museum, Athens

465. Copper-alloy ring handle of the Puerta del Perdón in the Almohad Mosque, Seville. Datable between 1172 and 1176

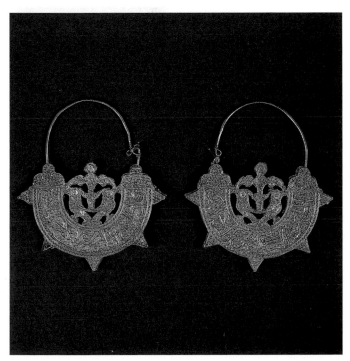

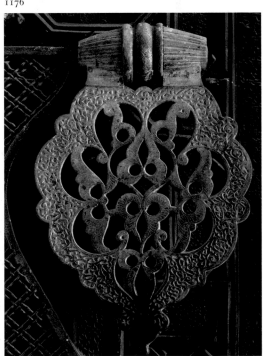

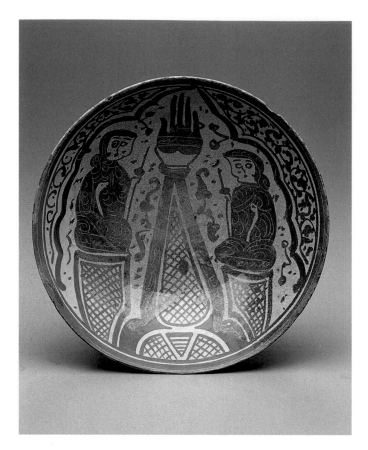

466. Lustre-painted bowl, D. 23 cm. Detroit Institute of Arts, Detroit

467. Glaze-painted fragmentary bowl, D. 25.5 cm. Mertola Museum, Mertola, Portugal

468. Two glaze-painted tiles. Each tile: 57 × 33.5 × 3 cm. Badiʿ Palace, Marrakesh

and often highlighted with incised details has been attributed to Malaga [466].[58]

The dating for this earliest Andalusian lustre-painted pottery is provided by examples of this group employed as *bacini* in the façades of Romanesque churches and/or campaniles in Italy, the dates of which range from 1063 until the third quarter of the twelfth century. During this approximately one-hundred-year period, Malaga was under the domination first of the Zirids ruling from Granada and later of the Almoravids. This tradition was ultimately to give rise to the so-called Alhambra vases and also to effect a strong influence on other later Spanish lustre-painted pottery.[59]

Another type of pottery that was in vogue in the western Islamic lands during the late eleventh century employs a decorative technique that seems to have evolved first in the Maghrib and gradually spread eastward to Anatolia and Iran, where it was to enjoy great popularity. This ware, known as *cuerda seca* (burnt cord) after its method of decoration,[60] employs many motifs common on contemporary lustre-painted ware [467] and is also datable by means of *bacini*.[61] Before the various designs were painted with coloured glazes, each area to receive glaze was circumscribed by a thin line of a greasy substance mixed with manganese, which prevented the different colours from running together. When fired, the grease burned away and left a dark matte line outlining the motifs. This technique was also used for architectural decoration [468]. These two unique large red earthenware tiles, covered with an opaque green-ish-white glaze and decorated with a bold angular script executed in aubergine glaze, must have formed part of a striking frieze in the unknown building for which they were commissioned.[62]

As is the case in other parts of the Islamic world, the production of luxury lustre-painted ware did not exist at all in certain areas of the western Islamic lands or was often confined to only one manufacturing centre in a given country – the technique being a closely guarded secret passed down from father to son or spreading to another country only with the emigration of artisans seeking work in more prosperous capitals. We have noted also that in other areas this technique was copied using less expensive and time-consuming methods [183, 184]. Al-Andalus is no exception to these

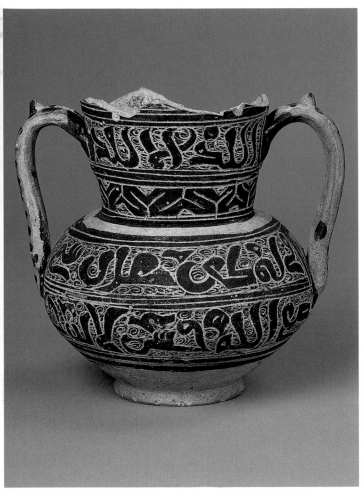

469. Painted and incised earthenware jar, H. 14 cm. Ayuntamiento de Valencia

470. Moulded, incised, and green-glazed wellhead. Dated 586/1190, H. 52.5 cm. Musée Ethnographique, Tetouan, Morocco

established rules. In Murcia, during the Almohad period, a type of sgraffito pottery was produced that appears to imitate many characteristics of the Malaga lustre-painted group [469].[63] Also typical of this period is a type of green glazed moulded and/or stamped pottery that was utilized for many different functions, including wellheads [470].[64]

THE ART OF THE BOOK

The Qur'an [471] known as the *mashaf al-hadina* was copied, illuminated, and bound in Qayrawan in 1020 by 'Ali ibn Ahmad al-Warraq for Fatima, the nurse (*al-hadina*) of the Zirid ruler Badis ibn al-Mansur. This monumental Qur'an was written in a variety of the New Style script peculiar to the western Islamic lands[65] that was executed in this *mashaf* in a particularly masterful, artistic, bold, and confident manner. It is surely manuscripts such as this which contributed to the reputation Qayrawan (a renowned theological centre) enjoyed for Qur'an production – its manuscripts being widely exported and carried throughout the Islamic world. That the interest in the production of exquisite manuscripts was particularly keen in this Ifriqiyan city at this time is substantiated by the survival of a treatise written by Badis's son,

the amir al-Mu'izz, a royal patron *par excellence* and one who, according to Ibn Khaldun as we have seen above, enjoyed the richest and most flourishing reign ever seen in the Maghrib. From this powerful and high-minded ruler we learn the steps in the manufacture of paper and about the art of bookbinding, the merits of calligraphy, the importance of good pens, the recipes for inks and their colours, and the components of glues used for adhering gold and silver to the leaves.[66] Unlike contemporary Qur'an manuscripts produced in the central or eastern Islamic lands, most of those calligraphed in the Maghrib during the early Medieval period, including the two codices being discussed here, were written on parchment.

The small, square Qur'an [472] was calligraphed and illuminated in Cordoba only six years after the work on the magnificent Kutubiyya *minbar* [457] was begun in the same Andalusian city.[67] The masterful combination of the geometric interlace pattern and the vegetal designs on the frontispiece from this codex bears close comparison with that on the lower arched entrance frames of the pulpit, perhaps indicating a vogue for such decoration in both Cordoba and the Almoravid capital city of Marrakesh at this time. Unfortunately, very few dated or datable objects in any

471. Leaf from a Qur'an. Dated 410/1020, H. 45.5 cm; W. 31 cm. Musée des Arts Islamiques de Kairouan

472. Frontispiece of a Qur'an manuscript. Dated 538/1143, 18 × 18.8 cm. Istanbul University Library

473. Leather bookbinding. Dated 654/1256. British Library, London

medium have survived from this period on which such a hypothesis could be tested.

The adoption and successful adaptation of this combination of designs in the subsequent period can be seen very clearly on the binding [473],[68] which covers one of five extant volumes of a ten-volume Qur'an calligraphed in Marrakesh in 1256 by the penultimate Almohad ruler, 'Umar al-Murtada. The artisan who created this beautiful cover was the inheritor of a rich leatherworking tradition in the Maghrib, one which we know for certain enjoyed royal patronage under both the Umayyads in al-Andalus and the Zirids in Ifriqiya (see Chapter 3, p. 100, above). The art of bookbinding reached great heights under the aegis of the Almohads, and here we see the fashion moving from the square format so popular under the Almoravids, their predecessors, to one clearly oriented vertically. The strapwork delineating the infinite repetition pattern is reserved against the intricate and densely tooled background patterns. Most importantly, however, this cover and those of the other

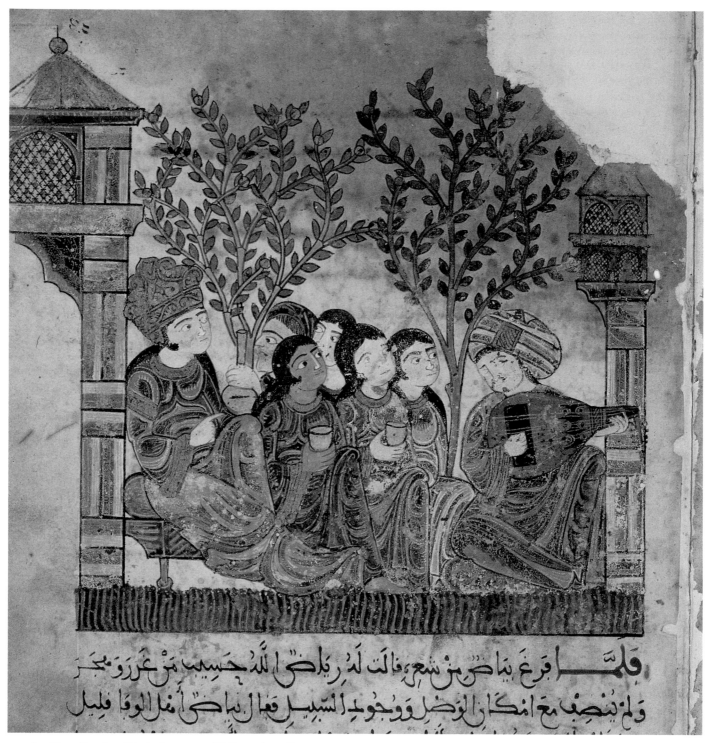

474. Leaf from *Bayad wa-Riyad*, 28.2 × 20 cm. Biblioteca Apostolica
Vaticana, Rome

extant volumes of this Qur'an are among the earliest surviving examples of gold tooling.[69] Once this technique reached Europe in the middle of the fifteenth century, it was to enjoy great popularity there.

The only illustrated manuscript known from the medieval Maghrib is a copy of the love story *Bayad wa-Riyad*.[70] Unfortunately, as the beginning and end of the text are missing, there is no clue to the precise date or place of origin of this codex. Among the fourteen surviving miniatures are several in which a garden party with musicians is depicted. In one, an old lady in profile holding up a bottle to pour is nearly identical to one of the 'drinking' ladies on the textile [460], and any of the young handmaidens with goblets could have served as a model for the other [474]. The similarities are further underscored by the shape of the platforms in miniature and textile, the concentric arrangements

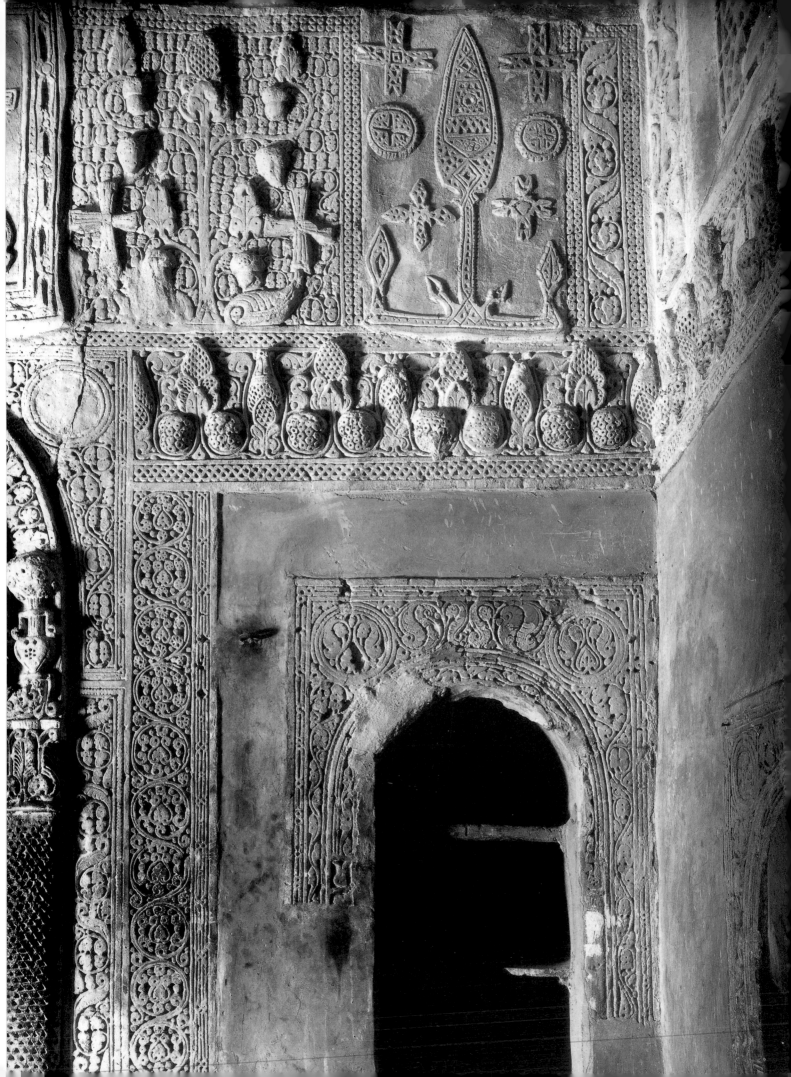

Islamic Art and non-Muslims

One of the striking features of the medieval Islamic civilization surveyed in this book is that during its formative as well as its more mature phase it incorporated, without destroying, many different cultures which continued to maintain their religious and social practices together with their art and material culture. Another striking feature is that, alone among the major cultures of pre-Columbian times, that of the Muslim world abutted all known major cultural areas of Europe, Africa, and Asia, except for Japan's. The Islamic world was, therefore, at the hub of possible exchanges. Mostly known in trade, these also involved ideas, scientific, mathematical, and medical knowledge, legends and fantastic lore, myths of all sorts, religious beliefs and practices, as well as, of course, artistic forms and techniques. The rhythm of these exchanges varied considerably from period to period and area to area, especially in dealing with the arts. Sometimes very visible, even if short-lived, as in Norman Sicily, at other times, as in Spain, subtly mixed with literature and music, or, as with China, only recently beginning to be recognized, the story of these artistic exchanges and contacts still remains to be fully explored. All we can provide here is a few concrete signposts and examples and a few observations and speculations about a process in which freak accidents of contacts between cultures could be as common as consistent patterns of relationships. While serving in part as a conclusion to six hundred years of artistic development over a vast area, this chapter is also an invitation to further research much more than a reflection on, or a summary of, work already done.

Christian, Jewish, Zoroastrian, and even Buddhist[1] communities within the Islamic world maintained traditions, especially in the religious sphere, that had developed long before the advent of Islam. However, most of the time these communities utilized for secular purposes the arts of the object and the urban spaces attributed to or sponsored by the ruling Muslim majority. Muslim travellers usually mention the presence of such non-Muslim communities, which during the period covered by this volume constituted a significant percentage of the total population. Apparelling differences possibly existed or were suddenly imposed at times of persecution,[2] but, on the whole, except for the architecture of the mosque and of other religious buildings or the decoration of Qur'anic manuscripts, most expressions and developments of Islamic art were not socially or religiously restrictive as to meaning or form. Consciously or not, wilfully or not, secular objects were made and buildings constructed for a rich and complex society, not for a specifically defined group and these affected, at times even reflected, a far richer mosaic of different people living together than existed in any of the neighbouring cultures. Thus, it is not surprising that the documents of the Cairo Geniza, those thousands of written fragments preserved in a synagogue in that city, have, quite properly, been used to define not only the material culture of the Jewish community in the Mediterranean basin between c.1000 and 1250 but that of a predominantly Muslim society in the same area and during the same period as well.

The presence of obviously Islamic motifs in many monuments of medieval Christian art, both east and west, has long been recognized. An older generation of scholars[3] considered this presence in terms of 'influences' or of 'impacts', identifying individual elements as Islamic (or 'oriental', as many of them had put it) and then seeking to explain their appearance in a non-Islamic context. But, as the concept of influence, even that of impact, is elusive and almost impossible to pin down in its actual operation, we have preferred to think in the somewhat broader terms of the presence of an awareness by other cultures of techniques, ideas, and motifs invented or developed in the Islamic world. Material culture and technology were shared by all within the Muslim realm and could be shared by outsiders as well.

There were a number of reasons for the presence of this awareness of Islamic art as regards the non-Muslim communities within the Islamic world as well as those on the frontiers of that world. One of the principal ones was the overwhelmingly secular character of an Islamic art which was not, for the most part, socially or religiously restrictive. Another was the particularly high level of technical competence exhibited by this art coupled with the cultural prestige enjoyed by Islamic society, at least until the artistic and cultural explosion in Romanesque Europe. A third reason may well have been that so much of Islamic art consisted of objects which could be moved from one locality to the other, not of works tied to a single place. One of the more unusual examples of this was the fact that the dowries of Jewish brides profited considerably from the sack of the Fatimid treasures in Cairo in 1068 and 1069. We know that, following the sack, 'the marketplaces and bazaars of Egypt were filled with commodities from the palace';[4] thus these items simply changed hands in the suq. Finally, it is worth recalling that the same craftsmen and artists, often belonging themselves to different religious communities, were employed by all members of the Islamic commonwealth.

One illustration of the long-known preservation and maintenance of other cultures and their arts under the umbrella of Islam is the Coptic art of Christian Egypt, which has customarily been considered as a coherent body of work within the Muslim world but outside of Islamic art.[5] In reality, matters are not so simple. Were it not for the incorporation of several crosses within some of its designs, the stucco decoration dating from 913–14 in a Coptic monastery in the Wadi al-Natrun [475] could have been found in any number of roughly contemporary Islamic buildings [27, 81].[6] The doors of Coptic churches or monas-

475. Stucco decoration, datable to 913–14. *In situ*, Church of al-ʿAdra, Dayr al-Suriani, Wadi al-Natrun, Egypt

teries [476] as well as other architectural elements executed in wood are, likewise, almost indistinguishable from such items commissioned by Muslims [313, 314].[7] The earliest dated Arabic manuscript in angular, so-called Kufic, script (901) is a gospel book on Mt Sinai, probably from Egypt.[8] In the twelfth and thirteenth centuries, Coptic Gospel books, one dated 1179–80 and another dated 1249–50 [477], have illustrations with a lively spirit comparable to that of the contemporary illustrations of the *Maqamat* [433][9] and, as is the case in a number of the paintings in the manuscript in the Institut Catholique such as that seen here, were it not for the text of the codex, these illustrations could just as easily have adorned an Arab Muslim text. A recently restored chapel of St Anthony in Luxor exhibits a painted ceiling of the twelfth or thirteenth centuries bearing decorative designs that are indistinguishable from those found on contemporary Muslim objects. Lustre-painted pottery bowls manufactured in Egypt during the Fatimid period incorporate Christian themes as their principal decoration [478].[10] These, also, can be identified as being made for the Coptic

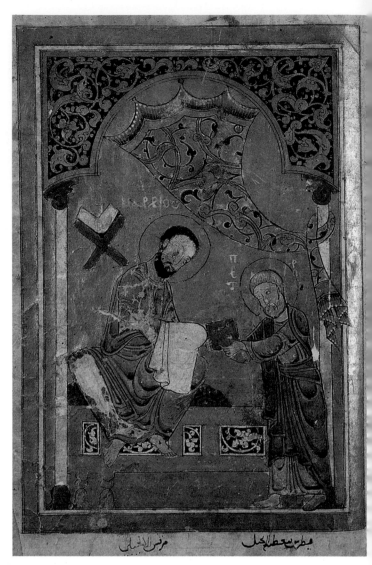

477. Leaf from Gospel codex. Dated 1249–50, height: 24 cm. Institut Catholique, Paris

478. Lustre-painted fragment. H.7.2 cm; W. 11.3 cm. Museum of Islamic Art, Cairo

476. Detail of carved wooden doors, datable between 1070 and 1100. *In situ*, Church of Anba Bishoi, Dayr Anba Bishoi, Wadi al-Natrun, Egypt

479. Mar Banham church, Iraq, Mosul area. Entrance. Mid-13th century.

as opposed to the Muslim community only because of the subject depicted. Everything else about these lustre-painted pottery objects is indistinguishable from those made for the non-Christian population of the country [321].

Fewer examples remain of a Syrian Christian art. But, during the prosperous twelfth and thirteenth centuries, new churches and monasteries were built in the Jazira, many, like the one in Mar Banham not far from Mosul in present-day Iraq, with elaborate decorated portals quite similar to those of Muslim monuments of the same area [479].[11] Illuminated and illustrated manuscripts from this period include many with ornamentation very similar to that in Arabic manuscripts with miniatures in which Islamic and Byzantine features are curiously mixed together, as in this painting depicting Christ's entry into Jerusalem from a *Lectionary of the Gospels* executed in the Monastery of Mar Mattai near Mosul in 1219–20 [480].[12] In recent years the discovery in Rusafa – the shrine city of St Sergius in the northern Syrian steppe – of silver vessels with Christian subjects and Syriac inscriptions and a lamp or incense burner decorated with sphinxes and several different varieties of quadrupeds and birds has drawn attention to a number of long-known silver objects, some with Christian subjects, made within the orbit of the Muslim world.[13] One such object is the footed bowl [481], presumably from Cilicia.

Within the Jewish community as early as the ninth century, manuscripts were written with calligraphy forming decorative designs or with illuminations reminiscent of con-

temporary works of Islamic art. One [482], executed in Fustat in 1008 or 1010, is from the earliest extant complete and dated Bible.[14] The wooden elements commissioned for Jewish buildings, like those for Christian edifices mentioned above, are, except for the incorporation of Hebrew inscriptions, also indistinguishable from those ordered for a Muslim context.[15]

In the central and western Islamic lands, a single motif, the subject matter of a manuscript, or simply the context might be the only indication as to whether an object, codex, or architectural monument was executed for the Muslim, Christian, or Jewish community. In Iran and Central Asia, whose older religions would soon disappear, traditional artistic practices prevailed for a considerably longer period of time. A small stylistic variant or a datable inscription may be the only clue to the production of an object or building after the Arab conquest, the technique of its making or the character of its expression suggesting an earlier date. Southwestern Iran, in particular, witnessed a resurgence of Zoroastrianism during the first centuries of Muslim rule, and it has been proposed, with considerable force of persuasion, that what had always been considered to be a Sasanian pre-Islamic palace in Sarvistan was in fact a tenth-century Zoroastrian firetemple.[16] Furthermore and as has previously been discussed, the existence of objects, mostly in silver, from the wide Iranian world which bear a relationship to Sasanian or Soghdian works in the same medium without being quite like them has given rise to the

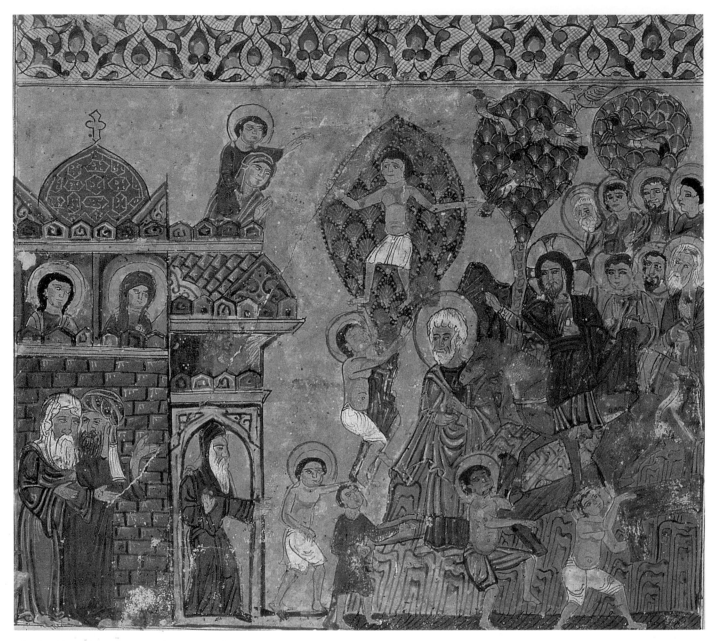

480. Leaf from Lectionary of the Gospels. Dated 1219–20, 22 × 25 cm.
Biblioteca Apostolica, Vatican

historically rather absurd category of 'post-Sasanian art'.[17] While some of these objects are rather mediocre descendants of the fine art of metalworking practised around the Sasanian court or in the Soghdian principalities of Central Asia, quite a few are of high artistic merit. Their adaptations of the earlier styles or iconography sometimes permit attributions to some of the various dynasties that ruled Iran in early Islamic times. The bowl [483] belonged to, and perhaps was made for, a late eighth-century prince of Tabaristan.[18]

Let us simply highlight several of the multitude of artistic exchanges and contacts effected during the period covered here between the Islamic world and the major cultural areas adjoining it.

At the present state of our knowledge we know more about the importance of the Central Asian frontier with China, Tibet, or various Turkic empires in connection with trade and the movement of peoples than regarding cultural and artistic contacts. One of the reasons for this is that the archeological exploration of Mongolian and Central Asian sites in China is still in its infancy. However, the influence of Iranian metalwork on some earthenware vessels (of the *sancai* and also the white-ware variety) produced during the Tang dynasty (618–907) has been recognised for some time, and the great importance of the medium of textile weaving for cultural and artistic contacts on this eastern frontier is slowly beginning to come into focus as well.[19] In both of these instances it was along the Silk Route that these exotic goods were traded eastwards – and westwards.

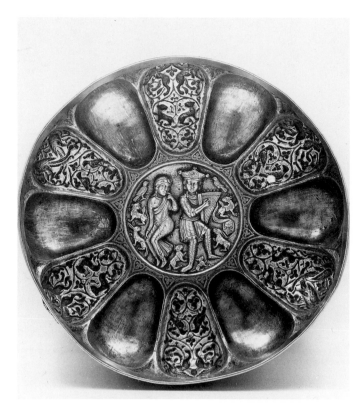

481. Gilded silver footed bowl with niello inlay. D. 27 cm. The Hermitage Museum, St Petersburg

482. Folio from a Bible. Dated 1008 or 1010, 33.8 × 29.8 cm. St Petersburg Public Library, St Petersburg

483. Silver bowl with niello inlay. Datable to the late 8th century, D. 23.5 cm. Iran Bastan Museum, Tehran

Nordic trade from the Caspian Sea to central Russian lands and to Scandinavia existed no doubt, at least in the ninth and tenth centuries,[20] but the main Muslim settlements on the Volga are from later times. The presence of hoards of coins from Islamic lands in Scandinavia has been known for a long time, as have the Islamic textiles excavated at Vyborg in Sweden.[21] It is also possible, although more speculative, to compare the abstract ornamental patterns of early medieval northern European art with those of the Abbasid or Fatimid periods, but it is more difficult to posit cultural connections.

The Caucasian/Anatolian frontier was quite different, with early Muslim settlements along the Caspian Sea as well as more or less independent Armenian and Georgian kingdoms. The former was particularly important in being at times under the political domination of Muslim caliphs, while maintaining its involvement in the politics of the Byzantine empire. It expanded all the way to the Mediterranean during the latter part of our period. Most importantly for our purposes, however, is the fact that it had been a major centre of artistic endeavour since the fifth century, and its architectural technology was used both by the Fatimids of Egypt in the second half of the eleventh century and by the *beyliks* of Anatolia throughout the twelfth and thirteenth centuries. In fact, the whole of Anatolia was, in many ways and for many centuries, a frontier culture in which Christian and Muslim communities lived together in

peace and in war, with many languages spoken, and with many cults from ancient times preserved in the new religions.

Some very remarkable and unusual monuments illustrate this very particular spirit of the Caucasian/Anatolian frontier of Islam. On the small island of Akhtamar located in Lake Van in eastern Anatolia, the Armenian king Gagik (r. 908–36) built a palace known only from texts and a church (datable between 915 and 921) which has been preserved. The façade of the church bears a representation of king Gagik himself dressed in rich clothes [484] which could well have come from the Islamic world [94]. But, more remarkably, it is also ornamented with a frieze of relief sculptures showing a prince in contemporary Arab attire surrounded by scenes of revelry and hunting [485]; these representations are clearly comparable in subject, if not necessarily in form, to Early Islamic images [139, 145] and to the whole iconography of pastime that became associated with the Muslim world in general. It is possible to detect an awareness of Islamic ornamental motifs and compositions in the beautifully carved stone funerary slabs (known as *khatchk'ars*) which appear in the late ninth century and in the illuminations of some manuscripts, although their illustrations derive from different sources. In the thirteenth century Armenian architecture developed its own adaptation of the Islamic *muqarnas*.[22]

The arts of medieval Georgia seem to have been less affected by the techniques and themes of Islamic art, and even its enamelled metal creations seem to have been largely independent of Islamic models. There are, however, several striking exceptions. In the realm of architecture, an eleventh-century Georgian monastery not far from Antioch is adorned with stone decoration resembling that of Umayyad palaces and, very recently, Islamic features have been detected in a medieval palace complex in Abhazia.[23] And then there is the seemingly unique case of the Innsbruck plate [486]. A small object made for the Artuqid ruler Rukn al-Dawla Abu Sulayman Dawud (r. 1114–42), this shallow two-handled copper vessel is decorated on both the obverse and the reverse with cloisonné enamel. This decoration includes a representation of the ascension of Alexander the Great as well as depictions of court entertainers such as wrestlers, acrobats, dancers, musicians, and a variety of birds and real and imaginary animals. It bears inscriptions in both Arabic and Persian, the latter being quite poorly written. Made for a royal Muslim patron, this object, which is far more interesting than beautiful, was long considered to be a work of Islamic art. However, it is now believed to have been executed by a Georgian craftsman.[24] Islamic prototypes can likewise be recognized in the glazed pottery produced in this borderland. Technical as well as striking decorative parallels can be found between the 'splashed sgraffito ware' made in northern Syria during the medieval Islamic period and that unearthed during the excavation of the potters' quarter in medieval Tiflis, which the excavators date between the middle of the twelfth century and the 1230s when the area was destroyed during the Mongol invasion never to be restored again.[25]

Within this rapid overview of the Caucasian/Anatolian frontier, one must also mention the presence of Islamic

484. Detail of façade Church of the Holy Cross, Island of Akhtamar, Lake Van, datable between 915 and 921.

objects, motifs, techniques, and ideas in Byzantium itself as well as in the Balkans and Greece. There are details of paintings in Cappadocian churches which have clear parallels in early Islamic art, possibly through common Late Antique sources.[26] In much of Greece and in the Balkans, imitations of Arabic writing which have been called 'kufesque' by George C. Miles are frequent in architectural decoration and occasionally in the ornamentation of objects.[27] Glazed ceramic architectural decoration in both Constantinople and in Preslav, Bulgaria, appears to be the direct result of contact with the Islamic world, which utilized such ornamentation to its greatest advantage from the ninth century on.[28] Another example of an Islamic presence in Byzantine architecture occurred around 1200 when John Comnenus built in Constantinople a palace known as the Mouchroutas (a word derived from Syriac and meaning 'cone', probably a form of *muqarnas*). We are told that its ceiling was decorated with striking designs of all sorts, and the effect must have been similar to that of Iraqi or North African *muqarnas* domes of the late eleventh and twelfth centuries.[29] These multiple uses of Islamic motifs in Byzantine art are also well illustrated by a cup for which a Constantinopolitan craftsman invented a meaningless but almost plausible Arabic inscrip-

485. Detail of facade Church of the Holy Cross, Island of Akhtamar, Lake Van, datable between 915 and 921.

486. Two-handled enameled copper vessel. Datable between 1114 and 1142. Diameter: 26.5 cm. Tiroler Landesmuseum Ferdinandeum, Innsbruck

tion to accompany or set off an apparently equally meaningless but plausible gallery of Antique male figural types.[30] Thus it is that contemporary Islam and the classical past become part of the exotic 'other' to Byzantium.

Sicily, conquered by the Arabs by 902, was taken over by Norman knights around 1060, and the latter fostered during the twelfth century a truly original episode of medieval civilization in which, according to standard interpretations, the cultures of the Latin West, Greek Byzantium, and the Muslim Arabs existed in creative harmony, at least in so far as the arts were concerned. A more sophisticated recent view is that the forceful and imaginative Roger II (d. 1154) promoted his own ambitions by sponsoring not so much an eclectic mix of different traditions as a thoughtful combination of new artistic skills from all over the Mediterranean in order to demonstrate the legitimacy of his power.[31] However one is to appreciate the motives of Roger II and of his two immediate successors, there is no doubt that themes and techniques from the Islamic world were used in the composition of Sicilian palaces like the Cuba and especially the Ziza, both still extant in Palermo. The latter in particular has been well preserved and consists of several storeys arranged around a court-like open space with an elaborate

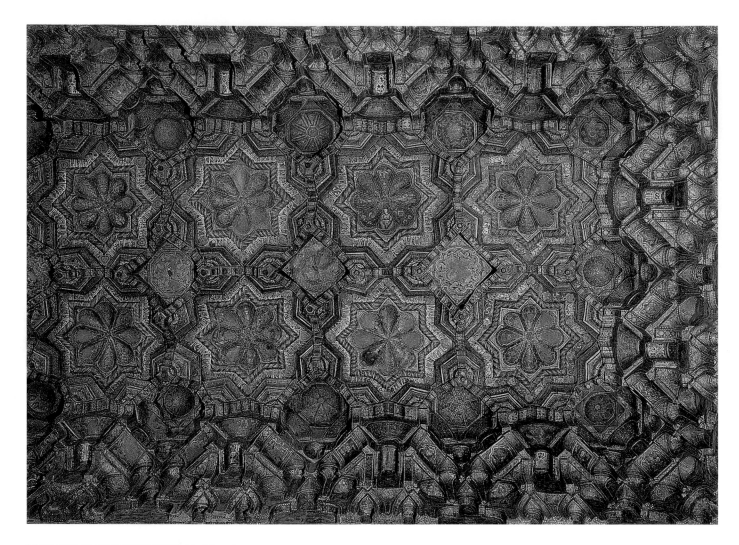

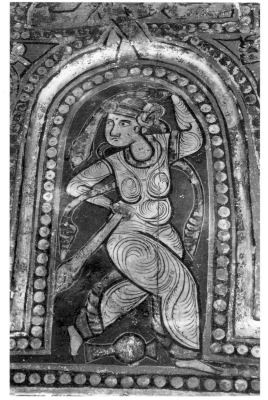

487. Painted wooden ceiling, datable to the middle of the 12th century. *in situ*, Cappella Palatina, Palermo

488, 489. Details of ceiling in Fig. 487

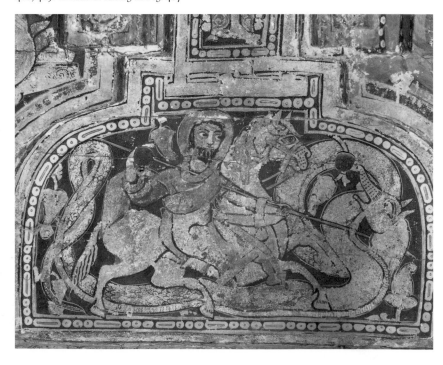

fountain. The *muqarnas* vaults of this principal room or area certainly copy or imitate those adorning somewhat earlier extant palaces in North Africa (above, pp. 189–90). The many traces of Norman gardens left in Sicily also betray an indebtedness to similar Islamic creations in North Africa and al-Andalus.[32] Small churches like S. Giovanni de Eremeti in Palermo have domes which vaguely look like those on Islamic mausolea; and, when the Norman prince Bohemond was returning from the Crusades, he had a mausoleum built in Bari which is quite Syrian.

But the two Norman works that most often come to mind when discussing Islamic art are the ceiling of the Cappella Palatina in Palermo founded by Roger II in 1140[33] and his mantle dated 1133–34.[34] The ceiling is the largest preserved *muqarnas* cover for a rectangular space [487], and the surfaces of the hundreds of units of which it is comprised are replete with paintings of all sorts of personages, animals, scenes from daily life, mythical subjects, inscriptions, and just plain vegetal ornament. The motifs bear at times a striking resemblance to Fatimid lustre-painted ceramics [488], and it is indeed possible that artists trained in Cairo or in North Africa were involved in the practical work of painting the ceiling.[35] But many other scenes [489] cannot as easily be fitted into a traditional Islamic idiom and their various styles still await full explanation. The most convincing interpretation of the ceiling is as a sort of heavenly canopy filled with good omens covering the ceremonial space of the Christian king.

As has been discussed earlier, the institution of the *tiraz* devoted to the manufacture of textiles was a royal prerogative in the Islamic world.[36] As such, it was adopted by Roger II, and the mantle [490] is the most outstanding production of the Norman looms and one of the most spectacular medieval textiles extant. Like its Islamic prototypes, it bears an angular Arabic inscription surrounding its entire outer edge containing the information that it was woven in the palace of Palermo in 1133–34. Its symmetrical design has close parallels in the Muslim world, while its semicircular configuration is purely western. Its subject matter of a lion restraining a camel has long been interpreted as a symbol of power, but may well be instead an evocation of cosmic good fortune for the ruler.

Although the ceiling and mantle provide intrinsic clues as to their non-Islamic origins, much of the carved woodwork produced in Sicily under the Normans would be equally at home in a Muslim or a Christian setting, as would the many painted ivory containers produced on the island.[37] The latter comment can also be made about another group of ivories, with deeply carved decoration, that was made on the Italian mainland. There is no question that the veritable encyclopedia of creatures popular at the time which is to be found decorating these oliphants, caskets, and writing case, attributed variously to Amalfi or to Venice [491], exhibits a style strongly reminiscent of that prevalent under the contemporary Fatimid dynasty [316, 317, 331, 343].[38]

In Spain, Arab and Berber Muslims ruled a territory with a primarily Christian population that maintained its cultural autonomy for centuries. Even before the beginning of the *reconquista* there were exchanges of motifs between Christians and Muslims. Effects of these exchanges can be seen in what is known as Mozarabic (from the Arabic *musta'rib* meaning 'arabicized') art, the art of Christians living under Muslim rule and, by extension, the art of independent Christian kingdoms in the north that used motifs

490. Silk mantle embroidered with gold thread and pearls. Dated 1133–34, diameter: 3 meters. Kunsthistorisches Museum, Vienna

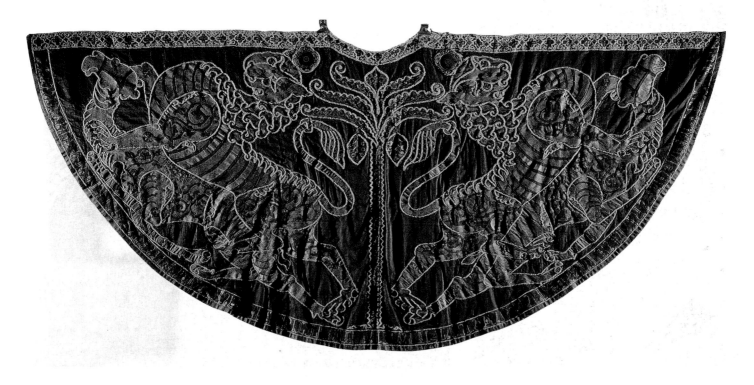

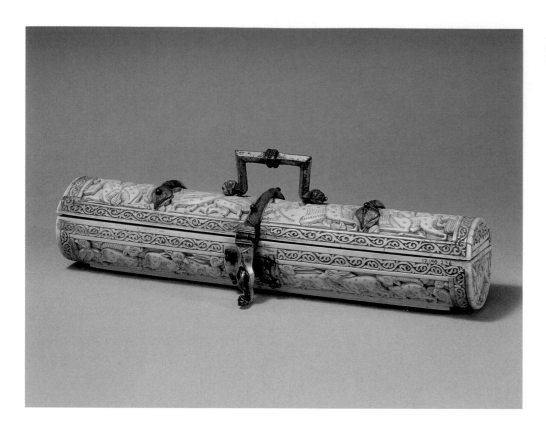

491. Carved ivory writing case. 24 × 4 cm. Metropolitan Museum of Art, New York

from the Muslim-ruled south. Interesting ideological explanations have been provided for this phenomenon which affected the architecture of churches[39] and, according to some scholars, the strikingly colourful illustrations added in the tenth and eleventh centuries to a group of manuscripts of the commentary on the Apocalypse by the monk Beatus.[40] Although an Islamic impact seems evident in the illustrations of a ninth-century manuscript known as the Biblia Hispalense,[41] the problem is more complicated with the Beatus manuscripts because of the absence of suitable models in the Islamic world. If there was an impact, it was at the level of the transmission not of specific motifs but of attitudes, in a desire to develop complex images in two dimensions only and without any sort of relief. The peculiar problems posed by works of art which seem to be poised between two cultures is well illustrated in Spain by the copper-alloy aquamanile in the shape of a bird [492]. It contains an Arabic inscription stating that it was made by a Christian named 'Abd al-Malik and another in Latin claiming that it was an 'opus Solomonis', a work of Solomon.[42] Another good example of Spanish objects balanced between two cultures are the so-called *maravedi* dinars minted in Toledo for Alfonso VIII of Castile (*r.* 1158–1214). In the style of Almoravid dinars, these gold coins (in addition to a cross and the Latin letters *ALF* for the above-mentioned king) bear Arabic inscriptions containing his name and calling him the amir of the Catholics, calling the Pope the *imam* of the Christian faith, and also providing the information that they were issued in the name of the Father, the Son, and the Holy Ghost.[43] This is only one of many examples that could be cited here of Islamic coins influencing the production of those on the Muslim frontiers. In earlier chapters, we mentioned how these influences worked in the other direction as

well. Throughout the period covered by this book there was a constant flow of two-way connections.

As the *reconquista* progressed, Islamic rule diminished, but Muslim inhabitants remained under Christian rule, and, more to the point for our purposes, in the territories held by Christian lords the taste for high Cordoban and later Muslim culture remained. This is the period when Mudejar (from the Arabic *mudajjan* meaning 'made or permitted to remain') art makes its appearance. Initially referring to the art made by Muslims for Christians, the meaning of this word was eventually extended to identify forms and techniques associated with Muslims and with Islamic art.[44] The beginnings of Mudejar art are to be seen in Muslim religious buildings that were transformed into churches, such as the Bab Mardum mosque in Toledo (above, p. 87), which became the church of Cristo de la Luz in 1221. A Mudejar synagogue has remained, the Ibn Shoshan synagogue of the thirteenth century in Toledo that was eventually converted into the church of Santa Maria la Blanca, with a wall decoration which could have adorned a Muslim building.[45] There are a few additional examples before 1250 of buildings undergoing function transfers, although the major monuments of Mudejar architecture, for instance in Seville, are later than our period.

In central France, in the cathedral of Le Puy in the mountains of the Auvergne, the façade is decorated with long pseudo-Arabic inscriptions, so good that some scholars have tried to decipher their meaning, or, at the very least, the meaning of the models used.[46] The unknown artisans who did the work were probably thinking of an exotic 'Orient' rather than of a text in Arabic.

A discussion of even a few of the multitude of artistic exchanges and contacts effected between the Islamic world

and the major cultural areas adjoining it would be seriously lacking without a mention of the enigmatic glass vessels known as the Hedwig group [493]. They are variously dated between the tenth and twelfth centuries, and numerous suggestions – including Egypt, Syria, the Byzantine realm, Italy, and Germany – have been put forward over the last century as to where these beakers might have been made. At this juncture in our knowledge the only relatively secure statement that can be hazarded about these vessels is that they are not Islamic. However, it would not be surprising some day to find evidence that they were executed in imitation of a type of Islamic glass called *muhkam* that was mentioned as being in the Fatimid treasury at the time of its dispersal in 1067–68. This highly valued glass was itself an imitation, in this case of vessels of carved precious (emerald and ruby) or semi-precious (rock crystal and turquoise) stones.[47]

Islamic art made an impact also in areas beyond the immediate frontiers of its realm, an impact effected specifically by the movement of Islamic objects into those regions. In addition to the importance of trade, there were visitors from afar who travelled to and from Muslim lands and brought souvenirs of their travels and reported on what they saw, thereby feeding the exotic hankering of any culture. Objects from Muslim lands found their way into the private treasuries of kings and of ecclesiastical establishments, often

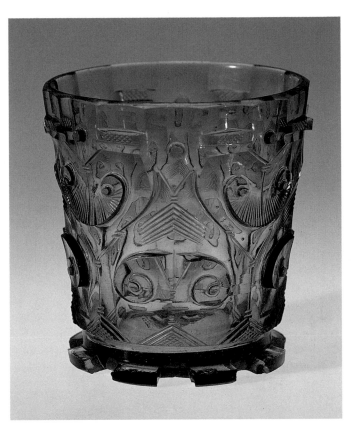

493. Cut-glass beaker. H: 10.3 cm. Coburg Castle, Coburg

492. Copper-alloy bird. H: 39.5 cm. Louvre Museum, Paris

very far from their place of origin. There were exchanges between Abbasid, Fatimid, and other Muslim rulers and their Christian, Buddhist, or Hindu counterparts, as in the celebrated instance of the gifts alleged to have been sent to Charlemagne by Harun al-Rashid.[48] One such gift was an ivory object (perhaps a chess figure) consisting of a howdah-bearing elephant and numerous personages who are clearly Indian. In addition to the figure seated in the howdah and the eight foot-soldiers and four mounted warriors depicted, another two figures appear to perform an acrobatic feat on the head of the elephant from the back of a horse. On its base the object bears an angular Arabic inscription identifying the craftsman as a member of a prominent Arab family during the early Islamic period, some members of which had close connections with Sind.[49] And, in a wonderful letter of *c*.940, the emperor Constantine VII writes that he marvels at the 'Arabic cup' from which he drinks while eating and before going to bed.[50] The impact, if any, of the presence of Islamic objects in secular or ecclesiastical treasuries is difficult to estimate, but the quantity of such objects is immense.[51]

Objects taken in war became trophies reused for ostentatious presentation or for whatever other purposes might have been needed. Although the art of the Crusaders in Palestine or Syria was little affected by Islamic art, the Crusades themselves were a very important source of booty, and textiles, being easily folded and thus transportable, were particularly prized. As was the case with the Veil of St Anne and the textile of Saint-Josse discussed earlier [203], they often became objects of veneration. However, they served

ancillary purposes as well.[52] On the other hand, the Muslim flags taken in battle decorating the sanctuary of the kings of Aragon in Las Huelgas [461][53] and the so-called Pisa griffin that appears to have been part of the large booty taken by the Pisans after their successful invasion of the Zirid capital, Mahdiyya, in the summer of 1087 [337] were all reused as victory monuments.[54]

A few examples may illustrate the variety of problems involved in dealing with these objects which were variously transported from the Muslim world. The occurrence of Islamic ceramic bowls ornamented with a great variety of motifs and employing various techniques that were used as *bacini* on the façades of Romanesque churches and/or campaniles especially in Italy was mentioned earlier.[55] The question as to why such bowls were used to decorate these Christian buildings has not, to date, been satisfactorily answered. Another large group of Islamic objects, in this instance of glass, presents a similar conundrum as to why and how it found its way to its present location. During the last twenty years excavations in China have unearthed more than forty of these objects in repositories of religious significance such as pagodas, stupas, and tombs. As is the case with the *bacini*, not only are they in very fine condition but they can be quite precisely dated and are being used to date Islamic glass objects found in the Muslim world itself.[56]

In conclusion, as one of us wrote some time ago apropos Europe:

> For over 1,300 years the worlds of Islam and of Europe have been in more or less constant confrontation. It has been a dynamic relationship, and often a tense one. But . . . the West has had nothing but admiration for the arts of the Near East. This was something much more than mere passive acceptance. It manifested itself in the association of whatever was available of this art with its most revered institutions, whether sacred or mundane, and in artistic borrowings of one type or another by the West from the East.[57]

What is the reason for this presence that covered the widest possible area and encompassed many, if not all, of the media? First of all, in order to imagine and comprehend the impact of Islamic art before 1250, it is not sufficient simply to make a list of motifs and to place them on a map or in chronologi-cal order. That impact was also felt in attitudes toward design or colour, so that the Beatus manuscripts in Spain or the ornaments of northern Europe can be compared or related to works of Islamic art. This can be done because of similar approaches to imparting beauty to objects, manu-scripts, or buildings. The non-Muslims within and outside the Islamic world greatly appreciated and admired that world's ability to decorate flat surfaces with appealing and often colourful patterns. Much more thought must be given, however, to such theoretical issues before proper conclu-sions can be articulated on the fundamental question of sep-arating an awareness of motifs, designs, and patterns from the deeper cultural or individual instincts of seeking and providing visual pleasure.

Second, because of its development of an ornament with-out iconographic charge and of many techniques for the making of beautiful objects, Islamic art became the secular and just slightly exotic paragon of medieval culture from the Atlantic to the frontiers of China. It maintained this role until the technological and industrial changes which occurred, first in Italy, in the thirteenth century. But it was not simply a matter of adorning buildings, people, or the dead with beautiful motifs and objects. It was also that its own forms, even calligraphy, could always be understood and appreciated without demanding an awareness of their significance within Islamic culture. They were exotic no doubt, but they were not alien.

And, finally, there is still a point in seeking to explain the impact of Islamic art through contrasting its presence or absence by areas, periods, and social or other categories. Was there a constant presence in Byzantium and Spain? Did the Christian world of Egypt express itself in a more particular way than the Syrian one? Were the primary sources of import and inspiration located in the Mediterranean area with Iran and India playing a much less important role and Central Asia being still less significant? When and why did the northern connection dry up – the one so eagerly sought in the ninth century by the traveller Ibn Fadlan on behalf of the Abbasid caliphate? Is there not much more to see in the arts of Africa and east Asia than we know how to detect? All these and many other questions are for future generations to resolve, but they testify to the astounding wealth and vital-ity of the first six centuries of Islamic art.

Abbreviations

AIEO	*Annales de l'Institut d'Études Orientales*
Bull. MMA	*Bulletin of the Metropolitan Museum of Art*
Creswell, EMA	K. A. C. Creswell, *Early Muslim Architecture*, 2 vols. (Oxford, 1932, 1940, 2nd ed. 1969; repr. 3 vols, New York, 1979)
Creswell, MAE	K. A. C. Creswell, *The Muslim Architecture of Egypt*, 2 vols. (Oxford, 1952–59; repr. New York, 1979)
EI	*The Encyclopaedia of Islam*, 2nd ed., Leiden, 1960 continuing
Ettinghausen Collected Papers	R. Ettinghausen, *Islamic Art and Archaeology: Collected Papers* (Berlin, 1984)
Hillenbrand, Islamic Architecture	R. Hillenbrand, *Islamic Art and Architecture* (London, 1999)
IJMES	*International Journal of Middle East Studies*
JESHO	*Journal of the Economic and Social History of the Orient*
Marçais, Architecture	G. Marçais, *L'architecture musulmane d'Occident* (Paris, 1954)
MIFAO	*Mémoires de l'Institut français d'Archéologie Orientale du Caire`*
MMAF	*Mémoires de la Mission archéologique française au Caire*
Survey	A. U. Pope ed., *A Survey of Persian Art from Prehistoric Times to the Present*, 12 vols. (London and New York, 1938–39)

Notes

CHAPTER I

1. Al-Azraqi, *Akhbar al-Makkah*, vol. 1 of F. Wüstenfeld, *Geschichte der Stadt Mekka* (Leipzig, 1858, repr. ed., Beirut, no date). For an exercise in the interpretation of al-Azraqi in a different context see O. Grabar, 'Upon Reading al-Azraqi', *Muqarnas* 3 (1985).

2. D. T. Potts, *The Arabian Gulf in Antiquity* (Oxford, 1990); A. R. Al-Ansary, *Qaryat al-Faw: A Portrait of Pre-Islamic Civilisation in Saudi Arabia* (London, 1982); T. Fahd, ed., *L'Arabie préislamique et son environnement historique et culturel* (Strasbourg, 1987); 'L'Arabie Antique de Karib'il à Mahomet', *Revue du Monde Musulman et de la Méditerrannée* 61 (Aix en Provence, 1991–93); I. Shahid, 'Byzantium in South Arabia', *Dumbarton Oaks Papers* 33 (1979); see also periodicals such as *Atlal* published by the Department of Antiquities of Saudi Arabia and the international journal entitled *Arabian Archaeology and Epigraphy*, edited by D. Potts since 1990.

3. For the Ka'ba the best and most accessible source is the *Encyclopedia of Islam*, 2nd ed. (Leiden, 1960 to date).

4. A verse in Abul Faraj al-Isfahani, *Kitab al-Aghani*, 20 vols (Cairo, 1968–69) 1, 15, among many such sources, refers to Madinese palaces decorated with paintings and with high towers, but it is uncertain whether the reference is to pre-Islamic or early Islamic times. For a sceptical evaluation of the riches in the possession of Mekkan merchants see Patricia Crone, *Meccan Trade and the Rise of Islam* (Princeton, 1987).

5. Not much has been written on the subject since Ignaz Goldziher, 'Die Handwerke bei den Arabern', *Globus* 66 (1894), 203–05.

6. In addition to the citations in note 2, see Richard Ettinghausen, 'The Character of Islamic Art', in Nabih Faris, ed., *The Arab Heritage* (Princeton, 1946), 252; Charles J. Lyall, ed., *The Mufaddaliyat* (Oxford, 1918), 92 ff., and *The Diwans of Abid b. al-Abbas* (Leiden, 1913), 23; Peter J. Parr, G. L. Harding, and J. E. Dayton, 'Preliminary Survey in N. W. Arabia, 1969', *Bulletin, Institute of Archaeology, University of London* 8:9 (1970), 193–242; the excellent survey by D. Potts, 'Arabia', in Jane Turner, ed., *The Dictionary of Art* (London, 1996); and B. Finster, 'Arabien in der Spätantike', *Deutsches Archäologisches Institut, Archäologische Anzeiger* (1996).

7. Often reproduced, for instance in Richard Ettinghausen, 'Notes on the Lusterware of Spain', *Ars Orientalis* 1 (1954), fig. 13; E. Will, *Les Palmyréniens* (Paris, 1992), 156.

8. Jean Sauvaget, *La Mosquée omeyyade de Médine* (Paris, 1947), 145 ff.; Robert B. Serjeant, 'Mihrab', *Bulletin of the School of Oriental and African studies* 22 (1959), 439–52; Grabar, *Formation*, 120–22; A. Papadopoulo, *Le Mihrab* (Leiden, New York, 1988); N. Khoury, 'The Mihrab, from Text to Form', *International Journal of Middle Eastern Studies* 30 (1998).

9. The standard study is still Gustav Rothstein, *Die Dynastie der Lahmiden in al-Hira* (Berlin, 1899). For more up-to-date, if at times controverted, views see the numerous studies by Irfan Shahid, including his several volumes of *Byzantium and the Arabs* (Washington, D.C. 1984–93) and the entry 'Lakhmids', in *The Encyclopedia of Islam*, 2nd ed.

10. Richard le Baron Bowen and Frank Albright, *Archaeological Discoveries in South Arabia* (Baltimore, 1958); Paolo M. Costa, *The Pre-Islamic Antiquities at the Yemen National Museum* (Rome, 1978); W. Daum, *Yemen, Three Thousand Years of Art and Civilization* (Innsbruck, 1987); various articles in Paolo Costa, *Studies in Arabian Architecture* (Aldershot, 1994).

11. Arthur G. and Edmond Warner, trans., *The Shahnama of Firdausi*, 9 vols (London, 1905–10) 6, 385.

12. Al-Hasan ibn Ahmad al-Hamdani, *Al-Iklil*, trans. Nabih Faris, *The Antiquities of South Arabia* (Princeton, 1938), 123, 14, 17, 26–27.

13. See primarily the various studies by I. Shahid. For remarks on archaeological information see Heinz Gaube, *Hirbet Baida Arabische Palast aus Südsyrien* (Beirut, 1974); Maurice Sartre, *Bostra, des origines à l'Islam* (Paris, 1995); Jean-Marie Dentzer, ed., *Hauran I* (Paris, 1995); T. Ulbert et al., *Rusafa* (Mainz, 1983 and ff.).

14. J. Burton, *An Introduction to the Hadith* (Edinburgh, 1994).

15. M. Hamidullah, 'Asthetik und Kunst in der Lehre des Propheten', *Akten des 24. Orientalischen-Kongresses* (Wiesbaden, 1959), 359 ff., and Grabar, *Formation*, ch. 4, present some views and examples. See Doris Abu Sayf-Behrens, *Schönheit in der Arabischen Kultur* (Munich, 1998), 23–6, for an interesting new approach.

16. This is true only for the Ka'ba itself; up to very recent times the surrounding areas underwent enormous changes, which have never been fully analysed. For a rare attempt see R. A. Jairazbhoy, 'The History of the Shrines at Mecca and Medina', *Islamic Culture* 1962 (January–February). See also the

very long descriptions in the entries s.v. Makkah and Madinah in the *Encyclopedia of Islam*.

17. The best summary of the history of the mosque is Saleh Lamei Mostafa, *Al-Madina al-Munawwara* (Beirut, 1981); his reconstructions are the most likely. For a very imaginative interpretation see *Hillenbrand, Islamic Architecture* (New York, 1994), 39–42.

18. Carl H. Becker, 'Die Kanzel im Kultus des laten Islam', *Islamstudien* 1 (Leipzig, 1924), 450–71; Sauvaget, *Mosquée omeyyade*, 140–44; Creswell, *EMA* 1, 13–14.

19. On the basis of one poetical fragment, the suggestion as been made that the Prophet built a separate *masjid* (Ghazi Bisheh, *The Mosque of the Prophet in Madinah*, University of Michigan thesis, 1981); the possibility does exist, although the evidence at this stage is not conclusive.

20. On these see now Mostafa, *Al-Madina*, 135 ff.

21. Qur'anic passages and passages from the Traditions dealing with mosques have been gathered by Husayn Munis, *Al-Masajid* (Kuwait, 1981), 11–29.

22. Erica C. Dodd and Shereen Khairallah, *The Image of the Word* (Beirut, 1981), for examples. See also O. Grabar, 'Art and Architecture', in *Encyclopedia of the Qur'an* (Leiden, forthcoming).

23. Thomas Arnold, *Painting in Islam* (Oxford, 1928), 5.

24. Grabar, *Formation*, ch. 4; and Grabar 'Islam and Iconoclasm', in Anthony Bryer and Judith Herrin, eds, *Iconoclasm* (Papers given at the ninth Spring Symposium of Byzantine Studies, University of Birmingham, March 1975) (Birmingham, 1977), 45–52; Patricia Crone, 'Islam, Judeo-Christianity and Byzantine Iconoclasm', *Jerusalem Studies in Arabic and Islam* 2 (1980), for a very different approach.

25. Bishr Farès, *Essai sur l'esprit de la décoration islamique* (Cairo, 1952).

26. Erica Dodd, 'The Image of the Word', *Berytus* 18 (169), 35–79. For a more spiritual view one can consult various works by Annemarie Schimmel, such as *Islamic Calligraphy* (Leiden, 1970) and *Calligraphy and Islamic Culture* (New York, 1984).

27. For a somewhat different approach to writing see the very recent works of Yasser Tabbaa, 'The Transformation of Arabic Writing', *Ars Orientalis* 21 (1991) and 24 (1994), and Oleg Grabar, *The Mediation of Ornament* (Princeton, 1992).

28. Carl Becker, 'Der Islam als Problem', *Der Islam* 1 (1910), 16.

29. The high level of economic development of conquered areas has been demonstrated for Iraq by the surveys carried out by Robert McC. Adams, *Land Behind Baghdad* (Chicago, 1965) and *The Uruk Countryside* (Chicago, 1972) and by the growth of the large entrepôt at Siraf on the Persian Gulf: D. Whitehouse, 'Excavations at Siraf', *Iran* 6–13 (1968–75). A few final reports have been published as well. Explorations and excavations in Syria, Jordan, and Palestine over the past ten years have very much modified, if not revolutionized, the earlier notion of a decline just before the Muslim conquest. For examples see Maurice Sartre, *Bosra* (Paris, 1985), Georges Tate, *Les Campagnes de la Syrie du Nord* (Paris, 1992), Michele Piccirillo, *The Mosaics of Jordan* (Amman, 1993), Robert Schick, *The Christian Communities of Palestine from Byzantium to Islam* (Princeton, 1995), and the published volumes of the 'Bilad al-Sha'm' conferences held intermittently since 1985. Much of this information has been conveniently summarized and interpreted by C. Foss, 'Syria in Transition A.D. 550–750', *Dumbarton Oaks Papers* 51 (1997). The same economic wealth is true of Central Asia. In fact the separation between pre-Islamic and Islamic material cultures is becoming increasingly difficult to establish.

30. For an introduction to Coptic art see Klaus Wessel, *Koptische Kunst* (Recklinghausen, 1963), for more recent summaries, see the articles on Coptic art by Lucy-Ann Hunt in *The Dictionary of Art* (London, 1996).

31. For examples see below, p. 26.

32. The exact character and importance of Sasanian art are still a matter of debate, and the view expressed here is in part that of the medieval Muslim tradition and of the Iranocentrism of certain recent scholarship. In reality matters may have been less brilliant. Compare Roman Ghirshman, *Persian Art: The Parthian and Sasanian Dynasties* (New York, 1962) and Prudence Harper, *The Royal Hunter: Art of the Sasanian Empire* (New York, 1978) and *Silver Vessels of the Sasanian Period 1: Royal Imagery* (New York, 1988) with Oleg Grabar, *Sasanian: Silver* (Ann Arbor, 1967), Lionel Bier, *Sarvistan: A Study in Early Iranian Architecture* (University Park, 1986), and D. Thompson, *Stucco from Chal-Tarkhan* (Warminster, 1976).

33. Daniel Schlumberger, *L'Orient hellénisé* (Baden-Baden, 1969) for the

earlier period. More specific information is found in various books by Jules Leroy.

34. Sirarpie Der Nercessian, *Armenian Art* (Paris, 1978), and now Jean-Michel and Nicole Thierry, *Armenian Art* (New York, 1989); Tania Velmans, *L'arte della Georgia* (Milan, 1996).

35. Guitty Azarpay, *Soghdian Painting* (Berkeley, 1979), is the most accessible introduction.

36. André Grabar, *L'Iconoclasme byzantin* (Paris, 1957) for a survey of texts and appropriate visual documents. Many other explanations exist by now, and it is striking how every generation seeks its own interpretation of this phenomenon.

CHAPTER 2

1. Recent excavations carried out during a major overhaul of the area south of the Great Mosque of Damascus may have brought to light remains from that palace. No results of these excavations have as yet been made available.

2. These include only remains which have been either properly studied or are otherwise dated or datable. There is a large number of houses, mosques, at times larger establishments for which an Umayyad or early Islamic date is possible. These are works of what is now called vernacular architecture, essentially an architecture for which the *time* of construction is not a significant factor. For examples see Jean Sauvaget, 'Observations sur les monuments omeyyades', *Journal Asiatique* 231 (1939), 1–59; Geoffrey King, 'A Mosque Attributed to 'Umar', *Journal of the Royal Asiatic Society* (1978), 109–23; and many examples in M. A. al-Bakhit and Robert Schick, eds, *The Fourth International Conference on Bilad al-Sha'm* (Amman, 1989) and *Bilad al-Sha'm During the Abbasid Period* (Amman, 1991). A case at point is that of the ruined mosque of Baalbek in Lebanon. It looks like a 'vernacular' mosque reusing older materials and receiving some decorative veneer in the fourteenth century. Yet, for political reasons, it is proclaimed today as an 'Umayyad' mosque.

3. Creswell, *EMA* 1, 65–131 and 213–322; S. Nusaibeh, *The Dome of the Rock* (New York, 1996). For interpretation see Oleg Grabar, 'The Umayyad Dome of the Rock', *Ars Orientalis* 3 (1959), 33–62, and *Formation*, 48–67. For different and more elaborate views see Oleg Grabar, *The Shape of the Holy* (Princeton, 1996), Amikam Elad, *Medieval Jerusalem and Islamic Worship* (Jerusalem, 1995), and the many essays edited by Julian Raby, *Bayt al-Maqdis* (Oxford, 1992).

4. Josef Van Ess in Raby, ed., *Bayt al-Maqdis*.

5. Much of this is still hypothetical and controversial. See Werner Caskel, *Der Felsendom und die Wallfahrt nach Jerusalem* (Cologne, 1963), with a poetic fragment on p. 28 which I interpret differently, and Priscilla Soucek, 'The Temple of Solomon in Islamic Legend and Art', in Joseph Gutman, ed., *The Temple of Solomon* (Ann Arbor, 1976), 73–124. Additional new studies are by Nasser Rabbat, 'The Meaning of the Umayyad Dome of the Rock', *Muqarnas* 6 (1989), and 'The Dome of the Rock Revisited', *Muqarnas* 10 (1993); Nuha Khoury 'The Dome of the Rock, the Ka'ba and Ghumdan', *Muqarnas* 10 (1993).

6. Creswell, *EMA* 1, 78–79.

7. A few fragments of mosaic seen by C. Clermont-Ganneau, *Archaeological Researches in Palestine During the Years 1873–4*, 2 vols (London, 1899 and 1896) 1, 187 ff., were rediscovered during the restorations carried out in the early 1960s; they were never published and their whereabouts are unknown to me.

8. For a brilliant, if erratic, statement of the issue see Michel Ecochard, *Filiation des monuments grecs, byzantins, et islamiques* (Paris, 1977); these issues have been recently picked up again by D. Chen, 'The Design of the Dome of the Rock', *Palestine Exploration Quarterly* 112 (1980), and 'The Plan of the Dome of the Rock', *Palestine Exploration Quarterly* 117 (1985).

9. Marguerite van Berchem, 'The Mosaics of the Dome of the Rock in Jerusalem and of the Great Mosque in Damascus', in Creswell, *EMA* 1, 252 ff.; Grabar, *Shape of the Holy*, and Nusaibeh, *Dome of the Rock*, for complete surveys of mosaics. For a new interpretation within a review of the Haram in general see Myriam Rosen-Ayalon, *The Early Islamic Monuments of the Haram al-Sharif* (Jerusalem, 1989) and R. Shani, 'The Iconography of the Dome of the Rock,' *Jerusalem Studies in Arabic and Islam* 23 (1999).

10. Max van Berchem, *Matériaux pour un Corpus Inscriptionum Arabicarum*, 3 vols, *MIFAO* 43–45, (Cairo, 1920–22), vol. 2, *Syrie du Sud*, 2x, 237 ff.; Grabar, *Shape of the Holy*, 59 ff.; Sheila Blair in Raby, *Bayt al-Maqdis*.

11. Quite often one half of a symmetrical motif on the soffits of the arches was done with greater care than the other half.

12. Lisa Golombek, 'The Draped Universe of Islam', in Priscilla P. Soucek, ed., *Content and Context of Visual Arts in the Islamic World* (College Park, PA, 1980).

13. Sauvaget, *Mosquée omeyyade*. Although still the most forceful and logical statement of a thesis, Sauvaget's interpretative chapter should be reviewed in the light of new evidence; see, in particular, the previously cited works by S. Lamei *Al-Madina* and Robert Hillenbrand *Islamic Architecture*.

14. R. W. Hamilton, *The Structural History of the Aqsa Mosque* (Jerusalem, 1949). The main issue lies in the actual chronology of archeologically retrieved sequences of construction; see Henri Stern, 'Recherches sur la mosquee al-Aqsa', *Ars Orientalis* 5 (1963), 28–48; K. A. C. Creswell and James Allen, *A Short Account* (Oxford, 1989), 73; O. Grabar, *The Shape of the Holy*, 118–19 and *passim*; Amikam Elad, *Medieval Jerusalem*; and the forthcoming study by J. Raby, which the author kindly lent to me.

15. The identification of all these alleged early mosques is not always secure. Especially in Syria, Jordan, and Palestine there is a tendency to call mosque any building with a niche on the south side. See references in various articles by G. King (above, note 2) and others; a typical example is found in Svend Helms *et al.*, *Early Islamic Architecture in the Desert* (Edinburgh, 1980).

16. Creswell, *EMA*, 1, 22–28; F. Safar, *Wasit* (Cairo, 1945), Creswell and Allen, *A Short Account*, 40–41.

17. In his description of the rebuilding of the mosque at Kufa, al-Tabari (*Annales*, ed. M. J. de Goeje (Leiden, 1879–1901) 1, 238–39) says that the roofs were 'built like the roofs of Greek churches'; Creswell (*EMA* 1, 25) believes that this referred to trussed gabled roofs, although it is not likely that this was very common.

18. Louis Massignon, 'Explication du plan de Kufa (Iraq)', *Mélanges Maspéro*, 3 vols, *MIFAO* 66–68 (Cairo, 1934) 3, 337–60; Hichem Djait, *Al-Kufah, naissance de la ville islamique* (Paris, 1986), with, among other contributions, important discussions of the Arabic terminology used in the buildings of the city; A. Dietrich, 'Die Moscheen von Gurgan zur Omaijadenzeit', *Der Islam* 40 (1964), 1–7.

19. Creswell, *EMA* 1, 35–37 and 58–61.

20. See the controversy between Sauvaget, *Mosquée omeyyade*, 103 ff., and K. A. C. Creswell, 'The Great Mosque of Hama', in R. Ettinghausen, ed., *Aus der Welt der islamischen Kunst: Festschrift für Ernst Kühnel* (Berlin, 1959), 48–53; and *EMA* 1, 17–21.

21. Sauvaget, *Mosquée omeyyade*, 149 ff.; Creswell, *EMA* 1, 32–3; Grabar, *Formation*, 122.

22. Although very common, the minaret is not compulsory; at times it was added long after the mosque was built, as in Jean Sauvaget, 'Les Inscriptions arabes de la mosquée de Bosra', *Syria* 22 (1941), 53 ff.; Hillenbrand, *Islamic Architecture*, had devoted a whole chapter to the minaret.

23. Joseph Schacht, 'Ein archäischer Minaret-Type, in Ägypten und Anatolien', *Ars Islamica* 5 (1938), 46–54, and 'Further Notes on the Staircase Minaret', *Ars Orientalis* 4 (1961), 137 ff.

24. R. J. H. Gottheil, 'The Origin and History of the Minaret', *Journal of the American Oriental Society* 30 (1909–10), 137 ff.

25. Grabar, *Formation*, 118–20, for the traditional view; Jonathan Bloom, *The Minaret* (Oxford, 1989) for the more persuasive new view.

26. For example the spiral type used in Samarra [63] and copied at Ibn Tulun in Fustat [66] or the cylindrical ones found in Iran (Janine Sourdel-Thomine, 'Deux minarets d'époque seljoukide en Afghanistan', *Syria*, 30 (1953), 108–36, and Myron Bement Smith, 'The Manars of Isfahan', *Athar-é Iran* 1 (1936), 313–65).

27. Gaston Wiet and André Maricq, *Le Minaret de Djam* (Paris, 1959), where this extraordinary structure and related ones in India are discussed; see also below, p. 152 and Bloom, *Minaret, passim*.

28. Sauvaget, *Mosquée omeyyade*, 152, and other references given above.

29. Creswell, *EMA* 1, 151 ff. Recent (before 1996) clearings and restorations have given a new look to the building and uncovered many hitherto invisible features which need full investigation.

30. Sauvaget, *Mosquée omeyyade*, 69 ff.

31. Muhammad ibn Ahmad al-Muqqadasi, *Kitab Ahsan al-taqlim*, ed. M. J. de Geoje, *Bibliotheca Geographorum Arabicorum* 3 (Leiden, 1906), 157, relates that the dome was in front of the *mihrab* by the late tenth century.

32. Etienne Quatremère, *Histoire des sultans mamlouks de l'Égypte*, 2 vols (Paris, 1837–45) 2, 273.

33. Oleg Grabar, 'La Grande Mosquée de Damas et les origines architecturales de la mosquée', in André Grabar, ed., *Synthronon* (Paris, 1968), 107–14.

34. Creswell, *EMA* 1, 197 ff.

35. Sauvaget, *Mosquée omeyyade*, 152–53.

36. The flat *mihrab* inside the cavern of the Dome of the Rock which Creswell (*EMA* 1, 100) believed was contemporary with the construction of the monument has been shown to be Fatimid; other flat early ones may have existed in Wasit in Iraq and in Qastal in Jordan, but the interpretation of these archeological remains is uncertain; see Eva Baer, 'The Mihrab in the Cave of the Dome of the Rock', *Muqarnas* 3 (1985); Safar, *Wasit*, fig. II, Patricia Carlier, 'Qastal al-Balqa', in Bakhit and Schick eds, *Bilad al-Sha'm* (1989).

37. R. B. Serjeant, 'Mihrab', *Bulletin of the School of Oriental and African Studies* 23 (1959), 439–53; Nuha Khoury, 'The Mihrab: From Text to Form', *International Journal of Middle Eastern Studies* 30 (1988).

38. Sauvaget, *Mosquée omeyyade*, 83 ff.; Henri Stern, 'Les Origines de l'architecture de la mosquée omeyyade', *Syria* 28 (1951), 272–73.

39. As a symbol it may in fact have already been used on a rare early Islamic coin: George C. Miles, 'Mihrab and Anazah: A Study in Early Islamic Iconography', in George C. Miles, ed., *Archaeologica Orientalia in Memoriam Ernst Herzfeld* (Locust Valley, NY, 1952), 156–71, although the theme there may have been simply the reflection of a triumphal arch.

40. These points emerge from Sauvaget, *Mosquée omeyyade*, and Joseph Schacht, 'An Unknown Type of Minbar and Its Historical Significance', *Ars Orientalis* 2 (1957), 149–73.

41. Elie Lambert, 'La Synagogue de Dura-Europos et les origines de la mosquée', *Semitica* 3 (1950), 67–72.

42. A partial exception should be made for the Aqsa Mosque, from which carved woods [87] have been preserved and some information exists about mosaics; cf. below, p. 194.

43. Marguerite van Berchem in *Cresswell, EMA* 1, 229 ff.

44. For example, H. A. R. Gibb, 'Arab–Byzantine Relations under the Umayyad Caliphate', *Dumbarton Oaks Papers* 12 (1958), 219–33; Marguerite van Berchem, however, did not accept his explanation. Published opinions have varied since then.

45. For example in Saloniki; Marguerite van Berchem and G. Clouzot, *Mosaiques chrétiennes* (Geneva, 1924), 67 ff.; see now J.-M. Spieser, *Thessalonique et ses monuments* (Paris, 1984). The point has already been made by Eustache de Lorey, 'L'Hellénisme et l'Orient', *Ars Islamica* 1 (1934), 26.

46. Marguerite van Berchem in *Cresswell, EMA* 1, 371 ff., where all the texts are gathered.

47. André Grabar, *L'Iconoclasme byzantin* (Paris, 1957), 165.

48. For a full discussion of the Damascus mosaics as images of a Muslim paradise see Barbara Finster, 'Die Mosaiken der Umayyadenmoschee', *Kunst des Orients* 7 (1970), 83–141; Klaus Brisch, 'Observations on the Iconography of the Mosaics in the Great Mosque of Damascus', in Soucek, ed., *Content and Context*; Gisela Hellenkemper-Salier, 'Die Mosaiken der Grossen Moschee von Damaskus', *XXXV corso di cultura sull'arte Ravennata e Bizantina* (Ravenna, 1988).

49. Al-Muqqadasi, *Ahsan al-Taqasim*, ed. M. J. de Goeje (Leiden, 1906), 157.

50. Ibn Shakir, as quoted in Quatremère, *Historire des sultans*, 2.

51. Richard Ettinghausen, *Arab Painting* (Geneva, 1962), 22 ff.

52. See the works, already cited, by Stern and Hamilton; also O. Grabar, *Shape*, p. 112 and below, p. 194.

53. Myriam Rosen-Ayalon, 'The First Mosaic Discovered at Ramla', *Israel Exploration Journal* 26 (1976).

54. I am not certain whether already in Umayyad times there was a formal term for the covered part of a mosque. Later it became known as the *bayt al-salat* ('house of prayer'); earlier it was simply the *mughatta*, 'covered place'.

55. For Wasit see Safar, *Wasit*. The mosque's *qibla* was changed quite early from the southwest to the south; for an intriguing but probably incorrect explanation see Michael Cook and Patricia Crone, *Hagarism* (Cambridge, 1977), 21–28. For a first attempt at elucidating some of the newly published texts on Jerusalem see the recent work by A. Elad, mentioned earlier; the major problem lies in the degree of reliability later descriptions can be given to explain early buildings.

56. Robert NcC. Adams, *Land Behind Baghdad* (Chicago, 1965), 85.

57. For Hallabat, *Cresswell, EMA* 1, 502–5; Jean Sauvaget, 'Remarques', *Journal Asiatique* 231 (1939), 20–22. For Siraf, David Whitehouse, *Siraf II: The Congregational Mosque and other Mosques from the Ninth to the Twelfth Centuries* (London, 1980).

58. For Raqqa, the publications of the long-standing activities of the Syrian Department of Antiquities and of the German Archeological Mission are still not really available. For a preliminary survey see chapter 1 in Michael Meinecke, *Patterns of Stylistic Change in Islamic Architecture* (New York, 1996). For Qasr al-Hayr East see Oleg Grabar, Renata Holod, James Knudstad, and William Trousdale, *City in the Desert: Qasr al-Hayr East* (Cambridge, 1978).

59. Mark Horton, *Shanga* (London, 1996) and a more general survey, 'Primitive Islam and Architecture in East Africa', *Muqarnas* 8 (1991).

60. For an early mosque in Sind see F. A. Khan, *Banbhore* (Pakistan Department of Archaeology, Karachi, n.d.); also S. M. Afshaque, 'The Grand Mosque of Banbhore', *Pakistan Archaeology* 6 (1969) and M. Abdul Ghafar, 'Fourteen Koufic Inscriptions', *ibid.* 3 (1966), where the key inscription is, however, dated A.H. 209 instead of 109.

61. Paolo Costa and Ennio Vicazio, *Yemen, Land of Builders*, trans. Daphne Newton (London, 1977), and Paolo Costa, 'Lo moschea grande di Sana', *Annali Istituto Orientale di Napoli* (1974), 487–506, reproduced in his *Studies in Arabian Architecture* (Aldershot, 1994). Also Barbara Finster, 'An Outline of Islamic Religious Architecture in Yemen', *Muqarnas* 9 (1992) with references to her other works. For Busra see the notes in M. Meinecke, *Patterns of Stylistic Change*, 50. Much unpublished work has been done in Busra.

62. See James Knudstad, 'The Darb Zubayda Project: 1396/1976', *Atlal* 1 (1397/1977) and reports in subsequent issues of this journal. A fascinating

paper on the subject by Bernard O'Kane is due to be published in Saudi Arabia.

63. J. Bloom, *Minaret*, pp. 81–83.

64. L. Van den Berghe, *Archéologie de l'Iran ancien* (Leiden, 1959), pl. 67b, p. 47, shows a Sasanian fire tower which bears a superficial resemblance to the minaret, but its structure is in fact quite different, and it too is an unusual building. For new and different views see the volume by J. Bloom on the minaret and the appropriate chapters in Hillenbrand, *Islamic Architecture*.

65. E. Pauty, 'L'Évolution du dispositif en T', *Bulletin d'Etudes Orientales* 2 (1947), 60 ff.

66. B. Fransis and M. Ali, 'Jami abu Dulaf', *Sumer* 3 (1947), 60 ff.

67. Herzfeld, *Geschichte* (Hamburg, 1948), 137, has estimated it to a million inhabitants.

68. *Cresswell, EMA* 2, 332–59.

69. *Cresswell, EMA* 2, 208–26 and 308–20, and Marçais, *Architecture*, 9 ff. Creswell and Marçais defend two slightly divergent interpretations on the evolution of the building in the ninth century.

70. Alexandre Lézine, *Architecture de l'Ifriqiya* (Paris, 1966), esp. 25 ff.; Leon Golvin, *Essai sur l'architecture religieuse musulmane* (Paris, 1974), 1, 123 ff.

71. Christian Ewert and Jens-Peter Wisshak, *Forschungen zur Almohadischen Moscheen* 1 (Mainz, 1981), 15–20, fig. 20.

72. Georges Marçais, 'Remarques sur l'esthétique musulmane', *AIEO* 4 (1938), 62 ff.

73. Oleg Grabar, 'Umayyad 'Palace' and the Abbasid Revolution', *Studia Islamica* 18 (1963), 5–18.

74. These include the work of the German Archeological Institute in Raqqa (some preliminary reports by Michael Meinecke in *Damaszenische Mitteilungen*), Madinat al-Far (directed by Claus-Peter Haase), Donald Whitcomb's exploration of Aqaba, John Oleson at Humaymah, Patricia Carlier at Qastal (doctoral dissertation *Qastal, château umayyade*, Aix en Provence, 1984), Jacques Beaujard and others at Umm al-Rassas and Umm al-Walid (Jacques Beaujard, *Entre Byzance et l'Islam*, Geneva, 1996), among many others. For a convenient recent survey covering parts of the areas involved see C. Foss, 'Syria in Transition, A.D. 550–750', *Dumbarton Oaks Papers* 51 (1997).

75. Bloom, 'The *Qubbat al-Khadra* and the Iconography of Height in Early Islamic Architecture', *Ars Orientalis* 23 (1993).

76. Oleg Grabar, 'Al-Mushatta, Baghdad, and Wasit', in *The World of Islam (Studies in Honour of P. K. Hitti)* (London, 1959), 99–108.

77. Mohammad Ali Mostafa, 'Excavations at Kufa', *Sumer* 10 (1954), 73–85.

78. For Amman see A. Almagro, *El palacio omeyyade de Amman I* (Madrid, 1984), E. Olavani-Giocoecheni, *Amman II* (Valencia, 1985), and Alistair Northedge's unpublished dissertation at the University of London (1981). For Jerusalem Meir Ben-Dov, *In the Shadow of the Temple* (New York, 1982), with tentative and uncertain reconstructions, and M. Rosen-Ayalon, *Early Islamic Monuments* for interpretations. Umayyad levels have been recognized in many Syrian, Jordanian, and Palestinian excavations, but they have not been assembled together to allow for conclusions.

79. It is difficult to give an exact number, because only excavations can demonstrate an Umayyad date; compare, for instance, the very different lists made by Sauvaget, 'Observations,' *Journal Asiatique*, 231, and *Cresswell, EMA* 1, 514; or else the controversy surrounding Qasr al-Abyad (Heinz Gaube, *Ein Arabischer Palast in Südsyrien* (Beirut, 1974). Anjarr in Lebanon (*Cresswell, EMA* 1, 478–81) still poses problems, as does the citadel at Amman. For a summary list with comments see Oleg Grabar, 'Umayyad Palaces Reconsidered', *Ars Orientalis* 23 (1993).

80. For example, *Cresswell, EMA* 1, 403–06; opposition by Sauvaget, 'Remarqnes,' and 'Châteaux omeyyades de Syrie', *Revue des Etudes Islamiques* 39 (1967), 1–42, and Oleg Grabar, review of *EMA*, *International Journal of Middle Eastern Studies* 3 (1972), 217–22, and *Formation*, 162–65, among several recent discussions of the topic, as in Robert Hillenbrand, 'La Dolce Vita in early Islamic Syria', *Art History* 5 (1982).

81. Grabar *et al.*, *City in the Desert*, 29–33.

82. *Cresswell, EMA* 1, 447–49; Stephen Urice, *Qasr Kharana, an Early Islamic Monument in Transjordan* (Harvard University, 1981). New information on the inscriptions and grafitti can be found in Frédéric Imbert's doctoral dissertation, *Corpus des inscriptions arabes de Jordanie du Nord* (Aix en Provence, 1996).

83. In addition to the sites mentioned earlier see Martin Almagro *et al.*, *Qusayr Amra: residencia y baños omeyas en el desierto de Jordania* (Madrid, 1975), and for a general survey *Hillenbrand, Islamic Architecture*, ch. VII.

84. On the triconch see Irving Lavin, 'The House of the Lord', *Art Bulletin* 44 (1962).

85. It was never quite alone, as was guessed by Sauvaget, *Les Monuments historiques de Damas*. Beirut, 1932, 15–16, and demonstrated by Almagro, *Qusayr Amra*, and Claude Vibert-Guigue, *La peinture omeyyade du Proche-Orient: l'exemple de Qusayr Amra* (doctoral dissertation, Université de Paris I, 1997). But it was the main building on the site, which is not the case elsewhere.

86. Robert Hamilton, *Khirbat al-Mafjar* (Oxford, 1959), 67 ff.

87. Edmond Pauty, *Les Hammams du Caire* (Cairo, 1932), 87.

88. Priscilla Soucek, 'Solomon's Throne, Solomon's Bath', *Ars Orientalis* 23 (1993).

89. These were noted by J. A. Janssen and R. Savignac, *Mission archéologique en Arabie III: Les châteaux arabes de Qesair Amra, Haraneh, et Tuba* (Paris, 1922), 81, but published by Christel in K. Brisch, ed., Kessler, 'Die beiden Mosaikboden in Qusayr Amra', *Studies in Islamic Art and Architecture in Honour of Professor K. A. C. Creswell* (Cairo, 1965), 105–31; and Almagro *et al.*, *Qusayr Amra*, 54–55, figs 9–10 and pl. XIII.

90. For baths this has been demonstrated several times, for instance by Frank Edward Brown in *Preliminary Report of the Sixth Season at Dura Europos* (New Haven, 1936), 59–61.

91. Ettinghausen, *Arab Painting*, 36 ff., and *From Byzantium to Sasanian Iran and the Islamic World* (Leiden, 1972), not all of whose conclusions are entirely acceptable.

92. Doris Behrens-Abu Sayf, 'The Lion-Gazelle Mosaic at Khirbat al-Mafjar', *Muqarnas* 14 (1997).

93. Robert Hamilton, 'Carved Plaster in Umayyad Architecture', *Iraq* 15 (1953), 43 ff.

94. O. Grabar, 'Survivances classiques dans l'art de l'Islam', *Annales Archéologiques Arabes Syriennes* 21 (1971), and Grabar, *Formation*, 160–61.

95. The crown on one of the Qasr al-Hayr West figures seems to be an original Umayyad one; Daniel Schlumberger, 'Les Fouilles de Qasr el-Heir el-Gharbi (1936–1938): rapport préliminaire', *Syria* 20 (1939), 353.

96. See Miles as in Note 39 and Michael Bates, below, note 167.

97. Oleg Grabar, 'The Painting of the Six Kings at Qusayr Amrah', *Ars Orientalis* 1 (1954), 185–87; Ettinghausen, *Arab Painting*, 32.

98. Garth Fowden, *Empire to Commonwealth* (Princeton, 1993), 143–49. His forthcoming book on Qusayr Amra will develop a better balanced explanation of the monument.

99. The astronomical meaning of the ceiling has been elucidated by Fritz Saxl in *Creswell, EMA* 1, 424–31.

100. Ettinghausen, *Arab Painting*, 33 ff.

101. This is true of paintings (Oleg Grabar in Hamilton, *Khirbat al-Mafjar*, 308–14) as well as of sculpture, as can be seen in the posthumous volume by Daniel Schlumberger *et al.*, *Qasr al-Hayr Gharbi* (Paris, 1986), where many sculptures and paintings are published but not discussed.

102. Almagro *et al.*, *Qusayr Amra*. The problems posed by the restoration have been critically raised by Vibert-Guigue in his dissertation mentioned earlier.

103. Oleg Grabar, 'La place de Qusayr Amrah dans l'art profane', *Cahiers Archéologiques* 36 (1988). On a more general level see Oleg Grabar, 'L'Art omeyyade de Syrie, source de l'art islamique', in Pierre Canivet and Jean-Paul Rey-Coquais, eds, *La Syrie de Byzance à l'Islam* (Damascus, 1992).

104. Excellent photographs are published in several works by Nelson Glueck, for instance *Rivers in the Desert* (New York, 1959), figs 51 ff.

105. For example Kara Shahr (Sir Aurel Stein, *Serindia*, (Oxford, 1921), CXXXV ff.) or Varaksha (Vasilii Afanasevich Shishkin, *Varaksha* (Moscow, 1963)).

106. Analysis by *Creswell, EMA* 1, 596–603; see also Leo Trumpelman, *Mschatta: ein Beitrag zum Verständnis des Kunstkreises, zur Datierung und zum Stil der Ornamentik* (Tübingen, 1962). Excellent summary of the situation by Michael Meinecke and Volkmar Enderlein, 'Mshatta Fassade', *Jahrbuch der Berliner Museen* 24 (1992).

107. Stern, 'Les Origines'.

108. Hamilton, *Khirbat al-Mafjar*, 139 ff.

109. The notion of liturgy long used to explain this art has been criticized by Sauvaget, *Mosquée omeyyade*, 114 ff.

110. Main summary in *Creswell, EMA* 2, 1–38, modified in part by Oleg Grabar, 'Mshatta, Wasit, and Baghdad', 99 ff., and *Formation*, 165–71; Lassner, *The Topography of Baghdad* (Detroit, 1970), and *The Shaping of Abbasid Rule* (Princeton, 1980), part 2.

111. A later representation of this rider exists in manuscripts of the *Automata* by al-Jazari; see F. R. Martin, *The Miniature Painting and Painters of Persia* (London, 1912) 2, pl. 2, and Grabar, *Formation*, pl. II. His significance is unclear; he can hardly have acted as a weather vane. Medieval texts indicate that the lance always pointed towards approaching enemies, so perhaps the rider had some magical or symbolic meaning.

112. Curiously enough it was a Byzantine ambassador who pointed out to the caliph that his palace was like a prison to him; al-Khatib al-Baghdadi, *Tarikh Baghdad* (Baghdad, 1931) 1, 100–05.

113. The relation of Baghdad to earlier palaces has already been sketched by Jean Sauvaget, 'Les Ruines omeyyades de Andjar', *Bulletin du Musée de Beyrouth* 2 (1939), III. See also Qasr al-Hayr East (Grabar *et al.*, *Qasr al-Hayr*, ch. 2, notes 65, 80). For a cosmic interpretation see Charles Wendell, 'Baghdad: Imago Mundi and Other Foundation Lore', *IJMES* 2 (1971).

114. Summary and bibliography in *Creswell, EMA* 2, 39–49, to be consulted with the reports of excavations carried out by the Syrian Department of Antiquities in *Annales Archéologiques de Syrie*, especially vols 4–5 (1954–55), 69 ff., and 6 (1956), 25 ff.; by the German Institute (latest summary in Meinecke, *Stylistic Change*); and new Syrian works, as by Qasem Toueir on Hiraqlah in Canivet and Rey-Coquais, *La Syrie*.

115. *Creswell, EMA* 2, 94–100, with full bibliography; more recently, Werner Caskel, 'Al-Uhaidir', *Der Islam* 39 (1964), 28–37, and R. Pagliero *et al.*, 'Uhaydir, an Instance of Monument Restoration', *Mesopotamia* 2 (1967).

116. In recent years some questions have been raised about the date of many Sasanian buildings related to Ukhaydir; see Lionel Bier, *Sarvistan: A Study of Early Iranian Architecture* (University Park, PA, 1986), who reopened the debate as to whether techniques of construction and decoration are Sasanian or new.

117. Alistair Northedge, 'An Interpretation of the Palace of the Caliph at Samarra', *Ars Orientalis* 23 (1993), with references to all other recent studies by himself and others; note in particular Northedge and R. Faulkner, 'Planning Samarra', *Iraq* 47 (1987).

118. Al-Maqrizi, *Kitab al-Mawa'idh*, trans. P. Casanova in *Mémoires de l'Institut Français d'Archéologie Orientale au Caire* 3 (1906), 215–18.

119. The main study on Tunisia is by M. Solignac, 'Recherches sur les installations hydrauliques', *AIEO* 10 (1952). The other monuments are all in *Creswell's EMA* 2.

120. These palaces have been published on the basis of Herzfeld's notes by Creswell, *EMA* 2 II 232–43, 265–70, and by Alistair Northedge in *Ars Orientalis* and 'The Palaces at Istabulat', *Archéologie Islamique* 3 (1993); see also Iraq Government Department of Antiquities, *Excavations at Samarra 1936–69, I, Architecture* (Baghdad, 1940), and J. M. Rogers, 'Samarra: A Study in Medieval Town Planning', in A. H. Hourani and S. M. Stern, eds, *The Islamic City* (Oxford, 1970), and Hillenbrand, *Islamic Architecture*, ch. VII.

121. The main textual source is Istakhri's description of the palace Abu Muslim (cited in *Creswell, EMA* 2, 3–4). The archeological sources are the palaces of Qyrq Qyz (plan published by E. Herzfeld, 'Damascus', *Ars Islamica* 9 (1942), 35) and Haram Köshk (G. A. Pugachenkova, *Puti razvitia arhitektury iuzhnogo Turkmenistana* (Moscow, 1958), 154), among many Central Asian examples. Many of these can be found in S. Khmelnitskii, *Zwischen Kushan und Arabern* (Berlin, 1989), and *Mezhdu Arabami i Turkami* (Berlin, 1989).

122. Herzfeld, op. cit. (Note 67), pl. XXXIV. Alistair Northedge, 'The Racecourses at Samarra', *Bull School of Oriental and African Studies* 53 (1990).

123. Maqrizi, *Kitab al-Mawa'idh*, trans. P. Casanova in *MIFAO* 3 (1906), 215–18.

124. *Creswell, EMA* 2, 283–86.

125. O. Grabar, 'The Earliest Islamic Commemorative Structures', *Ars Orientalis* 6 (1966), 7–46; Sheila Blair, 'The Octagonal Pavilion at Natanz', *Muqarnas* 1 (1983).

126. André Lézine, *Le Ribat de Sousse* (Tunis, 1956). See also 'Ribat' in *Encyclopedia of Islam*.

127. See below, p. 61.

128. The use of ajouré marble in the *mihrab* in Qayrawan is, partly at least, to be explained by peculiar features of local piety; Marçais, *Architecture*, 51–54.

129. Ernst Herzfeld, *Der Wandschmuck der Bauten von Samarra* (Berlin, 1923).

130. *Creswell, EMA* 2, 286–88.

131. Maurice Dimand, 'Studies in Islamic Ornament I', *Ars Islamica* 4 (1937), and 'Studies in Islamic Ornament II', in G. C. Miles, ed., *Archaeologica Orientalia in Memoriam Ernst Herzfeld* (Lowst–Valley, NY, 1952).

132. Herzfeld, *Wandschmuck*, figs 222, 228, 230, and a few others are exceptions.

133. Dimand, 'Studies II'.

134. Ernst Kühnel, *Die Arabeske* (Wiesbaden, 1949), 5.

135. The most recent discussion is by Dimand, 'Studies II', following Kühnel and Herzfeld.

136. E. Kühnel, 'Die islamische Kunst', in A. Springer, *Handbuch der Kunstgeschichte* (Leipzig, 1929) 6, 395.136.

137. See, for instance, S. I. Rudenko, *Kultura Maseleniia Gornogo Altaia* (Moscow, 1953), pls 89–90.

138. E. Herzfeld, *Die Malereien von Samarra* (Berlin, 1927).

139. See, for example, Sir Aurel Stein, *Ancient Khotan II* (Oxford, 1907), pl. LXIII; *Serindia IV* (Oxford, 1921), pls XLIV (especially M111.0019) and XLV (M.V. 004). See also *Along the Ancient Silk Routes: Central Asian Art from the West Berlin State Museum* (New York, 1982).

140. Including the pearl frames, animals with non-naturalistic all-over spots, and monochrome backgrounds. See A. Y. Yakubovsky *et al.*, *Zhivopis drevnego Panjikenta* (Moscow, 1954), fig. 13, pls VII–XI and XXXIII; A. Belenitski, *Asie Centrale* (Geneva, 1968), ch. IV, and all surveys of Central Asian painting.

141. D. S. Rice, 'Deacon or Drink', *Arabica* 5 (1958).

142. Herzfeld, *Geschichte der Stadt Samarra*, 240.

143. Maqrizi, *Kitab al-Mawa'idh*, 216–17.

144. J. Sauvaget, 'Remarques sur l'art sassanide', *Revue des Études Islamiques*, 12 (1938), 113–31, on the contrary, proposed what could be called a 'post-Hellenistic' definition for Umayyad art in general but the 'post-Sasanian' rubric seems to have been the one most widely used and perpetuated and, therefore, the most detrimental to a perception of the art of the earliest dynasty in the Muslim world as one that was breathing on its own.

145. Although it has never been doubted that pre-Islamic objects or elements from such objects would have survived the Muslim conquest and been utilized (together with contemporary non-Islamic objects) by the new patrons, striking proof of this appears to exist in a large copper-alloy brazier found in an Umayyad context: cf. J. B. Humbert, O.P., 'El-Fedein/Mafraq, école biblique et archéologique française', in F. Villeneuve, ed., *Contribution française a l'archéologie jordanienne* (Amman, 1989), 129–30.

146. Numerous comparative examples could be cited such as those in wood, glazed and unglazed pottery and carved stone to name just a few.

147. Compare with window grilles in al-Andalus (cf. *Al-Andalus: The Art of Islamic Spain*, exh. cat., The Metropolitan Museum of Art, New York, 1992, cat. no. 42) and with such grilles in Egypt between 1000 and 1250 (e.g. Creswell, *MAE* 1, (New York, 1978), pls 7, 9).

148. For a similar design in marble at Madinat al-Zahra, see [137].

149. This statement is true also for the decoration on the metal tie-beams in the Dome of the Rock. See *Creswell, EMA* 2, pls 25–27 for other wooden soffits from the Aqsa Mosque.

150. Henri Stern, 'Quelques oeuvres sculptées en bois, os, et ivoire de style omeyyade', *Ars Orientalis* 1 (1954), 119–31.

151. A. J. 'Amr, 'Umayyad Painted Pottery Bowls from Rujm al-Kursi, Jordan', *Berytus* 34 (1986), 14–59; Robert K. Falkner, 'Jordan in the Early Islamic Period, the Use and Abuse of Pottery', *Berytus* 41 (1993–94), 41, for a rebuttal of 'Amr's dating of this ware; and Donald Whitcomb, 'Khirbet al-Mafjar Reconsidered: The Ceramic Evidence', *Bulletin of the American Schools of Oriental Research* 271 (August, 1988), 51–67. There was a later vogue for this type of pottery in Madinat al-Zahra in al-Andalus [140]. For a closely related pottery type made in Egypt see Chapter 3, note 29.

152. Florence E. Day, 'Early Islamic and Christian Lamps', *Berytus* 7 (1942), 65–79; P. B. Bagatti, 'Lucerne fittili (la cuore) nel Mueso della Flagellazione in Gerusalemmi', *Faenza* 35 (1949), 98–103; Nabil I. Khairy and 'Abdel-Jalil A. 'Amr, 'Early Islamic Inscribed Pottery Lamps from Jordan', *Levant* 18 (1986), 143–53; 'Abdel-Jalil 'Amr, 'More Islamic Inscribed Pottery Lamps from Jordan', *Berytus, Archaeological Studies* 34 (1988), 161–68. It is entirely possible that lamps of this type were also made in centers other than Jarash.

153. A carved ceramic mould for creating a decoration very similar to that in the principal band was excavated in Istakhr by the Oriental Institute in Chicago (A24718 12/433). An object made locally from the excavated mould would have differed from that made in Basra only in that, instead of the arches and their borders being filled with concentric circles at times arranged in an imbrication pattern, those areas on the Istakhr vessel contained vegetal designs.

154. This object was previously published as having been made during the eleventh or twelfth century; see Eva Baer, 'Jeweled Ceramics from medieval Islam: A Note on the Ambiguity of Islamic Ornament', *Muqarnas* 6 (1989), 85–86. All of its features, including the style of calligraphy employed, are consistent with an eighth-century date and it should be so considered; see M. Jenkins, 'Islamic Pottery: A Brief History', *Bull. MMA* (Spring 1983), 5. The use of the term *tiraz* in this inscription to denote a factory for the manufacture of pottery is a previously unrecorded early meaning of this word; see Glossary and A. Grohmann, 'Tiraz', *Encyclopaedia of Islam*, 1st ed., 785–93 for the conventional meaning of this term.

155. Adolf Grohmann, *Arabische Paläographie* 2 (Vienna, 1971), pl. XIV, 2, for a good photograph of this object although his interpretation of the name has been superseded by that put forward in *The Arts of Islam*, exh. cat., Hayward Gallery, London, 8 April–4 July 1976, 213, no. 250.

156. A. U. Pope, *Survey* (London and New York, 1938–39) 4, pls 187–91, 194, 196. It was pottery in this group that gave rise to that known as *Kerbschnitt*. See [102].

157. Friedrich Sarre, 'Die Bronzekanne des Kalifen Marwan II. im Arabischen Museum in Kairo', *Ars Islamica* 1 (1934), 10–14.

158. Oleg Grabar feels that this particular decoration is a restoration of the original pattern (personal communication).

159. Compare ajouré decoration on rim with that on soffit in [87].

160. M. M. Diakonov, 'Ob odnoi rannci arabskoi nadpisi', *Epigrafika Vostoka* 1 (1947), 5–8; English résumé by Oleg Grabar in *Ars Orientalis* 2 (1957), 548. However, Boris Marshak, 'Bronzovoi Kuvshin', *Iran i Srednia Azia* (Leningrad, 1973), dates it later, as does Sheila Blair, *Islamic Inscriptions* (Edinburgh, 1998), 117–18. A. S. Melikian-Chirvani, *Islamic Metalwork from the Iranian World, 8th–18th Centuries: Victoria and Albert Museum Catalogue* (London, 1982), 25 and 37, notes 22–25. Not withstanding earlier readings of the inscription on the rim of this vessel, the correct transliteration and transla-

tion are: *min san'at Abi Yazid mimma 'umila bi-l-Basra sanat tis' wa-sittin* (The work of Abu Yazid in Basra in the year sixty-nine). For comparison see Marilyn Jenkins, 'Islamic Art in the Metropolitan Museum of Art', *Arts and the Islamic World* 3: 3 (autumn 1985), 54.

161. Concerning the attitude toward craftsmen in general during this early period cf. Mehmet Aga-Oglu, 'Remarks on the Character of Islamic Art', *Art Bulletin* 36 (1954), 191–92.

162. I want to thank Dr Michael Bates, American Numismatic Society, New York, for positively identifying this governor for me and sharing with me the information that the Abbasid caliph mentioned by the name 'Abdallah on this object assumed the epithet al-Mansur after a battle near Kufa in 763 (see Mas-'udi, *(Kitab) al-Tanbih wa-al-ishraf*, Bibliotheca Geographorum Arabicorum 8 (Leiden, 1967), 341), thus corroborating the date of manufacture of this object within the period of the brief governorship of 'Abdallah ibn al-Rabi'. For other references to this pyxis cf. Ernst Kühnel, *Die islamischen Elfenbeinskulpturen VIII.–XIII. Jahrhunderts* (Berlin, 1971), cat. no. 18. It has been reported that thousands of ivory fragments were recovered at Humeima (Jordan) during the 1995–96 excavation season of an early eighth-century *qasr*; see *Fondation Max van Berchem Bulletin*, 10 (Geneva, December 1996), esp. fig. 1, p. 1 – this brief report states that, at the time of publication, no specific parallels had been identified; and *ibid.*, Edition Speciale (Geneva, December 1998), illustration p. 6.

163. Grohmann, *Arabische Paläographie*, 87, Abb. 59.

164. The patterned textiles represented on wall paintings from Afrasiyab also bear close comparison to these early Islamic fabrics.

165. See above, note 154; R. B. Serjeant, 'Material for a History of Islamic Textiles up to the Mongol Conquests', *Ars Islamica* 9 (1952), 60–68; S. D. Goitein, 'Petitions to Fatimid Caliphs from the Cairo Geniza', *Jewish Quarterly Review* 45 (1954), 34–35.

166. Janine Sourdel-Thomine and Bertold Spuler, *Die Kunst des Islam* (Berlin, 1973), pl. 74a–c. This design is found in many media and variations during this period. In addition to the examples seen earlier in metal and depicted on walls (see also colour plate VIII in the publication cited above), it is also found on a stone balustrade and painted floor from Qasr al-Hayr West. Marilyn Jenkins, 'Islamic Art', 56 and note 1.

167. For the best summation of the history of early Islamic coinage see Michael Bates, 'History, Geography, and Numismatics in the First Century of Islamic Coinage', *Revue Suisse de Numismatique* 65 (1986), 231–62; see also Michael Bates, 'Byzantine Coinage and Its Imitations, Arab Coinage and Its Imitations: Arab–Byzantine Coinage', *Aram* 6 (1994), 381–403.

168. Marilyn Jenkins and Manuel Keene, *Islamic Jewelry in the Metropolitan Museum of Art* (New York, 1983), 15.

169. In the last quarter century several groups of objects formerly considered pre-Islamic have been dated in the seventh and eighth centuries, which could make them Umayyad, if not necessarily sponsored by Muslim patrons. They include metalwork, some so-called post-Sasanian silver pieces, and a group of large and beautifully decorated objects of copper alloy, Coptic textiles, and even stuccoes hitherto thought to be Sasanian. It was also not so long ago that one of the most important mid-eighth-century Islamic palaces – Mshatta – was considered by leading scholars to be pre-Islamic, as were some ivories. See Boris Marshak, 'Ranneislamskie bronzovya bliuda', *Trudy Hermitage Museum* 19 (1978); Deborah Thompson, *Coptic Textiles in the Brooklyn Museum* (New York, 1971); *Stucco from Chal Tarkhan-Eshqabad near Rayy* (Warminster, 1976); Stern, 'Quelques oeuvres'.

170. Ernst Herzfeld, 'Die Genesis der islamischen Kunst', *Der Islam* 1 (1910), esp. 32.

171. Such stylization of the Late Antique vine scroll can also be seen on objects in other media, such as ivories of the period, e.g. Marilyn Jenkins, ed., *Islamic Art in the Kuwait National Museum* (London, 1983), 32.

172. See B. Moritz, *Arabic Palaeography* (Cairo, 1905) pls 1, 2 for Qur'an folio of similar period with closely related designs.

173. Fragmentary sections of another side or sides of this object can be found in the Islamisches Museum, Berlin; see Elise Anglade, *Catalogue des boiseries de la section islamique, Musée du Louvre* (Paris, 1988), 36, fig. 19a.

174. That the technique not only continued to be employed during the peri-od covered by this book but was also further refined is evidenced by the *minbar* from the Kutubiyya Mosque in Marrakesh [Title page, 457], which is one of the most masterful and beautiful examples of woodworking produced in the medieval Muslim world.

175. See pp. 57 and 58 above and Ernst Kühnel, *The Arabesque: Meaning and Transformation of an Ornament* (Graz, 1977).

176. Richard Ettinghausen, 'The "Beveled Style" in the Post-Samarra Period', in G. C. Miles, ed., *Archaeologica Orientalia in Memoriam Ernst Herzfeld* (Locust Valley, NY, 1952), 72–83; H. G. Evelyn-White, *The Monasteries of the Wadi 'n Natrun, Part III: The Architecture and Archaeology* (New York, 1933), pls 68–70; K. A. C. Creswell, *Early Muslim Architecture* 2 (New York, 1979), pls 101–14; and A. S. Melikian-Chirvani, 'Baba Hatem, un

chef d'oeuvre inconnu d'époque ghaznevide en Afghanistan', in A. Tajvide and M. Y. Kiani, ed., *The Memorial Volume of the Vth International Congress of Iranian Art and Archaeology*, 11–18 April 1968 (Tehran, 1972), 108–24.

177. It must be remembered that, although, for the most part, extant examples bear no applied decoration, most of these architectural elements were originally painted. See E. Pauty, *Les Bois sculptés jusqu'à l'époque ayyoubide* (Cairo, 1931), pl. XXI, nos 4141, 6280/1 and 8800.

178. Pauty, *Les Bois sculptés*, pls XII, nos 4720 and 4721; XIV, nos 3801 and 4616; XV–XVIII.

179. Oleg Grabar, *The Mediation of Ornament* (Princeton, 1992), 22–23.

180. *Masterpieces of Islamic Art in the Hermitage Museum*, exh. cat., Kuwait, 1990, cat. no. 1, pp. 20–21 and 10. See also Friedrich Sarre, 'Bronzeplastik in Vogelform, ein sasanidisch-frühislamisches Rauchergefass', *Jahrbuch der Preussischen Kunstsammlungen* 51 (1930), 159–64; Museum für Islamische Kunst, Berlin, *Katalog* (Berlin/Dahlem, 1971), no. 234, pl. 37. See also Figure 187 in the first edition of the present work.

181. See R. Ettinghausen, 'The "Wade Cup" in the Cleveland Museum of Art, Its Origin and Decorations', *Ars Orientalis* 2 (1957), 332–33, text figure D and pl. 11, fig. 36.

182. Some of these vessels are early examples of the use of a glazed surface for coloured designs, e.g. see M. Jenkins, 'Islamic Pottery', 6, no. 3, which illustrates how green stain-painting in the glaze is used to highlight certain areas of the decoration.

183. Mas'udi, *Les prairies d'or*, 6, ed. and trans. C. Barbier de Meynard and Pavet de Courteille (Paris, 1861–77), 295; 8, 19, 298.

184. F. E. Day, 'A Review of "The Ceramic Arts, A History" in *A Survey of Persian Art*', *Ars Islamica* 8 (1941), 24.

185. For a good colour illustration of this object see Jonathan Bloom and Sheila Blair, *Islamic Arts* (London, 1997), 106, no. 57. See also George T. Scanlon, 'Early Lead-glazed Wares in Egypt: An Imported Wrinkle', in S. Seikaly, R. Baalbaki and P. Dodd, eds, *Quest for Understanding: Arabic and Islamic Studies in Memory of Malcolm H. Kerr* (Beirut, 1991), 253–62.

186. Monique Kervran, 'Les Niveaux islamiques du secteur oriental du tepe de l'Apadana, II: Le matériel céramique', *Cahiers de la Délégation Archéologique Française en Iran* 7 (1977), 75–161. An almost identical object was found at Samarra; cf. F. Sarre, *Die Keramik von Samarra* (Berlin, 1925), pl. XXXV, 4. Provincial wares decorated in this technique and glazed have been found in Ifriqiya. See also Alastair Northedge, 'Friedrich Sarre's *Die Keramik von Samarra* in Perspective', *Continuity and Change in Northern Mesopotamia from the Hellenistic to the early Islamic Period: Proceedings of a colloquium at the Seminar für Vorderasiatische Altertumskunde, Freie Universität Berlin, 1994* (Berlin, 1996), 229–58.

187. Arthur Lane, *Early Islamic Pottery* (London, 1947), 10: "'Ali ibn 'Isa, governor of Khurasan, sent as a present to Harun al-Rashid twenty pieces of Chinese Imperial porcelain, the like of which had never been seen at the caliph's court before, in addition to two thousand other pieces of porcelain.'

188. Robert B. Mason and Edward J. Keall, 'The 'Abbasid Glazed Wares of Siraf and the Basra Connection: Petrographic Analysis', *Iran* 29 (1991), 51–66. For more on the ceramic finds from Siraf see Moira Tampoe, *Maritime Trade between China and the West: An Archaeological Study of the Ceramics from Siraf (Persian Gulf), 8th to 15th centuries A.D.* (Oxford, 1989).

189. Pope, *Survey* 2, 1483 and 5, pl. 574D; *Masterpieces of Persian Art* (New York, 1945), pl. 48; Phyllis Ackerman, *Guide to the Exhibition of Persian Art*, The Iranian Institute (New York, 1940), 145; Ulrike al-Khamis, 'An Early Islamic Bronze Ewer Reexamined', *Muqarnas* 15 (1998), fig. 16, p. 16.

190. John Carswell, *Blue and White: Chinese Porcelain and its Impact on the Western World* (Chicago, 1985)

191. The origins of this technique lie within the Early period, although exactly when and where it was first discovered is still an open question. Only two extant lustre-painted glass objects are dated (a fragment in the Museum of Islamic Art, Cairo, bearing the date 163/779–80) or datable (in the same museum, the bowl of a goblet found in Fustat containing the name of an Egyptian governor who served for only one month in 773 [110]. Another lustre-painted glass piece, in the National Museum, Damascus, bears an inscription stating that it was made in Damascus. We have no way of determining at this point in our research how soon after the discovery of this technique the dated or datable pieces were made or whether Damascus was the only place where this luxury glassware was manufactured.

192. Marilyn Jenkins, 'Medieval Maghribi Luster-painted Pottery', in *La céramique médiévale en Méditerranée occidentale, V–XV siècles: actes du colloque internationale C.N.R.S., Valbonne, 1978* (Paris, 1980), 335.

193. The tiles around the *mihrab* are of both the polychrome and monochrome type, providing us with conclusive proof that the two varieties of lustre-painted ware were contemporary no matter where the monochrome type was manufactured, whether locally or in Basra.

194. This motif had appeared on painted stucco tiles in the early third century at, for example, the synagogue of Dura-Europos; C. H. Kraeling, *The*

Excavations at Dura Europos. Final Report 8, part I: *The Synagogue* (New Haven, 1956), pl. XI. The unusual background decoration seen on this tile configuration is also known on a three-dimensional object; cf. SC4076, The Freer Gallery of Art, Washington, D.C.

195. Al-Mu'tasim commissioned potters of Basra to manufacture the ceramics required for his new city of Samarra. These tiles must have been among the commissioned work.

196. The Islamic tradition of glazed ceramic architectural decoration, to which this ninth-century production gave rise, was no less glorious. The ornamentation of buildings, both inside and out, with glazed tiles was a decorative device that was to remain a hallmark of the architecture of the Muslim world for the next thousand years and one which was to exert a strong influence on such decoration in the West as well.

197. See Jenkins, *Islamic Pottery*, 9, for a brief description of this technique.

198. Marilyn Jenkins, 'The Palmette Tree: A Study of the Iconography of Egyptian Lustre Painted Pottery', *Journal of the American Research Center in Egypt* 7 (1968), 119–26. Another rare variety of lustre-painted pottery – that decorated in gold on a cobalt-blue ground – should perhaps be placed in this monochrome group. See Louvre Museum, no. S191 found at Susa; and, Islamic Museum, Cairo, no. 13996. This colour scheme was to become popular again in twelfth- and thirteenth-century Syria.

199. Victoria and Albert Museum, *Review of the Principal Acquisitions during the Year 1930* (London, 1931), 14–15, fig. 8; Victoria and Albert Museum, *Review of the Principal Acquisitions during the Year 1931* (London, 1935), 8–10; photograph of fragment from Rayy in Herzfeld Archive, Washington, D.C.; Louvre Museum, no. MAO 432. Alastair Northedge and Derek Kennet, 'The Samarra Horizon', in *The Nasser D. Khalili Collection of Islamic Art, vol. IX: Cobalt and Lustre* (London, 1994), 25 where blue-painted is mentioned as the earliest in Samarra horizon; also p. 33 where monochrome lustre is placed between 885 and 895. Not only were monochrome lustre-painting and cobalt-pigmented painting contemporary but the tile decoration on the *qibla* wall of the Great Mosque of Qayrawan is proof that polychrome and monochrome lustre-painted pottery were in production at the same time as well. See also G. Curatola, *Eredità dell'Islam: arte islamica in Italia* (Venice, 1993), cat. no. 9. What we do not yet know and may never know is precisely when the production of lustre-painting and cobalt-pigmented painting began in Basra and for how long it continued.

200. Northedge and Kennet, 'The Samarra Horizon', 34 and no. 33, p. 44, and F. Sarre, *Die Keramik von Samarra*, pls XXIX,2 and XXX,3. This method of decoration seems to have spread rapidly to Egypt and Syria and possibly to Iran and Central Asia in the ninth century. See [185] for a later use of this technique.

201. Marilyn Jenkins, 'Al-Andalus, Crucible of the Mediterranean', in *The Art of Medieval Spain, A.D. 500–1200*, exh. cat., New York, 1993, 75. Although one cannot be absolutely sure, one must assume that the marble panels were already carved as there would have been no reason to import plain marble. Support for such a hypothesis is provided by the *minbar* from the Kutubiyya Mosque. It was made in Cordoba and shipped and transported overland in pieces to Marrakesh where it was assembled in its present form. For a discussion of this masterpiece see Chapter 7 below.

202. George T. Scanlon, 'Fustat and the Islamic Art of Egypt', *Archaeology* 21 (1968), 191. Thus, as may be the case with Umayyad jewellery, glass from this period may be 'misfiled' as well.

203. See pp. 69, 70 and note 191, and Marilyn Jenkins, 'Islamic Glass: A Brief History', *Bull. MMA* (fall 1986), 23.

204. The name may be that of the mould's creator or that of the gaffer, or perhaps they were one and the same person.

205. D. S. Rice, 'Early Signed Islamic Glass', *Journal of the Royal Asiatic Society* (1958), 8–16.

206. A group of silver ewers produced during the period of Sasanian rule and another group subsequently manufactured in Iran after the Muslim conquest of that country also derive, ultimately, from the same imperial Roman form.

207. Veronika Gervers, 'An Early Christian Curtain in the Royal Ontario Museum', in Veronika Gervers, ed., *Studies in Textile History in Memory of Harold B. Burnham* (Toronto, 1977) 1977, 74.

208. For a fuller characterization of the Cairo Geniza referred to here see S. D. Goitein, *A Mediterranean Society, vol. I: Economic Foundations* (Berkeley, 1967), 1–28.

209. Goitein, *A Mediterranean Society, vol. IV: Daily Life* (Berkeley, 1983), 117.

210. Louise W. Mackie, 'Increase the Prestige: Islamic Textiles', *Arts of Asia*, 26: 1, 84 (Jan.–Feb. 1996).

211. Goitein, *Mediterranean Society*, vol IV 127–29.

212. Goitein, *Mediterranean Society*, vol IV 128. This reed is identified by Muqaddasi as *halfa'*. Both Nasir-i Khosrow and Idrisi praise such reed mats and refer to them as *husur samaniyya*. *Tissus d'Egypte temoins du monde arabe,*

VIII–XV siècles: Collection Bouvier, exh. cat., Musée d'Art et d'Histoire de Genève, 1993–94, 131. Contrary to a note in the latter catalogue and per Goitein's identification, it is not necessary to look to Isfahan for the origin of the term *saman*.

213. François Déroche, *The Abbasid Tradition: Qur'ans of the 8ᵗʰ to the 10ᵗʰ Centuries A.D.* (London, 1992), 27–33; pp. 17–25 provide a good and succinct introduction to the structure, ruling and illumination of Qur'an manuscripts.

214. See, for example, Moritz, *Arabic Palaeography*, pls 1–16.

215. Marilyn Jenkins, 'A Vocabulary of Umayyad Ornament: New Foundations for the Study of Early Qur'an Manuscripts', *Masahif Sanaʿa'*: (Kuwait, 19 March–19 May 1985), 19–23. Hans-Caspar Graf von Bothmer, 'Masterworks of Islamic Book Art: Koranic Calligraphy and Illumination in the Manuscripts found in the Great Mosque in Sanaa', in Werner Daum, ed., *Yemen, 3000 Years of Art and Civilization in Arabia Felix* (Innsbruck, 1987), 178–87; 'Architekturbilder im Koran: eine Prachthandschrift der Umayyadenzeit aus dem Yemen', *Pantheon* 45 (1987), 4–20. Grabar, *Meditation*, 155–93.

216. Von Bothmer, while agreeing with Jenkins-Madina's tentative dating of this codex, does not agree with her attribution of this Qur'an manuscript to Greater Syria. He believes that it was produced in the Yemen. Grabar suggests a later dating than either Jenkins-Madina or von Bothmer. The latter author feels that the illuminations on the double frontispiece represent a mosque. Grabar proposes four possible architectural interpretations for these depictions, three of which assume that the building (or buildings) is a mosque. In view of the numerous Late Antique elements that were adopted and adapted during this creative epoch in the history of Islamic art, at this juncture in our knowledge of the art of this formative period the possibility cannot be ruled out that this double frontispiece is an Islamic adaptation of the archectural settings so prevalent on the opening pages of Christian texts. The equally early illuminated Qur'an folio referred to in note 172 exhibits an arcade hung with similar glass lamps.

217. G. Bergsträsser and O. Pretzel, *Geschichte des Qorans, III: Die Geschichte des Qorantexts*, ed. T. Nöldeke, 2nd ed. (Leipzig, 1938), 253.

218. Déroche, *Abbasid Tradition*, 37.

219. François Déroche, 'Collections de manuscrits anciens du Coran à Istanbul: rapport préliminaire', in J. Sourdel-Thomine, ed., *Etudes médiévales et patrimoine turc*, Cultures et Civilisations Médiévales (Paris, 1983), pl. IIb and fig. 1, p. 151.

220. Colour reproductions of several pages from early Qur'an manuscripts can be found in M. Lings, *The Quranic Art of Calligraphy and Illumination* (London, 1976), pls I–V. See also M. Lings and Y. H. Safadi, *The Quran: Catalogue of an Exhibition of Quran Manuscripts at the British Library*, 3 April–15 August 1976 (London, 1976); *Splendeur et majesté: corans de la Bibliothèque Nationale* (Paris, 1987); and Déroche, *Abbasid Tradition*.

221. The decorative frontispieces seem to correspond to the illuminated pages with portraits of pagan Greek or Christian patrons or authors; in one Qur'an section we even find the same framework as around the sixth-century dedication portrait of a Byzantine princess, though in the Muslim version it encloses only a simple rosette. This relationship was first noted by Grohmann in T. W. Arnold and A. Grohmann, *The Islamic Book* (Leipzig, 1929), 125 and note 107.

222. O. Grabar, *The Mediation of Ornament*, 70–77.

223. G. Marçais and L. Poinssot, *Objets kairouanais du IXe au XIIIe siècle* I (Tunis, 1948), pls I–XXX; and, for binding discussed here, see pp. 46–49 and fig. 14.

224. Yasser Tabbaa, 'The Transformation of Arabic Writing: Part I, Qur'anic Calligraphy', *Ars Orientalis* 21 (1991), 121–30. For a contemporary treatise on penmanship cf. F. Rosenthal, *Four Essays on Art and Literature in Islam* (Leiden, 1971), 20–49.

225. D. S. Rice, *The Unique Ibn al-Bawwab Manuscript in the Chester Beatty Library* (Dublin, 1955), is the main source of information on this manuscript.

226. Tabbaa, 'Transformation', Part I, 130–48.

227. Rice, *The Unique Ibn al-Bawwab Manuscript*, 2–3, 30–31, 35. For the official attitude that permitted a secretary to do occasional forging when it was for an important reason, see R. Levy, ed., *The Nasihat-nama, Known as Qabus-nama* (London, 1951). See also Levy's translation of this work, *A Mirror for Princes: The Qabus-nama* (New York, 1951), 209–10; D. James, *The Abbasid Tradition*, 20, note 13.

228. E. Herzfeld, 'Die Genesis der Islamischen Kunst', *Der Islam* I (1910).

229. This has been the position defended by Herzfeld in many of his works and it has influenced many subsequent writers such as Kühnel, Dimand, and Ettinghausen. For an interesting and imaginative review of these topics see Terry Allen, *Five Essays on Islamic Art* (Solipsist Press, Sebastopol, 1988), especially ch. 1.

230. M. M. Ahsan, *Social Life under the Abbasids* (London, 1979), has a good selection of these accounts, but arranged for different purposes than that of studying the arts.

231. E. Kühnel, *The Arabesque*, tran. R. Ettinghausen (Graz, 1977).

232. The first to have developed these ideas was L. Massignon in a seminal article 'Les Méthodes de réalisation artistique des peuples de l'Islam', *Syria* 2 (1924). His arguments have been overextended by some of his followers, such as A. Papadopoulo, *Islam and Muslim Art* (New York, 1979). But the notion of atomism has been revived by Yasser Tabbaa in recent years, among other places, in 'The Muqarnas Dome', *Muqarnas* 3 (1985).

233. The fundamental recent book on geometry, with thoughtful summaries on the Abbasid period, is by G. Necipoglu, *The Topkapi Scroll* (Los Angeles, 1995).

CHAPTER 3

1. The major points of uncertainty concern the exact nature of the first addition and the significance of the Villaviciosa Chapel (cf. note 4 below).

2. Some (*Creswell, EMA* 2, 138–61) have doubted its existence, claiming that a later legend about a Christian church was only invented in imitation of what happened in Damascus under al-Walid. Actually, remains of a church were found on the site, but it was probably not as significant as the sanctuary of John the Baptist in Damascus, and its impact on the mosque was probably limited. Cf. M. Ocaña Jiménez, 'La basílica de San Vicente', *Al-Andalus* 7 (1942), 347–66.

3. The uncertainty about the lateral enlargements of the first mosque is due to the apparent contradiction between a text published by E. Lévi-Provençal in *Arabica* 1 (1954), 89ff. (discussed by E. Lambert, 'L'Histoire de la grande mosquée de Cordoue', *AIEO* 2 (1936), 165ff.) and certain decorative motifs (E. Lambert, 'De quelques incertitudes', *AIEO* 1 (1934–35), 176ff.) on the one hand, and the lack of trace of foundation wall (L. Torres Balbás, in *Al-Andalus* 6 (1941), 411ff.) on the other. For an attempt to reconstruct the conflicting evidence see L. Torres Balbás, *La mezquita de Cordôba* (Madrid, 1965), 36, and F. H. Giménez, 'Die Elle in der arabischen Geschichtsschreibung', *Madrider Mitteilungen* 1 (1960), 190–91.

4. Although it is generally agreed that the Villaviciosa dome dates from al-Hakam's time, there are some documents which may suggest that ʿAbd al-Rahman III made some sort of addition there. The main one is a passage in Ibn Idhari, *al-Bayan*, ed. G. S. Colin and E. Lévi-Provençal, 2 (Leiden, 1951), 228; cf. Marçais, *Architecture*, 139.

5. Christian Ewert, *Spanisch-islamische Systeme sich kreuzender Bogen* (Berlin, 1968), Klaus Brisch, *Die Fenstergritter und verwandte Ornamente der Haupt moschee von Cordoba* (Berlin, 1966), and Henri Stern, *Les Mosaiques de la grande mosquée de Cordoue* (Berlin, 1976), are all excellent and detailed studies of various parts of the mosque, but they need to be put into a wider framework for full understanding of the building. For attempts in that direction see R. Hillenbrand, 'The Ornament of the World: Medieval Cordoba as a Cultural Center', in S. K. Jayyusi, *The Legacy of Muslim Spain* (Leiden, 1992) and Nuha Khoury, 'The Meaning of the Great Mosque of Cordoba in the Tenth Century', *Muqarnas* 13 (1996).

6. The ostensible reason for the addition was the increase of the city's population; it was done towards the north east because the palace occupied the area to the south west.

7. Al-Mansur's masons did, however, cheat in details; for instance, in order to give the effect of two colours, they used not brick and stone but painted plaster.

8. The most important is the minaret, in its present shape built by ʿAbd al-Rahman III around an earlier minaret; Feliz Hernandez Giménez, *El Alminar de Abd al-Rahman III en la Mezquita Mayor de Cordôba* (Granada, 1975), with some interesting considerations on the history of form.

9. Bloom, *Minaret*, 106–09.

10. Marçais, *Architecture*, 151–52; Geoffrey King, 'The Mosque of Bab Mardum', *Art and Archaeology Research Papers* 2 (1972), 29–40; Christian Ewert, 'Die Moschee bei Bab al-Mardum', *Madrider Mitteilungen* 17 (1977), 287–354.

11. Auguste Choisy, *Histoire de l'architecture* (Paris, 1899), 2, 22–23.

12. André Godard, 'Les Voûtes iraniennes', *Athar-é Iran* 4 (1949).

13. Henri Terrasse, *L'Art hispano-mauresque* (Paris, 1932), 139–40.

14. Evariste Lévi-Provençal, *Inscriptions arabes d'Espagne* (Leiden and Paris, 1931); Oleg Grabar, 'Notes sur le mihrab de la Grande Mosquée de Cordoue' in A. Papadopoulo, ed., *Le Mihrab dans l'architecture et la religion musulmanes* (Leiden and New York, 1988).

15. A. Dessus-Lamare, 'Le Mushaf de la mosquee de Cordoue', *Journal Asiatique* 230 (1938), 555; see also remarks by N. Khoury in *Muqarnas* 13, and J. Dodds, *Architecture and Ideology in Early Medieval Spain* (University Park, PA, 1990), 94 and ff.

16. Klaus Brisch, 'Zum Bab-al-Wuzara', in Charles Geddes, ed., *Studies in Islamic Art and Architecture in Honour of K. A. C. Creswell* (Cairo, 1965), 30–48.

17. Robert Hillenbrand, 'The Use of Spatial Devices in the Great Mosque

of Còrdoba', in *Islão e arabismo na península Ibérica* (Evora, 1988); Rafael Moneo, 'The Mosque and the Cathedral' *FMR* (1988).

18. Listed in Marçais, *Architecture*, 156 ff.

19. General summary by Antonio Vallejo Triano in Jerrilynn D. Dodds, ed., *Al-Andalus* (New York, 1992) and his *Madinat al-Zahra: el salón rico de 'Abd al-Rahman III* (Cordoba, 1995); various issues of *Cuadernos de Madinah al-Zahra* (from 1987 onward), and D. Fairchild Ruggles, *Gardens, Landscape and Vision in the Palaces of Islamic Spain* (University Park, 2000). One should add that a second similar palace-city was planned. It went by the name of Madina al-Zahira, but, so far, too little is known about it to deserve elaborate discussion.

20. D. F. Ruggles, 'The Mirador in Abbasid and Hispano-Umayyad Garden Typology' *Muqarnas* 7 (1990).

21. Marçais, *Architecture*, 171 ff., for full bibliography on more precise subjects, to which must be added the works of Brisch and Ewert mentioned earlier and, especially Basilio Pavón Maldonado, *El arte hispano musulmán en su decoración geométrico* (Madrid, 1975) as well as the very recent C. Ewert, *Die Dekorelemente der Wandfelder im Reichen Saal von Madinat az-Zahra* (Jahrhunderts, 1996).

22. *Marçais, Architecture*, 18–80; M. Gómez-Moreno, *El arte árabe, Ars Hispaniae*, 3 (Madrid, 1947). fig. 245.

23. This was the term used to designate the areas of the Iberian peninsula under Islamic control.

24. S. D. Goitein, *A Mediterranean Society: The Jewish Communities of the Arab World as Portrayed in the Documents of the Cairo Geniza, vol. I: Economic Foundations* (Berkeley and Los Angeles, 1967), 43, says that the term *al-Maghrib* was used, during the period in question, to mean all of North Africa west of Egypt, including Muslim Sicily, with Spain forming a subsection.

25. James Allan, *Metalwork of the Islamic World: The Aron Collection* (London, 1986), 16.

26. *The Art of Medieval Spain, A.D. 500–1200*, exh. cat., Metropolitan Museum of Art, New York, 1993, cat. nos.: 32, 35, pp. 86–87, 90.

27. For grilles at the Great Mosque of Damascus, cf. *Creswell, EMA* 1, part 1, fig. 92, p. 175 and plate 59; for grilles at Qasr al-Hayr West, cf. *ibid.* part 2, pls 88e, f and 89.

28. *The Art of Medieval Spain*, 77, illustration at left. For other Andalusian marble objects with figural decoration cf. *ibid.*, cat. no. 31, pp. 85–86, and Manuel Gomez-Moreno, *Ars Hispaniae III: El Arte Árabe Español hasta los Almohades Arte Mozárabe*, (Madrid, 1951), figs 245–48, 250–51, and 328.

29. See Chapter 2 above, p. 62 and especially note 151. Unglazed and painted ware was also made in contemporary Egypt: G. T. Scanlon, 'Fustat Expedition: Preliminary Report 1965, Part II', *Journal of the American Research Center in Egypt* 6 (1967), pl. IVa, and 'Fustat Expedition: Preliminary Report 1968. Part II', *ibid* 13 (1976), 82, fig. 5 and pl. XIXa.

30. See Chapter 2 above, pp. 68–69 and [103]. Later echoes of this ware will be seen, as well, in the Fayyum, Fez, Carthage, and Mertola.

31. Marilyn Jenkins, *Medieval Maghribi Ceramics: A Reappraisal of the Pottery Production of the Western Regions of the Muslim World*, Ph.D. diss., New York University, 1978, 83 and pl. VII, fig. S1; *The Art of Medieval Spain*, 75; and Marilyn Jenkins, 'Western Islamic Influences on Fatimid Egyptian Iconography', *Kunst des Orients* 10 (1975), 100, fig. 20. For the Egyptian version of such wares see G. T. Scanlon, 'Slip-painted Early Lead-glazed Wares from Fustat: A Dilemma of Nomenclature', *Colloque International d'Archéologie Islamique*, Cairo, 3–7 fevrier 1993, Institut Français d'Archéologie Orientale, *Textes Arabes et Etudes Islamiques* 36 (1998), 21–53, a category that is also related – as regards its decorative motifs – to the group represented by the dish [101].

32. *Al-Andalus*, cat. no. 28, pp. 234–35; Jenkins, *Medieval Maghribi Ceramics*, 89 and note 28, pl. XIX, fig. E2.

33. Marilyn Jenkins, 'Al-Andalus: Crucible of the Mediterranean' in *The Art of Medieval Spain*, 73–84 (esp. 75–77); *Medieval Maghribi Ceramics*, 106–11; 208–10; 'Western Islamic Influences', 91–107.

34. *Art of Medieval Spain*, cat. no. 52, pp. 102–03; Jenkins, *Medieval Maghribi Ceramics*, 129, note 130; pp. 197, 208–10; pl. C. At this period in the Byzantine capital as well as in provincial areas of the realm, glazed ceramic tiles were being employed as architectural decoration. Many of these were convex and were used as mouldings or served as engaged columns or capitals. Cf. E. S. Ettinghausen, 'Byzantine Tiles from the Basilica in the Topkapu Sarayi and Saint John of Studios', *Cahiers Archéologiques* 7 (1954), 79–88, and *Al-Andalus*, cat. no. 223.

35. For this see *Creswell, EMA* 2, 317–19, pls 89–90.

36. Unfortunately, modern restoration has obliterated the original composition.

37. See above, Chapter 2, note 192. The Arabic text of this passage and its translation is given in G. Marçais, *Les faiences à reflets métalliques de la grande mosquée de Kairouan* (Paris, 1928), 10.

38. M. S. Dimand, 'Studies in Islamic Ornament, I, Some Aspects of Omaiyad and Early 'Abbasid Ornament', *Ars Islamica*, 4, (1937), 294, figs 1–3,

where the piece is thought to be from Takrit, but Edmond Pauty pointed to a more likely Baghdad origin ('Sur une porte en bois sculpté provenant de Baghdad', *Bulletin de l'Institut Français d'Archéologie Orientale* 30 (1930), 77 and 81, pl. IV).

39. See the still very classical design of the vine *rinceaux* in the half-dome over the *mihrab* at Qayrawan; *Marçais, Architecture* (Paris, 1954), p. 53.

40. *Al-Andalus*, cat. no. 41; Musée du Petit Palais, *De l'empire romain aux villes impériales: 6000 ans d'art au Maroc*, exh. cat., Paris, 1990, 188–91; Stefano Carboni, 'The Historical and Artistic Significance of the Minbar from the Kutubiyya Mosque', in Jonathan Bloom *et al.*, *The Minbar from the Kutubiyya Mosque* (New York, 1998), 51–52 and figs 35 and 36.

41. For descriptions, transcriptions of inscriptions, and bibliographies, E. Kühnel, *Die islamischen Elfenbeinskulpturen, VIII.–XIII. Jahrhunderts* (Berlin, 1971), supercedes J. Ferrandis, *Marfiles arabes de occidente* I (Madrid, 1935). See also J. Beckwith, *Caskets from Cordoba* (London, 1960).

42. Kühnel, *Elfenbeinskulpturen*, 32–33, pl. VIII; *Al-Andalus*, cat. no. 2, p. 192.

43. Kühnel, *Elfenbeinskulpturen*, 33–34, pl. XII. This piece was formerly in the cathedral of Zamora.

44. Kühnel, *Elfenbeinskulpturen*, 38–39, no. 31, pls XVII, XVIII; *Al-Andalus*, cat. no. 3, pp. 192–97.

45. A recent, rather comprehensive, interpretation of the decoration on this pyxis is to be found in Francisco Prado-Vilar, 'Circular Visions of Fertility and Punishment: Caliphal Ivory Caskets from al-Andalus', *Muqarnas* 14 (1997) 19–42.

46. Kühnel, *Elfenbeinskulpturen*, 36–37, no. 28, pls XIII, XIV. This pyxis is signed by Khalaf, who also made a rectangular box with a flat cover for Subh in Madinat al-Zahra in 966.

47. W. Caskel, *Arabic Inscriptions in the Collection of the Hispanic Society of America* (New York, 1936), 35–36. In pre-Islamic times Arab poets had compared the female breast to the ivory boxes that were at that time made in foreign lands (I. Lichtenstadter, 'Das Nasib in der altarabischen Qaside', *Islamica* 5 (1931), 46); when in the tenth century a comparable stage of luxury and cultural achievement had been reached in an Arab milieu, the poet reversed the comparison. One verse also may suggest that the little drilled holes along the edges of the leaves may have contained jewels. If so, the colourful casket would have corresponded to a long oriental tradition, for instance the brightly hued wall decorations of Achaemenid palaces and the equally colourful painted stuccoes of Samarra.

48. Kühnel, *Elfenbeinskulpturen*, 41–43, no. 35, pls XXII–XXVI; *Al-Andalus*, cat. no. 4, pp. 198–201.

49. Kühnel, *Elfenbeinskulpturen*, 43–44, no. 36, pls XXIX–XXX.

50. *Arts of Islam*, exh. cat., Hayward Gallery, London, 1976, no. 145, and Jonathan M. Bloom, 'The Fatimids (909–1171), Their Ideology and Their Art', *Islamische Textilkunst des Mittelalters: Aktuelle Probleme 'Riggisberger Berichte' 5'* (1997), pp. 20–21 and fig. 2.

51. Yasser Tabbaa, 'The Transformation of Arabic Writing: Part 2, The Public Text', *Ars Orientalis* 24 (1994) 121–26. Similar tentative beginnings in the western lands of the Muslim world can likewise be seen on a contemporary carved ivory box from al-Andalus (cf. above p. 95 and note 42) and in the stippled and foliated angular inscription on 'Abd al-Malik's casket dated 1004/05 also discussed above and now in Pamplona.

52. Perry B. Cott, *Siculo-Arabic Ivories* (Princeton, 1939).

53. *Art of Medieval Spain*, cat. no. 38a, p. 94.

54. M. Jenkins and M. Keene, *Islamic Jewelry in the Metropolitan Museum of Art* (New York, 1983), no. 52.

55. *Al-Andalus*, cat. no. 17, p. 220.

56. Andalusian jewellery items from the succeeding, *taifa*, period also incorporate glass cabochons in their decoration; cf. Gomez-Moreno, *El arte arabe*, figs 402a, c. However, at this stage in our knowledge of glass production in the early Islamic period, we cannot be sure whether glass was being manufactured in al-Andalus itself or whether the glass objects found at Madinat al-Zahra and other sites in the peninsula (cf. *ibid.*, fig. 403) and that used for these glass cabochons were being imported from centres in Egypt, Syria, or Iraq. However, later Spanish glass production is well attested and famous. We know that glass vessels were in use in Andalusia after 821, the year in which the singer Ziryab came from Iraq to settle in Cordoba and 'the people of Andalus learnt from him to use vessels of fine glass, in preference to those of gold and silver' (Makkari, *Analectes sur l'histoire et la littérature des arabes en Espagne*, ed. R. Dozy *et al.* (Leiden, 1855–61, 2, 88)).

57. *Al-Andalus*, cat. no. 10, pp. 210–11; *Art of Medieval Spain*, 80; and Christie's London, *Islamic Art and Indian Miniatures*, auction cat., 25 April 1997, London, lot no. 259.

58. *Art of Medieval Spain*, 81, upper left and all of note 19, p. 84; *De Carthage à Kairouan*, exh. cat., Musée du Petit Palais, Paris, 20 octobre 1982–27 février 1983, no. 294.

59. *Al-Andalus*, 168.

60. *Art of Medieval Spain*, 74, 83, and Chapter 7, below, p. 278 and [456].

61. Large basins of water played equally important roles in the architecture of this period.

62. Cf. Gomez-Moreno, *El arte arabe*, fig. 395b; *Art of Medieval Spain*, 101–02, no. 50, and Archaeological Museum, Cordoba, no. D92.9.

63. See particularly the Tbilisi ewer, Chapter 2, above, p. 63 and [92].

64. *Masterpieces of Islamic Art in the Hermitage Museum*, exh. cat., Dar al-Athar al-Islamiyyah, Kuwait, 1990, cat. no. 3, pp. 10–11 in English section and p. 23 in Arabic–Russian section; and G. Fehervari, *Islamic Metalwork of the Eighth to the Fifteenth Century in the Keir Collection* (London, 1976), cat. no. 2, p. 33 and color pl. A and pl. Ia–d.

65. The head of the cock is very similar to that on a Spanish copper-alloy aquamanile in the Louvre, no. 1519, *Arts de l'Islam, des origines à 1700*, exh. cat., Paris, Orangerie des Tuileries, 22 juin–30 août 1971, no. 147. See also Oleg Grabar, 'About a Bronze Bird', in Elizabeth Sears and T.K. Thomas, *Reading Medieval Images: The Art Historian and the Object* (Ann Arbor, 2001).

66. Jonathan M. Bloom, 'Al-Ma'mun's Blue Koran', *Mélanges D. Sourdel*, ed. L. Kalus, published as *Revue des Etudes Islamiques* 54 (1986), 61–65; 'The Early Fatimid Blue Koran Manuscript' in François Déroche, ed., *Les manuscrits du moyen-orient: essais de codicologie et de paléographie* (Istanbul and Paris, 1989), 95–99, and 'The Early Fatimid Blue Koran Manuscript', *Graeco-Arabica* 4 (Athens, 1991), 171–78; *De Carthage à Qayrawan*, no. 350; Institut National d'Archéologie et d'Art, *30 ans au service du patrimoine: de la Carthage des Phéniciens à la Carthage de Bourguiba*, exh. cat., Tunis, 1986, no. IV.10; 'The Qur'an on Blue Vellum: Africa or Spain?', *The Qur'an and Calligraphy, a Selection of Fine Manuscript Material*, Bernard Quaritch, catalogue 1213 (1995), 7–15; and F. Déroche, *The Abbasid Tradition: Qur'ans of the 8th to the 10th Centuries A.D.* (London, 1992), no. 42, pp. 92–95.

67. Several individual folios written in ink on red-dyed parchment with silver ornamental devices are extant from the end of the eighth century. See *The Abbasid Tradition*, no. 11, and Los Angeles County Museum of Art, Los Angeles, M.2002.1.389, M.2002.1.390 (unpublished).

68. Brahim Chabbouh, 'Un ancien registre de la Bibliothèque de la Grande Mosquée de Kairouan', *Revue de l'Institut des Manuscrits Arabes* 2, fasc. II (Cairo, 1956), 339–74. This statement is in agreement with Bloom's finding but disagrees with that of the Quaritch catalogue. When Marilyn Jenkins-Madina was in Qayrawan in the spring of 1993, one *juz'* of the Blue Qur'an (it was not possible to ascertain whether or not it was complete) was still housed in Qayrawan – in the Musée des Arts Islamiques de Raqqada.

69. Alexandre Papadopoulo, *Islam and Muslim Art* (New York, 1979), colour pl. 117. Another parallel from the second half of the ninth century is the decoration on an *ansa* illuminating the Amajur Qur'an, one folio of which is illustrated [118]; cf. Déroche, 'Collections de manuscrits anciens du Coran à Istanbul: rapport préliminaire' in *Etudes médiévales et patrimoine turc*, pl. IIb.

70. Such a dating based on the illumination fits with that of Déroche for these pages that is grounded in the calligraphic style. However, Bloom's dating in the middle of the tenth century would not be precluded if the entire manuscript was *retardataire*. More work still remains to be done on this seemingly unique manuscript. See also Yasser Tabbaa, 'The Transformation of Arabic Writing: Part I, Qur'anic Calligraphy', *Ars Orientalis* 21 (1991), 143.

71. See Déroche, 'Collections de manuscrits anciens du Coran à Istanbul: rapport préliminaire' in *Etudes médiévales et patrimoine turc*.

72. Déroche, *The Abbasid Tradition* 34 and 132–37. Déroche has proposed substituting the term 'Abbasid scripts' for the old designation 'Kufic' as regards any description of the types of Arabic script that supplanted *hijazi*. He has divided the 'Abbasid scripts' into the 'Early Abbasid styles' and the 'New Style'. Except for the 'Early Abbasid Style' which she has called simply angular script (see also Chapter 2, above, pp. 74–75, and [117, 118], Marilyn Jenkins-Madina has adopted Déroche's terminology. Yasser Tabbaa, 'Transformation', part I, note 33, states that Déroche's term 'New Abbasid' or 'New Style' is 'perhaps the most appropriate since it seems to refer to the reforms of Ibn Muqla, who was almost certainly behind the development of this script or group of scripts'.

73. Tabbaa, 'Transformation', part I, 130, characterizes Qur'ans written in the 'New Style' script as, for the most part, differing from those executed in the 'Early Abbasid' script also in their medium, format, diacritical marks, and verse count.

74. Quaritch catalogue, 9.

75. *Arts of Islam*, no. 506 and *De Carthage à Qayrawan*, no. 321.

76. G. Marçais and L. Poinssot, *Objets kairouanais, IX au XIII siècle, reliures, verreries, cuivres et bronzes, bijoux* (Tunis, 1948), no. 64, pp. 142–44, fig. 28. The important cache of bindings found by Poinssot in the Great Mosque of Qayrawan is discussed in this publication.

77. See Goitein, *A Mediterranean Society*, vol. 1, 112, for an eleventh-century letter citing the importance of Tunisia *vis-à-vis* the leather industry in general and the production of bindings in particular.

78. *Al-Andalus*, 177, fig. 3.

79. Jenkins, *Medieval Maghribi Ceramics*, 73.

80. See, however, the essays, many very thoughtful ones, by various authors in Jerrilynn Dodds, ed., *Al-Andalus* (New York, 1992), and J. Dodds, 'The Arts of al-Andalus' as well as other essays in the volume edited by S. K. Jayyusi, *The Legacy of Muslim Spain* (Leiden, 1992).

81. For instance, Luis Caballero Zoreda, 'Un canal de transmición de lo classico' *Al-Qantara* 15 and 16 (1994–95).

82. See, however, the analyses by R. Holod in Dodds, *Al-Andalus*, and F. Prado-Vilar, 'Circular Visions of Fertility and Punishment: Caliphal Ivory Caskets from al-Andalus', *Muqarnas* 14 (1997), pp. 19–42.

83. The elaboration of this complex world owes much to Dodds, *Architecture and Ideology*.

84. Marguerite van Berchem, 'Sedrata, un chapitre nouveau de l'histoire de l'art musulman', *Ars Orientalis* 1 (1952).

CHAPTER 4

1. R. N. Frye, ed., *The Cambridge History of Iran* 4, *From the Arab Invasion to the Seljuqs* (Cambridge, 1975), provides basic historical and cultural information about Iran, including a chapter on the arts by O. Grabar, 329–63.

2. George C. Miles, *The Numismatic History of Rayy* (New York, 1938) and E. J. Keall, 'The Topography and Architecture of Medieval Rayy,' *Akten VII Kongress für Iranistik* (Munich, 1979). Most of the archives are at the University Museum in Philadelphia and the Oriental Institute in Chicago.

3. This conclusion may well be modified by ongoing archeological activities such as the surveys and excavations being carried out in Merv.

4. Al-Narshakhi, *The History of Bukhara*, trans. R. N. Frye (Cambridge. 1954), 48ff.; for Nishapur, al-Muqaddasi, *Ahsan al-Taqalim* (Leiden, 1906), 316, with a curious dome in the mosque; for Qum see the anon. *Tar'ikh-i Qum* (Tehran, 1934), 37–38; for Shiraz, Donald N. Wilber, *The Masjid-i 'Atiq of Shiraz* (Shiraz, 1972). For a recent survey see B. Finster, *Frühe Iranischen Moscheen* (Berlin, 1994).

5. Eugenio Galdieri, *Isfahan: Masğid-i ğuma*, 3 vols (Rome, 1972–73); O. Grabar, *The Great Mosque of Isfahan* (New York, 1990).

6. Summaries in A. Godard, 'Historique du Masjid-e djuma', *Athar-e Iran* I (1936), 216ff.

7. See below, pp. 140–141.

8. Main publication by A. Godard, 'Le Tari-khana de Damghan', *Gazette des Beaux-Arts* 12 (1934); *Survey* 2, 933–34.

9. *Survey* 2, 934–39.

10. K. Pirnia, 'Masjid-e jami-e Fahraj', *Bastan-Chenassi va Honar-e Iran* 5 (1970), 2–14; Bianca M. Alfieri and Ricardo Zipoli, 'La moschea gami de Fahrag', *Studi iranici* (Rome 1977), 41–76; R. Hillenbrand, 'Abbasid Mosques in Iran', *Rivista di Studi Orientali* 59 (1985). For an overview see A. Hutt, *Iran* (London, 1977).

11. It is not absolutely certain that the present domes, two of which are later, necessarily correspond to earlier ones.

12. Copious bibiliography in Russian. Main description by A. Iu. Iakubovskij in *Gos. Ermitazh, Trudy otdela Vostoka* 2 (1940), 113ff., who dates it no later than the ninth century. V. A. Nilsen, *Monumentalnaia arkhitektura Bukharskovo oazisa* (Tashkent, 1956), 27ff., proposes an eleventh-century date. Both authors use ceramic evidence for their dates but do not describe the evidence. The foundation of the small mosque at Bukhara known as the Magoki Attari may also be of the tenth century. For all these buildings see now S. Khmelnitskii, *Mezhdu Arabami i Tiurkami* (Berlin and Riga, 1992), esp. pp. 72 and ff., and *Mezhdu Samanidami i Mongolami* (Berlin and Riga, 1996), esp. 69 and ff. for a large number of related buildings.

13. Lisa Golombek, 'Abbasid Mosque at Balkh', *Oriental Art* 15 (1969), 173–89.

14. Above, p. 29, and p. 87.

15. A. Godard, 'Les Anciennes Mosquées de l'Iran', *Athar-é Iran* 1 (1936), 185–210; also in *Third International Congress on Persian Art* (Leningrad, 1939), 70–77, summarized in *L'Art de l'Iran* (Paris, 1962), 340ff.

16. For Yazd-i Khwast see M. Siroux, 'Le Masjid-e jumeh de Yazd', *Bulletin de l'Institut Français d'Archéologie Orientale* 44 (1947).

17. J. Sauvaget, 'Observations sur quelques mosquées', *AIEO* 4 (1938); answer by Godard in *Arts Asiatiques* 2 (1956), 48–97.

18. Discussion in O. Grabar. 'The Earlier Islamic Commemorative Structures', *Ars Orientalis* 6 (1966), 7–46.

19. E. Diez, *Churasanische Baudenkmäler* (Berlin, 1918), 7–46.

20. Below, pp. 195–97.

21. The best description in English is by L. Rempel in *Bulletin of the American Institute for Persian Art and Archaeology* 4 (1936), pp. 198–208; all later Russian discussions are taken into consideration by S. Khmelnitski, esp. *Mezhdu Arabami*, 125ff.

22. E. Schroeder in *Survey* 2, 946.

23. Often reproduced as in *Survey* 1, 535 (drawing and discussion) and pl. 237.

24. A. Iu. Iakubovskij and others, *Zhivopis Drevnego Piandshikenta* (Moscow, 1954), pl. xx; O. Grabar, 'The Islamic Dome, Some Considerations', *Journal of the Society of Architectural Historians* 22 (1963).

25. G. A. Pugachenkova, *Mavzolei Arab Ata* (Tashkent, 1963); Khmelnitski, *Mezhdu Arabami*.

26. For references see Grabar in *Earliest Commemorative Monuments* and now the two recent books by S. Khmelnitski which contain additional buildings and discussions; for Baba Khatun, *Mezhdu Samanidami*, 188 ff.

27. Diez, *Churasanische Bandenkmäler*; Godard in *Survey* 2, 970.

28. Charles T. Wilkinson, *Nishapur, Some Early Islamic Buildings and their Decoration* (New York, 1982).

29. These establishments were discovered during several surveys carried out by Soviet academies in the 1940s, 1950s, and 1960s (led by S. P. Tolstov, G. A.. Pugachenkova, E. Masson, and others). They are summarized and harmonized in the two volumes by Khmelnitski.

30. Wilkinson, *Nishapur* with references to older publications and discussions, especially those by W. Hauser in *Bull. MMA* 32 (1938) and subsequent years.

31. I. Ahrarov and L. Rempel, *Reznoi Shtuk Afrasiaba* (Tashkent, 1971). Major Franco–Russian–Uzbek excavations in Afrasiab have brought to light stunning paintings of this time.

32. André Godard, 'The Jurjir Mosque in Isfahan', *SPA* 14, 3100–03. For its inscription and other comments see Grabar, *Great Mosque of Isfahan*, pp. 47–49.

33. *Hillenbrand, Islamic Architecture*, had devoted a large and rich chapter to this function.

34. The International Merv Project has conducted six seasons (beginning in 1992) of archaeological fieldwork in the ancient and medieval cities of Merv in two three-year collaborations. Two of the excavations initiated to date have focused on Islamic levels, one of the Early Islamic period and the second from the Early and Late Medieval Islamic periods. That of the earliest Islamic period has been completed and is being prepared for publication; that of the two later Islamic periods is still ongoing. As we go to press, a new five-year plan is being inaugurated that will take the excavation to 2002.

35. Z. Maysuradze, *Keramika Afrasiaba* (Tbilisi, 1958); C. K. Wilkinson, 'The Glazed Pottery of Nishapur and Samarkand', *Bull. MMA*, N.S. 20 (1961), 102–15; Sh. S. Tashkhodzhaev, *Khudozhestvennaia polivnaia keramika Samarkanda: IX – nachala XIII vv* (Tashkent, 1967); *Terres secrètes de Samarcande, céramique du VIIIe au XIIIe siècle*, exh. cat., Institute du Monde Arabe, Paris, 26 juin–27 septembre 1992.

36. C. K. Wilkinson, *Nishapur: Pottery of the Early Islamic Period* (New York, 1973).

37. J. C. Gardin, *Céramiques de Bactres* (Paris, 1957); *Mémoires de la Délégation Archéologique Française en Afghanistan* 18, *Lashkari Bazar: une résidence royale ghaznevide et ghoride* (Paris, 1964–78) 2; Gardin, *Les Trouvailles: céramiques et monnaies de Lashkari Bazar et de Bust* (Paris, 1963).

38. Wilkinson, *Nishapur*, 194–98. See Chapter 3, above, pp. 93, 94, for a discussion of the imitations of this same Iraqi type in the western Islamic lands.

39. M. Pezard, *La Céramique archaique de l'Islam et ses origines* (Paris, 1920), pls XCI and XCVIIIB; Pope, *Survey* 5, pls 562B and 563; and M. Jenkins, 'Islamic Pottery', *Bull. MMA* 40:4 (1983), figs 6 and 7.

40. See Chapter 2, above, p. 70.

41. See, for instance, Wilkinson, 'The Glazed Pottery of Nishapur and Samarkand,' 105, fig. 6.

42. Abdullah Ghouchani, *Inscriptions on Nishabur Pottery* (Tehran, 1986) is an important source for the inscriptions found on this pottery type. Those objects discussed in nos 59, 32, 42, 52, and 25 bear the specific inscriptions mentioned here. See also Oleg Grabar, book review, *Epigrafika Vostoka* (Oriental Epigraphy), 1–8, ed. V. A. Krachkovskaia, *Ars Orientalis* 2, esp. 556.

43. R. Sellheim, *Die klassisch-arabischen Sprichwortersammlungen insbesondere des Abu Abaid* (The Hague, 1954).

44. See above, p. 118. For a reading of the inscription on the bowl in [189] see Ghouchani, *Nishabur Pottery* no. 23. For an interesting sociological interpretation of several of these pottery styles cf. Richard W. Bulliet, 'Pottery Styles and Social Status in Medieval Khurasan', in A. Bernard Knapp, ed., *Archaeology, Annales, and Ethnohistory* (Cambridge, 1992), 75–82.

45. R. Ettinghausen, 'The 'Wade Cup' in the Cleveland Museum of Art, Its Origin and Decorations', *Ars Orientalis* 2 (1957), 356–59, text figure w, and pl. 8, fig. 23.

46. A. Lane, *Early Islamic Pottery* (London, 1947), pl. 16A, and Wilkinson, *Nishapur*, 172, no. 14.

47. Pope, *Survey* 5, pl. 621. This variety of pottery was previously known as Sari.

48. For some useful literature on this question see R. J. Charleston, 'A Group of Near Eastern Glasses', *Burlington Magazine* 81 (1942), 212–18; A.

von Saldern, 'An Islamic Carved Glass Cup in the Corning Museum of Glass', *Artibus Asiae* 18 (1955), 257–70; P. Oliver, 'Islamic Relief Cut Glass: A Suggested Chronology', *Journal of Glass Studies* 3 (1961), 9–29; K. Erdmann, 'Neuerworbene Gläser der islamischen Abteilung', *Berliner Museen* 11 (1961), 35–39, figs 4–11. See also A. A. Abdurazakov, 'Medieval Glasses from the Tashkent Oasis', *Journal of Glass Studies* 11 (1969), 31–36. The most recent general discussion is M. Jenkins, 'Islamic Glass', *Bull. MMA* 44:2 (1986). See also J. Kroger, *Nishapur: Glass of the Early Islamic Period* (New York, 1995), 137–46, and *Glas*, Berlin, Staatliche Museen Preussischer Kulturbesitz, Museum für Islamische Kunst (Mainz am Rhein, 1984), cat. nos 193–97. See Chapter 6, below, pp. 206–7, notes 85, 94.

49. An Jiayao, 'Dated Islamic Glass in China', *Bulletin of the Asia Institute*, N.S. 5 (1991), 123–38. In this article the author states that 'It is not coincidental that much of the glass found in China is similar to that of [found at] Nishapur. And, to go a further step, we may see this glass as the product of Iranian workshops and shipped to China via the Silk Road.' At this juncture in our study of glass production in the Muslim world, however, the possibility that this dish and the six found in the Famen Temple were made west of Iran cannot yet be ruled out since other complete and fragmentary vessels so decorated have been found also in Egypt, Syria, and Iraq.

50. *Masterpieces of Islamic Art in the Hermitage Museum*, exh. cat., Dar al-Athar al-Islamiyyah, Kuwait, 1990, no. 19, p. 14 and V. Loukonine and Anatoli Ivanov, *Lost Treasures of Persia, Persian Art in the Hermitage Museum* (Washington, DC, 1996), no. 96, p. 118.

51. R. Harari, 'Metalwork After the Early Islamic Period', *Survey* 3, 2482, fig. 811a, b; Ettinghausen, 'The "Wade Cup"', 338, 339 and fig. H; Phyllis Ackerman *et al.*; *Exhibition of Persian Art*, (New York, The Iranian Institute, 1940), p. 329D; G. Wiet, *L'Exposition persane de 1931* (Cairo, 1933), 17–18, no. 7 and pl. IV, no. 7.

52. The single inscription band 3.0 cm. wide encircling the interior wall just below the rim (not indicated in the drawing seen here) consists of aphorisms, according to Dr Abdullah Ghouchani, Musée Iran Bastan, Tehran. The often-stated fact that the single inscription band 2.5 cm. wide encircling the exterior wall just below the rim consists of standard pious expressions and the phrase *amal Abu-Nasr Muhammad ibn Ahmad al-Sijzi* is hereby confirmed.

53. For the dating of this and the next object on epigraphic grounds see Max van Berchem, 'Inscriptions mobilières arabes en Russie', *Journal Asiatique*, 10 sér. 14 (1909), 402–03, nos 127, 128.

54. Y. I. Smirnov, *Vostochnoe Serebro: Argenterie Orientale* (St. Petersburg, 1909), pl. LXX; J. Bloom and S. Blair, *Islamic Arts* (London, 1997), 116, fig. 64.

55. Simpler versions of this type exist in base metals. The most common of these are the copper-alloy hemispherical vessels with simple, usually all-over, compartmentalized patterns such as can be seen in Ettinghausen, 'The "Wade Cup"', pls 4–7, figs 13–17, 21.

56. Wiet, *L'Exposition persane*, 10–21, nos 8–14, pls Ib, II, III.

57. James Allan, *Nishapur: Metalwork of the Early Islamic Period* (New York, 1982), 27 and 60–61, no. 1.

58. This form was ubiquitous during this and the succeeding period and is found in several different media.

59. Krishna Riboud, 'A Newly Excavated Caftan from the Northern Caucasus', *Textile Museum Journal* 4:3 (1976), 21–42. See also P. O. Harper, *The Royal Hunter: Art of the Sasanian Empire* (New York, 1978), cat. no. 60, and the hippogriff in stucco from Qasr al-Hayr al-Gharbi, K. A. C. Creswell, *EMA* 1, part 2 (New York, 1979), pl. 86e. For a slightly later Byzantine example with identical prototypes cf. *The Glory of Byzantium: Art and Culture of the Middle Byzantine Era, A.D. 843–1261*, exh. cat., New York: Metropolitan Museum of Art, 1997, cat. no. 148. The textile [94] and that discussed in Chapter 2 above, p. 64, also evolved from the same Sasanian prototypes. See also Harper, *Royal Hunter*, cat. nos 57–59 and James C. Y. Watt and Anne E. Wardwell, *When Silk was Gold: Central Asian and Chinese Textiles* (New York, 1997), cat. no. 5.

60. See textile depicted [180].

61. E. Combe, J. Sauvaget, and G. Wiet, eds, *Répertoire chronologique d'épigraphie arabe* (Cairo, 1933) 4, no. 1507, with bibliographical data. M. Bernus, H. Marchal, and Gabriel Vial, 'Le Suaire de Saint-Josse – Musée de Louvre, Dossier de recensement', *Bulletin de Liaison du Centre International d'Etude des Textiles Anciens* 33 (Lyons, 1971), 22–57.

62. J. H. Schmidt, 'Persian Silks of the Early Middle Ages', *Burlington Magazine* 57 (1930), 290, pl. IIIA; G. Wiet, 'Un tissu musulman du nord de la Perse', *Revue des Arts Asiatiques* 10 (1936), 173–79.

63. This fragment belongs to a series of silk textiles that were among the marvels of the early Islamic world and, as such, were copied far and wide. For the best synopsis known to Marilyn Jenkins-Madina of the 'Buyid silk' problem see: Louise W. Mackie, 'Increase the Prestige: Islamic Textiles', *Arts of Asia* 26:1 (January–February 1996), 87–89. See also Sheila S. Blair, Jonathan M. Bloom, and Anne E. Wardwell, 'Reevaluating the Date of the "Buyid" Silks by Epigraphic and Radiocarbon Analysis', *Ars Orientalis* 22 (1993), 1–42.

We are considerably less informed as regards objects made for and used by the various courts in the eastern Islamic lands than we are about those that were executed for a wealthy middle class – the category into which the vast majority of the objects discussed in this chapter fall. Contemporary texts such as that by Ibn al-Zubayr are tantalizingly rich, appearing to be full of information but, in fact, being general to a fault upon closer examination. Cf. Ghada H. Qaddumi, *Book of Gifts and Rarities (Cambridge, MA, 1996)*, paragraphs 70 and 75.

64. See Chapter 2, above, pp. 76, 78 [121, 122].

65. For a discussion of the early history of paper, with full bibliography, see N. Abbott, 'A Ninth-Century Fragment of the "Thousand Nights", New Light on the Early History of the Arabian Nights', *Journal of Near Eastern Studies* 8 (1949), 144–49. Now see also A. Grohmann, *Arabische Paläographie* (Graz, 1967), 105 ff. and Jonathan Bloom, 'Paper in the Islamic Lands', *Aramco World Magazine* (in press).

66. F. E. Karatay, *Istanbul Universitesi Kutuphansei: Arapca yazmalar katalogu* 1 (Istanbul, 1951), 3, 8, pl. v. See also D. S. Rice, *The Unique Ibn al-Bawwab Manuscript in the Chester Beatty Library* (Dublin, 1955), 9–10, and Tabbaa, 'Transformation' part I, 127 and figs 8, 9.

67. Almost all of the Qur'an manuscripts written in the 'New Style' scripts were executed in paper instead of parchment except for those produced in the Maghrib.

68. For a Carolingian version in the Hellenistic tradition see G. Thiele, *Antike Himmelsbilder* (Berlin, 1898), 105–07, fig. 31.

69. For the author see S. M. Stern, "Abd al-Rahman b. 'Umar al-Sufi', *Encyclopedia of Islam* 1, 2nd ed. (Leiden, 1954), 86–87; for the Oxford manuscript and later versions see E. Wellesz, 'An Early al-Sufi Manuscript in the Bodleian Library in Oxford', *Ars Orientalis* 3 (1959), 1–26. A colour reproduction of the constellation Virgo can be found in R. Ettinghausen, *Arab Painting* (Geneva, 1962), 51. Another early manuscript, dated 1005–11, also copied from the author's holograph is in St Petersburg.

70. O. G. Bolshakov, A. M. Belenitski, and I. V. Bentovich, *Srednevekovyi Gorod Srednei Azii* (Leningrad, 1973).

71. L. Golombek, 'Draped Universe', P. Soucek (ed.), *Content and Context* (University Park, 1988).

72. L. Bier, *Sarvistan, a Study in Early Iranian Architecture* (University Park, PA, 1986).

73. A. S. Melikian-Chirvani, 'Le Royaume de Salomon', *Le Monde Iranien et l'Islam* 1 (1971).

74. G. Qaddumi, *Book of Gifts*, pp. 159–62. The only problem with this account is its similarity to the account of the show put together by the Abbasids to greet the Byzantine ambassador. The practice as such may well have been repeated, but the description of what was shown may well have become standardized in literary accounts.

75. The most prolific of the scholars involved is G. A. Pugachenkova, but the fullest statements for the originality of the arts of Central Asia have been made by L. Rempel and later M. S. Bulatov.

PART TWO: PROLOGUE

1. The best introduction consists in the chapters written by H. A. R. Gibb, B. Lewis, and C. Cahen in K. M. Setton, ed., *A History of the Crusades* 1 and 2 (Philadelphia, 1958–62). Since then the following have added significantly either to information about this period or to its interpretation: Marshall Hodgson, *The Venture of Islam* (Chicago, 1974), esp. 1–368; D. H. Richards, ed., *Islamic Civilisation 950–1150* (Oxford, 1973); J. A. Boyle, ed., *The Cambridge History of Iran* 5 (Cambridge, 1968) and many entries in the *Encyclopedia of Islam*. For the Fatimids see Hans Halm, *The Fatimids and Their Tradition of Legitimacy* (London, 1997).

2. D. Wasserstein, *The Caliphate in the West* (Oxford, 1993); U. Rubin and D. Wassestein, *Dhimmis and Others: Jews and Christians in the World of Islam* (Winona Lake, IN, 1997); P. Scales, *The Fall of the Caliphate of Cordoba* (Leiden, 1994); T. Glick, *From Muslim Fortress to Christian Castle* (Manchester, 1995).

3. C. Cahen, 'Mouvements populaires et autonomisme urbain', *Arabica* 5 and 6 (1958–59).

4. See J. Pedersen, 'Masjdid', *Encyclopedia of Islam*, part I, sections E and F, part III. For a more recent statement on the teaching done in the *madrasas* see G. Makdisi, 'Muslim Institutions of Learning', *Bulletin of the School of Oriental and African Studies* 34 (1961); J. Sourdel-Thomine, 'Locaux d'enseignement', *Revue des Etudes Islamiques* 44 (1976); and D. Sourdel, 'Reflexions sur la diffusion de la madrasa en Orient', *Revue des Etudes Islamiques* 44 (1976); G. Makdisi, *The Rise of Colleges* (Edinburgh, 1981).

5. For texts a notable exception is K. Erdmann, *Ibn Bibi als kunsthistorische Quelle* (Istanbul, 1962); for inscriptions, at least for Iran, see now S. Blair, *The Monumental Inscriptions from Early Islamic Iran and Transoxiana* (Leiden, 1992).

CHAPTER 5

1. Few of these buildings have been properly published; photographic surveys (generally incomplete), plans, and partial descriptions can best be found in several articles by A. Godard in *Athar-é Iran* 1 (1936), and in E. Schroeder's contribution to *SPA*, 981 ff., with a large number of photographs and plans. The only well-published monument is Barsian, by M. B. Smith in *Ars Islamica* 4 (1937). For Isfahan see E. Galdieri, *Isfahan: Masgid-i guma*, 3 vols (Rome, 1972, 1973, and 1984), and O. Grabar, *The Great Mosque of Isfahan* (New York, 1990). Sauvaget's remarks in *AIEO* 4 (1938), 82 ff., have not lost their pertinence. Among more recent and quite thorough investigations are Robert Hillenbrand, 'Seljuq Dome Chambers in Northwest Iran', *Iran* 14 (1976); D. Wilber, 'Le Masğid-i ğami de Qazwin', *Revue des Etudes Islamiques* 41 (1973); J. and D. Sourdel, 'Inscriptions seljoukides', *Revues des Etudes Islamiques* 42 (1974), 3–43; S. R. Peterson, 'The Masjid-i Pa Minar in Zavareh', *Artibus Asiae* 39 (1978); C. Adle, 'Le Minaret du masjid-é jome de Semnan', *Studia Iranica* 4 (1975). Nearly every travel or survey (for instance the series published in *Archaeologische Mitteilungen aus Iran* or the many volumes of the Historical Society of Iran devoted to individual cities and provinces, e.g. I. Afshar, *Yadgarha-i Yazd* (Tehran, A.H. 1354), contains important information.

2. A. Lézine, 'Hérat', *Bulletin d'Etudes Orientales* 18 (1964).

3. D. Schlumberger, 'Le Palais ghaznévide de Lashkari Bazar', *Syria* 39 (1952), fig. 1; Schlumberger *et al.*, *Lashkari Bazar* (Paris, 1978), iA, 67–70, 23.

4. G. A. Pugachenkova, *Puti razvitia arkhitektury iuzhnogo Turkmenistana* (Moscow, 1958), 245 ff.; R. Hillenbrand, 'Saljuq Monuments of Iran III', *Kunst des Orients* 5–10 (1976), 9; for all mosques in Central Asia see now S. Hmelnitski, *Mezhdu Samanidami i Mongolami* (Riga and Berlin, 1996).

5. V. A. Nilsen, *Monumentalnaia Arkhitektura Buharoskogo Qazisa* (Tashkent, 1956), 70 ff.

6. For Damghan see C. Adle and A. S. Melikian-Chirvani, 'Les Monuments du xIème siècle au Damqan', *Studia Iranica* 1 (1972).

7. G. A. Pugachenkova and L. I. Rempel, *Vydaiuchtiecia Pamiatniki arkhitektury Uzbekistana* (Tashkent, 1958), 155 ff.

8. Known from a minaret; see below, p. 150.

9. In addition to the ones mentioned in note 5, A. Gabriel, 'Le Masdjid-i djumah d'Isfahan', *Ars Islamica* 2, part I (1935), and E. Galdieri, 'Précisions sur le Gunbad-e Nizam al-Mulk', *Revue des Etudes Islamiques* 43 (1975).

10. Above, pp. 105–6.

11. The best photograph of this part is fig. 174 in A. Godard, *Athar-e Iran* 1 (1936).

12. All the inscriptions are published in E. Combe *et al.*, *Répertoire chronologique d'épigraphie arabe* (Cairo, 1931–54), nos 2775, 2776, and 2991; and S. Blair, *Monumental Inscriptions*, 106 and ff.

13. Ibn al-Athir, *Tarikh*, sub anno 442; Grabar, *Great Mosque*, 55.

14. This part of the mosque, to the left of the present entrance, may have served as a sort of deposit for earlier fragments. Its archeological investigations have not yet been made available.

15. Abu Nu'aym, *K. Akhbar Isfahan*, ed. Sven Dedering (Leiden, 1931–34), 17–18.

16. Galdieri's reconstruction in *Revue des Etudes Islamiques* is archaeologically reasonable but its visual implications are not satisfactory.

17. This was the explanation proposed by Sauvaget in *AIEO* 4 (1938), 82 ff.; other equally unprovable possibilities are given by Blair, *Monumental Inscriptions*, p. 166, and Grabar, *Great Mosque*, 53 ff.

18. Aby Nu'aym, *K. Akhbar Isfahan*; al-Mafarrukhi, *Kitab-e Mahhassin-e Isfahan* (Tehran, 1933), 84 ff.

19. The contemporaneity of the four *iwans* is far from proved, and only the archeological investigation interrupted by the Iranian revolution would have provided a definitive answer to the query.

20. At Ardistan these include two dates and remains from an earlier mosque; the most sensible explanation has been provided by Sauvaget; see also Blair, *Monumental Inscriptions*, 52.

21. A. Godard discovered it; *Athar-e Iran* 1 (1936), 298 ff. See also Peterson, 'The Masjid-i Pa Minar'.

22. The size of the piers varies from place to place, and often instead of barrel-vaults domes were used.

23. Below, p. 153.

24. The theory has been stated categorically only in A. Godard, 'L'Origine de la madrasa', *Ars Islamica* 15–16 (1951), 1 ff.; its elements can be found in M. van Berchem, *Matériaux pour un Corpus Inscriptionum Arabicarum*, 1, *Egypte* (Cairo, 1899 ff.), 1, 265–66; E. Herzfeld, 'Damascus', *Ars Islamica* 9 and 10 (1942 and 1943), *passim*; see also Pedersen, 'Masdjid'. Hillenbrand, *Architecture*, has devoted a whole chapter to the problems of the *madrasa*.

25. A. Talas, *La Madrasah Nizamiyya* (Paris, 1939), 27–28; Mustafa Jawad, 'Al-Madrasah al-Nizamiyya', *Sumer* 9 (1953), 317–42.

26. Creswell, *MAE* 2 104 ff.; Pugachenkova, *Puti*, 341 ff. For Khargird see the comments on the inscriptuion by Blair, *Monumental Inscriptions*, 149 ff. The

earliest archeologically retrieved *madrasa* is supposed to be the one discovered by Nemtseva in Samarqand; see N. B. Nemtseva, 'Istoki Kompositsii i etapy formirovaniya Ansabla Shakhi-Sinda', trans. J. M. Rogers, *Iran* 15 (1977). Her functional identification and dating of the excavated remains to the middle of the eleventh century are possible, but the reconstruction of the building's plan is very uncertain and some doubt exists about the correctness of her identification. The next known *madrasa* is in the mountains of Afghanistan; see M. J. Casimir and B. Glatzer, 'Šah-i Mashad', *East and West* 2 (1971).

27. Pugachenkova, *Puty*, 260–64; M. E. Masson, 'O nadpice', *Epigrafika Vostoka* 7 (1953), 7 ff.; Hmelnitski, *Mezhdu Samanidami i Mongolami*, 73.

28. F. Sarre, *Denkmäler persischer Baukunst* (Berlin, 1901/1910), 13 ff.. Ch. Adle, 'Damghan' in *Encyclopaedia Iranica*; Blair, *Monumental Inscriptions*, 93 and 123.

29. Sarre, *Denkmäler*, 56–57; Ch. Adle, 'Notes sur Rey', in *Mélanges Jean Perrot* (Paris, 1990).

30. *SPA*, pl. 335.

31. In more than one instance, including the Kharraqan 'towers', the distinction between tower and canopy has been blurred, and one of the problems of Iranian mausoleums is precisely one of devising an appropriate typology and the vocabulary to go with it. See R. Hillenbrand in many studies based on his monumental doctoral dissertation at Oxford and the fundamental work by Abbas Daneshvari, *Medieval Tomb Towers of Iran: An Iconographical Study* (Lexington, KY, 1986).

32. Pugachenkova, *Puty*, 286; see also R. Hillenbrand, 'Saljuq Monuments in Iran II', *Iran* 10 (1970), for the Takistan example datable in two phases, c.1100 and 1174–75.

33. For Sangbast see D. Sourdel and J. Sourdel-Thomine, 'A propos des monuments de Sangbast', *Iran* 17 (1979). For Yazd see R. Holod, 'The Monument of Duvazdah Imam in Yazd', in D. K. Kouymjian, ed., *Studies in Honor of George C. Miles* (Beirut, 1974); I. Afshar, *Yadgarha-i Yazd* (Tehran, A.H. 1354) 2, 311 ff., and Blair, *Monumental Inscriptions*, 103.

34. D. Stronach and T. Cuyler Young, Jr, 'Three Octagonal Seljuq Tomb Towers from Iran', *Iran* 4 (1966), 39–22; S. M. Stern, 'The Inscriptions of the Kharraqan Mausoleums', *Iran* 4 (1966); Blair, *Monumental Inscriptions*, 134–35, 172–73.

35. Pugachenkova, *Puti*, 315–28; Hmelnitski, *Mezhdu*, 247. The ongoing exploration of Merv by a joint British-Russian-Turkmen expedition is bound to bring out additional and accurate information on this striking monument.

36. A. Godard, *Les Monuments de Maragha* (Paris, 1934). *Arkhitektura Azerbayjana epoha Nizami* (Baku, 1947) has excellent summaries on most monuments; for a concise analysis of their significance see L. C. Bretanitskij, *Zodchestvo Azerbayjana XII–XV vv* (Leningrad, 1961). The Nakichevan mausoleums were described by Sarre, *Denkmäler*, 9 ff.

37. A. M. Pribytkova, *Pamiatniki arkhitektury XI veka v Turkmenii* (Moscow, 1955), 6–38; O. Grabar, *Ars Orientalis* 2 (1957), 545; E. Diez, *Khorasan* (Munich, 1923); Hmelnitski, 196–97.

38. E. Cohn-Wiener, *Turan* (Berlin, 1930), 34–6, pls x ff.

39. J. Sourdel-Thomine, 'Deux minarets d'époque seljoukide en Afghanistan', *Syria* 30 (1953), 131 ff., which includes only northeastern Iranian minarets; for an earlier list see M. B. Smith, 'The Manars of Isfahan', *Athar-e Iran* 1 (1936), 316, note 2; Diez, *Khorasan*, 166–67; G. C. Miles, 'Inscriptions on the Minarets of Saveh', in K. Brisch, ed., *Studies for Professor K. A. C. Creswell* (Cairo, 1965). R. Hillenbrand, *Architecture*, has devoted a whole chapter to minarets and J. Bloom has proposed original explanations for their appearance in Iran.

40. There are still problems around the exact terminology used in the past for these towers, now called *manars*; Max van Berchem in Diez, *Churasanische Baudenkmäler* (Berlin, 1918), 112 ff. and Bloom, *Minaret*, 157 ff.

41. A. Maricq and G. Wiet, *Le Minaret de Djam* (Paris, 1959).

42. E. Diez, 'Siegesthurme in Ghazna', *Kunst des Orients* 1 (1950); G. Azarpay, 'The Islamic Tomb Tower', in A. Daneshvari, ed., *Essays in Islamic Art and Architecture* (Malibu, 1981).

43. Pugachenkova, *Puty*, 184 ff.; A. M. Belenitskii, I. B. Bentovich, and O. G. Bolshakov, *Srednevekovyi Gorod Srednei Azii* (Leningrad, 1973), esp. 132 ff.; Hmelnitski.

44. Belenitsky *et al.*, *Srednevekovyi Gorod*, 203 ff.

45. Schlumberger, *Lashkari Bazar et al.*, 89 ff., and esp. pls 3 and 25 ff.; T. Allen, 'Notes on Bust', *Iran* 26–28 (1988–90).

46. Architectural remains published in *Trudy Akedmiy Nauk Uzbek SSR*, ser. 1, 2 (Tashkent, 1945), 133 ff.; stucco in B. P. Denike, *Arhitekturnyi ornament Srednei Azii* (Moscow, 1939), 49 ff.

47. Still unpublished in their details; see A. Bombaci, *The Kufic Inscription . . . in the . . . Royal Palace of Mas'ud III at Ghazni* (Rome, 1966).

48. *SPA*, pls 271–72; I. I. Umniakov, 'Rabat-i Malik', *V. V. Bartoldy Turkestanskie Druzia (Festschrift V. V. Barthold)* (Tashkent, 1927), 179 ff; for a different date see Nilsen, *Monumentalnaya arkhitektura*, 55; all recent plans, after excavations following the destruction of the standing wall, are in

Nemtseva, 'Robat-i Malik', in L. I. Rempel, ed., *Hudozhestvennaya kultura Srednei Azii* (Tashkent, 1983); Hmelnitski, *Mezhdu*, 289, and Hillenbrand, *Architecture*, 343.

49. Pribytkova, *Pamiatniki Arkhitektury XI veka v Turkmenii*, (Moscow, 1955), 39 ff.

50. A. Godard, 'Khorasan', *Athar-e Iran* 4 (1949), 7 ff. See also examples in E. Herzfeld, 'Damascus II', *Ars Islamica* 10 (1943), figs 2 and 31.

51. M. B. Smith in *Ars Islamica* 4 (1937) and 6 (1939) and now Galdieri for Isfahan and various publications of monuments by R. Hillenbrand. For Central Asia the major works are those of Nilsen, Pribytkova, Pugachenkova, and Hmelnitski.

52. Wood was certainly used in some areas, as, for instance, in Khiva, in Central Asia.

53. A. Godard, *Athar-e Iran* 1 (1936), figs 21, 34, 40, 43, 44.

54. Pribytkova, *Pamiatniki Arkhitektury*, figs 49, 51, 48.

55. The only major exception known to me is the mausoleum at Alamberdar (Pribytkova, *Pamiatniki Arkhitektury*, fig. 77), where bricks are arranged so as to form a sort of pendentive.

56. Gulpaygan shows an interesting and unexplained variation in *survey*, pl. 309.

57. Above, p. 112.

58. *Survey*, pl. 274A.

59. An alternative explanation, perhaps historically more logical but, at this stage of knowledge, more difficult to demonstrate, is that this development of the *muqarnas* had already taken place in Iraq.

60. J. Rosintal, *Le Réseau* (Paris 1937); *Pendentifs, trompes et stalactites* (Paris, 1928).

61. A. Godard, 'Voûtes iraniennes', *Athar-e Iran* 4:2 (1949).

62. Photographs of vaults and drawings in *SPA*, pls 295–300, figs 332–34, 365–66.

63. E. Schroeder and others had argued for the irrational proportions of the Golden Mean, *SPA*, 1027–29; recently A. Özdural has demonstrated that a completely different system based on geometry rather than numbers was involved; his main work is yet to appear; as a preliminary introduction see 'Omar Khayyam, Mathematicians and Conversations with Artisans', *Journal of the Society of Architectural Historians* 54 (1995).

64. M. S. Bulatov, *Geometricheskaia garmonizatsiia v arkhitekture Srednei Azii IX–XV vv* (Moscow, 1978). See, however, the work of Özdural and others, which is providing a different interpretation.

65. For instance, the proclamation of the faith in the minaret of Jam, the secular poetry of the palace at Ghazni, or the sacred preservation of legal documents in Qazvin. The iconography of ornament still awaits its study.

66. D. N. Wilber, 'The Development of Mosaic Faience', *Ars Islamica* 6 (1939).

67. A rare exception is J. Bergeret and L. Kalus, 'Analyse de décors épigraphiques à Qazwin', *Revue des Etudes Islamiques* 45 (1972).

68. A. U. Pope in *SPA*, 1284 ff.; L. I. Rempel, *Arkhitekturnyi ornament Uzbekistana* (Tashkent, 1961); B. Denike, *Arhitekturnyi ornament Srednei Azii* (Moscow, 1939).

69. Such are general books like S. and H. Scherr-Thoss, *Design and Color in Islamic Architecture* (Washington, 1969), with excellent photographs.

70. Denike, *Ornament*, figs 33–66, and J. Sourdel in Schlumberger, *Lashkari Bazar*.

71. See the work of A. Özdural quoted above.

72. List in *SPA*, 1299 ff.

73. S. Flury, 'Le Décor épigraphique des monuments de Ghazni', *Syria* 6 (1925); J. Sourdel-Thomine, *Syria* 30 (1953).

74. Cf. the quotations in Rempel, *Arkhitekturnyi ornament*, 252 ff., or in Bulatov's work, to be modified by the sophisticated suggestion of an operating team of mathematicians and architects made by Özdural.

75. R. M. Riefstahl, 'Persian Islamic Stucco Sculpture', *The Art Bulletin* 13 (1931); *SPA*, pls 514 ff. While most large sculptures of courtiers seem genuine, some doubt exists around large stucco panels with representations of court scenes.

76. J. Sourdel in *Revue des Etudes Islamiques* 42 (1974). For Ghazni see A. Bombaci, *The Kufic Inscription*.

77. U. Scerato, 'The First Two Excavations at Ghazni', *East and West*, N.S. 10 (1959).

78. P. Brown, *Indian Architecture, vol. 2, (The Islamic Period)* (Bombay, 1949), 7; Sir John Marshall, 'The Monuments of Muslim India', *The Cambridge History of India* 3 (Cambridge, 1928), 575 ff.; See now also J. C. Harle, *The Art and Architecture of the Indian Subcontinent* (Pelican History of Art). (New Haven and London, 1994), chs 30–33.

79. Wiet and Maricq, *Le Minaret de Djam*, 53, for an analysis of a monument which still awaits its definitive investigator.

80. Wiet and Maricq, *Le Minaret de Djam*, 67; H. Goetz, 'Arte dell'India musulmana', in *Le civiltà dell'oriente* 4 (Rome, 1962), 784.

81. M. Shokoohy, *Bhadrésvar, The Oldest Inslamic Monuments in India* (Leiden, 1988); with N. H. Shokooky, 'The Architecture of Baha al-Din Tughril in the region of Bayana, Rajasthan,' *Muqarnas* 4 (1987).

82. S. D. Goitein, 'The Main Industries of the Mediterranean Area as Reflected in the Records of the Cairo Genizah', *Journal of the Economic and Social History of the Orient* 4 (1961), 172; and *A Mediterranean Society, vol. 1: Economic Foundations* (Berkeley and Los Angeles, 1967), 99, 101–08.

83. 'Tiraz', *The Encyclopedia of Islam*, 1st ed. (Leiden, 1934), 785–93. No detailed study of the development of tiraz fabrics in the Saljuq period has yet been undertaken, but a begining can be made by gathering scattered examples in E. Combe, J. Sauvaget, and G. Wiet, *Répertoire chronologique d'épigraphie arabe* 7–11 (Cairo, 1936–41).

84. For information on the Iranian textile industry see R. B. Serjeant, 'Material for a History of Islamic Textiles up to the Mongol Conquest', *Ars Islamica* 10 (1943), 71–104; 11 (1946), 98–119, 131–35; for Tustar in particular, see 10, 72–75.

85. See also V. Loukonine and A. Ivanov, *Lost Treasures of Persia, Persian Art in the Hermitage Museum* (Washington, D.C., 1996), no. 97, pp. 118–19.

86. See L. W. Mackie, 'Increase the Prestige: Islamic Textiles', *Arts of Asia*, 26 (Jan.–Feb. 1996). fig. 65. Such a layout is also visible in [204].

87. Only one mace has been preserved, partly owing to its more solid mass. This object, now in the Museum of Islamic Art, Cairo, no. 15207, was published without discussion in R. Harari, 'Metalwork after the Early Islamic Period', in A. U. Pope, ed., *Survey* 12, pl. 1289B. A group of medieval Iranian copper-alloy objects has been tentatively identified as bucklers used in duelling; A. S. Melikian-Chirvani, 'Bucklers, Covers, or Cymbals? A Twelfth-Century Riddle from Eastern Iran', in R. Elgood, ed., *Islamic Arms and Armour* (London, 1979), 97–111.

88. O. Grabar, 'Fatimid Art, Precursor or Culmination', in S. H. Nasr, ed., *Isma'ili Contributions to Islamic Culture* (Tehran, 1977), 207–24; O. Grabar, 'Les Arts mineurs de l'Orient musulman à partir du milieu du XIIe siècle', *Cahiers de Civilisation Médiévale 11:2* (Poitiers, 1968), 181–90; R. Ettinghausen, 'The Flowering of Seljuq Art', *Metropolitan Museum Journal* 3 (1970), 113–31; and M. S. Simpson, 'Narrative Allusion and Metaphor in the Decoration of Medieval Islamic Objects', in M. S. Simpson and H. L. Kessler eds, *Pictorial Narrative in Antiquity and the Middle Ages* (Washington, D.C., 1985), 131–49.

89. L. A. Mayer, *Islamic Metalworkers and Their Works* (Geneva, 1959). At this juncture we can only speculate as to why there is such a marked increase in the number of dated objects during this period.

90. M. Abu-l-Faraj al-'Ush, 'A Bronze Ewer with a High Spout in The Metropolitan Museum of Art and Analogous Pieces', in R. Ettinghausen, ed., *Islamic Art in the Metropolitan Museum of Art* (New York, 1972), 187–98; see also *Lost Treasures of Persia*, cat. no. 104, pp. 126–27, and Eva Baer, *Metalwork in Medieval Islamic Art* (Albany, 1983), 95–99. For a lustre-painted ceramic ewer exhibiting a similar shape see Metropolitan Museum of Art, New York, acc. no. 66.175.2.

91. On the development of these new scripts see D. S. Rice, *The Wade Cup in the Cleveland Museum of Art* (Paris, 1955), chapter IV, and R. Ettinghausen, 'The "Wade Cup", in the Cleveland Museum of Art, its Origin and Decorations', *Ars Orientalis* 2 (1957), 356–59.

92. The novel and very characteristic small configurations of seven circles or of flowers in a tall vase seen on this object seem to have been the hallmarks of certain workshops in Khurasan. The profile of this vessel is strongly reminiscent of that in [201].

93. A ewer in Tblisi (see *Lost Treasures of Persia*, cat. no. 117, pp. 136–37) permits the dating of the entire group to which this candlestick belongs; cf. E. Atil, W. T. Chase, and P. Jett, *Islamic Metalwork in the Freer Gallery of Art* (Washington, D.C., 1985), 95–101.

94. The earliest surviving object on which this combination of inlay and chasing was employed is a penbox dated 1148; cf. L. T. Giuzalian, 'The Bronze Qalamdan (Pen-Case) 542/1148 from the Hermitage Collection (1936–1965)', *Ars Orientalis* 7 (1968), 95–119.

95. The known early pieces with silver inlay are discussed with references in Ettinghausen, 'The "Wade Cup"', 332–33, and 'Further Comments on the Wade Cup', *Ars Orientalis* 2 (1959), 198.

96. This object has been studied in detail by R. Ettinghausen, 'The Bobrinski "Kettle", Patron and Style of an Islamic Bronze', *Gazette des Beaux-Arts*, 6e sér. 24 (1943), 199–203. See also A. S. Melikian-Chirvani, *Islamic Metalwork from the Iranian World 8th–18th Centuries* (London, 1982), 82–83, note 61. For another Herati kettle cf. *Lost Treasures of Persia*, no. 126, pp. 144–45.

97. Ettinghausen, 'The Flowering of Seljuq Art', 120–25.

98. E. Baer, 'An Islamic Inkwell in The Metropolitan Museum of Art', in R. Ettinghausen, ed., *Islamic Art in the Metropolitan Museum of Art* (New York, 1972), 199–211.

99. The object has been studied by M. M. Dyakonov, 'Un aquamanile en bronze daté de 1206' (in Russian with French summary), *IIIe Congrès*

International d'Art et d'Archéologie Iraniens: Mémoires* (Moscow and Leningrad, 1939), 45–52.

100. For a study of the image of a lion attacking a bull in ancient and Islamic times see W. Hartner and R. Ettinghausen, 'The Conquering Lion, the Life Cycle of a Symbol', *Oriens* 17 (1964), 161–71.

101. One of the scenes depicted on the body of the cow is a representation of the playing of backgammon (Arabic and Persian: *nard*). A very similar scene is represented on the so-called Bobrinski bucket discussed above; see Ettinghausen, 'The Bobrinski Kettle', 203.

102. See note 93 above.

103. See respectively Ettinghausen, 'The Bobrinski Kettle'; L. T. Giuzalian, 'Bronzov'ui kuvshchin 1182', in *Pamyatniki Epokhi Rustaveli* (Leningrad, 1938), 227–36; R. Ettinghausen, 'Sasanian and Islamic Metalwork in Baltimore', *Apollo* 84 (December 1966), 465–69; M. Aga-Oglu, 'A Preliminary Note on Two Artists from Nishapur', *Bulletin of the Iranian Institute* 6–7 (1946), 121–24; and E. Herzfeld, 'A Bronze Pen-case', *Ars Islamica* 3 (1936), 35–43. See also Melikian-Chirvani, *Islamic Metalwork*, 69–71, 72, and A. S. Melikian-Chirvani on two more recently discovered works: 'Les Bronzes du Khorasan, I', *Studia Iranica* 3 (1974), 29–50. Atil, Chase, Jett, *Islamic Metalwork*, no. 14, pp. 102–10.

104. Other metalworking centres in northeastern Iran undoubtedly existed but have not so far been identified.

105. One recently discovered centre in this general area is Siirt. See James Allan, 'From Tabriz to Siirt – Relocation of a 13th century Metalworking School', *Iran* 16 (1978), 182–3, and *Islamic Metalwork: The Nuhad es-Said Collection* (London, 1982), nos 7–10, pp. 58–73. See below, Chapter 6, pp. 247–49.

106. R. Ettinghausen, 'The Flowering of Seljuq Art', 126–27.

107. The present whereabouts of the piece, known as the Peytel Cup, is not known; for a drawing and discussion see Ettinghausen, 'The "Wade Cup"', 340–41, and for a photograph Rice, *The Wade Cup*, pl. XIVb.

108. Giuzalian, 'Bronzov'ui kuvshchin 1182', 230–31.

109. A. S. Melikian-Chirvani, 'Silver in Islamic Iran: The Evidence from Literature and Epigraphy', in Michael Vickers, ed., *Pots and Pans: A Colloquium on Precious Metals and Ceramics in the Muslim, Chinese, and Graeco-Roman Worlds (Oxford Studies in Islamic Art* 3) (Oxford, 1986), 89–106. See also J. W. Allan, 'The Survival of Precious and Base Metal Objects from the Medieval Islamic World', in *Pots and Pans*, 57–70. For Byzantine parallels cf. A. Bank, *Byzantine Art in the Collections of Soviet Museums* (Leningrad, 1977), pls 213–15 and 216, 217.

110. M. Jenkins and M. Keene, *Islamic Jewelry in the Metropolitan Museum of Art* (New York, 1983); Jenkins and Keene, 'Djawhar', *The Encyclopaedia of Islam*, supplement to vol. 2, new edition (Leiden, 1982), 250–62.

111. See, for instance, A. Lane, *Early Islamic Pottery: Mesopotamia, Egypt and Persia* (London, 1947), pl. 63A.

112. For a preliminary study of polychrome faience mosaic see D. Wilber, 'The Development of Mosaic Faience in Islamic Architecture in Iran', *Ars Islamica* 6 (1939), 16–47. The earliest surviving dated example (1242) of total surface tiling is not in Iran but in the Sircali Madrasa in Konya, Anatolia; the master responsible hailed from Tus in Khurasan, however, and it may therefore be assumed that such colourful assemblages were already known in eastern Iran. For a discussion of this building, with references, see Wilbur, 'Development', 39–40, and Chapter 6, below, p. 252 and [417].

113. D. S. Rice, 'Studies in Islamic Metal Work – III', *Bulletin of the School of Oriental and African Studies* 15 (1953), 232–38.

114. One cycle of illustrations from the *Shahnama* painted on a ceramic vessel has been discussed in G. Guest, 'Notes on a Thirteenth Century Beaker', *Ars Islamica* 10 (1943), 148–52. See also M. Aga-Oglu, 'A Rhages Bowl with a Representation of an Historical Legend', *Bulletin of the Detroit Institute of Arts* 12 (1930), 31–32; M. S. Simpson, 'The Narrative Structure of a Medieval Iranian Beaker', *Ars Orientalis* 12 (1981), 15–24; 'Narrative Allusion', esp. notes 3, 4 and appendix, pp. 143–46; M. V. Fontana, *La leggenda di Bahram Gur e Azada, materiale per la storia di una tipologia figurativa dalle origini al XIV secolo* (Istituto Universitario Orientale, Series Minor 24) (Naples, 1986); and Firouz Bagherzadeh, 'Iconographie iranienne: deux illustrations de Xel'at de l'année 538H. 1187 apr. J.-C.', in L. DeMeyer and E. Haerinck ed., *Archaeologia Iranica et Orientalis: Miscellanea in Honorem Louis Vanden Berghe*, (Gent, 1989), 1007–28.

115. Some of these verses have been translated in M. Bahrami, *Recherches sur les carreaux de revêtement lustré dans la céramique persane du XIIIe au XVe siècle (étoiles et croix)* (Paris, 1937), 52–69.

116. See Robert B. Mason, *Islamic Glazed Pottery: 700–1250* (D. Phil. thesis, University of Oxford, 1994), for an excellent technical and scientific discussion of composite or stonepaste bodies. Dr Mason's petrographic work is without peer and is very quickly changing the way Islamic art historians approach the problem of the provenance of the vast pottery production within the Muslim world. Considerably more work, however, needs to be done in con-

junction with archeologists and art historians before the very precise dating suggested in this dissertation can be verified. See also J. Allan, 'Abu'l-Qasim's Treatise on Ceramics', *Iran*, 11 (1973), 111–20, for a contemporary account of the ceramic production in this important centre.

117. Not all of the moulded ceramic objects made at this time in the eastern Islamic lands were pierced. Many from Greater Iran (including those from present-day Afghanistan) exhibited only mould-generated designs.

118. The preferred modern spelling for this town, Kashan, is used elsewhere in this publication.

119. M. Pezard, *La Céramique archaique*, pls XIII–XXV; Arthur Lane, 'The Early Sgraffito Ware of the Near East', *Transactions of the Oriental Ceramic Society* 11 (1938), 40–41, pl. 14a, c; *Early Islamic Pottery*, pls 30, 31A.

120. For a valuable contribution on this subject see O. Watson, *Persian Lustre Ware* (London and Boston, 1985). This particular type of lustre-painted pottery was previously thought to have been manufactured in Rayy and that in [270] in Gurgan. See also Lane, *Early Islamic Pottery*, 37–38, and M. Jenkins, 'Islamic Pottery: A Brief History', *Bull. MMA*, (Spring 1983), 13 and 24.

121. O. Grabar, 'Les Arts Mineurs', 188. Thanks to the efforts of Abdullah Ghouchani, Iran Bastan Museum, Tehran, and Hamid Dabashi, Columbia University, New York, any hopes that the Persian inscription on this bowl might provide a clue as to the event taking place here have been dashed. It is simply a quatrain that according to Ghouchani appears on many other lustre-painted pottery objects.

122. O. Watson, 'Documentary Mina'i and Abu Zaid's Bowls,' in *The Art of the Saljuqs in Iran and Anatolia* (Costa Mesa, CA, 1994), 170–77 and pls 160–68, and *Persian Lustre Ware* 68, 70, and 78, fig. 49.

123. E. Atil, *Ceramics from the World of Islam* (Washington, D.C., 1973), no. 46, pp. 104–05.

124. Aga-Oglu, 'A Rhages Bowl', and Guest, 'Notes'.

125. Simpson, 'Narrative Structure' and 'Narrative Allusion'.

126. This identification was first made by Renata Holod in a paper delivered at the Freer Gallery of Art, Washington, D.C., in January 1973, unpublished.

127. Grabar, 'Les Arts Mineurs'.

128. R. Ettinghausen, 'Important Pieces of Persian Pottery in London Collections', *Ars Islamica*, 2 (1935), 49, and Pope, *Survey* 5, part 1, pl. 734A. This bowl appears to be the earliest dated Iranian underglaze-painted object extant.

129. Watson, *Persian Lustre Ware*.

130. R. Ettinghausen, 'Evidence for the Identification of Kashan Pottery', *Ars Islamica* 3 (1936), 44–75.

131. Lane, *Early Islamic Pottery* pls 62–64.

132. G. D. Guest amd R. Ettinghausen, 'The Iconography of a Kashan Luster Plate', *Ars Orientalis* 4 (1961), 25–64, pls 1–22.

133. Pope, *Survey*, 632–35, 702–03; Watson, *Persian Lustre Ware* 131, 181, 185, and 176–82.

134. Watson, *Persian Lustre Ware*, pp. 37–44.

135. Ettinghausen, 'The Flowering of Seljuq Art', 125–26.

136. An Jiayao, 'Dated Islamic Glass in China', *Bulletin of the Asia Institute*, N.S. 5 (1991), fig. 13.

137. Ibn al-Zubayr, trans. Ghada H. Qaddumi, *Book of Gifts and Rarities* (Cambridge, MA, 1996), paragraphs 79, 84, and 374; also R. Ettinghausen, 'The Covers of the Morgan *Manafi'* Manuscript and Other Early Persian Bookbindings', in D. Miner, ed., *Studies in Art and Literature for Belle da Costa Greene* (Princeton, 1954), 472–73.

138. Y. Tabbaa, 'The Transformation of Arabic Writing: Part 1, Qur'anic Calligraphy', *Ars Orientalis*, 21, 1991, p. 140 and fig. 37, attributes this manuscript to either Iraq or Iran.

139. R. Ettinghausen and O. Grabar, *The Art and Architecture of Islam 650–1250*. Harmondsworth, 1987. 356, and O. Grabar, *The Mediation of Ornament* (Princeton, 1992), pp. 74–76.

CHAPTER 6

1. S. D. Goitein, *A Mediterranean Society*, 3 vols (Berkeley, 1967–77), among many studies by this scholar, and essays by B. Lewis, G. von Grunebaum, O. Grabar, and others in A. Raymond, M. Rogers, and M. Wahba, eds, *Colloque International sur L'histoire du Caire* (Leipzig, 1973). See now the exhibition catalogue *Trésors fatimides du Caire* (Institut du Monde Arabe, Paris, 1998) or its Viennese version *Schätze der Kalifen* (Vienna, 1998) and the forthcoming volume edited by M. Barrucand of the congress on the Fatimids held in Paris in 1998.

2. G. Marçais, *La Berbèrie musulmane et l'Orient* (Paris, 1946, repr. Casablanca, 1991).

3. The main book on Fatimid architecture is K. A. C. Creswell, *Muslim Architecture of Egypt* (Oxford, 1952). More recent studies are mentioned with the monuments or issues they discuss.

4. Creswell, MAE, 1–10; Marçais, *Architecture*, 78 ff.; S. M. Zbiss, 'Mahdia et Sabra-Mansouriya', *Journal Asiatique* 244 (1956), 78 ff.; Alexandre Lézine, *Mahdiya* (Paris, 1965).

5. For two different views on the interpretation of the remains see Creswell, MAE, 3–5, and Marçais, *Architecture*, 90–92; mostly superseded by Lézine, 17 ff.

6. Marçais, *Architecture*, 78–79; Zbiss, 'Mahdia', 79 ff.

7. M. Canard, 'Le Cérémonial fatimite et le cérémonial byzantin', *Byzantion* 21 (1951). See now P. Saunders, *Ritual, Politics, and the City in Fatimid Cairo* (Albany, 1994).

8. Creswell, MAE, 5–9; Marçais, *Architecture*, 69–70; Lézine, *Mahdiya*, 65 ff., with many improvements in interpretation.

9. Zbiss, 'Mahdia', on the whole theme see G. Marçais, 'Salle, Antisalle', *AIEO* 10 (1952), 274 ff.

10. L. Golvin, *Le Maghreb Central à l'époque des Zirides* (Paris, 1957).

11. Latest statement by Lucien Golvin, *Recherches archéologiques à la Qala des Banu Hammad* (Paris, 1965).

12. F. Gabrieli, 'Il palazzo hammadita di Biǧaya', in R. Ettinghausen, ed., *Festschrift für Ernst Kühnel* (Berlin, 1959).

13. Golvin, *Recherches*, 123 ff.

14. Ugo Monneret de Villard, *Le pitture musulmane al soffitto della Cappella Palatina in Palermo* (Rome, 1950).

15. Maqrizi, *Khitat*, 2 vols (Cairo, A.H. 1270).

16. Published in MMAT and MIFAO.

17. M. van Berchem in MMAF 19 (1903), with supplement by G. Wiet in MIFAO 52 (1929).

18. For Fustat exacavations see the numerous reports by G. Scanlon, especially in the *Journal of the American Research Center in Egypt* (*ARCE*); for recent summaries R.-P. Gayraud, ed., *Colloque International d'Archéologie Islamique* (Cairo, 1998) and *Annales Islamologiques* 29 (1995).

19. The origin of the word is discussed by Creswell, MAE, 21–22.

20. M. Herz, *Die Baugruppe von Qalaun* (Hamburg, 1919).

21. In MMAF 1 (1887–89).

22. E. Pauty, *Les Palais et les maisons d'époque musulmane au Caire*, MIFAO 63 (1933).

23. Maqrizi, *Khitat* 1, 432–33.

24. Nasir-i Khosrow, *Sefer-Nameh*, trans. C. Schefer (Paris, 1881), 127 ff.

25. Ten are enumerated by Maqrizi, *Khitat* 1, 465 ff.

26. M. Canard, 'La Procession du nouvel an', *AIEO* 13 (1955), based on Inostrantzev's great work on the subject; see also Saunders, *Ritual*.

27. Creswell, MAE, 129 ff.; Aly Baghat and A. Gabriel, *Les Fouilles de Foustat* (Paris, 1932). Scanlon in particular has commented on many such houses.

28. Creswell, MAE, 59, fig. 23.

29. Whether this was so hinges on the interpretation of Maqrizi, *Khitat* 2, 273; 2, 21–27; Creswell, MAE, 36, believed that there were domes at the corners of the hall of prayer, although the text mentions a dome 'in the first arcade to the right of the *mihrab*'.

30. Maqrizi, *Khitat*, 280–81.

31. For a new interpretation of the Hakim mosque see Jonathan Bloom, 'The Mosque of el-Hakim in Cairo', *Muqarnas* 1 (1982).

32. Creswell, MAE, 94 ff.

33. S. Flury, *Die Ornamente der Hakim- and Ashar-Moschee* (Heidelberg, 1912), whose comparative material is, however, much out of date.

34. Creswell, MAE, 104.

35. I. Bierman, *Writing Signs, the Fatimid Public Text* (Berkeley, 1998).

36. H. Stern, in *Ars Orientalis* 5 (1963); O. Grabar, *The Shape of the Holy* (Princeton, 1996), 135–69.

37. O. Grabar, 'The Earlier Islamic Commemorative Structures', *Ars Orientalis* 6 (1966), 7–46. For a different view see Youssouf Ragheb, 'Les Premiers Monuments funéraires de l'Islam', *Annales Islamologiques* 9 (1970), 21–36. One should note the peculiar earlier occurrence of the Tabataba mausoleum in Cairo, if this is what it was; Creswell, MAE 2, 16 ff., and Grabar, 11; see also C. Taylor, 'Reconstructing the Shi'i Role', *Muqarnas* 9 (1992).

38. Creswell, MAE, 107 ff.

39. Creswell, MAE, 131 ff., with a full account of the disaster which led to the disappearance of the inscriptions; A. M. Abd al-Tawab, *Stèles islamiques de la Nécropole d'Aswan*, rev. Solange Ory (Cairo, 1977).

40. J. Bloom, 'The Mosque of the Qarafa in Cairo', *Muqarnas* 4 (1987).

41. A very interesting group of tombs with important finds of textiles has recently been uncovered by Gayraud.

42. Maqrizi, *Khitat*, 2, 298.

43. Creswell, MAE 1, 241 ff.

44. Creswell, MAE 1, 275 ff.

45. Maqrizi, *Khitat* 2, 289.

46. Creswell, MAE 1, 11; above, pp. 29, 87.

47. Creswell, MAE 1, 222 ff. and 247 ff.

48. *Creswell, MAE* I, 155 ff.; Max van Berchem, 'Une mosquée du temps des Fatimides au Caire', *Bulletin de l'Institut d'Egypte* 3 (1899), 605 ff.; Grabar, *Commemorative*, 27–29.

49. *Creswell, MAE* I, 110 ff.

50. Such is my interpretation of an example in a Coptic church which was taken by Creswell to be an experimental one (*Creswell, MAE* I, fig. 131).

51. For a more sophisticated explanation see J. Bloom, 'The Muqarnas in Egypt', *Muqarnas* 5 (1988).

52. Bloom, 'Muqarnas', 162–63.

53. Caroline Williams, 'The Cult of Alid Saints in the Fatimid Monuments of Cairo', *Muqarnas* 1 (1983).

54. S. D. Goitein, 'The Main Industries of the Mediterranean Area as Reflected in the Records of the Cairo Geniza', *Journal of Economic and Social History of the Orient* 4 (1961), 168–69.

55. For documentation on textile production, for example, see R. B. Serjeant, 'Material for a History of Islamic Textiles up to the Mongol Conquest', *Ars Islamica* 13–14 (1948), 88–113.

56. These data have been recorded by al-Qadi al-Rashid ibn al-Zubayr, *Kitab al-Dhakha'ir wa-l-Tuhaf*, ed. M. Hamidullah (Kuwait, 1959), trans. and annot. G. al-Qaddumi. *Book of Gifts and Rarities* (Cambridge, MA, 1996) paragraphs 370–414 and by Maqrizi in *Kitab al-Mawa'iz wa'l-I'tibar bi-dhikr al-khitat wa'l-Athar* I (Bulaq, 1854), 414–16, trans. P. Kahle, 'Die Schätze der Fatimiden', *Zeitschrift der Deutschen Morgenländischen Gesellschaft*, N.F. 14 (1935), 338–61. They form the basis of Zaky M. Hassan, *Kunuz al-Fatimiyin (The Treasures of the Fatimids)* (Cairo, 1937).

57. Serjeant, 'Material', 111–13, again quoting Maqrizi.

58. In spite of the enormous numbers mentioned by Maqrizi, only about 181 carved rock-crystal pieces have been discovered so far; see K. Erdmann, 'Neue islamische Bergkristalle', *Ars Orientalis* 3 (1959), 201.

59. R. Ettinghausen, 'The "Beveled Style" in the Post-Samarra Period', in G. C. Miles, ed., *Archaeologica Orientalia in Memoriam Ernst Herzfeld* (Locust Valley, N.Y., 1952), 75, pl. X no. 3.

60. E. Pauty, *Catalogue général du Musée Arabe du Caire* (Cairo, 1931), pls XXIII–XXV.

61. The vogue for similarly decorated doors was to continue in Egypt for more than a hundred years. The panelled doors depicted on the stone façade of the Mosque of al-Aqmar (1125) are quite close in design to those illustrated here and also resemble the wooden doors in the mosque itself. See Figure 305; D. Behrens-Abouseif, 'The Façade of the Aqmar Mosque in the Context of Fatimid Ceremonial', *Muqarnas* (1992) 9, fig. 4, p. 34; and M. Jenkins, 'An Eleventh-Century Woodcarving from a Cairo Nunnery', in R. Ettinghausen, ed., *Islamic Art in the Metropolitan Museum of Art* (New York, 1972), fig. 20, 238. Eight similar door panels found in the area of Raqqa (*Ebla to Damascus: Art and Archaeology of Ancient Syria*, exh. cat., Washington, D.C., 1985, cat. no. 271, pp. 522–23) testify to the popularity of this type of architectural ornament in Greater Syria at this time as well. Its echoes can be seen as late as *c.*1143 in the doors of La Martorana in Palermo, Sicily.

That such decoration continued for coffered wooden ceilings and corbels can be seen in the representations of such architectural elements in stone on Bab al-Futuh (1087); cf. Creswell, *MAE* I (Oxford, 1952), pls 65c, d and 66a, b.

62. See Pauty, *Catalogue*, pls XLI and XLII.

63. Pauty, *Catalogue*, pls XLVI–LVIII. Some of the themes have been analysed by G. Marçais, 'Les Figures d'hommes et de bêtes dans les bois sculptés d'époque fatimite musulmane', *Mélanges Maspero, III: Orient islamique* (Cairo, 1940), 241–57. See also Jenkins, 'Eleventh-century Woodcarving' 227–30; Pauty, *Catalogue*, pl. XXXVIIIab; and *Treasures of Islam*, exh. cat. Musée d'Art et d'Histoire, Geneva, 1985, cat. no. 357, p. 343. For excellent illustrations of the series illustrated [315] and many other objects produced under Fatimid aegis and presently housed in the Museum of Islamic Art, Cairo, see *Schätze der Kalifen: Islamische Kunst zur Fatimidenzeit*, exh. cat., Vienna, 16 November 1998–21 February 1999.

64. See R. Ettinghausen, 'Early Realism in Islamic Art', *Studi orientalistici in onore di Giorgio Levi della Vida* I (Rome, 1956), 259–62. Echoes of this stylistic trend can be seen in the fragmentary wooden ceiling of the first half of the twelfth century from the Cappella Palatina, now in the Galleria Regionale della Sicilia, Palermo; cf. G. Curatola, *Eredità dell'Islam: arte islamica in Italia*, exh. cat., Palazzo Ducale, Venice, 30 October 1993–30 April 1994, cat. no. 86, pp. 197–98. Both of these groups of wood-carvings will be discussed in Chapter 8.

65. *Islamic Art in Egypt, 969–1517*, exh. cat., Cairo, April 1969, cat. no. 234, p. 246, fig. 40.

66. J. Sourdel-Thomine and B. Spuler, *Die Kunst des Islam* (Berlin, 1973), fig. 240, and Chapter 7, below [457].

67. See *30 ans au service du patrimoine*, Institut National d'Archéologie et d'Art, Tunis, 1986, nos IV.51–54, 56, pp. 257–59.

68. E. Kühnel, *Die islamischen Elfenbeinskulpturen VIII–XIII Jahrhunderts* (Berlin, 1971) pl. XCIX. For illustrations of other similar plaques in Berlin and the Louvre see also pls XCVII–XCVIII.

69. We know that this illusion of three dimensions was highly appreciated in eleventh-century Egypt from al-Maqrizi's report of an artistic competition in which an Iraqi painted a dancing girl in such a way that she seemed to be emerging from a niche, but was outdone by his Egyptian rival, who painted a dancing girl as if she were entering a niche. For references to this passage and a discussion of its significance see R. Ettinghausen, 'Painting in the Fatimid Period: A Reconstruction', *Ars Islamica* 9 (1942), 112–13.

70. M. Jenkins, 'The Palmette Tree: A Study of the Iconography of Egyptian Lustre Painted Pottery', *Journal of the American Research Center in Egypt* 7 (1968), 119–26, and R. Pinder-Wilson, 'An Early Fatimid Bowl Decorated in Lustre', in R. Ettinghausen, ed., *Aus des Welt der islamischen Kunst: Festschrift fur Ernst Kühnel* (Berlin, 1959), 139–43. Another large single fragment from this dish was seen by Marilyn Jenkins-Madina in 1974 in the International Ceramics Museum, Faenza, Italy, acc. no. AB1231.

71. M. Jenkins, 'Muslim: An Early Fatimid Ceramist', *The Metropolitan Museum of Art Bulletin* (May 1968), 359–69. Contrary to A. Contadini, *Fatimid Art at the Victoria and Albert Museum* (London, 1998), 80, the motif (or motifs) decorating the centre of this dish is impossible to ascertain.

72. G. Berti and L. Tongiorgi, *Ceramici medievali delle Chiese di Pisa* (Rome, 1981), 56 and tav. CLXXXIX, top.

73. F. Aguzzi, 'I bacini della Torre Civica', *Sibrium* (1973–75), fig. 1, p. 191, and fig. 4, p. 192. M. Jenkins-Madina's dating for such ware supersedes that suggested by V. Porter and O. Watson in their '"Tell Minis" Wares', in *Syria and Iran: Three Studies in Medieval Ceramics* (Oxford Studies in Islamic Art, 4) (1987), 175–248. See also M. Jenkins, 'Early Medieval Islamic Pottery: The Eleventh Century Reconsidered', *Muqarnas* 9 (1992), 56–66.

74. As with the wood, it is not at all surprising to find an increase of human and animal motifs in Fatimid Egyptian ceramic objects given the traditions of their predecessors, the Aghlabids, and of their forebears in Ifriqiya – 'it was simply a part of their tradition and it could have come into Egypt as early as they did. As to how it happened, there are many possible answers, some of which include the fact that the conquering Fatimids could have brought potters or pottery or both with them from Sabra al-Mansuriyya; trade with the Ifriqiyan capital and/or with Spain and al-Qal'a; potters emigrating from a ruined Madinat al-Zahra or Sabra al-Mansuriyya after the bedouin invasion – the devastation of Ifriqiya more or less occurring during the time of the liquidation of the Fatimid imperial treasury.' M. Jenkins, 'Western Islamic Influences on Fatimid Egyptian Iconography', *Kunst des Orients* 10 (1976), 105, in response to O. Grabar, 'Imperial and Urban Art in Islam: The Subject Matter of Fatimid Art', *Colloque International sur l'Histoire du Caire* (Cairo, 1972), 173–89.

75. Acc. no. 14987. M. Mostafa, 'Fatimid Lustred Ceramics', *Egypt Travel Magazine* 2 (1954), fig. 10.

76. Museum of Islamic Art, Cairo, no. 13080. See also E. J. Grube, *Islamic Pottery of the Eighth to the Fifteenth Century in the Keir Collection* (London, 1976), 138–42, pl. facing 136, top. For a general discussion of ceramics see M. Jenkins, 'Islamic Pottery', *Bull. MMA*, 40:4 (1983). Pieces with clearly identifiable Christian subject matter fall into this undatable lustre-painted group as well. Reflecting the important role that Coptic Christians played in medieval Egyptian society, clerics, for example, are represented, and on one fragment Christ is depicted making the gesture of blessing; cf. exh. cat., *Schätze der Kalifen*, cat. no. 126, p. 159. See also a dish with an image of a priest swinging a censer, now in the Victoria and Albert Museum, London, in A. Lane, *Early Islamic Pottery: Mesopotamia, Egypt and Persia*, London, 1947, pl. 26A, and see also M. Jenkins-Madina entry in *The Glory of Byzantium: Art and Culture of the Middle Byzantine Era, A.D. 843–1261*, exh. cat., New York, 1997, cat. no. 273, p. 417. For a discussion of the inscriptions on this bowl see M. Jenkins, 'Sa'd: Content and Context', in Priscilla P. Soucek, ed., *Content and Context of Visual Arts in the Islamic World* (University Park, PA, 1988), pp. 67–89.

77. M. Jenkins, 'Early Medieval Islamic Pottery'; also R. B. Mason, R. M. Farquhar, and P. E. Smith, 'Lead-Isotope Analysis of Islamic Glazes: An Exploratory Study', *Muqarnas* 9 (1992), 67–71. This category was previously thought to have come from the Garrus district of Iran.

78. The compelling parallels between the ornamentation on wares of this type and those with lustre-painted decoration are just beginning to be explored. Perhaps this find will eventually help scholars to answer the questions raised above about the date of the luster group with figural designs. One is also struck by the similarity between the decoration on these ceramic objects and that on a type of metalwork (see R. Ettinghausen and O. Grabar, *Art and Architecture of Islam, 650–1250 A.D.* (London, 1987), fig. 252, which has been variously dated and attributed. Perhaps this wreck can help to answer questions about the metal group as well.

79. M. Jenkins-Madina, 'Glazed Pottery', in G. F. Bass, S. Matthews, J. R. Steffy, and F. H. vanDoorninck, Jr, *Serce Limani: An Eleventh-Century Shipwreck, Volume II: The Cargo* (in press – Texas A & M University Press). For discussion of earlier such ware, see above, Chapter 4, p. 118 and [185].

80. Jenkins, 'Western Islamic Influences' and Scanlon 'Slip-painted Early

Lead-glazed Wares from Fustat: A Dilemma of Nomenclature', *Colloque International d'archéologie Islamique*, Cairo, 3–7 fevrier, 1993. Besides Ifriqiya, southern Spain, and Egypt, such ware was also made in what is now Portugal cf. C. Torres, *Cerâmica islâmica portuguesa*, exh. cat., Fundação Calouste Gulbenkian, Lisbon, 16–27 November 1987, no. 79. It is clear from this accidental find, however, that the theory that within a century after the height of the 'Samarra revolution' sgraffiato ware 'dominated to the exclusion of many of the earlier wares' (see E. J. Grube, *Cobalt and Lustre: The First Centuries of Islamic Pottery* (London, 1994), 34) should not be construed to cover splash-decorated ware. Bacini in the Abbazia in Pomposa further confirm a date for this vase in the first half of the eleventh century; cf. G. Ballardini, 'Pompose e i suoi Bacini', *Faenza* 24 (1936), 121–28, tavola XXX. This category was previously known as 'Fayyumi'.

81. V. Porter and O. Watson, '"Tell Minis" Wares,' *Syria and Iran: Three Studies in Medieval Ceramics*, (Oxford Studies in Islamic Art), eds. J. Allan and C. Roberts, IV, Oxford, 1987, p. 238, figs B8a, B9; pp. 242–43, figs B24–B29, and p. 245, fig. C8. Pottery of a very similar type was also produced in Ifriqiya and Portugal e.g. G. Vitelli, *Islamic Carthage: The Archaeological, Historical and Ceramic Evidence*, Institut National d'Archéologie et d'Art de Tunisie, CEDAC, Dossier 2, 1981, 112, no. 1.13; and C. Torres, *Ceramica*, nos 52–56.

82. See Jenkins, 'Early Medieval Islamic Pottery,' fig. 19, p. 63.

83. Berti and Tongiorgi, *Ceramici medievali*, no. 81, pl. CLXXXVI.

84. The technique employed in executing the decoration on both of these ceramic types is identical to that used on the champlevé group except that on the former groups it is the body itself that is carved away and not simply the slip. Jenkins, 'Early Medieval Islamic Pottery,' 64.

85. It has been assumed, solely on the basis of ten fragmentary relief-cut glass vessels with calligraphic, vegetal, or figural decoration excavated at Nishapur, that such sophisticated table ware was produced in that city; cf. J. Kroger, *Nishapur: Glass of the Early Islamic Period*, (New York, 1995), 20–21, 137–46. Opinions are divided, but Marilyn Jenkins-Madina, for the reasons outlined below, feels much more comfortable placing the manufacture of the highly refined relief-cut glass vessels and those of rock crystal in Egypt or Iraq. Not only was the number of the finest relief-cut glass objects recovered at Nishapur exceedingly small but the fact that no kilns for any type of glass-making were discovered during the excavations at that site and no contemporary texts sing the praises of any type of Nishapur glass production makes one question, at this juncture in our study of this medium, whether glass was produced in Nishapur at this time at all. However, as our study of glass production in the Muslim world is in its infancy, this statement may have to be modified at a later date.

86. The first was that during which the earliest lustre-painted glass vessels were produced.

87. Perhaps the only other artisans to apply this exacting and difficult lapidary technique to glass with such perfect skill were the fashioners of the Late Antique so-called *diatreta* cups; cf. D. B. Harden, H. Hellenkemper, K. Painter, and D. Whitehouse, *Glass of the Caesars* (Milan, 1987), cat. nos 134–39, pp. 238–49.

88. Its mounting is not original to the object. The engraved gold, interior, mounting is dated to the tenth century and the gilded silver exterior mounting with Byzantine enamel and filigree decorated plaques set with semi-precious stones is dated to the twelfth or thirteenth centuries; cf. Avinoam Shalem, *Islam Christianized: Islamic Portable Objects in the Medieval Church Treasuries of the Latin West* (Frankfurt, 1996), no. 77, p. 227 and fig. 16. See also H. R. Hahnloser, ed., *Il tesoro de San Marco* (Florence, 1971), 2 vols, cat. no. 117. Although Marilyn Jenkins-Madina does not yet have a satisfactory reading for the Arabic word in angular script carved on the base of this bowl, the likelihood of its reading 'Khurasan' is extremely slight, as this is the name not of a city or town but of a province. This particular type of metal, which is exceedingly rare for three-dimensional objects, was not used for coin weights until the reign of the Fatimid caliph al-ʿAziz (*r.* 975–96). Two other complete objects in this metal are the carafe in the Corning Museum of Glass, Corning, N.Y.: (*Islam and the Medieval West*, exh. cat., State University of New York at Binghamton, 6 April–4 May 1975, cat. no. G9), and a lustre-painted object in the Metropolitan Museum of Art (see M. Jenkins, 'Islamic Glass: A Brief History', *Bull. MMA*, (Fall 1986), 23, no. 21). Threads of this metal are also to be seen on glass objects from the Arab world, e.g. Los Angeles County Museum of Art, Los Angeles, M.2002.1.501.

89. See Kahle, 'Schätze', 329–62, esp. items 8, 10, 27, and Priscilla Soucek, 'Minaʾi', *Encyclopaedia of Islam*, N.S. 7, 73. The green relief-cut glass vessel in Venice (cf. *The Treasury of San Marco Venice*, exh. cat., New York, Metropolitan Museum of Art, 1984, cat. no. 27, p. 100, and Shalem, *Islam Christianized*, 59 and 228, fig. 53) is, most probably, one such vessel made in imitation of an emerald receptacle. See also M. Jenkins-Madina, 'Fatimid Decorative Arts: The Picture the Sources Paint', in *L'Egypte fatimide: son art et son histoire* (Paris, 28, 29, and 30 mai 1998, (Paris, 1999)).

90. One of these is a closely related, and roughly contemporary (1000–08),

rock-crystal ewer in the Pitti Palace, Florence (see Ettinghausen and Grabar, *Art and Architecture*, 194, fig. 179), which in 1998 was accidentally broken (see 'Oops, It Slipped', *Art Newspaper* (January 1999). The third datable object in this medium is a crescent in the name of al-Zahir (*r.* 1021–36) in the Germanisches Nationalmuseum, Nuremberg (Ettinghansen and Grabar, 193, fig. 178).

91. The similarly shaped glass ewer (without, however, the relief-cut decoration) found in the Northern Pagoda of Chaoyang and datable to the Chongxi reign (1032–51) of the Liao dynasty may indicate that the glass versions imitated those in rock-crystal, see An Jiayao, 'Dated Islamic Glass in China', *Bulletin of the Asia Institute*, N.S. 5 (1991), fig. 17. The glass ewer discussed in Chapter 5 [281] with its datable parallel unearthed in China supports a similar conclusion.

92. *The Treasury of San Marco*, nos 31, 32, pp. 216–27.

93. C. J. Lamm, *Mittelalterliche Gläser und Steinschnittarbeiten aus dem Nahen Osten* (Berlin, 1930) 1, 211, nos 10, 11, pl. 75 no. 10. For a list of other early arrivals in Europe see K. Erdmann, 'Fatimid Rock Crystals', *Oriental Art* 3 (1951), 142. The first section of Shalem, *Islam Christianized*, 17–125, is a good discussion of why Islamic objects are to be found in European church treasuries and how they got there.

94. In view of the close technical and stylistic relationship between relief-cut glass and carved rock crystal, the latter mainly worked in Egypt, and of the great number of pieces of this type of glass reported in contemporary accounts, as well as of vessels and fragments of this variety actually found there, we must conclude that such glass was manufactured in Egypt during the early Fatimid period and even before. Although no indisputable evidence of glass manufacture has been excavated in Fustat, the Geniza documents provide conclusive proof that glass (of unspecified types except for the moulded variety) was being produced in Egypt during the Medieval Islamic period; cf. Goitein, *A Mediterranean Society, Vol. I*, 94, 110, 363, and 365. It also seems highly probable that it was made in Iraq where, in the ninth century, Basra had a reputation as an outstanding glass producing centre (Lamm, *Mittelalterliche Gläser* 2, 496–98, esp. nos 76, 81–83, 91, 92). The only examples of glass dating from the ninth or tenth century to provide epigraphic evidence of an Iraqi origin, however, are lustre-painted pieces associated with Basra and the mould-blown vessels from Baghdad discussed in Chapter 2, above (R. Ettinghausen, 'An Early Islamic Glass-Making Center', *Record of the Museum of Historic Art, Princeton University* I (1942), 4–7; D. S. Rice, 'Early Signed Islamic Glass', *Journal of the Royal Asiatic Society* (April, 1958), 12–16, fig. 4, pls IV–VI). As it did in Egypt, the cutting of semi-precious stones in Iraq probably affected the glass industry, for, according to the famous Iranian scientist al-Biruni, Basra was the outstanding centre for the carving of rock crystal (P. Kahle, 'Bergkristall, Glas and Glasflusse nach dem Steinbuch von el-Beruni', *Zeitschrift der Deutschen Morgenländischen Gesellschaft*, N.F. 15 (1936), 332). It must have been a well-organized craft, for al-Biruni speaks of highly paid designers who found the most suitable shape for each rock and of carvers who executed the work. Unfortunately, however, with one possible exception (a small flaçon found during the excavations of Wasit, the first important town to the north of Basra on the Tigris route; Erdmann, 'Bergkristalle', 202, text figure A and fig. 4), none of the existing carved rock crystals can be definitely attributed to Basra. Sheila Blair, 'An Inscribed Rock Crystal from 10th-century Iran or Iraq', *Riggisberger Berichte* 6 (1998), 345–53.

95. For a carafe with a very similar decoration found at Sabra al-Mansuriyya, see G. Marçais and L. Poinssot, *Objets kairouanais, IXe au XIIIe siècle: reliures, verreries, cuivres et bronzes, bijoux*, Notes & Documents, XI – Fasc. 2 (Tunis, 1952), 379–82, LV, LVIII. The bodies of the animals depicted on both the illustrated beaker and the vessel found in Ifriqiya are ornamented with hatched lines, a convention very popular on pottery produced in Ifriqiya and at Qalʿat Bani Hammad in present-day Algeria.

96. Jenkins, *Islamic Glass*, no. 31, pp. 30–31.

97. Jenkins, *Islamic Glass*, no. 41, p. 34.

98. Lamm, *Mittelalterliche Gläser* 1, 109, no. 3.

99. R. B. Serjeant, *Islamic Textiles, Material for a History up to the Mongol Conquest* (Beirut, 1972), 135–60. See also J. A. Sokoly, 'Towards a Model of Early Islamic Textile Institutions in Egypt' and Y. K. Stillman, 'Textiles and Patterns Come to Life Through the Cairo Geniza', both *Riggisberger Berichte* 5 (1996), 115–22 and 35–52, respectively.

100. *Trésors fatimides du Caire*, exh. cat., 'Institut du Monde Arabe, 28 April–30 August 1998, cat. no. 209, pp. 232–33; one other piece in the Metropolitan Museum of Art, New York, acc. no. 29.136.4, unpublished, and that in *Tissus d'Egypte témoins du monde arabe VIII–XV siècles, Collection Bouvier*, exh. cat., Musée d'Art et d'Histoire, Geneva, 1993–94, cat. no. 134. The most important of these is, unquestionably, the Veil of Saint Anne, which is complete and dated and bears the name of the ruler and his vizier – thus providing the date for the few extant fragments of the same type. However, it is difficult to reproduce and, when shown in detail, the individual motifs are not rendered as beautifully as those on the New York fragment illustrated here.

101. Serjeant, *Islamic Textiles*, 142–43. In addition to that illustrated here and that mentioned in the previous note, the Metropolitan Museum of Art possesses two simpler fragments of this textile category. Employing a minimal amount of silk, these may have been knock-offs for the *hoi polloi* of the epitome in royal fashion at the turn of the eleventh century (acc. nos 1974.112.14a and 1974.113.14b).

102. Ernst Kühnel, 'Four Remarkable Tiraz Textiles', in G. C. Miles, ed., *Archeologica Orientalia in Memoriam Ernst Herzfeld* (Locust Valley, N.Y., 1952), 144–49.

103. The largest published group of such animals of copper alloy is to be found in G. Migeon, *Manuel d'art musulman* (Paris, 1927), figs 182–91; the only more critical evaluation is by K. Erdmann, 'Islamische Giessgefässe des 11 Jahrhunderts', *Pantheon* 22 (1938), 251–54. See also E. C. Dodd, 'On the Origins of Medieval *Dinanderie*: The Equestrian Statue in Islam', *Art Bulletin* 51 (1969), 220–32; and 'On a Bronze Rabbit from Fatimid Egypt', *Kunst des Orients* 8 (1972), 60–76.

104. See *The Art of Medieval Spain, A.D. 500–1200* (exh. cat., New York, 1993), illustration p. 81.

105. M. Jenkins, 'New Evidence for the Possible Provenance and Fate of the So-Called Pisa Griffin', *Islamic Archaeological Studies* 1 (1978) (Cairo, 1982), 79–85. For two different views see A. S. Melikian-Chirvani, 'Le Griffon iranien de Pise: matériaux pour un corpus de l'argenterie et du bronze iraniens, III', *Kunst des Orients* 5 (1968), 68–86, and *Al-Andalus: The Art of Islamic Spain*, exh. cat., New York, 1992, cat. no. 15, pp. 216–18. A large metal lion sculpture recently sold at auction and published in Curatola, *Eredità dell'Islam*, pp. 128–29, Figures 43a and 43b, shares a number of striking technical and stylistic parallels with the so-called Pisa griffin. Since scientific and art historical research currently being undertaken on the lion, as this book goes to press, seems to be pointing to a European and not an Islamic provenance for that object, all prior attributions to the griffin – including that presented here – must be considered as under review at this time.

106. Judging from the decoration on these two sculptures, however, it seems plausible to assume that from the small copper-alloy figure of a long-eared deer in the Museum of Islamic Art, Cairo, no. 15062 (see E. C. Dodd, 'On a Bronze Rabbit from Fatimid Egypt', *Kunst des Orients* 8 (1972), fig. 13), the development progressed into the type of copper-alloy sculpture represented by the rabbit which, in turn, points the way to the griffin.

107. E. Meyer, 'Romanische Bronzen und ihre islamischen Vorbilder', in R. Ettinghausen, ed., *Aus der Welt der islamischen Kunst*, 317–22.

108. *Art of Medieval Spain*, no. 47, pp. 99–100. Dr Carboni's reading of the inscription on this object not only confirmed the sources regarding silver objects with niello decoration but provided us with proof of the beauty of their execution. See also S. D. Goitein, *A Mediterranean Society, Vol. IV* (Berkeley, Los Angeles, and London, 1983), 223 and note 533, p. 429. In October 1998 a massive hoard of about six hundred copper-alloy objects was excavated in Tiberias under the auspices of the Archeological Institute of The Hebrew University. Found in conjunction with coins, this large cache of candelabra, bowls, trays, jugs, oil lamps, incense burners, numerous receptacles and household items such as handles and legs of furniture promises to revolutionize our understanding of the metalworking industry during the Fatimid period. In spite of numerous requests, the authors were unable to secure any photographs of this material or to ascertain the dates of the coins. Another large cache, of more than two hundred – principally metal – objects, was found in 1995 during the ongoing excavations in Caesarea conducted by the combined Caesarea Expedition and the Israeli Antiquities Authority. See Ayala Lester, Y. D. Arnon and Rachel Polak, 'The Fatimid Hoard from Caesarea: A Preliminary Report,' in *L'Egypte fatimide son art et son histoire* (ed. M. Barrucand), Paris, 1999, pp. 233–48. Among the metal finds are candlesticks, basins, jugs, bowls, trays, and braziers. Unlike the Tiberias hoard, however, no coins were found in the Caesarea cache.

109. *Glory of Byzantium*, cat. nos. 274–78, pp. 418–21.

110. For example, see Ettinghausen, *Early Realism in Islamic Art*, 267–69; *Arab Painting* (Geneva, 1962), 54–6; and E. J. Grube, *The World of Islam* (London, 1966), 67. See also O. Grabar, 'Fatimid Art, Precursor or Culmination', in S. H. Nasr, ed., *Isma'ili Contributions to Islamic Culture* (Tehran, 1977), esp. 218.

111. Since any direct Fatimid influence on the style or iconography of the wooden ceiling of the Cappella Palatina in the Norman royal residence in Palermo, Sicily (built for the Christian king Roger II in the 1140s), is impossible to prove (there being no documents or inscriptions to indicate the nationality of the craftsmen responsible) and up to now has only been conjectured, this monument will be discussed not here but in Chapter 8.

112. D. S. Rice, 'A Drawing of the Fatimid Period', *Bulletin of the School of Oriental and African Studies* 21 (1958), 31–39, and Dalu Jones, 'Notes on a Tattooed Musician: A Drawing of the Fatimid Period', *Art and Archaeology Research Papers* 7 (1975), 1–14. B. Gray, 'A Fatimid Drawing', *British Museum Quarterly* 12 (1938), 91–96. E. J. Grube, 'Three Miniatures from Fustat in the Metropolitan Museum of Art in New York', *Ars Orientalis* 5 (1963), 89–95, pls 1–6. Contrary to the view expressed by the latter author, the relationship of text to illustration on both the verso and the recto of the folio illustrated [343] is not clear and it is doubtful that Ka'b al-Ahbar himself is the author of the manuscript. For the most recent bibliography on such drawings, in general, cf. *Schätze der Kalifen*, cat. nos 20–25, 28–32, 36, 37, 41, 121, pp. 84–93, 95–96, 99, and 154–55.

113. Ibn al-Zubayr, trans. Gh. H. Qaddumi, *op.cit.*, paragraph 413.

114. Contadini, *Fatimid Art*, 11, 12, figs 7, 8 notwithstanding. Other than the date of the manuscript in the Chester Beatty Library cited by her (a date that falls during the rule of a number of other Muslim dynasties besides the Fatimid), she gives no cogent and supportable reason for that particular Qur'an to qualify as the only Fatimid Egyptian Qur'an to have survived to this day.

115. These are the Geniza documents whose data has been analysed but not exhausted by S. D. Goitein, *A Mediterranean Society*, 6 vols (Berkeley, 1967–93).

116. The most accessible document is the *Kitab al-Dhakha'ir*, trans. G. Qaddumi, *Book of Gifts* (Cambridge, 1996).

117. These episodes have been integrated in a broad fresco of artistic collecting by Joseph Alsop, *The Rare Art Traditions* (Princeton, 1981), 156.

118. I. Bierman, *Writing Signs*.

119. O. Grabar, *The Shape of the Holy* (Princeton, 1996), 135 ff.

120. Nasir-i Khosrow, *Sefer-nameh* (tr. Albany, 1986) pp. 42–57.

121. See another form of these conclusions in O. Grabar, 'Le Problème de l'art fatimide', in M. Barrucand, ed., *L'Egypte fatimide son art et son histoire* (Paris, 1999).

122. R. Ettinghausen, 'Early Realism in Islamic Art', in *Collected Papers*, 158.

123. Some preliminary thoughts were presented by O. Grabar in 'Imperial and Urban Art in Islam', with a response by M. Jenkins in 'Western Islamic Influences.'

124. J. Bloom, 'The Origins of Fatimid Art', *Muqarnas* 3 (1985), pp. 20–38 hinted in this direction in a persuasive and provocative paper.

125. Topography and bibliography of Baghdad in G. Makdisi, 'The Topography of Eleventh Century Baghdad', *Arabica* 6 (1959); S. A. Ali, *Baghdad, madinat al-salam* (Baghdad, 1985), for a general survey of the city. Introductions to other cities can be found in the *Encyclopedia of Islam*.

126. A. Hartmann, *An-Nasir li-Din Allah* (Wiesbaden, 1975).

127. For the eleventh century and earlier the main source is *al-Khatib al-Baghdadi*, ed. and trans. G. Salmon, *L'Introduction topographique* (Paris, 1904); then Ibn al-Jawzi, *al-Muntazam* (Hyadarabad, 1938 and ff.). See also J. Lassner, *The Topography of Baghdad in the Early Middle Ages* (Detroit, 1970).

128. Creswell, *MAE* 2, 124 ff.; H. Schmid, 'Die Madrasa al-Mustansiriyya in Baghdad', *Architectura* 9 (1979). Hillenbrand, *Architecture*, 223–24.

129. L. Massignon, *Mission en Mesopotamie* 2 (Cairo, 1912), 41 ff.; see also F. Sarre and E. Herzfeld, *Archäologische Reise im Euphrat- und Tigris-Gebiet (Forschungen zur islamischen Kunst* 1) (Berlin, 1911) 1, 44–45.

130. E. Herzfeld, 'Damascus', *Ars Islamica* 9, 13–14 (1942), 18 ff.; also M. Jawad, 'Al-Imarat al-islamiyah', *Sumer* 3 (1947), 38 ff. Y. Tabbaa, 'The Muqarnas Dome', *Muqarnas* 3 (1985), to be revised and put in a wider context in his forthcoming *Transformations in Islamic Architecture during the Sunni Revival*.

131. Herzfeld, *Reise* 1, 151 ff.

132. M. Awad, 'Al-Qasr al-Abbasi', *Sumer* 1 (1945).

133. Sarre and Herzfeld, *Reise* 2, 151 ff.; Massignon, *Mission* 2, 47 ff.

134. Creswell, *EMA* 1, 644 ff.; D. S. Rice, 'Medieval Harran', *Anatolian Studies* 2 (1952).

135. See Max van Berchem and J. Strzygowski, *Amida* (Heidelberg, 1910) 1; A. Gabriel, *Voyages archéologiques* (Paris, 1940) 1, 85 ff.; M. Sözen, *Diyarbakir'da Türk Mimarisi* (Istanbul, 1971); also a general attempt at characterizing Ortoqid architecture by A. Altun, *Anadoluda Artuklu Devri Türk Mimarisinin Gelismesi* (Istanbul, 1978).

136. Archeological investigations, especially rescue operations surrounding the building of dams on the Euphrates, are slowly bringing to light interesting new documents on the material culture of the area; see, for example, Scott Redford, 'Excavations at Gritille', *Anatolian Studies* 36 (1986).

137. N. Elisséev, 'Les Monuments de Nur al-Din', *Bulletin des Etudes Orientales* 13 (1949–50). Y. Tabbaa's thesis *The Architectural Patronage of Nur al-Din*, New York University, 1982.

138. Excellent introduction by M. Meinecke, 'Rakka', in *Encyclopedia of Islam*, 2nd ed.

139. Sarre and Herzfeld, *Reise* 2, 215 ff.

140. Elisséev, 'Les Monuments', 37–38.

141. Sarre and Herzfeld, *Reise* 1, 123 ff.; D. Sourdel and J. Sourdel-Thomine, 'Notes d'épigraphie et de topographie', *Annales Archéologiques de Syrie* 3 (1953). The minaret has, since then, been relocated; A. Raymond and others, *Balis II: Histoire de Balis* (Damascus, 1995) for an introduction to the site.

142. A. Gabriel, 'Dunaysir', *Ars Islamica* 4 (1936).

143. Gabriel, *Voyages Archéologiques*, 227 ff.

144. Gabriel, *Voyages archéologiques*, 263 ff.

145. Gabriel, *Voyages archéologiques*, 221 ff.; see also Sauvaget in *AIEO* 4 (1938), 82 ff.

146. Gabriel, *Voyages archéologiques*, 255 ff.

147. Gabriel, *Voyages archéologiques*, 3 ff.; see also Ara Altun, *Mardinde Türk devri mimarsi* (Istanbul, 1971).

148. This had been established by Gabriel and Sauvaget in *Voyages*, 184 ff. For interpretations see T. Allen, *A Classical Revival in Islamic Architecture* (Wiesbaden, 1986), and T. Sinclair, 'Early Artukid Mosque Architecture', in J. Raby, ed., *The Art of Syria and the Jazira 1100–1250* (Oxford, 1985).

149. S. al-Diwahji, 'Madaris al-Mausil', *Sumer* 13 (1957).

150. Gabriel, *Voyages archéologiques*, 195 ff.

151. Sarre and Herzfeld, *Reise* 2, 234 ff. More recently some archaeological work has been accomplished in some of these shrines; Sa'id al-Diwahji in *Sumer* 10 (1954). It should be added that the plans published by Sarre and Herzfeld are far from reliable.

152. For these see mostly C. Preusser, *Nordmesopotamische Baudenkmäler* (Leipzig, 1911), 2 ff. For related Christian monuments see J. M. Fiey, *Assyrie chrétienne* (Beirut, 1965) and *Mossul chrétienne* (Beirut, 1959).

153. Al-Harawi, *Guide des lieux de pélerinage*, trans. J. Sourdel-Thomine (Damascus, 1957), 135–59.

154. G. Bell, *Amurath to Aurath* (London, 1924), 48–51; Elisséev, *Monuments*, 36; the site has recently been investigated by A. R. Zaqzuq, 'Fouilles de la citadelle de Ja'bar', *Syria* 62 (1985); Cristina Tonghini, *Qal'at Jabbar Pottery* (Oxford, 1998).

155. Elisséev, *Monuments*, 36–37.

156. Gabriel, *Voyages archéologiques*.

157. Rice, 'Medieval Harran'.

158. J. Warren, *Art and Archaeology Papers* 13 (1978); C. Hillenbrand in Raby, ed., *Syria and the Jazira*.

159. Sarre and Herzfeld, *Reise* 2, 239.

160. Sarre and Herzfeld, *Reise* 2, 11.

161. W. Hartner, 'The Pseudoplanetary Nodes of the Moon's Orbit', *Ars Islamica* 5 (1937), has explained them and provides sources for its original publication by C. Preusser.

162. For Aleppo the classical study is by J. Sauvaget, *Alep* (Paris, 1941); it has been much revised in recent years; E. Wirth and H. Gaube, *Aleppo: historische und geographische Beiträge* (Wiesbaden, 1984), present a very different view of the city. For Damascus, Sauvaget, 'Esquisse d'une histoire de la ville de Damas', *Revue des Etudes Islamiques* 8 (1934), 421–80, and now Dorothée Sack, *Damaskus: Entwicklung und Struktur einer orientalisch-islamischen Stadt* (Mainz am Rhein, 1989).

163. See e.g. J. Sourdel-Thomine, 'Le Peuplement de la région des "villes mortes"', *Arabica* 1 (1954); D. Sourdel, 'Ruhin, lieu de pélerinage musulman', *Syria* 30 (1953).

164. E. Herzfeld, *Matériaux pour un Corpus Inscriptionum Arabicarum: Syrie du Nord: Alep* (Cairo, 1954), 143 ff.; Sauvaget, *Alep*, and 'Inventaire des monuments musulmans de la ville d'Alep', *Revue des Etudes Islamiques* 5 (1931), 73; Wirth and Gaube, *Aleppo*; and now Y. Tabbaa, *Construction of Power and Piety in Medieval Aleppo* (University Park, PA, 1997).

165. J. Sauvaget, *Les Monuments historiques de Damas* (Beirut, 1932), 16; Sack, *Damaskus*.

166. J. Sauvaget, 'Les Inscriptions arabes de la mosquée de Bosra', *Syria* 22 (1941); M. Meinecke, *Patterns of Stylistic Change in Islamic Architecture* (New York, 1995), 31 ff.

167. Best account in Max van Berchem, *Matériaux pour un Corpus Inscriptionum Arabicarum. Deuxième partie; Syrie du Sud: Jérusalem* (*MIFAO* 42–45), 2 vols (Cairo, 1920–27). A thesis on the subject of Ayyubid monuments in Jerusalem is being completed by M. Harawy at Oxford University; in the meantime see S. Jarrar, 'Suq al-Ma'rifa: An Ayyubid Hanbalite Shrine in al-Haram al-Sharif', *Muqarnas* 15 (1998).

168. Sauvaget, *Monuments*, 95–96; E. Herzfeld, 'Damascus: Studies in Architecture – IV', *Ars Islamica* 13–14 (1948), 1118 ff.

169. Sauvaget, *Monuments*, 64; Herzfeld, 'Damascus', 123 ff.

170. Sauvaget, 'Inventaire', 82 and 86 for a few remains; D. Sourdel, ed., *La Description d'Alep d'Ibn Shaddad* (Damascus, 1953), 42 ff.

171. R. Lewcock in W. Daum, ed., *Yemen* (Innsbruck, 1987); B. Finster, 'An Outline of the History of Islamic Religious Architecture in Yemen', *Muqarnas* 9 (1992), for an introduction to the subject with bibliographies.

172. Creswell, *MAE* 2, 94 ff.

173. J. Sauvaget *et al.*, *Monuments ayyoubides de Damas*, 4 vols (Paris, 1938 ff.) 1, 120.

174. On these issues see now Tabbaa, *Medieval Aleppo* and his forthcoming *Sunni Revival*.

175. E. Herzfeld, 'Damascus: Studies in Architecture – II', *Ars Islamica* 11–12 (1946), 32–38.

176. Sauvaget, *Monuments*, 100–02.

177. Summarized in Creswell, *MAE* 2, 104 ff.

178. Creswell, *MAE*, 64 ff.

179. Creswell, *MAE*, 88 ff.

180. J. Sauvaget *et al.*, *Monuments ayyoubides* 3, 92 ff.; M. Ecochard and C. LeCocur, *Les Bains de Damas*, 2 vols (Beirut, 1942–43); for Aleppo see Sauvaget, 'Inventaire'.

181. J. Sauvaget, 'Caravanserails syrens', *Ars Islamica* 6 (1939).

182. Sourdel, ed., *La Description d'Alep d'Ibn Shaddad*, 2.

183. Sauvaget, *Monuments Ayyoubides*, 46; E. Herzfeld, 'Damascus: Studies in Architecture – I', *Ars Islamica* 9 (1942), 1–53.

184. T. Allen, *Five Essays on Islamic Art* (Sebastopol, CA, 1988).

185. S. Saouaf, *The Citadel of Aleppo* (Aleppo, 1958); Herzfeld, *Matériaux* 77 ff.; Rogers, *The Spread of Islam* (Oxford, 1976), 43 ff.; Tabbaa, *Aleppo*, 53 ff.

186. D. J. Cathcart King, 'The Defenses of the Citadel of Damascus', *Archaeologia* 94 (1951). The building has now been cleared and is in the process of being investigated.

187. Creswell, *MAE* 2, 1–63; N. Rabbat, *The Citadel of Cairo* (Leiden, 1995) which, however, deals primarily with its later phases.

188. A. Abel, La Citadelle ayyubite de Bosra', *Annales Archéologiques de Syrie* 6 (1956).

189. Sourdel, ed., *La Description d'Alep d'Ibn Shaddad*, 24; Herzfeld, *Alep*, 134–45.

190. J. Sauvaget, 'L'Architecture musulmane en Syrie', *Revue des Arts Asiatiques* 3 (1934); further remarks throughout other studies by Sauvaget and Herzfeld, as well as in specialized articles such as J. Lauffray, 'Une madrasa ayyoubide de la Syrie du Nord', *Annales Archéologiques de Syrie* 3 (1953) and especially maurice Ecochard, *Filiation de monuments grecs, byzantins et islamiques* (Paris, 1977), summarizing some of his earlier works on architectural forms and their creation.

191. *Monuments ayyoubides* 1, 21–23. However, it was already used in the eighth century at Qasr al-Hayr West, where stone and brick were used together.

192. Creswell, *MAE* 2, pl. 19; many instances exist in Syria.

193. Besides Herzfeld's work and J. Sourdel-Thomine's contribution in *Monuments ayyoubides* 4, see the classic article by Max van Berchem, 'Inscriptions arabes de Syrie', *Mémoires de l'Institut Egyptien* 3 (1900) and Tabbaa, *Aleppo*, 99 ff.

194. *Monuments ayyoubides* 2, pl. XV.

195. Creswell, *MAE* 2, 84 ff.

196. *Monuments ayyoubides* 3, 121 ff.

197. Creswell, *MAE* 2, p. 138, note 5.

198. For instance J. Sauvaget, *Les Perles Choisies d'Ibn ach-Chihna* (Beirut, 1933), 136.

199. Tabbaa, 'Survivals and Archaisms in the Architecture of Northern Syria', *Muqarnas* 10 (1993); Terry Allen, *A Classical Revival*.

200. For Mayyafariqin see A. Gabriel, *Monuments turcs d'Anatolie* (Paris, 1931–34) 2, 143.

201. F. Sarre, *Reise in Kleinasien* (Berlin, 1986), 47–48; Sarre, *Konia* (Berlin, 1921); I. H. Konyali, *Konya Tarihi* (Konya, 1964), esp. 293 ff; Scott Redford, 'The Aleddin Mosque', *Artibus Asiae*, 51 (1991); T. Baykara, *Türkiye Selcuklurlari Devrinde Konya* (Ankara, 1985).

202. Gabriel, *Monuments*, 32 ff.

203. Gabriel, *Monuments* 2, 39 ff and 174 ff.

204. Gabriel, *Monuments* 2, 173 ff.

205. Gabriel, *Monuments* 2, 176; B. Ünsal, *Turkish Islamic Architecture* (London, 1959), 17. The mosque is attributed to a vizier of Kilicarslan II in the late twelfth century; for justification see E. Diez and O. Aslanapa, *Türk Sanati* (Istanbul, 1955), 55.

206. Gabriel, *Monuments* 1, 62 ff and 46 ff.

207. Gabriel, *Monuments* 2, 155 ff.

208. Sarre, *Reise*, 51–54; Konyali, *Konya Tarihi*, 4 523 ff; Baykara, *Konya*.

209. Ünsal, *Architecture*, 36–38; S. K. Yetkin, *Turkish Architecture* (London, 1966), 22 ff; for the problem of the building's date see M. J. Rogers, 'The Date of the Çifte Minare Madrasa', *Kunst des Orients* 8 (1974).

210. Sarre, *Reise*, 48–51; Yetkin, *Turkish Architecture*, 28 ff; Konyali, *Konya Tarihi*, 950, 1049.

211. D. Kuban, *Anadolu-Türk Mimarisinin Kaynak ve Sorunlari* (Istanbul, 1965), argues for the convergence between Islamic needs and local practices; see S. Redford, 'The Seljuqs of Rum and the Antique', *Muqarnas* 10 (1993).

212. Thus Amasya in Ünsal, *Architecture*, 45 and Yetkin, *Turkish Architecture*, 35 ff.

213. For the *waqfs* or endowment deeds in Anatolia see A. Durukan, 'Anadolu Selçukler Sanati Açinsinlari Vakfieyeleri Önemi', *Vakiflar Dergisi* 26 (1997).

214. H. W. Duda, *Die Seldschukengeschichte des Ibn Bibi* (Copenhagen, 1959), 146–48.

215. F. Sarre, *Der Kiosk von Konia* (Berlin, 1936).

216. K. Erdman, 'Seraibauten', *Ars Orientalis* 3 (1959), and especially S. Redford, 'Thirteenth Century Rum Seljuq Palaces', *Ars Orientalis* 23 (1994).

217. S. Lloyd and D. S. Rice, *Alanya* (London, 1958); also Rice, 'Medieval Harran' 196, and various articles by S. Redford on the upper Euphrates valley.

218. K. Erdmann, *Das anatolische Karavansaray des B. Jahrunderts*, 3 vols (Berlin, 1961–76); A. T. Yavuz, 'The Concepts that Shaped Anatolian Seljuq Caravanserais', *Muqarnas* 14 (1997).

219. Erdmann, *Das anatolische Karavansaray*, 169 ff.

220. Erdmann, *Das anatolische Karavansaray*, 83 ff.

221. Fundamental studies on architectural decoration have appeared already some time ago which have not yet been fully digested by scholarship at large. They are: G. Öney, *Anadolu Selçuklu Mimarisinde Süsleme ve el Sanatlari* (Ankara, 1978); S. Ögel, *Anadolu Selçuklulari'nin Taş Tezyinati* (Ankara, 1966); M. Meinecke, *Fayencedekorationen seldschukischer Sakralbauten in Kleinasien* (Tübingen, 1976).

222. Y. Crowe, 'Divrigi: Problems of Geography, History and Geometry', in W. Watson, ed., *Colloquies on Art and Architecture* 4 (London, 1974).

223. See the formal analysis made by Ht. Glück, *Die Kunst der Seldschuken* (Leipzig, 1923); more recently, S. Ögel, *Anadolu Selçuklu Sanati* (Istanbul, 1986). For lists of sculptures see Diez and Aslanapa, *Türk sanati*, 208–11; K. Otto-Dorn, 'Türkische Grabsteine', *Ars Orientalis* 3 (1959); K. Erdmann, 'Die beiden türkischen Grabsteine', *Beiträge In Memoriam Ernst Diez* (Istanbul, 1963); G. Öney, 'Dragon Figures', *Belleten* 33 (1969).

224. A convenient but partial list has been drawn by T. Rice, *The Seljuqs* (London, 1961), 136; see also L. Mayer, *Islamic Architects* (Geneva, 1956); Z. Sönmez, *Anadolu Türk-Islam Mimarisinde Sanatçilar* (Ankara, 1989); Ht. Crane, 'Notes on Saldjuq Architectural Patronage in Thirteenth Century Anatolia', *JESHO* 33 (1993).

225. O. von Falke, *Kunstgeschichte der Seidenweberei* 1 (1913), 107–08; A. C. Weibel, 'Francisque-Xavier Michel's Contributions to the Terminology of Islamic Fabrics', *Ars Islamica* 2 (1935), 221–22. F.-X. Michel, *Recherches sur le commerce, la fabrication et l'usage des étoffes de soie, d'or, et d'argent, et autres tissus précieux en Occident, principalement en France, pendant le moyen âge*, 2 vols (Paris, 1852–54).

226. For information on the textile industry in northern and central Mesopotamia, see R. B. Serjeant, 'Materials for a History of Islamic Textiles up to the Mongol Conquest', *Ars Islamica* 9 (1942), 69–92.

227. For discussion of these two Spanish copies, see F. L. May, *Silk Textiles of Spain: Eighth to Fifteenth Century* (New York, 1957), 24–27, and F. E. Day, 'The Inscription of the Boston "Baghdad" Silk – A Note on Method in Epigraphy', *Ars Orientalis* 1 (1954), 191–94. See *Al-Andalus: The Art of Islamic Spain*, exh. cat., New York, 1992, 105–06 and *The Art of Medieval Spain: 500–1200 A.D.*, exh. cat., New York, 1993, pp. 108–09.

228. R. B. Serjeant, 'Materials for a History of Islamic Textiles up to the Mongol Conquest', *Ars Islamica*, 15–16 (1951), 33–34.

229. Serjeant, 'Materials', *Ars Islamica* 9 (1942), 91–92.

230. *When Silk Was Gold: Central Asian and Chinese Textiles*, exh. cat., New York, 1997, cat. nos 43–45, pp. 154–59 and fig. 63, p. 135.

231. For this inference drawn from the *nisba* 'al-Turabi', see Rice, 'Studies in Islamic Metal Work – III', *Bulletin of the School of Oriental and African Studies* 15 (1953), 230.

232. These coins are illustrated in S. Lane Poole, *Coins of the Urtukid Turkumans (Foes of the Crusaders)* (London, 1875). For a complete bibliography of this mirror see *An Exhibition of Medieval Renaissance and Islamic Works of Art*, Trinity Fine Art Ltd. exh. cat., New York, 9–22 November 1995, cat. no. 2, pp. 8–11.

233. See, for illustrations of this statement, [410, 411]; *Syrie: Mémoire et Civilisation*, exh. cat., Paris, 14 September 1993–28 February 1994, cat. no. 321, and similar motifs on several different types of glazed pottery bowls from Syria; as well as [404, 423, 424]. For a door-fitting exhibiting animal forms cf. *The Anatolian Civilisations*, 3 vols, exh. cat., Istanbul, 1983, no. D.96, vol. 3, p. 60.

234. *The Anatolian Civilisations*, no. D.128, vol. 3, p. 71; *The Glory of Byzantium*, no. 282, p. 424.

235. *The Anatolian Civilisations*, no. D.125, vol. 3, p. 68, and D.96, p. 60.

236. *The Anatolian Civilisations*, no. D.127, vol. 3, p. 70. The second set of fittings, in gold with some of the elements bearing traces of niello inlay, bear the name of al-Malik al-Salih 'Imad al-din Isma'il (r. 1310–32), a ruler of the Ayyubid branch at Hama which survived the Mongol invasion. This and a local Kurdish principality around Hisn Kayfa were the only two branches of the Ayyubids to survive the Mongol sweep. That in Hama lasted until 1342 and that in Diyarbakr was ended by the Aq Qoyunlu. M. Jenkins and M. Keene, 'Djawhar', in *Encyclopaedia of Islam, Supplement to vol. II*, new edition (Leiden, 1982), 255 and figs 12 and 23; R. Hasson, *Early Islamic Jewellery* (Jerusalem, 1987), cat. no. 127, p. 95. For a depiction of the new belt type – consisting of a large gold roundel, or several roundels, on a cloth or leather strap – that appears to have become prevalent at the onset of the fifteenth century, cf. M.

237. Jenkins and M. Keene, *Islamic Jewelry in the Metropolitan Museum of Art* (New York, 1983), 101, fig. 9.

237. Ethnographic Museum, Konya, 7591; D. S. Rice, 'Studies in Islamic Metalwork V', *Bulletin of the School of Oriental and African Studies* 17 (1955), 207–12; *The Anatolian Civilisations*, no. D.141, vol. 3, p. 76.

238. 'God is the Light of the heavens and the earth; the likeness of His Light is as a niche wherein is a lamp (the lamp is in a glass, the glass is as it were a glittering star) kindled from a Blessed Tree, an olive that is neither of the East nor of the West whose oil wellnigh would shine, even if no fire touched it; Light upon Light; (God guides to His Light whom He will.).' This sura was also often used to decorate enamelled and gilded glass mosque lamps.

239. The box is discussed and illustrated in D. S. Rice, 'Studies in Islamic Metal Work – II', *Bulletin of the School of Oriental and African Studies* 15 (1953), 62–66. For further reference to Isma'il ibn Ward, which provides evidence that this artist may have been a resident of Mosul, see D. James, 'An Early Mosul Metalworker: Some New Information', *Oriental Art* 26 (1980), 318–21.

240. For a list of twenty-eight objects, with references, see D. S. Rice, 'Inlaid Brasses from the Workshop of Ahmad al-Dhaki al-Mawsili', *Ars Orientalis* 2 (1957), 325–26.

241. D. S. Rice, 'The Brasses of Badr al-Din Lu'lu', *Bulletin of Oriental and African Studies* 13 (1951), 627–34.

242. G. Wiet, 'Un nouvel artiste de Mossoul', *Syria* 12 (1931), 160–62, and Harari, 'Metalwork after the Early Islamic Period', in *Survey*, 2496–97.

243. The scenes enumerated here are all to be found on the ewer illustrated in this volume in Figures 406 & 407, no. 56.11 in the Cleveland Museum of Art. See also, Rice, 'Inlaid Brasses', 287–301.

244. Rice, 'Inlaid Brasses', 323.

245. Ibn Sa'id, writing about 1250; for a translation of the relevant passage, see Rice, 'Inlaid Brasses', 284.

246. Rice, 'Inlaid Brasses', 321–25; see also M. Aga-Oglu, 'About a Type of Islamic Incense Burner', *The Art Bulletin* 27 (1945), 28–45.

247. See E. Atil, *Art of the Arab World* (Washington, D.C., 1975), 65–68, and references given there, and E. Atil, W. T. Chase, and P. Jett, *Islamic Metalwork in the Freer Gallery of Art* (Washington, D.C., 1985), no. 18, pp. 137–47. See also in this connection, T. Ulbert *et al.*, *Resafa III: Der kreuzfahrerzeitliche Silberschatz aus Resafa-Sergiupolis* (Mainz am Rhein, 1990).

248. L. T. Schneider, 'The Freer Canteen', *Ars Orientalis* 9 (1973), 137–56; Atil, *Art*, 69–73, and Atil, Chase, and Jett, *Islamic Metalwork*, no. 17, pp. 124–36. See also R. Katzenstein and G. Lowry, 'Christian Themes in Thirteenth Century Islamic Metalwork', *Muqarnas* 1 (1983), 33–68, and, E. Baer, *Ayyubid Metalwork with Christian Images* (Leiden, 1989), in which the Freer canteen and related pieces are discussed.

249. Rice, 'Inlaid Brasses', 322.

250. Rice, 'Studies in Islamic Metalwork', 11, 66–69; Atil, *Art*, 61–63.

251. F. Sarre, 'Islamische Tongefässe aus Mesopotamien', *Jahrbuch der Königlich Preuszischen Kunstsammlungen* 26 (1905), 69–88; and G. Reitlinger, 'Unglazed Relief Pottery from Northern Mesopotamia', *Ars Islamica* 15–16 (1951), 11–22.

252. For an illustration of the Gate of the Talisman see R. Hillenbrand, *Islamic Art and Architecture* (London and New York, 1999), fig. 97, p. 124.

253. A. Lane, *Early Islamic Pottery: Mesopotamia, Egypt and Persia* (London, 1947), 38–39, 44–45; J. Sauvaget, 'Tessons de Rakka', *Ars Islamica* 13–14 (1948), 31–45; and E. J. Grube, 'Raqqa Keramik in der Sammlung des Metropolitan Museum in New York', *Kunst des Orients* 4 (1963), 42–78. See also P. J. Riis and V. Poulsen, *Hama: Fouilles et recherches 1931–1938* 4 (part 2), *Les Verreries et poteries médiévales* (Copenhagen, 1957), 120–283; A. Lane, 'Medieval Finds at al-Mina in North Syria', *Archaeologia* 87 (1937), 19–78; and F. Sarre, 'Die Kleinfunde', in *Baalbek: Ergebnisse der Ausgrabungen in den Jahren 1898 bis 1905* 3 (Berlin and Leipzig, 1925), 113–36. For a general discussion of ceramics see M. Jenkins, 'Islamic Pottery', *Bull. MMA* 40:4 (1983).

254. This basin and the bowl [413] have been attributed to Raqqa.

255. See M. Jenkins, ed., *Islamic Art in the Kuwait National Museum: The al-Sabah Collection* (London, 1983), 84. As is mentioned below, lustre-painting on a coloured ground is also found among the so-called Tell Minis pieces as well as on those from Konya [415]. Another, highly unusual example exhibiting lustre-painting on cobalt is the slightly curved pair of tiles in the Museum of Islamic Art, Cairo (no. 14761). Such a combination is also met with in the early Islamic period, e.g. a ninth-century bowl in the Museum of Islamic Art, Cairo (no. 13996) with a lustre-painted elephant on a cobalt ground and on a signed bowl from Susa now in the Louvre (no. S191).

256. *Art from the World of Islam 8th–18th century*, exh. cat., *Louisiana Revy* 27:3 (March 1987), cat. no. 121, p. 91.

257. For examples of ceramic furniture cf. Metropolitan Museum of Art, New York, acc. nos 42.113.2 and 57.61.13; and for examples of ceramic mosque lamps cf. Metropolitan Museum of Art, New York, acc. nos 14.40.809 and 57.61.17.

258. Another pottery type produced in Syria at this time was that known as 'splashed sgraffito ware', one that appears to have enjoyed great popularity in both the Islamic and Byzantine realms. This small Syrian group is attributed to the second half of the twelfth or first half of the thirteenth century on the basis of close parallels for its decoration to be found on the lustre-painted ware manufactured during this period at a centre in northern Syria [411] and on the strikingly similar decorative parallels to be found among the objects unearthed in Tiflis, in the Byzantine borderland of Georgia, vessels that the excavators date between the middle of the twelfth century and the 1230s when the area was destroyed during the Mongol invasion never to be restored again; cf. M. N. Mitsishvili, *A Glazed Pottery Workshop in Medieval Tbilisi (9th–13th centuries)* (Tblisi, 1979).

259. The Mosque of ʿAla' al-Din in Konya from 1220 also incorporates in its decoration an underglaze-painted round tile.

260. Examples of three-dimensional objects in both underglaze-painted colour schemes can be seen in the Konya Museum, as can unfinished lustre-painted bowls. The center where these glazed vessels were maded has not yet been determined.

261. For a discussion of this building, with references, see D. Wilber, 'The Development of Mosaic Faience in Islamic Architecture in Iran', *Ars Islamica* 6 (1939), 39–40.

262. *Trésors fatimides du Caire*, exh. cat., Paris, 1998, cat. no. 58, p. 128.

263. Hillenbrand, *Islamic Art and Architecture*, fig. 94, p. 122.

264. This beaker was first identified and its inscription read by Dr Stefano Carboni. It is discussed by him in 'Glass Production in the Fatimid Lands and Beyond', in *L'Egypte fatimide: son art et son histoire*, Paris, 28, 29, et 30 mai 1998, (Paris, 1999).

265. *Arts of Islam*, exh. cat., Hayward Gallery, London, 1976, cat. no. 135.

266. *The Anatolian Civilisations*, no. D.60, vol. 3, p. 45.

267. Lamm, *Mittelalterliche Gläser* 1 (Berlin, 1930), 278–79, with earlier bibliography; and A. E. Berkoff, 'A Study of the Names of the Early Glass-making Families as a Source of Glass History', in *Studies in Glass History and Design: Papers Read to Committee B Sessions of the VIIIth International Congress on Glass, held in London 1st–6th July, 1968* (London, n.d.), 62–65. M. Wenzel, 'Towards an Assessment of Ayyubid Glass Style', in Julian Raby, ed., *The Art of Syria and the Jazira 1100–1250* (Oxford and New York, 1985), 99–112. For a general discussion on glass see M. Jenkins, 'Islamic Glass', *the Metropolitan Museum of Art Bulletin* 44:1, (1986).

268. Uhland's poem, written in 1834, can be found in many collections, for example *Gedichte von Ludwig Uhland: Jubilaums-Ausgabe* (New York, 1887), 352–54; for Longfellow's translation of 1841, see *The Complete Poetical Works of Longfellow* (Cambridge ed.) (Boston, 1883), 613, 677.

269. R. Ettinghausen and O. Grabar, *Art and Architecture*, fig. 395, p. 374.

270. A few lids and separate bowls exist. The lidded bowl in the National Museum, Damascus, which was brought to my attention by my colleague Dr Stefano Carboni, does not appear to be a complete container. It seems to comprise elements from two different objects. The New York object, broken and restored when it was acquired by the Metropolitan Museum of Art in 1926, was recently dismantled, cleaned, and some of the missing areas newly restored by the Museum's Objects Conservation Department.

271. J. Allan, 'Investigations into Marvered Glass: I', in *Islamic Art in the Ashmolean Museum* (Oxford and New York, 1995), p. 22; Maria M. Mota, *Catálogo das Louças Islamicas*, Volume 1, Louças seljúcidas (Lisbon, 1988) pp. 62–63.

272. See Chapter 5, p. 178 and note 133. For bibliographies on Maʿali ibn Salam and his son Salman see L. A. Mayer, *Islamic Woodcarvers and Their Works* (Geneva, 1958), 48–49, 63–64; see also E. Herzfeld, 'Damascus: Studies in Architecture – II', *Ars Islamica* 10 (1943), 57–58.

273. C. J. Lamm, 'Fatimid Woodwork, Its Style and Chronology', *Bulletin de l'Institut d'Egypte* 18 (1936), 77; and Herzfeld, 'Damascus', 63–65. Herzfeld identified the donor as a son of the great Seljuq vizier Nizam al-Mulk (1018–92).

274. The carved elements on the *minbar* dated 1153 from the Mosque of al-ʿAmadiyya in Mosul are exclusively decorated with motifs executed in the bevelled style; cf. *Arts of Islam*, cat. no. 452.

275. The mosque of Nur al-Din was destroyed in 1982 during disturbances in Syria. The *minbar* is discussed by Herzfeld, 'Damascus', 43–45.

276. Herzfeld, 'Damascus', 45. The Mosul *mihrab* is illustrated in Sarre and Herzfeld, *Reise* 2 (Berlin, 1920), figs 234–35, 241; the Samarra door in E. Herzfeld, *Bab al-Ghaibah (Door of Disparition) at Samarra* (Baghdad, 1938).

277. The *minbar* was destroyed by arson in 1969. For a discussion see M.van Berchem, *Matériaux pour un Corpus Inscriptionum Arabicarum*, part 2, *Syrie du Sud, II, Jerusalem 'Haram'* (Cairo, 1925), 393–402; and Herzfeld, 'Damascus'. A complete list of the monuments of Nur al-Din, with references, is given in N. Elisseeff, 'Les Monuments de Nur ad-Din: inventaire, notes archéologiques et bibliographiques', *Bulletin d'Etudes Orientales* 13 (1949–51), 7–43. Other wood-carvings connected with Nur al-Din include a door in his hospital at

Damascus (1154) and a *mihrab* in the citadel of Aleppo (1168).

278. E. Herzfeld, *Matériaux pour un Corpus Inscriptionum Arabicarum*, part 2, *Syrie du Nord: inscriptions et monuments d'Alep, 1* (Cairo, 1955), 124–28.

279. Konya Museum 332; R. M. Riefstahl, 'A Seljuq Koran Stand with Lacquer-Painted Decoration in the Museum of Konya', *The Art Bulletin* 15 (1933), 361–73. *The Anatolian Civilisations*, no. D.176, vol. 3, p. 93.

280. Illustrated in K. Otto-Dorn, *Kunst des Islam* (Baden-Baden, 1965), 161 and G. Öney, *Anadolu Selçuklu Mimarisinde Süsleme ve El Sanatlari* (Ankara, 1978), fig. 96.

281. *The Anatolian Civilisations*, no. D.174, vol. 3, p. 92, and Michael Meinecke, 'Islamische Drachenturen', *Museums Journal, Berichte aus den Museen, Schlössern und Sammlungen im Land Berlin*, 3 series 4 (Oktober 1989), 54–58.

282. Öney, *Anadolu Selçuklu* 71–76, and *The Anatolian Civilisations*, nos. D.51–53, vol. 3, pp. 41–43.

283. For the latter theory cf. Hillenbrand, *Islamic Art and Architecture*, p. 123.

284. Öney, *Anadolu Selçuklu*, 31–58, and *The Anatolian Civilisations*, nos. D.159, 160, vol. 3, p. 84.

285. Qutb al-Din Abu al-Muzaffar Muhammad ibn Zangi ibn Mawdud; cf. D. James, *The Master Scribes: Qur'ans of the 10th to 14th Centuries* (New York, 1992), no. 7, pp. 44–49.

286. The only other extant Zangid Qur'ans are listed in James, *Master Scribes*, 49, note 7. To this all-Syrian group should be added the *juz'* in the Musée de l'Epigraphie Arabe, Damascus, bearing an endowment notice stating that the Qur'an was donated to the al-Nuriyya *madrasa* in Damascus by the building's founder, Nur al-Din ibn Mahmud, in 1166–67. See *Syrie: mémoire et civilisation*, exh. cat., Paris, 14 September 1993–28 February 1994, no. 319, p. 425.

287. M. Onder, *The Museums of Turkey and Examples of the Masterpieces in the Museums* (Turkiye Is Bankasi, 1977), 215–16. I would like to take this opportunity to thank Priscilla Soucek, Institute of Fine Arts, New York University, for bringing this reference to my attention. James, *Master Scribes*, 194.

288. B. Saint Laurent, 'The Identification of a Magnificent Koran Manuscript', in François Déroche, ed., *Les Manuscrits du moyen-orient* (Istanbul and Paris, 1989), 115–24.

289. For al-Sufi and Ibn Bukhtishu see articles ʿAbd al-Rahman b. ʿUmar al-Sufi' and 'Bukhtishu', in *Encyclopaedia of Islam*, 2nd ed. 1 (Leiden, 1960). Illustrations of the *Kitab al-Baytara* by Ahmad ibn Hasan ibn al-Ahnaf are discussed by Ernst Grube in 'The Hippiatrica Arabica Illustrata: Three 13th Century Manuscripts and Related Material', *Survey* 14, 3138–55. For al-Zahrawi see S. K. Hamarneh, 'Drawings and Pharmacy in al-Zahrawi's 10th Century Surgical Treatise', *United States National Museum Bulletin* 228 (1961), 81–94; on the Dioskorides manuscripts see, for instance, M. Sadek, *The Arabic Materia Medica of Dioscurides* (Quebec, 1983); and D. R. Hill, trans. and ed., *The Book of Knowledge of Ingenious Mechanical Devices (Kitab fi Maʿrifat al-Hiyal al-Handasiyya) by Ibn al-Razzaq al-Jazari* (Dordrecht and Boston, 1974). For a general discussion of the tradition of Arab borrowing from Greek scentific texts see K. Weitzmann, 'The Greek Sources of Islamic Scientific Illustrations', in G. C. Miles, ed., *Archaeologica Orientalia in Memoriam Ernst Herzfeld* (Locust Valley, N.Y., 1952), 244–66.

290. See 'Kalila wa-Dimna', in *Encyclopedia of Islam*. A brief discussion of the 'mirrors for princes' is to be found in T. Benfey, trans., *Pantschatantra: Fünf Bücher indischer Fabeln, Märchen und Erzählungen* 1 (Leipzig, 1859), intro., xv–xxviii.

291. See the articles, 'al-Hamadhani' and 'al-Hariri', in *Encyclopedia of Islam*. For a translation of the latter see T. Chenery and F. Steingass, *The Assemblies of al-Hariri*, 2 vols (London, 1867–98).

292. The manuscripts are, respectively, Topkapi Sarayi Ahmet III 3493; Bibliothèque Nationale, Paris, Ar. 5847; and Academy of Sciences, St Petersburg, s23. The first has been published by O. Grabar, 'A Newly Discovered Illustrated Manuscript of the Maqamat of Hariri', *Ars Orientalis* 5 (1963), 97–109; a number of illustrations from the Paris and St Petersburg copies have been published in colour in R. Ettinghausen, *Arab Painting* (Geneva, 1962), 104–24. See also H. Corbin *et al.*, *Les Arts de l'Iran: l'ancienne Perse et Baghdad* (Paris, 1938), for complete list of miniatures in the Paris manuscript; most recently, O. Grabar, *The Illustrations of the Maqamat* (Chicago and London, 1984). See also *Pages of Perfection: Islamic Paintings and Calligraphy from the Russian Academy of Sciences, St Petersburg*, exh. cat., Paris, Lugano and New York, 1995, cat. no. 18, pp. 144–55.

293. See, for example, Ettinghausen, *Arab Painting*, 114.

294. Ettinghausen, *Arab Painting*, 61–70; D. S. Rice, 'The Aghani Miniatures and Religious Painting in Islam', *The Burlington Magazine* 95 (1953), 128–36; S. Stern, 'A New Volume of the Illustrated Aghani Manuscript', *Ars Orientalis* 2 (1957), 501–03; and B. Lewis, ed., *Islam and the Arab World: Faith, People, Culture* (New York, 1976), 22, top, left and right.

295. The leading example is a thirteenth-century illustrated copy of al-Mubashshir, *Mukhtar al-hikam wa mahasin al-kalim*, Topkapi Sarayi Ahmet III 3206. See Ettinghausen, *Arab Painting*, 75–77; 'Interaction and Integration in Islamic Art', in G. E. von Grunebaum, ed., *Unity and Variety in Muslim Civilization* (Chicago, 1965), pls VI, VIIa; F. Rosenthal, *Das Fortleben der Antike im Islam* (Zurich and Stuttgart, 1965) pl. I facing p. 48; and M. S. Ipsiroglu, *Das Bild im Islam* (Vienna and Munich, 1971), 20, fig. 5. The text is discussed in F. Rosenthal, 'Al-Mubashshir ibn Fatik: Prolegomena to an Abortive Edition', *Oriens* 13–14 (1960–61), 132–58.

296. Weitzmann, 'Greek Sources'; E. Grube, 'Materialien zum Dioskurides Arabicus', in R. Ettinghausen, ed., *Aus der Welt der islamischen Kunst: Festschrift fur Ernst Kuhnel* (Berlin, 1959), 163–94; H. Buchthal, '"Hellenistic" Miniatures in Early Islamic Manuscripts', *Ars Islamica* 7 (1940), 125–33; and L.-A. Hunt, 'Christian–Muslim Relations in Painting in Egypt of the Twelfth to Mid-Thirteenth Centuries: Sources of Wallpainting at Deir es-Suriani and the Illustration of the New Testament MS Paris, Copte-arabe 1/Cairo, Bibl. 94', *Cahiers Archéologiques* 33 (1985), 111–55.

297. Ettinghausen, *Arab Painting*, 67–80.

298. E. Grube, 'Materialien'; Ettinghausen, *Arab Painting*; F. E. Day, 'Mesopotamian Manuscripts of Dioscurides', *Bulletin of the Metropolitan Museum of Art*, N.S. 8 (1950), 274–80; and H. Buchthal, 'Early Islamic Miniatures from Baghdad', *The Journal of the Walters Art Gallery* 5 (1942), 16–39. Many of the miniatures from the 1224 manuscript have been removed and dispersed among western collections: a number are in the Freer Gallery of Art – see Atil, *Art of the Arab World*, 53–60 – and several are in the Metropolitan Museum of Art.

299. They are Ahmet III 3493 in the Topkapi Sarayi, Istanbul; Ar. 2898 in the Bibliothèque Nationale, Paris; and Ar. 5323 in the British Library, London. For some discussion of these manuscripts see E. Wellesz, 'An Early al-Sufi Manuscript in the Bodleian Library in Oxford: A Study in Islamic Constellation Images', *Ars Orientalis* 3 (1959), 1–26. See also Chapter 4 above, p. 129 and [208].

300. Ar. 6094, Bibliothèque Nationale, Paris; Buchthal, 'Hellenistic Miniatures'.

301. The Pseudo-Galen manuscript, Ar. 2964, Bibliothèque Nationale, Paris, has been published by B. Farès, *Le Livre de la Thériaque: manuscrit arabe à peintures de la fin du XIIe siècle conservé à la Bibliothèque Nationale de Paris* (Cairo, 1953).

302. Buchthal, 'Hellenistic Miniatures'.

303. The only exceptions to this statement are some Byzantine borrowings for garments and landscape and the adoption from western India of the device of drawing faces in three-quarter view with the 'projecting farther eye'.

304. S. Guthrie, *Arab Social Life in the Middle Ages: an Illustrated Study* (London, 1995).

305. Some of these references are given in R. Ettinghausen, 'Early Shadow Figures', *Bulletin of the American Institute for Persian Art and Archaeology* 6 (1934), 10–15; and in G. Jacob, *Geschichte des Schattentheaters im Morgen- und Abendland*, 2nd ed. (Hanover, 1925), 39–55.

306. Ettinghausen, *Arab Painting*, 100–03.

307. Ettinghausen, *Arab Painting*, 135–37.

308. See note 292, above.

309. Ettinghausen, *Arab Painting*, 61–62.

310. The most complete publication of this manuscript is A. S. Melikian-Chirvani, 'Le Roman de Varqe et Golšah', *Ars Asiatiques* 22, special number (1970), 1–262; A. Daneshvari, *Animal Symbolism in Warqah and Gulshah* (Oxford, 1986).

311. See, for example, *Kitab al-Diryaq* in Vienna, Ettinghausen, *Arab Painting*, 91.

312. For illustrations of fols 21v, 37v, 46r, 57v, and 58v, see A. S. Melikian Chirvani, 'Le Roman', plates facing pp. 98 top and 99 top, and figs 21, 36, 46, 57, and 59, and A. Ates, 'Un vieux poème romanesque persan: récit de Warqah et Gulshah', *Ars Orientalis* 4 (1961), fig. 36. For related ceramics see, for example, A. U. Pope, 'The Ceramic Arts in Islamic Times, A: The History', *Survey*, 10 pls 632–35; 702–03; and R. Ettinghausen, 'Evidence for the Identification of Kashan Pottery', *Ars Islamica* 3 (1936), 44–45. See also R. Ettinghausen, *Arab Painting*, 84, 112 and 121, as well as Qur'an no. 11 in the Mevlana Museum, Konya, dated 603 A.H., A.D. 1206–07.

313. Priscilla Soucek, 'Ethnic Depictions in Warqah ve Gulshah', *9 Milletlerarasi Turk Sanatlari Kongresi, Cilt III* (Ankara, 1995), 223–33. Such knights are also to be found on the canteen mentioned above, p. 248.

314. M. K. Ozergin, 'Selcuklu sanatcisi Nakkas 'Abdul'Mu'min el-Hoyi hakkinda', *Belleten* 34 (1970), 219–29. Soucek, 'Ethnic Depictions', suggests the possibility that the manuscript was illustrated during the latter part of the reign of 'Ala' al-Din Kayqubad ibn Kaykhusraw (r. 1219–37).

315. G. K. Bosch *et al.*, *Islamic Bindings & Bookmaking* (exh. cat., Chicago, 1981), 56.

316. R. Ettinghausen, 'Near Eastern Book Covers and their Influence on European Bindings: A Report on the Exhibition "History of Bookbinding" at the Baltimore Museum of Art, 1957–58', *Ars Orientalis* 3 (1959), 121.

317. *Arts of Islam*, exh. cat., Hayward Gallery, London, 1976, cat. no. 510, and M. Weisweiler, *Der islamische Bucheinband des Mittelalters* (Wiesbaden, 1962), pl. 41, fig. 60.

CHAPTER 7

1. All these mosques are in Marçais, *Architecture*, 191 ff.; see also Terrasse, *L'Art hispano-mauresque*, 298 ff., and L. Torres Balbás, *Artes almoravide y almohade* (Madrid, 1955); for a photographic survey see D. Hill and L. Golvin, *Islamic Architecture in North Africa* (London, 1976); remarkably detailed and accurate drawings and descriptions in C. Ewert, *Forschungen zur almohadischen Moscheen*, several volumes (Mainz, 1981–). New drawings of most of these mosques in Hillenbrand, *Islamic Architecture*.

2. Jacques Caillé, *La Mosquée de Hassan à Rabat* (Paris, 1954).

3. J. Schacht in *Ars Orientalis* 2 (1957).

4. Marçais, *Architecture*, 75–76; cf. Also the examples given by M. Zbiss, 'Documents d'architecture fatimite d'Occident', *Ars Orientalis* 2 (1959).

5. Hillenbrand, *Islamic Architecture*, 54 ff., has the best provisional summary of the question.

6. J. Meunié, H. Terrasse, and G. Deverdun, *Nouvelles recherches archéologiques à Marrakesh* (Paris, 1957); G. Deverdun, *Marrakesh* (Rabat, 1959). A new and original solution for this building will be provided by Yasser Tabbaa in his forthcoming book.

7. H. Basset and H. Terrasse, *Sanctuaires et forteresses almohades* (Paris, 1932); T. Glick, *From Muslim Fortress to Christian Castle* (Manchester, 1995) for examples.

8. They may have been preceded by the earlier Toledo gate of Visagra; Marçais, *Architecture*, 217–18; for more recent work on Islamic Toledo see Clara Delgado Valero, *Toledo Islamico* (Toledo, 1987) and F. J. Sanchez-Palencia *et al.*, *Toledo, arqueologìa en la ciudad* (Toledo, 1996).

9. Hillenbrand, *Islamic Architecture* 446; Julio Navarro Palaz on, *Una casa islamica en Murcia* (Murcia, 1991) and *Casas y palacios de al-Andalus* (Grenada, 1995).

10. C. Robinson, *Palace Architecture and Ornament in the Courtly Discourse of the muluk al-Tawa'if*, Ph.D. dissertaion, University of Pennsylvania, 1995.

11. For a remarkable example of a ribbed dome in Tlemcen see Marçais, *Architecture*, 196; also in the Qarawiyyin, H. Terrasse, *La Mosquée al-Qaraouiyin à Fez* (Paris, 1968); Torres Balbás, *Arte*, pls 6 and 14.

12. Chn Ewert, *Islamische Funde in Balaguer und die Aljaferia in Zaragoza* (Berlin, 1971); M. E. Sebastiàn *et al.*, *La Aljaferia de Zaragoza* (Zaragoza, 1988); anon., *La Aljaferia* (Zaragoza, 1998). C. Ewert also published a full study of the mosque of Tinmal before the recent restorations, esp. his *Forschungen zur Almohadische Moscheen* (Mainz, 1991).

13. Cynthia Robinson, 'Memory and Nostalgia in Taifa court culture', *Muqarnas* 15 (1998).

14. See Chapter 3 above, p. 94–5 and [144] for a discussion of the *minbar* Buluggin ordered for the Mosque of the Andalusians in Fez when he held the latter city for the Fatimids between 979 and 985.

15. P. Sebag, *The Great Mosque of Kairouan*, trans. R. Howard (London and New York, 1965), 68–69, 72, 73.

16. This beam belongs to the group supporting the ceiling of what Creswell calls the 'ordinary aisles' of the mosque, i.e. not of the central aisle or of the transverse aisle in front of the *qibla* that was taken down in 1925. P. Sebag, *Great Mosque*, 50–51.

17. Cf. *Ebla to Damascus: Art and Archaeology of Ancient Syria*, exh. cat., Washington, D.C., 1985, nos 259, 260, p. 516, for ceiling fragments from Palace B in Raqqa/Rafiqa, *c.*835. 514 planks from the composite beams supporting the ceiling of the transverse aisle in Qayrawan's congregational mosque are considered to belong to the original ceiling of the mosque; see K. A. C. Creswell, *EMA* 2 (Oxford, 1940), pp. 221–23, pl. 50.

18. These beams are currently housed in the Aqsa Museum, Jerusalem. See R. W. Hamilton, *The Structural History of the Aqsa Mosque* (London, 1949), pl. LXXVI.

19. 'Abd al-Rahman Ibn Khaldun, *Kitab al-'ibar*, trans. M. de Slane, *Histoire des Berbères* (Algiers, 1852–56), vol. 2, 43–44; Abu 'Ubayd al-Bakri, *Al-masalik wa-l-mamalik*, trans. M. de Slane, *Description de l'Afrique septentrionale* (Algiers, 1913), 105.

20. See L. deBeylié, *La Kalaa des Beni-Hammad, une capitale berbère de l'Afrique du Nord au XIe siècle* (Paris, 1909), 66, fig. 53. The carved stucco decoration from the walls of the buildings in Sedrata in present-day Algeria (908–1077) are part of the same phenomenon. These North African sources for *muluk al-tawa'if* architectural ornament are evidence for Robinson's hypothesis that 'the Taifa states reached out to the architectural milieu ... of the larger Islamic and Mediterranean world'; C. Robinson, 'Arts of the Taifa Kingdoms',

in *Al-Andalus: The Art of Islamic Spain*, exh. cat., New York, 1992, 59.

21. M. Jenkins, 'Medieval Maghribi Luster-Painted Pottery,' in *La Céramique médiévale en Mediterranée occidentale, Colloques Internationaux C.N.R.S., no. 584* (Paris, 1980), 335–42.

22. M. Jenkins-Madina, 'From Qayrawan to Qal'at bani Hammad: Ceramic Architectural Decoration in the Medieval Maghrib', in *Festschrift for Michael Meinecke Damaszener Mitteilungen*, 11, 1999, pp. 285–95, p. 38–39.

23. See M. Jenkins, *Medieval Maghribi Ceramics: A Reappraisal of the Pottery Production of the Western Regions of the Muslim World*, Ph.D. diss., New York University, 1978, 211–21 and nos Q9, Q38–85, Q91–129.

24. Ch. 6, pp. 188–89.

25. See Jenkins, *Medieval Maghribi Ceramics*, 212 and pl. XCVI, top.

26. Jenkins, *Medieval Maghribi Ceramics*, 219–21.

27. Chapter 3 above, pp. 91–92.

28. *Al-Andalus*, cat. no. 7, pp. 204–06.

29. *Al-Andalus*, cat. no. 16, p. 219.

30. *The Art of Medieval Spain A.D. 500–1200*, exh. cat., New York, 1993, 78, upper left.

31. *The Art of Medieval Spain*, no. 37, pp. 92–93. A number of marble basins of the tenth and eleventh century have survived from the Maghrib.

32. *The Art of Medieval Spain*, 83.

33. Stone lions were used as fountainheads in Mallorca; cf. G. Rossello-Bordoy, *Decoracion zoomorfica en las Islas Orientales de al-Andalus* (Palma de Mallorca, 1978), 37–40, and see also M. Jenkins, 'Al-Andalus, Crucible of the Mediterranean', in *The Art of Medieval Spain* photo bottom p. 82, for examples from Qal'at Bani Hammad, and pp. 80–81 for copper-alloy examples. There is a glazed pottery lion fountainhead in the Archeological Museum, Seville.

34. They were judged to be of such remarkable craftsmanship that, by comparison, the Muslims of the East seemed unable to carve wood so elegantly. See Ibn Marzuq, *Masnad*, quoted in H. Basset and H. Terrasse, *Sanctuaires et forteresses*, 234, and H. Terrasse, *L'Art hispano-mauresque*, 383.

35. This tradition may, to a large extent, account for the unusually large number of Maghribi *minbars* (as opposed to those from the central or eastern Islamic lands) extant from the period covered here. For a discussion of this practice see J. Schacht, 'An Unknown Type of Minbar and Its Historical Significance', *Ars Orientalis* 2 (1957), 149–53.

36. G. Marçais, 'La Chaire de la Grande Mosquée d'Alger', *Hesperis* 1 (1921), 359–85; Basset and Terrasse, *Sanctuaires et forteresses*, 238, with correction of date; M. Gomez-Moreno, *El arte arabe espanol hasta las Almohades; arte mozarabe (Ars Hispaniae 3)* (Madrid, 1951), 282–83, fig. 348; and L. Torres Balbás, *Artes almoravide y almohade*, 3, pl. 39. Of forty-five original panels twenty-eight are square, whereas along the steps there are seven trapezoidal and ten triangular panels. Only seven panels have geometric designs, which, unlike those in the *minbar* at Qayrawan, are not open work.

37. Basset and Terrasse, *Sanctuaires et forteresses*, 234–40; Terrasse, *L'Art hispano-mauresque*, 383–95; J. Sauvaget, 'Sur le minbar de la Kutubiyya de Marrakech', *Hesperis* 36 (1949), 313–19; Torres Balbás, *Artes almoravide y almohade*, 31, 45–6, pls 40–41; and J. M. Bloom *et al.*, *The Minbar from the Kutubiyya Mosque* (New York, 1998).

38. See Chapter 2 above, p. 65 and [98] for a discussion of this technique in the early Islamic period. It seems highly likely that this type of decoration spread to al-Andalus via the same route followed by so many of the motifs and techniques already discussed here.

39. H. Terrasse, 'La Mosquée d'al-Qarawiyin à Fes et l'art des Almoravides', *Ars Orientalis* 2 (1957), 145–47, pls 17–18.

40. Basset and Terrasse, *Sanctuaires et forteresses*, 310–35, figs 119–28, pls 40–44.

41. H. Terrasse, *La Mosquée des Andalous à Fes* (Paris, n.d.), 35–36, 50–52, pls 49, 53, 93–96.

42. See R. B. Serjeant, 'Materials for a History of Islamic Textiles up to the Mongol Conquest', *Ars Islamica* 15–16 (1951), 29–40, 55–56. For the original 'attabi fabrics see the references collected by R. B. Serjeant, 'Materials for a History of Islamic Textiles up to the Mongol Conquest', *Ars Islamica* 9 (1942), 82. For imitations see *ibid.*, 10 (1943), 99; 11–12 (1946), 107–08, 116, 138; and 15–16 (1951), 33.

43. See Chapter 6, above, note 227.

44. F. E. Day, 'The Inscription of the Boston "Baghdad" Silk: A Note on Method in Epigraphy', *Ars Orientalis* 1 (1954), 191–94; E. Kühnel, 'Some Observations on Buyid Silks', in A. U. Pope, ed., *Survey* 14 (London and New York, 1967), 3080–89; 'Die Kunst Persiens unter den Buyiden', *Zeitschrift der Deutschen Morgenländischen Gesellschaft*, N.F. 31 (1956), 90; H. A. Elsberg and R. Guest, 'Another Silk Fabric Woven at Baghdad', *Burlington Magazine* 44 (1934), 271–72; and M. Jenkins, in *The Art of Medieval Spain*, 77.

45. The largest fragment of the chasuble is still in a reliquary in the church of Quintanaortuna near Burgos in Spain. D. G. Shepherd, 'A Dated Hispano-

Islamic Silk', *Ars Orientalis* 2 (1957), 373–82. The technical features peculiar to this group include a diaper weave with a 2-2-4 grouping of warp threads in the ground weave, as well as a distinctive 'honeycomb' method for binding the gold wefts. For a discussion of this whole group see C. Partearroyo, 'Almoravid and Almohad Textiles', *Al-Andalus: The Art of Islamic Spain*, exh. cat., New York, 1992, 105–13.

46. This 'lion-strangler' silk was found in the tomb of Bishop Bernard of Calvo (d. 1243) at Vich, and a piece of it is now in the Cleveland Museum of Art. See D. G. Shepherd, 'A Twelfth-Century Hispano-Islamic Silk', *The Bulletin of the Cleveland Museum of Art* 38 (1951), 59, and 'Another Silk from the Tomb of St. Bernard Calvo', *ibid.*, 75.

47. P. Deschamps, 'Les Fresques des cryptes des cathédrales de Chartres et de Clermont et l'imitation des tissus dans les peintures murales', *Monuments et Mémoires Publiés par l'Académie des Inscriptions et Belles-Lettres* 48 (1954), 91–106, figs 11–12; and M. Vieillard-Troiekouroff, 'La Cathédrale de Clermont du ve au XIIIe siècle', *Cahiers Archéologiques* 11 (1960), 231, 245–47.

48. Shepherd, 'A Dated Hispano-Islamic Silk', *Ars Orientalis* 2 (1957) 381–82.

49. For a general discussion of the technique and style of this group see D. G. Shepherd, 'A Treasure from a Thirteenth-Century Spanish Tomb', *The Bulletin of the Cleveland Museum of Art* 65 (1978), 111–34. See also D. G. Shepherd, 'The Hispano-Islamic Textiles in the Cooper Union Collection', *Chronicles of the Museum for the Arts of Decoration of the Cooper Union* 1 (1943), 351–405.

50. See Shepherd, 'The Hispano-Islamic Textiles', 382, fig. 16.

51. *The Meeting of Two Worlds: The Crusades and the Mediterranean Context*, exh. cat., Ann Arbor, 1981, no. 4, p. 26.

52. C. Partearroyo, 'Almoravid and Almohad Textiles'.

53. *The Art of Medieval Spain*, cat. no. 55, pp. 104–05, and M. Jenkins, 'Fatimid Jewelry, Its Subtypes and Influences', *Ars Orientalis* 18 (1988), 39–57.

54. *The Glory of Byzantium: Art and Culture of the Middle Byzantine Era, A.D. 843–1261*, exh. cat., New York, 1997, cat. no. 279, pp. 421–22.

55. For a fine example of an Almoravid door handle cf. R. Landau, *Morocco: Marrakesh, Fez and Rabat* (New York, 1967), fig. 53, p. 86.

56. As can be seen in the illustration, the infinite repetition pattern on these Almohad doors is a less complex one than that seen in [464].

57. See above, p. 275–76 and [451].

58. M. Jenkins, 'Medieval Maghribi Luster-painted Pottery', 338–42, and *Medieval Maghribi Ceramics*, 152–69, 177–88. See also *The Art of Medieval Spain*, cat. no. 53, p. 103.

59. Another type of pottery produced in al-Andalus and decorated in this technique is that with a moulded design highlighted with lustre-painting. Extant examples of this much rarer type are to be found at Instituto de Valencia de Don Juan, Madrid (see Gomez-Moreno, *El arte arabe*, figs 382, 383, p. 320), and in the Islamic Museum in Mertola, Portugal.

60. Before the various motifs were painted with coloured glazes, each area to be painted was circumscribed by a thin line of a greasy substance mixed with manganese, which prevented the different colours from running together. When fired, the grease burned away and left a dark matte line outlining the motifs.

61. G. Berti and L. Tongiorgi, *I bacini ceramici medievale delle chiese di Pisa* (Rome, 1981), tav. LII–LIV.

62. Badi' Palace, Marrakesh. Each tile was originally designed to be bolted to the wall.

63. Fragments of this type of pottery were found at Bougie, where it might also have been imitating luster-painted ceramics see M. Jenkins, *Medieval Maghribi Ceramics*, 175–76 and pl. CVIII, fig. 1.

64. Musée du Petit Palais, *De l'empire romain aux villes impériales: 6000 ans d'art au Maroc*, exh. cat., Paris, 1990, cat. no. 651.

65. The folios [154] are another example of the western Islamic variety of the New Style script.

66. Mu'izz ibn Badis, '*Umdat al-kuttab wa-'uddat dhawi al-albab*', trans. Martin Levey, *Mediaeval Arabic Bookmaking and its Relation to Early Chemistry and Pharmacology* (Philadelphia, 1962).

67. *Al-Andalus*, cat. no. 75, pp. 304–05.

68. R. Ettinghausen, 'Near Eastern Book Covers and their Influence on European Bindings: A Report on the Exhibition "History of Bookbinding" at the Baltimore Museum of Art, 1957–58', *Ars Orientalis* 3 (1959), 113–31; and P. Ricard, 'Sur un Type de Reliure des Temps Almohades', *Ars Islamica* 1 (1934), 74–79.

69. For an earlier square, gold-tooled binding cf. *Al-Andalus*, cat. no. 78, p. 308. Even earlier examples of gold tooling may have existed in the Maghrib since Ibn Badis gives us technical information about stamping with gold; cf. note 66, above.

70. For a translation of the text into Spanish and ten of the fourteen surviving miniatures see A. R. Nykl, *Historia de los amores de Bayad y Riyad: una*

chantefable oriental en estilo persa (New York, 1941).

71. R. Ettinghausen, *Arab Painting* (Geneva, 1962), 125 ff., and *Al-Andalus*, cat. no. 82, fol. 26v, p. 313.

CHAPTER 8

1. R. Bulliet, 'Naw Behar and the Survival of Iranian Buddhism' *Iran* 14 (1976); A. S. Melikian-Chirvani, 'L'Evocation littéraire du bouddhisme dans l'Iran musulman', *Le Monde Iranien et l'Islam* 2 (1974).

2. For all matters dealing with the types of clothing and their uses see Y. Stillman, 'Libas', in *Encyclopaedia of Islam*, 2nd ed.

3. A. Grabar, *Recherches sur les influences orientales dans l'art balkanique* (Paris, 1928) and in his *L'Art de la fin de l'Antiquité et du Moyen Age* (Paris, 1968), esp. 653 ff.; K. Erdmann, 'Arabische Schriftzeichen als Ornaments', *Akademie der Wissenschaften in Mainz, Abhandlungen der geistiges Klasse* 9 (1953); R. Ettinghausen, 'The Impact of Muslim Decorative Arts and Painting on the Arts of Europe', and O. Grabar, 'Architecture', in J. Schacht and C. E. Bosworth, eds, *The Legacy of Islam* (Oxford, 1974); R. A. Jairazbhoy, *Oriental Influences in Western Art* (Bombay, 1965); J. Baltrusaitis, *Le Moyen Age fantastique* (Paris, 1981), esp. 99 ff.

4. Ibn Zubayr, *Kitab al-Dhakha'ir wa-l-Tuhaf*, trans. and annot. G. al-Qaddumi, Book of Gifts and Rarities, Cambridge, MA, 1996, 230. The point about the dowries was made to one of us orally by the late Professor S. D. Goitein.

5. Good survey mostly by Lucy-Ann Hunt in *The Dictionary of Art*. Much of Coptic art is known through exhibitions. For the latest see *Staatliche Museen zu Berlin: Ägypten, Schätze aus dem Wüstensamd* (Wiesbaden, 1996). There are numerous specialized catalogues of Coptic textiles, e.g. from the Bargello in Florence (Florence, 1996), the Palazzo Mansi in Lucca (Lucca, 1995), from a private collection in Switzerland (coll. Bouvier) exhibited in Paris, Institut du Monde Arabe, *Tissus d'Egypte* (Paris, 1993), or from the Musée de Cluny, by A. Lorquin, *Les tissus coptes au Musée National du Moyen Age, Thermes de Cluny* (Paris, 1992).

6. See Hugh G. Evelyn-White, *The Monasteries of the Wadi 'n Natrun*, part III (New York, 1933), pls LXVI–LXXI.

7. E. Pauty, *Bois sculptés d'églises coptes: époque fatimide* (Cairo, 1930); Hugh G. Evelyn-White, *Monasteries*, pls XXVIIA and LXXXVIB; and M. Jenkins, 'An Eleventh-Century Woodcarving from a Cairo Nunnery', in R. Ettinghausen, ed., *Islamic Art in The Metropolitan Museum of Art* (New York, 1972), 227–40.

8. Y. Marmaré, *Catalogue of Arabic Gospels in Mt. Sinai* (in Greek) (Athens, 1985), figs 4, 1.

9. Above, p. 261 and J. Leroy, *Les Manuscrits coptes et coptes-arabes* (Paris, 1974), esp. 113 ff and 157 ff.

10. For another example see M. Jenkins-Madina, entry in *The Glory of Byzantium: Art and Culture of the Middle Byzantine Era, A.D. 843–1261*, exh. cat., New York, 1997, cat. no. 273, p. 417.

11. J. M. Fiey, *Assyrie chrétienne* 3 vols. (Beirut, 1965–68) and *Mar Bhanam* (Baghdad, 1970).

12. J. Leroy, *Les Manuscrits syriaques à peintures* (Paris, 1964), pls 70 ff. for additional illustrations from this manuscript and others from Or. 7170 in the British Library from c.1220–30.

13. Y. I. Smirnov, *Vostochnoe Serebro* (St Petersburg, 1909), pl. XV among others; B. P. Darkevych and B. Marshak, 'O tak nazyvaemym syriiskom bliude', *Sovietskaia Arkheologia* 50 (1976). See also the more accessible B. Marshak, *Silberschätze des Orients* (Leipzig, 1976), esp. 96 ff and 315 ff. For the Rusafa discoveries see Th. Ulbert *et al.*, *Resafa III: der Silberschatz* (Mainz am Rhein, 1990). According to some of their latest investigators, certain of these may have perhaps been executed in Central Asia.

14. B. Narkiss, *Hebrew Illuminated Manuscripts* (Jerusalem, 1969), 44 and pl. II. See also 42 and pl. I for an early fragment dated around 929.

15. E. Anglade, *Catalogue des boiseries de la section Islamique, Musée du Louvre* (Paris, 1988), cat. no. 45, pp. 74–7.

16. L. Bier, *Sarvistan* (University Park, PA, 1986).

17. See above, pp. 59–60. J. Sauvaget, 'Remarques sur l'art sassanide', *Revue des Etudes Islamiques* (1938); B. Marshak, *Sogdieskoe Serebro* (Moscow, 1971), for objects that would have been made already after the Muslim conquest. See also his *Silberschätze des Orients* (Leipzig, 1976).

18. P. Harper, *The Royal Hunter: Art of the Sasanian Empire*, exh. cat. (New York, 1978), cat. no. 26. In this connection see also Deborah Thompson, *Stucco from Chal Tarkhan-Eshqabad near Rayy* (Warminster, 1976).

19. *When Silk Was Gold: Central Asian and Chinese Textiles*, exh. cat. New York, 1997, James C. Y. Watt and Anne E. Wardwell (eds), 20–51; J. Rawson, 'Tombs or Hoards: The Survival of Chinese Silver of the Tang and Song Periods, Seventh to Thirteenth Centuries A.D.' and W. Watson, 'Precious Metal – Its Influence on Tang Earthenware', in *Pots and Pans: A Colloquium on Precious Metals and Ceramics in the Muslim, Chinese and Graeco-Roman Worlds,*

Oxford 1985 (Oxford, 1986), 31–56 and 153–74, respectively.

20. P. Golden, article, 'Rus', in *Encyclopedia of Islam*, 2nd ed.

21. M. Stenberger, *Die Schatzfunde Gotlands der Wikingerzeit* (Kungl. Vetterhets. Historie och Antikvitets Akademien, Stockholm, 1958) I, 247, 250–54, 351–52; A. Geijer, *Oriental Textiles in Sweden* (Copenhagen, 1951), 16–19, and 'Oriental Textiles in Scandinavian Versions', in *Aus der Welt der islamischen Kunst: Festschrift für Ernst Kühnel zum 75. Geburtstag am 26.10.1957* (Berlin, 1959), 323–35.

22. Latest summaries on Armenian art in J. M. Thierry and P. Donabedian, *Les Arts arméniens* (Paris, 1987), T. F. Mathews and R. S. Wiech, *Treasures in Heaven* (New York, 1994), and various authors in J. S. Turner, ed. *The Dictionary of Art* (London, 1996). For Akhtamar see S. Der Nercessian, *Akhtamar, Church of the Holy Cross* (Cambridge, 1965), who also provides the very important text describing Gagik's palace and who surveys critically earlier and more speculative interpretations of the sculptures by K. Otto-Dorn and I. Ipsiroglu.

23. W. Djobadze, *Archeological Investigations in the Region West of Antioch on-the-Orontes* (Stuttgart, 1986), figs XLIX and L, pp. 158–59 and pls 73–75; L. G. Hrushkova, *Likhni* (Moscow, 1998), 75 ff.

24. A long bibliography on this object can be found in, *The Glory of Byzantium*, Helen C. Evans and William Wixom (eds), exh. cat. (New York, 1997), 422–23. The new interpretation of the object is the one proposed by S. Redford, 'How Islamic Is It', *Muqarnas* 7 (1990).

25. Compare, for example, O. Grabar *et al.*, *City in the Desert: Qasr al-Hayr East* (Cambridge, MA, 1978) 1, 121–22; and 2, 218–19 and 230–31; J. Soustiel, *La Céramique islamique* (Fribourg, 1985), 135, fig. 163; A. Lane, *Early Islamic Pottery* (London, 1947), fig. 35 B; F. Sarre and E. Herzfeld, *Archäologische Reise im Euphrat- und Tigris-gebiet* (Berlin, 1911) 3, pl. CXIII; C. V. Bornstein and P. P. Soucek, *The Meeting of the Two Worlds: The Crusades and the Mediterranean Context* (Ann Arbor, 1981), 16, 44; and M. N. Mitsishvili, *A Glazed Pottery Workshop in Medieval Tbilisi (9th–13th centuries)* (Tbilisi, 1979).

26. J. M. Thierry, *Haut Moyen Age en Cappadoce* (Paris, 1994), among other places.

27. George C. Miles, 'Byzantium and the Arabs', *Dumbarton Oaks Papers* 18 (1964); see also R. Ettinghausen, 'Kufesque in Byzantine Greece, the Latin West and the Muslim World', in *Ettinghausen Collected Papers*, 72 ff.

28. *Byzantium*, cat. nos 223 and 224; E. S. Ettinghausen, 'Byzantine Tiles from the Basilica in the Topkapu Sarayi and Saint John of Studios', *Cahiers Archéologiques* 7 (1954), 79–88; M. Jenkins, *Medieval Maghribi Ceramics: A Reappraisal of the Pottery Production of the Western Regions of the Muslim World*, Ph.D. diss., New York University, 1978, 189–221.

29. C. Mango, *The Art of the Byzantine Empire* (New York, 1972), 128–29.

30. H. R. Hahnloser, *Il tesoro di San Marco* (Florence, 1971), pls LXXXIX ff.; latest study with comments on most previous ones in I. Kalavrezou, 'The Cup of San Marco', *Festschrift für Florentine Mütterich* (Munich, 1985), pp. 167–74.

31. W. Tronzo, *The Cultures of His Kingdom, Roger II and the Cappella Palatina in Palermo* (Princeton, 1997).

32. G. Bellafiore, *La Ziza di Palermo* (Palermo, 1978) and *Architettura in Sicilia nelle età islamica e normanna* (Palermo, 1990).

33. Basic publication is U. Monneret de Villard, *La pitture musulmane al soffito della Cappella Palatina* (Rome, 1950). For later discussions see Tronzo, *Cultures*. Paintings of a similar character were also found in the later church of Cefalù: M. Gelfer-Jørgenson, *Medieval Islamic Symbolism and the Paintings in the Cefalù Cathedral* (Leiden, 1986).

34. See Tronzo, *Cultures*, 142, note 29, for the most pertinent bibliography on this mantle. Forthcoming study by O. Grabar in D. James, ed., *Islamic Art at the Margins* (Los Angeles, 2001).

35. R. Ettinghausen argued that the Palermo paintings are our best example of Fatimid painting: 'Painting of the Fatimid Period', *Ars Islamica* 9 (1942). Recent views have been more nuanced.

36. Above, p. 64.

37. For examples of Norman woodwork cf. Bellafiore, *Architettura in Sicilia*, figs 120, 122, and 123, and figs 164–68; for the painted ivories cf. P. B. Cott, *Siculo-Arabic Ivories* (Princeton, 1939).

38. E. Kühnel, *Die islamischen Elfenbeinskulpturen, VIII.–XIII. Jahrhundert* (Berlin, 1971), nos 60–61, 66–70, and 76–86, and D. M. Ebitz, *Two Schools of Ivory Carving in Italy and Their Mediterranean Context in the Eleventh and Twelfth Centuries*, Ph.D. diss., Harvard University, 1979, esp. 129–395.

39. J. Dodds, *Architecture and Ideology in Early Medieval Spain* (University Park, PA, 1989).

40. Latest statement by J. Williams, *The Illustrated Beatus* (London, 1994). Beautiful pictures in H. Stierlin, *Los Beatos de Liébano y el arte mozarabe* (Madrid, 1985).

41. Among other places A. Grabar, *L'Art de la fin de l'Antiquité et du Moyen âge*, Paris, 1968, 3, pl. 163b.

42. The piece has been published in Parisian exhibition catalogues. O. Grabar in E. Sears and T. K. Thomas, *Reading Medieval Images* (Ann Arbor, 2001).

43. *Al-Andalus: The Art of Islamic Spain*, exh. cat., New York, 1992, 385 and cat. no. 133, p. 390, and M. L. Bates, *Islamic Coins* (The American Numismatic Society, New York, 1982), 32–33.

44. The period is a very difficult one to articulate properly, because it has been very much used to demonstrate contemporary concerns. See T. F. Glick, *From Muslim Fortress to Christian Castle* (Manchester, 1995). For the arts see Basilio P. Maldonado 'Mudejar Art,' in *The Dictionary of Art*, and J. Dodds in S. Jayyusi, *The Legacy of Muslim Spain* (Leiden, 1992), and V. Mann, T. Glick, and J. Dodds, *Convivencia: Jews, Muslims and Christians in Medieval Spain* (New York, 1992).

45. N. Kubisch, *Die Synagoge Santa Maria La Blanca* (Frankfurt, 1995).

46. A. Fikri, *L'Art roman du Puy et les influences islamiques* (Paris, 1934).

47. M. Jenkins-Madina, 'Fatimid Decorative Arts: The Picture the Sources Paint', in *L'Egypte fatimide: son art et son histoire* (Paris, 28, 29, and 30 mai 1998 (Paris, 1999)), and A. Shalem, *Islam Christianized: Islamic Portable Objects in the Medieval Church Treasuries of the Latin West* (Frankfurt, 1996), 58–60 and 113–15.

48. C. Buckler, *Harun al-Rashid and Charles the Great* (London, 1931); M. Hmidullah, 'Embassy of Queen Bertha', *Journal of the Pakistan Historical Society* 1 (1953). For a gift of gold jewellery to the Byzantine king Romanos I

49. Kühnel, *Elfenbeinskulpturen*, 30–31 and pls VI and VII. This piece may be relatable to the works of Indian art brought to Baghdad and Mecca in early Islamic times.

50. I. Kalavrezou, 'The Cup of San Marco', 173.

51. Shalem, *Islam Christianized*. The collective work edited by F. Gabrieli, *Gli Arabi in Italia* (Milan, 1979) is an impressive example of a mass of objects gathered in a non-Muslim country.

52. R. Ettinghausen, 'Impact', 297, and *Al-Andalus*, cat. no. 23.

53. M. Gomez-Moreno, *El Panteon Real de las Huelgas de Burgos* (Madrid, 1946).

54. M. Jenkins, 'New Evidence for the Possible Provenance and Fate of the So-called Pisa Griffin', *Islamic Archaeological Studies* 1 (1978) (Cairo, 1982).

55. Above, pp. 203–4.

56. An Jiayao, 'Early Glass Vessls of China', *Kaogu Xuebao* 4 (1984), 413–47 trans. M. Henderson, 'Early Chinese Glassware', (*The Oriental Ceramic Society Translations* 12), 1987; An Jiayao, 'Dated Islamic Glass in China', *Bulletin of the Asia Institute*, N.S. 5 (1991), 123–38. See also Chapter 4 above, p. 122 and Chapter 5 above, pp. 178–80.

57. Ettinghausen, 'Impact', p. 292.

Diogenes cf. *The Glory of Byzantium*, cat. no. 274, p. 418.

Bibliography

Compiling an appropriate bibliography for this volume turned out to be a particularly onerous task. For individual media and major periods the Grove *Dictionary of Art*, probably available in most academic institutions, provides generally good – and at times remarkably complete – bibliographies up to 1995. The notes to our chapters contain references to the learned studies we have used and to the places where readers may find additional illustrations or discussions pertinent to the arguments put forward in the text. Detailed compilations of appropriate literature can be found in the, admittedly less readily available, bibliographies initiated by K. A. C. Creswell in 1961 and continued by G. Scanlon, M. Meinecke, and now J. Bloom (forthcoming). All these are, by their very nature, outdated by the time of their publication and unfortunately the field of Islamic art is not covered by the computerized bibliographies in RILA.

In order to avoid useless repetitions either of our own notes or of resources readily available elsewhere, we decided to imagine our bibliography as a list of those books and periodicals needed by a library to allow for the study of Islamic art at all levels of teaching and for the possibility of taking the first steps in original research. We did not try to be complete and we avoided rare and out-of-print items unless they are truly indispensable. We have included only those noted articles which are considered to be seminal or are to be found in periodicals not included in our general list. And in the section 'History and Texts' we have included such Arabic or Persian texts as exist in translation; originals, when we used them, are mentioned in our notes.

1. Basic Resources
2. History and Texts
3. General Works
4. Exhibition Catalogues
5. Periodicals
6. Architecture
 a. General
 b. Forms and Decoration
 c. Anatolia
 d. Central Asia
 e. Iraq, Egypt, Syria, the Jazira, and Yemen
 f. India
 g. Iran
 h. The Muslim West
7. The Arts of the Object
 a. Ceramics
 b. Glass and Crystal
 c. Metalwork, Jewelery, and Arms and Armour
 d. Numismatics
 e. Textiles
 f. Woodwork, Ivory, and Stone-Carving
8. The Arts of the Book

1. BASIC RESOURCES

BOSWORTH, C. E. *The New Islamic Dynasties: A Chronological and Genealogical Manual.* Edinburgh, 1996.

BRICE, W. C. *An Historical Atlas of Islam.* Leiden, 1981.

COMBE, E., SAUVAGET, J., and WIET, G., eds. *Répertoire chronologique d'épigraphie arabe.* 19 vols. Cairo, 1931–64; 1982 continuing.

CRESWELL, K. A. C. *A Bibliography of the Architecture, Arts and Crafts of Islam.* Cairo, 1961; *First Supplement,* Cairo, 1973; *Second Supplement,* Cairo, 1984.

DODD, E. C., and KHAIRALLAH, S. *The Image of the Word.* 2 vols. Beirut, 1981.

The Encyclopaedia of Islam, 1st ed., Leiden, 1913.

The Encyclopaedia of Islam, 2nd ed. Leiden, 1960 continuing.

The Encyclopaedia of Islam on CD-ROM. First CD-ROM: Vols 1–9. Leiden, 1999, with supplements forthcoming (first update: Vols 1–10 expected in 2000; second update: Vols 1–11 expected in 2001).

FREEMAN-GRENVILLE, G. S. P. *The Muslim and Christian Calendars.* London, 1963; repr. 1977.

HUGHES, T. P. *Dictionary of Islam.* Repr. London, 1988.

LEWIS, B., LAMBTON, A. K. S., and HOLT, P. M., eds. *The Cambridge History of Islam.* 2 vols. Cambridge, 1970.

ROPER, G. J., and BLEANEY, C. H., eds. *Index Islamicus on CD-ROM: A Bibliography of Publications on Islam and the Muslim World from 1906 to 1996.* Cambridge, 1998.

TURNER, J. S., ed. *The Dictionary of Art.* London, 1996.

YARSHATER, E., ed. *Encyclopaedia Iranica.* London, Boston, Henley, 1985–90; Costa Mesa, CA, 1992–98; New York, 1999 continuing.

2. HISTORY AND TEXTS

AHSAN, M. M. *Social Life under the Abbasids.* London and New York, 1979.

AL-BALADHURI. *Futuh al-Buldan,* trans. P. K. Hitti and F. C. Murgotten. *The Origins of the Islamic State.* 2 vols. New York, 1916–24.

DONNER, F. M. *Narratives of Islamic Origins: The Beginnings of Islamic Historical Writings.* Princeton, 1998.

ERDMANN, K. *Ibn Bibi als kunsthistorische Quelle.* Istanbul, 1962.

GABRIELI, F. *Arab Historians of the Crusades.* London, 1969.

GARCIA GOMEZ, E., ed. and trans. *El califato de Cordoba en el 'Muqtabis' de Ibn Hayyan: anales palatinos del califa de Cordoba al-Hakam II, por 'Isa Ibn Ahmad al-Razi (360–364 H.=971–975 J.C.).* Madrid, 1967.

GOITEIN, S. D. *A Mediterranean Society: The Jewish Communities of the Arab World as Portrayed in the Documents of the Cairo Geniza.* 6 vols. Berkeley, 1967–93.

AL-HARAWI. *Guide des lieux de pèlerinage,* trans. J. Sourdel-Thomine. Damascus, 1957.

IBN HAWQAL. *Kitab surat al-Ard,* trans. J. H. Kramers and G. Wiet. *Configuration de la terre.* Beirut, 1964; trans. M. J. Romani Suay. *Configuracion de mundo. Textos Medievales* 26. Valencia, 1971.

HAWTING, G. R. *The First Dynasty of Islam: The Umayyad Caliphate A.D. 661–750.* London, 1986.

HODGSON, M. G. S. *The Venture of Islam.* 3 vols. Chicago, 1974.

HUMPHREYS, R. S. *Islamic History: A Framework for Inquiry.* Princeton, 1991.

IBN JUBAYR. *The Travels of Ibn Jubayr,* trans. R. J. C. Broadhurst. London, 1952.

IBN KHALDUN. *Kitab al-ibar,* trans. M. de Slane. *Histoire des Berbères et des dynasties musulmanes de l'Afrique septentrionale.* 4 vols. Paris, 1925; repr. 1968–69.

IBN KHALDUN. *The Muqaddimah, an Introduction to History,* trans. F. Rosenthal. New York, 1958.

IBN MUNQIDH, USAMAH. *An Arab-Syrian Gentleman and Warrior in the Period of the Crusades,* trans. P. K. Hitti. New York, 1929.

IBN AL-MUQAFFA. *Kalila wa Dimna,* trans. A. Miquel. *Le Livre de Kalila et Dimna.* Paris, 1957.

IBN AL-NADIM. *Kitab al-Fihrist,* trans. B. Dodge. *The Fihrist of al-Nadim.* 2 vols. New York, 1970.

IBN ZUBAYR. *Kitab al-Dhakha'ir wa-l-Tuhaf,* ed. M. Hamidullah. Kuwait, 1959; trans. and annot. G. al-Qaddumi. *Book of Gifts and Rarities.* Cambridge, MA, 1996.

AL-IDRISI. *Description de l'Afrique et de l'Espagne,* trans. and annot. R. Dozy and M. J. de Goeje. Leiden, 1968.

AL-IDRISI. *L'Italia descritta nel Libro de Re Ruggero,* trans. M. Amari and C. Schiaparelli. Rome, 1883.

KAHLE, P. 'Die Schätze der Fatimiden,' *Zeitschrift der Deutschen Morgenländischen Gesellschaft,* N.F., Band 14, 1935, pp. 329–62.

KENNEDY, H. *The Prophet and the Age of the Caliphates: The Islamic Near East from the Sixth to the Eleventh Century.* London and New York, 1986.

KHALIDI, T. *Arabic Historical Thought in the Classical Period.* New York, 1994.

AL-KHATIB AL-BAGHDADI. *Ta'rikh Baghdad,* trans. J. Lassner, *The Topography of Baghdad in the Early Middle Ages: Texts and Studies.* Detroit, 1970.

LESTRANGE, G. *The Lands of the Eastern Caliphate: Mesopotamia, Persia, and Central Asia from the Moslem Conquest to the Time of Timur.* Cambridge, 1905; repr. New York, 1976.

LESTRANGE, G. *Palestine under the Moslems: A Description of Syria and the Holy Land from A.D. 650 to 1500.* London, 1890; repr. Beirut, 1965.

AL-MAQRIZI. *Description historique et topographique de l'Egypte,* trans. P. Casanova. (MIFAO, 3). Cairo, 1906.

MARÇAIS, G. *La Berbérie musulmane et l'Orient au Moyen Age.* Paris, 1946; repr. Casablanca, 1991.

AL-MAS'UDI. *Les Prairies d'or,* ed. and trans. C. Barbier de Maynard and P. de Courteille, Paris, 1861–77; revised by C. Pellat, Paris, 1962–89.

MIQUEL, A. *La Géographie humaine du monde musulman jusqu'au milieu de 11e siècle.* 4 vols. Paris, 1967–88.

AL-MUQADDASI. *Description of Syria: including Palestine,* trans. and annot. G. LeStrange. New York, 1971.

AL-MUQADDASI. *Kitab ahsan al-Taqlim,* ed. M. J. de Goeje. (*Bibliotheca Geographorum Arabicorum* 3). Leiden, 1906.

AL-NARSHAKHI. *The History of Bukhara,* trans. R. N. Frye. Cambridge, MA, 1954.

NASIR-I KHOSROW. *Sefer-Nameh,* ed. and trans. C. Schefer. Paris, 1881; trans.

and annot. W. M. Thackston, Jr. *Naser-e Khosraw's Book of Travels*. Albany, 1986.

RENARD, J. *In the Footsteps of Muhammad: Understanding the Islamic Experience*. New York, 1992.

RENARD, J. *Seven Doors to Islam: Spirituality and the Religious Life of Muslims*. Berkeley, 1996.

RENARD, J. *Windows on the House of Islam: Muslim Sources on Spirituality and Religious Life*. Berkeley, 1998.

RICHARDS, D. H., ed. *Islamic Civilization 950–1150*. Oxford, 1973.

SAUNDERS, J. J. *A History of Medieval Islam*. New York, 1965.

AL-TABARI. *Tarikh al-rusul wa-al-muluk*, ed. M. J. de Goeje as *Annales*. 13 vols. Leiden, 1879–1901, 15 vols. Leiden, 1964–65; trans. by various scholars, eds E. Yar-Shater, S. A. Arjomand, *et al.* Albany, 1985 continuing.

AL-TABARI. *The Early ʿAbbasi Empire*, trans. J. A. Williams. 2 vols. Cambridge, 1988.

WARNER, A. G., and WARNER, E., trans. *The Shahnama of Firdausi*. 9 vols. London, 1905–10.

WOOD, R. *Kalila and Dimna: Selected Fables of Bidpai*. New York, 1980.

YAQUBI. *Kitab al-Buldan*, ed. M. J. de Goeje. (*Bibliotheca Geographorum Arabicorum* 7). Leiden, 1892.

3. GENERAL WORKS

ADLE, C., ed. *Art et société dans le monde musulman*. Paris, 1982.

BAER, E. *Sphinxes and Harpies in Medieval Islamic Art: An Iconographic Study*. Jerusalem, 1965.

BLAIR, S. *Islamic Inscriptions*. New York, 1998.

BLOOM, J., and BLAIR, S. *Islamic Arts*. London, 1997.

BREND, B. *Islamic Art*. Cambridge, MA, 1991.

BRISCH, K., ed. *Studies in Islamic Art and Architecture in Honour of K. A. C. Creswell*. Cairo, 1965.

BRISCH, K., KROGER, J., *et al. Museum für Islamische Kunst*. Berlin, 1980.

CURATOLA, G. *Le arti nell'Islam*. Rome, 1990.

DANESHVARI, A., ed. *Essays in Islamic Art and Architecture in Honor of Katharine Otto-Dorn*. Malibu, CA, 1981.

ECOCHARD, M. *Articles et mémoires: hommage à Michel Ecochard*. Paris, 1985.

EL-SAID, I. *Islamic Art and Architecture: The System of Geometric Design*. Reading, 1993.

ETTINGHAUSEN, R., ed. *Aus der Welt der islamischen Kunst: Festschrift für Ernst Kühnel zum 75. Geburtstag am 26.10.1957*. Berlin, 1959.

ETTINGHAUSEN, R. *From Byzantium to Sasanian Iran and the Islamic World: Three Modes of Artistic Influence*. Leiden, 1972.

ETTINGHAUSEN, R. *Islamic Art and Archaeology: Collected Papers*. Berlin, 1984.

ETTINGHAUSEN, R., ed. *Islamic Art in the Metropolitan Museum of Art*. New York, 1972.

ETTINGHAUSEN, R. *Studies in Muslim Iconography, I, The Unicorn (Freer Gallery of Art Occasional Papers: 1, 3)*. Washington, DC, 1950.

FERRIER, R. W. *The Arts of Persia*. New Haven and London, 1989.

Fjerde del Jubilaeumsskrift 1945–70. C. L. Davids Samling, Copenhagen, 1970.

FOLSACH, K. VON. *Islamic Art: The David Collection*. Copenhagen, 1990.

FORKL, H. *Die Gärten des Islam*. Stuttgart, 1993.

GABRIELI, F., ed. *Gli Arabi in Italia*. Milan, 1979.

GIBB, H. A. R. *Studies on the Civilisation of Islam*, eds S. Shaw and W. Polk. Boston, 1962.

GLADISS, A. VON, ed. *Metall, Stein, Stuck, Holz, Elfenbein, Stoffe Islamische Kunst 2*. Mainz/Rhein, 1985.

GOMEZ-MORENO, M. 'El árte arabe español hasta los Almohades; arte mozárabe.' *Ars Hispaniae*, 3. Madrid, 1951.

GRABAR, O. *The Formation of Islamic Art*. Revised and enlarged ed. New Haven and London, 1987.

GRABAR, O. *The Mediation of Ornament*. Princeton, 1992.

GRABAR, O. *Penser l'art islamique: une esthétique de l'ornement*. Paris, 1996.

GRABAR, O. *Studies in Medieval Islamic Art*. London, 1976.

HASSAN, Z. M. *Kunuz al-Fatimiyin*. Cairo, 1937.

HERZFELD, E. 'Die Genesis der islamischen Kunst', *Der Islam* I (1910), 27–63.

HILLENBRAND, R. *Islamic Art and Architecture*. London, 1999.

Iraq Department of Antiquities. *Excavations at Samarra, 1936–1939, II, Objects*. Baghdad, 1940.

IRWIN, R. *Islamic Art*. London, 1997.

'Islamic Art', *Bulletin of the Metropolitan Museum of Art* 33:1 (1975).

The Islamic World. Intro. by S. C. Welch. The Metropolitan Museum of Art, New York, 1987.

Islamische Kunst in Berlin: Katalog Museum für Islamische Kunst. Staatliche Museen Preussischer Kulturbesitz, Berlin, 1971.

JENKINS, M., ed. *Islamic Art in the Kuwait National Museum: The al-Sabah Collection*. London, 1983.

KEENE, M. *Selected Recent Acquisitions*. Kuwait, 1984.

KÜHNEL, E. *The Arabesque*, trans. R. Ettinghausen. Graz, 1977.

LOUKONINE, V., and IVANOV, A. *Lost Treasures of Persia: Persian Art in the Hermitage Museum*. Washington, D.C., 1996.

MARÇAIS, G., and Poinssot, L. *Objets kairouanais du IXe au XIIe siècle: reliures, verreries, cuivres et bronzes, bijoux*. 2 vols. Tunis, 1948–52.

MIGEON, G. *Manuel d'art musulman*. 2 vols. Paris, 1927.

MILES, G. C., ed. *Archaeologica Orientalia in Memoriam Ernst Herzfeld*. Locust Valley, NY, 1952.

MILES, G. C. 'Mihrab and Anazah: A Study in Early Islamic Iconography', in G. C. Miles, ed., *Archaeologica Orientalia in Memoriam Ernst Herzfeld*, 156–71. Locust Valley, NY, 1952.

MONNERET DE VILLARD, U. *Introduzione allo studio dell'archaeologia islamica*. Venice, 1966.

Oxford Studies in Islamic Art. Oxford and New York, 1985 continuing.

PAL, P., ed. *Islamic Art: The Nasli Heeramaneck Collection*. Los Angeles, 1973.

PAPADOPOULO, A. *Islam and Muslim Art*. New York, 1979.

POPE, A. U., ed. *A Survey of Persian Art from Prehistoric Times to the Present*. 12 vols. London and New York, 1938–39.

ROBINSON, B., ed. *Islamic Art in the Keir Collection*. London, 1988.

SAUVAGET, J. *Mémorial Jean Sauvaget*. 2 vols. Damascus, 1954.

SCARCIA, G. *Il volto di Adamo: Islam: la questione estetica nell'altro Occidente*. Venice, 1995.

SHALEM, A. *Islam Christianized: Islamic Portable Objects in the Medieval Church Treasuries of the Latin West*. Frankfurt, 1996.

SOUCEK, P., ed. *Content and Context of Visual Arts in the Islamic World: Papers from a Colloquium in Memory of Richard Ettinghausen*. University Park, PA, 1988.

SOURDEL, D., and SOURDEL, J. *La Civilisation de l'Islam classique*. Paris, 1968.

SOURDEL-THOMINE, J., and SPULER, B. *Die Kunst des Islam*. Berlin, 1973.

STIERLIN, H. *Islam*. Cologne, 1996.

TORRES BALBÁS, L. 'Arte almohade, arte nazarí; arte mudéjar', *Ars Hispaniae*, 4. Madrid, 1949.

AL-ʿUSH, A., JOUNDI, A., and ZOUDHI, B. *Catalogue du Musée Nationale de Damas*. Damascus, 1976.

WHITCOMB, D. *Before the Roses and Nightingales: Excavations at Qasr-i Abu Nasr, Old Shiraz*. New York, 1985.

4. EXHIBITION CATALOGUES

ʿABDUL RAHMAN, N., MARECHAUX, P., *et al. Sana'a, parcours d'une cité d'Arabie: [exposition]*. Paris, 1987.

Al-Andalus: The Art of Islamic Spain, Dodds, J. D., ed. New York, 1992.

ALLAN, J. W. *Medieval Middle Eastern Pottery*. Oxford, 1971.

The Anatolian Civilisations: Istanbul, May 22–October 30, 1983, v 3. Istanbul, 1983.

Art from the World of Islam 8th–18th Century, Louisiana Revy 27:3 (March 1987). Humlebaek, Denmark, 1987.

The Art of Medieval Spain, A.D. 500–1200. New York, 1993.

Arts de l'Islam, des origines à 1700, dans les collections publiques françaises, Orangerie des Tuileries, 22 juin–30 août 1971. Paris, 1971.

The Arts of Islam: Hayward Gallery, 8 April–4 July, 1976. London, 1976.

ATIL, E., ed. *Art of the Arab World: Catalogue of an Exhibition, Freer Gallery of Art*. Washington, D.C., 1975.

ATIL, E. *Ceramics from the World of Islam*. Washington, D.C., 1973.

ATIL, E., ed. *Islamic Art and Patronage: Treasures from Kuwait*. New York, 1990.

BERNUS-TAYLOR, M., ed. *Arabesques et jardins de paradis: collections françaises d'art islamique: Musée du Louvre, Paris, 16 octobre 1989–15 janvier 1990*. Paris, 1989.

BERNUS-TAYLOR, M., *et al. Céramique de l'Orient musulman: technique et évolution*. Paris, 1979.

BORNSTEIN, C., *et al. The Meeting of Two Worlds: The Crusades and the Mediterranean Context, The University of Michigan Museum of Art, May 9–September 27, 1981*. Ann Arbor, 1981.

BOSCH, G. K., *et al. Islamic Bindings and Bookmaking, Catalogue of an Exhibition, University of Chicago, May 18–August 18, 1981*. Chicago, 1981.

CARBONI, S., and MASUYA, T. *Persian Tiles*. New York, 1993.

CURATOLA, G. *Eredità dell'Islam: arte islamica in Italia*, Palazzo Ducale, 30 October 1993–30 April 1994. Venice, 1993.

CURATOLA, G., and SPALLANZANI, M. *Mattonelle islamiche: esemplari d'epoca e loro fortuna nella Manifattura Cantagalli*. Florence, 1985.

De Carthage à Kairouan, Musée du Petit Palais, Paris, 20 octobre 1982–27 février 1983. Paris, 1982.

De l'empire romain aux villes impériales: 6000 ans d'art au Maroc/Min al-Imbaraturiyah al-Rumaniyah ila-al-awasim al-atiqa: sittat alaf sanah min al-funun bi-al-Maghrib/ Catalogue of an exhibition to have been held at the Musée du Petit Palais, Paris, in early 1991. Paris, 1991.

EVANS, H. C., and WIXOM, W. D., eds. *The Glory of Byzantium: Art and Culture of*

the Middle Byzantine Era, A.D. 843–1261. New York, 1997.

FALK, T., ed. *Treasures of Islam: Catalogue of an Exhibition at the Musée d'Art et d'Histoire, 1985*. Geneva, 1985.

FERBER, S., ed. *Islam and the Medieval West: A Loan Exhibition at the University Art Gallery April 6–May 4, 1975*. Binghamton, NY, 1975.

FOLSACH, K. VON, and BERNSTED, A. K., *Woven Treasures: Textiles from the World of Islam*. Copenhagen, 1993.

GLADISS, A. VON., ed. *Islamische Kunst, verborgene Schätze: Ausstellung des Museums für Islamische Kunst, Berlin: Selm, Schloss Cappenberg 10.9.–23.11.1986: Berlin-Dahlem 18.12.1986–15.2.1987*. Berlin, 1986.

HARPER, P. *The Royal Hunter: Art of the Sasanian Empire*. New York, 1978.

L'Islam dans les collections nationales. Galeries nationales d'éxposition du Grand Palais, 2 mai–22 août 1977. Paris, 1977.

JAMES, D. *Das Arabische Buch: eine Ausstellung Arabischer Handschriften der Chester Beatty Library, Dublin, im Museum für Kunst und Gewerbe, Hamburg, aus Anlass des Euro-Arabischen Dialoges, Kulturelles Symposium 1983 / The Arab Book: An Exhibition of Arabic Manuscripts from the Chester Beatty Library, Dublin at the Museum für Kunst und Gewerbe, Hamburg, on the Occasion of The Euro-Arab Dialogue, Cultural Symposium, April 1983*. Hamburg, 1983.

JAMES, D. *Qur'ans and Bindings from the Chester Beatty Library: A Facsimile Exhibition*. London, 1980.

LINGS, M., and SAFADI, Y. H. *The Qur'an: Catalogue of an Exhibition of Qur'an Manuscripts at the British Library 3 April–15 August 1976*. London, 1976.

Masahif San'a. Kuwait, 1985.

Masterpieces of Islamic Art in the Hermitage Museum. Kuwait, 1990.

Pages of Perfection: Islamic Paintings and Calligraphy from the Russian Academy of Sciences, St. Petersburg. Lugano, 1995.

SOUCEK, P. *Islamic Art from the University of Michigan Collections, Kelsey Museum of Archaeology, February 4–April 16, 1978*. Ann Arbor, 1978.

Splendeur et majesté: corans de la Bibliothèque Nationale. Paris, 1987.

Terres secrètes de Samarcande: céramique du VIIIe au XIIIe siècle. Institut du Monde Arabe, Paris, 26 juin–27 septembre 1992. Paris, 1992.

Tissus d'Egypte témoins du monde arabe VIIIe–XVe siècles. Geneva, 1993.

TORRES, C. *Cerâmica islâmica portuguesa: catálogo, Fundação Calouste Gulbenkian, Lisbon, 16–27 Novembro 1987*. Mertola, 1987.

Trésors d'Orient: Paris [14 juin–fin octobre] 1973, Bibliothèque Nationale. Paris, 1973.

Trésors fatimides du Caire: exposition présentée à l'Institut du Monde Arabe du 28 avril au 30 août 1998. Paris, 1998; *Schätze der Kalifen, Islamische Kunst zur Fatimidenzeit*. Vienna, 1998.

A Tribute to Persia: Persian Glass: Catalog of a Special Exhibition, Spring–Summer 1972, Prepared in Honor of the 2500th Anniversary of the Founding of the Persian Empire. Corning, NY, 1972.

Variety in Unity: A Special Exhibition on the Occasion of the Fifth Islamic Summit in Kuwait. Kuwait, 1987.

La Voie royale: 9,000 ans d'art au royaume de Jordanie, Musée du Luxembourg, 26 novembre 1986–25 janvier 1987. 2 vols. Paris, 1986.

WATT, JAMES C. Y., and WARDWELL, ANNE E. *When Silk Was Gold: Central Asian and Chinese Textiles*. New York, 1997.

5. PERIODICALS

Al-Andalus (Madrid–Granada, 1933–78; continued by *Al-Qantara*)

Les Annales Archéologiques de Syrie (Damascus, 1950–)

Annales de l'Institut d'Etudes Orientales (Paris, 1934/35–62; N.S. 1964–)

Annales Islamologiques (Cairo, 1954–)

Annali Instituto Orientale di Napoli (Naples, 1967–82)

Annual of the Department of Antiquities of Jordan (Amman, 1951–)

Arabica (Leiden, 1954–)

Archäologische Mitteilungen aus Iran (Berlin, 1929–38; N.F. 1968–)

Archéologie Islamique (Paris, 1990–)

Ars Islamica (Ann Arbor, MI, 1934–51; continued by *Ars Orientalis*)

Ars Orientalis (Ann Arbor, MI, 1954–)

Art and Archaeology Research Papers (London, 1972–83)

Athar-é Iran (Haarlem, 1936–49)

Al-Atlal (Riyad, 1977–)

Baghdader Mitteilungen (Berlin, 1960–)

Belleten (Ankara, 1937–)

Berytus (Beirut, 1934–)

Bulletin d'Etudes Orientales (Beirut, 1931–)

Bulletin of the American Institute for Iranian Art and Archaeology (New York, 1937–38; continued by *Bulletin of the Iranian Institute*)

Bulletin of the American Institute for Persian Art and Archaeology (New York, 1931–36; continued by *Bulletin of the American Institute for Iranian Art and Archaeology*)

Bulletin of the Asia Institute (Shiraz, 1967–77; Detroit, 1987–)

Bulletin of the Iranian Institute (New York, 1941–46; later superseded by *Bulletin of the Asia Institute*)

Bulletin of the School of Oriental and African Studies (London, 1917–)

Cuadernos de Madinat al-Zahra' (Cordoba, 1987–)

Der Islam (Berlin, 1910–)

East and West (Rome, 1950–)

Epigrafika Vostoka (Leningrad/St Petersburg, 1947–)

Iran (London, 1963–)

Iranica Antiqua (Leiden, 1961–)

Iraq (London, 1934–)

Islamic Archaeological Studies (Cairo, 1982–)

Islamic Art (New York, 1981–)

Israel Exploration Journal (Jerusalem, 1950/51–)

Journal Asiatique (Paris, 1836–)

Journal of the American Research Center in Egypt (Princeton, 1962–)

Journal of the Royal Asiatic Society (London, 1834–1990; Cambridge 1991–)

Kunst des Orients (Wiesbaden, 1950–79)

Madrider Mitteilungen (Heidelberg, 1960–)

Le Monde Iranien et l'Islam (Geneva, 1971–77)

Muqarnas (New Haven, 1983–84; Leiden, 1985–)

Al-Qantara (Madrid, 1980–)

Quarterly of the Department of Antiquities in Palestine (Jerusalem, 1931–50; continued by *Annual of the Department of Antiquities of Jordan*)

Revue des Etudes Islamiques (Paris, 1927–)

Studia Iranica (Paris, 1972–)

Studia Islamica (Paris, 1953–)

Sumer (Baghdad, 1945–)

Syria (Paris, 1920–)

6. ARCHITECTURE

A. GENERAL

ALLEN, T. *A Classical Revival in Islamic Architecture*. Wiesbaden, 1986.

ALLEN, T. *Five Essays on Islamic Art*. Sebastopol, 1988.

BLOOM, J. *Minaret, Symbol of Islam*. Oxford Studies in Islamic Art 7. Oxford, 1989.

BRANDENBURG, D. *Die Madrasa: Ursprung, Entwicklung, Ausbreitung und künstlerische Gestaltung der islamischen Moschee-Hochschule*. Graz, 1978.

CRESWELL, K. A. C. *A Short Account of Early Muslim Architecture*. Harmondsworth, 1958. Revised and supplemented by J. W. Allan, Aldershot, 1989.

CRESWELL, K. A. C. *Early Muslim Architecture*. 2 vols. Oxford, 1932–40; 2nd ed., 1969; repr. 3 vols, New York, 1979

CRESWELL, K. A. C. *The Muslim Architecture of Egypt*. 2 vols. Oxford, 1952–59, repr. New York, 1979.

ECOCHARD, M. *Filiation des monuments grecs, byzantins et islamiques*. Paris, 1977.

FRANZ, H. G. *Palast, Moschee und Wüstenschloss: das Werden der islamischen Kunst, 7.–9. Jahrhundert*. Graz, 1984.

FRANZ, H. G. *Von Baghdad bis Cordoba: Ausbreitung und Entfaltung der islamischen Kunst 850–1050*. Graz, 1984.

FUSARO, F. *La citta islamica*. Preface, F. Gabriele. Rome, 1984.

GLICK, T. *From Muslim Fortress to Christian Castle*. Manchester, 1995.

GOLVIN, L. *Essai sur l'architecture religieuse musulmane*. 4 vols. Paris, 1970–79.

GOLVIN, L. *La Madrasa médiévale: architecture musulmane*. Aix-en-Provence, 1995.

GRABAR, O. *The Shape of the Holy: Early Islamic Jerusalem*. Princeton, 1996.

HILL, D. *Islamic Architecture in North Africa: A Photographic Survey*, with an introduction by R. Hillenbrand. Hamden, CT, 1976.

HILL, D., and Grabar, O. *Islamic Architecture and its Decoration*. London, 1964.

HILLENBRAND, R. *Islamic Architecture: Form, Function and Meaning*. New York, 1994.

KING, G. R. D. *The Historical Mosques of Saudi Arabia*. London and New York, 1986.

KUBAN, D. *Muslim Religious Architecture*. 2 vols. Leiden, 1974–85.

MAYER, L. A. *Islamic Architects and their Works*. Geneva, 1956.

MICHELL, G., ed. *Architecture of the Islamic World*. London, 1978.

MUNIS, H. *Al-Masajid*. Kuwait, 1981.

NECIPOGLU, G., ed. *Pre-modern Islamic Palaces. Ars Orientalis* 23 (1993).

PAPADOPOULO, A. *Le Mihrab dans l'architecture et la religion musulmanes: actes du Colloque International tenu à Paris en mai, 1980*. Leiden and New York, 1988.

SEVCENKO, M. B., ed. *Theories and Principles of Design in the Architecture of Islamic Society*. Cambridge, 1988.

STERN, S. M., and Hourani, A., eds. *The Islamic City*. Oxford, 1969.

STIERLIN, H. *Islam*. Cologne and New York, 1996.

B. FORMS AND DECORATION

ALBARN, K., *et al. The Language of Pattern: An Enquiry Inspired by Islamic Decoration.* New York, 1974.

BULATOV, M. S. *Geometricheskaia garmonizatsiia v arkhitekture Srednei Azii IX–XV vv.: istorikoteoreticheskoe issledovanie.* Moscow, 1978.

DENIKE, B. P. *Arkhitekturnyi ornament Srednei Azii.* Moscow, 1939.

EL-SAID, I., and PARMAN, A. *Geometric Concepts in Islamic Art.* London, 1976.

FARÈS, B. *Essai sur l'esprit de la décoration islamique.* Cairo, 1952.

FLURY, S. *Die Ornamente der Hakim und Ashar Moschee.* Heidelberg, 1912.

MEINECKE, M. *Fayencedekorationen seldschukischer Sakralbauten in Kleinasien.* 2 vols. Tübingen, 1976.

MONNERET DE VILLARD, U. *Le pitture musulmane al soffitto della Cappella Palatina in Palermo.* Rome, 1950.

NECIPOGLU, G. *The Topkapi Scroll: Geometry and Ornament in Islamic Architecture.* Santa Monica, CA, 1995.

ROSINTHAL, J. *Pendentifs, trompe et stalactites dans l'architecture orientale.* Paris, 1928.

ROSINTHAL, J. *Le Réseau.* Paris, 1937.

SERJEANT, R. B. 'Mihrab', *Bulletin of the School of Oriental and African Studies* 22 (1959), 439–52.

SHAFEI, F. M. *Simple Calyx Ornament in Islamic Art.* Cairo, 1957.

C. ANATOLIA

ALTUN, A. *Anadoluda Artuklu Devri Türk Mimarisinin Gelismesi.* Istanbul, 1978.

ALTUN, A. *Mardin'de Türk Devri Mimarisi.* Istanbul, 1971.

ASLANAPA, O. *Turkish Art and Architecture.* New York, 1971.

ERDMANN, K. *Das anatolische Karavansaray des 13. Jahrhunderts.* 3 vols. Berlin, 1961–76.

GABRIEL, A. *Voyages archéologiques dans la Turquie orientale.* 2 vols. Paris, 1940.

GABRIEL, A. *Monuments turcs d'Anatolie.* 2 vols. Paris, 1931–34; repr. Istanbul, 1989.

HILLENBRAND, R., ed. *The Art of the Saljuqs in Iran and Anatolia: Proceedings of a Symposium Held in Edinburgh in 1982.* Costa Mesa, CA, 1994.

KUBAN, D. *Anadolu-Türk Mimarisinin, Kaynak ve Sorunlari.* Istanbul, 1965.

KURAN, A. *Anadolou medreseleri.* Ankara, 1969.

ÖGEL, S. *Anadolu Selçuklularî'nin Taş Tezyinati.* Ankara, 1966.

ÖGEL, S. *Der Kuppelraum in der türkischen Architektur.* Istanbul, 1972.

ÖNEY, G. *Anadolu Selçuklu Mimarisinde Süsleme ve El Sanatlari.* Ankara, 1978.

REDFORD, S. 'The Alaeddin Mosque in Konya Reconsidered,' *Artibus Asiae* 51 (1991), 54–74.

SCHNEIDER, G. *Geometrische Bauornamente der Seldschuken in Kleinasien.* Wiesbaden, 1980.

SÖNMEZ, Z. *Baslangictan 16. yuzyila kadar Anadolu Türk-Islam Mimarisinde Sanatçilar.* Ankara, 1989.

SÖZEN, M. *Anadolu Medreseleri. Seldçuklular ve Beylikler devri.* 2 vols. Istanbul, 1970.

SÖZEN, M. *Diyarbakir'da Türk Mimarisi.* Istanbul, 1971.

ÜNSAL, B. *Turkish Islamic Architecture in Seljuk and Ottoman Times 1071–1923.* London, 1959.

YAVUZ, A. T. 'The Concepts that Shape Anatolian Seljuq Caravanserais,' *Muqarnas* 14 (1997), 80–95.

D. CENTRAL ASIA

AHAROV, I., and REMPEL, L. *Reznoi Shtuk Afrasiaba.* Tashkent, 1971.

BELENITSKII, A. M. *Central Asia*, trans. J. Hogarth. London, 1969.

BELENITSKII, A. M., BENTOVICH, I. B., and BOLSHAKOV, O. G. *Srednevekovyi Gorod Srednei Azii.* Leningrad, 1973.

BOMBACI, A. *The Kufic Inscription in Persian Verses in the Court of the Royal Palace of Mas'ud III at Ghazni.* Rome, 1966.

BRANDENBURG, D. *Samarkand: Studien zur islamischen Baukunst in Uzbekistan.* Berlin, 1972.

DIEZ, E. *Churasanische Baudenkmäler.* Berlin, 1918.

DIEZ, E. *Persien: Islamische Baukunst in Churasan.* Darmstadt, 1923.

GARDIN, J. C., SCHLUMBERGER, D., and SOURDEL-THOMINE, J. *Lashkari Bazar: une résidence royale ghaznévide, II, Les Trouvailles: céramiques et monnaies de Lashkari Bazar et de Bust.* Paris, 1963.

GOLOMBEK, L. 'Abbasid Mosque at Balkh', *Oriental Art* 15 (1969), 173–89.

HERRMANN, G., *Monuments of Merv.* London, 2000.

KHMELNITSKII, S. *Mezhdu Arabami i Tiurkami.* Berlin and Riga, 1992.

KHMELNITSKII, S. *Mezhdu Samanidami i Mongolami.* Berlin and Riga, 1996.

KHMELNITSKII, S. *Zwischen Kuschanen und Arabern.* Berlin, 1989.

MARICQ, A., and WIET, G. *Le Minaret de Djam (Mémoires de la Délégation Archéologique Française en Afghanistan 16).* Paris, 1959.

NILSEN, V. A. *Monumentalnaia Arkhitektura Bukharskovo Oazisa.* Tashkent, 1956.

PUGACHENKOVA, G. A. *Mavzolei Arab-ata.* Tashkent, 1963.

PUGACHENKOVA, G. A. *Puti razvitia arkhitektury iuzhnogo Turkmenistana.* Moscow, 1958.

REMPEL, L. I. *Arkhitekturnyi ornament Uzbekistana.* Tashkent, 1961.

E. IRAQ, EGYPT, SYRIA, THE JAZIRA, AND YEMEN

'ABD AL-BAQI, A. *Samarra: 'asimat al-dawla al-'arabiyya fi ahd al-'abbasiyin.* Baghdad, 1989.

ALLEN, T. 'The Tombs of the 'Abbasid Caliphs in Baghdad', *Bulletin of the School of Oriental and African Studies* 46 (1983), 421–31.

ALI, S. A. *Baghdad, madinat al-salam.* Baghdad, 1985.

ALMAGRO, M., CABALLERO, L., ZOZOYA, J., and ALMAGRO, A. *Qusayr 'Amra: residencia y baños omeyas en el desierto de Jordania.* Madrid, 1975.

AL-AMID, T. M. *The Abbasid Architecture of Samarra in the Reign of both al-Mu'tasim and al-Mutawakkil.* Baghdad, 1973.

BEHRENS-ABOUSEIF, D. *Islamic Architecture in Cairo: An Introduction.* Leiden and New York, 1989.

BEHRENS-ABOUSEIF, D. *The Minarets of Cairo.* Cairo, 1985.

BELL, G. L. *Palace and Mosque at Ukhaidir: A Study in Early Muhammadan Architecture.* Oxford, 1914.

BERCHEM, M. VAN. *Matériaux pour un Corpus Inscriptionum Arabicarum: Egypte I (MMAF 19).* Cairo, 1894–1903.

BERCHEM, M. VAN. *Matériaux pour un Corpus Inscriptionum Arabicarum. Deuxième Partie: Syrie du Sud: Jérusalem (MIFAO 43–5).* 2 vols. Cairo, 1920–27.

CANIVET, P., and REY-COQUAIS, J.-P. *La Syrie de Byzance à l'Islam VIIe–VIIIe siècles: actes du Colloque Internationale.* Damascus, 1992.

COSTA, P. M. *The Pre-Islamic Antiquities at the Yemen National Museum.* Rome, 1978.

COSTA, P., and VICARIO, E. *Yemen, Land of Builders*, trans. D. Newton. London, 1977.

CRESWELL, K. A. C. *Muslim Architecture of Egypt.* 2 vols. Oxford, 1952–59.

ECOCHARD, M., and LECOEUR, C. *Les Bains de Damas.* 2 vols. Beirut, 1942–43.

ETTINGHAUSEN, R. *From Byzantium to Sasanian Iran and the Islamic World.* Leiden, 1972.

FIEY, J. M. *Assyrie chrétienne*, 3 vols. Beirut, 1965–68.

FIEY, J. M. *Mossul chrétienne.* Beirut, 1959.

FINSTER, B. 'Die Freitagsmoschee von Sana'a. I', *Baghdader Mitteilungen* 9 (1978), 92–133.

FINSTER, B. 'Die Freitagsmoschee von Sana'a. II', *Baghdader Mitteilungen* 10 (1979), 179–92.

FINSTER, B. 'Islamische Bau- und Kunstdenkmäler im Yemen', *Archäologische Berichte aus dem Yemen* 1 (1982), 223–75.

FINSTER, B., and SCHMIDT, J. *Sasanidische und frühislamische Ruinen im Iraq (Baghdader Mitteilungen 8)* (1976).

GAUBE, H. *Ein arabischer Palast in Südsyrien, Hirbat el-Baida.* Beirut, 1974.

GRABAR, O., HOLOD, R., KNUDSTAD, J., and TROUSDALE, W. *City in the Desert: Qasr al-Hayr East (Harvard Middle East Monograph Series 23–24).* Cambridge, MA, 1978.

HAMILTON, R. W. *Khirbat al-Mafjar.* Oxford, 1959.

HAMILTON, R. W. 'Khirbat al-Mafjar: The Bath Hall Reconsidered', *Levant* 10 (1978), 126–38.

HAMILTON, R. W. *The Structural History of the Aqsa Mosque.* Jerusalem, 1949.

HAMILTON, R. W. *Walid and His Friends: An Umayyad Tragedy.* Oxford, 1988.

HERZFELD, E. 'Damascus: Studies in Architecture', *Ars Islamica* 9 (1942), 1–53; 10 (1943), 13–70; 11–12 (1946), 1–71; 13–14 (1948), 118–38.

HERZFELD, E. *Geschichte der Stadt Samarra.* Hamburg, 1948.

HERZFELD, E. *Die Malereien von Samarra (Die Ausgrabungen von Samarra III).* Berlin, 1927.

HERZFELD, E. *Der Wandschmuck der Bauten von Samarra und seine Ornamentik.* Berlin, 1923.

AL-JANABI, T. J. *Studies in Mediaeval Iraqi Architecture.* Baghdad, 1982.

LASSNER, J. *The Topography of Baghdad in the Early Middle Ages.* Detroit, 1970.

MOSTAFA, S. L. *Al-Madina al-Munawwara.* Beirut, 1981.

PREUSSER, C. *Nordmesopotamische Baudenkmäler altchristlicher und islamischer Zeit.* Leipzig, 1911.

RABY, J., ed. *The Art of Syria and the Jazira, 1100–1250.* Oxford and New York, 1985.

RAYMOND, A., ROGERS, M., and WAHBA, M., eds. *Colloque International sur l'Histoire du Caire.* Cairo, 1974.

SACK, D. *Damaskus: Entwicklung und Struktur einer orientalisch-islamischen Stadt.* Mainz am Rhein, 1989.

SAFAR, F. *Wasit: The Sixth Season's Excavations.* Cairo, 1945.

SAOUAF, S. *Aleppo, Past and Present: Its History, Its Citadel, Its Museum and Its Antique Monuments.* Aleppo, 1958.

SARRE, F., and HERZFELD, E. *Archäologische Reise im Euphrat- und Tigris-gebiet.* 4 vols. Berlin, 1911–20.

SAUVAGET, J. *Alep*. Paris, 1941.

SAUVAGET, J. *Les Monuments historiques de Damas*. Beirut, 1932.

SAUVAGET, J. *La Mosquée omeyyade de Médine*. Paris, 1947.

SAUVAGET, J., ECOCHARD, M., and SOURDEL-THOMINE, J. *Les Monuments ayyoubides de Damas*. 4 vols. Paris, 1938–50.

SCANLON, G. *Fustat Expedition: Final Report*. Winona Lake, IN, 1986.

SCHLUMBERGER, D. 'Les Fouilles de Qasr el-Heir el-Gharbi (1936–1938): Rapport préliminaire', *Syria* 20 (1939), 195–238.

SCHMID, H. *Die Madrasa des Kalifen al-Mustansir in Baghdad: eine baugeschichtliche Untersuchung der ersten universalen Rechtshochschule des Islam*. Mainz am Rhein, 1980.

SEBAG, P. *The Great Mosque of Kairouan*, trans. R. Howard. London and New York, 1965.

SERJEANT, R. B., and LEWCOCK, R., eds. *San'a, an Arabian Islamic City*. London, 1983.

TRUMPELMAN, L. *Mschatta: ein Beitrag zur Bestimmung des Kunstkreises, zur Datierung und zum Stil der Ornamentik*. Tübingen, 1962.

VARANDA, F. *The Art of Building in Yemen*. Cambridge, MA, and London, 1982.

WIET, G. *Matériaux pour un Corpus Inscriptionum Arabicarum: Egypte 2 (MIFAO 52)*. Cairo, 1929–30.

F. INDIA

BROWN, P. *Indian Architecture*, vol. 2, *The Islamic Period*. Bombay, 1949.

HARLE, J. C. *The Art and Architecture of the Indian Subcontinent*, chapters 30–33. 2nd ed., New Haven, 1994.

HUSAIN, A. B. M. *The Manara in Indo-Muslim Architecture*. Dacca, 1970.

KHAN, F. A. *Banbhore*. Karachi, 1982.

SHOKOOHY, M., and SHOKOOHY, N. H. 'The Architecture of Baha al-Din Tughrul in the Region of Bayana, Rajasthan', *Muqarnas* 4 (1987) 114–32.

SHOKOOHY, M. *Bhadreśvar, The Oldest Islamic Monument, in India* (Leiden and New York, 1988).

G. IRAN

ADLE, C., and MELIKIAN-CHIRVANI, A. S. 'Les Monuments du XIe siècle du Damqan', *Studia Iranica* 1 (1972), 229–97.

BIER, L. *Sarvistan, a Study in Early Iranian Architecture*. University Park, PA, 1986.

BRETANITSKII, L. S. *Zodchestvo Azerbaidzhana XII–XV vv.* Leningrad, 1961.

DADASHEV, S. A. *Arkhitektura Azerbaidzhana Epokha Nizami*. Baku, 1947.

DANESHVARI, A. *Medieval Tomb Towers of Iran: An Iconographical Study*. Lexington, KY, 1986.

DIEZ, E. *Churasanische Baudenkmäler*. Berlin, 1918.

DIEZ, E. *Islamische Baukunst im Churasan*. Hagen, 1923.

GALDIERI, E., ed. *Isfahan: Masgid-i guma*. 2 vols. Rome, 1972–73.

GODARD, A. *Les Monuments de Maragha*. Paris, 1934.

GODARD, A. 'Le Tari-khana de Damghan' *Gazette des Beaux-Arts*, 6 sér. 12 (1934), 225–35.

GRABAR, O. *The Great Mosque of Isfahan*. New York, 1990.

HERDEG, K. *Formal Structure in Islamic Architecture of Iran and Turkestan*. New York, 1990.

HILLENBRAND, R., ed. *The Art of the Saljuqs in Iran and Anatolia: Proceedings of a Symposium held in Edinburgh in 1982*. Costa Mesa, CA, 1994.

SARRE, F. *Denkmäler persischer Baukunst*. Berlin, 1901–10.

THOMPSON, D. *Stucco from Chal Tarkhan-Eshqabad near Rayy*. Warminster, 1976.

WATSON, W., ed. *The Art of Iran and Anatolia from the 11th to the 13th Century A.D.* London, 1975.

WHITEHOUSE, D. *Siraf III: The Congregational Mosque and Other Mosques from the Ninth to the Twelfth Centuries*. London, 1980.

WILBER, D. N. *The Masjid-i 'Atiq of Shiraz*. Shiraz, 1972.

H. THE MUSLIM WEST

AZUAR RUÍZ, R. *Denia Islamica: arqueología y poblamiento*. Alicante, 1989.

BARGEBURH, F. *The Alhambra: A Cycle of Studies on the Eleventh Century in Moorish Spain*. Berlin, 1968.

BARGEBURH, F. 'The Alhambra Palace of the 11th Century'. *Journal of the Warburg and Courtauld Institutes* 19 (1956), 192–258.

BASSET, H., and TERRASSE, H. *Sanctuaires et forteresses almohades*. Paris, 1932.

BAZZANA, A., *et al. Les Châteaux ruraux d'al-Andalus: histoire et archéologie des Husun du sud-est de l'Espagne*. Madrid, 1988.

BAZZANA, A. *Maisons d'al-Andalus: habitat médiéval et structures du peuplement dans l'Espagne orientale*. Madrid, 1992.

BELLAFIORE, G. *Architettura in Sicilia nelle eta islamica e normanna (827–1194)*. Milan, 1990.

BENAVIDES COURTOIS, J., *et al. El arte mudejar*. Madrid, 1995.

BINSHANHU, A. *La Dynastie almoravide et son art*. Algiers, 1974.

BORRAS GUALIS, G. *El arte Mudejar*. Teruel, 1990.

BOUROUIBA, R. *L'Art religieux musulman en Algérie*. Algiers, 1973.

BRISCH, K. *Die Fenstergitter und verwandte Ornamente der Hauptmoschee von Cordoba*. Berlin, 1966.

CABAÑERO SUBIZA, B. *Los restos islamicos de Maleján (Zaragoza): nuevos datos para el estudio de la evolución de la decoración de la época del Califato al período Ta'ifa*. Zaragoza, 1992.

CAILLÉ, J. *La Mosquée de Hassan à Rabat*. 2 vols. Paris, 1954.

CARA BARRIONUEVO, L. *La Almería islámica y su Alcazaba*. Almeria, 1990.

CASTEJÓN, R. 'Madinat al-Zahra' en los autores árabes. II: Traducciones' *Al-Mulk* 2 (1961–62), 146 ff.

CONTRERAS VILLAR, A., and VALLEJO TRIANO, A. *Madinat al-Zahra' el salón de 'Abd al-Rahman III*. Cordoba, 1995.

DELGADO VALERO, C. *Materiales para el estudio de morfología ornamental del arte islámico en Toledo*. Toledo, 1987.

DICKIE, J. 'The Islamic Garden in Spain' in R. Ettinghausen and E. MacDougall, eds, *The Islamic Garden* (Dumbarton Oaks Colloquium on the History of Landscape Architecture), 89–105. Washington, D.C., 1976.

DODDS, J. D. *Architecture and Ideology in Early Medieval Spain*. University Park, PA, 1990.

ESCO, C., GIRALT, J., and SENAC, P. *Arqueología Islámica en la Marca Superior de al-Andalus*. Huesca, 1988.

EWERT, C. *Islamische Funde in Balaguer und die Aljaferia in Zaragoza*. Berlin, 1971.

EWERT, C. 'The Mosque of Tinmal (Morocco) and Some New Aspects of Islamic Architectural Typology', *Proceedings of the British Academy* 72 (1966), 116–48.

EWERT, C. *Spanisch-islamische Systeme sich kreuzender Bögen: I, Die senkrechten ebenen Systeme sich kreuzender Bogen als Stutzkonstruktionen der vier Rippenkuppeln in der ehemaligen Hauptmoschee von Cordoba*. Madrider Forschungen, 2. Berlin, 1968.

EWERT, C. *Spanisch-islamische Systeme sich kreuzender Bögen: III, Die Aljaferia in Zaragoza*. Parts 1 and 2. Madrider Forschungen 12. Berlin, 1978 and 1980.

EWERT, C., and WISSHAK, J.-P. *Forschungen zur almohadischen Moscheen: 1, Vorstufen: Hierarchische Gliederungen westislamischer Betsale des 8. bis 11. Jahrhunderts: die Hauptmoscheen von Qairawan und Cordoba und ihr Bannkreis*. Mainz-am-Rhein, 1981.

GOLVIN, L. *Le Magrib central à l'époque des Zirides*. Paris, 1957.

GOLVIN, L. *Recherches archéologiques à la Qal'a des Banu Hammad*. Paris, 1965.

HERNANDEZ, F. *Madinat al-Zahra': arquitectura y decoración*. Granada, 1985.

HILL, D., and GOLVIN, L. *Islamic Architecture in North Africa*. London, 1976.

JIMENEZ MARTIN, A., *et al. Arquitectura en al-Andalus*. Barcelona, 1996.

LÉVI-PROVENÇAL, E. *Inscriptions arabes d'Espagne*. Leiden and Paris, 1931.

LÉZINE, A. *Architecture de l'Ifriqiya: recherches sur les monuments aghlabides*. Paris, 1966.

LÉZINE, A. *Mahdiya: recherches d'archéologie islamique*. Paris, 1965.

LÉZINE, A. *Le Ribat de Sousse*. Tunis, 1956.

LOPEZ GUZMAN, RAFAEL, ed. *La arquitectura del islam occidental*. Granada, 1995.

MARÇAIS, G. *Algérie médiévale*. Paris, 1957.

MARÇAIS, G. *L'Architecture musulmane d'occident*. Paris, 1954.

MASLOW, B. *Les Mosquées de Fes et du nord du Maroc*. Paris, 1937.

NAVARRO PALAZÓN, J. 'El Alcazar (al-Qasr al-Kabir) de Murcia', *Anales de Prehistoria y Arqueologia*. Murcia, 1991–92, 219–30.

NAVARRO PALAZÓN, J., ed. *La casa hispano-musulmana: aportaciones de la Arqueología*. Granada, 1990.

PAVÓN MALDONADO, B. *El arte hispanomusulmán en su decoración geométrico*. Madrid, 1975; 2nd ed. Madrid, 1989.

PAVÓN MALDONADO, B. *Arte Toledano: islámico y mudejar*. Madrid, 1973; 2nd ed. Madrid, 1988.

PAVÓN MALDONADO, B. *Tratado de arquitectura hispanomusulmana*. Madrid, 1990.

ROBINSON, C. 'Seeing Paradise: Metaphor and Vision in *Taifa* Palace Architecture', *Gesta* 36:2 (1997), 145–55.

ROSELLO-BORDOY, G. *Decoración zoomórfica en las islas orientales de Al-Andalus*. Palma de Mallorca, 1978.

SAENZ-DIEZ, J. I. *Las acunaciones del califato de Córdoba en el Norte de Africa*. Madrid, 1984.

SALIM, S. *Al-masajid wa-al-qusur fi al-Andalus*. Alexandria, 1986.

SANCHEZ SEDANO, M. *Arquitectura musulmana en la provincia de Almería*. Almeria, 1988.

SECO DE LUCENA, L. 'Los palacios del Taifa Almeriense de al-Mu'tasim', *Cuadernos de la Alhambra* 2 (1965), 15–20.

STERN, H. *Les Mosaiques de la grande mosquée de Cordoue*. Berlin, 1976.

TERRASSE, H. *L'Art hispano-mauresque des origines au XIIIe siècle*. Paris, 1932.

TERRASSE, H. *La Mosquée al-Qaraouiyn à Fez*. Paris, 1968.

TORRES BALBÁS, L. *La Alcazaba y la Catedral de Málaga*. Madrid, 1960.

TORRES BALBÁS, L. *Artes almoravide y almohade*. Madrid, 1955.

TORRES BALBÁS, L. *Ciudades Hispanomusulmanas*. Intro. and concl., H. Terrasse. Madrid, 1971.

TORRES BALBÁS, L. *La mezquita de Córdoba y las ruinas de Madinat al-Zahra*. Madrid, 1952.

VALOR PIECHOTTA, M., ed. *El último siglo de la Sevilla Islámica (1147–1248): exposición Real Alcazar de Sevilla, 5 dic. 1995–14 enero 1996*. Seville, 1995.

7. THE ARTS OF THE OBJECT

A. CERAMICS

BAGHAT, A., and MASSOUL, F. *La Céramique musulmane de l'Egypte*. Cairo, 1930.

BAHRAMI, M. *Gurgan Faiences*. Cairo, 1949.

BAHRAMI, M. *Recherches sur les carreaux de revêtement lustré dans la céramique persane du XIIIe au XIVe siècle (étoiles et croix)*. Paris, 1937.

BERTI, G., and TONGIORGI, L. *I bacini ceramici medievali delle chiese di Pisa*. Rome, 1981.

ETTINGHAUSEN, R. 'Evidence for the Identification of Kashan Pottery', *Ars Islamica*, 3 (1936) 44–75.

FROTHINGHAM, A. W. *Lustrewares of Spain*. New York, 1951.

GHOUCHANI, A. *Inscriptions on Nishabur Pottery*. Tehran, 1986.

GRUBE, E. J. *Cobalt and Lustre: The First Centuries of Islamic Pottery (Nasser D. Khalili Collection of Islamic Art 9)*. London, 1994.

GRUBE, E. J. *Islamic Pottery of the Eighth to the Fifteenth Century in the Keir Collection*. London, 1976.

JENKINS, M. 'Islamic Pottery: A Brief History', *The Metropolitan Museum of Art Bulletin*, N.S. 40:4 (1983).

KOECHLIN, R. *Les Céramiques musulmanes de Suse au Musée du Louvre*. Paris, 1928.

LANE, A. *Early Islamic Pottery, Mesopotamia, Egypt and Persia*. London, 1947.

LLUBIA, L. M. *Ceramica medieval espanola*. 2nd ed. Barcelona, 1973.

MARÇAIS, G. *Les Faiences à reflets métalliques de la grande mosquée de Kairouan*. Paris, 1928.

OLMER, P. *Catalogue général du Musée Arabe du Caire: les filtres de gargoulettes*. Cairo, 1932.

PHILON, H. *Early Islamic Ceramics: Ninth to Late Twelfth Centuries*. London, 1980.

PORTER, V. *Medieval Syrian Pottery*. Oxford, 1981.

PUERTAS TRICAS, R. *La ceramica islamica de cuerda seca en la Alcazaba de Malaga*. Malaga, 1989.

REITLINGER, G. 'Unglazed Relief Pottery from Northern Mesopotamia', *Ars Islamica*, 15–16 (1951), 11–22.

RIIS, P. J., and POULSEN, V. *Hama: fouilles et recherches (1931–1938)*, 4 (part 2), *Les Verreries et poteries médiévales*. Copenhagen, 1957.

ROSEN-AYALON, M. *Mémoires de la Délégation Archéologique en Iran, Mission susiane: Ville Royale de Suse, IV: La Poterie islamique*. Paris, 1974.

SARRE, F. *Die Keramik von Samarra (Die Ausgrabungen von Samarra 2)*. Berlin, 1925.

SOUSTIEL, J. *La Céramique islamique: le guide du connaisseur*. Fribourg, 1985.

TONGHINI, C. *Qal'at Ja'bar Pottery: A Study of a Fortified Site of the late 11th–14th Centuries*. New York, 1998.

WATSON, O. *Persian Lustre Ware*. London and Boston, 1985.

WILKINSON, C. K. *Nishapur: Pottery of the Early Islamic Period*. New York, 1973.

B. GLASS AND CRYSTAL

ʿABD AL-KHĀLIQ, H. *al-Zujaj al-islami fi matahif wa-makhazin al-athar fi al-Iraq (maʿ dirasah awwaliyyah ʿan al-zujaj al-qadim) (The Islamic Glass in the Iraqi Museums and Stores)*. Baghdad, 1976.

AUTH, S. H. *Ancient Glass at the Newark Museum from the Eugene Schaefer Collection of Antiquities*. Newark, 1976.

CLAIRMONT, C. W. *Catalogue of Ancient and Islamic Glass*. Benaki Museum, Athens, 1977.

HASSON, R. *Early Islamic Glass*. Jerusalem, 1979.

JENKINS, M. 'Islamic Glass: A Brief History', *Bull. MMA*, (Fall 1986).

KROGER, J. *Glas*. Museum für Islamische Kunst, Berlin. Mainz/Rhein, 1984.

KROGER, J. *Nishapur: Glass of the Early Islamic Period*. New York, 1995.

LAMM, C. J. *Mittelalterliche Gläser und Steinschnittarbeiten aus dem Nahen Osten*. 2 vols. Berlin, 1930.

LAMM, C. J. *Oriental Glass of Medieval Date Found in Sweden and the Early History of Lustre-Painting*. Stockholm, 1941.

MORTON, A. H. *A Catalogue of Early Islamic Glass Stamps in the British Museum*. London, 1985.

C. METALWORK, JEWELLERY, AND ARMS AND ARMOUR

ALLAN, J. W. *Islamic Metalwork: The Nuhad Es-Said Collection*. London, 1982.

ALLAN, J. W. *Metalwork of the Islamic World: The Aron Collection*. London, 1986.

ALLAN, J. W. *Nishapur: Metalwork of the Early Islamic Period*. New York, 1982.

ALLAN, J. W. *Persian Metal Technology: 700–1300 AD*. Oxford, 1979.

ALEXANDER, D. *The Arts of War: Arms and Armour of the 7th to 19th Centuries (Nasser D. Khalili Collection of Islamic Art 21)*. New York, 1992.

ATIL, E., CHASE, W. T., and JETT, P. *Islamic Metalwork in the Freer Gallery of Art*. Washington, D.C., 1985.

BAER, E. *Ayyubid Metalwork with Christian Images*. Leiden, 1989.

BAER, E. *Metalwork in Medieval Islamic Art*. Albany, 1983.

BARRETT, D. *Islamic Metalwork in the British Museum*. London, 1949.

CONTENT, D., ed. *Islamic Rings and Gems: The Benjamin Zucker Collection*. London, 1987.

CURATOLA, G., and SPALLANZANI, M. *Metalli islamici dalle Collezione Gran Ducali/ Islamic Metalwork from the Grand Ducal Collection (Lo specchio del Bargello 3)*. Florence, 1981.

ELGOOD, R., ed. *Islamic Arms and Armour*. London, 1979.

ETTINGHAUSEN, R. 'The "Wade Cup" in the Cleveland Museum of Art, its Origin and Decorations,' *Ars Orientalis*, 2 (1957) 327–66.

FEHERVARI, G. *Islamic Metalwork of the Eighth to the Fifteenth Century in the Keir Collection*. London, 1976.

HASSON, R. *Early Islamic Jewellery*. Jerusalem, 1987.

JENKINS, M., and KEENE, M. *Islamic Jewelry in the Metropolitan Museum of Art*. New York, 1983.

MARSHAK, B. *Silberschätze des Orients: Metallkunst des 3.–13. Jahrhunderts und ihre Kontinuität*. Leipzig, 1986.

MAYER, L. A. *Islamic Metalworkers and Their Works*. Geneva, 1959.

MELIKIAN-CHIRVANI, A. S. *Le bronze iranien*. Paris, 1973.

MELIKIAN-CHIRVANI, A. S. *Islamic Metalwork from the Iranian World, 8th–18th Centuries*. London, 1982.

RICE, D. S. *The Wade Cup in the Cleveland Museum of Art*. Paris, 1955.

SCERRATO, U. *Metallici islamici*. Milan, 1966.

SMIRNOV, Y. I. *Vostochnoe serebro: argenterie orientale*. St Petersburg, 1909.

WARD, R. *Islamic Metalwork*. New York, 1993.

WENZEL, M. *Ornament and Amulet: Rings of the Islamic Lands (Nasser D. Khalili Collection of Islamic Art 16)*. London and New York, 1993.

D. NUMISMATICS

ALBUM, S. *A Checklist of Islamic Coins*. Santa Rosa, CA, 1993; 2nd ed., 1998.

BATES, M. *Islamic Coins*. American Numismatic Society, Handbook no. 2. New York, 1982.

The Coinage of Islam: Collection of William Kazan. Beirut, 1983.

HENNEQUIN, G. *Catalogue des monnaies musulmanes de la Bibliothèque Nationale. Asie pré-Mongole; les Salğūqs et leurs successeurs*. Paris, 1985.

ILISCH, L. *Sylloge Numorum Arabicorum Tübingen: IVa Bilād aš-Šām I: Palästina*. Tübingen, 1993.

KORN, L. *Sylloge Numorum Arabicorum Tübingen: IVc Bilād aš-Šām III: Hamāh*. Tübingen and Berlin, 1998.

MAYER, L. A. *Bibliography of Moslem Numismatics, India Excepted*. 2nd ed., London, 1954.

MAYER, T. *Sylloge Numorum Arabicorum Tübingen: XVb Nord- und Ostzentralasien, Mittelasien II*. Tübingen and Berlin, 1998.

MEDINA GÓMEZ, A. *Monedas hispano-musulmanas: manual de lectura y clasificacion*. Toledo, 1992.

MITCHINER, M. B. *Oriental Coins and Their Values: The World of Islam*. London, 1977; repr. 1998.

SCHWARZ, F. *Sylloge Numorum Arabicorum Tübingen: XIVd Hurāsān IV: Gazna/Kabul*. Tübingen and Berlin, 1995.

SPENGLER, W. F., and SAYLES, W. G. *Turkoman Figural Bronze Coins and Their Iconography. I: The Artuqids*. Lodi, WI, 1992.

SPENGLER, W. F., and SAYLES, W. G. *Turkoman Figural Bronze Coins and Their Iconography. II: The Zengids*. Lodi, WI, 1996.

TIESENHAUSEN, V. *Monety vostochnavo chalifata*. St Petersburg, 1873; repr. London, 1989.

TYE, R., and M. *Jitals: A Catalogue and Account of the Coin Denomination of Daily Use in Mediaeval Afghanistan and North West India*. Loch Eynort, Isle of South Uist, 1995.

WALKER, J. *A Catalogue of the Arab-Byzantine and Post-Reform Umayyad Coins*. London, 1956.

WALKER, J. *A Catalogue of the Arab-Sasanian Coins*. London, 1941.

ZAMBAUR, E. K. M. VON. *Die Münzprägungen des Islam, zeitlich und ortlich geordnet*, ed. P. Jaeckel. Wiesbaden, 1968.

E. TEXTILES

BAKER, P. L. *Islamic Textiles*. British Museum, London, 1995.
BRITTON, N. P. *A Study of Some Early Islamic Textiles in the Museum of Fine Arts, Boston*. Boston, 1938.
BURNHAM, D. K. *Warp and Weft: A Dictionary of Textile Terms*. New York, 1981.
CORNU, G., *Tissus Islamiques*. The Vatican, 1992.
FALKE, O. VON. *Decorative Silks* (New York, 1922).
Islamische Textilkunst des Mittelalters: Aktuelle Probleme. With contributions by M. A. M. Salim, *et al.* (*Riggisberger Berichte* 5). Riggisberg, 1997.
KENDRICK, A. F. *Catalogue of Muhammadan Textiles of the Medieval Period*. London, 1924.
KÜHNEL, E. *Islamische Stoffe aus ägyptischen Gräbern in der islamischen Kunstabteilung und in der Stoffsammlung des Schlossmuseums*. Berlin, 1927.
KÜHNEL, E., and BELLINGER, L. *Catalogue of Dated Tiraz Fabrics: Umayyad, Abbasid and Fatimid*. Washington, D.C., 1952.
LAMM, C. J. *Cotton in Medieval Textiles of the Near East*. Paris, 1937.
MAY, F. L. *Silk Textiles of Spain: Eighth to Fifteenth Century*. New York, 1957.
OTAVSKY, K., and SALIM, M. A. M. *Mittelalterliche Textilien* 1. Riggisberg, 1995.
REATH, N. A., and SACHS, E. B. *Persian Textiles and their Technique from the Sixth to the Eighteenth Centuries including a System for General Textile Classification*. London, 1937.
SCHMIDT, J. H. *Alte Seidenstoffe*. Braunschweig, 1958.
SERJEANT, R. B. 'Materials for a History of Islamic Textiles up to the Mongol Conquest', *Ars Islamica* 9 (1942), 54–92; 10 (1943), 71–104; 11–12 (1946), 98–145; 13–14 (1948), 75–117; 15–16 (1951), 19–85.
SPULER, F. *Islamic Carpets and Textiles in the Keir Collection*. London, 1978.

F. WOODWORK, IVORY, AND STONE-CARVING

ANGLADE, E. *Catalogue des boiseries de la section islamique, Musée du Louvre*. Paris, 1988.
BECKWITH, J. *Caskets from Cordoba*. London, 1960.
BLOOM, J., *et al. The Minbar from the Kutubiyya Mosque*. New York, 1998.
COTT, P. B. *Siculo-Arabic Ivories*. Princeton Monographs in Art and Archaeology, Folio Series 3. Princeton, 1939.
CUTLER, A. *The Craft of Ivory: Sources, Techniques, and Uses in the Mediterranean World, A.D. 200–1400* (*Dumbarton Oaks Byzantium Collection Publications* 8). Washington, D.C., 1985.
DAVID-WEILL, J. *Catalogue général du Musée Arabe du Caire: les bois à épigraphes*. 2 vols. Cairo, 1931–36.
FERRANDIS, J. *Marfiles arabes de occidente*, 1 and 2. Madrid, 1935–40.
KALUS, L. *Catalogue des cachets, bulles et talismans islamiques*. Paris, 1981.
KALUS, L. *Catalogue of Islamic Seals and Talismans*. Oxford, 1986.
KÜHNEL, E. *Die islamische Elfenbeinskulpturen VIII.–XIII. Jahrhunderts*. Berlin, 1971.
MAYER, L. A. *Islamic Woodcarvers and Their Works*. Geneva, 1958.
PAUTY, E. *Catalogue général du Musée Arabe du Caire: les bois sculptés jusqu'à l'époque ayyoubide*. Cairo, 1931.
PAUTY, E. *Bois sculptés d'églises coptes (époque Fatimide)*. Cairo, 1930.
WIET, G., *et al. Catalogue général du Musée Arabe du Caire: steles funéraires*. Cairo, 1936–42.

8. THE ARTS OF THE BOOK

ABBOTT, N. *The Rise of the North Arabic Script and its Kur'anic Development, with a Full Description of the Kur'an Manuscripts in the Oriental Institute*. Chicago, 1939.
ANWAR, A. *Catalogue of Arabic Manuscripts in the National Library, Tehran*. 3 vols. Tehran, 1977–79.
ARBERRY, A. J. *A Handlist of Arabic Manuscripts in the Chester Beatty Library*. Dublin, 1955–56.
ARBERRY, A. J. *The Koran Illuminated: Handlist of Korans in the Chester Beatty Library*. Dublin, 1967.
ARNOLD, T. W. *Painting in Islam: A Study of the Place of Pictorial Art in Muslim Culture*. Oxford, 1928.
ARNOLD, T. W., and GROHMANN, A. *The Islamic Book: A Contribution to Its Art and History from the VII–XVIII Century*. Leipzig, 1929.
BOTHMER, H.-K. VON. *Kalila und Dimna: Ibn al-Muqaffa's Fabelbuch in einer Mittelalterlichen Handschrift: Cod. arab. 616 der Bayerischen Staatsbibliothek, München*. Wiesbaden, 1981.
DÉROCHE, F. *The Abbasid Tradition: Qur'ans of the 8th to 10th Centuries A.D.* (*Nasser D. Khalili Collection of Islamic Art* 1). London, 1992.
DÉROCHE, F. *Catalogue des manuscrits arabes. 2, Manuscrits musulmans, tome I, 1: Les Manuscrits du Coran aux origines de la calligraphie coranique*. Paris, 1983. *Tome I, 2: Les Manuscrits du Coran du Maghreb à l'Insulide*. Paris, 1985.
ETTINGHAUSEN, R. *Arab Painting*. Geneva, 1962.
ETTINGHAUSEN, R., and SWIETOCHOWSKI, M. L. 'Islamic Painting', *Bull. MMA*, N.S. 36:2 (1978).
FARÈS, B. *Le Livre de la Thériaque: manuscrit arabe à peintures de la fin du XIIe siècle conservé à la Bibliothèque Nationale de Paris*. Cairo, 1953.
GRABAR, O. *The Illustrations of the Maqamat*. Chicago, 1984.
GROHMANN, A. *Arabische Paläographie*. 2 vols. Vienna, 1967–71.
HALDANE, D. *Islamic Bookbindings in the Victoria and Albert Museum*. London, 1983.
JAMES, D. *The Master Scribes: Qur'ans of the 10th to 14th Centuries A.D.* (*Nasser D. Khalili Collection of Islamic Art* 2). New York, 1992.
JAMES, D. *Qurans and Bindings from the Chester Beatty Library*. London, 1980.
KHAN, G. *Bills, Letters, and Deeds: Arabic Papyri of the 7th to 11th Centuries* (*Nasser D. Khalili Collection of Islamic Art* 6). New York, 1993.
KHATIBI, A., and SIJELMASSI, M. *The Splendour of Islamic Calligraphy*. New York, 1976.
LEROY, J. *Les Manuscrits coptes et coptes-arabes illustrés*. Paris, 1974.
LEROY, J. *Les Manuscrits syriaques à peintures*. Paris, 1964.
LINGS, M. *The Quranic Art of Calligraphy and Illumination*. London, 1976.
MARTIN, F. R. *The Miniature Painting and Painters of Persia, India, and Turkey from the Eighth to the Eighteenth Century*. London, 1912.
MELIKIAN-CHIRVANI, A. S. 'Le Roman de Varque et Golšah', *Arts Asiatiques* 22, special number (1970), 1–262.
MORITZ, B., ed. *Arabic Palaeography: A Collection of Arabic Texts from the First Century of the Hidjra till the Year 1000*. Cairo, 1905.
RICE, D. S. *The Unique Ibn al-Bawwab Manuscript in the Chester Beatty Library*. Dublin, 1955.
SADEK, M. M. *The Arabic Materia Medica of Dioscurides*. St-John-Chrysostome, Quebec, 1983.
SAFADI, Y. H. *Islamic Calligraphy*. London, 1978.
WEISWEILER, M. *Der islamische Bucheinband des Mittelalters nach Handschriften aus deutschen, hollandischen, und turkischen Bibliotheken*. Wiesbaden, 1962.

Additions 2005

BLOOM, J. *Paper before Print* (New Haven, 2001)
CABAŞERO SUBIZA, B. ed. *La Aljaferia* (Zaragoza, 1998)
CARBONI, S. *Glass from Islamic Lands* (Kuwait and New York, 2001)
FOWDEN, G. *Qusayr 'Amra* (Berkeley and Los Angeles, 2004)
GRABAR, O. *Maqamat of al-Hariri by al-Wasiti* (TouchArt, London, 2003)
ROBINSON, C. *In Praise of Song, the Making of Courtly Culture in al-Andalus and Provence, 1005–1134* (Leiden, 2002)
SEIPEL, W. ed. *Nobiles Officinaĕ* (Vienna, 2004)
WATSON, O. Ceramics from Islamic Lands (Kuwait and London, 2004)

Index to the Bibliography

ABBOTT, N. 8
ʿABD AL-BAQI, A. 6E
ʿABD AL-KHĀLIQ, H. 7B
ʿABDUL RAHMAN, N., and MARECHAUX, P. 4
ADLE, C. 3
ADLE, C., and MELIKIAN-CHIRVANI, A. S. 6G
AHAROV, I., and REMPEL, L. 6D
AHSAN, M. M. 2
ALBARN, K. 6B
ALBUM, S. 7D
ALEXANDER, D. 7C
ALI, S. A. 6E
ALLAN, J. W. 4, 7C
ALLEN, T. 6A, 6E
ALMAGRO, M., CABALLERO, L., ZOZOYA, J., and
 ALMAGRO, A. 6E
ALTUN, A. 6C
AL-AMID, T. M. 6E
The Anatolian Civilisations 4
Al-Andalus 5; continued by *Al-Qantara*
ANGLADE, E. 7F
Les Annales Archéologiques de Syrie 5
Annales de l'Institut d'Etudes Orientales 5
Annales Islamologiques 5
Annali Instituto Orientale di Napoli 5
Annual of the Department of Antiquities of Jordan 5
ANWAR, A. 8
Arabica 5
ARBERRY, A. J. 8
Archäologische Mitteilungen aus Iran 5
Archéologie Islamique 5
ARNOLD, T. W. 8
ARNOLD, T. W., and GROHMANN, A. 8
Ars Islamica 5
Ars Orientalis 5
Art and Archaeology Research Papers 5
Art from the World of Islam 8th–18th Century 4
The Art of Medieval Spain, A.D. 500–1200 4
Arts de l'Islam, des origines à 1700 4
The Arts of Islam 4
ASLANAPA, O. 6C
Athar-é Iran 5
ATIL, E. 4
ATIL, E., CHASE, W. T., and JETT, P. 7C
Al-Atlal 5
AUTH, S. H. 7B
AZUAR RUÍZ, R. 6H
BAER, E. 3, 7C
BAGHAT, A., and MASSOUL, F. 7A
Baghdader Mitteilungen 5
BAHRAMI, M. 7A
BAKER, P. L. 7E
AL-BALADHURI 2
BARGEBURH, F. 6H
BARRETT, D. 7C
BASSET, H., and TERRASSE, H. 6H
BATES, M. 7D
BAZZANA, A. 6H
BECKWITH, J. 7F
BEHRENS-ABOUSEIF, D. 6E
BELENITSKII, A. M. 6D
BELENITSKII, A. M., BENTOVICH, I. B., and
 BOLSHAKOV, O. G. 6D
BELL, G. L. 6E
BELLAFIORE, G. 6H
Belleten 5
BENAVIDES COURTOIS, J. 6H
BERCHEM, M. VAN. 6E
BERNUS-TAYLOR, M. 4
BERTI, G., and TONGIORGI, L. 7A
Berytus 5

BIER, L. 6G
BINSHANHU, A. 6H
BLAIR, S. 3
BLOOM, J. 6A, 7F
BLOOM, J., and BLAIR, S. 3
BOMBACI, A. 6D
BORNSTEIN, C. 4
BORRAS GUALIS, G. 6H
BOSCH, G. K. 4
BOSWORTH, C. E. 1
BOTHMER, H.-K. VON. 8
BOUROUIBA, R. 6H
BRANDENBURG, D. 6A, 6D
BREND, B. 3
BRETANITSKII, L. S. 6G
BRICE, W. C. 1
BRISCH, K. 3, 6H
BRISCH, K., KROGER, J. et al. 3
BRITTON, N. P. 7E
BROWN, P. 6F
BULATOV, M. S. 6B
Bulletin d'Etudes Orientales 5
*Bulletin of the American Institute for Iranian Art
 and Archaeology* 5
*Bulletin of the American Institute for Persian Art
 and Archaeology* 5
Bulletin of the Asia Institute 5
Bulletin of the Iranian Institute 5
*Bulletin of the School of Oriental and African
 Studies* 5
BURNHAM, D. K. 7E
CABAÑERO SUBIZA, B. 6H
CAILLÉ, J. 6H
CANIVET, P., and REY-COQUAIS, J.-P. 6E
CARA BARRIONUEVO, L. 6H
CARBONI, S., and MASUYA, T. 4
CASTEJÓN, R. 6H
CLAIRMONT, C. W. 7B
*The Coinage of Islam: Collection of William
 Kazan* 7D
COMBE, E., SAUVAGET, J., and WIET, G. 1
CONTENT, D. 7C.
CONTRERAS VILLAR, A., and VALLEJO TRIANO, A. 6H
CORNU, G. 7E
COSTA, P. M. 6E
COSTA, P., and VICARIO, E. 6E
COTT, P. B. 7F
CRESWELL, K. A. C. 1, 6A, 6E
Cuadernos de Madinat al-Zahra' 5
CURATOLA, G. 3, 4
CURATOLA, G., and SPALLANZANI, M. 4, 7C
CUTLER, A. 7F
DADASHEV, S. A. 6G
DANESHVARI, A. 3, 6G
DAVID-WEILL, J. 7F
De Carthage à Kairouan 4.
De l'empire romain aux villes impériales 4
DELGADO VALERO, C. 6H
DENIKE, B. P. 6B
Der Islam 5
DÉROCHE, F. 8
DICKIE, J. 6H
DIEZ, E. 6D, 6G
DODD, E. C., and KHAIRALLAH, S. 1
DODDS, J. D. 4, 6H
DONNER, F. M. 2
East and West 5
ECOCHARD, M. 3, 6A
ECOCHARD, M., and LECOEUR, C. 6E
ELGOOD, R., 7C
The Encyclopaedia of Islam 1

Epigrafika Vostoka 5
ERDMANN, K. 2, 6C
ESCO, C., GIRALT, J., and SENAC, P. 6H
ETTINGHAUSEN, R. 3, 6E, 7A, 7C, 8
ETTINGHAUSEN, R., and SWIETOCHOWSKI, M. L. 8
EVANS, H. C., and WIXOM, W. D. 4
EWERT, C. 6H
EWERT, C., and WISSHAK, J.-P. 6H
FALK, T., 4
FALKE, O. VON. 7E
FARÈS, B. 6B, 8
FEHERVARI, G. 7C
FERBER, S. 4.
FERRANDIS, J. 7F
FERRIER, R. W. 3
FIEY, J. M. 6E
FINSTER, B. 6E
FINSTER, B., and SCHMIDT, J. 6E
Fjerde del Jubilaeumsskrift 1945–70 3
FLURY, S. 6B
FOLSACH, K. VON 3
FOLSACH, K. VON, and BERNSTED, A. K. 4
FORKL, H. 3
FRANZ, H. G. 6A
FREEMAN-GRENVILLE, G. S. P. 1
FROTHINGHAM, A. W. 7A
FUSARO, F. 6A
GABRIEL, A. 6C
GABRIELI, F. 2, 3
GALDIERI, E. 6G
GARCIA GOMEZ, E. 2
GARDIN, J. C., SCHLUMBERGER, D., and SOURDEL-
 THOMINE, J. 6D
GAUBE, H. 6E
GHOUCHANI, A. 7A
GIBB, H. A. R. 3
GLADISS, A. VON 3, 4
GLICK, T. 6A
GODARD, A. 6G
GOITEIN, S. D. 2
GOLOMBEK, L. 6D
GOLVIN, L. 6A, 6H
GOMEZ-MORENO, M. 3
GRABAR, O. 3, 6A, 6G, 8
GRABAR, O., HOLOD, R., KNUDSTAD, J., and TROUS-
 DALE, W. 6E
GROHMANN, A. 8
GRUBE, E. J. 7A
HALDANE, D. 8
HAMILTON, R. W. 6E
AL-HARAWI 2
HARLE, J. C. 6F
HARPER, P. 4
HASSAN, Z. M. 3
HASSON, R. 7B, 7C
HAWTING, G. R. 2
HENNEQUIN, G. 7D
HERDEG, K. 6G
HERNANDEZ, F. 6H
HERRMANN, G. 6D
HERZFELD, E. 3, 6E
HILL, D. 6A
HILL, D., and GOLVIN, L. 6H
HILL, D., and GRABAR, O. 6A
HILLENBRAND, R. 3, 6A, 6C, 6G
HODGSON, M. G. S. 2
HUGHES, T. P. 1
HUMPHREYS, R. S. 2
HUSAIN, A. B. M. 6
IBN HAWQAL 2
IBN JUBAYR 2

IBN KHALDUN 2
IBN MUNQIDH, USAMAH 2
IBN AL-MUQAFFA 2
IBN AL-NADIM 2
IBN ZUBAYR 2
AL-IDRISI 2
ILISCH, L. 7D
Iran 5
Iranica Antiqua 5
Iraq 5
Iraq Department of Antiquities. *Excavations at Samarra* 3
IRWIN, R. 3
Islamic Archaeological Studies 5
Islamic Art 5
'Islamic Art', *Bulletin of the Metropolitan Museum of Art* 3
The Islamic World 3
Islamische Kunst in Berlin 3
Islamische Textilkunst des Mittelalters: Aktuelle Probleme 7E
Israel Exploration Journal 5
JAMES, D. 4, 8
AL-JANABI, T. J. 6E
JENKINS, M. 3, 7A, 7B
JENKINS, M., and KEENE, M. 7C
JIMENEZ MARTIN, A. 6H
Journal Asiatique 5
Journal of the American Research Center in Egypt 5
Journal of the Royal Asiatic Society 5
KAHLE, P. 2
KALUS, L. 7F
KEENE, M. 3
KENDRICK, A. F. 7E
KENNEDY, H. 2
KHALIDI, T. 2
KHAN, G. 8
AL-KHATIB AL-BAGHDADI 2
KHATIBI, A., and SIJELMASSI, M. 8
KHMELNITSKII, S. 6D
KING, G. R. D. 6A
KOECHLIN, R. 7A
KORN, L. 7D
KROGER, J. 7B
KUBAN, D. 6A, 6C
KÜHNEL, E. 3, 7E, 7F
KÜHNEL, E., and BELLINGER, L. 7E
Kunst des Orients 5
KURAN, A. 6C
LAMM, C. J. 7B, 7E
LANE, A. 7A
LASSNER, J. 6E
LEROY, J. 8
LESTRANGE, G. 2
LÉVI-PROVENÇAL, E. 6H
LEWIS, B., LAMBTON, A. K. S., and HOLT, P. M. I
LÉZINE, A. 6H
LINGS, M. 8
LINGS, M., and SAFADI, Y. H. 4
LLUBIA, L. M. 7A
LOPEZ GUZMAN, RAFAEL, 6H
LOUKONINE, V., and IVANOV, A. 3
Madrider Mitteilungen 5
AL-MAQRIZI 2
MARÇAIS, G. 2, 6H, 7A
MARÇAIS, G., and POINSSOT, L. 3
MARICQ, A., and WIET, G. 6D
MARSHAK, B. 7C
MARTIN, F. R. 8
MASLOW, B. 6H
Masterpieces of Islamic Art in the Hermitage Museum 4
AL-MASʿUDI 2
MAY, F. L. 7E
MAYER, L. A. 6A, 7C, 7D, 7F
MAYER, T. 7D
MEDINA GÓMEZ, A. 7D

MEINECKE, M. 6B
MELIKIAN-CHIRVANI, A. S. 7C, 8
MICHELL, G., 6A
MIQUEL, A. 2
MIGEON, G. 3
MILES, G. C. 3
MITCHINER, M. B. 7D
Le Monde Iranien et l'Islam 5
MONNERET DE VILLARD, U. 3, 6B
MORITZ, B. 8
MORTON, A. H. 7B
MOSTAFA, S. L. 6E
MUNIS, H. 6A
AL-MUQADDASI 2
Muqarnas 5
AL-NARSHAKHI 2
NASIR-I KHOSROW 2
NAVARRO PALAZÓN, J. 6H
NECIPOGLU, G. 6A, 6B
NILSEN, V. A. 6D
ÖGEL, S. 6C
OLMER, P. 7A
ÖNEY, G. 6C
OTAVSKY, K., and SALIM, M. A. M. 7E
Oxford Studies in Islamic Art 3
Pages of Perfection: Islamic Paintings and Calligraphy from the Russian Academy of Sciences 4
PAL, P. 3
PAPADOPOULO, A. 3, 6A
PAUTY, E. 7F
PAVÓN MALDONADO, B. 6H
PHILON, H. 7A
POPE, A. U. 3
PORTER, V. 7A
PREUSSER, R. 6E
PUERTAS TRICAS, R. 7A
PUGACHENKOVA, G. A. 6D
Al-Qantara 5
Quarterly of the Department of Antiquities in Palestine 5
RABY, J., ed. 6E
RAYMOND, A., ROGERS, M., and WAHBA, M., 6E
REATH, N. A., and SACHS, E. B. 7E
REDFORD, S. 6C
REITLINGER, G. 7A
REMPEL, L. I. 6D
RENARD, J. 2
Revue des Etudes Islamiques 5
RICE, D. S. 7C, 8
RICHARDS, D. H. 2
RIIS, P. J., and POULSEN, V. 7A
ROBINSON, B. 3
ROBINSON, C. 6H
ROPER, G. J., and BLEANEY, C. H. I
ROSELLO-BORDOY, G. 6H
ROSEN-AYALON, M. 7A
ROSINTHAL, J. 6B
SACK, D. 6E
SADEK, M. M. 8
SAENZ-DIEZ, J. I. 6H
SAFADI, Y. H. 8
SAFAR, F. 6E
EL-SAID, I. 3
EL-SAID, I., and PARMAN, A. 6B
SALIM, S. 6H
SANCHEZ SEDANO, M. 6H
SAOUAF, S. 6E
SARRE, F. 6G, 7A
SARRE, F., and HERZFELD, E. 6E
SAUNDERS, J. J. 2
SAUVAGET, J. 3, 6E
SAUVAGET, J., ECOCHARD, M., and SOURDEL-THOMINE, J. 6E
SCANLON, G. 6E
SCARCIA, G. 3
SCERRATO, U. 7C

SCHLUMBERGER, D. 6E
SCHMID, H. 6E
SCHMIDT, J. H. 7E
SCHNEIDER, G. 6C
SCHWARZ, F. 7D
SEBAG, P. 6E
SECO DE LUCENA, L. 6H
SERJEANT, R. B. 6B, 7E
SERJEANT, R. B., and LEWCOCK, R. 6E
SEVCENKO, M. B. 6A
SHAFEI, F. M. 6B
SHALEM, A. 3
SHOKOOHY, M. 6F
SHOKOOHY, M., and SHOKOOHY, N. H. 6F
SMIRNOV, Y. I. 7C
SÖNMEZ, Z. 6C
SOUCEK, P. 3, 4
SOURDEL, D., and SOURDEL, J. 3
SOURDEL-THOMINE, J., and SPULER, B. 3
SOUSTIEL, J. 7A
SÖZEN, M. 6C
SPENGLER, W. F., and SAYLES, W. G. 7D
Splendeur et majesté: corans de la Bibliothèque nationale 4
SPULER, F. 7E
STERN, H. 6H
STERN, S. M., and Hourani, A. 6A
STIERLIN, H. 3, 6A
Studia Iranica 5
Studia Islamica 5
Sumer 5
Syria 5
AL-TABARI 2
TERRASSE, H. 6H
Terres secrètes de Samarcande: céramique du VIIIe au XIIIe siècle. 4
THOMPSON, D. 6G
TIESENHAUSEN, V. 7D
Tissus d'Egypte témoins du monde arabe VIIIe–XVe siècles 4
TONGHINI, C. 7A
TORRES, C. 4
TORRES BALBÁS, L. 3, 6H
Trésors d'Orient 4
Trésors fatimides du Caire 4; *Schätze der Kalifen, Islamische Kunst zur Fatimidenzeit* 4
A Tribute to Persia: Persian Glass 4
TRUMPELMAN, L. 6E
TURNER, J. S. I
ÜNSAL, B. 6C
TYE, R., and M. *Jitals* 7D
AL-ʿUSH, A., JOUNDI, A., and ZOUDHI, B. 3
VALOR PIECHOTTA, M. 6H
VARANDA, F. 6E
Variety in Unity 4
La Voie royale: 9,000 ans d'art au royaume de Jordanie 4
WALKER, J. 7D
WARD, R. 7C
WARNER, A. G., and WARNER, E. 2
WATSON, O. 7A
WATSON, W. 6G
WATT, JAMES C. Y., and WARDWELL, ANNE E. 4
WEISWEILER, M. 8
WENZEL, M. 7C
WHITCOMB, D. 3
WHITEHOUSE, D. 6G
WIET, G. 6E, 7F
WILBER, D. N. 6G
WILKINSON, C. K. 7A
WOOD, R. 2
YAQUBI 2
YARSHATER, E. I
YAVUZ, A. T. 6C
ZAMBAUR, E. K. M. VON. 7D

Glossary

This glossary of frequently used Arabic, Persian (P), and Turkish (T) words does not include those words which are fairly well known and can be found in standard English dictionaries.

'abaya (*'abā'a*) cloak-like woollen wrap

ablaq decorative technique of alternating stone of different colours

amir (*amīr*) lit. 'commander'; title for a prince, ruler, or chief

arq or *arg* (P) citadel, or part of a citadel

atabeg title of high dignitary under the Saljuqs and their successors

attabi (*'attābī*) a type of fabric, named after a quarter of the city of Baghdad

bayt lit. 'house'; in architecture, the term used to describe the living units within palaces and residences

beylik (T) an area or domain ruled by a bey (a Turkic title for a lord or chief)

dar al-hadith (*dār al-ḥadīth*) institution devoted to the teaching of the Traditions of the Prophet

dihqan (*dihqān*) (P) a member of the feudal aristocracy or land-owning gentry

gach (P; *ganch* in Tajik) stucco

habb (*ḥabb*) a large, unglazed pottery storage jar

hadith (*ḥadīth*) prophetic tradition; narrative relating to the deeds and utterances of the Prophet Muhammad and his Companions

hammam (*ḥammām*) bath

haram (*ḥaram*) something holy or sacred; sanctuary

al-Haramayn (colloquial for *al-Ḥaramān*) the two holy places, Mecca and Madina

imam (*imām*) leader, especially of ritual prayer; the term is sometimes applied to religiously guided political leaders

imamzade (*imāmzāde*) lit. 'mausoleum'; the tomb of a prominent descendant of an imam

imaret (T, from Arabic *'imāra*, 'building') a public soup kitchen

iqta' (*iqṭā'*) feudal system of granting fiefs to army chiefs

iwan (*īwān*) a vaulted hall, walled on three sides, with one end entirely open

jahiliyya (*al-jāhilīya*) the 'time of ignorance' or period of Arab paganism preceding the advent of Islam

juz' pl. *ajzā'* a thirtieth part of the Qur'an

kashi (*kāshī*) (P.; abb. of *kāshānī*) the term for tiles, or trimmed pieces of pottery serving to cover completely or partially the interior and/or the exterior of buildings

khangah (*khānaqā*) (A/P) a communal dwelling for mystics

khatib (*khaṭīb*) preacher; pronouncer of the sermon (*khuṭba*) at Friday prayers

khutba (*khuṭba*) Muslim Friday sermon

madhhab each of the four orthodox schools of Islamic law or jurisprudence (see *sharia*)

madrasa lit. 'school'; specifically, an institution developed in the eleventh century for the training of the religious elite

majlis an assembly, a ruling council, or a parliament

maqamat (*maqāmāt (pl.)*) lit. 'meetings'; a genre of Arabic rhythmic prose

maqsura (*maqṣūra*) in a mosque, an enclosure in the vicinity of the *mihrab*, usually set aside for use by the ruler

mashaf, pl. *masahif* (*maṣḥaf, pl. maṣāḥif*) book, volume; generally applied to a copy of the Qur'an

mashhad lit. 'place of witnessing'; commemorative sanctuary for purposes of prayer, pilgrimage, and private piety

masjid lit. 'place of prostration'; mosque

maydan (*maydān*) a large, open space; a square or plaza, usually for ceremonial functions

mazar (*mazār*) a mausoleum or shrine

mihrab (*miḥrāb*) a niche in the wall of a mosque which indicates the *qibla*, the direction of Mecca, towards which all Muslims turn in prayer

mina'i (*minā'ī*) (P) type of pottery with polychrome stain- and overglaze-painted decoration

minbar lit. 'platform', 'dais'; pulpit in a congregational mosque from which the sermon (*khuṭba*) is delivered during worship on Fridays

muezzin (*mu'adhdhin*) announcer of the hour of prayer

muluk al-tawa'if (*mulūk al-ṭawā'if*) 'princelings', 'petty kings'; feudal lords who governed independent principalities in Spain following the breakdown of the Umayyad Caliphate of Cordoba in the early eleventh century

muqarnas three-dimensional architectural ornament composed of tiers of niche-like elements, sometimes likened to stalactites

musalla (*muṣallā*) lit. 'place for prayer'; a public, open-air place for prayer, usually outside a city's gates

naskhi the ordinary cursive Arabic script

nisba adjective denoting descent, origin, orientation or profession

pishtaq (P) (*pīshṭāq*) high arch or gateway on the façade of a building

qal'a fort; fortress; citadel

qasab (*qaṣab*) gold and silver thread; gold and silver embroidery; brocade

qibla the direction of prayer towards the Ka'ba in Mecca

qubba dome; cupola; domed tomb or shrine

rabad (*rabaḍ*) outskirts, suburb

rahle (Arabic, in Turkish usage) folding stand for a Qur'an

ribat (*ribāṭ*) frontier fortress and center for devout warriors

riwaq (*riwāq*) portico

rubaiyyat (*rubā'īyāt*) 'quatrains'; any poem written in quatrains

sahn (*ṣaḥn*) yard; courtyard, most frequently, of a mosque; patio

salat (*ṣalāt*) lit. 'prayer' or 'worship'; canonical, or ritual, prayer consisting of a series of movements and recitations

shahristan (*shahristān*) (P) central walled city of a large urban centre

sharia (*sharī'a*) the revealed, or canonical, law of Islam

Shi'ism (from *shī'a*, lit. 'party') one of the two principal branches of Islam; Shi'ites recognize only 'Ali and his descendants as rightful successors of the Prophet

shubbak (*shubbāk*) a fenced opening; a window

simurgh (*sīmūrgh*) (P) name of a mythical bird

Sufism Islamic mysticism

Sunnism (from *al-sunna*, 'the Prophet's sayings and actions') orthodox Islam, which accepts the *sunna* as legally binding precedents

taifa (from *ṭā'ifa*, 'sect', 'faction', 'religious minority') abbreviation of *mulūk al-ṭawā'if* (see above)

tiraz (*ṭirāz*) (P, 'embroidery') inscribed textiles made in state workshops for distribution by a ruler to his courtiers; by extension, an ornamental band of fabric bearing an inscription; *dār al-ṭirāz* factory for textile manufacture

türbe (T, from Arabic *turba*) tomb; funerary monument

waqf religious endowment; endowment in general

ziyada (*ziyāda*) the outer enclosure or extension of a mosque

Index

Numbers in *italic* refer to illustrations

Aachen palace church, 20
Abarquh tomb tower, 146
Abbasids, 10-11, 29, 30, 31, 33, 36, 78, 79, 83, 87, 91, 92, 93, 94, 97, 98, 101, 115, 117, 133, 161, 170, 200, 204, 210, 227, 233, 243, 250, 236, 295; architectural decoration, 57, 58; cities and palaces, 51-6; art of the object, 62, 65, 66, 67-72 *passim*
ʿAbd Allah ibn Muhammad al-Konyali, 258
ʿAbd al-Malik, caliph, 10, 15, 19, 20, 64, 95
ʿAbd al-Malik, artisan, 300
ʿAbd al-Muʿmin ibn Muhammad, 263
ʿAbd al-Rahmann, 84
ʿAbd al-Rahman II, 83, 200
ʿAbd al-Rahman III, 83, 89, 95, 310n
ʿAbd al-Rahman ibn Muʾawiya, 83
ʿAbdallah ibn al-Rabi, al-Amir, 63, 308n
Abhazia, Georgian palace complex, 296
ablaq technique, 231
Abu al-Ala al-Maʿarri, 133
Abu Ayyub Muhammad, 98
Abu Ibrahim Ahmad, 69, 71
Abu Jaʿfar Ahmad ibn Sulayman, 269
Abu Nuwas, 79
Abu Shama, 255
Abu Yazid, 63
Abu Yusuf Yaʿqub al-Mansur, 280
Aden, 63, *63*
ʿAdud al-Dawla, 129
al-Afdal, 197
Afghanistan, 11, 105, 116, 117, 129, 134, 135, 150, 153, 159, 160, 163, 164, 167, 178, 183
Afyon, mosque, 234
Aghlabids, 11, 71, 83, 94, 98, 100, 101, 275, 318n
Ajmer, 165
Akhtamar, Church of the Holy Cross, 296, *296-7*
ʿAla al-Din Kayqubad, 256
Aldrevandin, Magister, 253
Aleppo, 217, 223, 227, 261; citadel, 227, *230*, 231, 233, 249; construction and decoration, 231; Firdaws *madrasa*, 225, 227, *227*; Firdaws mosque, *231*, 232; Great Mosque, 255; *madrasas*, 225, 225-6, 227; market, 227; woodwork, 254, 255; Zahiriya *madrasa*, 225, *226*
Alexander the Great, 7, 213, 296
Alfonso VIII of Castile, 300
Algeria, 83, 187, 188, *189*, 189-90, 265, 269, 275
Algiers, Great Mosque, 269, 280
Ali, 10, 110, 145, 195, 215
Ali ibn Ahmad al-Warraq, 285
Ali ibn Yusuf, 280, 284
Almeria, textile production, 281
Almohads, 134, 135, 203, 269, 273, 278, 280, 281, 282, 283, 285, 286
Almoravids, 134, 269, 278, 280, 281, 282, 283, 286, 300
Amajur, 75, 98
Amman, citadel, 36, 39
Anatolia (al-Rum), vii, 4, 134, 135, 139, 145, 154, 160, 170, 187, 196, 215, 217, 227, 232, 233-43, 244, 264, 265; architecture, 234-41, 264; book illumination, 258, *258*, 262; caravanserai, *240*, 240-1; ceramics, 250, 251-2, *251-2*, 284; Christians in, 295-6; construction and decoration, 241-2; *madrasas*, 235-9; mausoleums, 239; mosques, 234-5; stucco decoration, *256*, 256-7; woodwork, 255, 255-6, *256*
al-Andalus/Andalusia *see* Spain
ʿAnjar, 74

Ankara, Haci Hasan Mosque, 255
Antioch, 133; Georgian monastery near, 296
Anvari, 134
aquamaniles, 168, *169*, 170
arabesque, 66, 79, 120, 161, 172, 182, 213, 232, 233, 242, 244, 247, 249, 250, 255, 257, 258, 262, 273, 278, 283
Arabia, vii, 11, 109, 187, 264; pre-Islamic, 3-5
Arabian Nights, 56
architectural decoration, 15, 19, 50-1, 57-9, 90, 92, 101, 159-65, 171-2, 178, 232-3, 241-2, 252, 257, 272-4, 324-5n; glazed ceramic, 160, 171-2, 178, 251-2, *275*, 275-7, *276*, 284, *284*, 296, 309n, 311n; *see also* painting and sculpture; stucco decoration
Ardistan, 160, 163; *mihrab, 158*, 161; mosque, 109, 139, 143, *155*, 158, 161
Armenia, Armenian art, viii, 8, 87, 128, 134, 199, 213, 217, 218, 222, 239, 264, 295-6, *296-7*
arq, 152
art of the book *see* bookbinding; illuminations; manuscripts
art of the object, 57, 59-73, 91-8, 116-28, 165-80, 200-11, 243-57, 274-85, 291
Artuq Shah, 244, 246
Artuqids, 134, 244, 246, 255, 264, 296
Asad al-Iskandarani, 250
Ascalon, 190
Ashir palace, *288*, 288-9
Asnaf, mosque of al-Abbas, 225
Assur, 70
astronomy, 129, *129*
Aswan, cemetery, 195, *195*; *mashhad*, 197, 198
atomism, 79
Avicenna (Ibn Sina), 105, 134
Ayyubids, 134, 135, 201, 215, 217, 222, 227, 231, 233, 243, 244, 248, 250, 251, 252, 253, 264, 322n
Azerbaijan, 134, 135, 139, 145, 146, 148, 160, 183, 239, 263
al-ʿAziz, 201, 206, 209, *209*
al-Azraqi, *Akhbar al-Makkah*, 3

Baalbek mosque, 305n
Baba Khatun mausoleum, 113
Babylon, 70
bacino/bacini, 202, 203, 206, 284, 302
Badis ibn al-Mansur, 285
Badr al-Din Luʾluʿ, 134, 217, 222, 247
Badr al-Jamali, 134, 197, 199
Baeza, 281
Baghdad, 10, 11, 15, 36, *50*, 51, 51-2, *52*, 54, 55, 69, 71, 73, 76, 79, 80, 91, 94, 96, 97, 101, 125, 130, 133, 134, 135, 145, 187, 193, 264, 269, 281; Abbasid, 51-2, 54; architecture, 215-17; calligraphy, 76; Gate of the Talisman, 217, 249; Green Dome, 52, *52*; al-Mansur mosque, 30, 52, *52*; Mongols' sack of (1258), 261; mosques, 30, 36, 52; Mustansiriya, *214-15*, 215-16, 225, *249*, 250; Suq al-Ghazi minaret, 261, *216*; textiles, 243, 281; Tomb of Zubayda, 216
Bahnasa curtains, 73
Baku, 140, 150, 178
Balaguer fortified palace, 269
baldacchino, 243
Balis (now Meskene), 218
Balkh, 11, 105, 130, 145; Masjid-i Nuh Gunbadh mosque, *108*, 109
Banabhore mosque, 29
Bani Hud, 269

Banu Hilal, 275
Banu Sulaym, 275
Bari mausoleum, 299
Barsian mosque, 109, 139, 143, 158
Basra, 10, 11, 15, 20, 36, 69, 79, 93, 215, 319n; ceramics, 62, *62*, 67, 68, 93, 205, 309n; metalwork, 63, *63*
baths, 40, 41-2, *42*, 43, *43*, 56, 233
Bayad wa-Riyad, *287*, 287-8
Bayana, 165
bayt al-salat, 306n
Beatus manuscript, 300, 302
Beirut, red glassware, 253
Benjamin of Tudela, 215
Berbers, 83, 134, 187, 189, 269, 274, 280, 281
Berchem, Max von, 145, 190
Beysehir mosque, 234
Bhadrésvar, 165
Bible, Hebrew, from Fustat, 293, *295*
Biblia Hispalense, 300
Bidba (or Bidpai), 259
al-Biruni, 105, 319n
'Blue Qurʾan', 98, *99*, 101
Bohemond, 299
bookbinding, leather, 76, *76*, 100, *100*, 180, *180*, 182, 263, *263*, 285, *286*, 286-7
Bougie (Bijaya), 189, 277, 278, 283
bricks, brickwork, 116, 146, *154*, 156, 157, 158, 159, 160, 161, 162, 183, 218, 231, 241, 250, 264
Buddhism, Buddhists, 11, 129, 291, 301
building materials, 156, 231, 241
Bukhara, 105, 130, 139, 140, 150, 156, 158, 160; Kalayan minaret, *151*, 152, 161; Magoki Attari mosque, 312n; Samanid mausoleum, *110*, 110-12, 113, 116, 146, 158
Buluggin ibn Ziri, 274
Burujird, mosque, 139
Busra, citadel, 230; *madrasa*, 225, *226*, 227; mosque, 29, 223, 231
Buyids, 11, 105, 106, 115, 116, 129, 130, 134, 141

Cairo, vii, 10, 133, 190-6, 206; al-Aqmar Mosque, *196*, 197, 199; al-Azhar Mosque, *191*, 192, 192-3, 194, 195; Bab al-Nasr, 199, *199*; citadel, 230, 231, 233; construction and decoration, 231; Dayr al-Banat, Coptic convent, 202; Fatimids in, 190-213 *passim*, 225, 274; Great Eastern Palace, 190; al-Hakim Mosque, *192-3*, 193-5, 200; Ibn Tulun Mosque, 87, 193, 194, 213; al-Juyushi Mosque, *196*, 197, *197*, 198, *198*, 199; libraries of Dar al-ʿIlm, 212; *madrasas*, 225; mausoleum of the Abbasids, 227, 231, 233; Mosque of the Elephants, 197; mosques, *191*, 192-7, 198, 199; Qarafa Mosque, 195; sack of Fatimid Treasures in, 291; al-Salih Talaʾi Mosque, 197; tomb of al-Shafiʾi, 227, *228*, 231; walls, 199, *199*; Western Palace, 190, 201, 203; *see also* Fustat
Cairo Geniza, 73, 208, 253, 281, 291, 319n
calligraphy/writing, viii, 6-7, 19, 63, 68, 73, 74, 75, 76, 78, 79, 92, 93, 97, 98, 120, 125, 128, 129, 162, 166, 181, 203, 212, 232, 251, 257, 264, 273, 282, 283, 285, 286, 293; cursive scripts, 76, 78; Kufic (angular) script, 292, 312n; Mustansiriyya, 264; New Style script, 285

Cappadocian art, 296
caravanserais, 37, 134, 153-4, 162, 222, 227, 231, 240-1, 264
Caspian Sea, 145, 165, 295
Caucasus, 125, 135, 139, 162, 178, 234
Central Asia, 8, 59, 79, 105, 134, 135, 139, 145, 146, 149, 152-3, 154, 157, 158, 159, 160, 178, 294, 302
Charlemagne, 301
China, Chinese, 135, 139, 154, 187, 212, 291, 294; ceramics, 70, 93, 118, 173, 294; glass, 122, 180, 302, 313n, 319n
Christians, Christian art, 3, 4, 7, 8, 11, 15, 17, 19, 21, 24, 83, 101, 107, 118, 133, 135, 187, 217, 222, 243, 248, 264, 265, 281, 288, 291-302
Cilicia, 222
cisterns, 55
citadels, 227, 230-1, 233, 264
cloisonné technique, 282, 282, 296
coins, 45, 130, 244, 295; Arab-Sasanian, 64, 64-5; maravedi dinars, 300
Constantinople, 7, 258, 296-7; Mouchroutas palace, 296
copper-alloy, 62-3, 63, 64, 66, 66-7, 97, 97-8, 98, 123, 124, 125, 166, 166-70, 167-70, 171, 172; animal and bird sculpture, 97, 97-8, 210, 210; aquamaniles, 168, 169, 170, 300, 301; Bobrinski bucket, 167, 168, 183; Pisa griffin, 210, 210, 320n; Wade cup, 166, 167
Coptic Christians, Coptic art, 3, 7, 8, 25, 202, 209, 291-3, 292, 308n, 318n
Cordoba, 31, 83, 96, 100, 101, 133, 272, 273, 277, 280; domes, 85-6, 86, 87, 93; fountain, 97; Qur'an manuscripts, 285, 286; Great Mosque, 82-6, 83-90, 89-90, 101, 193, 269; domes, 85-6, 86, 87, 93; maqsura, 82, 83, 84; mihrab, 84, 84, 85, 86, 89, 89, 90, 90, 93, 95; minbar, 280; San Esteban gate, 89; sculptured marble panels, 95; Villaviciosa Chapel, 84, 85, 87
Creswell, K.A.C., 24, 51, 57, 190, 199, 230
Crete, 282-3
Crusades, Crusaders, 187, 217, 222, 230, 254, 262-3, 264, 265, 299, 301
crypts, 148
Ctesiphon, 7
Cuenca, ivory work, 277
cuerda seca technique, 284

Damascus, 3, 10, 15, 20, 21, 91, 97, 134, 223, 227, 231, 248, 263, 309n; Adiliya, 225, 226, 228; citadel, 227; dar al-hadith, 225, 226, 231; Great Mosque, 21, 22, 22-6, 23-5, 28, 37, 60, 61, 74, 76, 94, 193, 218; Hanbalite mosque, 223; al-Khadra palace, 36; madrasas, 225, 226, 227; Maydaniya, 233; Mosque of Repentance, 223; Nur al-Din's hospital, 227, 229; palace of the Umayyads, 15; pottery, 250, 251
Damavend mausoleum, 146
Damghan, 140, 156, 160, 178; minaret, 151, 161; mosque, 106, 108, 116; tower tomb, 146, 146
Damietta, 209
dar al-hadith, 225, 226, 231
Darb Zubayda, 29
Dawud ibn Salama, 248
Daya-Khatun, 157; caravanserai, 154
Delhi, 164, 165; Qutb Minar ensemble, 164; manar of Qutb al-Din, 163, 164; mausoleum, 164; mosque, 162, 164
diatreta cups, 319n
Dihistan (Mashhad-i Misriyin) mosque, 145
dihqans, 115
Diocletian, 146
Dioskorides, 258; De materia medica, 259, 261
Divrik (Divrigi), 241; mosque and hospital, 233-4, 234-5, 239, 241-2

Diyar Mudar, 217
Diyar Rabi'a, 217
Diyarbakr, 217, 221; city walls, 222, 222, mosque, 218, 220
domes, 4, 46, 46, 85-7, 86, 93, 141, 142, 147, 157, 158-9, 182, 183, 193, 194, 195, 197, 198, 216, 218, 227, 231-2, 241, 272, 296; double, 158, 162
door fittings, copper-alloy, 244, 245, 283, 283
doors, wooden, decorated, 255, 255, 291-2, 292, 318n
Dunaysir (now Koçhisar), 134, 218, 219
Dura-Europos, 8; palace, 153

Edessa (now Urfa), 8, 218, 222; sanctuary of, 221
Egypt, 7, 10, 11, 21, 31, 33, 66, 67, 73, 79, 97, 109, 128, 133, 134, 135, 173, 187, 215, 221, 222, 225, 264; Ayyubid, 215, 217, 222, 264; Coptic Christians/art in, 291-3, 292, 318n; construction and decoration in, 231-3; Fatimid, 187, 190-213, 222, 223, 250, 251, 252, 264, 296-200, 274, 318n; glass, 206-9, 212, 319n; ivories, 203, 212; Mamluk, 232; mausoleums, 195, 195-6, 197-8, 227, 228, 233; metalwork, 210-11, 212; mosaics, 233; mosques, 21, 191, 192-7, 198, 199; pottery, 202, 203-6, 212, 250, 251, 252, 296-7, 318n; 1060-1171: 196-200; textiles, 72, 72, 209-10, 212; Tulunids, 11, 59, 66, 128, 194, 200; woodwork, 200-3, 212; see also Aswan; Cairo; Fustat
enamel, 252, 252-3, 253, 296, 297
epigraphy, 231, 232, 241
Erzerum, Cifte Minareli madrasa, 235, 236, 236
Eskisehir, Sayid Ghazi tomb, 239

al-Fadl, 99
Fahraj mosque, 107
al-Farabi, 105, 134
Fars province, 139
Fatima, 285
Fatimids, Fatimid art, viii, 85, 91, 96, 97, 101, 110, 133, 134, 135, 173, 174, 187-213, 215, 217, 222, 223, 225, 233, 250, 251, 252, 254, 264, 265, 274, 275, 278, 282, 291, 292, 295, 299, 301, 318n, 320n
al-Faw excavations, 3
Fayyum, 62, 73
Ferdosi, 172; Shahnama, 11, 105, 134, 172, 175
Fez, 83, 272; Mosque of the Andalusians: minbar, 94, 94-5, 280; Qarawiyyin Mosque, 269, 272, 273, 273, 280, 283, 283
figural art, Muslim opposition to, 6, 8, 19, 26
filigree work, 171, 282
fire-temples, 111, 293
floor coverings, 73, 73, 127, 127-8, 200
fortresses, 269
fountains, 97-8, 278, 278
Fustat, 10, 15, 21, 55, 67, 70, 72, 127, 127, 190, 190, 192, 205, 319n; Amr mosque, 31; Hebrew Bible from, 293, 295; mosque of Ibn Tulun, 30-1, 31, 32, 33, 36; Nilometer, 54, 55; wall painting from 198; see also Cairo

Gagik, 296
geometric decoration, geometry, 60, 61, 62, 63, 68, 75, 76, 79, 92, 94, 161, 167, 172, 181, 187, 199, 213, 232, 241, 242, 243, 251, 251, 255, 257, 264, 269, 272, 273, 280, 282, 285
Georgia, 8, 218, 264, 295, 296, 297
Ghassanids, 4-5
ghazi warriors, 234
Ghaznavids, 105, 123, 134, 153, 161, 163
Ghazni/Ghazna, 11, 116, 117, 134, 159, 162, 163; manar of Ma'sud, 150, 152, 152; palace, 153

Ghiyath al-Din, 150
Ghiyath al-Din Kaykhusraw, 252-3
Ghorids, 134, 161, 163, 164
glass, 71-2, 178, 206-9, 252-4, 302, 311n, 319n; cut glass, 200, 206-7; Egyptian Fatimid, 206-9, 212, 319n; enamelled and/or gilded, 252, 252-3, 253; Hedwig glass, 301, 301; Iranian, 121, 122-3, 130, 313n; lustre-painted, 71, 72, 208, 209, 252, 309n, 319n; marvering and combing technique, 253, 254; mould-blown, 71, 72, 208; muhkam, 301; relief-cut, 178, 206, 206-7, 207, 319n; rock crystal, 200, 206-7, 207, 212, 319n; trailed thread/thread decorated, 71, 71-2, 178, 178, 180, 208; Venetian, 253; wheel-cutting, 178, 207, 207, 208
Godard, A., 109, 145, 158
gold, 65, 166, 171, 171, 200, 209, 210-11, 211, 248, 258, 282, 283-4, 283; Spanish diadem, 96-7, 97
Gospel books/codices, Coptic, 292, 292
Granada, 275, 277, 281; Alhambra, 275; Patio de los Leones, 278, 278
granulation, 171, 282
Gulpaygan mosque, 109, 139
Gunbad-i Qabus, tower mausoleum, 113, 113, 115, 116, 146
Gurgan, 62, 62, 67, 281

habb, 249, 249, 257
hadith, 5, 10, 15
al-Hakam II, 83, 84, 85, 89, 90, 93, 95, 100, 280
al-Hakim, 200, 203
Hama, 20, 322n; Great Mosque, 21, 254
al-Hamadhani, 259
al-Hamdani, Antiquities of South Arabia, 4
Hammad ibn Buluggin, 275
Hammadids, 275-6, 278, 283
al-Hanafi, 216
haram, 4
al-Hariri, 134; Maqamat of, 259, 260, 261, 262, 292
al-Harith ibn Hammam, 259
Harran, 217, 218, 221, 222
Harun al-Rashid, 10, 53, 301
Hasan al-Qashani, 173
Hatra, 8
Hauran, 231
Hazara, mosque, 107, 108, 109
Herat, 11, 105, 130, 140, 167, 170, 183
Heron of Alexandria, 258
Herzfeld, Ernst, 51, 57, 59, 79, 145, 218
hijra, ix, 3, 7, 64, 73
al-Hirah, 4, 62, 67
Hisham, 10, 37, 84
Hisham II, 95, 97
Hisn Kayfa (now Hasankeyf), 217
hospitals, 227, 229, 234, 239-40
Husayn, 215
hypostyle mosques see mosques

Iberian peninsula see Spain
Ibn al-Ahnaf, 258
Ibn al-'Arabi, 288
Ibn Bakhtishu, 258, 261-2
Ibn Fadlan, 302
Ibn Hawkal, 73
Ibn al-Haytham, 288
Ibn Hazm, 288
Ibn Jubayr, 215
Ibn Khaldun, 274, 282, 285
Ibn Muqla, Abu 'Ali Muhammad, 76, 79
Ibn al-Nadim, 73; The Fihrist, 73
Ibn Rushd, 288
Ibn Tulun, Ahmad, 31, 33, 55, 57
Ibn Tumart, 282

Ibn Ziri, Buluggin, 94
Ibn Zubayr, 211, 212
Ibrahim ibn Mawaliya, 247
Ibrahim of Bhadresvar, 165
al-Idrisi, 243
Idrisids, 83
Ifriqiya, 11, 55, 56, 79, 83, 85, 91, 92, 94, 95, 96,
 97-8, 101, 187, 189, 210, 212, 213, 269, 274,
 275, 278, 286, 318n; ceramics, 93, *93*, 204;
 Fatimids in, 187-8, 203, 275; fountains, 98;
 minbar, *94*, 94-5; Zirids in, 274, 275; *see also*
 Qal'at Beni-Hammad; Qayrawan
Ikhshidids, 11
illuminations/illustrations, manuscript/book,
 viii, *74*, *75-6*, 77, 98, 99, 129, 181-2, *182*,
 212, *212*, *257*, 257-63; *287*, 287-8; Christian,
 292, *292*, 293, *293-4*; Hebrew, 293; *see also*
 manuscripts
'Imad al-Din Zangi, 252
imam, 5, 24, 56
Imam Dawr (or Dur) mausoleum, 216, *216-17*
incense burners, 167, 293
India, 8, 105, 135, 139, 154, 163-5, 187, 200, 265,
 301
inlaying, 67, 167, 168, 170, 171, 183, 212, *245-6*,
 247, *247*, 248, *248*, 264
Innsbruck plate, 296, *297*
Iplikçi Mosque, 235
iqta, 133
Iran (Persia), 7, 8, 15, 20, 21, 22, 56, 70, 87, 105-
 30, 133, 134, 135, 139, 162, 165, 217, 225,
 233, 242; ceramics, 116-21, 130, 160, 171-8,
 183, 252, 284, 316n; construction, 154, 156,
 157, 158; glass, *121*, 122-3, 130; manuscripts,
 128-9, 259, 262; mausoleums, 110-15, 116,
 145-50, 221, 315n; metalwork, 123-5, 130,
 166-71, 247, 294; mosques, 105-10, 139-45,
 218; secular buildings, 115-16, 227; stucco
 decoration, 128, 171, *171*; textiles, 165-6,
 209, 243, 244; towers and minarets, 150-2
Iraq, vii, 4, 10, 11, 15, 20-1, 22, 24, 30-1, 36, 41,
 42, 52, 66, 69, 70, 78, 79, 93, 105, 110, 117,
 128, 133, 144, 187, 203, 213, 217, 231, 233,
 248, 249, 256, 257, 264, 319n; Abbasids in,
 30, 51, 78, 79, 125, 128, 130, 135, 215-17;
 palaces, 194; textiles, 64, 243; *see also*
 Baghdad; Basra, Samarra
Isfahan, vii, 78, 105, 128, 134, 150, 281; Great
 Mosque (Masjid-i Jomeh), 105, *105*, 109,
 138-9, 140-3, *140-3*, 145, 154, 156, 157-8,
 163; court, 140, 141, *140-1*; domes, 141, *142*,
 157, 158-9, 160, 182; gate, 141, 143, *143*;
 Jurjir Mosque, 115-16, *116*, 128
Isfarayin, 170
Ismail ibn Ward, 247
Ismail the Samanid, tomb of, 110
ivories, *95*, 95-6, *96*, 101, 170, *202*, 203, 211, 212,
 276, 277, 278, 299, *300*, 301, 308n
iwans, 52, 54, 56, 109, 140-1, 143, 144, 145, 149,
 153, 154, 157, 160, 162, 183, 190, 215, 227,
 236, 239
iwan-tomb, 239

Jabal Says, palace, 40
Jacobite Christians, 217
Jahiz, 79
Jalal al-Din Rumi, 134, 255; *Masnavi* of, 257-8,
 258
Jam, 159, 160, 164; *manar* of Ghiyath al-Din,
 150, 152, *152*, 161, 162, 163
Jarash, 67
al-Jazari, 258
Jazira, 133, 170, 187, 199, 215, 217-22, 239, 242,
 244, 250, 256, 257, 264; architecture, 217-22;
 book illustrations, 257, 258, 262, 264;
 Christian art in, 293, *294*; metalwork, 244,
 245, 246, *246*, 247-9, 260, 264; mosques,

217-18, *218-20*, 221; pottery, 249, 257, 262;
 sanctuaries and mausoleums, 221
Jazira ibn Umar (now Cizre), 217, 222; Ulu
 Cami, 246
Jerusalem, vii, 3, 20, 21, 24, 36, 133, 134, 190,
 213; al-Aqsa mosque, 26, 28, 57, 61, *61*, 71,
 92, *194*, 195, 233, *254*, 275, 306n; citadel,
 227, 230; Dome of the Rock, 3, *14*, 15-20,
 16-18, 24, 25, 26, 35, 50, *60*, 60-1, 62, 63,
 65, 67, 74, 79, 308n; *Haram al-Sharif*, 16,
 233; Jewish Temple, 20; *madrasas*, 225;
 mosaics, 233; mosques, 22, 28, 223
jewellery, 129, 200, 204, 311n; gold and silver, 65,
 96, 125, 166, 171, *171*, *282*, 282-3
Jewish community/art, 83, 291, 293, *295*
Jibal province, 139
Jibla, mosque of Arwa bint Ahmad, *224*, 225
jihad, 254, 255
Jordan, 4, 20, 36, 39
al-Jurjani, 105

Kalila wa-Dimna, 259, *259*, 261, 262
Karaman, *imaret*, 255
Kashan, ceramics, 173, 174, 177-8, 254, 262
kashi see tiles
Kayqubad ibn Kaykhusraw, 344
Kayseri, 241; Gevher Nesibe Hatun hospital,
 239; Khuand Khatun complex (mosque,
 madrasa, tomb), *232*, 234, 235; Sahibiya
 madrasa, 235; Saraj al-Din *madrasa*, 235
Kerbela, 215, 216; canopy tomb, 110
Kerman, mosque, 139
Khabur, 257
khangah, 150, 227
khan, 134, 241, 264
Khargird *madrasa*, 141
Kharput mosque, 218
Kharraqan, 158, 159, 160; mausoleum, 5, 146,
 147-8, 163
khatib, 31, 197
al-Khawarnaq palace, 4
Khirbat al-Mafjar, *39*, 40-1, *41*, *42*, 42-3, *43*, 45,
 46, 46-7, *47*, 49, 49-50, 51, 65, 67, 74, 90
Khirbat al-Minya, 40, 41, 42, 50
Khirbat al-Tannur, 49
Khiva, 140
Khorezm, 159
Khorsabad, 70
Khumarawayh ibn Ahmad ibn Tulun, 56, 59
Khurasan, 10, 11, 79, 105, 117, 119, 122, 127,
 129, 130, 165, 167, 170
al-Khurasani, 96
Khusrau II, 64
Khusrawgird tower, 152
khutba, 5, 193
Khwarezmshahs, 135
Kievan Rus, 133
kitab al-Aghani, 261, 262
Konya, 134, 240, 241, 247, 255, 257, 322n; Ala
 al-Din Mosque, *232*, 234, 241; carpets, 127;
 Ince Minareli *madrasa*, 236, *237-9*, 241;
 Karatay *madrasa*, 236, *237*, 241, 263; manu-
 script illumination, 258, *258*; pottery and
 tiles, 250, *251*, 252, *252*; Qilich Arslan
 palace, 252; Sircali *madrasa*, 235, 241, 252,
 252, 316n; stone relief from citadel, *256*, 257
Kubadabad palace, 240, *251*, 252, 253; stucco
 cupboard from, *256*, 256-7
Kufa, 10, 11, 15, 40, 41, 79, 215, 216; *dar al-
 imara*, 36; mosque, 20, *20*, 36, 305n
Kurds, 134, 135, 217, 244

lahwa, 41
Lakhmids, 4, 5
lamps, 62, *246*, 246-7, 253, 323n
Lashkari Bazar, 116, 117, 140, 153, 159, 160;
 arch, *159*; palace, 153, *153*

Le Puy Cathedral façade, 300
leather, leatherwork, 180, *180*, 286; *see also* book-
 binding
Lectionary of the Gospels, 293, *294*
linen, *72*, 72-3, 209, *209*
Luxor, St Anthony's chapel: painted ceiling, 292

madhhab, 10
Madina, 3, 5-6, 10, 15, 20, 24, 63, 73; House of
 the Prophet, 3, *5*, 5-6, 7, 20, 21, 24, 28;
 mosque, 21, 22, 24
Madinat al-Zahra, *88*, 89-90, 96, 97, 100, 189,
 277, 311n, 318n; fountain, 97; marble door-
 jamb from Hall of 'Abd al-Rahman, *91*, 91-2
Madinat Siqilliyya (Palermo), 99, 100, *100*
madrasa, 134-5, 145, 150, 215, 221, 225-7, *225-6*,
 231, 315n; Anatolian, 234, 235-9, 241
Maghrib, 70, 91, 97, 99, 203, 206, 210, 269, 274,
 275, 277, 280, 282, 283, 284, 286, 287-8,
 325n; *see also* Algeria; Ifriqiya; Morocco;
 North Africa; Spain
Mahdiyya, 92, 302; mosque, *186*, 187-8, *188*,
 193; palace, 187, *187*
Mahmud of Ghazna, 11, 134, 163
majlis (hall), 52
Malaga, 281, 284, 285
Malatya mosque, 218
al-Malik al-Nasir II Salah al-Din Yusuf, 252
al-Malik al-Salih Ayyub, 248
al-Malik al-Salih 'Imad al-Din Isma'il, 322n
Mamluks, Mamluk art, 16, 135, 201, 232, 252
al-Ma'mun, 19
Manafi al-Hayawan, 261-2
manar, 152, *152*, 163, 164; *see also* minaret
al-Mansur, 10, 51, 52, *52*, 62
al-Mansur, vizier, 84, *85*, 95
manuscripts/books, 'author portraits', 260, 261;
 Bayad wa-Riyad, 287, 287-8; Beatus, 300,
 302; *belles-lettres*, 258, 259-60, 261; Biblia
 Hispalense, 300; 'carpet pages', 182, *182*,
 257, *257*; Christian art, 293, *294*; 'Early
 Abbasid', 99, *99*; frontispiece, 75-6, 260,
 261, *261*, 262, 264; al-Hariri's *Maqamat*,
 259, *260*, 261, 262; *hijazi*, 73-4; Hebrew,
 293; *Kalila wa-Dimna*, 259, *259*, 261, 262;
 Masnavi of Jalal al-Din Rumi, 257-8, *258*;
 'New Style', 99-100, 129, 181, 285; philo-
 sophical treatises, 258, 261; princely fron-
 tispiece, 262; Qur'anic, 73-8, *73-5*, 77, 98-
 100, *98-100*, *128*, 128-9, *180*, 181, *181*, 183,
 212, *257*, 257-8, 285-7, *286*, 291; al-Sufi's
 treatise on fixed stars, 129, *129*; technical
 and scientific texts, 258-9, 260, 261; *warka
 wa-Gulshah*, 262-3; *see also* bookbinding;
 calligraphy; illuminations
Manzikert, battle of, 134, 233
maqamat, 134, 259-60, *260*, 261, 262, 264
al-Maqqari, 100, 243
al-Maqrizi, 190, 193, 318n
maqsura, 21, 31, *82*, 83, 84, 141, 189, 254, 274,
 274
Mar Banham church, 293, *293*
Mar Mattai Monastery, 293
Maragha, Gunbad-i Qabud mausoleum, 148,
 150, 160; 'red' mausoleum, 148
maravedi dinars, 300
Mardin, 217; mosque, 218
Marib dam, 4
marquetry, *65*, 65-6, *202*, 202-3, 212, 280
Marrakesh, 285, 286; Almohad gate, 269, 280;
 Badi Palace, *284*; Kutubiyya mosque, 269, 273,
 279, 280, 281, 283; minaret, 273; *minbar*,
 279, 280, 285; Mosque of the Kasbah, 280;
 Qubbat al-Barudiyin, 269, *271*, 272
martyria, 17, 112, 145, 198
marvering and combing technique, 253, *254*
Marwan II, 62, 63, 64

Marwan ewer, 62-3, *63*, 98
mashhad, 158, 197, *198*, 200, 221, *221*, 227
masjid see mosques
mausoleums, 56, 162, 163, 164, 215, 299;
 Anatolian, 236, 239; canopy, 110-13, 146,
 148, 149, 196; Egyptian, *195*, 195-6, 197-8,
 227, *228*, 233; Indian, 165; Iranian, 110-15,
 116, 145-50, *151*, 315n; Iraqi, 216; Jazira,
 221; *pishtaq*, 149; tower, 113, 115, 146, *146*,
 148, 149
maydan, 55, 152
Mayyafariqin (now Silvan), 217; mosque, 218,
 234
Mecca, 3, 4, 15, 73, 190; a'ba, *2*, 3, 20, 26, 269,
 304n; *qibla*, 5; pilgrimage to, 5
Mehne mausoleum, 149
Merida aqueduct, 89
Merv, 10, 11, 105, 116, 130, 134, 140, 145, 158,
 160, 170, 313n; central walled city, 152;
 citadel, 152; governor's palace, 152-3;
 mosque-mausoleum of Sanjar, *146*, *148*, 149,
 157, 163; suburb, 152
Mesopotamia, 3, 134, 139, 152, 187, 199,
 204,209, 213, 231, 233, 275; *see also* Jazira
metalwork, 62-3, *63*, 64, *66*, 66-7, *122-4*, 123-5,
 130, 166-71, 172, 183, 210-11, *210-11*, 212,
 244-9, 264, 282-3, 294, 296, *297*, 308n; cast-
 ing, 171, 244; chasing, 167, 171, 212; decora-
 tion, 96-7, 167-71; inlaying, 67, 167, 168,
 170, 183, 212, *245-6*, 247, *247*, 248, *248*,
 264, 320n; repoussé technique, 96, 167, 171,
 247; *see also copper-alloy; gold; silver*
Midrasids, 227
mihrab, 4, 6, 23, 24-5, 26, 28, 29,30, 31, 33, 35,
 57, 69, 90, 107, 109, 141, *158*, 160, 161, 177,
 183, 188, 192, 193, 194, 199, 218, *219*, 221,
 221, 227, *231*, 232, 233, 235, *252*, 254, 257,
 269, 273, 305n; Cordoba Great Mosque, 84,
 84, 85, *86*, 89, 90; Qayrawan Great Mosque,
 70, 71, 98
mina'i ware, 175, 252
minarets, 21-2, 28, 30, *32*, 150, *151*, 152, *152*,
 161, 162, 163, 193, 216, *216*, 218, *218*, 225,
 235, 236, 269, *270*, 273, 305n
mirrors, *245, 246*
'mirrors for princes', 259
Monastir *ribat*, 56, *57*
Mongols, Mongol invasions, 10, 115, 133, 135,
 145, 163, 170, 182, 215, 217, 222, 233, 243,
 252, 261, 296, 322n
Morocco, 83, 91, 94, 101, 134, 190, 277, 288;
 architecture, 269, 273
mosaics, 24, 25-6, 42, *42*, 50, 90, 187, 195, 233;
 Anatolian, 241, 252, *252*; al-Aqsa Mosque,
 Jerusalem, *194*, 233; Damascus Great
 Mosque, 24, *25*, 25-6; Dome of the Rock,
 Jerusalem, 16, *17*, 19, 26; Khirbat al-Mafjar,
 42, 42-3; polychrome faience, 172, 316n
mosque, 3, 4, 5, 20-36, 53, 160, 291; Anatolian,
 234-5; congregational (al-masjid al-jami),
 20-2, 29, 52, 107, 109, 145, 150, 192, 196,
 197, 217, 218, *219*, 223, 234, *269*, *270*, *273*,
 275; court façade, 107; Eastern Islamic
 lands, 105-10, 139-45; Egyptian, *191*, 192-7,
 198, 199; hypostyle, 21, 24, 28, 29, 30, 31,
 33, 36, 85, 89, 106, 107, 109, 140, 141, 143,
 164, 188, 192, 193-4, 218, 223, 234, 269,
 274; Indian, *162*, 164, 165; Iranian, 105-10,
 139-45, 218; Jazira, 217-18, *218-20*, 221;
 9th-century, 30-6; North African, 187-8,
 189, 269, *279*, 280; 7th- and 8th-century, 20-
 9; Spanish, 83-9, 269, *270*; Syrian, 21, 22-6,
 29, 223-5; Western Islamic lands, 83-91, 269
Mosul, 217, 221, 244, 293; Great Mosque,
 minaret, 217-18, *218*; *habb*, 249, *249*;
 Mashhad of Awn al-Din, 221, *221*; metal-
 work, 247-9, 264; *mihrab* from, *221*; Qara

Saray, 222; textiles, 243
Mount Sinai Gospel book, 292
Mozarabic art, 299-300
Mshatta, 40, *40*, 41, 51, 57, 67, 94, 153, 187, 189,
 308n; carved stone triangles, 50, *50*, 51, 65
Mu'awiyah, 10
al-Mughira, 95
Muhammad the Prophet, 3, 4, 5-6, 10, 15, 21;
 death of (632), 10, 73; House of, 3, *5*, 5-6, 7,
 20, 21, 24, 28; Night Journey to *Masjid al-
 Aqsa*, 15
Muhammad I, 100
Muhammad, Ghorid sultan, 164
Muhammad ibn Ahmad ibn Yasin, 128
Muhammad ibn Makki al-Zanjani, 146
al-Muhtadi, 59
al-Mu'izz, 96, 187, 213
al-Mu'izz al-Dawlah, 11
Mukhlis ibn 'Abd Allah al-Hindi, 258
muluk al-tawa'if (Taifa kings), 133, 277, 278, 282,
 324-5n
al-Muqaddasi, 26, 190
muqarnas, *114*, 115, 116, 130, 157, 158, 160, 162,
 189, 198, 199, 200, 213, 216-17, 218, 231,
 241, 269, 272, *272*, 273, 296, 299; half- 218,
 241; squinch, 157, 183, *198*, 218, 231, 233
Murcia, 281, 285; *castellejo* of, 269
Muslim ibn al-Dahhan, 203
al-Musta'li, 209
al-Mustansir, 187, 200, 201, 212, 215
Mustansiriyya, 264
al-Mu'tasim, 54, 261
al-Mutawakkil, 10, 30
al-Mutazz, 59
al-Muti', 209

Nabateans, 4
Najaf, 215, 216; canopy tomb, 110
Nakhichevan mausoleum, 148, 160
al-Nasir, 215, 217
Nasir-i Khosrow, 190, 209, 213
naskh, 78, 172, 176, 178
Nasr, Samanid prince, 110
Nasr ibn Ahmad, 130
Las Navas de Tolosa, 135
Nayin mosque, 107, *107*, 115, 116, 128, 160
Nestorian Christians, 130, 217
niello decoration/inlay, 96, *122*, *124*, 125, 166,
 171, 210, *211*, *276*, 277, 295
Niksar, Haci Cikinik tomb, 239
Niriz mosque, 109, *109*
Nishapur, 11, 105, 115, 116, 130, 170; ceramics,
 116-17, *118*, *119*, 125; glass, *121*, 122, 313n,
 319n; *muqarnas*, *114*, 115, 198; silver amulet
 case, 125; stucco wall panels, *114*, 115, *115*,
 116, *127*, 128, 256
Nisibin, 257
Nizam al-Mulk,134, 141, 145, 215
Nizami, 134, 172
North Africa, 7, 11, 22, 31, 33, 56, 100, 101, 133,
 135, 187, 194, 195, 269-88 *passim*; architec-
 ture, 187-90, 268, 269-74; Fatimids in, 187-
 90, 274; Zirids in, 274; *see also* Algeria;
 Ifriqiya; Morocco
Nur al-Din, 217, 218, 225, *226*, 227, 231
Nur al-Din Mahmud, 254, 255, 264

Omar Khayyam, 134, 159
opus sectile technique, 75
Ottoman Empire *see* Turkey

Palermo, Cappella Palatina, 190, 273, *298*, 299,
 320n; Cuba place, 297; S. Giovanni de
 Eremeti, 299; Ziza palace, 297, 299
Palestine, 10, 11, 19, 20, 26, 36, 42, 43, 54, 55,
 62, 79, 133, 135, 187, 213, 215, 222, 264,

301; *see also* Jerusalem
Palmyra, 4, 8, 49; temple of Bel, relief, 4, *4*
Panchatantra, 259
Panjikent, 59; Soghdian frescoes 112
paper, 74, 78, *128*, 128-9, 285; *see also* manu-
 scripts
Parthians, 68
Pazyryk (Siberia), 127
Persepolis, 130
Persia *see* Iran
Persian language, 105, 134, 162, 183, 265, 296
Persian literature/poetry, 105, 134, 183
Pisa, San Sisto Church: *bacino*, *202*, 203
Pisa griffin, 210, *210*, 302, 320n
pishtaq, 149, 150
Portugal, 91
'post-Sasanian art', 59, 294, 308n
pottery/ceramics, 116-21, 171-8, *172-8*, 183,
 249-52, 283-5, 302, 316-16n; Abbasid, 62,
 67, 67-70, 72; Alhambra vases, 284; architec-
 tural decoration, 160, 171-2, 178, 251-2, *275*,
 275-7, *276*, 284, *284*, 286, 296, 309n, 311n,
 325n; *champlevé*, *204*, 204-5, 207, 319n;
 composite or stone-paste, 173; *cuerda seca*
 ware, 284; Egyptian, *202*, 203-6, 212, 213,
 250, 251, 252, 296-7, 318n; *habb*, 249, *249*,
 257; incised and/or carved, 173, *173*, *205*,
 205-6, 252; Iranian, 116-21, 130, 160, 171-8,
 183, 252, 262, 284, 316n; Kashan-style, 173,
 174, 177-8, 254, 262; *Kerbschnitt*, *67*, 67-8;
 lakabi, 206; large-scale miniature style, 175,
 175; lustre-painted, *68*-9, 69-70, *70*, *71*, 72,
 117, *117*, 172, 173, 174, *174-5*, 177, *177*,
 178, *178*, *179*, 183, *202*, 203-4, *204*, 211, 212,
 213, 249, 250, *250*, 251, *251*, 252, 258, *275*,
 275-6, 283-4, *284*, 285, *292*, 292-3, 299,
 309n, 318n, 322n, 323n; *minai* ware, 175,
 252; miniature style, 174-5; monumental
 style, 174; moulded and/or stamped green-
 glazed, 285, *285*; 'Muharram' bowls, 175,
 175; North African, 189, *275*, 275-6, *276*;
 opaque white-glazed, *68*, 68-70, 117, 205;
 silhouette ware, *173*, 173-4, 176; *sgraffito*
 ware, 251, 285, 296, 323n; Spanish, *92*, 92-3,
 93, 277, 283-5, 325n; splash-decorated, *205*,
 205, 296, 323n; Syrian, 204, 205-6, 249, 250,
 252, 258, 296, 323n; Tell Minis ware, 204,
 205-6, 250-1, 252, 322n; Umayyad, 62, *62*,
 64, 67, 92; underglaze painted, *173*, 176-7,
 177, 251, *251*, 252, 262, 323n; unglazed
 household vessels,62, *62*, 249; *see also* tiles
Preslav, Bulgaria, 296
Pseudo-Aristotle, 258
Pseudo-Galen, 258, 261, 262
Ptolemy, *Almagest*, 130
pyxis, ivory, *63*, 63-4, *95*, 95-6

Qabiha, 59
Qabus ibn Vashmgir, 113
Qa'id Abu Mansur Bukhtakin, 127
Qal'a Jabar, 222
Qal'a Najm, 222
Qal'at Beni Hammad (or Qal'a of the Beni
 Hammad), *189*, 189-90, 275-7, 283
Qasim ibn 'Ali, 248
Qasr al-Hayr East, 28, *36*-7, 37, 39, 41
Qasr al-Hayr West, 40, 42, 43, *43*, *44*, 45, 47,50,
 51, 61, *61*, 71, 74, 90, 92, 189
Qasr al-Milh, 63
Qasr Hallabat mosque, 28
Qasr Kharana, *38*, 39-40
Qayrawan, 10, 57, 89, 90, 95, 98, 188; Qur'an
 production, 285, *286*; Great Mosque, 21, 33,
 33-5, 35-6, 57, *68*, 69, 70, 71, 98, 106, 193,
 274-5; glazed and lustre-painted tiles, *68*, 69,
 69, 70, 71; library, 98-9, *99*, 100; mihrab, *70*,
 71; minbar, *93*, 94, 98, 280; qibla wall, 57;

wood beams with painted decoration, 274-5, *275*; wood *maqsura*, *274*, 274-5, 278
Qazvin, 157, 162, 163; mosque, 139
qibla, 22, 23, 24, 25, 30, 35, 57, 84, 107, 109, 115, 140, 141, 143, 158, 164, 188, 194, 197, 215, 218, 232, 235, 269
Qum, 105, 178
Qur'an, viii, 5, 6-7, 10, 15, 19, 26, 89; Amajur, 312n; 'Blue Qur'an', 98, *99*, 101; Ibn al-Bawwab, 76, 78, 128; Isfahan, 128, *128*, 129; manuscripts, 73-8, *98-100*, *128*, 128-9, *180*, 181, *181*, 183, *212*, 257, 257-8, 285-7, *286*, 291; Qarmatian, 258, *258*; Qutb al-Din, 257
Qur'an stand, 255, *255*
Qurva mosque, 139, 140
Qusayr Amra, 37, 40, *41*, 41-2, 43, *44*, 45, 46, 47, 50; astronomical ceiling, 46, *46*; bath paintings, 48-9, *48-9*, 65; painting of the Six Kings, 45, *45*

rabad, 152
Rabat, minaret, 273; mosque, *268*, 269; Oudaia Gate, 269, *271*
Raja' ibn Hayweh, 20
Ramla, cisterns, 55; mosaic floor, 26
Raqqa,28, 36, 52-3, 58, 62, 217; Baghdad Gate, 222, *223*; minaret, 218
Rasa'il Ikhwan al-Safa', 261
Al-Rashidun, 10
Ravenna, 20, 24
Rayy, 105, 115, 129, 162; mosque, 139; tomb tower, 146
al-Razi, 105
repoussé technique, 96, 167, 171, 247
ribat, 56, 150
Ribat Sharaf, 154, *154*, 156, 157, 160
Ribat-i Malik, *153*, 154
rock crystal, 200, 206-7, *207*, 212, 319n
Roger of Sicily, 190, 297, 299, 320n
rugs and carpets *see* floor coverings
Rujm al-Kursi, 62
Rukn al-Dawla Abu SulaymanDawud, 296
Rusafa, 4, 10, 40, 293, *295*

Sabra al-Mansuriyya, 203, 204, 212, 274, 318n; throne room, 288, *288*
Sadaqa ibn Yusuf, 278
Sadir palace, 4
Saffarids, 11, 105
Saint-Josse, textile, *126*, 126-7, 301
Saladin (Salah al-Din), 187, 201, 222, 225, 227, 230, 233, 255
salat, 5
Saljuqs, 105, 109, 133, 134, 135, 143, 145, 160, 162, 165, 215, 222, 227; Anatolian, 215, 233-43, 244, 250-7 *passim*, 264; Great, 134, 140, 145
Samanids,11, 105, 110-12, 115, 116, 117, 130, 133, 134, 146, 256
Samarqand, 10, 105, 115, 130; Afrasiyab, 115, 116, 130; ceramics, 116, 117, 119, 120, 125
Samarra, 15, 21, 30-1, 33, 36, *54*, 54-6, 67, 70, 79, 89, 90, 96, 97, 120, 129, 189, 194, 204, 211, 256, 274; al-Ashir palace, 87; Balkuwara palace, 55, 56; fresco paintings, 59, *59*; Great Mosque, *27*-8, 30, 36, 194; Imam Dur mausoleum, 216, *216*-17; Istabulat palace, 55; Jawsaq al-Khaqani palace and Bab al-Amma' gate, *55*, 55-6, 59, *59*; Mosque of Abu Dulaf, *29*, 30-1, 33, 36; Mosque of Ibn Tulun, 57, 58; Qubba al-Sulaybiya, 56, *56*; stucco decorations (Styles A, B and C), 57-9, *57-8*, 66, 90, 94, 115, 128, 161, 200, 207, 254; tiles, 69-70, 72
San'a, Great Mosque, *29*, 74, 225
Sangbast, mausoleum/tombs, 146, *156*, 157, *157*
Sanjar, 134, 146

Sanjar Shah, 252
Sarakhs, mausoleum, 149, *150*
Sarha mosque, *223*, 225
Sarvistan, Zoroastrian fire-temple, 293
Sasanian empire/art, 7, 8, 10, 15, 19, 20, 43, 45, 51, 52, 54, 59, 60, 63, 64, 65, 66, 68, 74, 87, 95, 112, 118, 123, 124, 125, 126, 127, 130, 156, 165, 170, 243, 244, 262, 278, 293-4, 304n, 308n
Sayyidah Ruqqayah (*mashhad*), 197
Sedrata, 101, 324n
Seljuqs *see* Saljuqs
Semnan tower, 152
Serçe Limani shipwreck, 205, 207, 208, 209
Seville, 83, 277, 281; minaret, 269, *270*, 273; mosques, 283, *283*, 269; Mudejar architecture, 300
shahristan, 152
Shams al-Din Iltutmish, 164
Shanqa mosque, 29
shariah, 10, 11
Shi'ites, 10, 11, 56, 79, 105, 133, 134, 145, 187, 195, 200, 213, 215, 216
Shiraz, 105; mosque, 107, 139
shubbak, 190
Shuja' ibn Man'a, 247
Sicily, 11, 91, 135, 212; Muslim, 83, 99, 100, 101; Norman,viii, 133, 187, 189, 190, 291, 297-9
sidilla, 190
silk, silk production, 72, *72*, *164-5*, 165-6, 209, *209*, 212, 243, 244, *244*, *280-1*, 281-2, *282*, 299, *299*, 313n
silver, 65, 96, *96*, *122-4*, 123-5, 166, *166*, *170*, 170-1, 200, 210, *211*, 246, *246*, 247, *247*, *248*, *276*, 277-8, 293-4, *295*, 308n
Sin, 158
Sinjar, 217, 249, 257; al-Khan caravanserai, 222, *223*
Siraf mosque, 28, 105, 106, 116
Sistan province, 123
Sivas, castle mosque, 235, 242, *242*; façades, 241-2, *242*; Gök *madrasa*, 235; Izzedin Keykavus hospital, 240
Soghdian art/culture, 8, 105, 112, 126, 130, 293, 294
Solomon, Prophet-King, 41, 52, 130
Solomon, metal worker, 300
Spain, 7, 11, 22, 91, 109, 133, 134, 135, 200, 203, 269-88 *passim*; architecture and architectural decoration, 83-91, 269-74, 277; art of the object, 91-8, 277-85; ceramics, 90, 92-3, 277, 283-5, 325n; Christian art in, 299-300; metalwork, 97, 97-8, 125; ivories, 95-6, 101, 204, 277; mosques, 83-9, 269, *270*; Mozarabic art, 299-300; Mudejar art,300; *reconquista* in, 134, 299, 300; *taifa* period, 92, 277, 311n; textiles, 97, 101, 209, 281-2; Umayyads in, 83-101 *passim*, 133, 274, 277; window grilles, 92; *see also* Cordoba; Granada; Madinat al-Zahra; Seville,Toledo
squinch, 85, 157, *157*, 183, 195, 198, 218,241, 272
squinch-net, 157
stone carving, 43, 50, 90, 92, 199, 231, 241, *256*, 257, 264, 278, *278*, 296, *296-7*
stucco decorations / sculpture, 43, 57-9, 61, 66, 90, 92, 94, 101, *107*, 113, *114*, 115, *115*, 116, 128, 156, 160, *161*, 161-2, 171, *171*, 192, 193, 194, 195, 199, 213, 216, 222, *256*, 256-7, *273*, 275, *290*, 291, 308n,324n
al-Sufi, ʿAbd al-Rahman, 258, 261; *Book of the Fixed Stars*, 129, *129*, 171
Sufism,11, 133, 135, 145, 227, 234
Sulayman 62, 66
Sultan Han, *240*, 241, *241*, 242, *243*
Sunnism,Sunnis, 10, 11, 133, 134, 145, 187, 212, 215, 217, 225, 233, 248, 264, 269

Susa, 83
Sus (Sousse), 67; mosque, 105; *ribat*, 56
Syria, 4, 7, 8, 10, 11, 19, 20, 21, 22, 24, 36, 41, 43, 52, 53, 54, 58, 78, 79, 85, 92, 95, 101, 130, 133, 134, 135, 145, 170, 173, 178, 187, 196, 206, 211, 213, 215, 217, 218, 221, 222, 234, 242, 249, 264, 265, 301; architecture, 223-33, 264; Christian art, 293; construction and decoration, 231-3, 241; Fatimid, 187, 204, 205-6, 222; glass, 206, 209, 252, 253; *madrasas*, 225-7, 235; mausoleums, 227; metalwork, 248, *248*; mosques, 21, 22-6,29, 223-5; manuscript illumination, 258; pottery, 204, 205-6, 249, 250, 252, 258, 296, 323n; Tell Minis ware, 204, 205-6, 250-1, 252, 322n; textiles, 243; Umayyad, 10, 15, 65, 78, 79; woodwork,254, 255; Zangid and Ayyubid, 223-33, 248, 250; *see also* Damascus

al-Tabari, 305n
Tadzhikistan, 116, 129
Tahirids, 11, 105
Taj al-Mulk, 143
Takrit, 249
Talas, battle of, 10
Tanukhi, 79
Taq-i Bustan, rock reliefs, 64; textiles, 126
Tashkent, 130; school of,159
Tell Minis ware, 204, 205-6, 250-1, 252, 322n
Tercan, Mama Hatun mausoleum, 239
textiles,20, 72, 72-3, 95, 97, 101, 125-8, *126*, 165-6, 243, 281-2, 294, 295, 308n; brocaded lampas technique, 281; cotton, 165; Egyptian, 209-10, 212; Iranian, 165-6, 209, 243, 244; linen, 72, 72-3, 209, *209*, qasab, 209; Norman Sicilian, 299, *299*; reed mat, 73, *73*; Spanish, 97, 101, 209, 281-2; *tiraz*, 64, 73, 97, 166, 171, 209-10, 282, 299, 308n; woollen, *63*, 64, *72*, 72-3, 165; *see also* silk
thulth, 78
Tiberias, 73, 320n
Tiflis, 296, 323n
tiles, ceramic, 57, *68*, *69*, 69-70, 72, 93, *93*, 160, 172, *177*, 177-8, 212, 251-2, *252*, 254, 257, *275*, 275-6, 283, 309n,315n; *cuerda seca* , *284*, *284*; *see also* pottery
Tim, 157, 158; mausoleum, *112*, 112-13, 116
Tinmal, mosque, 269, *270*, 272, *273*
tiraz, 64, 97, 166, 171, 209-10, 282, 299, 308n
Tirmidh, 163; palace, 153, 159, 160; stuccoes, 161, *161*
Tlemcen mosque, 269, 273
Toledo, 83, 101, 277; Bab Mardum mosque (later: Christo de la Luz), 87, *87*, 101, 300; Ibn Shoshan synagogue (later: Santa Maria la Blanca), 300
tombs *see* mausoleums
towers, 150-2,199; *see also* mausoleums; minarets
Transoxiana, 11, 79, 105, 118, 129
'tree of life' motif, 61, 92, 94
Tulunids, 11, 59, 66, 128, 194, 200
Tunisia *see* Ifriqiya
Tur Abdin, 8
türbe see mausoleums
Turfan, 59
Turkey, Turks, Ottoman Empire,viii, 16, 105, 133, 134, 135, 145, 205, 217; *see also* Saljuqs
Turkic people/tribes, viii-ix, 8, 11, 59, 105, 130, 133, 134, 135, 244, 246, 260
Turkish language, 105
Turkmenistan, 10, 116, 129, 149
Tustar, Khuzistan, 165
Tyre, 75

Ukhaydir, palace of, *53*, 53-4, 153, 187, 307n

'Umar al-Murtada, 286
Umayyad, 3, 5, 10, 11, 15, 16, 17, 19, 20, 23, 24, 25, 26, 28, 29, 31, 33, 36, 52, 78-9, 83, 101, 125, 133, 188, 195, 200, 210, 218, 223, 273, 278, 286, 296, 306n, 308n; architectural decoration, 57, 58; art of the object, 59-65, 67, 91-8; cities and palace, 36-51; manuscripts, 73-4, 75; Spanish, 83-101 *passim*, 133, 274, 277, 278, 280
'Uqba ibn Nafi, 33
Urgench mausoleum, 149
Uskaf-Bani-Junayd mosque, 28
Uzbekistan, 10, 116
Uzgend mausoleum, 149

Varakhsha, 59
Veil of St Anne, 301, 319n
Veramin, 178

Wadi al-Natrun, stucco decoration, *290*, 291
al-Walid, 10, 20, 48, 61; mosques of, 22-6, 28, 29, 31
Warqa wa-Gulshah, *262*, 262-3
Wasit, 10, 20, 319n; mosque, 28 palace, 36
wellheads, ceramic, 285, *285*
wheel-cutting technique, 178, 207, *207*, 208
window grilles, *60*, 61, *61*, 92, *92*, 94
wood carving, woodwork, 61, *61*, 199, 200-3, *200-1*, 204, 211, 212, 213, 231, 241, 254-6, *154-5*, 281, 299; bevelled, 66, *66*, 200, 201; carved panels, *64*, *65*, 65-6, *66*, 201, *201*, 202; marquetry, *65*, 65-6, *202*, 202-3, 280; *minbars*, *93-4*, 94-5
writing *see* calligraphy

Yahya ibn Mahmud al-Wasiti, 261
Yahya ibn Umayya, 62
Yaqut al-Mustasimi, 264
Yazd (Yazd-i Kwast), Duvazde Imam tomb, 157, *157*; mausoleum, 146; mosque, 107, 110, 139
Yazid ibn Salam, 20
Yemen, vii, 4, 5, 10, 11, 187, 215, 222-3, 225
Yusuf ibn Naghralla, palace of, 278

Zabid mosque, 225
al-Zahir Ghazi, 227
al-Zahrawi, 258
Zangids, 134, 215, 217, 222, 227, 231, 233, 244, 254, 257, 264
Zaragoza (Saragossa), 277; Aljaferia, 269, 272, *272-3*, 274, 275
Zavareh, *masjid-i Pamonar*, *mihrab*, *160*, 161; mosque, 139, 143-4, *144*, 160
Zawi ibn Ziri, 275
Zirids, 189, 288, 274, 275, 278, 286, 302
Ziryab, singer, 83, 311n
Zivrik Han, *240*, 241
ziyadas, 30
Zoroastrianism, 11, 115, 291, 293